TERRIBLE HONESTY

Ann Douglas has taught American studies at Harvard, Princeton
and Columbia University, where she is now professor of English and
Comparative Literature. Her previously published works include
The Feminization of American Culture.

TERRIBLE
HONESTY

MONGREL
MANHATTAN
IN THE 1920S

ANN DOUGLAS

PAPERMAC

First published 1995 by Farrar, Straus and Giroux, New York

First published in Great Britain 1996 with corrections by Picador

This edition published 1997 by Papermac
an imprint of Macmillan Publishers Ltd
25 Eccleston Place, London SW1W 9NF
and Basingstoke

Associated companies throughout the world

ISBN 0 333 64688 6

Printed and bound in Great Britain by
Mackays of Chatham plc, Chatham, Kent

ACKNOWLEDGMENTS

I have accumulated many debts in the fifteen years I have worked on this book. My first and greatest is to my mother, Margaret Wade Taylor, to whom this book is dedicated. An exemplar of gallantry, loyalty, and fun—the qualities most prized in the era that preceded her own—she has sustained the writer as well as the work.

I have been fortunate in spending the last twenty years in a university department where freedom is possible, perhaps inevitable, and good-heartedness is the stock-in-trade; professional as well as private aid has come steadily from my Columbia colleagues Jack Salzman (of the Center for American Cultural Studies), Marcellus Blount, Andrew Delbanco, and George Stade, all of whom read various chapters and offered valuable criticism. Robert Ferguson and Priscilla Wald read it all, early, and meticulously; they pointed the way at every turn. Jean Howard's arrival at Columbia in 1988 changed my life and this book immeasurably for the better; her intellectual authority, warmth, and sheer high spirits blew the door open and made the world a bigger, more exciting place. The other members of the Jean Howard Reading Group at the Gender Institute, Martha Howell, Carolyn Walker Bynum, Elizabeth Blackmar, Natalie Boymel Kampen, and Elaine Combs-Schilling, also read and commented incisively on portions of the manuscript. I am indebted to several chairpersons who permitted extensive leaves and safeguarded my welfare, especially Joan Ferrante, David Kastan, and Michael Seidel. Heartfelt thanks are due a number of younger scholars who worked with me as graduate students, particularly Lisa New, Claire Rossini, Julia Stern, Meryl Altman, Chris Castiglia, Tan Lin, Julie Abraham, Patrick Horrigan, and Augusta Rohrbach; I have learned a great deal about American culture from their work. I am grateful to all the Columbia undergraduates who took courses

with me between 1979 and 1993 based on the materials in this book; their participation provided the sharpest, most accurate readings of my own interpretations.

I have been inspired by my greatest teachers in and out of the classroom: Perry Miller, Alan Heimert, Morton Bloomfield, Carl Schorske, Peter Wood, Michael Walzer, D. W. Robertson, Norbert Bromberg, and Howard Mele. I owe thanks to the National Center for the Humanities, where I began this book on a fellowship in 1978–79, and to the National Endowment for the Humanities, whose grant allowed me to finish it in 1993–94.

For the last twenty-five years I have been blessed with the example of my friend Elizabeth Kendall, whose extraordinary writing on American culture has been a model for my own; she read the book in all its drafts and offered invaluable criticism. Margo Jefferson, to whom this book is also dedicated, my teacher, friend, and collaborator within and without the university, brought her matchless knowledge and love of popular American culture to this book and its author; she could be said to take up where Perry Miller left off, and she has been the finest critic of my work's strengths and weaknesses. Without her lectures, reviews, and essays, her library and record collection, her generosity of mind and astonishing precision of insight and expression, it would not be here; if America is, as some of its founders called it, a "republic," Margo uncovered for me its true dimensions and gave me my freedom in it. I would also like to acknowledge the contribution of the late Jay Fellows, my companion in the darkest years, who encouraged me to pick up this book when I had abandoned it; he was there, listening with a superb intelligence that made me rise to whatever heights I could sight. It is the regret of my life that he did not live to better what we shared.

A number of other friends steadied my course in the last six years, particularly Martha McAndrew, Charles M. Young, the late Gay Brewster and his wife, Marjorie, Greg Panger, Marcia Bromberg, Bill Lewis, and, above all, the incomparable Eileen Fitzpatrick. Karen Hornick was splendidly helpful, and my photo researcher, Enid Klass, was tireless, meticulous, and inspired. I thank my agent, Loretta Barrett, whose boundless interest in the project in all its drafts provided enthusiasm, criticism, and hope. My brilliant editor, Elisabeth Sifton, who often seemed to know more about my subject than I did, vastly improved the book's organization and prose; she asks the best of an author, and her idea of the best is as creative as the mind itself. Finally, thanks also to Laura Van Wormer, who read the book, saved its author, and told me I was writing about "the soul of a generation."

FOR

MARGARET WADE TAYLOR

AND

MARGO LILLIAN JEFFERSON

WITH GRATITUDE AND LOVE

CONTENTS

CONTENTS

TERRIBLE HONESTY

ORPHANS: LOSS AND

LIBERATION

I am by trade and calling an Americanist, and I believe, contrary to much current academic opinion, that America *is* a special case in the development of the West. To say otherwise is, I think, to ignore plain fact. From the start the nation has had a tangible and unique mission concocted of unlimited natural resources, theological obsessions, a multiracial and polyglot population, and unparalleled incentives and opportunities for democratization and pluralism that culminated in the early modern era in the development of the media, all initially based in New York. Those media have for seventy-odd years now provided much of the world, for good and bad, with its common language. I also believe there is a national psyche; I have attempted to catch the American psyche in perhaps its most revealing moment, the decade after the Great War (as this generation called World War I), when America seized the economic and cultural leadership of the West.

At home and abroad in the 1920s, the nation was usually referred to not as the "United States" but as "America." The term the "United States" admits to possible divisions among separate parts of the national self; this relatively modest title did not come into wide circulation until the 1930s, the era of the Depression and growing worldwide Fascism, when the limits of American power became painfully visible. Americans in the 1920s liked the term "America" precisely for its imperial suggestion of an intoxicating and irresistible identity windswept into coherence by the momentum of destiny; this generation had little reason to anticipate history's hardest lessons.

It was not until the 1950s that the American economist W. W. Rostow coined the term "takeoff" to mark the moment when a national economy becomes self-sufficient, self-propelled, but America's greatest takeoff occurred in the late 1910s and 1920s. All historical circumstances in the 1918–

3

28 decade—America's exemption from the economic consequences of the Great War, a war that devastated its European and English rivals, the congeniality of the violent and innovative mood abroad to America's longstanding cultural disposition, and its possession of new technologies and unsuspected treasures of elite and popular art of major importance to modern needs—these seemed effortlessly to conspire to assure the country's global preeminence. America at the close of the Great War was a Cinderella magically clothed in the most stunning dress at the ball, a ball to which Cinderella had not even been invited; immense gains with no visible price tag seemed to be the American destiny. "We were the most powerful nation," wrote F. Scott Fitzgerald, summing up the elated and cocksure mood of the postwar generation in a 1931 essay, "Echoes of the Jazz Age." "Who could tell us anymore what was fashionable and what was fun?"

The era that saw America become the world's most powerful nation also saw New York gain recognition as the world's most powerful city. The census of 1920 declared America for the first time in its history an urban nation, and New York was the largest city in that urban nation. Chicago was on the rise as well, Washington and Boston had their champions, but New York was the first, and to date the last, American city to become, in the phrase popularized by the German cultural historian Oswald Spengler in *The Decline of the West* (a best-seller in translation) a "World City"; Spengler considered New York's rise "the most pregnant event of the nineteenth century." In a letter of 1921, Scott Fitzgerald, abroad for his first extended visit to England and Europe, chided his friend the New York critic Edmund Wilson for his Anglophile views. "Culture," Fitzgerald told Wilson in a brilliantly American dictum, "follows money"; New York, not London, will soon be the "capital of culture."

In the decade after the war, America entered its own post-colonial phase. Newly fascinated with their own cultural resources, the American moderns repudiated the long ascendant English and European traditions and their genteel American custodians as emblems of cultural cowardice; they were proud to learn that they spoke, not English, but "The American Language," as H. L. Mencken officially named it in a monumental and witty study of 1919. Still more important, Americans, black and white, discovered their African-American heritage of folk and popular art; the deepest roots of American culture, it appeared, lay in what the black leader W.E.B. Du Bois described as the Negro's endlessly exploited and long unacknowledged "gift of story and song." The last was indeed first, and the "Talented Tenth" (Du Bois's phrase) of America's black men and women in the 1920s chose the term the "New Negro" to describe themselves; it signaled a fresh beginning, a conscious, organized, and insistent access of power to those whom America

had robbed and dismissed. They also spoke, not, as we usually do today, of "African Americans" (or "African-Americans") but of "Aframericans" and even of "Aframerica." They knew that their race had an American lineage at least as long and comprehensive as any white American could boast.

The situation was thus one of complex and double empowerment; at the moment that America-at-large was separating itself culturally from England and Europe, black America, in an inevitable corollary movement, was recovering its own heritage from the dominant white culture. My book is an attempt to describe, first, the larger American emancipation and, then, the African-American movement of liberation within it. Although these movements can be and usually are studied separately, they are at bottom, as the terms "Aframerica" and "Aframericans" were meant to suggest, inextricable; whites and blacks participated and collaborated in both projects. White consciousness of the Negro's rights and gifts (however severe the limitations of that consciousness) and black confidence that Negroes could use white models and channels of power to achieve their own ends (however mistaken time would prove that confidence to be) reached a peak of intensity in the 1920s never seen in American history before or since. This black and white collaborative energy crested in New York.

A good part of New York's cultural preeminence and power in the 1920s came from the simple fact that New York was chief mecca to the hundreds of thousands of Negroes emigrating from South to North in the Great War years and bringing their "gift of story and song" with them. It was in the 1920s that Harlem became "Harlem" in the sense in which we use the word today; uptown Manhattan was now a black metropolis, what the African-American writer James Weldon Johnson hailed as "Black Manhattan," and it hosted the dazzling array of black talent and ambition celebrated by blacks and whites as the "Harlem Renaissance." No other American city of the 1920s was as receptive to black talent as New York was; no other city pioneered in black and white art and entertainment to the degree New York did. Harlem Negroes, whatever their point of origin, Johnson explained in *Black Manhattan* (1930), "become New Yorkers astonishingly soon"; they fit right in with a "truly cosmopolitan" city like New York, whose "natural psychology [is] . . . to minimize rather than magnify distinctions." Only a "World City" is vast enough to welcome extreme ethnic and racial diversity and concoct the brew of blasé tolerance and vividly random curiosity that is the New York style.

Dorothy Parker, the city's wittiest muse, planned to entitle her autobiography (never written) "Mongrel." Parker was presumably referring to her own mixed Jewish and Wasp heritage, but she could have been talking of racially and ethnically mixed "mongrel" Manhattan; indeed, conservative race ideo-

logues of the day used the word "mongrelization" to describe (with horror) the imminent era of miscegenation. My own focus will be more on the whites than on the blacks—my perspective is perhaps inevitably a white one—but it should not be forgotten for a moment that in the 1920s Manhattan was, to appropriate the title of a sketch Parker published in the late 1920s about the new racially mixed social scene, an "Arrangement in Black and White."

The two movements, cultural emancipation of America from foreign influences and celebration of its black-and-white heritage, had for a brief but crucial moment a common opponent and a common agenda: the demolition of that block to modernity, or so she seemed, the powerful white middle-class matriarch of the recent Victorian past. My black protagonists were not matrophobic to the same degree as my white ones were, but the New Negro, too, had something to gain from the demise of the Victorian matriarch.

White middle-class women had seized the reins of national culture in the mid- and late-Victorian era. Harriet Beecher Stowe wrote the century's biggest best-seller in *Uncle Tom's Cabin* (1852) and consolidated the virtual stranglehold of America's women authors on the fiction market. Frances E. Willard headed the Women's Christian Temperance Union, which made prohibition the law of the land in 1919; her followers prayed "God or Frances E. Willard help me!" Mary Baker Eddy founded Christian Science and emerged as "Mother Mary," shrewd dictator of an economic and religious empire. The reformer Carrie Chapman Catt enlisted a President as her ally and eulogist and won the vote for women in 1920. The woman's movement these leaders represented propagated a moralistic posture of Anglo-Saxon racial exclusivity and lobbied for a sentimentalized God stripped of masculine authority and made over in the image of the matriarch herself, a God who had become, in Eddy's term, the "Father-Mother God." In calling these women "matriarchs," I follow their own usage; this was the first generation of women to explore, however imprecisely, the notion of "matriarchy," or female-dominated society, and to make it their goal and ideal.

The moderns aimed to ridicule and overturn everything the matriarch had championed. Parker curtly dismissed the "pure and worthy Mrs. Stowe" as "mother, wife and authoress" and added, "Thank God, I am content with less!" Kenneth M. Goode and Harford Powell, Jr., advertising men, informed the world that a typical American schoolboy, asked to identify Frances E. Willard, labeled her, perhaps not altogether erroneously, "an American pugilist." Eddy was attacked by leading male modernists from Ernest Hemingway to Langston Hughes. The men and women who succeeded Carrie Chapman Catt scorned the suffrage crusade she had led and championed the Negroes she had intended to banish.

Of course, the situation was not so simple or straightforward as the moderns' matricidal declarations and acts would have us believe. For starters, the Victorian matriarch was less powerful and less privileged than her attackers took her to be. The moderns were fiercely astute about her failings, but many of these failings can be attributed to her lack of real political and economic power, to her efforts to compensate in terms of moral and cultural influence for the responsibilities and rights she was denied in the economic and political realms. One might argue that the apparent ascendancy of the matriarch in the high Victorian period and her subsequent demolition in the early twentieth century constitute nothing but a crisis in a firmly patriarchal or male-dominated culture; women getting a little power in a society that preferred them to have none were perceived as monstrous usurpers and punished within an inch of their lives. There can be no doubt that the Victorian matriarch was scapegoated by her descendants; the ills of an entire society were laid at the door of the sex whose prestige is always held expendable.

But the moderns' case against the white middle-class Victorian woman is nonetheless a pressing one. Although nineteenth-century America may have been in historical fact far from the matriarchy its feminist leaders envisioned and idealized, its mainstream cultural expression was almost as "feminized"—the word the urban moderns repeatedly used to condemn Victorian American culture—as its later detractors claimed. It is easy, I think, to underestimate cultural power, particularly cultural power like the Victorian matriarch's, that is grounded largely in religious organizations, beliefs, and practices; many people today do not consider religious expression a crucial arena in a society's life. We do well to remember that neither the Victorians nor the moderns shared this appraisal. I myself believe that America's identity was, and is, at bottom, a theological and religious one; I also believe that conscious and acknowledged cultural influence, however distorting its effects when not backed by full political and economic responsibilities, is indeed power. The matriarch's authority, however the moderns exaggerated it, was the ascendant cultural force in late-Victorian America, and it did not disappear after the Great War.

The moderns themselves could not altogether sever the umbilical cord; the very weapons they used against the matriarch were borrowed without acknowledgment from her arsenal. T. S. Eliot's poem *The Waste Land* (1922), one of the central masculinizing documents of the era, hailed by James Joyce as the poem that ended "the idea of poetry for ladies," is, in Eliot's own phrase, a "nerves monologue"; *The Waste Land* is the unmistakable product of a long feminine gynophobic and gynophiliac tradition of overwrought poetry, hysteria, and Spiritualist séances. The New Negro bor-

rowed from the white middle-class woman's movement, too. An influential 1920s urbanologist, Robert Park, dubbed the Negro "the lady of the races," and the New Negro, in devising his strategy of self-empowerment through cultural ascendancy rather than direct economic or political protest, was following the example of his white feminine predecessors even as he overturned their racist assumptions. Moreover, the moderns' finest achievements in popular culture, from Al Jolson's vaudeville act to the new skyscrapers of Manhattan, had secret roots in the older matriarchal culture they opposed.

The matrophobia of the moderns was not only unfair to the Victorian women it criticized but ambivalent and unresolved, complicated by unexplored issues of gender and race difference, and blind to the psychological consequences such resistance entails. Revolutions in consciousness so radical are bound to fall short of completion, and it is better for those engaged in them that they do; violent repudiation always spells undiagnosed need for what is repudiated. But the fact remains: in an era of open lawbreaking, symbolic matricide was the crime of choice, and it affected American culture in crucial ways.

Thanks to the revolt against the matriarch, Christian beliefs and middle-class values would never again be a prerequisite for elite artistic success in America. Nor would plumpness ever again be a broadly sanctioned type of female beauty; the 1920s put the body type of the stout and full-figured matron decisively out of fashion. Once the matriarch and her notions of middle-class piety, racial superiority, and sexual repression were discredited, modern America, led by New York, was free to promote, not an egalitarian society, but something like an egalitarian popular and mass culture aggressively appropriating forms and ideas across race, class, and gender lines. This culture billed itself as irreverent if not irreligious, the first such in American annals, alert to questions of honesty but hostile to all moralizing. The tone might be as dark as Parker's bitter bons mots and Bessie Smith's grief-and-rage-struck blues or as lighthearted as Eubie Blake's piano rags and Fitzgerald's happiest harlequinades, but the primary ethos of all the urban moderns was accuracy, precision, and perfect pitch and timing. It was an ethos the white moderns labeled "terrible honesty." (The phrase was Raymond Chandler's.)

Terrible Honesty is a sequel of sorts to my earlier study of Victorian culture, The Feminization of American Culture (1977), in which I documented the matriarchal ethos at work in the arenas of reform, theology, literature, and gender definition in the mid-nineteenth century. That study was inevitably, I think, located in New England; my current study is just as inevitably focused on New York.

In the mid-Victorian era, P. T. Barnum, fabulous entertainer, circus

entrepreneur, and father of public relations, found a willing audience for his freaks and stunts and hoaxes, not in his native New England (where he was occasionally run out of town or arrested for libel), but in New York, where audiences were pleased, as the cultural critic Constance Rourke wrote in *Trumpets of Jubilee* (1927), by the "pains" Barnum had taken "to delude them on so preposterous a scale." Barnum's greatest heir, the New York journalist Robert Ripley, creator in the 1920s of the wildly successful and long-lived "Believe It or Not" column, claimed he had gotten "rich off the ridiculous—the dirt-cheap unbelievable antics of humanity"; "their folly," he summed up the Barnum ethos, "is my fortune." Ripley clearly meant to speak of all mankind, but his words can be appropriated to a more specific situation. It is worth remembering that the overearnest and rapacious Victorian matriarchs whom the 1920s metropolitans aimed to ridicule, if not eradicate, were in the main New Englanders like Eddy and Stowe or Midwesterners who were New Englanders by origin like Willard and Catt. When New York found its fun in the pious and pompous follies of New England, and did so via syndicated columns, movies, radio programs, and recorded songs that reached national and global audiences, the modern era began.

Nineteenth-century New England had played sponsor to the Victorian reform impetus, and New York was long regarded by reformers as a too-secular holdout against the vision of America espoused by the seventeenth-century Founding Father John Winthrop as the "city on a hill," a beacon to the corrupt Old World. Concord's Transcendentalist seer, Ralph Waldo Emerson, confessed in 1840 that he "always suffered some loss of faith" in cities. A few years later he told his adventurous friend the writer and feminist Margaret Fuller—Fuller was then preparing to abandon Boston for New York—that in New York the "endless rustle of newspapers" made him feel "not the value of their classes, but of my own class–the supreme need of the few worshippers of the Muse"; he disliked what he suspected was New York's hunger for a mass audience. But he apologized for his "poorness of spirit"; he knew he was failing some important and especially American test. In his next "transmigration," he wrote Fuller, he would "choose New York."

One can't be sure if a transmigrated Emerson did one day settle in New York, but many people chose New York in the years to come. In 1927, the English tourist and novelist Ford Madox Ford recorded his impressions of the city in a book entitled with bravado *New York Is Not America*. There can be, he rejoices, no "governing Middle Class," no consistent moral consensus, in a city flooded by a tidal wave of commuters, immigrants, and blacks; no single university dominates the New York scene as Harvard presides over Boston's intellectual life. Instead, Ford has discovered a "gay, charming,

and artistically harmless smart set" flourishing in the "City of the Good Time." "To be rich and gay" is the supreme end of life, Ford reports, in the only definitively anti-Puritan metropolis in America. Ford loved New York; later, in the Midwest, he relished a man's refusal to permit his wife to be seated with Ford on a lecture platform because it was known that he had come to this particular nest of Babbitts straight from New York. He noted with equally little concern that New York lacked history as well as morals. There are few sights worth seeing in his opinion, no Tower of London, no Liberty Bell.

Ford's take on New York is superficial but not altogether inaccurate. Observers have long noted that New York is the largest city in the world that is not a capital city. To date, moreover, the city has given its country only one President, Theodore Roosevelt. Albany took the capitalship of the state from New York in 1797; New York was capital to the nation only briefly, from 1785 to 1790. Abigail Adams regretted the shift of government headquarters to Philadelphia. "When all is done," she remarked succinctly, "it will not be Broadway."

The creation of Washington, D.C., in the 1790s as the national capital is usually attributed to the eighteenth-century American penchant for remote, uncrowded, and uncorrupted sites and the need to strike a compromise between North and South. But the choice of Washington had other sources, too. America is the only major Western nation whose capital city was deliberately built to be that, the only country whose capital is a kind of showcased national toy. With its laid-out avenues, its stately replication of monuments, its uniform quasi-classical architectural manner, Washington seems deliberately antithetical to New York's stylistically jumbled assemblage of buildings and chaotic profusion of commercial enterprises, all advertising New York's, and America's, ethnically and racially diverse population. Fittingly, late-nineteenth-century Washington sponsored the literate and refined culture of the educated middle-class Negro while New York played host, a few decades later, to Aframerica's most indigenous and characteristic popular music, dance, and humor, all directly derived from the ill-educated multitudes of the Negro "folk."

In the eyes of its critics, New York's historical record left much to be desired. Any large city represents intricate problems in economic and cultural development that have little to do with progress, and the notion of progress, a progress fueled by highly visible ideals, is at the heart of America's understanding of its own history. New York is particularly elusive in these terms. Even the parvenu Chicago, not incorporated until 1833, is more palatable, or at least more easily sighted, from this perspective than its older metropolitan competitor in the East. Chicago—with its extraordinarily rapid

growth, what Morris Mackey unkindly called in *The New Yorker* on March 12, 1927, its "portentous stupor of gestation," its entangling dependence on several huge industries, its frantic efforts to be the worst or best of cities, its ongoing compulsion to explain and romanticize itself—fits into the feverishly moralized patterns of empire that Americans often confuse with history. New York simply does not.

According to all accounts, the Dutchmen who settled "New Amsterdam" were more interested in financial advancement and security than in establishing religious truth. Unlike the English dissenters who settled New England, the Dutch brought their festivals with them and kept them alive; the Atlantic seaboard colony was pleasure-loving and tolerant from the start. In the 1640s, the rebellious Anne Hutchinson was allowed to take refuge in Long Island (where Indians massacred her) after Boston exiled her for heresy. A few Quakers were persecuted by Governor Peter Stuyvesant in the 1640s and 1650s, but New York's inhabitants issued him a "Remonstrance," as did the Dutch West India Company. In the 1690s, the New York population assimilated a Jewish community of forty-three members and their synagogue. In marked contrast to Boston, no serious witch scares broke out.

New York's patriotic services to the nation were negligible. The American Revolution took place in New York as well as in Virginia and Massachusetts, but there were no stirring words about "liberty or death" uttered in New York for later schoolchildren to memorize; no single shot "heard round the world" was fired in or near the metropolis. The battles of Brooklyn Heights, Throgs Neck, and White Plains in 1776 were British victories; Americans won a modest victory at Harlem Heights on September 26, 1776, merely keeping the British temporarily at bay. The city soon became the British and loyalist headquarters; native inhabitants left it in large numbers, and only the British and German troops domiciled there, flanked by what two recent historians of the city, George Lankevich and Howard Furer, have wryly termed "a large and grasping corps of prostitutes," kept the city's population at a mere 12,000. The New York delegation to the Continental Congress abstained from voting. Matters did not improve in later times of national crisis. South Carolina threatened to secede from the Union in 1860; so, briefly, did New York, or at least its controversial mayor Fernando Wood and its leading businessmen. It was duly noted that fewer Columbia students left school to fight in the Civil War than Harvard or Yale men.

In 1902, after decades of rule by the Tammany machine, a reform administration took office under Mayor Seth Low, former president of Columbia University. Lincoln Steffens, then doing the muckraking research for his pioneering book *The Shame of the Cities* (1904), found Low's government the best of any large American city. Yet Low's regime lasted only one year;

in 1903, New Yorkers voted in the corrupt Tammany candidate, George McClellan, on the grounds, as far as Steffens could determine them, that they "do not like the way [Low] smiles." Steffens noted, "It was precisely the righteousness of the reform magistrates that was unpopular"; New Yorkers like the "human element." Jimmy Walker, the "Nightclub Mayor" of the 1920s, was the "human element," New York style, incarnate.

The journalist Franklin P. Adams, who published under his initials F.P.A., thought that Walker was "a light-hearted and frivolous-minded person very like myself." Thousands of less sophisticated New Yorkers identified with the mayor just as easily. Walker was forced to resign his office in 1932 for countenancing corruption, but New Yorkers missed him. As Robert Benchley remarked, where the reformer saw a "criminal," the New Yorker might find "darned good company." A poll of 1944 showed that Walker was still the people's first choice for mayor, topping even the incumbent Fiorello La Guardia; for his part, Walker always warmly acknowledged La Guardia as the best mayor New York had ever had.

The debonair Walker came from working-class Irish stock; however dilatory and scant his reform impulses might be, his sympathies were with the people and they knew it. His most popular act in office was his successful opposition in 1928 and 1929 to the IRT subway's proposed seven-cent increase in fare. He showed little prejudice against blacks or ethnic minorities; he lifted the restriction against the hiring of black doctors at Harlem Hospital, and he was among the few public officials who greeted Charles Lindbergh in 1927 after his trans-Atlantic flight and found no need for oratorical references to Lindbergh's Nordic lineage. In the 1940s, La Guardia shocked his admirers by giving the disgraced Walker a well-paid municipal job. La Guardia was known for his racially and ethnically sensitive politics; perhaps he recognized in Walker an ally, if one in nightclub dress.

Walker's hostility to Victorian ideals was marked, and he discounted as hypocrisy the belief that a civic post dictates impeccably moral behavior to its occupant. Though married and Catholic, he squired Ziegfeld girl Betty Compton to the city's top night spots, particularly his favorite, the Casino in Central Park. "It's Jim Walker's life I'm living," he asserted. "It's not La Guardia's life, nor Benjamin Franklin's life, nor Carry Nation's life, but my own." Walker took 149 days off in the first thirty months of his tenure, but who paid for his lengthy vacations and why seemed to him questions that touched him, if at all, outside his official capacity. Reproached for the high salary he pulled in, a salary actually raised by $15,000 just after the Crash, he quipped: "That's cheap. Think what it would cost if I worked full-time!"

Walker's morals were hazy; under Judge Samuel Seabury's pressure during the investigation into the misdeeds of his administration in 1931, he made

the lame admission, "If it's unethical, it's wrong." Franklin Delano Roosevelt, then governor of New York State and running for President, engineered Walker's resignation on September 1, 1932. But Walker had his own ethics. He remained an admirer of the Roosevelts, particularly of Eleanor; in the end, he held no one to blame for his fall but himself. Of course, he voted against Roosevelt in the 1932 Democratic primary, but that was not personal: Al Smith, F.D.R.'s colorful opponent, was the Tammany choice. Walker's very flamboyance was laced with a stringent sense of discipline. Insouciant but never soft, he dressed à la mode and installed a dressing room under his office in City Hall where he changed his clothes three times a day. His wife, Alice, didn't darn his socks, she once explained, because he never wore them out. He was equally precise in his manner; all the messy emotions—regret, reproach, anger, need—were foreign to him.

Walker was not an educated man or a man interested in education. A *New Yorker* profile of 1925 noted without disapproval that he had read only six books in the last fifteen years. Instead, "he has leaned heavily on the alertness of his own mind." Walker liked to say that he learned "by ear"; he was as quick and as casual as the city he loved, "loved" in his words, "more than anything in the whole wide world." As a young man, he had frequented vaudeville theaters and turned out songs for Tin Pan Alley; in 1908, he'd had a hit in "Will You Love Me in December as You Do in May?" A witty extempore speaker, Walker was a master of the wisecrack, and he found no situation that could not be enlivened by a jest. On one occasion, a heckler stood up at a public gathering Walker was addressing and yelled, "Liar!" "Now that you have identified yourself," Walker replied, "please sit down." When a delegation of Swiss admirers presented him with a 500-pound cheese at City Hall, Walker thanked them and asked, "Will some-one run out and get me a cracker?" On the night of his death in 1946, it was fittingly the restaurateur Toots Shor who provided his epitaph: "Jimmy! Jimmy! When you walked into the room, you brightened up the joint!"

If America told the world, to recall Scott Fitzgerald's words, "what was fashionable and what was fun," New York headed the enterprise. Modern American culture, with its mongrel markings, its extremes of formalism and commerciality, of avant-garde innovation and media smarts, of sheer elation and hard-core despair, is unimaginable without New York City. New York, as Ford Madox Ford suggested, might or might not be America, but in the 1920s the city was cornering, expanding, and reinventing the nation's cultural market, and it summoned a far-flung generation to its service.

Consider the literary field. Boston had been America's literary capital in the early nineteenth century, and most of the writers we associate with Boston, from Ralph Waldo Emerson and Catharine Maria Sedgwick to James

Russell Lowell and Nathaniel Hawthorne, were born and lived there or near there. Boston published what Boston supplied and could monitor: integrity itself. In the mid-nineteenth century, however, New York publishers began to lure New England writers to their rosters. Thanks to new marketing and advertising strategies and a series of technological breakthroughs, the Harper brothers were increasing the sales potential of books to mass-culture dimensions, and by the late 1850s their firm was the biggest publisher, not just in America, but in the world. Harper's aggressive tactics of modernization, promotion, and theft had turned what had been a profession or a trade into a big-business venture, and in the next half century or so, New York's publishing edge became a virtual monopoly.

The first book clubs, the Book-of-the-Month Club and the Literary Guild, founded in 1923 and 1926 respectively and dedicated to polling and publicizing "best-sellers," a marketing invention of the 1900s and 1910s, were located in New York. The city could also boast the country's most successful "tabloid," a phenomenon new in 1919, the *Daily News*, with a circulation of roughly one million, and its liveliest newspaper, the *World*, the paper that perfected the syndicated column and the Op-Ed page and served as predecessor and model to the city's most characteristic and modish magazines, *Vanity Fair*, *Smart Set*, and *The New Yorker*. Publishing and printing now comprised New York's second largest industry after the making of women's garments. New York in the 1920s could boast more, many more, famous writers on its rosters than Boston had ever claimed, but most of them were outsiders and émigrés, drawn to the city by its publishers, theaters, and promotional know-how and daring. If Boston's literary stars had been homegrown, New York's were largely imports. What had been born elsewhere came to maturity, and the spotlight, in New York.

New York was also America's music capital in the 1920s, though the city had not initially monopolized the music business any more than it had publishing. Sales of sheet music laid the foundation for the modern music industry in America, and in the 1870s music publishers like Oliver Ditson in Boston, Lee and Walker in Philadelphia, John Church in Cincinnati, and Root and Cady in Chicago were serious competitors to New York companies. By 1900, however, the New York firm of T. B. Harms had conclusively beaten its rivals, and its success meant that the nascent recording industry was centered in New York as well; radio, first marketed as a domestic utility in 1920 and increasingly dominated by New York's NBC network (founded in 1926), provided air play and promotion. Just as nineteenth-century authors had been irresistibly drawn to Harper's new mass-marketing techniques, musicians of the postwar decade followed the new sound media to Manhattan.

Elegant Duke Ellington, Harlem's premier jazz bandleader and composer in the 1920s and long after, was born in Washington, D.C. Looking back on the creation of jazz from the perspective of 1960, Ellington noted that musicians were beginning to play the new music in the 1910s, not in New York, but in the West Indies, New Orleans, and Chicago, the first real Northern jazz stronghold. Not, however, until all these musicians (including himself) "converged in New York and blended together" in the early and mid-1920s, in Ellington's view, did jazz emerge as a widespread and recognized popular art form. The conglomerate of music publishers, practice and tryout rooms known as Tin Pan Alley, originally on West Twenty-eighth Street but moving up to the Times Square area in the 1920s, the increasingly powerful American Society of Composers, Authors and Publishers (ASCAP) founded in 1914, the country's best-known musicians, composers, lyricists, and singers, its most important booking agencies, radio networks, recording studios and labels, and the theatrical enterprises in which songs, performers, and songwriters found their best showcase—all were, if not native to New York, firmly transplanted and centralized there by the mid-1920s. What the city did not supply, it could attract, seduce, and control. "The whole world revolves around New York," Ellington concluded. "Very little happens anywhere unless someone in New York presses a button."

New York did not lead the nation in all business enterprises, however. Wall Street might supply the financial backing and negotiating table for American industry, but the city housed none of the hard-core industries—auto manufacture, meatpacking, iron and steel—that made Detroit, Pittsburgh, and Chicago urban employers on an immense scale. Indeed, James Weldon Johnson argues that Manhattan became the capital of Negro life in the 1920s precisely because it did not attract the "semi-skilled" workers whose best job opportunities lay in the big industries that New York lacked; it was the more artistic and cultivated Negroes, Johnson claims, who headed for New York and its rapidly expanding, commercializing cultural scene. New York was the center of the consumer's, not the producer's, life; its energy was as much a matter of appetite as activity. Packaging knowledge as information and dramatizing ideas as style, New York's essential product was attention itself. You might do the work of "making" outside the city, but you "made it" in New York, and everyone who was anyone knew it.

New York's population doubled between 1910 and 1930; among its new inhabitants were Scott and Zelda Fitzgerald, Sinclair Lewis, Elinor Wylie, Hart Crane, Sara Teasdale, Katherine Anne Porter, Thomas Wolfe, Edna St. Vincent Millay, Marianne Moore, Louise Bogan, Edmund Wilson, Robert E. Sherwood, Edna Ferber, John Dos Passos, George S. Kaufman, Ludwig Lewisohn, Gilbert Seldes, Van Wyck Brooks, Katharine Cornell,

Laurette Taylor, Charles Gilpin, Paul Robeson, Zora Neale Hurston, Noble Sissle, Eubie Blake, Langston Hughes, Nella Larsen, Rudolph Fisher, Claude McKay, Duke Ellington, Ethel Waters, Bix Beiderbecke, Cole Porter, Arna Bontemps, Jean Toomer, Wallace Thurman, Damon Runyon, Gene Fowler, Robert Ripley, Robert Benchley, James Thurber, E. B. White, Al Jolson, Babe Ruth, Hubert Fauntleroy Julian, Harry Houdini, and architect Raymond Hood. Although there were some natives on the scene—Jimmy Walker, Eugene O'Neill, Heywood Broun, George and Ira Gershwin, Lorenz Hart, Jerome Kern, Walter Winchell, Moss Hart, Walter Lippmann, and Fats Waller were all born and raised in New York—the overwhelming majority of the artists and performers who became identified with what Fitzgerald christened "the metropolitan spirit" were arrivistes, arrivistes filled with excitement and eager to escape their hometowns, the places F.P.A. liked to refer to collectively as "Dullsboro."

In the early and mid-1920s, Louise Brooks, a teenaged *Ziegfeld Follies* girl at the start of what would be a brief but memorable career as a dancer and movie star (most notably as the irresistibly amoral prostitute Lulu in G. W. Pabst's *Pandora's Box* of 1928), was photographed and written about as the essence of New York style. "Exquisitely hard-boiled," in the words of an April 1926 *Photoplay* story on "Manhattan Technique," she knew how to "BE COOL AND LOOK HOT." Brooks was one of the first American performers to introduce the Charleston—a Negro dance which debuted on the New York stage in 1923 in a black musical revue called *Runnin' Wild*—to eager Parisians. But Brooks was born and raised in Kansas, not New York. Restless and utterly self-assured, she had a sense of destiny young; she started dance lessons at eight and was performing as a paid professional by ten. By 1920, the fifteen-year-old Brooks knew herself to be "the secret bride of New York," and when, a year later, she got off the train from Wichita and looked around Grand Central Terminal, she "fell in love with New York forever."

Many other migrants responded to the city with the same intensity. The young black poet Arna Bontemps came to New York from Los Angeles (where he'd worked in the post office) in the summer of 1924; he found in Harlem's thronging Negro population and excited collective life a "foretaste of paradise." Hart Crane, who arrived in the city from Ohio in 1916 when he was seventeen, pronounced it "the most gorgeous city imaginable" and put his family on notice: "Believe me when I tell you that I am fearless . . . [and] determined on a valorous future and something of a realization of life." "How do I like New York?" the twenty-year-old Edna St. Vincent Millay wrote her mother and sisters back in Camden, Maine, in February 1913: "O inexpressibly!"

Although Dorothy Parker's family were New Yorkers, Parker was educated

in Morristown, New Jersey; as an adult she spent months abroad and years working in Hollywood. But she said little and wrote less about her travels or her background, her non-New York experience; her pose was that of a modern Athena sprung armed and glittering with malice from the city's pavements. Almost all Parker's stories are set in New York, but she gives no details of the scene; she never describes a building or a street. One senses that she doesn't need to; in her work New York is not a place but a world, even a world order, and her stories are imbedded there as in the inevitable. In a profile of her friend the New Jersey–born critic and radio host Alexander Woollcott, for *Vanity Fair* in 1934, Parker paused for a wonderful moment to remark: "Then he came to New York. Don't we all?"

When Parker's generation "all" came to New York, modern New York as we still know it today, with its skyscrapers, tunnels, bridges, and adjacent speedways, was under noisy and, it seemed, perpetual construction. The years between 1923 and 1931 saw the building of the Bronx River Parkway (1923), the Hutchinson River Parkway (1928), the Saw Mill River Parkway (1929), and the Cross County Parkway (1931). The Holland Tunnel was finished in 1927 and the George Washington Bridge in 1931. Between 1918 and 1931 the number of cars in New York jumped from a modest 125,101 to 790,123, a gain of roughly 600 percent; by the late 1920s, there were more cars in New York than in all of Europe. In 1929 and 1930 alone, five major skyscrapers—the Bank of Manhattan Trust, the Chrysler Building, the Chanin Building, the Daily News Building, and the Empire State Building—were finished or in process. New York as a feeding system to and from the world, as a coiled, concentrated, and competitive series of innovations, as an architectural advertisement of modernity, as what Walter Lippmann called in *A Preface to Morals* (1929) "a dissonance comprised of a thousand noises," was literally being hammered into place. In the course of the decade the humane and witty F.P.A. recorded in his "Diary of Samuel Pepys" column a growing irritation with New York's volume. He suffers from "Hammeraphobia"; he orders a partition built around his desk as sound-proofing. He notes his small son's remark near the elevator, "I can't hear me." As Edna St. Vincent Millay wrote home: "In New York you can *see* the noise!"

On November 13, 1929, *The New Yorker* remarked that the city had never before been so "torn up"; "One does not have to wait if one wants archae-ology." New York's volume is a sign of its protean ability to assume new shapes and discard old ones; the city changes before your eyes. The physical and architectural upheaval of the city was a symbol of its inner spirit. If Boston in the seventeenth, eighteenth, and nineteenth centuries had played host to the "American mind," as many historians, with Perry Miller at their

head, have believed, New York in the twentieth century was the site of something far more important: the American mood. Raymond Chandler once remarked that "Americans are of all people the quickest to reverse their moods," and New York was where these reverses were manufactured and recorded. Trendsetter to the nation and the world, New York finds its job in the commercialization of mood swings: the city translates the shifting national psyche into fashions of all kinds, from ladies' frocks and popular music to Wall Street stocks, ad layouts, and architectural designs, on a yearly, monthly, weekly, and daily basis. New York's rhythm is that of the inaccessible logic by which the nation feels up or down, elated or depressed, the tempo and pace at which it publicizes the new and buries the old. It's the rhythm that turns history into pop culture.

"It was characteristic of the Jazz Age," Fitzgerald remarked, "that it had no interest in politics at all." This was the age of "Red" scares and race riots, of a burgeoning Ku Klux Klan and shrinking labor unions, of stiff and biased immigration laws and an enormous and growing gap between the incomes of the wealthy and the poor. Shocking to tell, 71 percent of American families in the 1920s had annual incomes below $2,500, the minimum needed for decent living; in New York in the years just after the war, the average worker earned only $1,144 a year. But people didn't seem to care. The younger generation of Harlem artists turned their back on the struggle for economic and political opportunity undertaken by their just-predecessors. Black Manhattan put its money on culture, not politics; Negroes were to write and sing and dance their way out of oppression. Though the suffragists had won the vote in 1920, their daughters, most experts agreed, disdained to use it. Students of the Seven Sisters colleges joined the ranks of "Flaming Youth" and overwhelmingly ranked matrimony as more important than any career or public service they might pursue.

A cadre of Greenwich Village intellectuals and artists, led first by John Reed (tragically dead in 1920) and then by Max Eastman and occupied with socialist beliefs and a passionate interest in avant-garde ideas, filled "little magazines" and quasi-underground newspapers with their doings and convictions, but events and news of a less-high-minded sort occupied the broader culture. In 1927, the trial of a Queens housewife named Ruth Snyder and her lover, a corset salesman, for the murder of Ruth's husband received more coverage than the historic and controversial execution of the accused Boston anarchists Nicola Sacco and Bartolomeo Vanzetti. Few bothered trying to follow the troubled course of the National Association for the Advancement of Colored People (NAACP) or the Urban League, but anyone could pick up a paper and learn of the latest exploits of the flamboyant Negro pilot, the "Black Eagle," Hubert Fauntleroy Julian. Journalists covered the

doings of gangsters with avidity and dismissed law enforcers with terse satire. Gossip columns, especially Walter Winchell's column in the New York *Graphic* telling readers who was "that way" about whom, who expected "a bundle of joy," what couples were getting together or splitting up and why, and giving names, sold more newspapers than hard news did.

Movie stars like Mary Pickford, Douglas Fairbanks, and Charlie Chaplin had followings at home and abroad that a President might envy. When lofty-minded Woodrow Wilson led the nation to war in 1917, he was backed in his crusade for Liberty Bonds by Fairbanks, Pickford, Chaplin, and dozens of other entertainment celebrities. Pickford could be seen on posters "knocking out the Kaiser" and Wall Street was treated to a stunt in which Chaplin, standing on the athletic Fairbanks's shoulders, waved his hat in his enthusiasm for Liberty Bonds. The reporter and dramatist Ben Hecht, arriving in the city from Chicago in the war years, noted that New Yorkers believed that the war could be won by "writing the right songs for it and not losing your sense of humor." In fact, a New York tune, George M. Cohan's "Over There," was the hit of the war years. The now familiar American confusion between patriotism and entertainment had taken firm hold, and some of those involved criticized yet enjoyed the joke.

The Negro songwriters Eubie Blake and Noble Sissle, whose all-black musical revue *Shuffle Along* was a smash success on Broadway in 1921, might not have been surprised to learn that "I'm Just Wild about Harry," the hit song of their show, became the theme song for Harry Truman's presidential campaign of 1948. *Shuffle Along* centered on a farcical and corrupt election conducted in show-biz vernacular; Sissle and Blake knew that songwriters are competition for Presidents. So did George S. Kaufman and Morrie Ryskind. In 1931, working with the songwriting team of George and Ira Gershwin, they had a hit in their musical *Of Thee I Sing* about a mock presidential candidate named John P. Wintergreen. A good-natured lightweight, Wintergreen likes slogans such as "Vote for Prosperity and See What You Get" and "A Man's Man's Man"; his heroes are Mickey Mouse, Babe Ruth, and the Marx Brothers. He campaigns (and wins) on the "issues" of patriotism, family, and "Love" and his rendition in all forty-seven states of the show's catchiest number, "Of Thee I Sing, Baby." Wintergreen was an affectionate spoof on F.D.R., running that year against Herbert Hoover, and in later real-life campaigns a host of New York celebrities led by Walter Winchell would support F.D.R. as, among other things, an entertainer, a radio President well known to the nation through his Fireside Chats. Kaufman dubbed him "that grand old pal of the airways."

The preference for entertainment over politics was not simply a matter of corrupt and careless insouciance, poor values, and indifference, though these

played their part. The 1920s were at least as post-Marxist as anti-Marxist. Remember that this was the first age of the media, of book clubs, best-sellers, and record charts, of radios and talking pictures and phonographs; by the end of the decade, one of every three Americans owned a radio, three out of four went to the movies at least once a week, and virtually no one was out of reach of advertising's voice. Whatever the moderns' apathy toward conventional politics, they were altogether alert to the bewildering array of cultural artifacts and phenomena that a full-blown consumer society throws into the hustling stakes of history. This was the first generation to grasp the supremacy that mass culture would acquire, to realize that, in the late-capitalist or consumer society America was becoming, there might not be distinct classes as Marx had explicated them in his studies of early capitalism a half century earlier; instead of a clear distinction or face-off between the oppressor and the oppressed, there might be only a handy-dandy exchange between what the metropolitans termed "suckers" and "racketeers." In a consumer society, this generation saw, everyone, wittingly or unwittingly, gets to play the "sucker" one moment and the "racketeer" the next. "Andy Consumer" (a creature of General Electric's advertising campaign in the mid-1920s), when he is ready to believe all the advertisements written for "ginks like me," is a sucker; but a moment later, when Andy Consumer is palming his special line of business off on his own customers, he has become a racketeer. The role reversal goes on and on in an endless seriatim process. There are no classes in this shrewdly apolitical political vision, just people more and less deceived. Of course New Yorkers loved Jimmy Walker. If he was a racketeer, they, under the right circumstances, hoped to be racketeers as well; if they were suckers, F.D.R. had proved Walker just another sucker, too. Tricksters and impersonators appeared nightly as top Broadway entertainment; in mongrel Manhattan, con games were culture.

The urban writers and performers of the 1920s were the first to speculate that entertainment was to be America's biggest business and surest export and the most reliable source material for its history. They were the first to guess that American history might be less a chronicle of achievements and failures than a kind of cultural mood not amenable to any traditional form of theory, a detailed topography of "Fiction, Gossip, Theatre, Jokes and All Interesting" (to use the title an eleven-year-old T. S. Eliot gave to one of his *juvenalia*). Such a map must be read like fiction rather than explained like fact, attended to like gossip at a party, a performance in a theater, or a mugging in the alley, not analyzed like a problem in a laboratory. It must be addressed, not with the impassioned dulled interest we show our national credos, the Constitution and the Bill of Rights, but with the fascinated

skepticism we bring to a hoax, with the terror and delight we reserve for the most pervasive, creative, and deadly of adventures that is our actual pursuit of "life, liberty and . . . happiness."

The shift in cultural power in the modern era from New England to New York, the shift from reform-oriented, serious-minded, middlebrow religious and intellectual discourse to the lighthearted, streetwise, and more or less secular popular and mass arts as America's chosen means of self-expression, was not as decisive as it seemed. The Massachusetts-born Robert Benchley liked to jest about his struggle with "that old New England streak in me, that atavistic yearning for a bad time if a bad time is possible," but New York had always had its own dark thoughts and doom-struck prophets. Herman Melville, the greatest delineator in American letters of what he called the "power of blackness," was born and bred in New York; his career began amid the New York literary renaissance of the 1840s, and he died in the city (in 1891) after decades of bitter and obscure employment in the New York Customhouse. Appropriately, the rediscovery and re-evaluation of Melville that took place in the 1920s was largely the work of a group of New York critics—Raymond Weaver, Carl Van Doren, Henry A. Murray, Carl Van Vechten, and Lewis Mumford—who hailed him as the archetype of the American writer and a forerunner to Freud.

The connection between Melville and Freud is an important one. Like Melville, Freud found his subject in an unyielding "quarrel with God"; his work in the 1910s, 1920s, and 1930s constituted a sustained plea for a heroic and defiant atheism, and it took hold in New York as it did no place else on the globe including Freud's own city, Vienna. A number of my white protagonists read Freud's major works, quickly published in English translations by New York publishers; many more consulted the new Freudian analysts who were rapidly taking over New York's psychiatric practice, and all of them, willingly or otherwise, participated in a refashioning of American culture along visibly Freudian lines. Freud's crisis of faith was theirs. If New England stood for belief, New York stood for belief's dark twin, blasphemy.

Lighthearted as he meant to be, F.P.A., too, liked on occasion a tone of sacrilege. He once snapped that the question routinely asked of any non-combatant in the war—"And where were *you* in the Great War?"—might "embarrass, among others, God." Embarrassing God, to appropriate F.P.A.'s remark, taunting and defying him, was one of Manhattan's favorite sports, but the motive for the sport was finally less to discredit God than to flush him out of hiding; the blasphemist needs a God at least as much as the believer does. The New York moderns might attack the Victorian matriarch,

deified in the nineteenth century, with unholy and savage glee, but they did so in good part to rescue and defend the tough masculine Calvinist ethos they believed she had "feminized," sentimentalized, and betrayed. This, too, was the ethos the moderns called "terrible honesty," and its demands could be merciless. If the New York–dominated modern era had, as it claimed, fewer fools than the New England–based Victorian Age had spawned, it had more than its share of casualties.

On March 6, 1935, *The New Yorker* debated whether one was better off living in Kansas or in New York City. One lived longer in Kansas, but one was more often bored there, too. "We've decided," the magazine concluded, "to sit tight." The jest does not obscure the point. A decade's observation had taught *The New Yorker* that people die sooner in New York than they do elsewhere; the city may kill what it quickens. Its stepped-up rhythm and the accelerated pace which stokes the nation's excitation can become, not boring, never boring, but taxing, even life-threatening to those caught up in the beat.

In 1920, Scott Fitzgerald was in the midst of his first flush of enthusiasm for New York. Looking back from the perspective of 1931 on those youthful days right after the big success of his first novel, *This Side of Paradise* (1920), and his marriage to Zelda Sayre, the legendary belle of Montgomery, Alabama, he remembered "riding in a taxi one afternoon between very tall buildings under a mauve and rosy sky; I began to bawl because I had everything I wanted and knew I would never be so happy again." New York with its skyscrapers and taxis, its ethos of instant gratification-in-depth, was for Fitzgerald modernity's peak experience; he called it "toploftiness." But Scott left the city in 1921 for a long visit to his birthplace, St. Paul, Minnesota. Zelda was pregnant, and the couple felt it "inappropriate to bring a baby into all that glamour and loneliness." Zelda later noted ominously that New York resembled a "Bible illustration"; Scott apostrophized the metropolis in 1932 as "My Lost City."

Eugene O'Neill, born in 1888 in New York (in what would become Times Square), found much of the material for his plays in the city, but he avoided coming to New York whenever possible after the 1920s. New York was, he thought, "a swirl of excited nothingness." James Thurber, who helped to set the tone and content of the city's quintessential magazine, *The New Yorker*, moved in and out half a dozen times, taking refuge at different moments in Connecticut, Bermuda, and Paris. Like O'Neill, he became increasingly disturbed by New York life. On January 20, 1938, after one stay in the city, he wrote his *New Yorker* friend and collaborator E. B. White from the South of France, "There is nothing else in all the countries of the world like New York life . . . It does more to people, it socks them harder than life in Paris,

London or Rome possibly could." Sooner or later, New York will "get" anyone who tries to live there; it is "nothing but a peaceable Verdun." Verdun was the site of one of the most devastating battles of the Great War. In Thurber's view, New York is like the war: it provides overwhelming and unassimilable experience not suited even to those who seek it. Short-term inspiration could convert into long-term deterioration, if not outright disaster.

Like many of their contemporaries, Fitzgerald, Thurber, and O'Neill were alcoholics; the list includes Dorothy Parker, Hart Crane, Sinclair Lewis, Ernest Hemingway, Louise Brooks, Wallace Thurman, Fats Waller, Bessie Smith, Charles Gilpin, Bert Williams, Jean Toomer, Heywood Broun, Damon Runyon, Ring Lardner, Elinor Wylie, Louise Bogan, Edna St. Vincent Millay, Edmund Wilson, Thomas Wolfe, Harold Stearns, Robert Ripley, William Faulkner, Horace Liveright, Charlie MacArthur, John Barrymore, Laurette Taylor, Lorenz Hart, Robert Benchley, and the writer William Seabrook. Alcohol played a part in the death of all these people save possibly Bessie Smith. In fact, almost one-third of my protagonists were alcoholics or problem drinkers; the usual figure for the percentage of alcoholics to non-alcoholics in America is 10 percent. This was the generation that made the terms "alcoholic" and "writer" synonyms.

As a young man burning with talent and ambition, O'Neill wrote to his drama teacher, George Pierce Baker: "I want to be an artist or nothing." O'Neill and his peers prized their "craft" (as they liked to call it) above all else, and they knew that, whatever their drinking habits and choices at any given time, they could not do their best work while drinking heavily. But many of them discovered that they could not stay sober, or even semisober, while living or visiting in New York. O'Neill's wife Agnes Boulton tried in vain to keep O'Neill out of the city; he stopped drinking in the late 1920s, when he ceased to spend much time in New York. Fitzgerald sobered up also, in the late 1930s, when he was living not in New York but in Los Angeles.

Thurber, despite a worsening series of drunken rages and accidents, never seriously tried to give up alcohol. After he had moved out of the city, his compulsive visits there were made solely, it seemed, to drink. His last and most horrific spree was staged in New York in 1961 at the Algonquin Hotel; he had quite literally run away from his Connecticut home. Thurber drank nonstop for a month; he was legally blind and he kept setting himself on fire with his cigarettes. Convinced that he now knew "the real truth for the first time"—that people are "not funny: they are vicious and horrible and so is life"—he attacked or ignored everyone, including his long-suffering wife, Helen, who tried to stop him. On October 3 at 3 a.m., after dinner and drinks, endless drinks, at Sardi's East, Thurber keeled over in the bath-

room, hitting his head as he fell. He died in a New York hospital on November 2, while his wife was, as he had always predicted she would be at this particular moment, in the beauty parlor. His last words were "God bless—God damn."

Back in 1938, Thurber had written White that, once in New York, he "found [himself] drinking"; before he knew it, he had become a "tall, wild-eyed son of a bitch with hair in his eyes and a glass in his hand, screaming and vilifying," a figure that seemed to him, once out of the city and sober, sickening and barely recognizable. He seemed to have no control over this process; it was as if New York got him drunk against his will. Robert Ripley substantiated Thurber's diagnosis. Rip, an alcoholic and an active opponent of Prohibition, liked to remind his readers that the word "Manhattan" in the language of the Indians who were its original inhabitants means "Place of Drunkenness." To Ripley's mind, the real New Yorker had no business practicing or preaching abstinence and not much chance of success if he did.

Ripley had a point. New York was nowhere less amenable to reform than in its drinking habits. Prohibition, passed into law in 1919 and not repealed until 1933, was a joke in most of urban America, but in New York it was an all-out full-scale farce. Seven thousand arrests for alcohol possession or drinking in New York City between 1921 and 1923 (when enforcement was more or less openly abandoned) resulted in only seventeen convictions; observers estimated the number of illegal speakeasies, dives, and drugstores as somewhere between a monstrous 32,000 and an unbelievable 100,000. "YANKEES TRAINING ON SCOTCH" ran the shameless headline of a 1922 story about Babe Ruth's team. Bishop James Cannon, tireless leader of the Anti-Saloon League, referred to New York as "Satan's Seat." Some people during Prohibition, playing on John Winthrop's famous words about the "city on a hill," called New York the "City on a Still."

In the *North American Review* of November 1929, the New York–based sculptor Gutzon Borglum said, "No one would miss [New York] for the world," but, he added, "no one wants to end up there." The best writers and artists, it was believed, knew what was good for their art and got out of the commercialized and hard-drinking city. Black intellectual leaders and authors—W.E.B. Du Bois, James Weldon Johnson, and Alain Locke—kept their ties to the more sedate world of the Negro universities of the South throughout the feverish years; all three turned to academic posts in the South when the 1920s ended. Josephine Baker had repatriated to Paris for good by the mid-1920s; Fanny Brice, Jewish comic and *Ziegfeld Follies* star, took a permanent rest cure in Hollywood, where she died in 1951. William Faulkner had only brief contact with New York, though several of his most har-

rowing drunks occurred during visits there. Hemingway loved to boast that he spent little time in New York.

One can observe distinctions even among the writers who actually were based in New York. The more ambitious ones, like Fitzgerald, Millay, and O'Neill, had less to do with the city than did most of the writers who belonged to the staffs of the city's big newspapers or the witty men and women who lunched daily at the Algonquin Hotel's legendary "Round Table" and wrote the popular magazine pieces, syndicated columns, and plays of the day. Fitzgerald wished to be buried far from New York, in consecrated ground. In contrast, Damon Runyon, tough-guy reporter and author of slang fables about New York's "Guys and Dolls," requested that his ashes be scattered over Broadway so that he might "mingle with the throng [and] . . . keep hep with the scandal in my set." (Both men got their wish.)

The most inveterate New Yorkers, however, while still finding most of their material on the urban scene, made periodic retreats outside the city. Runyon's out-of-city home was in that paradise for speculators, Florida. The Harlem blues star Mamie Smith liked to shift the party to her Long Island home; the black heiress and hostess A'Lelia Walker inherited her mother's lavish estate in Irvington-on-the-Hudson. Fats Waller moved to St. Albans, Long Island (where crosses were burned on his lawn). Parker's retreat was in Pennsylvania; George S. Kaufman and S. J. Perelman had homes there, too. E. B. White and S. N. Behrman commuted to Manhattan from New England; Ring Lardner, Ben Hecht, Charlie MacArthur, Herbert Bayard Swope, and Robert Ripley had places on Long Island or in upstate New York. Heywood Broun, trying unsuccessfully to "taper off" on the city, moved to Connecticut. The compulsively alcoholic Negro novelist Wallace Thurman went farther afield; in the early 1930s, he made a pilgrimage to his boyhood home, Salt Lake City, then tried the Los Angeles area, only to return once more to Harlem.

The pattern is clear, I think. As a place, New York became for many people impossible; as an experience it was, often for the same people, essential. In *Pierre*, Melville's autobiographical novel of 1852, young Pierre Glendinning is driven by his demons from the rural paradise of his home Saddle Meadows to a bleak and cruel New York, where he meets desperation and death. But Pierre also finds his creativity in the city. His country home is beautiful but a sham; New York is overwhelming, but it is reality, and it is where he becomes a writer. Little wonder that the urban moderns rated Melville so highly; like Pierre, Wallace Thurman, who arrived in New York in 1925 and died there in 1934, felt that it "just seemed to pull me. I couldn't resist it." New York in the 1920s was a magnet attracting and concentrating the talents of a nation. Modern American culture was in good part the work

of a group of people displaced in a metropolitan setting; they realized there talents often fostered and sometimes fulfilled or outlived elsewhere.

The bad times, the alcoholic days of disappointment and despair, that afflicted Thurber, Fitzgerald, O'Neill, Thurman, and so many others, usually came later; for a few giddy and glorious moments in the 1920s, New York held out to its new inhabitants an extraordinary promise of freedom and creative self-expression. Although I have inevitably followed some of my themes and protagonists into the late 1920s and beyond, *Terrible Honesty* is the story of New York as it took shape in the decade between the Great War and the Crash, the years when the city seemed, in Scott Fitzgerald's words, "built with a wish," when it held "all the iridescence of the beginning of the world," when what would become problems, sometimes desperate ones, still wore the liberating guise of opportunity.

The Canadian humorist Stephen Leacock, a hero to the Algonquin–*New Yorker* circle, captured the city's charm in a sketch titled "A Hero in Homespun" (1911). The story offers a mock version of a vignette dear to Victorian tract writers: the innocent country boy's terrible experiences on his first day in New York. A clergyman whom the hayseed in question, Hezekiah Hayloft, has asked for help bites him on the ear; the failure of traditional authority and aid is comically open. Leacock hastens in on cue, apparently with the expected authorial indignation:

> Yes he did, reader! Just imagine a clergyman biting a boy in open daylight! Yet it happens in New York every minute. Such is the great cruel city! Think how it must feel to be alone in New York, without a friend or a relative at hand, with no one to know or care what you do. It must be great!

Rudolph Fisher, a sophisticated and satirically minded Harlem novelist, updated Leacock's parable in his story "City of Refuge" (1925). The hayseed here is an ignorant young Negro called King Solomon Gillis who has fled to Harlem from his Southern hometown, where he has shot a white man and faces a lynching. Dazzled by Harlem, the rustic Gillis is played for a sucker by a black con artist. As the story ends, Gillis is being arrested for drug dealing; it's a setup, but he doesn't care. All that matters to him is that the arresting officer is black—"a cullid policeman!"—a phenomenon he could never see in the South. ("Cullid" policemen were a relatively new phenomenon; the first was Harlem's Samuel J. Battle, appointed in 1911.) Gillis doesn't resist his arrest; "He stood erect, and the grin that came over his features had something exultant about it." He has met in New York a version of the fate he fled down South, but it feels altogether different because

this time it is his own. Harlem is still "a land of plenty" to Gillis; there may be no justice South or North, but in New York there's life, hope, the endless possibility of reversal and surprise.

What drew writers and performers to New York was precisely what dismayed the more conventionally minded: the chance it offered to be *un*cared for, *un*tended. Artists of the Jazz Age did not want, in Ben Hecht's words, "to plunge into . . . worlds" but rather to pull "*out* of worlds"; they wanted to "remain orphaned from the smothering arms of society." America itself was an orphan of sorts. Severed by its own act from its mother country, long disdained and disowned by its European forebears, America was proving just how powerful orphans could be. Orphans by definition originate their own genealogy; they are disinherited, perhaps, but free. They can see the world, as Edna St. Vincent Millay wrote a friend during her early days in the city, "with [their] own eyes, just as if they were the first eyes that ever saw."

One day in 1928, New Yorkers, looking up past the new skyscrapers to the sky itself, were astonished to see spirals of smoke spelling out the words "Smoke Lucky Strikes." The tobacco tycoon George Washington Hill, in conjunction with the public-relations man Edward Bernays and the ace war pilot Jack Savage, had launched the art of skywriting and aerial advertisement. Skyscraper New York was the birthplace of those all-powerful colonizers of space, the media; if, as Gertrude Stein believed, America was the oldest modern country in the world, New York might be the world's oldest modern city. Swindled for a handful of beads from its original inhabitants and served up on a tiny and fragile platter before the eyes of a breath-struck world, New York in the 1920s celebrated excitement, danger, record-making and record-breaking, catastrophe and farce, all of it, to borrow a phrase in heavy use among journalists of the day, "in full view of the spectators." New York was the capital of the twentieth century: it was both the city that Lewis Mumford called a potential "Nekropolis" and the place E. B. White eulogized as a "monument" to modern man's creative capacity for "mischief."

Terrible Honesty is based on the lives and works of roughly one hundred and twenty permanent or temporary New Yorkers, white and black. I have also included among my protagonists five writers and thinkers who were not New Yorkers but who were crucial influences on the New York scene. Whatever their physical distance from New York, the American expatriates and trend-setting writers Ernest Hemingway and T. S. Eliot, the Viennese father of psychoanalysis, Sigmund Freud, and Freud's two greatest opponents, the Harvard philosopher and psychologist William James and the Paris-based avant-garde author Gertrude Stein, were closely tied to the city by their commercial and private interests. All of them served as models and mentors

to my other subjects; Freud, James, and Stein in particular could almost be said to have defined the New Yorkers' cultural choices and psychological possibilities. Brokers between skepticism and faith in their broadest latitudes, Freud, James, and Stein collaborated, and disagreed, on the script of revolutionary cultural change that the metropolitan moderns enacted. Moreover, the contrast between Freud's posture of elite pessimism and James and Stein's stance of pluralistic optimism is crucial, I believe, to understanding the dual nature of 1920s New York—both a No Man's Land expert in modish despair and a city "built with a wish," breeding grounds for American pop art in its most felicitous and mongrel incarnations. This book is the story of all these men and women and the America they found and transformed.

Part One opens *in medias res* with a sketch of Manhattan, black and white, in action in its heyday in the 1920s. I present the culture's self-advertisements, its map of "Fiction, Gossip, Theatre, Jokes and All Interesting," and I detail the central ethos of the age, "terrible honesty," and its major players. In Part Two, I have attempted to find the plot behind the publicity, to go deeper into the dynamic of American metropolitan modernism by laying bare its origins in the conflicts of the Great War, the emergence of the nation as a superpower, and the matricidal scenario that accompanied and furthered America's ascension. Part Three is a study of the charged collaboration of white and black talent in 1920s Manhattan in its most potent and influential form, in the decade's major musical forms, ragtime, the blues, and jazz, all essential to America's dawning global hegemony in the fast growing field of popular culture. I close with an account of Manhattan's new skyscrapers, the supreme example of the elated and mongrel spirit of the age.

When Albert Einstein was able to predict the solar eclipse of May 1919, the world had discovered the theory of relativity: there are no absolutes in time or space. The laws that concerned the 1920s generation were not those of man or God, at least not as their Victorian predecessors had understood man or God. The laws that interested them were those of the universe itself and the psyche that confronts it, the laws of matter and density, of energy conservation and expenditure, of relative and multiple perspectives in which tragedy and comedy are twin impostors endlessly changing places. Laws had become dynamics, and the only virtue was honest reportage on their operation. The special chance of my protagonists was, as Hemingway once described Walter Winchell's mission, to try to "last three rounds" with the "modern Zeitgeist" that was sweeping America to power. It was an exhausting, exhilarating, possibly fatal opportunity. One and all, they took it. They were the shock troops of modernity; their art was a dispatch from the front lines concocted of adrenaline, bravado, and cultural ESP, and, to borrow a phrase from Ezra Pound, their news has stayed news.

SETTING THE STAGE

THE PLAYERS AND THE SCRIPT

≡

WHITE MANHATTAN IN THE AGE

OF "TERRIBLE HONESTY"

"THE AWFUL TRUTH"

On October 7, 1906, in Vienna, Sigmund Freud penned a summons to those thinking of enlisting in the infant army of psychoanalysis: "All those who are able to overcome their own inner resistance to the truth will wish to count themselves among my followers and will cast off the last vestiges of pusillanimity in their thinking." When he wrote these words, Freud was wooing the young Swiss psychiatrist Carl Jung to his camp, but he had in fact called an entire generation to the task of ruthlessly interrogating past and present lies. No group responded more eagerly to his call than the white urban American writers of the 1920s. As T. S. Eliot put it in *The Uses of Poetry* (1933), in words that echo Freud's: "Any one who does not wish to deceive himself by systematic lies" must acknowledge "the agony and horror of modern life." "Belief is dead" and there are no substitutes, Eliot warned, for lost belief. "Make-believe," the full-time occupation of one's elders, it seemed, was out, finished as a personal or cultural option.

In December 1912, Robert Underwood Johnson, the influential editor of *Century Magazine*, wrote a passage that could serve as a summation of the late-Victorian creed of make-believe, pusillanimity, and systematic lies which the modern generation was to defy: "No-one paints life as it is—thank heaven!—for we could not bear it. Somewhere we must compromise with the . . . indecencies, the horrors of life." In considering these words, it is important to realize that the issue between the Victorians and the moderns is not the nature of life. Johnson is not suggesting that the world is a beautiful or a good place, or even that the artist should believe it is; he is as far away from such notions as Eliot or Freud is. In fact, Johnson is openly admitting that the world is full of "indecencies" and "horrors"; he's advocating, in

Eliot's phrase, "make-believe," open falsification in the name of psychological survival, what the New York historian James Truslow Adams called the worship of "Pollyanna, Our Patron Saint."

Pollyanna was indeed America's patron saint for a good while. The novel by Eleanor Porter was a huge best-seller in 1913 and 1914; its sequel, *Pollyanna Grows Up*, hit the best-seller list in 1915. The actress Patricia Collinge made *Pollyanna* a hit on Broadway in 1916, and Helen Hayes took on the role with equal success in 1917; Mary Pickford played Pollyanna in a movie of 1920 that grossed (worldwide) more than 1 million, then a record-breaking figure. The story is a sensational if simple one. The eleven-year-old Pollyanna becomes a devotee of the mind-over-matter school when she discovers that she can be "glad" to be given a pair of crutches instead of the doll she wanted, because she doesn't need them. She christens this willfully optimistic counting of one's blessings the "Glad Game" and begins to proselytize in its name. The local doctor helps; he realizes that Pollyanna "is better than a six-quart bottle of tonic any day" and prescribes her glad game to all his patients, including himself. It is lucky he cooperates; he is aware that if there were more Pollyannas in the world, doctors would have to forsake medicine and go into "ribbon-selling and ditch-digging." By the story's close, everyone in Pollyanna's small New England town is competing in sunny-minded benevolence.

Perhaps Eliot in his strictures against make-believe was remembering Eleanor Abbott's *Molly Make-Believe*, a twin to *Pollyanna*, and a best-seller in 1910; Tom Eliot, like most middle-class American children at the time, had been raised on the didactic Rollo stories of Jacob Abbott, Eleanor Abbott's grandfather and mentor. Molly Make-Believe is a fetching young woman, a Miss Lonelyhearts who combines the optimistic innocence of an ingenue with the manipulative wiles of a call girl and the malicious airiness of Tinker Bell (*Peter Pan*, starring Maude Adams, was a Broadway hit in 1905). In a seamless flow of self-intoxicated effervescence, she engineers an arthritic and despairing young man's return to health and her own nuptials to the young man. Molly is the heroine of convalescence, a state of great interest to Abbott; other titles by Abbott include *The Sick-a-bed Lady* and *The White-Linen Nurse*.

Pollyanna and *Molly Make-Believe* were the most successful of a host of best-selling novels in the early twentieth century that popularized a unique and indigenous American tradition of lay therapeutics: the self-help and healing practices of the interconnected, quasi-religious, late-nineteenth-century movements known as Mind-cure, Spiritualism, and Christian Science. These therapies were dedicated to a principled denial of the "horrors of life," and they were dominated by feminine practitioners and popularizers.

In the first twenty years of the century, more than half the advertisements for Mind-cure treatments appeared in the big women's magazines like the *Ladies' Home Journal* and *Good Housekeeping*; most of the authors of Mind-cure fiction were women. Alice Hegan Rice summed up the Mind-cure ethos of wishful thinking in her best-selling novel *Mrs. Wiggs of the Cabbage Patch* (1901): "The substance of [Mrs. Wiggs's] philosophy lay in keeping the dust off her rose-colored spectacles." Mrs. Wiggs's spectacles were to gather considerable dust in modern America.

While Alice Hegan Rice, Eleanor Abbott, Eleanor Porter, and Robert Underwood Johnson protected themselves and their readers from what cannot be borne, the moderns sought it out; the "horrors of life" and the compromises that purport to mask them were the subject matter of the postwar generation. Its members prized a histrionic truthfulness above all else, including survival. They were committed, the critic Malcolm Cowley wrote in his memoir *A Second Flowering* (1974), to "being truthful, even if it hurt their family and friends, and most of all, if it hurt themselves." Opposing every form of "sentimentality," they prided themselves on facing facts, the harder the better; "facts" alone, Ezra Pound insisted, are the "acid" test of value.

The older generation was quick to accuse the younger one of lacking moral standards, but in truth the moderns wanted not fewer ethics but more searching ones. They attacked the pieties of their Victorian predecessors, not because they were inherently wrong or even unappealing, but because they were unattainable, and it was the business of those committed to "terrible honesty" to say so. Raymond Chandler said that "all writers are a little crazy but if they are any good they have a kind of terrible honesty." Although Chandler, born in 1888, was older than most of the writers who made it big on the modern urban scene, he came to his craft late; he did his apprenticeship in the 1920s, studying the prose of Hemingway and Dashiell Hammett and writing for the New York detective magazine *Black Mask*, and it is this generation, the urban writers of the 1920s, that he is in fact describing. They used very similar language to describe themselves.

Fitzgerald praised "terrible honesty" in *This Side of Paradise* (1920). The poet Sara Teasdale was called an artist of "fearful honesty." The highest compliment that Irwin Edman could pay Joseph Wood Krutch's *The Modern Temper* (1929), a dark analysis of the secular urban Zeitgeist, was to call it a "terrifyingly honest book." Marianne Moore valued "terrible truthfulness" above all else. Hart Crane was eulogized as a poet of "terrible sincerity"; the drama critic George Jean Nathan found Paul Robeson (appearing in Eugene O'Neill's *All God's Chillun Got Wings* [1924]) an emblem of "terrible sincerity." Louise Bogan, who exclaimed "Oh! How I hate a lie!" admired Emily Dickinson's "peculiar honesty, which in a world too frightened to be

honest, is particularly frightening." Djuna Barnes claimed, "I never lie . . . only mediocre sentimental persons lie." In *Leaves from the Notebooks of a Tamed Cynic* (1929), the young theologian Reinhold Niebuhr announced that there was need for "brutal honesty"; a few months after its publication, Niebuhr left Detroit for a post in (where else?) New York, at Union Theological Seminary.

Concern with "terrible honesty" was not limited to the elite circles of New York culture. In her autobiography *A Peculiar Treasure* (1939), Edna Ferber eulogized the "terrible integrity" of the Algonquinites of Round Table fame. Katherine Brush wrote in *Young Man of Manhattan* (1930) that New York's "newspaper people" are "surprised at nothing, awed by no one"; they possess "a terrible wisdom." Serializing a story for the *Ladies' Home Journal* in the fall of 1925, Corra Harris described her flapper heroine's "frightful, unscrupulous honesty," her "elemental honesty" in confronting "head-on the dreadfully diminishing wisdom of life as it is." Wild Clara Bow, a Brooklyn-born movie star, was notorious for her "flaming honesty." "The trouble with me," she said, "is I ain't no sneak."

American advertising found uses for the principle of "terrible honesty," too. Freud was the chosen mentor of Madison Avenue. The leading adman of the day, Edward Bernays, often called the "Father of Public Relations," who orchestrated the commercialization of a culture, was Freud's nephew and a self-conscious popularizer of his thought, and Freud's definition of the analyst-patient relationship gave advertisers wooing clients their model and their cue. According to Freud, the analyst plays "detective" to the patient's "criminal." The patient barricades himself against the analyst, against unwanted "truth" and "reality," against necessary self-knowledge, by a blocking process Freud called "resistance"; the analyst must help the patient to overcome this resistance in the interests of recovery. In a like spirit, the Listerine company urged prospective customers to play detective to their own criminal activities and odors. "Suspect yourself first!" Listerine advised the unwary victim of "halitosis." Even "your best friend" won't tell you the truth; you yourself will be the last to know your own open secrets. Like the psychiatrist, the advertiser posed as the client's only reliable source of aid.

This insistence that the prospective buyer face unpleasant truths before the consequences become unendurable is called "scare copy" in the advertising world, and it was first widely used in the 1920s. In scare copy, as in Freudian analysis, ignorance is definitely not bliss; sooner or later ignorance will get you in big trouble—and probably sooner. Standard Plumbing fixtures reminded the readers of *Better Homes and Gardens* in October 1929 that bathrooms "have aged more in the past year than in all twenty years before." To live in a house or apartment is apparently to be in a hazardous showcase

situation. Your home is as liable to what Freud called "slips," unwanted giveaways of secret agendas, as you are. What if those observant quasi-psychoanalyst intruders commonly called guests should "spot the one detail that cries out for attention"? What if they should see (in this instance) that your toilet seat does not match your toilet? Every day is final exam day, every activity a matter for a photo finish. S. J. Perelman warned that guests might drop by "[just] to sneer at your towels."

The now legendary wit of the 1920s was the product of a group of writers obsessed with reality and fact checking. Katherine Anne Porter, a resident of Greenwich Village then, headlined the new knowledge of a rapidly Freud-ianizing age: "THERE IS NO SUCH THING AS AN EXACT SYNONYM AND NO SUCH THING AS AN UNMIXED MOTIVE." The arts of exactitude, of distinguishing one thing from all else that may resemble it, were the moderns' stock-in-trade. Dorothy Parker labored for weeks, sometimes months, over a three-page sketch because, as a friend remarked, "every word had to be true." Broadway's king of comedy, George S. Kaufman, conducted "a demoniacal search for just the right word." Ring Lardner, master of the American slang vernacular, achieved his perfect verbal pitch by "listening and listening" to his fellow Americans till he "got them down cold." Ernest Hemingway, an expert in the sinister jokes of the cosmos, found the "elaborate falseness" of the once-celebrated nineteenth-century Romantics "embarrassing," and his only advice to aspiring writers was to do what he had done in his apprentice days in Paris as he labored to create his revolutionary, concentrated, and spare prose style: "Write one true sentence. Write the truest sentence that you know . . . that and no more." In a letter of March 31, 1925, he boasted that his prose was "so tight and so hard that the alteration of a word can throw an entire story out of key."

The New Yorker, one of the most successful and long-lived products of the decade's interest in the popular arts, set standards for accuracy of fact and word that were legendary almost as soon as the first copy hit the stands in February 1925. *The New Yorker*'s founder and editor, the brusque and eccentric Harold Ross, was, in the words of his magazine's star writer, James Thurber, "the most painstaking, meticulous, hairsplitting detail-criticizer the world of edit-ing has ever known." He tracked down a misplaced comma the way a detec-tive hunts a criminal and he feared sentimentality as the mark of a "sis" (sissy). Ross was congenitally suspicious of think-pieces; his magazine would contain no "articles of opinion." He spoke of H. W. Fowler's vigorous *Modern En-glish Usage* as a bible, as "the greatest damn book ever written," and he could preach for hours on the correct use of "that" and "which." He "clung to facts," Brendan Gill has reminisced, "as a drowning man clings to a spar." *The New Yorker*'s ethos, in the words of Ross's hand-picked successor, William Shawn,

was to honor the "genuine, authentic, real [and] true" and scorn the "specious, spurious, meretricious [and] dishonest."

Ross presided over the creation of the one-liner cartoon, working on the assumption that a single line, if it is the right line, can tell us everything; "everything," he liked to insist, "is expressible." A *New Yorker* slogan of sorts, this phrase advertised not only the magazine's commitment to the articulate but also its disdain of all that could not be conveyed in its trademark style: a mix of high standards, no pretensions, and infinite discipline, irony to the fore and emotions to the far rear. Thurber called it "playing it down." Strike a match, watch it sputter; in the words of a popular song of the day, "Ain't we got fun?"

Those who self-consciously write for the ages "go bad," in Hemingway's phrase, while those willing to master the apparently minor arts of acknowledged ephemera sometimes discover that, in the words of Heywood Broun, "there is terrific stamina in stuff and nonsense." In *Civilization in the United States* (1921), a symposium of essays hell-bent on exposing American culture as a dishonest charade, young Harold Stearns said of his generation, "We may not always have been wise; we have tried always to be honest." And, he adds, "we still know how to laugh at ourselves." One can face matters yet not solve them; laughing at others and oneself is "terrible honesty," too. In Brendan Gill's words: "Not a shred of evidence exists in favor of the argument that life is serious, though it is often hard and even terrible." Truth may be light or dark; it is accuracy of perception not solemnity of tone that counts.

In his retrospective look at the culture of his youth, *If You Don't Mind My Saying So* (1964), Joseph Wood Krutch noted that the "pessimism" of the young writers of the 1920s had been "defiant, anxious to confess or even to exaggerate its . . . gloom and so exuberant as to . . . regard its ability to face up to the awful truth as more than enough compensation for the awfulness of that truth." Nowhere more so, one might add, than in the games of matrimonial deception and recognition concocted by Arthur Richman in a play of 1922 titled *The Awful Truth*; in Hollywood, the director Leo McCarey, scriptwriter Vina Delmar (with uncredited help by Dorothy Parker), and actors Cary Grant and Irene Dunne turned the play into a movie (for the second time) in 1937. A young husband and wife suspect each other of infidelity. Their possible betrayal is presumably "the awful truth" of the title, but no one is in distress, no one gets worked up, no one is caught with his or her heart on anyone's sleeve. Indeed, as if in illustration of Krutch's words, the fun Grant and Dunne find in their efforts to expose "the awful truth," to work with and against each other's timing, is so heady that their contest becomes a collaboration and their divorce precipitates their remar-

riage. Masking and unmasking, playing it down, can be the tempo of pleasure at its most acute and canny.

All the popular arts coming out of Manhattan in the 1920s have a precision of pitch, a deftly antiseptic sting unique in the annals of American entertainment. Think of Dorothy Parker publicly skewering a young man who announced he "could not bear fools"; "That's funny," she replied, "your mother could." In a flash Parker has done a hard-core reality check that converts male pretension into female pain. Or think of Irene Dunne impersonating a working-class hussy in *The Awful Truth* to show up the superficiality of the socialite clan into which her ex, Cary Grant, plans to marry. Every outrageous move on Dunne's part precipitates another false move from the family of Grant's fiancée; the anything-goes comic spirit of the scene is nerved with a precision so tight as to be mathematical. Or consider Grant before the mirror in Dunne's apartment, trying on the hat that is so conspicuously not his, hoping it will fit, trying it on from every possible angle, wanting it to be his hat, and eliminating all possibilities one by one but "the awful truth": it is *not* his hat, Dunne *is* concealing another man on her premises—a discovery that will precipitate no calamity that fun cannot use as ammunition.

The 1920s stage comedies that became the 1930s romantic film comedies like *The Awful Truth* developed to new heights the reactive character, the person whose intelligence never sleeps, whom no amount of fast talking or sentimentality can fool, whose split-second reaction to the acts or words of another reshuffles perception instantly and decisively. This had traditionally been a minor part—there's so much the reactive character can't do; the flights of oratory and feeling dear to many dramatists are anathema to him —but not anymore. Starting with his hit play of 1921, *Dulcy*, George S. Kaufman specialized in the reactive character; collaborating with Moss Hart, he brought it to a peak of comic brilliance in 1939 in *The Man Who Came to Dinner*.

The reactive character here is a columnist, lecturer, talk-show host, and star personality at large named Sheridan Whiteside, a takeoff on the well-known Alexander Woollcott; Woollcott's friend Monty Woolley played "Sherry" on stage and on film. A venomous, inquisitorial, but generous prima donna, Sherry is temporarily and obstreperously confined to a wheelchair, but no pretense escapes him, no verbal cliché leaves his presence unscathed. To a nurse who snaps, "I can only be in one place at a time," Sherry replies, "That is very fortunate for this community." To the local doctor, who asks him to read the "tremendous manuscript" of his memoirs, *Forty Years an Ohio Doctor: The Story of a Humble Practitioner*, Sherry

37

answers wickedly: "I shall lose no time in reading it, if you know what I mean." The doctor doesn't, but the audience does. In the course of the play, Sherry smokes out a murderess and rearranges the lives of everyone around him. One of his many passions is collecting ancient bones and Egyptian mummies, and no skeletons are left in anyone's closet by the play's close. Our fun, it seems, has been a variant of the "Truth Game," a craze of the metropolitan 1920s on both sides of the Atlantic.

One of *The New Yorker*'s darlings, mentioned almost every week in the "Talk of the Town," was a brassy bold peroxide-blonde who called herself Texas Guinan. Texas came to New York from a career as a cowgirl in grade-B Westerns and other still more dubious activities, and she ran a number of New York's most famous speakeasies and nightclubs in the Prohibition era; quite a number—she was "padlocked" or closed by the police so many times that she eventually adopted a necklace made of padlocks. With her gold-plated, coral-inlaid telephone and armored car, her easy scorn for the law, Texas had a gangster aura. She offered poor booze and good entertainment to her customers at exorbitant prices. At her El Fay Club, a customer might shell out several hundred dollars for his table, his drinks, and the floor show; alcohol came as high as ten dollars a shot and even plain water had a price. Texas, who was famous for her salutation to patrons old and new, "Hello, suckers!," clearly adhered to the famous maxim coined by a man-about-town named Wilson Mizner, "Never give a sucker an even break." Perhaps it was some consolation to patrons to know that their loud hostess was paying stiff rates for police and/or mob protection and often not getting it; it was a kind of honor to share the joke with the star of the speakeasy racket. Texas's charm was that she pulled no punches. As *The New Yorker* commented on January 23, 1926, "It is always a pleasure to be gouged by home talent."

In *The 7 Lively Arts* (1924), a pathbreaking study of popular culture, Gilbert Seldes discussed at length the cinematic capers of Mack Sennett's Keystone Kops. Sennett's comedies originally came out of New York's Biograph Studio; they were largely based on Sennett's observation of the New York scene just before the Great War, and they are slapstick at its broadest and most inventive. Seldes concludes by remarking: "Our whole tradition of love is destroyed and outraged in these careless comedies; so also is our tradition of heroism." These words might sound like censure to some, but Seldes has no higher praise. He loved the new ebullient ragtime songs; they're aptly named, he points out, because they "literally . . . tear to rags the sentimentality of the song[s] which preceded" them. Likewise, the urbane F.P.A. thought Ring Lardner a better writer than Mark Twain. Why? Because, F.P.A. explained, Lardner is a keener observer than Twain and a

better "hater of the human four-flusher as he is." Comedy was the fearless art of deflation, a razor-sharp separation of the realists from the idealists, an exercise in accuracy befitting a newly mechanized and time-conscious age.

Seldes said that the "lively arts" work toward "a moment when everything is exactly right" and achieve it by split-second timing, tempo, and an infallible sense of their own beat and rhythm. More precision, more exactitude, was available in the 1920s than ever before; the new radio technology, an affair of exact sound and fast frequencies, represented the first accurate reproduction of sound and voice as precisely programmed entertainment in the world's history. Wristwatches replaced the old-fashioned and ponderous watch kept in a vest pocket—people now needed to know the time all the time—and the various terms still in use today for commodifying time gained wide circulation. People "buy time," "pass the time," "spend time," "borrow time," "steal time," "mark time," "waste time," even "kill time"; people are "on time," "in time," "doing time." In *Middletown* (1929), a pioneering study of urban American life, the sociologists Robert and Helen Lynd noted a sign in Muncie, Indiana, advertising a laundry service: "Time for Sale! Will You Buy?" As cultures urbanize, Lewis Mumford wrote in *Technics and Civilization* (1934), they are organized and divided into "time belts"; "abstract time" has become the "medium of existence." The first and the last mass medium is clock time itself; all other media dramatize and defer to the clock.

Fitzgerald employed 450 "time words" in *The Great Gatsby* (1925), by Matthew Bruccoli's count; the words "time," "moments," "minutes," "hour," "day," "week," "month," "year," "watch," "clock," and "time-table" appear over and over, making the novel resonate with the excitement and melancholy of those who live by the clock and the calendar. "Do you always watch for the longest day of the year and then miss it?" Daisy asks Nick in one of her haunting gusts of enchanted flirtatiousness. "I am a ghost now," Fitzgerald wrote in *The Crack-Up* essays, "as the clock strikes four." Dorothy Parker knew the night hours, too. "Twenty minutes past four, sharp, and here's Baby wide-eyed as a marigold," an insomniac protagonist announces in a sketch titled "The Little Hours."

When Hemingway said, "I am . . . in competition . . . with the clock—which keeps ticking," he spoke for the age. Whatever happens, time is never forgotten; 1920s culture is clock culture, and the clock is the ultimate reality check. In T. S. Eliot's famous line from *The Waste Land*, "HURRY UP PLEASE IT'S TIME." Spengler wrote that the clock stands for "the actuality of irreversibility," for the fact that, as Thomas Wolfe put it, "You can't go home again." Mumford, Krutch, and Eliot, like their mentors Freud and Spengler, looked histrionically to the imminent end of Western civilization; history itself was a process of countdown. "So we beat on," Fitzgerald concludes

The Great Gatsby in words that capture the ethos of "terrible honesty" at its most glamorous and nostalgic, "boats against the current, borne back ceaselessly into the past."

"POWER'S SCRIPT"

Every age fosters realists and idealists and fans the quarrel between them, but few eras make the confrontation between them the central all-engrossing conflict at every level of the culture as New York did in the 1920s. Few cultures have been so intent, open, and skillful in writing and reading what Hart Crane called "Power's Script." In the slang parlance of the day, what's the "angle"? Who's the "brains" of the outfit? Forget what is inclusive; what is, at least, incontestable? X-rays, a discovery of the late nineteenth century, came into wide use in the 1920s as a technique furthering medical knowledge and a metaphor explicating modern modes of perception, a "social X-ray," in the words of the public-relations man Ivy Lee, "which shall reveal the bone and the tissue, even the . . . heart of the body itself."

Exponents of "terrible honesty" were drawn to the reductive mode as the quickest route to certainty; they prided themselves on seeing through things, discarding the deceptive appearance for the underlying reality. As they saw through the surface content of cultural show to the merciless clock ticking inside, through history's processions to the *marche funèbre* they always become, so they saw through the so-called unmixed motive to the self-interested power-hungry impulse below, through the mind to the flesh, through the flesh to the skeleton, and through the conscious figure of civilized man himself to the savage, the beast in the unconscious psyche repressed and chained but ready, like Frankenstein's monster (played by Boris Karloff in a cinematic hit of 1931), to spring free and take over.

No version of the "terrible honesty" ethos was more congenial to the white moderns than the European theological movement called Neo-Orthodoxy, though the links were not always conscious ones. Shaken by the horrors of the Great War and led by the young Swiss theologian Karl Barth, whose monumental study *The Epistle to the Romans* (1919) gave the movement its creed, exponents of Neo-Orthodoxy wished to expose the lies of the liberal Victorian Protestant establishment and its effete whitewash of the evil human heart; they advocated a return to the grimmest, truest facts of Pauline and Calvinist theology. The American scholar Douglas Horton, later to be dean of Harvard Divinity School, seconded their move; he discovered Barth's work in a burst of excitement in the mid-1920s and published his translation of Barth's *The Word of God and the Word of Man* in 1928.

A new sternness, an urgent need to get back to basics, characterized thinkers outside the church as well. The Calvinism to which Barth wished to return had much in common with Freud's worldview. Gilbert Seldes observed in *The Stammering Century* (1928) that "one might as well be damned with Calvin . . . as with Freud"; neither believed in "deliverance" of any kind as a possibility for more than a handful of people. Freud reintroduced the notion of infant depravity, banished in the nineteenth century, under the rubric of infant sexuality, and said that, when all is said and done, human lives are determined and exhausted by the "reality principle" and the "death instinct." Writers echoed Barth's themes, too. If Barth told his contemporaries that they must "learn [their] theological ABCs all over again," Ezra Pound reproved the age for its "criminal" sloppiness and lectured on "The ABC of Reading." The white artists of the 1920s were less atheists, although that was their claim, than disbelievers in the liberal tradition that John Calvin in Europe and Jonathan Edwards in New England had opposed centuries before, and that Barth disdained now, adherents to a God so cruel in his absence, so punishing in his presence, that only the kind of embattled believers who designed and revived Calvinist theology and founded psychoanalysis could have conceived him. If Calvinism was, in Sara Teasdale's words, "the refusal to be made happy by faith in God," the white American writers of the 1920s were Calvinists. If theology is, as I think it is, honesty investigating its own claims to existence, the exponents of "terrible honesty," with Freud at their head, were theologians one and all.

"You are all a lost generation," Gertrude Stein told the young Ernest Hemingway in the early 1920s. Hemingway originally planned to call his first novel about the Paris scene "A Lost Generation" (it became *The Sun Also Rises*). He later disdained the phrase as a "dirty, easy label" and his peers joined his dissent, but the label stuck and they themselves were the ones who made it stick. The insistent knack of autobiography that characterized them again and again produced phrases that were loose elaborations on the idea of the lost generation. Elinor Wylie wrote of "Maledictions upon Myself," Louise Bogan of a "Solitary Observation Brought Back from a Sojourn in Hell"; Eliot wrote of "The Hollow Men" and *The Waste Land*, Hart Crane of "Faustus and Helen," Scott Fitzgerald of *The Beautiful and Damned*. Robert Benchley reported on *My Ten Years in a Quandary and How They Grew*, Frederick Lewis Allen on a "decade [that] was unhappy," Fitzgerald, again, on "The Lost Decade." With the light touch of the whip that was her trademark, Parker once christened her generation (including, of course, herself) "a ladies' auxiliary of the damned," "poor little ewe lambs that had gone astray." Beneath such words and phrases lay truth—half fact, half histrionics, but truth just the same, and theological truth to boot.

Many of Parker's contemporaries were biblically reared, perhaps the last generation in American literary annals to be so. They made frequent, even obsessive references to biblical words and parables, and they knew the word "lost" had a theological meaning. The members of a generation that was "lost" might be those of whom it was written in the Bible that they "gained the whole world" but lost their "souls"; they might be the "lost sheep"—in Parker's update, the "poor little ewe lambs that had gone astray"—whom Christ came to save. Or they could be the "Prodigal Son" who is lost and then found. One of Elinor Wylie's finest poems, "Birthday Sonnet," written shortly before her sudden death in 1928, begins: "Take home Thy Prodigal Child, O Lord of Hosts!" Modernism, Eliot believed, was a response and a corrective to the vitiation and "decay of Protestantism" and its sternest doctrines at the hands of liberal-minded believers in the nineteenth century. Sin, damnation, redemption: these were unyielding realities to the 1920s generation. To deny them was to forfeit one's art.

Despite Hemingway's attendance at the upbeat First Congregational Church as a boy in Oak Park, Illinois—or perhaps because of it—as a man he would explicitly scorn "the small, dried . . . wisdom of Unitarians"; the Unitarians had been the leaders in the liberalization of Protestantism that Oak Park had so conspicuously embraced. For his part, Hemingway chose to write clean and dark biblical parables about, in his words speaking of *The Sun Also Rises*, "how people go to hell." Katherine Anne Porter, a Methodist-born Southerner whose style was almost as stark as Hemingway's, devoted herself to studies of the Protestant Reformation, and planned to write a book about New England's Cotton Mather and his "witch-burning orgies" of the 1690s; as a girl she occasionally signed herself "Witch." Porter didn't finish the Mather biography, but her finest tales, "He," "Theft," "Magic," and "Noon Wine," are stories of original sin set in modern times that lay bare what Porter called the "never-ending wrong," the "incurable wrong" perpetrated by "the very hard heart."

The writers of the 1920s found their hero in Melville's Captain Ahab, God's apostate, "the American Lucifer" and "the American Faust," in Carl Van Doren's words, who is "bound to get at truth though it should blast him," and they consigned to oblivion all those who had ignored him: the nineteenth-century readers shamefully addicted to the sentimental treacle of what Nathaniel Hawthorne had called "a damned pack of scribbling women." The best-selling women authors of the Victorian era and their male allies—the essayists and poets of whom Longfellow, Lowell, and Whittier were the best known—were the literary branch of the Unitarian liberalization forces, and Constance Rourke described them in *American Humor* (1931) as "twittering" and "pretty" "poetasters and . . . storytellers" of the

"false-feminine"; those who read and praised them were merely slaves to the Victorian matriarch. The novelist and satirist Thomas Beer took on the matriarch, or "Titaness," as he wickedly dubbed her, in a best-selling retrospective of Victorian America entitled *The Mauve Decade* (1926). Beer hooted at her "self-deification" and scorned the "feminized" culture of third-rate art and fourth-rate thought over which she had presided as "a terrific machine of flatteries." Those who are flattered, the 1920s generation asserted, are blinded. What could the Titaness know of Melville's "power of blackness" or the ethos of "terrible honesty"?

Maternal guidance was forsworn. "No girl respects her mother these days," Gertrude Atherton observed in her best-selling novel *Black Oxen* (1923), "but her father has the advantage of being male." Women drank and talked like men, and men and women alike wanted to see and hear, if not everything, the worst of everything. They reified the Freudian father and his harsh "Oedipal" code of conflict and fled the mother and the vague, messy, shameful, obfuscating "pre-Oedipal" blur (the terms are Freud's) she brought with her like an infection. John B. Watson, an advertising man and the founder of Behavioralism, led the way: he had discovered Freud's work while a graduate student in psychology at Chicago, and he analyzed the myth of selfless maternal devotion in his popular book *Psychological Care of Infant and Child* (1928). Most mothers, Watson found, displace their unsatisfied sexual longings onto their children under the guise of "affection." In plain fact, they are "adult murderers of a child's disposition"; they "love [their] children to death." A Harvard professor, Thomas Morgan Rotch, had warned mothers in the 1890s that their milk might "act as a direct poison" to their children, and Watson preached weaning of all kinds as a cultural necessity. He aimed to masculinize the American family.

According to Watson, children must be given a room of their own from infancy on; couples who can't afford this arrangement should not have children at all. Children are to be kissed seldom—Watson suggested a handshake in place of a kiss—coddled never, and taught "as quickly as possible to do everything for [themselves]." With Hemingway, Watson apparently believed that "you can depend on just as much as you [yourself] have actually seen or felt." Overeager parental attention, in Watson's view, gives the child the illusion of having resources and options he does not, unaided, possess, and the fact that we are ultimately unaided was to the 1920s way of thinking the most basic fact of all. This was the first era in American history in which contraception was publicly promoted and scientifically researched—Margaret Sanger had opened the nation's first birth clinic in New York in 1915—and Watson wanted to see fewer as well as better mothers: "not more babies but better brought-up babies" was his goal. Watson's era would try to drop the

word "mother," a holy one in the Victorian era, for the more distant "parent."

In the March 1930 issue of the *Ladies' Home Journal*, Dr. Abraham Myerson referred to the good old days when "Freud had not yet corroded" the infant-mother tie, when "Watson had not yet destroyed the self-esteem of the mother by making her worse than useless in her own eyes." He got the point. Watson's advice to American mothers is not really advice but an exercise in "terrible honesty" at its most punitive. *Psychological Care of Infant and Child* is less a guide than an exposé, and diagnosis, of an illness: repressed sexuality. It was a diagnosis on everybody's lips. When it came to criticizing older ways, no weapon was sharper than the new psychoanalytic method with its monomaniacal emphasis on repressed sexuality as the unacknowledged source of all lofty-minded activities and ideals; psychoanalysis seemed expressly designed to make its enemies betray themselves.

What had driven Mary Baker Eddy to found Christian Science with its near-prohibition against sexual activity, its refusal to acknowledge pain and, some said, reality? Edwin Dakin, drawing heavily on psychoanalytic sources, gave the answer in a book provocatively titled *Mrs. Eddy: The Biography of a Virginal Mind* (1929). Eddy's motivation, unknown of course to her but writ large to later observation, lay in her "frustrated" sexuality and menopausal mood swings, her "inferiority complex," and her "hysteria." The governing board of the Christian Science Church censured the book and launched a boycott against it, but *The New York Times* ran a pro-Dakin story on December 7, 1929. Christian Science protest had only created fresh publicity for the enemy.

Men and women of the 1920s found out about the "Instincts and Their Vicissitudes"; people *are*, they discovered, their instincts, whether acted out or repressed. "Instincts and Their Vicissitudes" was the title of a 1915 paper by Freud, but it could also cover Hemingway's writings, which concentrated on "the body thinking and moving through a landscape," in Edmund Wilson's words. Indeed, all the writing of the urban 1920s is a gloss on the body and the workings of what Freud called "the primitive mind." Freud instructed his readers in another essay of 1915, "Thoughts for the Times on War and Death," that "civilized" and "hypocritical" camouflages come and go but "the primitive mind" they seek to disguise is "imperishable." He called the site of the "primitive mind" the "id" and identified it with "savage" peoples. Religion might be out, but superstition was in; exponents of "terrible honesty" dismissed the ideals of men, but they extensively noted men's affinities with the world of the savages and the animals.

Psychoanalysis was born in Paris in the mid-1880s, the legend goes, when Freud worked with the famous and histrionic French neurologist Jean Charcot in his studies of the major female malady of the nineteenth century,

hysteria, the pathological form of repressed sexuality Dakin later ascribed to Eddy. Charcot let his patients demonstrate their symptoms to his classes; at times he himself acted out the hysteric's seizures and tics. But Charcot was not Freud's only demonstrator of hysteria or his only drama teacher in Paris. Freud also saw the great French actress Sarah Bernhardt in Sardou's melo-drama *Théodora*; he described the experience in a long, excited letter of November 8, 1885.

Théodora is a high-minded but overwrought and doomed woman; now a queen, she has been a courtesan and a star of circus life, a trainer, or *dompteuse*, of the animals, a fierce sister to the tiger. The role was written especially for Bernhardt and it was in part about her. The erotic and high-strung actress was notorious for her turbulent liaisons; she was seen by many (including at times herself) as a classic case of hysteria, and she was repeatedly linked with animals, wild and otherwise. One critic described Bernhardt's return to the Théâtre Française in 1872 as "the wolf enter[ing] the sheep-fold"; by 1885, she had begun to collect a private menagerie of parrots, monkeys, cheetahs, lion and tiger cubs, exotic birds, and wolfhounds. She took her animals with her wherever she went, and a profusion of animal skins—tiger, jaguar, beaver, bear, buffalo, crocodile—lay heaped on floors and divans in her sumptuous living quarters in Paris. Bernhardt was as big an attraction in America, which she toured eight times between 1880 and 1918 (kicking off the star system in the process), as she was in France, and the conjunction of America's favorite dramatic muse and its chosen intel-lectual mentor was a momentous one.

Watching Bernhardt in *Théodora*, Freud was riveted. "How that Sarah plays!" he wrote Martha Bernays. "I believed at once everything she said." Bernhardt was, I believe, as important to Freud as Charcot was; a photograph of "La Divine Sarah" graced his office in Vienna in later years. In a char-acteristic act of modernization by gender theft, he discarded her lofty notions of the passions that consumed her stage personae but appropriated her studies in sexuality for his own fledgling science and her melodramatic role as lord of the animals for himself. His pioneering work *The Interpretation of Dreams* (1900), a study of the unconscious as it reveals itself in dreams, was an exegesis, in his words, of the "Mark of the Beast" (the phrase is from Rev-elations), and the titles of his case studies *The Rat Man* (1909) and *The Wolf Man* (1918) echoed the names of freak-show acts like "The Frog Man" and "The Monkey Girl," still vastly popular in America and Europe. Freud seemed to blur the distinction between man and beast, and many of his critics thought he was, in the words of Arthur E. J. Legge, the "suspicious character" who sneaks into the zoo and lets the animals out.

Photographs of Bernhardt posing as a corpse in an open coffin attracted

top prices in pornographic circles, and the turn-of-the-century years when Freud was working out his earliest theories were also pornography's heyday. Pisanus Fraxis's *Index librorum prohibitorum* (1877), *Centuria librorum absconditorum* (1879), and *Catena librorum tacendorum* (1885)—long and detailed guides to the underworld of forbidden and censored books—appeared during the years of Freud's young manhood and early medical training. The same years saw in America and Europe the largely female-sponsored "Purity" campaigns against vice in all its forms; these crusades against unbridled male lust, prostitution, venereal diseases, and impure reading matter inevitably disseminated much new information about the sexual practices they opposed. The Wasserman test for syphilis was first used in 1906, the Salerson treatment in 1910; by 1911 the *Ladies' Home Journal* was open to frank articles on prostitution. The preoccupation of both pornographers and crusaders was, to borrow a phrase from Djuna Barnes's novel *Nightwood* (1937), "purity's black backside."

Freud's conventionally minded wife, Martha, tried to protect their children from his analytic scrutiny, and it was rumored that she once described her husband's theories as "pornography." In an early letter of December 22, 1897, to Wilhelm Fliess, Freud himself referred to his psychoanalytic material as "my smut"; he confessed to Ernest Jones near the end of his life that if he could not think about sex, he could not think at all. Yet Freud liked to boast that he himself had had scant benefit from the extended license his work granted to sexual needs; he might think about sex and nothing else, but he never committed adultery, and he more or less ceased to have sexual relations with his wife sometime in the late 1890s, while he was in his early forties. He turned to celibacy, in other words, just as he was formulating his theory of sexuality; the timing seems more than coincidental.

Freud's theories were based on the startling disclosures he solicited from his largely feminine patients about their sexual experiences; they told him again and again (in his words), "No one [has] ever asked me about this before." Not surprisingly, as he noted in the essay of 1915 "Transference Love," the patient was apt to project her unfulfilled sexual desires onto the psychiatrist, and Freud found "an incomparable fascination about a noble woman who confesses her passion." On a less euphemistic level, he had reported in *Studies in Hysteria* (1895) a patient he called "Elizabeth Van R." having an orgasm as he "pressed or pinched" her legs, testing, or so he said, her response to pain. Freud was celibate professionally as well as personally; he advised analysts to observe such sexually charged behavior rather than respond in kind. But restraint has its own pleasures. Speaking of "Psychopathic Characters on the Stage," Freud wrote that "the spectator is a person who experiences too little"; he might have said that the ideal

46

spectator *must* "experience too little." There are many explanations for Freud's decision to end his sexual activity, but surely among them is the possibility that he found, as they say down on Times Square, he would "rather watch." He described this preference in an essay of 1910 on Leonardo da Vinci as the "intensive desire to look as an erotic activity."

A number of Freud's most basic assumptions about the human psyche— the dominance in his thought of the hydraulic model of fixed energies operating in a closed system, the overprivileged place given to curiosity, "the instinct of research" into sexual matters, in his words in *Three Essays on the Theory of Sexuality* (1905)—are ones he shared with the pornography and reform traditions. Freud supplied what pornography and reform alike willfully lacked, a theory of the unconscious, but he was playing modernizer as well as apostate to the past; what the Victorians had classified as vice, Freud explored and marketed as science. He sexualized the narrative of Western culture, and no one got the revamped storyline better than his American fans.

In a seminal book on advertising, *Propaganda* (1928), Freud's nephew Edward Bernays drew on "psychologists of the school of Freud" and urged advertisers to appeal to the powerful "motives which [men and women] conceal from themselves." Bernays was the man responsible for marketing Lucky Strike cigarettes to women, and others joined him in addressing the hitherto censored sexual motive. An ad for Camel cigarettes showed a young man lighting a woman's cigarette. The caption read: "Pleasure Ahead." Everyone apparently wanted the Woodbury soap girl with "the skin you love to touch." Men considering the "body" of General Motors' Fisher car were enticed, not by a picture of the car, but by a picture of a beautiful woman in décolleté evening dress standing next to it; she was "the Fisher Girl." Packaging the risqué song for mass consumption, the popular blues songs of the day were filled with what Scott Fitzgerald called "phallic euphemisms," transparent double entendres for the sexual act. Mae West, who sometimes sang the blues, wrote and starred in *Sex*, a hit on Broadway in 1926. She asked one avid male admirer: "Is that a pistol in your pocket or are you just glad to see me?" A woman fortune-teller had the same idea; she explained to the publisher Donald Friede that her method was "infallible" because she read, not the palm, not the bumps on the head, not the cards, but "the phallus."

Burly, hard-drinking, and chronically unshaved, Heywood Broun was upset to learn during one round of the Truth Game that he had no "sex appeal"; the term was a new one. Sex appeal, Elinor Glyn explained, was "It," and "It" was a pop version of Freud's id, an undefinable voltage of openly sexual energy. Glyn christened Clara Bow the "It Girl," but there

were other contenders for the title. In Greenwich Village, Manhattan below Fourteenth Street where the avant-garde made its headquarters after the war, the adventurous red-haired Edna St. Vincent Millay of "I Burn My Candle at Both Ends" fame was "It"; her lovers, male and female, were so numerous and enamored that they considered holding reunions. On one occasion, "Vincent," as she liked to be called, generously let two men make love to her at the same time; Edmund Wilson was assigned the top half of her body, John Peale Bishop the lower. Louise Brooks, the "secret bride" of New York, early acquired the nickname of "hellcat," and she referred to herself as "a startling little barbarian." Some thought her full name should read "Louise Brooks No Restraint," for she pursued with avidity what she dubbed "the truth, the full *sexual* truth." "I like to drink and fuck," she announced, and drink and fuck she did, usually in public places.

Going public with one's animal nature became a popular pastime in the 1920s. An interviewer from *Motion Picture* magazine reported that the "actress Tallulah Bankhead gives to all the functions their round Rabelaisian biological names." Tallulah liked to show as well as tell; exhibitionistic and alcoholic, she was notorious for her penchant for defecating in full view of her companions. Obese and greedy Alexander Woollcott, who claimed to have been born in Macy's show window (newly enlarged and redesigned in the 1920s), loved to discuss his magnificent bowel movements as he performed them, and he tiled his bathroom with pictures of himself on the john. Robert Ripley seemed to live in excrement. Anyone could smell out the fact that he seldom bathed; his nails were black with dirt, he gobbled and sucked his huge meals, and his monstrous buck teeth prompted one acquaintance to speculate that he had stolen them from a wild boar. Rip claimed to have had sex in diverse spots all over the world (the town of Hell, in Norway, was his favorite), and he actually kept and brutally ruled a "harem" of girls of every nationality near his private zoo on a Citizen Kane–scale estate in Mamaroneck, New York. In the eyes of this generation, love was nothing but a sublimation of sexual need, "a mere biological fact," in Joseph Wood Krutch's opinion, "ridiculous and disgusting," or in Damon Runyon's slang phrase, "strictly the old phedinkus." "The genitals [have no] beauty," Freud explained; "they have retained their animal cast."

Sometimes the confusion between men and animals was planned and strategic. Abroad, a number of doctors led by the Russian Serge Voronoff were transplanting chimpanzee glands into human males eager to increase their sexual potency and lengthen their lives. (Freud himself considered undergoing a form of this operation.) At home, John Romulus Brinckley of Kansas, a bogus doctor known to the world as "Goat Gland Brinckley," performed such operations by the thousands and advertised his procedure

on a coast-to-coast radio program. Don't be a "gelding," his spiel ran; be a "stallion, erect . . . stamping the ground, seeking the female!" Animals thinly disguised as humans grabbed headlines in the summer of 1926. "The Monkey Trial" in Dayton, Tennessee, in which John Scopes fought for his right to teach to Dayton's schoolchildren the Darwinian theory of man's evolution from the animals, was the first trial ever to be broadcast live on radio. Scopes lost the case in the courtroom but won it in the media. H. L. Mencken, covering the events for the Baltimore *Evening Sun*, surveyed Dayton's "primitive" Holy Rollers and fundamentalists with evident relish. "No wonder," he wrote, "the Romans finally bumped off the son of Joseph!" Was not Mencken's occupation, as he liked to say, "stirring up the animals" in the "zoo" that is America? Was not his favorite prey, the "Boobus Americanus," but another version of "the gaping primate"?

Mencken delighted to pose as an amateur anthropologist chronicling the savage idiocy of a supposedly civilized race, but there were professionals on the scene as well. The discipline of anthropology, heavily influenced by Freud and his equation of modern neurosis with the "savage" and the "primitive mind," was in its formative stages in the early decades of the twentieth century. The first Neanderthal skeleton was discovered in the Middle East in the mid-1920s; in 1925, Roy Chapman Andrews brought back dinosaur eggs from the Gobi Desert. At home, America was in the favored position, one unique among the world's major powers, of containing within its civilized borders two "primitive" peoples, the Native American "Indians" and the far more numerous and pressing group, the Negroes. If, according to the ethos of "terrible honesty," the savage lay in wait behind the civilized man, the Negro lay, repressed but potent, behind the white man. The principal task that "terrible honesty" set for the white urban American moderns was that of "facing the fact," as Harold Stearns wrote in *Civilization in the United States*, that America is no longer, if it ever was, an "Anglo-Saxon" country.

Debate raged about whether the white race was to be eclipsed or revivified by the darker peoples of the world. In *The Passing of the Great Race* (1916), Grant Madison (a New Yorker) warned against "reversion" by whites to the animal level of the Negro; Lathrop Stoddard elaborated Madison's warnings in 1920 in *The Rising Tide of Color*. Maurice Muret's *Le Crépuscule des nations blanches* (1925) was quickly translated into English and published in New York as *The Twilight of the White Races*. Others worried less about fending off the darker peoples than about saving them; an ever-wider public waited for news of the "giant rescue operation" designed to record the ways of primitive cultures quickly nearing extinction at the hands of the homogenizing forces of Western modernization.

The term "giant rescue operation" was Margaret Mead's; she was speaking

of the work of her teacher Franz Boas, one of the founding fathers of anthropology. Boas was an émigré from Germany to New York and head of the anthropology department at Barnard College; he pioneered in the study of American Indian and Negro cultures. Scarred, misshapen, and grotesque in appearance, Boas was himself a kind of sacred monster. Among his prize pupils were Melville Herskovits, a trailblazer in African-American studies; Ruth Benedict, then studying the visions of North American Indians; and the writer Zora Neale Hurston, who was measuring heads in Harlem and preparing to collect black folklore in the Deep South. Mead herself embarked on a field trip to Samoa to investigate what she would call *Coming of Age in Samoa*. Published in 1928 by William Morrow, Mead's book was a controversial surprise hit with the non-academic reading public.

Mead explained that the concept of celibacy was "absolutely meaningless" in the primitive culture of Samoa, and Mencken, reviewing the book in the November 1928 issue of *The American Mercury*, gleefully amplified her point: the Samoan "avoids repression by devoting himself to light and transient loves." Freda Kirchwey, editor of *The Nation*, noted in the October 17, 1928, issue that, by Mead's account, Samoans indulged in what civilized people call "promiscuity" and flourished as a result. Was Mead suggesting that modern Americans might do well to emulate their healthier so-called primitive ancestors? Mead, who seemed to acquire a new lover or husband on every expedition she made, tried to defend her book from those eager to praise or attack it as a tract for sexual liberation by pointing out that a mere 68 out of a total of 297 pages dealt with sex. But those 68 pages helped make the book a best-seller and put anthropology on the map.

Hemingway, a boyhood naturalist and member of the Agassiz Club in his hometown, repeatedly imaged life as the struggle between beast and beast, between, in other words, the human beast, man, and those whom man calls animals, a struggle most dramatically revealed in the Spanish bullfights that his stories and novels made a must-see for thousands of American tourists. Hemingway also popularized the hunting trip and the safari, and he told a portion of one of his famous hunting tales, "The Short Happy Life of Francis Macomber" (1936), from the point of view of the hunted beast, the lion. Those who stayed at home forged animal alliances, too. The ill-educated and uncouth Babe Ruth, the Yankee's star slugger, was nicknamed "Niggerlips" for his big mouth; some speculated he had Negro blood, but his first wife, Helen, sensed other affinities. Once, as the couple stood before the ape's cage in the zoo, she cried out: "Look, Babe, he knows you!" Louise Brooks planned to call her memoirs "Naked on My Goat." Marianne Moore, who thought poetry was "an unintelligible unmistakeable vernacular like the

language of the animals," created poetic menageries of eccentric and precise beasts.

Not infrequently, the tone of these latter-day bestiaries was more theological than anthropological, more Neo-Orthodox than Neo-Primitive. Freud had decreed that "Biology is destiny," but for Fitzgerald, that destiny was sometimes a nightmare; he never forgets that Dick Diver, the hero of *Tender Is the Night* (1934), though "dignified in his fine clothes . . . [is] yet swayed and driven as an animal." Yank, the hero of Eugene O'Neill's play *The Hairy Ape* (1922), is a brutal and confused sailor who stokes the furnaces of "hell." A Babe Ruth figure, neither man nor beast, he finds his only companion in an ape in the zoo, who embraces and strangles him. Djuna Barnes wrote haunted, witty fables of the damned, half-beast, half-man, who live in the "Nightwood" of modern life.

John Barrymore, actor and desperado, and the doom-struck torch singer Helen Morgan maintained their own zoos à la Bernhardt; Barrymore kept a vulture (among other pets), Morgan a not so tame lion. Barrymore specialized in roles that involved inhuman deformities, in "monsters" like Richard III, Svengali, and Jekyll's Hyde. A posthumously published poem by Elinor Wylie told the story of Nebuchadnezzar, the ancient biblical king forced to "crouch on his knees" like an animal and eat the "frosty seed of the grass" in expiation for his defiance of God's authority. It was a compelling image to the New York mind. Barrymore's friend the journalist Frank Butler went crazy and started roaming Central Park on all fours, eating grass and telling passersby he was Nebuchadnezzar. Some wits called New York City itself "Nebuchadnezzar's Home Town."

Whatever its pains or sins, the body had one great virtue in the eyes of practitioners of "terrible honesty." As the great dance pioneer Martha Graham liked to say, "Bodies never lie." A resident of Greenwich Village in the 1920s, she developed her savage choreography in the best Bernhardt manner by "walking," in her words, "up and down, back and forth . . . in the zoo before the lion's cage, studying his potential for violence." Graham believed "dancing is animal in its source" and she studied Indian and Negro dances; she was the first among the pioneers of modern dance to include people of color in her dance troupe. Her austere art of insistent distortion was for the few, but many less punitively minded people shared her views on the origins of dance.

From 1925 on, when the black dancer and singer Josephine Baker emigrated to Paris at the age of nineteen, her audience was almost exclusively white. She was representative of the new trends in vernacular dance in the broader culture, and she once remarked, with the characteristic combination

of sass and goodheartedness that brought Paris to her feet: "People have done me the honor of believing I'm an animal." "I love the animals," she said, "they are the sincerest of creatures." Like Graham, she found her inspiration in a zoo. Baker, at least at the beginning, was in part a comic star, and her model was a kangaroo. She, too, surrounded herself with a menagerie: dogs, cats, parrots and parakeets, pigeons, rabbits, monkeys, a snake, a pig, a goat, and a leopard misleadingly called Chiquita ("she" was actually a "he"). Baker and Chiquita became inseparable; she bought the leopard a collar of diamonds worth $20,000 and used him in her act at the Casino de Paris in the early 1930s.

The dances in vogue among white groups were borrowed from African-American culture and took their names from a bestiary—the Turkey Trot, the Grizzly Bear, the Fox Trot, the Monkey Glide; they emphasized, not, as the Victorians' favorite dance, the waltz, did, the patterned movement of feet in regular time, but the entire body's lively interpretation of an often surprising beat. I mean the *entire* body: Baker's dancing seemed to center on shaking her rear end. The "rear end exists," she commented, casually overturning decades of Victorian prohibitions; "I see no reason to be ashamed of it." Observers were enchanted with Baker's "heinie moving . . . fast behind her like a humming bird." Fast dancing (the Charleston, the Black Bottom, and the Lindy Hop) to the "hot" and "horribly primitive . . . syncopated passions" of jazz, as Percy Marks put it in *The Plastic Age* (1924), became the national sport and marathon dancing the national ordeal. A Charleston spree at New York's Roseland Ballroom in 1924 lasted twenty-four hours; the floor of the Pickwick Club in Boston collapsed during a Charleston number from the exertions of the dancers, killing fifty people. The first dance marathon was held in March 1923; the winner, Alma Cummings, stayed on her feet for twenty-seven hours. Within a year, Homer Morehouse beat her record by dancing for eighty-seven hours; the feat killed him.

The question that kept dancers and spectators going till they dropped was: how much can the body take? They were determined to know and discipline that body with unprecedented thoroughness and fanfare. The measurement of food's energy had been established in the 1890s, but calories were not widely understood until the late 1910s and 1920s; in the same years, vitamins were discovered and the Detecto bathroom scale was patented. One's weight was now a matter of daily and calculated vigilance. As Fannie Hurst—not only a popular New York novelist but a reluctant dieter—learned, the old "glandular alibis" were out. The "fundamental truth," she noted, is that "food makes fat"; only eating gets you fat, only not-eating gets you thin. In the fall of 1921, *The New York Times* covered an intensive weight-reduction

program hosted by New York Commissioner of Health Dr. Royal S. Cope-
land and subscribed to by "[Fifty] Fat Women"; the paper printed daily
accounts of the dieters' spartan fare. The title Hurst gave her account of her
dieting days says it all: *No Food with My Meals* (1935). Guided by brand-
new diet experts like Lulu Hunt Peters, whose *Diet and Health* (1918) was
a steady best-seller throughout the 1920s, Hurst's contemporaries went on
the first modern diet and collectively lost thousands, perhaps millions, of
pounds.

In the process, they found out that, in Hurst's words, "hungry eyes have
a . . . sharpened clarity"; eyeglasses were perfected and sales of optical goods
increased by 300 percent between 1880 and 1929. The men and women of
the 1920s were the first to ride in airplanes, and they took them to every
part of the globe, including the North Pole. They installed electric service
in their part of the American continent; they lit up and cleaned out and
looked hard at its dark places. Discarding soft-focus photography for sharp,
they made photojournalism (instead of text and sketches) the dominant form
of illustrated reportage; and for the first time since the Puritan era, the public
bought more nonfiction than fiction. The best-seller lists featured fact-filled
surveys like H. G. Wells's *Outline of History* (1920), Hendrik Willem Van
Loon's *Story of Mankind* (1921), and Will Durant's *The Story of Philosophy*
(1926). People eagerly purchased exposés of past and present credulities that
ranged from Mencken's vaudevillian *Prejudices* and Robert Ripley's *Believe
It or Not* collections to Henry Adams's eloquently hostile elegy to the Vic-
torian era, *The Education of Henry Adams*, a (posthumous) best-seller in
1918, and John Maynard Keynes's scathing analysis of *The Economic Con-
sequences of the Peace* (1919). Readers in the 1920s knew, as Ripley liked to
insist, that "truth is stranger than fiction."

This generation was the first in American history to make, buy, and fit
into ready-made, exact-sized (rather than "stock-sized") clothing. Its mem-
bers patented electric Victrolas, cameras, microphones, radios, and talking
pictures and initiated IQ tests, sex education, birth-control clinics, opinion
polls, consumer organizations, and syndicated gossip columns. Aiming to
leave little or nothing to the imagination, they found out more about
themselves, how they looked, how they sounded, what they wore, what they
said and did, with whom, where, and why, than any previous generation
had ever done, and they made of self-knowledge a fad and an industry.
Harold Stearns summoned his contemporaries to a "self-conscious and de-
liberately critical examination of ourselves without sentimentality and with-
out fear." New Yorkers flocked to the new psychoanalysts, and Leo Stein,
Scott Fitzgerald, Lewis Mumford, William Seabrook, and Edmund Wilson
among others took a sustained painful look at themselves in their moments

of breakdown. In *The Crack-Up* essays, Fitzgerald called it "the moving about of great secret trunks." "God," he added, "was it difficult!"

According to Malcolm Cowley, college students all across the country were copying the fashions and language of Hemingway's novel *The Sun Also Rises* in the mid-1920s; its most famous line was its last. Jake Barnes and Lady Brett have made a mess of their lives and they know they will continue to do so, but they tell each other that it all could have been different if only they had been able to consummate their love (Jake lost a crucial part of his genitals in the war). Jake comments on their moment of fantasy: "Isn't it pretty to think so?" Thinking might be glamorous but it was never "pretty" to this generation. Hemingway's line is a heavily ironic one, and irony, saying one thing and meaning another, the discourse of disbelief that claims a monopoly on self-knowledge and shreds the "pretty" in the interests of the true, became the only thoroughly accredited modern mode. As the moderns practiced it, irony played cruel stepfather to an orphaned faith.

Louise Brooks boasted that she and her peers were "inhumane executioners of the bogus" who confronted the "ugly," the "abhorrent . . . experience" head on. They introduced into what was left of polite society the full spectrum of long-tabooed profanity and a slang idiom that specialized in terms for reality or the facts (the "lowdown," the "scoop," the "dope," the "dirt") and the fake or meretricious ("bunk," "bogus," "baloney," "applesauce," "balls," "bull[shit]"); they tried to eliminate from their lexicon all the words like "sacred," "sacrifice," and "soul" that their Victorian predecessors had disfigured by overuse and misuse. Slang in the 1920s was the speech of bootlegging criminals and fast-talking vaudevillians, people who knew how to "fix" everything from the World Series to bathtub gin, the language of the instincts wised up to their own vicissitudes and insistently critiquing human claims to anything but strictly mortal turf. The rudely insistent "Who sez?" was a 1920s retort.

The aim of this generation was to conduct what Jack London advocated as "a savage investigation of biological fact" and convey it as nonchalance, to combine certain risk with manufactured immunity. "Look, Ma!" no affect—and all artifice. Declaring open season on every form of "make-believe," they professed not to care if the bullet lodged in their own hearts; self-hatred was the mark of high style. Dorothy Parker liked to bowl her "shattered heart" down the street and watch while "Every likely lad in town/ Gathers up the pieces." After all, she queried, "who's to say it mattered?"

"IT IS DRAMA OR IT IS NOTHING"

Asked to recite her poetry at a party, Edna St. Vincent Millay would toss back her hair, bare her long white neck—she speculated in an early poem that she would someday be "strangled"—and launch into full declamation. Reporting on one such occasion in his novel *I Thought of Daisy* (1929), Edmund Wilson said that "the effect" was at first to "embarrass" him; "it was a little as if a Shakespearean actor were suddenly, off the stage, to begin expressing private emotions with the intonations of a play." But gradually Millay's exquisite voice, with its "deep sonorities of sorrow and wonder, began to move [him] as much as a play," and he succumbed, half against his will, to the spell of her "awful drama." "I still want to knock 'em cold," Millay told Wilson a few years later, and she regarded no one as off-limits to her powers of command. Imagining herself dead and gone in an early poem titled "The Poet and His Book," she spoke with fierce posthumous ambition to those who might someday pick up this book of her poems among books marked down to "a casual penny" on some open stall: "Read me, do not let me die!" She asked only one thing, expected but one safety net, and that the flimsiest and the most essential: an audience. Her life lies in your attention.

If the stated goal of "terrible honesty" was the facts, its route there was pure theater. This was the most theatrical generation in American annals. Wilson dubbed his peers "The All-Star Literary Vaudeville," and Constance Rourke, the finest cultural historian of the decade, saw all American culture past and present—politics, religion, advertising, *everything*—as "theatrical"; "Everybody doubled. Everyone had precarious adventures." Most of my protagonists were employed for brief or long stretches of time in the theater, and all of them were actors, not so much professionals earning their living on the stage as amateurs given to theatricalizing their lives at every turn. Parker wrote of that "accursed race that cannot do anything unless they see, before and after, a tableau of themselves in the deed"; was she not every bit as much an actress as the various Broadway actresses who starred in roles, like Julie Glenn in Kaufman and Hart's *Merrily We Roll Along* (1934), based verbatim on her own unpaid but public performances? An amateur actor, as the 1920s practiced the trade, is the only professional, for (s)he is the one who never steps offstage.

Fitzgerald's characters, Wilson noted in a review of 1922, are creatures of "harlequinade"; they're actors posing as people. Think of Gatsby waiting for his long-deferred reunion with Daisy at Nick Carraway's small undignified cottage, "reclining against the mantelpiece in a strained counterfeit of perfect ease." Or the once legendary Gloria Patch in *The Beautiful and Damned*

(1922), now twenty-nine, checking her face in the mirror—her cheeks are "a trifle thinner," but she is, she thinks, "as fresh as ever"—before going to "Films Par Excellence" for the screen test on which she has pinned her dying hopes. Fitzgerald's protagonists are actors poised in the wings, patting their clothing into line for anticipated movement, noting the smells of the theater, the patterns of body and talk which the other actors are creating onstage, listening for the sharp, blank sound of their cue as it falls on the strangely indoor-outdoors air of backstage space. They are acutely on the edge of "going on," actors whose amateur standing only raises the stakes, Scheherazades telling stories as if their lives depended on it.

Acting is an art especially suited to those on the run, exponents of "terrible honesty" eager to get down to basics, minimalists and reductionists convinced that whatever is extra will be lost or "go bad," for actors are nomads who carry their work in their veins. They need never say with Othello, "Othello's occupation's gone"; they will never face a mirror empty of their image, for they are living synonyms of their profession. Wherever they find a site of conspicuousness and an audience at hand, actors are in business; they have their lines in their minds and the emotional repertoire that characterization demands is coded into the movements of their bodies and the expression of their features. (Fitzgerald called the latter "facial vocabulary.") An actor's work energy is locked into his biological energy: acting dictates the tightest fit possible between the calling and the called, the vocation and the invoked.

This tight fit between performer and performance, as the 1920s understood it, was not to be confused with the confessional mode. In Charles Brackett's novel *Entirely Surrounded* (1934), a roman à clef about the Algonquin circle at play in their Vermont retreat, Bemoseen, Dorothy Parker seems to be on a jag of self-revelation complete with drunken confidences and threats of suicide. She soon has the novel's naïve narrator, Henry, perching in trees with her as she emotes a bit hurriedly over nature and talks in greater detail about the "salt mines of love where the condemned serve life sentences," in particular, about her childhood romance with a stableman. Listening to Parker, Henry thinks she is airing her "subconscious," "talking this thing out," but Brackett knows he is mistaken. Parker is not exactly lying, but the confessional mode was one of many for her. It suited certain people and places, went with special hats and special gestures—shaded eyes, a small hand placed disarmingly on a man's large forearm, an upward glance of wistful melancholy—and it was a way of tightening and varying control, not losing it. Damon Runyon, who liked to boast "I know everyone," penned a note to his son at the end of his life (cancer had destroyed his larynx): "No one is close to me; remember that." With his finger, Runyon underlined

the last two words. People know each other's chosen self-presentations, not their so-called real selves.

The dominant theory of acting stressed that the actor should produce and interpret but not feel the emotions (s)he portrayed. Playwrights and actors like George S. Kaufman and James Cagney, who continued to work on stage or screen into the 1950s, detested the much touted Stanislavsky "Method" of immersion in the self in preparation for a role, a method first studied and imitated by American actors in the 1930s; such exaggerated and indulgent acts of introspection could only produce, in Cagney's phrase, "a totally superfluous personality." He insisted that he never "psyched [him]self up" for a scene. In the words of the actor DeWolf Hopper, "Acting is an art, not a spasm"; "The actress who makes her hearers weep is not the one who weeps herself, but the one who seems to weep." Hopper saw acting as both an expression of personality and its "studied suppression"; Eliot called it the "extinction of personality." The goal on stage and off was less to be oneself than to pick and play oneself.

The artist's task, Louise Bogan said, is to describe "the mask, not the incredible face." The persona in question might be ostensibly formal and separate from its author, like the gangster togs, gold tooth, and street idiom that the ultra-polite and well-bred actor Alfred Lunt assumed in Sidney Howard's play *Ned McCobb's Daughter* (1926), and the middle-aged mask the young T. S. Eliot donned in "The Love Song of J. Alfred Prufrock" (1915). Or the persona could be the look-alike, talk-alike, but nonetheless highly crafted and separate projections of themselves that Fitzgerald and Hemingway drew in their fiction and that performers like Al Jolson and Mae West made central to their acts. Gilbert Seldes dubbed these two kinds of self-pictorialization, distant and intimate, "actors" and "players" respectively. But they all knew the show must go on: it was the only game in town, and maybe in the cosmos. "Terrible honesty" *necessitates* theatricality.

The practitioners of "terrible honesty" were chroniclers of time's unpleasant surprises, and they knew that the defacements of significance will one day be all that is left of significance. Even clocks run down; sooner or later they become the drift they annotate. The fight between significance present and significance absent is a fixed fight; absence is the victor. But the staged fight is theater. All time is borrowed time, but theater is consciously, deliberately, conspicuously borrowed time. It was characteristic of Freud that his best insights came as he analyzed Oedipus, Lady Macbeth, Hamlet, and other what he termed "Psychopathic Characters of the Stage," and he believed that life is but a "detour" on the way to death; life's best achievements, he wrote in *Beyond the Pleasure Principle* (1920), are simply the result of the

"organism" trying "to die in its own fashion." Dying in one's own fashion is the most life has to offer; it is staging one's own show. Hemingway had the same idea. He said that all "true" stories end in "death but some people put on a very fine performance en route to the grave." Performance is the only respite there is from the relentless temporal progression that "terrible honesty" chronicles. In the words of Robert Frost, "It is drama or it is nothing."

In the late 1930s, John Barrymore, caught in a tightening noose of steep and multiple alimony payments, compulsive womanizing, bad publicity, ill health, and flagging talent, was clearly and deliberately drinking himself to death, but none of his friends tried to stop him. "If a man wants to kill himself," Charlie MacArthur said, "that's his privilege. Everybody destroys himself sooner or later." One did not interfere with an act of self-destruction any more than one got up in a theater while the play was in midstream to call out suggestions to the actors at work on the stage. From the perspective of "terrible honesty," Barrymore killing himself was still Barrymore performing. Hospitalized at the age of fifty-eight in 1940, he regained consciousness in an oxygen tent and quipped: "[This is] the first time I've ever been in a tent show." On his deathbed in May 1942, legend has it that he confessed to the priest summoned to administer the last rites that he still had "sinful thoughts"; he gestured weakly toward his exceedingly homely nurse. "Mischief never sickened in his soul," Barrymore's friend and biographer, Gene Fowler, commented. Barrymore was putting on a "very fine performance en route to the grave"; he was an example of the organism dying "in its own fashion."

The pursuit of drama amid the fear and fascination of "nothing," what Hemingway called "Nada," was the vocation of Broadway's writers and performers of the 1920s. What can't be solved as a problem can be enjoyed as theater. Where there is no meaning to be found, there is always a pose to be fashioned, and the best place to do it, they all agreed, was on the stage that only New York could provide.

In his evocation of Manhattan in "My Lost City" (1932), Fitzgerald depicted himself in New York (and later Zelda) always on the move, again and again approaching, then leaving the city: crossing from the Jersey shore by ferry to see Ina Claire in *The Quaker Girl*, tracking "that new thing the Metropolitan Spirit" by taxi on a "dark April afternoon" in Washington Square, "pulling" New York "after us over every portal" into "strange apartments . . . through the soft nights," retreating from New York to France, and returning by boat three years later to see "the city burst thunderously upon us in the early dusk." A creature of the freshest of greetings and the most poignant of farewells, Fitzgerald knew that New York, port to America,

port to the world, had long embodied the theater's most basic dynamic: the entrance and the exit, the histrionics and ambiguities of impact.

When Scott and Zelda and their peers came to New York, they found a new world that was already old: an industrial order of sorts so established in its slipshod exploitativeness as to offer the reassuring authenticity of permanently assembled history usable by art, and still in that process of quick formation which is modern art's parallel and incentive. A museum and a factory, New York in the 1910s and 1920s was a modern scene in action crying for comment, tantalizingly ready to express and be expressed. It was a photo shoot inviting models and masqueraders, a play in the vast business of being cast, a movie set calling those ready, like Fitzgerald, to live inside their "own movie of New York."

Visitors commented (perhaps surprisingly to New York's present-day inhabitants) on the dazzlingly clear quality of the air. In 1912, Edna Ferber, just arrived from the Midwest, found New York "harder, more brilliant [than Chicago] . . . This city had crystallized itself, had set itself. The sky was different . . . The people were etched with a sharper acid." People seen in New York appeared as acute, as carelessly and permanently vivid as only images of themselves could be. New York was the camera town. Always the sharp but unnoticed click: the face caught in the store window, the short sounds struck from the pavements, the air broken by buildings, the quick discarded moment, the disconnected continuous opportunities defining and defining without the solace or the dullness of meaning. New York, Zelda said, "is more full of reflections than of itself."

Modern photography began in America in the 1890s, when Alfred Stieglitz started taking pictures of New York's streets, parks, people, and buildings. Stieglitz had been living in Berlin, and when he came home at the age of twenty-six in 1890, he initially thought New York uninspiring, even photoresistant. But Stieglitz underwent something like a conversion experience in the next year or two; he realized that New York was not so much inimical to photography as insistent on a new approach to it. He needed to stop imposing on the American metropolis photographic techniques and ideas worked out in the very different circumstances of European cities, and to let New York itself call the shots. Thus was born the "straight" school of photography, the Photo-Secession Group that included Edward Steichen, Paul Strand, and Alvin Coburn, all intent on pictorial and dramatic effects but eschewing the heavy cosmeticizing and touch-ups then in vogue; Stieglitz founded America's premier photography journal, *Camera Work*, in 1903. The way one perceives things when looking at New York was, then, the impetus and precondition of Stieglitz's art; "New York was as important to photography," the historian William R. Taylor has commented, "as pho-

tography was to New York." The city changed forever "the history of perception" and the ways of recording it.

It is important to note that Stieglitz's conversion to the city had been triggered by its theater—seeing Eleonora Duse in *Camille* and the vaudeville act of the Broadway comics Weber and Fields was the start of what he called his "new vision"—for theater, like publishing and the music business, was then in the process of becoming a New York monopoly. The nineteenth-century theater had been a democratic affair of flourishing local companies and Broadway productions that routinely went "on the road" to cities, towns, and hamlets all across America for months and even years at a time. At the turn of the century, however, the New York theater producers and entrepreneurs Marc Klaw, Abe Erlanger, Charles Frohman, and (a bit later) the Shubert Brothers, in alliance with theatrical power brokers from other areas of the country, syndicated and monopolized the production and profits of almost every branch of theatrical activity; by 1910 or so, a successful production was by definition a New York one. As the press agent Brock Pemberton put it in 1926, plays in the past were produced "with both eyes on the road and only a squint at the New York box office. Now we try to guess at what New York wants without thought of whether the hinterland will be interested."

As early as 1900, New York boasted forty-one theaters to Paris's twenty-four and London's thirty-nine, and the 1920s witnessed an explosion of theatrical activity. By 1926, there were almost seventy theaters in New York, most of them in the charged and magical zone around Broadway from Twenty-eighth Street up to Fiftieth Street; twenty-six new theaters opened between 1924 and 1929. In 1927, by the theater historian Jack Poggi's count, 264 plays were produced; the average per year for the decade was a staggering 225, a rate never approached since. In an essay of 1932, "New York in the Third Winter," James Thurber claimed there were eighty-six "legitimate theatres" in New York; "New York is, of course, first and foremost a city of theatre-goers." By the time he made this assertion, however, movies had sounded the death knell of the legitimate theater as a broad-based phenomenon; by 1932, dozens of theaters had been converted into movie palaces, and banks owned more theaters than Shubert and Erlanger combined. The 1920s in New York coincided, then, exactly with the peak of American theatrical production; this peak was the decade's, and the city's, most striking and deepest-rooted characteristic.

Even the movies that supplanted the theater owed a good deal to New York; movies might be illegitimate theater, but any form of theatrical activity was irresistible to the New York temperament. The first studios were located in the New York area. Although most of them moved to Hollywood in the

course of the 1910s, an important minority stayed behind; as late as 1929, 24 percent of all American film production was still in New York. Astoria Studios remained in Queens as an adjunct of Paramount Pictures, and Fox opened a studio in the city in 1920. D. W. Griffith came back from the West Coast in 1919 to Mamaroneck, because the "money and brains" were in the East. New York had supplanted London as the world's banker by the end of the Great War, and as the movie industry developed into conglomerates of production and distribution facilities, New York provided the backing; shares of the Big Eight, as the leading studios were called, were traded on Wall Street, and by 1926 the movies were the fifth-largest industry in the United States. New York boasted more movie theaters than any other city in the world, roughly 800 of them, with an average seating capacity of 1,200. Fully one-third of American movies in the 1920s and early 1930s were set in New York, and many more of them were staffed by New York playwrights, directors, and actors.

The journalist and dramatist Herman Mankiewicz made his first trip to Hollywood in 1925. After a quick survey of the possibilities he telegraphed his friend Ben Hecht: "Millions are to be grabbed out here and your only competition is idiots. Don't let this get around." It did, of course, get around. The arrival of talkies two years later increased Hollywood's need for Broadway talent to crisis proportions; what had been a play one year was often a movie the next, and half of New York, it seemed, headed for Hollywood. Mankiewicz himself co-authored (with Orson Welles) the script of *Citizen Kane* in 1941, among many other less memorable vehicles. Ben Hecht did the screenplays for two of Hollywood's most influential early gangster movies, *Underworld* (1927) and *Scarface* (1932). S. N. Behrman wrote Garbo's scripts for *Queen Christina* (1933), *Anna Karenina* (1935), and *Two-Faced Woman* (1941). The Russian-born director Rouben Mamoulian made two landmark early talkies, *Applause* (1929) and *City Streets* (1931). Donald Ogden Stewart collaborated on *Dinner at Eight* in 1933 (from the play by Edna Ferber and George S. Kaufman) and *The Philadelphia Story* in 1940 (from the play by New York's Philip Barry). Preston Sturges wrote and directed a host of extraordinary films that included *Sullivan's Travels* and *The Lady Eve* (both from 1941). George Cukor came to play an important part in the film career of Katharine Hepburn, herself a product of the New York stage.

Hepburn was not alone. Douglas Fairbanks, Mary Pickford, James Cagney, W. C. Fields, the Marx Brothers, John Barrymore, Al Jolson, Eddie Cantor, Ruth Chatterton, Cary Grant, Irene Dunne, Fred Astaire, Ginger Rogers, Claudette Colbert, Clark Gable, Humphrey Bogart, Bette Davis, William Powell, Barbara Stanwyck, Leslie Howard, Paul Robeson, and Mae West, among others, were all Broadway actors before they were movie stars.

Tin Pan Alley's top talents, those who created the modern musical on the Broadway stage—George Gershwin, Irving Berlin, Cole Porter, and Jerome Kern—went West, too. By *Variety's* estimate, 205 New York stage-trained artists were under full-time contract to Hollywood in 1929, and another 200 were freelancing there. The apparent end to all-out theatrical activity in New York in the late 1920s was in good part a transference of that activity from East Coast to West, from live theatrical production to celluloid.

Film was not the only new medium to draw on New York talent. Early radio stars like Ed Wynn, Fanny Brice, George Burns and Gracie Allen, Will Rogers, Eddie Cantor, and Walter Winchell were veterans of the New York vaudeville and drama scene. Alexander Woollcott became radio's legendary "Town Crier" in 1929; F.P.A. was a panelist on a popular talk show called *Information, Please* in the 1930s. Television was a creation of the 1920s as well, though sets were not broadly marketed until the 1940s, and it, too, was New York–based; Winchell, Ben Hecht, Milton Berle, and Robert Ripley hosted shows in the medium's first decade. Gilbert Seldes worked in the corporate structures of CBS radio and television and published *Writing for Television: A Writer's Handbook* in 1952.

The attraction of the theatrically minded 1920s generation to the nascent media was a logical one. If to dramatize means to up the ante, to take a shortcut to the energy source, the nonprint media hold rich possibilities; they substitute voice and image for the written word, replace the abstract or conceptual with the vivid, the past with the present. They jump-start perception. What the traditional theater does for the relatively few, the media do for the masses. In media land, drama is everyone's birthright. New York heading for Hollywood in the 1920s was not so much betraying the theater as extending its reach; the new media allowed New York's "lively arts" to conscript the entire nation as their audience.

LIFE IN THE SPOTLIGHT

One reason the artists of the 1920s were drawn to the theater was that, in the theater, everything happens in public. It is indicative of the metropolitan Zeitgeist that diehard and theatrically minded New Yorkers like Parker, Benchley, E. B. White, Woollcott, and Broun all planned—even, in Parker's case, contracted—to write novels at some point in their careers but never did. In picking a profession or a mode of expression, one must be attracted to its perils as well as its privileges, and novel writing, to the Algonquin mind, apparently did not qualify.

The novelist, like the painter and the sculptor, usually does his work alone

and in private. If immediate approval is not forthcoming, he can wait, no matter how unhappily, for the praise of unborn generations. The dramatist, in contrast, is always a collaborator. Without actors, a director, a producer, and a live and present audience, he has no play. While the novelist and his readers are invisible to each other—the novelist does not hear the readers exclaim with delight, nor, conversely, is he forced to watch them toss aside his book with a yawn or a curse—the playwright and his audience are in the same place at the same time; the playwright meets with success or failure in a blaze of public attention. He is at the theater on opening night, watching the audience accept, or reject, his work; he attends the cast party after the show and waits with friends and other members of the production (in New York this was usually at Sardi's, the popular Broadway restaurant) for the newspaper reviews, which come in all at once and together very early the next morning. No success is as "marvellously satisfying," Moss Hart remarked, as success in the theater; a happy audience, Donald Ogden Stewart believed, is an unfailing "cure for everything." But no failure is so complete as that of the playwright, "pilloried in public," in George Ade's words, "scalped to slow music on a high pedestal with an amber light turned on the scene of his humiliation and thousands of people apparently enjoying the fun."

Broadway in the 1920s might be prosperous, but it was anything but stable. Given sharply mounting production costs, a play had to go over big with New York audiences and critics or have Hollywood potential, or both, to turn a profit. The mood around Broadway was akin, in Jack Poggi's phrase, to "betting on horses." The most successful playwrights, directors, and producers—Sam Harris, Jed Harris, Kaufman, Hart, Marc Connelly, Edna Ferber, S. N. Behrman, Philip Barry, Robert E. Sherwood, and even Eugene O'Neill—had more than one flop, but their failures did not deter them. Whether one scored a hit or "laid an egg," as *Variety* liked to put it, life in the theater was life-in-the-spotlight, a subject and pursuit that occupied all the artists of the metropolitan scene. None of them was adverse to fraternizing with drama's bastard kin, the art of self-promotion.

In a *New Yorker* piece of December 19, 1925, "Child's Play," E. B. White recounted the small drama of a waitress accidentally spilling a glass of buttermilk all over him in a restaurant. Her profuse apologies, the interested advice and comments of his fellow diners, put him wonderfully center-stage. He is gracious with his waitress, courteous but firmly independent with the onlookers; he rises from his chair "a smear. The exit is the story, I told myself . . . I had a perfect audience." He pays his bill and tips a quarter: " 'Let that take care of the buttermilk,' I said." Benchley, mocking the pseudo-rituals of record-breaking—what F.P.A. called the "What of it? Records" that govern a world of conspicuousness—inquired why we stop with the out-

of-doors weather in our interest in peaks and lows. Why not record equally fascinating facts such as the hottest temperature ever reached in Mrs. Albert J. Arnkle's guest bedroom at Bellclapper, Long Island? Note that it is the record-keeping fetish of the larger society that Benchley mocks; he was very interested in the temperature of Mrs. Arnkle's guest room if he happened to be in it.

In his "Pepys" column in the World, F.P.A. reported in minute detail on how much sleep he got, how long he worked, what clothes he wore, what plays he'd seen, what books he'd read, the small jests passed among his circle of friends. Heywood Broun chronicled at length his own opinions and his offspring's antics, no matter how trivial, in his "It Seems to Me" column, also in the World. James Thurber warned the readers of his comic memoir My Life and Hard Times (1933) that he did not mean the word "times" in the title to suggest that he planned to write about his age. No, his writing is "circumscribed by the short boundaries of his [own] pain and embarrassment . . . What happens to his digestion, the rear-axle of his car, and the confused flow of his relationships with six or eight people and two or three buildings is of greater importance . . . than what goes on in the nation or universe." The freely confessed hesitations and inadequacies of the New Yorker wits were merely excuses to lavish enormous care on no one but themselves; every piece was a stage set for the appearance of its author.

On November 14, 1925, The New Yorker described the city as a "gymnasium of celebrities" and would-be celebrities; there are always "more nonentities trying to attract attention and failing than celebrities trying to avoid attention and succeeding." New York attracted those who wanted, sometimes desperately, to find out not so much who they were as who they could appear to be, those who needed the gaze of others to come alive, exhibitionists and attention addicts who possessed, in Fitzgerald's words, "theatrical innocence," the preference of the "role of the observed to that of the observer." Cynical Thomas Beer thought the "whole 'Lost Generation' movement . . . as coldly commercial as a burlesque show"; if this was a "lost generation," it was lost in plain sight of all the spectators America could summon. Sheer and vast attention could substitute for lost meaning as well as the theater did. As Al Jolson put it in an ad he placed in Variety in the 1910s: "Watch me—I'm a Wow!"

Advertising is the production and sale of attention as a big-business venture, and the 1920s marked the golden age of American advertising. Revenues went from $682 million in 1914 to almost $3 billion in 1929, a high-water mark not to be reached again until after World War II. New York was the chief beneficiary. Like publishing and the music industry, advertising had once been scattered over several urban sites, but in the early 1920s, N. W.

Ayer of Philadelphia and Lord and Thomas of Chicago, two of the nation's leading agencies, recognized the inevitable and opened branches in New York. J. Walter Thompson, New York's largest advertising firm, doubled its staff, and the term "Madison Avenue" became, for the first time, as it has remained since, a synonym for the industry itself.

Madison Avenue acquired a host of new allies in the 1920s. Radio began ad-free in 1920, but after a period of tactful hesitation—would listeners object to the invasion of their homes by companies soliciting buyers for their products?—advertising took radio hostage and New York's all-powerful NBC network was the undisputed leader in this process. Although the first radio ads were tailored to fit the show on which they were heard, thus in theory subordinating the ad to the program, by 1932 2,354 hours of broadcasting featured 12,456 ads, 40 percent of which were "spot" announcements, ads that made no pretense of relevance to the content of whatever show they were sponsoring and interrupting. In other countries, the new broadcast media were paid for by the government and by fees levied on those who owned radio sets. Only in America was advertising the main or sole backer of all the mass media save film; only in America was advertising itself a medium of entertainment high and low. Only there was it promoted and vivified by some of the country's most talented performers, writers, and stars.

Sports were annexed by the burgeoning entertainment industry in the 1920s, and the man most responsible for their transformation was Babe Ruth, "our national exaggeration," as the sports reporter Bill McGeehan called him. "All or nothing" was his motto, and he epitomized the "Watch me— I'm a Wow!" ethos. Over the course of his career, he hit 714 home runs; in 1927 alone, he hit more home runs than any entire *team* in the American League, breaking nine world records along the way. In his first season with the Yankees in 1920, the Yankees became the first ball team ever to draw one million people; the "Idol of Millions!" was one of vaudeville's ads for a Babe Ruth appearance. The Babe had no real talents outside his genius for the game, but he was a hit in vaudeville nonetheless; he did a little mind reading and played the stooge blindfolded. He also starred in *The Babe Comes Home*, a movie of 1928, and he lent himself lavishly to Madison Avenue's new celebrity product-endorsement program.

The Babe endorsed everything from baseballs and baseball caps to cigars and cars, pronouncing Packards, Reos, and Cadillacs the best car on the road, sometimes in the same issue of the same magazine. In fairness to the "Sultan of Swat," it must be said that he at one time or another in his car-studded life purchased, drove, and wrecked all three of these makes and more. In her 1988 memoir, *My Dad the Babe*, Dorothy Ruth Pirone tells of one occasion when the Babe bought a new car, a Packard, in Boston. He

paid cash; installment plans held no charm for one who had, and liked to carry, thousands of dollars as loose change. Ruth drove the Packard straight off the showroom floor and headed for New York. He had a bad accident in Connecticut, but he climbed out of the window unscathed, to the amazement of the gathered spectators. He hitched a ride to the next town, where he bought yet another Packard—perhaps he didn't like to switch brands in the middle of a trip—again for cash, and drove home to New York. Could Packards have had a better endorsement?

More artistic types joined forces with Madison Avenue, too. Alfred Stieglitz's most brilliant acolyte, Edward Steichen, worked for *Vanity Fair* and the advertising firm of J. Walter Thompson. A number of New York writers wrote ad copy in their apprentice days, and almost all of them showed a lifelong fascination with advertising's style and impetus. The one-liner caption was born on Madison Avenue in the 1910s when Dorothy Parker refined her epigrammatic gifts by writing ads for women's underwear at *Vogue*. "Brevity is the soul of lingerie" was her best caption. Gilbert Seldes insisted that New York's most conspicuous advertisement, the huge electric Spearmint Gum sign in Times Square, enlivened by galvanic jumping men, was part of that special amalgam of lowbrow commerce and class entertainment he called the "lively arts." Roi Cooper Megrue and Walter Hackett celebrated advertising in their comedy *It Pays to Advertise*, a hit on Broadway in 1914, and George S. Kaufman half-heartedly attacked it in *The Butter and Egg Man* (1925). Alexander Woollcott endorsed Muriel cigars, though he didn't smoke them or any other brand. Benchley, ever a craven consumer, or "paying parasite," as he termed it, claimed that the aim of the various interests involved in selling America its goods and services was "to see who can humiliate me the most," and he found his comic kingdom in the new culture of credit, hype, and intimidation.

Marianne Moore delighted in advertising copy as a girl, later appropriating its fast, exact shifts and splices for the collages of her poetic art. She was a close friend of e. e. cummings; they shared a fascination with innovative typography that brought poetry into the visual realm of the ad layout. With their irregular rhythms and oddly broken lines, Moore's poems were designed, like ad copy, to tease and excite the eye, and their content owed something to advertising, too. In "The Arctic Ox (or Goat)," Moore presents this rare and idiosyncratic beast as if he were a bargain on sale. The ox (or goat) "sheds down ideal for a nest"; all told, "you could not have a choicer pet." "If you fear that you are reading an advertisement," the poem concludes, "you are."

An Isolte Motors slogan of 1927—"The ultra car of tomorrow ready to deliver today!!"—provides the best analogue and guide to Moore's optative

aesthetic. Elizabeth Bishop, getting to know her in the mid-1930s, soon realized that one could not anticipate her. Even when Bishop showed up for an appointment ahead of time, Moore was "always there first." Comically, celestially punctual, Moore liked the "little hedge / sparrow that wakes up seven minutes sooner than the lark." She shared with advertising—an industry that prides itself on anticipating your needs and promises you that what you want is already available, already out there waiting especially for you—the art of earliness.

Scott Fitzgerald spent only three months in the advertising world—at the firm of Bannion, Collier in the spring of 1920—but he was liable on any occasion, as his friend Edmund Wilson noted, to drop with lighthearted cheek into its language. Interviewers came away with flamboyantly quotable lines. "All women over thirty-five should be shot" was one Fitzgerald news flash. "Don't you know," he asked another reporter, "that I am one of the most notorious drinkers of the younger generation?" Scott had shrewd ideas about pushing his books. In a 1923 essay entitled "How I Would Sell My Book," he urged book dealers to fill an entire store window with nothing but copies of his latest book, then station "a man with large spectacles sitting in the midst of them, frantically engrossed in the perusal of a copy." Brash but incandescent self-promotion was one of the motive springs of the young Fitzgerald's art. "I am a fake," he liked to explain in a half-conscious homage to the values of Madison Avenue, "but not a lie."

In dreaming up sales-promotion tactics for his books Fitzgerald faced serious competition. Although advertising had taken the print medium captive as early as the 1860s, when newspapers and magazines started to rely on ever more conspicuous ads for the bulk of their revenue, the traditionally conservative field of book publishing had remained, despite the Harper Brothers' early lead, relatively resistant to advertising practices—until, that is, the advent of Horace Liveright of Boni & Liveright, the best-known publisher in 1920s New York. The popular New York novelists Gertrude Atherton and Anita Loos were Liveright authors; so were avant-garde writers like Freud and Eliot. A hard-drinking and witty man-about-town, Liveright had been a stockbroker before going into publishing, and in 1919 he hired Edward Bernays to help him bring publishing closer to Wall Street and Madison Avenue.

For *The Story of a Lover* (1919) by the anarchist writer Hutchins Hapgood, Bernays and Liveright solicited the opinions of America's reigning movie queens on the nature of love. Lillian Gish's dictum that love could not withstand the "waste of the carnal," or Dorothy Gish's opinion that money could not buy or "ravage" it, may have had little to do with Hapgood's book, but they helped to sell it. Waldo Frank's *Our America* (1919), a pioneering

attempt to psychoanalyze American culture, was launched with a barrage of articles sent gratis to newspapers all around the country: "Psychoanalyzing New York" or "New England" or "Chicago" or "The Middle West." While never a best-seller, *Our America* reached thousands of readers who had been made to believe, correctly or incorrectly, that Frank was talking about them. The excitement about these campaigns was that they made sellers out of books that were not natural sellers; they proved that advertising energy could *create* market receptivity and revenue.

Donald Friede started out working for Liveright, but he left at the end of the 1920s, as the profligate and overextended Liveright began to founder, to start his own firm, Covici, Friede; he pushed further on the trail that Liveright and Bernays had blazed. In 1930 he announced the imminent publication of *Speakeasy Girls*, a novel about "the young girls about town for whom the speakeasy is . . . home." The announcement—with its title, blurb, and jacket design—was a fabrication; *Speakeasy Girls* had not yet been written or even commissioned. When Hollywood studios, excited by Friede's ad, besieged him with offers for the movie rights, he found someone to write the book. In the next few years, using the same marketing strategy, he publicized, then commissioned and published, a series of books with catchy titles like *Bachelor's Wife*, *Her Body Speaks*, *The Sportsman on the Sofa*, and *Alimony Jail*. Following Bernays's lead with the Lucky Strike campaign, Friede planned a skywriting ad for a game book called *MURDER* in 1930: "Murder Is in the Air" the aerial legend ran. (Bad weather damped the efficacy of his gimmick.)

The fascination and familiarity with advertising on the part of New York's leading performers, publishers, and writers did not, I think, represent an artistic compromise or sellout on their part, though some of them later saw it that way. A consumer study of 1931 revealed that only 5 percent of the public believed any of the more obviously outrageous claims made by ads, and only 37 percent believed any ads at all. In the same year, the trade journal *Advertising and Selling* reported that many Americans considered advertising a "great joke," and the magazine *Ballyhoo*, a running spoof on advertising practices, began publication. Advertising was newly under attack in the early Depression years, but it had always represented a crux of belief and disbelief, an exercise in the "Believe It or Not" epistemology of omnivorous irreverence so prized by the 1920s generation. In a Buick ad of the late 1920s, an athletic larger-than-life young man seems to be rising over the Manhattan skyline; his eyes are raised, his face bathed in light, and he is lifting a Buick in the palm of his hand, as if offering it to the heavens. Will God put a stop to open insult? As a flagrant assertion of materialistic

values, as, in the words of the adman Leverett Lyon, "the only force at work against Puritanism [in] consumption," advertising, scare copy and all, was a dare, a test calculated to discover if the universe was indeed uninhabited, Neo-Orthodox angst translated into commercial farce.

But the broad-spread interest in advertising was not simply an expression of the amusing paradoxes of bad faith. Advertising is the art of mass communication, the only art, if it is one, that assumes that all knowledge is transmittable, and takes its audiences to be literally everyone, no exceptions allowed. This was a position shared in one form or another by the artists working in New York in the 1920s; they, too, believed that everything is capable of popularization. Even the high-minded Harold Ross let *The Reader's Digest* print and abridge *New Yorker* copy through the 1930s. Both the snobbish *New Yorker* and the *Digest*, begun in 1922 and designed for the self-improving millions eager for information, disliked what Edmund Wilson rebuked in 1927 as the "development of language beyond its theme"; both relied on spoken and speakable language. At no other period in American cultural history have so many new cultural styles and so much new knowledge been produced, transmitted, and assimilated with so slight an extension of rarified or technical vocabulary. To the current way of thinking, popularization was more a matter of dramatization than one of simplification. These were the heady, pioneering days of media development; the promise of unprecedented availability that the mass media hold out was not yet eclipsed by fear that what lent itself to vast availability might not be worth making available.

In 1950, Gilbert Seldes, after a quarter century of experience working in the entertainment industry, wrote a study of the media, *The Great Audience*. He was dismayed to discover that the "popular arts" of the 1920s had become the "mass" arts of the 1950s, which "deceive" rather than "divert," foster "addiction" instead of "participation," and grant popularity as a reward, not for trained and generous talent, but for mere media exposure; we get taped not live programming, scripts instead of improvisation, images instead of people. The 1920s were not, Seldes argued, the harbinger of a bright new day in American entertainment but "the last flowering of our popular arts." He later partially retracted this condemnation of media culture, but an important historical insight fueled his diatribe. The "lively arts" of the 1920s were not a matter of happenstance or a repeatable phenomenon available anytime to anyone who cared to work in this mode; they were, rather, located at a particular historical crossroads, an early phase in which the mass media were still subject to real, if partial, forms of control other than corporate and technological necessity, a time when the forces responsible for their devel-

opment were open to innovation and creativity, a moment when artistic achievement and mass distribution were not yet in conflict but worked together and invigorated one another.

A "lively art," as Seldes defined it, meant not only an art that involved liveliness or motion discernible to the eye or ear, but entertainment that was live rather than canned or prerecorded, purveyed by artists trained in the live-performance traditions of theater and vaudeville. Radio in the 1920s did not air new songs by playing records of them; the pop singer Gene Austin sold a million records of "My Blue Heaven" in 1927, but when you heard him singing the song on the radio, he was performing live. The 1920s were the first and perhaps the last moment when something like the practice of free will was possible in the consumer society and entertainment culture America was fast becoming. The decade witnessed a collaboration between the older forms of performance, on the one hand, and the new media and the advertising industry that backed them on the other, between elite and popular, more and less prestigious purveyors of culture, a collaboration that was possible because the boundaries between media fare, popular craft work, and elite art were not yet firmly drawn.

F.P.A. dined as a friend with Elinor Wylie and Edna St. Vincent Millay; Robert Benchley and Donald Ogden Stewart chummed with Scott Fitzgerald and Ernest Hemingway. Alexander Woollcott, scandalmonger deluxe, was on the best of terms with Gertrude Stein, high priestess of abstract modernism. Louise Bogan displayed an intense enthusiasm for the baseball tales of Ring Lardner and the productions of the vaudeville stage; e. e. cummings announced that Coney Island was of far greater interest than Venice and claimed that George Herriman, the creator of the *Krazy Kat* cartoon strip (Herriman was based first in Chicago, then in New York), was the greatest artist of the age. Edmund Wilson praised Seldes's *The 7 Lively Arts* for bringing Keystone Kops, Krazy Kat cartoons, and Al Jolson into the same "field of criticism" with the products of a more "classic Anglo-American culture." The erudite Wilson was himself a vaudeville aficionado who enjoyed turning a neat somersault or springing a magic trick in austere company. Hart Crane, always puzzled by the critics who faulted his difficulty, found contemporary inspiration in Charlie Chaplin, and Chaplin was impressed and disturbed, he tells us in *My Autobiography* (1964), by the "emotional outpouring" of Crane's masterpiece, *The Bridge*.

All these artists faced a new audience, changed in uncertain ways by its confused acceptance and interpretation of the expanded role mass art was in the backhanded process of giving it. All of them were "high lowbrows," to use Chaplin's phrase about himself, eager to capture mass acceptance and elite adulation in a single stroke. The tell-them-what-they-want-to-hear ethos

with which we are familiar today was present in the 1920s but still nerved with a heady and pragmatic respect for an idiom, a language both innovative and classic that might meet with wit and distinction the challenge of the new commercialized forms of mass communication. Fitzgerald, Hemingway, Parker, Stein, Millay, Wylie, Benchley, Woollcott, O'Neill, Runyon, Thurber, and Lardner expected to write best-sellers, and did. Even Faulkner hit gold in 1931 with his sensational Prohibition tale, *Sanctuary*, into which he put more care than he liked to admit.

A number of authors got the treatment that we today associate largely with movie and rock stars. In June 1928, Elinor Wylie, long a creature of scandal, now in the midst of both her last marriage and her last love affair (she died before the end of the year), had a bad fall down the stairs during an English house party. The New York *Post* headlined the event as Elinor Wylie "NEAR DEATH" and speculated that it might have been a suicide attempt; the dignified *Saturday Review* followed up with a more or less accurate report of the accident. When Scott Fitzgerald celebrated his fortieth birthday on September 24, 1936, the *Post* was once again on the spot. Fitzgerald was at the lowest ebb of his personal life and literary career, and the paper ran Michael Mok's sadistically detailed story under the headline "SCOTT FITZGERALD, 40, ENGULFED IN DESPAIR." Scott's hands were shaking, his face twitching, as he begged his hired nurse for "just one ounce" of gin, the article reported, and he moaned, "I've lost my grip." *Time* magazine quickly picked up the story, and a horrified Scott made an unsuccessful attempt to kill himself. On the right or wrong "Side of Paradise," Fitzgerald was always news.

Despite their affinities with advertising, Marianne Moore's precise fables were enigmas even to some of her poetic peers; she nonetheless sent her early verse hopefully to the mainstream *Atlantic Monthly*. Although the *Atlantic* never published her work, Moore's eccentric, primly rakish, and charming persona, her smart but strangely Victorian tailored outfits and trademark black tricorne hat, later made her almost as familiar as a movie star. In her days of fame, Moore discovered that (in her words) "celebrity costs privacy," but she did not seem to mind. The dangerous business of attention management and exploitation fascinated all the writers of her generation, whether as subject matter or life-style or both. Not one of them initially ruled out the possibility—the artist's version of the American dream—that (s)he could be at once status-soaked elite author, conscientious craftsperson, and mass artist or mass image.

Today's radio, television, and movie stars, talk-show hosts, and celebrity authors are formed as performers in good part by the media in which they appear, fully formed media that long antedated their appearance. The comparable people in the 1920s began their careers as the mass media were being

invented, when they were still plastic and receptive to influence. Formed by an older tradition of live performance and broad but limited and cohesive audiences, the early media stars had a vivid cultural identity that antedated any identity the media could bestow; they shaped the media as much as they were shaped by them. Their work, whatever its artistic merits (and they were usually high), had historic importance in forming the genres that still dominate mass culture today: the *New Yorker* "casual," the syndicated editorial page, the gossip column, the smart urban comedy for stage and screen, the gangster movie, the talk show, the ad layout, the continuity comic strip, the hit-single record, the sexually explicit novel, and the packaged public persona of mass celebrities whether sports heroes, actors, literary stars, or politicians.

BLACK MANHATTAN WEARING
THE MASK

THE MINSTREL TRADITION AND "THE COON AGE"

Dorothy Parker's line "Then he came to New York; don't we all?" applies to black New Yorkers in the 1920s even more forcibly than to white ones. Harlem's black population, a mere handful in 1900, rose to close to 200,000 during that decade. If white Americans experienced the shock of urbanization, black Americans felt a double shock, for the acceleration rate of their urbanization process was incomparably greater. White America had been steadily becoming more urban for a century; the 1920 census pronouncing America a predominately urban nation for the first time in its history was only the cap on a long, if chaotic, process. In contrast, in 1910, on the eve of the Great War, roughly 90 percent of America's Negro population still lived in the South, 78 percent of them in the countryside. However, blacks had begun to move to Southern cities in the late nineteenth century, searching for better job opportunities and greater freedom, and by the war years, the "Great Migration," as historians call the hegira of blacks from country to city, from South to North, was in full force.

In *Black Manhattan* (1930), James Weldon Johnson estimated the number of Negro migrants from South to North in the 1910s and 1920s at roughly 1.5 million. In fact, 454,000 blacks left the South between 1910 and 1920; 749,000 more did so in the next decade. Between 1900 and 1930, the total number of Negroes in the North increased by almost 300 percent; the black population in all American cities went from 22 percent in 1900 to 40 percent in 1930. In 1890, one in seventy people in Manhattan was a Negro; in 1930, one in every nine. The shift in geography spelled a shift in occupation. In 1890, 63 percent of black men were employed in agriculture, forestry, and fishing; only 7 percent were in manufacturing and mechanical pursuits. By

1930, however, the number of black men in agriculture was down to 42 percent, while the number employed in industry went up to 25 percent, and the trend continued apace, after the interruption of the Depression, in the 1940s and 1950s. In an essay collected in Alain Locke's anthology *The New Negro* (1925), "The New Frontage on American Life," the black activist and writer Charles S. Johnson argued that the differences between the agricultural South, which these Negroes had left, and the industrial North, to which they had come, were even greater than the differences between the white and black races: "In ten years Negroes have been actually transported from one culture to another." No other American ethnic or racial group of comparable size ever experienced anything approaching the magnitude of this seismic sociological shift.

However recent their arrival, these Negroes quickly became trendsetters on the entertainment scene of Northern cities. The term "jazz" was used very loosely in New York and elsewhere in the 1910s and 1920s to cover everything from ragtime to Eliot's *Waste Land*, from Tin Pan Alley tunes to what we now think of as jazz proper—the music of Duke Ellington and Louis Armstrong and their peers; but one thing was clear. If this was, as Fitzgerald said, "The Jazz Age," the age was black. Jazz, like the dances it spawned, like its predecessor ragtime and its companion the blues, was the creation of America's Negro population, and white urban Americans wanted to go straight to the source to get more of it. By the mid-1920s, Harlem was being advertised as the "Nightclub Capital of the World." About 125 nightclubs, led by the Cotton Club and Connie's Inn, served up African-American music and dancing to white patrons eager to enjoy a little regression back to jungle life and to participate, if only as voyeurs, in what was palpably the most exciting entertainment scene America had ever boasted.

A white tourist to Harlem named George Tichenor described the clubs for the *Theatre Arts Monthly* in 1934, at the tail end of the first nightclub era: "The big bass drum boom, boom. Enthusiastic wails writhe from the cornet—another flash from two dozen tawny, brown legs, whip-snapping . . . hip-twisting, and watch 'em strut! Boom, boom-de-boom, boom . . . One by one, our cherished biases are taken off like arctic overcoats. It becomes natural to laugh and shout in the consciousness of an emotional holiday." When the floor show has ended and the evening is over, one can slip back into "one's hat, coat, and niceties, and [be] once again . . . staid, proper, and a community pillar." Tichenor is describing slumming, dropping down social levels to vacation time, release; this was a premier sport for smart white Manhattan, though its consequences were not so easily donned and doffed as he thought.

Black performers playing jazz, singing the blues, dancing, and doing

comedy acts for white audiences at Harlem night spots had the long, rich, and complex tradition of minstrelsy behind them. Dating back to the 1840s as a specialty act, the minstrel show was a medley of purportedly Negro jokes, tall tales, song-and-dance routines, and spoofs of elite art and contemporary manners that had its roots in Southern Negro plantation culture, P. T. Barnum's dime museums and circuses, Southwest American lore about folk heroes like Davy Crockett and Mike Fink, and English pantomime and folk drama. Constance Rourke, herself a fan of the Harlem clubs and their music, gave a central place to the minstrel tradition in *American Humor*; she found it touched with "sudden extremes of nonsense" and a "tragic undertone" that were "new" to America's self-expression.

Minstrel shows were first performed for largely white audiences by white actors in blackface who claimed to have learned their art by observing Southern blacks. Then, in the 1860s, black minstrel artists began to put on shows for white and black audiences. These black minstrel groups brought America its dance styles—buck-and-wing, soft-shoe, stop-time or syncopated dances—as well as the music that inspired them, and the vaudeville comic monologue. But for black minstrels to succeed, they had to meet the expectations of their white audiences. They couldn't give realistic versions of minstrelsy's standard types, its "darkies" and "coons," its "Jim Crows" and "Zip Coons"; they couldn't offer open correctives to white distortions of black character. Instead, the Negro minstrel performer donned blackface himself and perforce imitated, with variations, the white performers playing, and distorting, blacks.

Minstrelsy depended on sexual as well as racial impersonation. Although in its later decades it had some female players, minstrelsy began as an all-male enterprise; men, black and white, essayed a series of female roles, ranging from the ingenue to the matron and the villainess. Doubling, even double doubling (a white man playing a black woman, for instance) was its *raison d'être*. This was the case even though, in the late nineteenth century, women actors were frequent presences on the American stage; in other words, minstrelsy adopted female impersonation not as a cultural necessity (as the all-male theater troupes of Shakespeare's day did) but as a cultural preference. It was the essence of minstrelsy that whites played blacks and blacks played whites-playing-blacks, that men played women and that performers enacted a range of material that included and mimicked all classes.

Rourke remarked apropos of minstrelsy that Americans loved the "sheer artifice of the double use of the mask," and no Americans loved "sheer artifice" so much as New Yorkers did. The first white and black minstrel players were largely Northern in origin, and as minstrelsy became big show business, New York established itself as the minstrel-show capital of America. One of minstrelsy's white blackface founders, Thomas Dartmouth Rice, was

born in New York in 1808; Dick Pelham and William Whitlock, two of the original Virginia Minstrels, the most important of the early white minstrel groups, were also New Yorkers, and Henry Wood, a star performer of Christy's and Wood's minstrels, was the brother-in-law of New York's mayor in the 1860s, the insouciant and cavalier Southern sympathizer Fernando Wood. New York vaudeville, which by the 1920s was providing the new mass media with most of their performers, like the "variety" acts that preceded it, was an elaboration and a spin-off of minstrelsy. As James Weldon Johnson points out in *Black Manhattan*, the minstrel show is "the only completely original contribution America has made to the theatre"; it is also the most important single source of American live entertainment.

Of course minstrelsy was racism in action: the expropriation and distortion of black culture for white purposes and profits. Thomas Dartmouth Rice began his career in the 1830s as "Jim Crow" and ended it in the 1850s playing Uncle Tom in ubiquitous dramatized versions of *Uncle Tom's Cabin*; from comic butt to Christian martyr was minstrelsy's typical and narrow range of Negro characterization. Johnson notes in *Black Manhattan* the "tragedy" of late nineteenth-century black actors eager to perform *Othello* and *Hamlet* but forced to make a living by doing the darky routines that whites expected and applauded. Nonetheless, this double mimicry, whites playing blacks and blacks playing whites-playing-blacks, was also art, and an especially American kind of art. Black minstrels not only imitated whites-playing-blacks but also burlesqued them; minstrelsy involved stereotype upon stereotype, opponents as look-alikes, mocking and criticizing each other.

Minstrelsy put the fooling techniques of black culture, the "puttin' on ole massa" routines of mimicry and role-playing developed in the days of slavery, at the heart of American entertainment. Blacks imitating and fooling whites, whites imitating and stealing from blacks, blacks reappropriating and transforming what has been stolen, whites making yet another foray on black styles, and on and on: this *is* American popular culture. From the 1830s, when Rice copied a song-and-dance routine from a Negro stablehand and called it "Jump Jim Crow," to the 1920s, when Ethel Waters was proud to be dubbed "the ebony Nora Bayes" (Bayes being a popular singer in white vaudeville), on to the 1950s, when Elvis Presley went over big as a white kid who sounded black and Chuck Berry made it by using white diction and enunciation for black music, American entertainment, whatever the state of American society, has always been integrated, if only by theft and parody. But the 1920s was the first decade in which such theft and parody were openly and widely sought and, at moments, celebrated. In the October 1927 issue of *The American Mercury*, Mencken observed that "no dance invented by white men has been danced at any genuinely high-toned shindig since

the far-off days of the Wilson Administration"; America had now entered the "Coon Age." Mencken was not altogether happy with this transformation, but he always acknowledged the obvious; the 1920s were the decade in which the Negroization of American culture became something like a recognized phenomenon.

When white minstrels in blackface began touring the country in the 1840s and 1850s, they awakened inexplicably fierce cravings in some of the young white boys in the audience. When George Thatcher, who later became a minstrel player himself, saw his first minstrel show as a boy in Baltimore, he was at once possessed, unable to think of anything else. "I found myself dreaming of minstrels," he wrote in an unpublished autobiographical sketch cited in Robert Toll's history of minstrelsy, *Blacking Up* (1974). "I would awaken with an imaginary tambourine in my hand and rub my face with my hands to see if I was blacked up . . . The dream of my life was to see or speak to a [minstrel] performer." Thatcher sounds as if, in seeing minstrelsy, he'd found his other half, and perhaps he had; he would have many heirs.

Although blackface declined during the 1920s, as the debasing stereotypes of minstrelsy came under increasing attack, a number of the biggest names in show business—black stars like Ma Rainey, Bessie Smith, Bert Williams, and Charles Gilpin, and white performers like Sophie Tucker, Al Jolson, and Eddie Cantor, among others—started out in versions of the minstrel show, and some performers continued to do blackface acts. The finale of the 1919 *Ziegfeld Follies* was a minstrel show number in which Eddie Cantor and Bert Williams, surrounded by the "Follies Pickaninnies" and blacked up as endmen Tambo and Bones, sang Irving Berlin's catchy "I Want to See a Minstrel Show." The chief *Follies* arranger in these years was the Harlem composer and performer Will Vodery; Flo Ziegfeld pioneered in black-and-white entertainment. Williams died in 1922, but Cantor blacked up well into the 1930s.

Despite his frenetic timing, Cantor had a winning streak of boyish sweetness, and his films were, in the best Ziegfeld manner, unusually hospitable to Negro talent. *Kid Millions* (1934) includes a spectacular minstrel production of Irving Berlin's song "Mandy," featured in the *Ziegfeld Follies* back in 1919, in which Eddie, with conspicuous good nature, takes a backseat to Harlem's fabulous tap duo, the then very young Nicholas Brothers, Fayard and Harold. In the movie, blacking up before the minstrel show, Eddie turns to his Negro dresser and says, "You know, you're lucky." It's the usual pigmentation joke—the black man needn't work to get the look Eddie's after—but the Negro gives him not a darky flash of teeth but a real smile; Eddie *means* it.

If actual blacking up, Eddie Cantor–style, decreased in the 1920s, blacking up, speaking metaphorically, increased dramatically. No black performers became major movie stars, though a number had film careers—film's mass audience included too many bigoted whites to make black stardom an economically viable investment for the big studios—but white stars flirted with varying degrees of Negritude. The idol of the era, Rudolph Valentino, born in southern Italy, was dark-skinned and lent himself to Latin, even Arab roles. In his most popular vehicle, *The Sheik* (1921), he portrayed a "savage" Arab who kidnaps a spirited young Englishwoman, played by Agnes Ayres. The movie is a study in miscegenation in ever darker hues. While in Valentino's hands, the girl is kidnapped again, this time by darker and more savage Arabs, and she is taken into a stronghold filled with fierce coal-black African henchmen. Valentino rescues her; the contrast between his coloring and the black hue of her captors is a pledge of his legitimacy. The Sheik turns out to be—surprise!—not an Arab but English and Spanish by birth, and the two marry. The experience of Valentino's biggest vehicle was a titillating journey into the world of blacking up; *The Sheik* itself is a slumming expedition à la George Tichenor, night visitor to Harlem, complete with a return for the slummer to his or her status as a "staid, proper . . . community pillar."

Cary Grant, né Archie Leach near Bristol, England, in 1904, was the first major movie star known, from the early 1930s on, for his perennial tan; his first wife, the actress Virginia Cherrill, was (wrongly) convinced he was Middle Eastern by descent, a "sheik" of some sort. Tanning the skin, shunned in the Victorian era, was newly fashionable. Sunlamps were first advertised in *Vogue* in 1923. Zelda Fitzgerald, who with Scott and their friends the Gerald Murphys, helped to make the sun-drenched Riviera *the* European resort for American expatriates and tourists, explained the tanning craze in *Save Me the Waltz*: "I love those beautiful tan people. They seem so free of secrets." Cary Grant was hardly free of secrets, however; a Jew and a troubled not so *sub rosa* gay man playing the role of ultra-romantic Wasp matinee idol to hundreds of thousands of female fans, he needed a permanent disguise.

Appropriately, Grant started out in mongrel Manhattan. He got his break on Broadway in 1927 playing a white male second lead in the musical *The Golden Dawn* (with lyrics by Oscar Hammerstein II and music by Emmerich Kalman), a hokey extravaganza about a white goddess and an African tribe. The tribe's members were played largely by white actors in blackface, but there were a few Negro actors onstage; Jack Carter, the "Black Barrymore" (later to play Crown in George Gershwin and DuBose Heyward's *Porgy and Bess* of 1935 and Macbeth in Orson Welles's all-black *Macbeth* of 1936), electrified audiences with his performance as a voodoo dancer. More than

a decade later, at a Hollywood party thrown to celebrate Grant's thirty-eighth birthday, Louis Armstrong and his band supplied the music, and the guests, including Grant, came in blackface. His tan was itself but light blackface; wearing light blackface on stage was, in fact, called "tanning up." Grant and many of his white peers aspired to be, like the chorines at the Cotton Club (in the words of a Cotton Club promo), "tall, tan, and terrific."

A GENERATION NOT LOST BUT FOUND

In the summer of 1922, the light-skinned Negro writer Jean Toomer took his dark-complexioned white friend Waldo Frank, a Greenwich Village author and idealistic apostle of Walt Whitman, on a short but intense trip to the rural South, to Spartansburg, South Carolina, to soak up black mores. This was a culture to which the well-bred Toomer, raised in cosmopolitan Washington, D.C., was almost as great a stranger as Frank. Both men were currently writing novels about the black experience: Toomer's *Cane*, an avant-garde, densely metaphorical exploration of the African-American heritage; Frank's *Holiday*, a turgid and pretentious protest against lynching. In an extension of the minstrel convention of impersonation, the two men posed in South Carolina as "blood brothers." Frank was accepted by blacks as one of them, just as Toomer would "pass" in later decades and be accepted by whites as white.

In a subsequent letter to Frank, Toomer emphasized their shared literary mission: "I cannot think of myself as being separated from you in the dual task of creating an American literature." Toomer and Frank read each other's novels in various drafts and arranged with their mutual publisher, Horace Liveright, to have their books issued on the same day in 1923. In a logical if unfortunate development, Toomer and Frank's mystically minded wife, the educator Margaret Naumberg, fell in love; Margaret divorced Waldo, although she and Jean did not marry. (Toomer later married, twice, other white women: the writer Margery Latimer and, after Latimer's death, the photographer Marjorie Content.) Frank's and Toomer's relationship was emblematic of a wider pattern of trans-race needs and debts.

The black men and women of particular interest to me in this book—performers Bert Williams, John Bubbles, Charles Gilpin, Paul Robeson, Bessie Smith, Mamie Smith, Ethel Waters, and Josephine Baker; musicians and composer-lyricists Eubie Blake, Noble Sissle, James P. Johnson, Fats Waller, Andy Razaf, Louis Armstrong, and Duke Ellington; writers Countee Cullen, Jean Toomer, Rudolph Fisher, Claude McKay, Wallace Thurman, Langston Hughes, Walter White, Nella Larsen, Zora Neale Hurston, and

Jessie Fauset; and intellectual leaders Alain Locke, Charles S. Johnson, James Weldon Johnson, and W.E.B. Du Bois—were welcomed, promoted, and exploited by a host of white New Yorkers as America's saving remnant of vitality, rhythm, and "virility" (the word was Malcolm Cowley's). They turned such promotion to their own purposes, for blacks had as much to gain from whites as whites did from them.

This, too, was a theatrical generation. The first unmistakable sign of the large part the Negro was to play in modern urban entertainment had been the appearance of a series of all-black musicals on Broadway in the 1890s, the first great age of black entertainment. John W. Isham's *Oriental America* (1896), Bob Cole and Billy Johnson's *A Trip to Coontown* (1898), and Will Marion Cook and Paul Laurence Dunbar's *Clorindy* (1898) were culminations and transformations of the minstrel show full of audacious new ragtime music and dancing, and they were very popular with mixed audiences. After a hiatus of a little more than a decade, Negro revues reappeared on Broadway in the 1920s, about twenty of them in all. Although they usually played in theaters north of the regular Broadway district around Times Square—in the West Fifties and Sixties—their influence was felt all along the Great White Way. The black musical set the style for white songwriters and dramatists; white artists often found their best interpreters in black performers and sometimes gave such performers their best vehicles. Dorothy Fields and Jimmy McHugh wrote the music for the Cotton Club's floor shows and for the all-black-cast revue *Blackbirds of 1928*. Both Ethel Waters and Louis Armstrong did wonderful recordings of the most popular number from *Blackbirds*, "I Can't Give You Anything but Love, Baby."

Serious white dramatists showcased black talent, too. Eugene O'Neill, who urged his black peers to "be yourselves! Don't reach out for our stuff which *we* call good!," pioneered in dramas about blacks, and black actors, not white ones in blackface, played these parts—a revolutionary move when O'Neill was starting out; he put on *The Dreamy Kid* in 1919 with an all-black cast and gave Paul Robeson the starring role in *All God's Chillun Got Wings* in 1924. Notoriously unhappy with actors who appeared in his plays, O'Neill later declared that the only actor whose talents and interpretation fully satisfied him was the Negro Charles Gilpin, acclaimed star of O'Neill's drama of the jungle, *The Emperor Jones* (1920). In 1926, Paul Green won the Pulitzer Prize for his play about a murdered black messiah, *In Abraham's Bosom*, starring Harlem's Jules Bledsoe. In 1927, the black actors Jack Carter, Frank Wilson, and Evelyn Ellis appeared in Dorothy and DuBose Heyward's *Porgy*, the first dramatic version of what was later to become *Porgy and Bess*. In 1930, Marc Connelly cast the black Richard Harrison in his first stage role as De Lawd in his play *Green Pastures*, a dramatic fable based on Negro

folklore about heaven, and ended up with a smash hit and a Pulitzer Prize.

At the end of the Great War, there were more black performers and musicians on hand than playwrights or novelists, for literacy, which had been denied to slaves before the Civil War, was almost as hard to come by for so-called freedmen; inevitably, the store of black literature at hand was a scant one by white standards. African-American literature in the early twentieth century was necessarily more dependent on white models than was black music, from which white popular American music had in good part derived in the first place, and a number of white writers and publishers were eager to play mentor, midwife, and profiteer to Negro literary talent. Carl Van Doren gave an address on "The Younger Generation of Negro Writers" at a black-and-white Civic Club gathering held in New York on March 21, 1924, to celebrate the publication of Jessie Fauset's novel *There Is Confusion*, hailed as the first of the "Negro Renaissance" (the *Herald Tribune* coined the term). Van Doren told his black listeners that they were uniquely qualified to bring to American literature the "color, music, gusto, the free expression of gay or desperate moods" it sorely needed.

Horace Liveright, the first major white publisher to back the nascent black literary movement, published *Cane, There Is Confusion,* and Nella Larsen's novel *Quicksand* (1928). Albert and Charles Boni brought out Alain Locke's pathbreaking anthology of essays, *The New Negro,* in 1925. Frederick Lewis Allen, editor in chief at *Harper's,* showcased Countee Cullen's poetry, and Heywood Broun editorialized at the *World* and other New York papers about black problems and triumphs. Max Eastman appointed Claude McKay co-editor at *The Liberator;* Louise Bryant and Sinclair Lewis encouraged and criticized his writing. Fannie Hurst hired Zora Neale Hurston, then studying with Franz Boas at Barnard, as her secretary and companion and introduced her to white literary circles. Vachel Lindsay promoted Langston Hughes; Sherwood Anderson championed the young Jean Toomer. Carl Van Vechten, writer, critic, photographer, and flaneur-at-large, served as liaison and PR man extraordinaire between Harlem and white New York, and Mencken opened the pages of his magazine, *The American Mercury,* to black writers and concerns, publishing fifty-four articles by and about blacks between 1924 and 1933. Mencken's attack on the South as "the Sahara of the Bozart" in 1920 gave powerful ammunition to blacks from the South like James Weldon Johnson and Negro satirists like George Schuyler and Theophilus Lewis, and he was tireless in his efforts to bring black talent to the notice of white publishers, most particularly his own publisher, Alfred A. Knopf; at Mencken's urging, Knopf published Walter White's first novel, *The Fire in the Flint,* in 1924 and reissued Johnson's *Autobiography of an Ex-Colored Man,* first printed anonymously in 1912, in 1927.

Cross-race analogies fostered by cultural proximity and creative rivalry proliferated. The corrosive, polemical, and confused satirical novels of Sinclair Lewis found echoes in those of Wallace Thurman, packed with self-hatred, hero worship, and self-consciously awkward writing. Lewis was almost alone among this generation of male white writers in using female protagonists as autobiographical stand-ins in his fiction, most importantly Una Golden in *The Job* (1917) and Carol Kennicott in *Main Street* (1920); Thurman followed suit with the tormented Emma Lou, heroine of his first novel, *The Blacker the Berry* (1929). The perfectly scanned and passionate poems of Countee Cullen sometimes read like companion pieces to the metaphysical, emotion-drenched, highly crafted poetry of Edna St. Vincent Millay. Alexander Woollcott's aesthetic of superlatives, his fascination with the diva and with the man-about-town, had much in common with Alain Locke's fastidious epistolary homages to powerful matriarchs and male troubadours. The lyrical expressionism of Toomer's prose in *Cane* anticipated the exuberantly splendid, self-indulgent rush of Crane's poem *The Bridge*; Eliot's obituary for Western civilization, *The Waste Land*, had a sequel in McKay's "The Desolate City," published the following year. A uniquely expressive mix of romantic imagination and shrewd observation characterized Fitzgerald's *The Great Gatsby* and Hurston's *Their Eyes Were Watching God* (1937).

In some cases, the cross-race influence is direct and easily traced. Cullen wrote his master's thesis at New York University on Millay, and attended her poetry readings; Millay shared with him a lifelong commitment to the Romantic poets, who had been banished from favor by the white male literary elite. Lewis was praised in Thurman's magazine *Fire!* as one of the "truly intellectual types," a "creative critic and thinker," and Lewis may have heard of Thurman from his protégé Claude McKay; in any case, he would imagine himself as a black man in an important late novel entitled *Kingsblood Royal* (1947). Crane and Toomer were friends who read each other's work, and McKay was conversant with Eliot's poetry. In other cases, like that of Hurston and Fitzgerald or Woollcott and Locke, no direct contact can as yet be found. But both patterns, of unmistakable influence and looser analogy, speak volumes about the degree to which, aware or otherwise, black and white metropolitans stood on shared ground.

If the white New Yorkers were engaged in a struggle to liberate themselves from their Victorian predecessors, the younger blacks of the Harlem Renaissance were rebelling against the rules of polite and well-spoken Negritude laid down by their most distinguished elders: Tuskegee Institute's founder and head, Booker T. Washington, a shrewd apostle of accommodation, dead in 1915 but still a potent influence; and Washington's long-lived and prolific opponent, W.E.B. Du Bois, editor in chief of *The Crisis*. In November

1926, the self-proclaimed "Younger Negro Artists," led by its daredevil editor, Thurman, and chief contributors, Hurston and Hughes, put out the first number of their short-lived but audacious magazine, *Fire!* The *Fire!* authors proudly wrote about just the things Du Bois and his right-hand woman at *The Crisis*, the skillfully genteel novelist of black manners Jessie Fauset, wished to downplay if not ignore: sex, color-consciousness, racism, and self-hatred, not among whites, but among blacks, the Negro as "primitive," "decadent" (the words are Thurman's), wild, colorful, and possibly dangerous.

Du Bois deplored Van Vechten's flamboyant and controversial novel of Harlem life, *Nigger Heaven* (1926)—Van Vechten, after all, had publicized in print his enthusiasm for "the squalor of Negro life, the vice of Negro life"—but the writers of *Fire!* suggested erecting a monument in Van Vechten's honor. They were discovering their own branch of "The American Language," and they used African-American urban slang and rural dialect, as Du Bois and Fauset never did, to convey, not just local color or humor, but their most serious thoughts and literary ambitions. "We younger Negro artists," Hughes announced, "intend to express our dark-skinned selves without fear or shame." "I'm black like that old mule," he insisted in an early poem; "Black and don't give a damn!" Some of Harlem's artists were blacking up, too; like their white contemporaries, the *Fire!* crew wished to shock.

This, too, was a lost generation in several senses. If the white moderns thought of themselves as orphans, the black moderns, whose ancestors were kidnapped from their native land and sold into slavery in an alien country, were, in fact, America's only truly orphaned group. The spirit uptown, as downtown, was militantly secular. American Negroes had long been associated with evangelical beliefs and revivalistic excess, but the New Negro found no more answers with God than his white peers did. Blacks, too, suffered the consequences of apostasy; the lives and work of Gilpin, McKay, Toomer, Larsen, Thurman, and Cullen are studies in the mixed moods of elation and melancholia, of anguish laced with stylistic innovation, commercial know-how and (in the cases of Gilpin, Toomer, and Thurman) booze, that we think of as trademark lost-generation material.

Thurman's and Larsen's protagonists in particular are "lost" in ways that echo and vary white literary fashion. The displaced and elegant Helga Crane of Larsen's novel *Quicksand*, who can go anywhere and stay nowhere, save in defeat, is kin to the neurasthenic Sibyl who opens Eliot's *Waste Land*, the Sibyl of Greek legend granted immortality but not youth, who "longs to die." Like the protagonists of Eliot's poem, Helga has vague religious longings, but religious experience here is only self-betrayal. Converted to evangelical faith in a storefront Harlem church, she marries a preacher and moves

to the Deep South, where she produces an unending series of babies—this from the woman who believed bringing more black children into an America that didn't want them a sin—and loses forever the self she never found. *Quicksand* ends in a post-childbirth scene, a terrifying amplification of the fear of procreation that haunts Eliot's poem.

Thurman's last novel, *Infants of the Spring* (1932), drew its title from the bible of the white lost generation, *Hamlet*, the subject of one of T. S. Eliot's most important early essays; and here, too, we find a wasteland in which biological or literary procreation is a kind of damnation. One woman character gets an abortion and advocates "race suicide" as the "the quickest way to cure human beings of their ills." The book's main protagonist, Raymond Taylor, a clear stand-in for Thurman, who prides himself on being "unafraid of stark truth," on preferring "brutal frankness to genteel evasion," is engaged in a corrosive running critique of the Harlem Renaissance itself as a forced and accelerated production of Negro talent unlikely to bring forth anything of lasting value.

In an early poem, "Yet Do I Marvel," Countee Cullen had exclaimed at a God who dared "Make a poet black, and bid him sing!" Cullen wrote "Suicide Chant[s]," but no one felt the paradoxes of black creativity in white America more keenly than Thurman did. He "had read everything," Langston Hughes said, but his "critical mind could find something wrong with everything he read." He "wanted to be a very great writer," but "none of his own work ever made him happy"; he considered his own efforts "vastly wanting." By the early 1930s, Thurman was "drinking more and more gin, and then threatening to jump out of windows at people's parties and kill himself"; he felt, in his own words, "an immense discouragement" and an increasing and "utter disbelief in my capacities, a total absence of desire." *Infants of the Spring* ends with the suicide of Raymond's friend, the talented Paul Arbian, who cuts his wrists in his bathtub. Paul had hoped to ensure by his death top posthumous publicity for his just-finished novel *Wu Sing: The Geisha Man* (an apostle of Wilde and Huysmans, Paul is flagrantly gay), but he has left the pages of his manuscript strewn around the bathtub; the tub overflows, and the pages are effaced forever; all that is visible is the title and a picture of a skyscraper "crumbling" and "falling" under "piercing white lights that are in full possession of the sky."

Thurman's gloomy prognosis for the literary renaissance was not without cause. Harlem authors were determined to close the gap between white and black literary productivity. By David Levering Lewis's count, twenty-six novels, ten volumes of poetry, five Broadway plays, and a flood of short stories and essays were published in the years 1925–35. Du Bois and Johnson wrote novels and poetry as well as history, political commentary, and propaganda;

Harlem's younger writers, led by Hurston and Hughes, tried to avoid dependency on white literary models by drawing their art directly from black music and folklore. But Harlem's new literature, whatever its sources, never exerted on the broader culture anything like the influence the black music of the day commanded, and it provided scant competition in market terms to the work of white writers. Virtually none of the black writers could support themselves on their published work, as the majority of white writers did; the only best-selling novel to come out of Harlem in the 1920s was McKay's colorful and controversial portrait of black urban life-styles, *Home to Harlem* (1928). Harlem's finest monthly magazine, *Opportunity*, at its peak under Charles Johnson's editorship in 1928, sold only 11,000 copies a month, and 40 percent of these were bought by white readers.

The best work coming out of white Manhattan in the 1920s was widely read and seriously reviewed when it appeared, and it continued to reach new readers and critics in the decades that followed; Fitzgerald's literary reputation, as well as his secure status as a best-selling author, came, in fact, after his death in 1940. In contrast, just as Thurman feared, most of the literature of black Manhattan did not survive its time; much of it went out of print and stayed out of print for decades. But Thurman was painfully wrong on one point: the difference in popularity, circulation, and longevity between black- and white-authored work did not necessarily turn on merit. *Cane*; Hurston's masterpiece, *Their Eyes Were Watching God*; Hughes's early poetry; Larsen's fictional studies of racial and feminine identity, *Quicksand*, and its successor of 1929, *Passing*; and Thurman's own work, particularly *The Blacker the Berry*—these are among the best literature to come out of New York in the modern era, yet they were reissued and recognized only after World War II. Many important books by black New Yorkers of the 1920s have not yet been reprinted by commercial publishers; there was no adequate edition of Hughes's poetry until Arnold Rampersad's in 1994.

The unequal treatment accorded black and white writers was sharply dramatized in 1930, when Nella Larsen was accused of plagiarism: she had taken the plot of "Mrs. Adis," a short story by the popular British writer Sheila Kaye-Smith, as the basis for her own story "Sanctuary," published in *Forum* in January 1930, and a letter to the editor in the April issue pointed out the "striking resemblance." A number of Larsen's black writer friends, perhaps jealous of her recent success, publicized the incident. No legal charges were brought, but Larsen's career never recovered. Larsen had made some changes in the material she had appropriated—while Kaye-Smith's heroine is forced to choose between the rival claims of motherhood and class, Larsen's heroine must choose between motherhood and race—and her powers of characterization and language are perceptibly superior to Kaye-

Smith's, but the storyline, tension, and pacing are indisputably those of "Mrs. Adis."

This act of literary theft is still shrouded in mystery and unidentified pain. Was it an instance of what Freud called "cryptamnesia," unconscious theft? If, as seems more likely, it was conscious borrowing, why didn't Larsen own the debt up front? Did she not realize that Kaye-Smith had written nothing that could compare with the two novels she had already published? As a former librarian, as an accomplished and conspicuously well-read writer, Larsen must have known the resemblance would be detected. Had she pushed her reworking just a step further, as she was more than competent to do, she could have claimed that she was simply using the tactics of appropriation, translation, and transformation with which white men like Eliot, Pound, and Joyce had made their reputations and inaugurated the modern era. Perhaps she feared that what was acceptable in them would be condemned in her, would offer further proof to white observers of the Negro's supposedly inferior powers of mind and originality; in America, whites may borrow from blacks with impunity, but Negro use of white materials is always suspect. Perhaps she was helpless in the face of so complex a moment of self-betrayal. So she closed her eyes, took the chance, and precipitated the punishment she feared.

Larsen wrote three more novels, for which she found no publisher; the manuscripts have not survived. These are, literally, lost texts. What became of Larsen herself, a consummate stylist, a woman of haunting beauty, high education, edged subtlety, and potent half-strengths, where she lived, how she died, was long unknown. It has recently been discovered, however, that she spent her last decades in obscurity as a nurse at Gouverneur Hospital in New York; her death on March 30, 1964, occasioned no obituaries.

Thurman's end was still more desolate. He had more than a touch of the Faustian and Mephistophelian in his character; his roommate, Bruce Nugent, spoke of his "almost diabolical power" of fascination, but the chief victim of his diabolism seemed to be himself. When *Infants of the Spring* appeared, Thurman was already in the last stages of alcoholism. Despite his doctor's warnings, he went on drinking, and in the summer of 1934 he hemorrhaged during a party he'd thrown in his apartment; surprise and terror and recognition were visible on his face as he fell before his guests' eyes. He lingered for six months in the incurable ward on Welfare Island, and died on December 22, 1934, aged thirty-two.

Black entertainers sometimes fared better, but not always. Charles Gilpin was dropped from the London run of *The Emperor Jones* purportedly for alcoholism and (to O'Neill's mind, perhaps a more serious charge) for changing in performance some of the play's more racist lines and epithets. By

1926, the actor many considered the greatest on the American stage was back where he had been when he was picked to star in *The Emperor Jones*, running an elevator. The next year he was fired from a Hollywood production of *Uncle Tom's Cabin* because he refused to play Tom as a sentimental and harmless darky, and what little chance of a continued career he'd had was finished. He died in a haze of alcoholism, poverty, and obscurity in 1930, aged fifty-two. Such a fate, such consignment to terrain unlit by public attention, did not befall even the least significant of the white writers and performers on the New York scene. To date there are no full-length reliable biographies of most of the important writers, organizers, and performers of the Harlem Renaissance—Larsen, Cullen, Fisher, Fauset, Walter White, Thurman, Locke, Gilpin, Charles Johnson, James P. Johnson, and Waters still await full biographical treatment—but there is at least one biography of all my white protagonists save Gilbert Seldes and Ludwig Lewisohn; major figures like Hemingway, Fitzgerald, and O'Neill are each the subject of dozens of biographies and reminiscences.

The Great War had been a catalyst for the black renaissance of the 1920s as for the white, but black hopes had been betrayed in the war more severely than white expectations. Several hundred thousand Negro Americans fought, many of them with undeniable courage, in Europe, and proportionately more black soldiers than white lost their lives; 14.4 percent of the enlisted blacks, compared to 6.3 percent of the whites. The French dubbed the New York regiment the "Harlem Hell Fighters." Surely, Negro leaders thought, this display of black patriotism would lead to improved conditions for Negroes in America. But at the war's conclusion, the American government refused to let its Negro soldiers participate in the victory parade down the Champs-Elysées in Paris, though blacks in European ranks marched with their white peers; black American soldiers were not included in the frieze depicting the Great War's troops on France's Panthéon de la Guerre. It was time, much of white America clearly believed, to put blacks back in their place. As soon as the troops came home, a brutal spate of Ku Klux Klan lynchings, race riots, and deportations began.

Despite all this evidence of injustice, neglect, and pain, no chronicler—and in recent years there have been many of them, notably David Levering Lewis, Nathan Huggins, Jervis Anderson, Houston Baker, and James De Jongh—has used the term "lost generation" to describe these writers and performers as a collective cultural presence, though individual lives and works, Toomer's and McKay's in particular, have been called representative of it. Perhaps this is because the New Negroes did not themselves use the term. The whites were not literally "lost," as their black peers were—indeed, they helped define the notion of conspicuousness in a celebrity-oriented age—but they

were culturally and psychologically dislocated to a degree they felt was unprecedented in the annals of American culture. They had lost, or been robbed of, they thought, some faith in the cultural center, some measure of stability they had assumed to be their birthright. In contrast, the black writers and performers faced a national culture in which the Negro artist had always been "lost"—until, the members of the Harlem Renaissance believed, the present. Now, they proclaimed, was the first hour of real hope for the Negro in America.

Although hopes for a new, livelier, and more honest culture ran high among white writers and artists, these hopes were, paradoxically, founded on their much publicized disenchantment, their chic disillusion with the ideals of the old Victorian ethos of uplift; they had a future, they believed, exactly to the degree they repudiated such notions. But uplift was an ideal to which their African-American peers gave new life and meaning. Inured but hardly acquiescent before extreme cultural displacement, black New Yorkers did not strike the pose of disillusion.

The Great War and its bitter lessons gave four of America's most important white writers their first books—John Dos Passos's *Three Soldiers* (1921), e. e. cummings's *The Enormous Room* (1922), Hemingway's *In Our Time* (1925), and Faulkner's *Soldier's Pay* (1926)—not to speak of a host of war novels by lesser writers like Laurence Stallings and Thomas Boyd. In contrast—though hundreds of thousands of Negroes saw action, though Negroes were writing fiction in unprecedented numbers, though war novels were a potent and commercial genre in the mid- and late 1920s, when the Harlem authors arrived on the scene—no Negro novel about the war appeared. Most of the male writers of the Harlem Renaissance had been too young to enlist in the Great War, but two of Harlem's finest journalists, George Schuyler and Theophilus Lewis, reviewers at *The Messenger* who also wrote fiction, served in the war. Yet Lewis did not take the experience as a literary subject; Schuyler did, but only in a series of sketches of Negro soldiers published in *Opportunity* in November 1930, "Black Warriors," a light satire directed at the soldiers themselves, not at their white superiors, much less at the war itself. Toomer and McKay, both born in the 1890s, were of age in 1917, and, though neither fought, this did not automatically disqualify them from writing about the war; Faulkner did not see action either. The issue was one of interest, not experience or eligibility.

The evidence suggests that for black writers the Great War did not emblematize modernity, as it did for whites, nor did it enforce cultural pessimism. This is hardly to say that the lessons of the war were lost on black Americans. More blacks than whites had evaded the draft, and some saw the war, in the words of Horace Cayton, as "something that didn't concern Negroes. It was a white folks' war." But the Negro's disillusion with the war

focused on the racial injustice it exemplified and furthered, rather than on the disturbing and violent realities that the war's new technologies and brutalities had laid bare; black skepticism and anger were social and political, virtually untouched by the quasi-metaphysical concerns that preoccupied the war's white chroniclers. In any case, the strategy of black Manhattan, as of most of black urban America in the 1920s, was to emphasize Negro achievement rather than detail Negro losses; whites may not have recognized Negro martial heroism, but blacks did.

W. Allison Sweeney, editor of Chicago's *Defender*, a radically minded black newspaper, put out a *History of the American Negro in the Great World War* in 1919. The book was proudly subtitled *His Splendid Record in the Battle Zones of Europe*, and it closed with a stirring glimpse of "a NEW AND BETTER DAY" ahead for the Negro and America—a popular image in black circles at the time. In 1924, the black poet Gwendolen Bennett, a contributor to *Fire!*, wrote: "We claim no part of racial dearth, / We want to sing the songs of birth!" Hughes saw "tomorrow / Bright before us / Like a flame." To the most famous poem by a white American to come out of the war, Alan Seeger's "I Have a Rendezvous with Death"—he was killed in action in 1916—Countee Cullen replied in 1921 with a poem entitled "I Have a Rendezvous with Life (with apologies to Alan Seeger)." The Harlem writers found their most obvious affinities in white New York with artists who by temperament, and in some cases by age, adhered to the prewar Zeitgeist of troubled Whitmanesque prophesy and idealism: Alfred Stieglitz, Waldo Frank, Paul Rosenfeld, critic and writer Gorham Munson, and Hart Crane.

Even the Depression, which hit black Manhattan harder than white New York, did not immediately extinguish Harlem optimism. The titles of Fitzgerald's two retrospective essays on the 1920s, both written hard on the heels of the decade, "Echoes of the Jazz Age" (1931) and "My Lost City" (1932), tell us how far off the feckless days he had chronicled already seemed to him. In contrast, James Weldon Johnson's retrospective on the politics and entertainment culture of *Black Manhattan*, largely written in the months just after the Crash, is a proud history of black struggle and achievement, a struggle that still feels, in Johnson's telling, in full and successful operation. Criticized for the book's upbeat tone, Johnson responded by explaining that his purpose had been to provide "a continuous record of the Negro's progress on the New York theatrical stage." As secretary of the NAACP, Johnson was well aware of the exploitation and poverty that scarred the Harlem artistic and political community, but he still believed its progress to be more telling than its poverty.

One should note Johnson's un-self-conscious use of the word "progress," one of the old-fashioned, moralizing, rose-colored-spectacles words that

Mencken, Van Vechten, Fitzgerald, Hemingway, and their white peers had struck from their vocabulary forever. It was not a matter simply of age: Johnson (born in 1871) was much older than Fitzgerald (born in 1896) and Hemingway (born in 1899) but so were Van Vechten and Mencken; and Hughes, who saw "tomorrow bright before us / Like a flame," was younger than both Fitzgerald and Hemingway. One might also note in this context that, although literary Harlem had its alcoholics, it had fewer of them than white Manhattan did. Of the ten most prominent Harlem modernists—Du Bois, Johnson, Locke, Fauset, Hughes, McKay, Thurman, Hurston, Toomer, and Larsen—only two (Thurman and Toomer) were alcoholics; in a roughly comparable group of white moderns—Mencken, Lewis, Fitzgerald, O'Neill, Parker, Thurber, Millay, Moore, Edmund Wilson, and Crane—only two (Moore and Mencken) were *not* alcoholics. Alcoholism is, among other things, a disease of despair, and it hit the white literary moderns harder than it did the black.

What, then, were the sources of black optimism? Awful to say, the backlash that followed the Great War, the wave of anti-black violence, was hardly new. What was new, as Du Bois, James Weldon Johnson, Locke, and Charles Johnson were aware, was that American Negroes now had in Harlem, however precarious its economic status, a haven and a stomping ground, the first "race capital," in Locke's words, "the first concentration in history of so many diverse elements of Negro life." "Their greatest experience," he wrote, "has been the finding of one another." In Rudolph Fisher's story "City of Refuge," Solomon Gillis leaves the subway at Lenox Avenue and 130th Street and catches his first glimpse of Harlem. He can hardly believe his eyes: "Negroes at every turn . . . big, lanky Negroes, short, squat Negroes; black ones, brown ones, yellow ones, men . . . women . . . children . . . Negroes predominantly, overwhelmingly everywhere!" In Harlem, Arna Bontemps discovered, it was "fun to be a Negro."

What was new for black America in the 1920s was that the "Talented Tenth" of Negroes, as Du Bois called them, were getting more exposure and financial backing than they had ever had before; political advancement might be curtailed, but cultural success looked possible. This sense of black opportunity was short-lived and never without doubts and conflicts, but in the early years of the modern era, New York's Talented Tenth felt themselves to be not lost but found; the description and reification of a modern world desperately in need of a lost religious significance, insistent in contemporary white expression, was not the preferred mode of the Harlem literary mind. Larsen's taut and mournful *Quicksand*, with its echoes of *The Waste Land*, and Thurman's *Infants of the Spring*, with its bitter reworking of the *Waste*

Land theme, were not taken as representative texts, as the last word on the Zeitgeist, by the Harlem moderns, not even, I think, by the Harlemites who wrote them, as *The Waste Land* was at once hailed by white moderns as the crucial text of the day.

The despair expressed in *Infants of the Spring* is not altogether unrelieved. Paul Arabian dies and takes his novel with him, but Raymond Taylor is at last at work on his own novel, which may well be the book we are now reading. In a crucial scene near the end of the book, Raymond's confused and unhappy white friend Stephen announces that he belongs to "Gertrude Stein's lost generation," but Raymond, despite his conflicts, does not. "You have something to fight for and against," Stephen tells him. Raymond has access, he himself realizes, to a "new store of energy" not available to Stephen, who faces "an impending eclipse" of his powers.

In a letter published in the September 1926 issue of *Opportunity*, Larsen made a similar point; she rebuked the black critic Frank Horne for his "blind" review of Walter White's second novel, a story of passing titled *Flight*. Horne had quoted a line from *Flight* that referred to a "lost race" and assumed the author was referring to blacks. This is where Horne "stumbles and falls," Larsen wrote, for White was actually referring to the "*white* race." Indeed, the notion that it is the white race, not the black, that is "lost" in America, was, as she claims, the "dominant note" of White's book. Mimi Daquin, White's mulatto heroine, after passing successfully in the world of white affluence, returns to her own materially impoverished people, because she discovers, in Larsen's words, that "there were no advantages of the spirit [for her] in the white world." To Larsen's mind as to White's, Negro culture, no matter how troubled it might be, contained the real riches of American life.

"Dream Variation," an early poem by Hughes, takes a long-shot view of the relationship between the dark and the light:

> To fling my arms wide
> In the face of the sun,
> Dance! Whirl! Whirl!
> Till the quick day is done
> Rest at pale evening.
>
> . . .
>
> A tall, slim tree.
>
> . . .
>
> Night coming tenderly
> Black like me.

Whatever the outcome of racial rivalries in the present, the compelling and seductive mysteries of the black experience will outlast and trivialize the full-lit intricacies of the dominant white culture. Hughes and his peers believed that history, the immemorial reach of time back of history, the drift back of everything, the psyche itself, was with the Negro. They did not explore the quasi-Calvinist theological implications of being a "lost" generation. They might be in revolt against their own genteel elders, they might have deserted the faith of their forebears, but they were not, in their own eyes, in Parker's mocking words about her white peers, "poor little ewe lambs who had gone astray" nor an "auxiliary of the damned." Calvinism, with its emphasis on preordained sin, did not speak to black Americans as forcibly as it did to white ones; the sins of the nation did not lie at their door.

The elaborate theology of seventeenth- and eighteenth-century Calvinism had been largely a white preserve. As one ex-slave put it: "The colored folks had their own code of religion, not nearly so complicated as the white man's." "Complicated" is not the right word, but "literate" might be, for theology is part of the tradition of written scholarship that the Puritans brought with them to the New World as their most precious privilege, a privilege their heirs did not extend to America's enslaved black population. All churches work to define and stabilize some notion of orthodoxy or correct belief, but the orthodoxy of the black church was from the start closer to the oral than to the written tradition, a matter of evangelical experience and moral conviction rather than of dogmatic theory and established creeds and platforms.

The black Protestant clergy's decline in power and prestige did not occur in the nineteenth century, as did the comparable decline in white Protestant clerical status, but began in the twentieth with the attacks on the black church leadership by Du Bois, A. Phillip Randolph, Chandler Owen, and other anticlerical Negro writers and intellectuals, nor was the decline at any time as steep. In part this was because the other prestigious professions siphoning off the white church's pool of elite recruits—law, medicine, and higher education—were by and large closed to blacks, but cultural factors were at work as well as economic and sociological ones. The liberalization and feminization of the white mainstream middle-class Protestant tradition in the Victorian era, and the modern resistance to it, were possible only in a print culture—this was an argument in good part over the interpretation of the written word—and it did not occur in the black churches, at least not to the same degree. The black literary moderns had nothing like the sense of Neo-Orthodox mission that marked the work of their white contemporaries, because theology had not been their heritage or concern in the first place.

I do not mean to suggest that there was no awareness of Calvinist theology

evident in the Harlem Renaissance. Du Bois was trained and bred in New England Congregationalism as a boy growing up in Great Barrington, Massachusetts; although he was at best agnostic, all his writings resonate with the lavish stringencies of the Puritan ethos. And black Manhattan shared in the ethos of "terrible honesty" insofar as it involved the end of pre-Oedipal blur and a new precision of sound and sight. Black ragtime and jazz entertainment dramatically raised the standards of exactitude and variation in timing and motion. The white novelist Mary Austin, praising the impeccably crafted art of Harlem's great song-and-dance man Bill ("Bojangles") Robinson, in *The Nation*, remarked that "the eye filmed and covered by 5,000 years of absorbed culture" is cleared by the "rhythm" of Robinson's flying feet. In her view, Bojangles represented "the great desideratum of modern art, a clean shortcut to areas of enjoyment long closed to us by the accumulated rubbish of the culture route." Black art offered a way out of the misty and bogus realm of the Titaness.

"Terrible honesty" as a focus on the rock-bottom facts was also a black phenomenon. Harlem's elite demanded of their audience, black and white, a new severity of mind. Du Bois had led the way in *The Souls of Black Folk* (1903), in his repudiation of what he took to be Booker T. Washington's equivocations and servility: "The way to truth and right lies in straightforward honesty, not in indiscriminate flattery." James Weldon Johnson praised his friend Mencken above all other white writers simply because "he is not afraid of anything: not even of the truth." Alain Locke announced in his essay "The New Negro" (1925) that the time had come to "settle down to a realistic facing of facts" about black and white America; the Negro poet and critic William Braithwaite urged his readers to drop the "indulgent sentimentalities" about the "happy, carefree, humorous Negro"; George Schuyler and Theophilus Lewis turned a scathing satiric eye on the follies of blacks and whites alike. Wallace Thurman, ever intent on hard-core objectivity, defended the right of whites to write about blacks on the grounds that "no race of people is exactly what it believes itself to be"; the New Negro actually invited harsh criticism. "The problem of the twentieth century," Du Bois said, "is the problem of the color line—the relation of the darker to the lighter races of men in Asia and Africa, in America and the islands of the sea," and he spearheaded the New Negro's attempt to find and evaluate his African roots, to understand his own cultural origins and identity. If self-examination was an ideal in the 1920s, no group of artists and thinkers pursued it more self-consciously and extensively than the leading citizens of black Manhattan.

Nor do I mean to suggest that religious hopes and doubts were not at play in the Harlem Renaissance, for they were, and in formative ways. But most

of its writers were concerned primarily not with the loss of Protestant theology, like their white peers, but with the legacy of black religious experience in its widest sense. *Cane* was the result of a brief sojourn in Georgia (just preceding the visit South with Waldo Frank), where Toomer experienced at firsthand the "folk-spirit" of the black "peasantry," in his words, a spirit condemned "to die on the modern desert" of urban life. *Cane* was "a swan-song. It was the song of an end." However, the "end" Toomer foresaw turned out to be the death of his own talent, not that of the black culture he eulogized and anatomized. *Cane* was the first and last novel he ever published; the racial heritage that he momentarily found in Georgia, and denied ever after, was apparently the only ticket to full creativity he possessed. Over the course of a long and troubled life, he tried out a half dozen religious practices and philosophies, all of them white in origin and in clientele, but he never took up Neo-Orthodoxy. A mystic bent on revivification, Toomer was not a worshipper of the stripped structures of fact "terrible honesty" purported to lay bare, nor were, I think, any of his black contemporaries other than, to a degree, McKay, Larsen, and Thurman. The New Negro might exemplify and practice "terrible honesty," but he did not reify it or polemicize for it.

The work written by the major white writers of the 1920s, most particularly Eliot and Hemingway, the work seized upon by contemporaries as talismanic and revelatory, came out of a mood of disciplined if exultant despair; the best writing of Toomer, McKay, Hurston, and Hughes—the four writers then perceived as the major figures of the Harlem Renaissance—came out of a shaded but tangible jubilance. The central aesthetic of black Manhattan was not one of diagnostic analysis, confrontation, and irony but a complex and often ambivalent form of celebration. What white moderns like Hart Crane, Waldo Frank, and Sherwood Anderson hoped to get from their friendship with black moderns like Toomer was the Negro genius for religious feeling, the saving expressiveness that American Calvinism in their view had conspicuously lacked. From the perspective of many whites and some blacks, black Manhattan offered not only an extension and variation of "terrible honesty" but an antidote, if one almost inaccessible, to "terrible honesty's" most punitive imperatives, a key to what Toomer, speaking of his own goal, called "the Spiritualization of America."

I have suggested that the theological themes of Neo-Orthodoxy that became popular in the 1920s were inseparable from Freud's new psychoanalytic discourse. It is not surprising that the writers of the Harlem Renaissance did not feel the strongly marked, almost compulsive affinities with Freudian thought evident among white writers; if Freud was Calvin's heir, among others, those uninterested in Calvin inevitably found less of importance in

Freud. Moreover, Freud's theories of what he called "the family romance," the tortured triangle of mother, father, and child that produces the Oedipus complex, had little to do with the African-American experience.

Freud's notion of the family romance came from his study of the educated and affluent white Viennese bourgeoisie, turn-of-the-century Europeans who lived in a form of what we today call the nuclear family. The traditional unit of two parents and their offspring was a social cluster that allowed its members, in Freud's telling, few appeals to those outside its limits; the child's possibilities of development were seen as restricted to whatever resources and pathologies his or her parents possessed. The family romance was Freud's most basic reality grid; he designed the analyst-and-patient relationship of transference and countertransference on its locked-and-interlocked-resources model; and it was also the ground, the source and justification, of his philosophic posture of extreme pessimism. To Freud's way of thinking, human beings, raised in the claustrophobic world of the family romance, have no real source of replenishment; once the family card has been played, the player's hand is empty. It is a matter of considerable debate whether theories and therapeutic practices like Freud's, based exclusively on the nuclear family structure, are useful in understanding the psychological configuration of a people whose family patterns in their native Africa, and to a degree in the Southern plantation life to which they were transported, were those of extended kinship relations and communal resources. People in groups may be healthier than those in small nuclear units; their pathologies are surely different.

The Methodist and Baptist camp revivals of the South and Southwest had provided the setting in which most American blacks found or confirmed their religious identities in the eighteenth and nineteenth centuries. With their hundreds and thousands of people, young and old, men and women, mixing indiscriminately in states of high excitation and breaking out at will in shouts and songs, all gathered to hear an itinerant preacher usually but by no means always white, the camp meetings operated on something like the model of extended-kin and communal rituals familiar to Africans and in part reproduced in the plantation milieu, and they presented a vivid contrast to the configurations of religious conversion known to whites in the Northeast. The Northeast had its own itinerant preachers in tents and fairgrounds, its own expressive revival tradition, but these co-existed and competed with a long-standing, central, and powerful emphasis on the settled pastor and his flock: a single minister who guided his congregation in more or less set sermons toward religious truth and examined the heart and conscience of individual parishioners in the privacy of his study or the parish-

ioner's home. This was a theological version of the nuclear family structure minus the mother; it was also a prototype for Freud's analyst-and-patient paradigm.

When Negro spirituals, sung in concert by black artists like Paul Robeson and Roland Hayes, became a vogue in the 1920s for white Americans, a number of African-American critics, Hurston and Locke among them, reminded white audiences that the spirituals, coming as they did out of camp meetings and church services, were not traditionally performed, or intended to be performed, by soloists, however talented. "The proper idiom" of all Negro spirituals and folk songs, Locke wrote in "The Negro Spiritual" is "group" or "chorale treatment." Hurston, Hughes, and many other black artists of the 1920s built their art on the extended kinship configurations of African-American religious and social life as surely as leaders of white literary modernism like Eliot and Hemingway built theirs on the nuclear model of Northeastern theological and social expression.

Whatever the original kinship patterns of African Americans, they had of course been disrupted and recast by centuries of slavery and forced miscegenation in a new and untamed world. In his chapter on the Negro spirituals as "Sorrow Songs" in *The Souls of Black Folk*, Du Bois drew attention to their "eloquent omissions and silences. Mother and child are sung, but seldom father . . . There is little of wooing and wedding . . . Home is unknown . . . Of deep, successful love, there is ominous silence." Fathers are missing in the backgrounds of my black protagonists more often than in those of my white ones, and the parents who appear in their fictional work are not always of the same race. What does one do with the "family romance" if, in Hughes's words in "Cross," "my old man's a white old man / And my mother's black?" The poem is not, strictly speaking, autobiographical—Hughes's parents were both, in fact, light-skinned blacks, but their union was brief and bitter, and in any case his ancestry included as many whites as blacks. A proto-Beat vagabond set traveling and writing by the mésalliance of his birth, Hughes wonders, "Where I'm gonna die, / Being neither white nor black?" How can he grow up, being the full child of neither parent, a full member of neither race? Nella Larsen's racial pedigree was different from Hughes's but equally mixed: her mother was white, her father black. The heroines in her fiction are of mixed blood, with one parent unknown or missing. If Freud's family romance cannot operate as a paradigm for the growth of these women, or lack of it, what, Larsen implicitly queries, can? Her novels are perfectly crafted and self-conscious case studies in search of a psychology. Some black writers made much of Freud's Oedipal configuration, but they tended to treat it as a part of the psyche of white America,

a national psyche in which their own Oedipal role was heavily scripted by white masters and mistresses.

The personal lives of the black moderns did not fit Freudian prescriptions either. Most of the best-known black male writers on the New York scene were homosexual; Hughes, Cullen, Thurman, Locke, and McKay, not to speak of minor talents like Richard Bruce Nugent and Harold Jackman, were homoerotic, men whose most important intellectual, social, and sexual ties were to other men. Of the Harlem Renaissance's recognized male literary stars, only Toomer was heterosexual, married, and a parent, but he was flagrantly remiss in his duties as husband and father, and in Jungian analysis late in life, he discovered a homosexual component in his psyche. McKay had a daughter by a brief early marriage, but he never saw her or apparently wished to.

McKay, like Locke, seems to have been relatively comfortable with his sexual orientation, but Cullen and Thurman were not. Both made disastrous and brief first marriages. Cullen married Du Bois's daughter, Nina Yolande, on April 9, 1928, but left for his European honeymoon accompanied, not by his wife, but by his intimate friend Harold Jackman. And when Thurman's wife, Louise Thompson, sued him for divorce in the late 1920s, she named his homosexuality as a leading cause of their incompatibility; Thurman had been picked up in a subway lavatory for homosexual acts in 1925. Cullen married again, more happily; Thurman did not. Neither had children. Langston Hughes never married and he had no children; indeed, as far as we know, he did not engage in an extended liaison with a member of either sex. Cultivating what his finest biographer, Arnold Rampersad, has called a "Peter Pan" style of guileful and erotic innocence, he obscured and shielded his sexual identity from clear scrutiny by anyone, probably including himself.

It is true that among the lesser white literary talents on the New York scene, there were some homosexual and childless men—Alexander Woollcott, George Jean Nathan, and Carl Van Vechten, for example, though Woollcott was celibate and Van Vechten married. Of the major white male moderns, however, only Hart Crane was gay, and even he had a serious affair with a woman (Malcolm Cowley's ex-wife, Peggy) in the last year of his life. He did not marry or have children, but almost all his white male peers did, and they wrote out of a lifelong commitment, no matter how ambivalent, to their official heterosexual identity. Try to imagine what the white 1920s generation would have been like if, like the Harlem Renaissance, its most important male ringleaders and spokesmen—say Sinclair Lewis, Mencken, Fitzgerald, and Hemingway—had been homosexual. One almost can't do it; the differences involved are too immense, too complex.

It is worth noting that on gender issues like these, New York's women writers did not divide along racial lines as neatly as the men did. White and black women artists of the time were all reluctant breeders. Djuna Barnes was gay and childless. Millay was bisexual; although she married, she had no children. Jessie Fauset, Nella Larsen, Zora Neale Hurston, Dorothy Parker, Sara Teasdale, Katherine Anne Porter, and Anita Loos were heterosexual women who married at some point in their lives, but none of them had children. Elinor Wylie strangely bemoaned her "childless" state while ignoring the child she did have, Phillip Hichborn III, the unhappy product of her first marriage, who committed suicide not long after her own death in 1928. Marianne Moore wanted to be a species of one; she chose celibacy. This defection of the women writers of the day from the demands of maternity and family is significant, but in Western culture, the credit and burden of setting a lineage has traditionally belonged to men; it was a burden the white male artists accepted and the blacks did not. Whatever their childhood experiences, New York's most gifted black male writers did not choose as adults to re-enact the "family romance"; not one of them invested, as "Papa" Hemingway so notably did, in the myth of the patriarchy dear to Freud's heart.

ROLE-PLAYING AND DISGUISE

It is one thing to be in search of the "primitive," as white artists of the 1920s were; another thing to be told, as the black New Yorkers were, that you *are* the primitive, the savage "id" of Freud's new psychoanalytic discourse, trailing clouds of barbaric, prehistoric, preliterate "folk" culture wherever you go. It is even worse to be informed, as Jessie Fauset repeatedly was, by blacks as well as whites, that your well-mannered persona is a fake, a cowardly failure to live up to, or down to, your exotic racial inheritance. The genteel Negro heroine of Van Vechten's *Nigger Heaven*, Mary Love, who has lost her "primitive birthright" to "glowing color" and "warm, sexual emotion," was a thinly disguised portrait of Fauset; Thurman dismissed such women in *Infants of the Spring* as those who feel constrained to "apprise white humanity of the better classes among Negroes."

Moreover, the black identity that whites, and some blacks, insisted that Harlemites enact was never straightforward, not even in the most obvious sense of race. Most of the leaders of the Harlem Renaissance were middle-class, well-educated, and light-skinned; Claude McKay, a pure-blooded Negro, sometimes felt himself an outsider among Harlem's literati on this score alone. Several of his peers were able to pass as white whenever they chose.

The aptly named Walter White, a novelist and organizer of the NAACP, was a graduate of Atlanta University, fair-haired and Anglo-Saxon in appearance; he was used to infiltrate far-right white-supremacy organizations. And Jessie Fauset's civilized persona was at least as authentic as that of any of the members of the self-proclaimed "primitive" *Fire!* school. The light-skinned, well-bred daughter of a distinguished Philadelphia family, she had graduated from Cornell (probably the first black woman to do so) Phi Beta Kappa in Classics in 1904; she polished her French in a year of study at the Sorbonne, and later got a master's degree in French from the University of Pennsylvania. Her eye for literary excellence was impeccable and her taste varied; if anyone "discovered" the resolutely Negro Langston Hughes, it was Fauset, who began publishing his poetry in the *Brownies' Book*, a magazine for black children, in January 1921.

Jean Toomer was a descendant of one of America's most influential and well-placed black families and, if not all white as he later claimed—he explained that his grandfather had only pretended to be colored in order to win office in Reconstruction Louisiana—he was in plain fact more white than black. To "pass," to aspire to be everywhere a "foreigner," as Toomer did; to think of oneself as a "citizen of the world" rather than as an American or African American, as Fauset sometimes did; to be uncertain, as Du Bois was, whether one's nation was America or Africa—such predicaments raise questions of identity more radical than any that a white American faced.

The African-American artist's status as cultural agent was equally precarious. White modern artists in the 1920s were the self-designated heirs and beneficiaries of late-Victorian mainstream culture, and as such they were strategically situated to shape the new culture inaugurated by the media and advertising industries and to attract the largest audiences to its enterprises. But however distinguished and educated the families of black artists and intellectuals like Fauset or Toomer might be, they could hardly see themselves as acknowledged heirs of mainstream Victorian culture; whatever part they played in modernizing its legacy, it was not expected or solicited. Dozens of prizes for talented Negroes, funded by whites, were instituted and awarded in the 1920s, but the rewards and responsibilities of full cultural participation were not among them.

Back in the 1860s, when blacks had begun performing their own minstrel shows, they had wooed patrons by claiming that they alone, as ex-slaves, could bring "genuine" plantation "darkies" to the stage; they attracted large followings, black and white, and almost put their white rivals out of the running. This claim of ex-slavery status was self-conscious PR-wise showmanship; most early black minstrels, Robert Toll has found, were not, in fact, ex-slaves. Audiences and critics nonetheless greeted them as the genuine

article, as they had hoped, but with the disparaging difference that they were treated not as disciplined artists interpreting their own material but as "genuine Negroes indulging in reality," in the words of one reviewer, and as such presumably in need of expert management. The Negro manager faced considerable difficulties in any case, trying to arrange bookings with white theater owners, most of whom disliked or refused to deal with Negroes. By 1900, minstrelsy, black and white, was run by whites, a state of affairs perpetuated on the black-and-white entertainment scene in the 1920s and beyond.

The mainspring of the Harlem Renaissance was the black theater, but the two most important and well-established black theaters in Harlem, the Lafayette and the Lincoln, like most of the nightclubs and stores that surrounded them, were white-owned and run. Although the drama critic Theophilus Lewis made repeated calls for a black national theater and stressed that the vitality of black drama depended on black playwrights rather than on black actors, he was fighting a losing battle. James Weldon Johnson pointed out in *Black Manhattan* that, while Negro performers gained recognition in the course of the 1920s, Negro playwrights and directors were worse off at the decade's end than they had been at its start; a swell of black performers had made white playwrights, directors, and producers eager to utilize their talents, men who already had the connections their black peers lacked. No matter how much artists like Eddie Cantor and impresarios like Flo Ziegfeld were attracted to black performers and their traditions, however dependent their own art was on black sources, they did not question the prevailing economic order in which blacks were employees, never employers. When Hughes, a prolific and acclaimed poet and novelist, tried to find work in Hollywood in the mid-1930s he discovered that while Hollywood had some use for black actors, it had none for black writers; scripting spells control, and control was a white prerogative.

Blacks might be every bit as "addicted to the spotlight," in Thurman's phrase, as their white peers, but they knew nothing of the hands-on participation in media development that Gilbert Seldes, for instance, with all the print media of the metropolis open to him and working in key positions at CBS radio and television, or Walter Winchell, with his syndicated columns and his prime-time radio show, enjoyed. Yet the fact that Negroes were outsiders to the power-broker scene altered rather than lessened their impact. Dependent on white funding, publishers, and patrons, they were forced to negotiate white control in ways that helped to clarify and intensify as well as obscure the modern black artistic enterprise.

At one moment in *The Great Gatsby*, Fitzgerald's narrator, the circumspect romantic-against-his-will, Nick Carraway, is driving with the elegant

mobster Jay Gatsby in Gatsby's flashy cream-colored car, extended to a "monstrous length" and "swollen" with appurtenances, from Long Island to New York via the Queensboro Bridge; from the vantage point of the bridge the city appears to be "seen for the first time, in its first wild promise of all the mystery and the beauty in the world." A hearse passes Gatsby's car, then a limousine "driven by a white chauffeur, in which sat three modish negroes, two bucks and a girl"; "the yolks of their eyeballs rolled toward us in haughty rivalry." Nick's condescending language signals his inability to read this moment right, but he gets the point. These "modish negroes" are Gatsby's rivals, perhaps his superiors, if only in audacious pretense; after all, their chauffeur is *white*. Once "we've slid over this Bridge," Nick thinks, and "laugh[s] aloud" to imagine it, "anything can happen . . . anything at all." In New York the presence of the New Negro was as public as the subway system and as far underground.

White New Yorkers defying Prohibition enjoyed flaunting in broad daylight the pretense of secrecy that lawbreaking involved. They loved the ultra-slim hip flasks that eliminated the telltale bulge of a bottle, the passwords needed to open speakeasy doors, the proliferating slang and nonsense terms for booze and drinking. Edmund Wilson listed more than a hundred terms for "drunk" in his "Lexicon of Prohibition" (1927); they include "squiffy," "owled," "scrooched," "zozzled," "stricken," "spifflicated," "featured," "leaping," and "wapsed down" as well as the more obvious "stinko," "loaded," "stewed," and "fried." Cabaret slummers and Prohibition officials alike used role-playing and disguise. One colorful agent, the vaudevillian Izzy Einstein, employed so many costumes in his pursuit of the multitudes defying the law that he was dubbed the "Lon Chaney of Prohibition," but his best ploy proved to be playing himself. "Care to serve a hard-working prohibition agent a drink?" he'd ask some unsuspecting bartender, who would laugh, pour the drink, and be arrested. Damon Runyon liked to refer to the bootlegging gangsters and drinkers who peopled his slang fables as "citizens"; "citizens" in Prohibition America, Runyon reminds his readers, were lawbreakers one and all. Prohibition allowed ordinary New Yorkers to invest as eagerly and self-consciously in performance as did entertainment stars like Al Jolson and John Barrymore.

Satirically open secrets constituted the high style in 1920s New York, and the writers and performers of black Manhattan were the highest of high stylists on the scene. Whatever their personal ethics, they were closer in status to real outlaws than Runyon's "citizens" could ever be. Izzy might occasionally and profitably pose as himself, but his black peers were always playing themselves and taking enormous risks in doing so; what was pretense for whites was reality for them. One must remember that at that time in

most of America, for a black man even to look at a white woman, for a black person to address any white one on terms of open equality, was to commit a crime punishable by trumped-up charges and lynching.

When Eugene O'Neill cast the white actress Mary Blair as the female lead opposite Paul Robeson in his 1924 drama of miscegenation, *All God's Chillun Got Wings*, he was breaking a centuries-long taboo. Before the play opened, word got out that Blair was called upon by the play to kiss Robeson's hand; a furor swept New York and, from New York, much of the nation. The New York *American* gleefully warned of the "RIOT" *God's Chillun*, a "DIRECT BID FOR DISORDERS," was sure to produce; various city groups lobbied to stop the play from opening. O'Neill had protected himself by making his white heroine go crazy before she kissed his black hero's hand, and *Chillun* duly opened to an unnotable run, but the ruckus was evidence that injunctions against black-white intimacy did not cease at New York City's gates.

The casting in 1934 of George Gershwin and DuBose Heyward's Negro "folk opera," *Porgy and Bess*, a story of love, tragedy, and hope set in the heart of the rural South, was less controversial but equally indicative of the complexities of black and white role-playing. George Gershwin, Jewish composer and egocentric genius, had sprung direct from black music and from those white composers like Irving Berlin who had appropriated African-American ragtime just before him. Gershwin's first hit song was a "Plantation"-type number called "Swanee," put over by Al Jolson in blackface in 1919; he also wrote a Harlem operetta for *George White's Scandals* of 1922, complete with ragtime, blues, and spirituals. A close friend of Fats Waller, Gershwin could often be seen at Harlem parties and night spots, patently at ease. His collaborator on *Porgy and Bess*, DuBose Heyward, had immersed himself in the South Gullah dialect, customs, religion, and mores of the Negro population in his native Charleston, South Carolina, and its adjacent islands, and when Gershwin made a trip to the Charleston area to get musical ideas, Heyward remarked that the trip was less a visit for him than a homecoming. On one outing to a black church, George took over, unasked, from the lead Negro "shouter" and worked jubilantly against the intricate rhythmic background of hand-clapping and foot-tapping provided by the congregation; after all, "I Got Rhythm," introduced in 1930 by Ethel Merman in the musical *Girl Crazy*, was one of his recent hits.

Gershwin and Heyward had thought of using some white blackface performers in their opera—Jolson, in particular, self-billed as "the Blackface with the Grand Opera Voice," had mounted an all-out campaign for the lead—but they decided to go with the times and hire an all-black cast. They quickly found their Sportin' Life—a sexualized, hip, and flashy descendant of minstrelsy's "Zip Coon," in John W. Bubbles (né John William Sublett),

a dancer and singer already famous as a partner in the Broadway team of "Buck [Ford Lee Washington] and Bubbles." During rehearsals, it sometimes seemed that Bubbles *was* Sportin' Life. An insouciant and cavalier trouble-maker intent on his own performance, he couldn't read music and refused to conform to the rules and regulations of a big Broadway production. But no one fired him; he was, all agreed, the most brilliant and resourceful member of a highly talented cast.

For the lead part of Porgy, the crippled peddler whose faith illumines the tragedy of passion that is *Porgy and Bess*, Gershwin and Heyward found their man in a different and quite unexpected quarter. Todd Duncan was a voice teacher at Howard University and a serious singer who had appeared in a recent all-black New York production of Mascagni's opera *Cavalleria Rus-ticana*. (In 1945, playing in the New York City Opera Company's production of Leoncavallo's *I Pagliacci*, he was to become the first Negro performer to sing with a major white American opera company.) Duncan didn't volunteer for *Porgy and Bess*; Gershwin pursued him. Trained in classical music and wedded to it, Duncan had no previous interest in the show tunes that were Gershwin's specialty; for his audition, he sang lieders, arias, and a few spirituals. Gershwin was impressed, Duncan intrigued and amused. "Imagine a Negro," he wrote a friend, "auditioning for a Jew, singing an old Italian aria!"

In the course of working together, Duncan and Gershwin became friends. They visited Charleston together, as Waldo Frank and Jean Toomer had traveled to South Carolina back in 1923, to soak up black music and speech. But neither of them could "pass." Duncan told an interviewer, decades later, that he had lodged in Charleston with "a wonderful Negro family—a doctor. Gershwin wanted to stay there too but he didn't. The races were then too far apart. I couldn't stay at the white hotel and they didn't want him." Each found himself, however, or said he did, in the other. Gershwin kidded Duncan that he was more Jewish than he was; Duncan in turn retorted that Gershwin was more black than he was. Who was tipping or concealing his hand in this bantering exchange? Who, for that matter, was doing more acting onstage, the highly trained, elite-art performer Todd Duncan, singing in an unfamiliar jazz idiom and playing someone nothing like himself, or John Bubbles, the master of pop dance rhythms, simply putting those rhythms to use in a new arena and apparently playing someone just like himself?

If "terrible honesty" necessitated drama, it was not the only thing that did so, not above 110th Street, anyway; sheer danger worked just as well. The "terrible honesty" ethos of white modernism played off an omnipresent and theatricalized sense of danger, less of perceived and objective danger—the white artists, as I have repeatedly remarked, were in actual fact privileged

and protected—than willed, even pretend danger; one upped the stakes to get the adrenaline needed for the appointed cultural task of attack and stylization. John Barrymore's persona in his last years was complex and even unfathomable, but the penalties for unmasking were largely internal, not external ones. In contrast, the theatrical impetus of the New Negro stemmed from the presence of real and undeniable danger; living off this danger was the black cultural task.

The most important reason that the strategy of "terrible honesty" was not preferred among blacks in the 1920s was the simple fact of the risks involved. The blazoning of truths that one's society would prefer to deny is by definition an attention-grabbing, adversarial strategy, one most easily and effectively utilized by those whom society has no reason or desire to sacrifice, namely, its own chosen elite. The New Negro was a figure with few claims on mainline America's attention, interest, or sympathy. If he insulted or displeased, he could be cut off, erased, without a thought or regret. Inevitably, then, "terrible honesty" in black Manhattan, whether in a novel, a blues song, or a Broadway revue, was an affair of subversion rather than assertion, of creative deceit and displacement rather than denunciation and attack.

No matter how timing- and rhythm-conscious the drama of the white moderns might be, it was, both as life-style and theatrical art, a set piece; one took one's stand, so to speak, in a tension-laden posture of artifice, a kind of freeze-frame. Beautiful and aloof Elinor Wylie, immaculately polished in person and verse, dressed of an evening in glittering silver sheaths from Paris's great couturier Paul Poiret. Her mode was what Fitzgerald called in *The Great Gatsby* "an unbroken series of successful gestures," an obsession with the unmistakable. Josephine Baker also liked to turn up in a Poiret gown, but this was never her primary look. Onstage and off, she was noted for something close to nudity, nudity accentuated by a belt of bananas around her hips or a long feather curling provocatively between her legs, and at the most unexpected moments she would start mugging: she'd cross her eyes, throw her bronze limbs akimbo into a comically quick kaleidoscope of fractured motion, turning on the glamorous and provocative image she'd created but a moment before. Her real look was surprise.

In *Black Manhattan*, Johnson described a moment anticipatory of Baker's aesthetic, an occasion that he considered the breakthrough for the modern Negro musical theater in New York. It took place in 1905 at Proctor's Twenty-third Street Theatre. The all-black Memphis Students were, he writes (overturning several white claims on his way), the "first modern jazz band ever heard on a New York stage." The band, an ensemble of singers and players using banjos, mandolins, guitars, saxophones, drums, a violin, a double bass, and a few brass instruments, astonished white New York. What caught

the audience's attention was not just the new music but the fact that almost all the twenty band members played instruments *and* sang *and* danced, and did so more or less at the same time. Buddy Gilmore, the drummer, did juggling tricks and acrobatic stunts as he manipulated "a dozen noise-making devices aside from the drum"; even Will Dixon, the composer-conductor, danced as he conducted, danced to conduct, his body anticipating the beat the music was about to take. More amazing still, some of the musicians, in Johnson's words, "played one part while singing another. That is, for example, some of them, while playing the lead, sang bass, and some, while playing an alto part, sang tenor, and so on, in accordance with the instrument each man played and his natural voice."

We are dealing here with the proverbial white astonishment at the Negro's superior powers of rhythm, but in a highly complex and culturally resonant form. As Johnson describes the Memphis singers, we see the demonstration for white Manhattan of an African-American aesthetic of simultaneous and separate motions and beats. African and African-American dancers, their new white fans were discovering, could keep two, three, even four distinct and different rhythms going at once, each performed by a separate part of the dancer's body. It's all one body, but the body apparently doesn't know it. Belly and shoulders may go separate ways; the legs aren't commandeered into mimicry by what the arms are doing. The hands and feet pick up separate rhythms that play against each other but never collapse into one another. Baker's biographer Phyllis Rose describes it as "playing the various parts of the body as though they were instruments"; Zora Neale Hurston called it "the rhythm of segments." Different rhythms create different personae, all operating spontaneously; the African-American performer can't be "caught."

For both the black Manhattan moderns and the white, theater was the only means of turning danger into profit and art; drama allows its participants to find whatever meaning, whatever measure of safety, that danger allows. For the New Negro, however, danger was constant, omnivorous, fluid, and unstable; it necessitated the use of that plurality of masks Africa had donated and minstrelsy had elaborated and Americanized. The chosen mode of black Manhattan was one of contrasting, shifting rhythms as a fractured but infinite series of impersonations never culminating in the dénouement of unmasking. The African-American poet Paul Laurence Dunbar had written, "Why should the world be overwise, / In counting all our tears and sights? / Nay, let them only see us while / We wear the mask." The Negro pianist Sammy Price, speaking of the Harlem scene of the 1920s and 1930s to Barry Singer, remarked that no one could tell the history of that era: "It's too jumbled . . . and fragmented. Nobody ever told it straight—even as it was happening, we was inventing it. And don't think that was no accident neither." Disguise

was so necessary to the black performer that final unmasking, stasis, telling it "straight," in Price's phrase—even if presented, as it was in white art, as an artificial and theatrical gesture—became the ultimate taboo.

Harlem's greatest natural resource, its birthright art of expressiveness, also constituted its most self-conscious and strategic defense. The black moderns were the supreme players in the masquerade that was 1920s Manhattan culture, players whose disguises were doubly necessary ones that could not be, and were not intended to be, fully decoded by their white audiences and collaborators or, perhaps, even by themselves. If the New Negro's performance, whether flamboyant or genteel, was but half-seen, half-recognized, and half-understood, at once overexposed and "within the Veil," in Du Bois's phrase, this also ensured that black performance would be transmitted to the larger culture and absorbed by it in a state both incomplete, even mutilated, and strangely, potently, intact. And the black performance *was* transmitted to the larger culture, by the new mass media.

Amos 'n' Andy, the most successful radio show in American entertainment history, which premiered on Chicago's WMAQ station in 1926 (moving to NBC in 1929) and starred the white vaudevillians Freeman Gosden and Charles Correll, was an updated minstrel show that apparently borrowed its style from *Shuffle Along*'s black librettist-comedians, Flournoy Miller and Aubrey Lyles; Miller wrote some of its dialogue in the 1930s and after. By the late 1920s, black musicians could be heard on the major networks and recording labels. Negroes might not have their hands on the controls of media culture, but a significant portion of what Rourke called "American Humor," some of what Mencken dubbed the "American Language," and almost all the new "jazz" music—in other words, the mainstay content of the radio and record industries—were Negro in origin.

Much of the intellectual, economic, and cultural history of the United States I will be discussing in the next few chapters is a history of white Euro-America; it took place largely outside the arenas in which blacks had some share of visibility. Still, America's takeoff in the years after the Great War changed black history as decisively as it changed white. America's economic boom, stoked by the war, opened thousands of new jobs in the industrial North to unskilled black labor and transformed black Americans from a rural people to an urban one; the new city-based mass media gave black culture for the first time in its history the means of wide reproduction and accurate transmission. If the New Negro's goal was to shape "a more compelling and powerful image in American popular culture," in the words of the African-American critic Gerald Early, he succeeded, briefly but irrevocably; cultural power, even if conscribed and only partially acknowledged, coming to a people who had long been denied it, who had been robbed of credit for

shaping America's expression, spelled an access of energy and authority as forceful and intoxicating as any that white Americans experienced in the modern urban era. As Bessie Smith, a black woman from a Southern slum to whom singing the blues brought fame and fortune, put it on her debut record of 1923, "Down Hearted Blues": "Got the world in a jug, got the stopper in my hand."

≡≡≡

OFFSTAGE INFLUENCES:
FREUD, JAMES, AND STEIN

OUTSIDE INSIDERS

After doing a stint in Europe as a soldier in the Great War, Hemingway planned to get a job as a reporter in New York. Although he went to Chicago and then Paris instead, his New York ties were critical to his career. As a novice author, he tried again and again to crack the big metropolitan magazines, especially the Philadelphia stronghold of his friend Scott Fitzgerald, *The Saturday Evening Post.* Like his urban peers, Hemingway aimed to be praised by "highbrows" and read by everyone with a "high school education" (he did not attend college himself); he never intended to be confined to the honorific but unpublicized small-circulation "little magazines" that provided the only outlet for his early stories and poems. He broke into the commercial realm in 1925 when Horace Liveright published his first book, *In Our Time,* but Fitzgerald, with characteristic generosity, had already brought him to the attention of his own editor, the soon-to-be-legendary Maxwell Perkins; Hemingway broke with Liveright and moved to the better established and still more prestigious firm of Charles Scribner. In 1926, Scribner's brought out his first full-length novel, *The Sun Also Rises,* which became a bestseller; his short fiction began appearing in *Scribner's Magazine, The Atlantic Monthly,* and (a bit later) *Cosmopolitan.* He remained a Scribner's author, and a best-selling one, until his suicide in 1961.

Living in Paris in the 1920s, Hemingway was hardly cut off from America or New York; Paris was awash with Americans and a hotbed of enthusiasm for things American. In 1924, Paris had 32,000 permanent American residents; July alone brought 12,000 American tourists. There were two American movie theaters and a number of American Negro jazz performers, in addition to Josephine Baker, who were star attractions of Parisian nightlife.

American cigarettes were advertised in French newspapers and available everywhere in shops, and all the big New York papers had flourishing Paris editions. Harold Stearns, who took up residence in Paris shortly after finishing *Civilization in the United States*, observed, "You could have sworn you were only in a transplanted Greenwich Village . . . except for the fact [that] some people stubbornly persisted in talking French." Paris represented not just a distinctively European milieu but select American and New York materials in a foreign setting; expatriates like Hemingway found there the place to assimilate and express overwhelmingly powerful contemporary material they had been confronted with elsewhere. In the words of Van Wyck Brooks, " 'Discovering' or 'rediscovering' America might have been called their métier."

Many of Hemingway's friends were long-term or temporary New Yorkers; the list includes Robert Benchley, Harold Loeb, Charles MacArthur, Donald Ogden Stewart, Dorothy Parker, and John Dos Passos, as well as F. Scott Fitzgerald and Max Perkins. He met most of these people while living in Paris; Paris allowed him instant access to New York's all-powerful literary establishment. Loeb and Stewart, both Parisian acquaintances, served as unpaid agents, securing and negotiating the Liveright contract for him in 1925, just as Fitzgerald, whom he also met in Paris, did his advance work at Scribner's. In any case, Hemingway was shrewd enough to realize that Paris could showcase his talents in a way that New York might not. Fitzgerald, then at the peak of his popularity, had preempted New York as his special city, his trademark audience; pathologically competitive, Hemingway preferred fighting for trophies he was sure he could win. His capture of Paris, which he showed off to the untraveled Fitzgerald in the early days of their friendship, and his subsequent usurpation of Scott's place in the expatriate circle of the Gerald Murphys, evened the score.

It was characteristic of Hemingway's complicated and obsessive relationship with New York that he prefaced his most important statement about his own artistic hopes and fears, in *Green Hills of Africa* (1935), with a denunciation of "writers in New York" as "angleworms in a bottle, trying to derive knowledge and nourishment from their own contact," all "afraid to be alone." Hemingway posed as the only serious artist among the popular modernists, a living and self-congratulatory reproach to the uneasy New York literary conscience; he could and did rule the American metropolis more effectively at a distance.

In the first flush of his infatuation with Hemingway in the fall of 1925, Fitzgerald put Mencken on notice that Hemingway was "doing rather more thinking and writing than the young men around New York," and penned an homage entitled "How to Waste Material—A Note on My Generation,"

a review of *In Our Time* published in the May 1926 issue of *The Bookman*. Comparing the spare eloquence of Hemingway's art to the "spendthrift" ways of his contemporaries, Fitzgerald presented him as a kind of redeemer offering a "renewal of excitement" to those willing to read "these stories in which Ernest Hemingway turns a corner into the street." Dorothy Parker found in Hemingway's contempt for New York the key to his sex appeal and praised his "grace under pressure" in several abjectly adulating reviews. Her last words on her deathbed in New York in 1967 were a query: "Did Ernest really like me?" Needless to say, he didn't. Many others on the New York scene also defined themselves in the light of Hemingway's example, and the New York influence was, whatever his disclaimers, a mutual one.

James Mellow, one of Hemingway's recent biographers, has convincingly argued that Hemingway feared New York more than he disdained it; it represented his darker side, his affinities with homosexuality, dissolution, and failure, aspects of himself he wanted to write about, not live. Either way, he was anything but immune to the city's fascination. On a three-week visit in 1926, he pronounced New York "a damned beautiful place" and spent his time "cock-eyed" in the company of Parker, Elinor Wylie, and a host of others in the smart set. He jestingly instructed a friend to "deny rumors that I was in New York. It was some impostor," but it wasn't. A man whose compulsive need for companionship matched that of any of the New York writers he scorned, whose most frequent request in the letters with which he bombarded friends was to "write me all the dirt," who kept up with the work of Benchley, Stewart, MacArthur, Thurber, Parker, and Hecht as well as Fitzgerald, Dos Passos, and Wilson, who wrote one play (*The Fifth Column*) and took on a series of offstage dramatic roles (writer, big-game hunter, modern warrior, matador, boozer, lover, and mankind's "Papa"), roles that gradually preempted what offstage life he had—such a writer had at least as much in common with New York as he did with Chicago or Paris.

When Hemingway substituted for Ford Madox Ford in the summer of 1924 as Paris editor of *The Transatlantic Review*, he at once changed the magazine's orientation from Anglo-European to New York–American, publishing three stories by Donald Ogden Stewart and one by Ring Lardner. A few years later, he modeled the witty and attractive character Bill Gorton, in *The Sun Also Rises*, on Stewart. Fitzgerald and others noted the resemblances between Hemingway's laconic stories and Lardner's characteristic style—in high school, Hemingway had occasionally signed his work "Ring Lardner, Jr." He picked "Robert E. Benchley" as his code name when he and his then mistress, Pauline Pfeiffer, were exchanging secret love letters as his first marriage was dissolving in 1926, and he later praised Thurber as the best writer in America. He had allies in black Manhattan as well. Wallace

Thurman believed that "Hemingway exemplified the spirit of the twenties more than any other contemporary American." Claude McKay professed a "vast admiration" for the stories of *In Our Time*, finding them as "brutal and bloody as life," and Parker detected traces of the Hemingway manner in McKay's novel *Home to Harlem*. Hemingway idolized the black *Follies* star Bert Williams and absorbed the blues-and-jazz sensibility he discovered in Chicago's racially mixed nightclubs in the early 1920s into his own back-to-basics style. His chosen nonwhites were the Indians he'd known firsthand in his boyhood summers in the wilds of Michigan, but blacks appear insistently if sporadically throughout his early fiction and poetry; he, too, saw the American character as a mongrel one.

Hemingway saved his highest praise for Walter Winchell, the gossip columnist who had grown up on New York's poorest, dirtiest streets and vaudeville stages and considered himself the "New Yorkiest" (a Winchellism) person around; "Broadway bred me, Broadway fed me, / Broadway's where I want to die" was his way of putting it. Winchell claimed to have invented the "low blow," and over the years more and more of Hemingway's friends testified that he specialized in low blows himself; he saluted Winchell as a "terrific little pro, a rough-house artist, maybe the only newspaperman in the world who could last three rounds with the zeitgeist." Hemingway began his career as a newspaperman, too, in 1917, in tough and unruly Kansas City, another enclave of black culture; and the persona of the big-city reporter—a "casual figure," in Ben Hecht's phrase, "full of anonymous power," facing a polyglot underworld of gangsters and immigrants and protected only by his capacity for tough talk and hard thought—was one that Hemingway elaborated and expanded but never outgrew. It makes sense that his impact on the urban genres of crime and violence, whether in fiction or film, was greater than that of any other American writer. Hemingway experienced modern life as combat, as an affair of danger, bravado, wit, and stoicism.

T. S. Eliot was a far more radical expatriate than Hemingway. While Hemingway returned to America in the late 1920s to live in Key West, Florida, Eliot, once settled in London in the years just before the Great War, never again lived in the United States, though he had important interests in America and New York. As an editor at the English publishing house of Faber & Faber and a critic who presided over the pages of the prestigious *Criterion* review, Eliot followed and encouraged the careers of a number of New York's most gifted avant-garde writers, publishing Djuna Barnes's novel *Nightwood* with a laudatory introduction in 1937 and writing a glowing foreword for the *Collected Poems* of Marianne Moore in 1939. But his highbrow connections don't tell the full story. Eliot was a shrewd

operator on the literary scene, and in his own way he wanted to make it big as much as Hemingway did. Always more concerned to "convince people that I know how to write a popular play" than to be celebrated as the difficult poet of *The Waste Land*, he eventually achieved his goal with *The Cocktail Party*, which premiered in January 1950, not on London's West End, but on Broadway. *Time* magazine put him on the cover in March and autograph hunters besieged him everywhere he went.

A practitioner of no mean skill in the broad and fast idiom of city life himself, Eliot was a long-time fan of New York's most famous vaudevillians, the Marx Brothers, particularly Groucho. The two men corresponded for years and finally met in 1964; Groucho had boned up on *The Waste Land* to please his "celebrated pen pal," but Eliot preferred to talk on more Marxian topics. He also admired Thurber, to whom he wrote fan letters and sent clippings of absurd news stories—one was headlined "TWO BITTEN BY APE" —that he thought were "Thurber items." No one did more to establish the new boundaries between elite and popular art than Eliot did, and few transgressed them as freely.

English contemporaries like Wyndham Lewis and Clive Bell saw *The Waste Land* as a form of "jazz," and the comparison bespeaks not only a loose use of the word but an important cultural connection. Eliot's hometown, St. Louis, with its large black population and rich Negro musical culture, was in many ways a Southern metropolis, and the young Eliot described his own accent as that of a "a Southern boy with a nigger drawl." Some nicknamed him "Possum"; he once signed himself (on a postcard to Ezra Pound) "Tar Baby." Like George Thatcher in Baltimore a half century earlier, Tom Eliot had dreamed of donning darker guises, of shaping his image by the blackface in the mirror, and he experimented with minstrel personae and language as he was perfecting his craft in the years after the Great War. Insisting that his poetic instrument was not the lute, with its classical and romantic connotations, but the jazz-harmonica of African-American music, he repudiated the genteel singing of the vapid women songstresses of the late Victorian era for the stronger fare of Negroes with bared teeth and wide smiles . . . "That's the stuff!" The "Sweeney" fragments, written in the early 1920s, included a song, performed by the minstrel characters Tambo and Bones, that was a free version of "Under the Bamboo Tree," a "coon song" by the black songwriters J. Rosamund and James Weldon Johnson, and a big hit in Eliot's boyhood years.

Eliot did not publish any work by African Americans in *The Criterion*, and he deliberately lost his "nigger drawl" and even his American accent in his years at Harvard and abroad; he adopted the ultra-formal initialed version of his name—"Tom Eliot" became "T. S. Eliot"—sometime around 1916.

But the vividly indigenous language and sartorially splendid personae of the Zip Coons and Jim Crows of minstrel and variety theatrical shows, entertainment that Eliot loved in its various permutations throughout his long life, form one of the chief, if seldom detected, strains in his poetic achievement.

Like the minstrel artists he'd seen as a boy in St. Louis, like the New York writers he admired in his adulthood, Eliot found much of his art in his wit and flair for parody. In the marginalia of his own revered and influential critical essays, he was apt to pencil a dismissive word or two: "double talk," "coo!" The dauntingly learned footnotes he appended to *The Waste Land* featured citations in Latin, Italian, French, and German that sent critics scurrying into vast and pretentious research forays, but Eliot candidly described them as "a remarkable composition of bogus scholarship." His famed difficulty as a poet did not stem solely from his erudition; he was at least as notable for the skill with which he used his learning to consolidate his authority as for the learning itself. He cautioned a friend to cut what he appeared to know by half, not to confuse, in other words, a smart PR move with the real thing. Edmund Wilson for one saw that Eliot's impeccable ear for conversational language and his brilliantly dramatic sense of timing kept him readable, no matter how recherché his allusions, quotations, and symbols might be.

Eliot was difficult to read in much the same way as the art of black Manhattan was hard to interpret: he, too, was a supreme trickster, and he had a habit of playing comically ironic roles, of making jokes that he himself, by his various learned and solemn critical dicta, had rendered many devoted readers incapable of getting. But not all his readers in New York. Parker mocked the overallusive Eliotian style of "bogus scholarship" in her sketch "The Little Hours," the irritated monologue of an insomniac unable to remember in their complete form the "quotations beautiful from minds profound" that might send *her*, whatever effect they had on an elite mind like Eliot's, to sleep. Thurber presented E. B. White with a series of cartoons entitled "La Flamme and Mr. Prufrock" on the occasion of White's marriage to *New Yorker* editor Katharine Angell in November 1929. (The strong-minded Angell had a touch of the Titaness; she occasionally referred to herself as a "matriarch," and others called her "Mother Superior.") Thurber and White were preoccupied with just the comedy of masculine embarrassment played out before the eyes of intimidating women, the awkward and self-conscious rites of passage of the male manqué, that forms the theme of "J. Alfred Prufrock."

By and large, however, Eliot and his work were treated as a serious affair. Elinor Wylie, one of his followers and rivals, reviewed *The Waste Land*

reverentially and astutely for *The New Yorker* in 1923; Louise Bogan kept a picture of Eliot on the wall of her study. Marianne Moore introduced him to her mother and brother—a signal honor in her family-centered life—and admired him above all his contemporaries. Robert Sherwood announced that his own play *Reunion in Vienna* (1931) was an exposition of Eliot's poem "The Hollow Men" (1925). Later, in the 1940s, the New York critic Delmore Schwartz described Eliot as the "Literary Dictator" of modernism, but other still more imposing titles had already been bestowed on him. His English friend Mary Trevelyn called him "Pope," and his first wife, the pathologically histrionic Vivienne, once explained her submission to her husband by remarking: "One does not argue with God or question his ways." Vivienne's submission, alas, was not complete enough, and Eliot consigned her to an insane asylum in 1933. She spent the rest of her unhappy life trying in vain to re-establish contact and fantasizing his return.

Eliot's city was London, of course, but *The Waste Land*, an inclusive meditation on the modern metropolis as "Nekropolis," had obvious resonances in New York circles. Fitzgerald described *The Great Gatsby* as a tale " 'of New York life' or 'modern society,' " and the name "T. J. Eckleberg," the austere ironic billboard figure who presides over a wasteland of ashes and is mistaken for God by the demented and homicidal George Wilson, is a play on the name "T. S. Eliot." Fitzgerald sent Eliot a copy of *The Great Gatsby* inscribed to the "Greatest of Living Poets from his entheusiastic [sic] admirer" (spelling was never his long suit). Eliot in turn praised the novel as "the first step American fiction has taken since Henry James," and later tried to get the English rights to *Tender Is the Night* for Faber & Faber. Fitzgerald read *The Waste Land* aloud to its visibly pleased author when the two met in Baltimore in the early 1930s and included it in a course on the world's greatest books that he designed for his Hollywood lover, Sheilah Graham, a few years later.

Hemingway's response to Eliot's implacably growing importance was an unstable mix of hostility and homage. On one occasion in 1924, he offered to "grind Mr. Eliot into a fine dry powder"; on another, he openly borrowed a key Eliot allusion for the title of his short story "In Another Country" (1927). The story details a soldier's crack-up under the pressures of the Great War, and its themes have much in common with those of that "nerves monologue" *The Waste Land*, composed in the midst of Eliot's own nervous collapse in 1921. The phrase "in another country" is from Marlowe's *Jew of Malta* ("Thou has committed— / Fornication, but that was in another country, / And besides, the wench is dead"), and Eliot had used it as the epigraph for his early poem "Portrait of a Lady" (1917). Hemingway always recognized a competitor for his own turf. If not Pope or God, Eliot was to

New York circles a kind of lay bishop bearing vestiges of ecclesiastical authority into an uneasily secular age. Together Eliot and Hemingway set the tone of metropolitan modernism as one of complex, witty, and theologically laced disillusion played out in no-man's-land.

Neither Eliot nor Hemingway was as important to the urban moderns, however, as three writers and thinkers clearly separate from the New York scene in both space and time: Sigmund Freud and his two most important American rivals and critics, the philosopher and psychologist William James, based in Cambridge, Massachusetts, and James's student, the expatriate American writer Gertrude Stein, based in Paris. All three were much older than the New Yorkers of the 1920s (James was born in 1842, Freud in 1856, Stein in 1874), but they debated and determined the chances of psychological and cultural survival and gave the metropolitan moderns weapons for the struggle; all three played a part in the development of black and white culture in metropolitan America.

Freud's relevance to the black moderns might have been less than to the white ones, but his quasi-anthropological equation of the "primitive mind" and the "savage" with the unconscious and the id helped to shape the New Negro's creative possibilities. Langston Hughes pledging that he was like "that old mule— / Black and don't give a damn!," Jean Toomer describing the black spirit pressing against the white as "symbolic of the subconscious penetration of the conscious mind," Zora Neale Hurston explaining that in Negro speech "Everything is acted out. Unconsciously for the most part of course"—all these writers were working within a Freudian perception of the Negro's psychological positioning and cultural role. When Freud prophesied in his "Thoughts for the Times on War and Death" (1915) that the cataclysm that was the Great War would strip away the superimpositions of "cultural hypocrisy" and let "the primaeval man within us into the light," he was unawares predicting the Harlem Renaissance and the world of 1920s New York, in which, as Cole Porter put it, "Black's white today . . . / Anything goes!"

As for William James, he was a seminal influence on W.E.B. Du Bois, who studied with him at Harvard in the 1890s. In his memoir *Dusk of Dawn* (1940), Du Bois wrote that his determination to "probe for truth . . . landed me squarely in the arms of William James . . . for which God be praised." His talk of being in James's arms was not altogether metaphorical. Cambridge was strictly segregated during his years there, Du Bois tells us, but "I was repeatedly a guest in the house of William James, my guide to clear thinking" and "my friend." James read Du Bois's *The Souls of Black Folk* in 1903 and passed it on to his brother the novelist Henry James as "a decidedly moving book." Henry believed it "the only 'Southern' book of any distinction pub-

lished in many a year." William did not grasp Du Bois's full distinction or significance—he described him to Henry merely as "a mulatto ex-student of mine"—and he did not devote himself to civil rights or to the study of Negro culture, but he was quick to detect, and to condemn, the increasingly racist cast of American thought and activity around the turn of the century. He found the idea of the "white man's burden" a mere cover-up for imperialist greed, an excuse for "impos[ing] our order" on those unable to defend themselves, and an index of the bankruptcy of so-called modern civilization. An early, fierce, and outspoken opponent of the "epidemic" of lynching in the South and North at that time, he thought that lynchers, including the "leading citizens" involved, should be hanged. The lynching of Negroes, the colonization and extirpation of the world's darker peoples—these were anathema to one who had built his thought on a passionate belief in diversity and openmindedness; as his student Walter Lippmann put it, James "would listen for truth from anybody."

James once confided, "I daily pray *not* to grow in discrimination and to be suffered to aim at superficial pleasures," a comment on his brother Henry's elaborate and difficult prose style; it might be said that he laid the philosophical basis for the American preference for popular culture over elite and self-consciously difficult art, for the choice of culture over politics that gave the Harlem Renaissance its point of origin. His notion of American culture as a plural and heterogeneous affair of simultaneous affects, collaboratively improvised out of what he called "the will to personate," was a viewpoint congenial to black aims and achievements; what the syncopated black ragtime music of the 1890s and 1900s was to Euro-American classical music, the quicksilver and irregular Jamesian discourse was to traditional Western thought. And it is notable that the three white New York writers of the 1920s most profoundly engaged with notions of "other" Americans," with the American identity as a complex tissue of ethnic, racial, and cultural difference—namely Gilbert Seldes, Constance Rourke, and Marianne Moore—were all openly indebted to him. He would not, I think, have been unhappy to learn that the results of his pragmatic method as the moderns played it out were more radical than his own; James staked everything on the likelihood of the unexpected hypothesis or conclusion turning up where it was needed, if not wanted.

Gertrude Stein, too, like Du Bois was indebted to James, who had been her teacher at Harvard in the 1890s. Though, like James, she was not free of racial bias, she disavowed as he did the idea of "the white man's burden"; blacks were crucial to her artistic enterprise. Her first published work, *Three Lives* (1909), three tales of American working-class women, included the tragedy of a troubled mulatto woman called Melanctha; in an unpublished letter of 1906, she ruefully remarked, "I have to content myself with niggers

and servant girls and the foreign population generally." But she also claimed that *Three Lives* was "revolutionary," the first "modern" literary work, and indeed it was the first work of serious American fiction to break entirely with the conventions of the nineteenth-century novel and its confinement to white middle-class people and problems. James Weldon Johnson pronounced "Melanctha" a "marvelous" work; he was pleased that Stein treated blacks without fuss, as "normal members of the human family." He had read "Melanctha" at Carl Van Vechten's urging. Van Vechten, the self-appointed champion of black Manhattan, was Stein's most dedicated American supporter.

For her opera, *Four Saints in Three Acts*, with music by Virgil Thomson, a smash hit in New York in 1934, Stein went with an all-black cast of singers and actors. What was revolutionary about this move was that Stein's protagonists were written as white; she was not, in other words, casting black players for black parts, as O'Neill had done in *The Emperor Jones* in 1920, and as Gershwin did in *Porgy and Bess* in 1935, but using black performers for "white" parts on the simple grounds that, in Thomson's educated opinion, they would do a better job with his music and her words than white performers could. The Negro cast of *Four Saints* was, everyone agreed, magnificent; the black actors loved Stein's audaciously wide-eyed language and they could be heard offstage, according to Thomson, speaking to one another in quotations from her script.

As surely as the New Yorkers, black and white, I have already mentioned, James, Stein, and Freud were early exponents and exemplars of varying forms of wit, drama, and role-playing, and they played out among themselves the debate between what I have been describing as white theology and the black religious sensibility, between Euro-American cultural pessimism and Aframerican cultural optimism, between dogma and experience, between privatized and communal expression. They were conflicting referees sparking and monitoring the modern struggle for self-definition, and all three had strong if not always acknowledged ties to the American modern scene in general and to New York in particular.

NEW YORK TIES

James died in 1910, but he was nonetheless part of the American avant-garde he did not live to see in full flower. On May 29, 1910, he wrote to his daughter, only half in jest: "I wish translators would let my works alone—they are written for my own people exclusively!" He thought of his psychology and philosophy as uniquely American, and Stein agreed. She also claimed James, not as her mentor—she saw herself as above or outside

such an obvious pattern of influence—but as one of those she liked to designate as her "forerunners." Why? Because he was the only nineteenth-century writer who was so "American" that he "felt the method of the twentieth century." To be American, Stein's logic went, is to be modern, irrespective of dates; the more American, the more modern. She proved her point by effortlessly adapting and incorporating James into her own experimental art. As George Santayana, another of James's pupils at Harvard, put it, James was the first American to break with the "Genteel Tradition" of the Anglophile Victorian era, the man who embodied all that was "new" to the world, all that was "ultra-modern," "radical," and even "shocking" in American culture. He represented "the true America."

That America was urban. Born in New York City in 1842, James spent most of his formative years, 1847–55, there. And though as a young man he made extensive visits to Europe and eventually settled happily as a professor of philosophy and psychology at Harvard University, he remained in some sense a New Yorker by temperament. In the city on February 14, 1907, he spoke of having

> caught the pulse of the machine [of New York], took up the rhythm, and vibrated mit [with it] and found it simply magnificent. The courage, the heaven-scaling audacity of it all, and the *lightness* withal, as if there was nothing that was not easy, and the great pulses and bounds of progress so many in directions all simultaneous that the co-ordination is indefinitely future, give a kind of *drumming background* of life . . . I'm sure that once *in* that movement and at home all other places would seem insipid.

In James's telling, New York was the incarnation of his own vitalist and buoyant discourse, a complete epistemology of curiosity, motion, and experimentation. Several decades after James's visit, E. B. White would explain New York's appeal by remarking: "Everything is optional." Options and the autonomy they make possible were James's stock-in-trade.

If America's other most renowned thinker, the eighteenth-century Calvinist theologian Jonathan Edwards, was an expression of "the New England Mind," James was the exponent of the New York style, of its mood and tempo. Dashiell Hammett, who wrote his famous detective novels while living in New York in the late 1920s and early 1930s, thought that "tempo" meant "not how things are remembered" but "how things happen"; tempo is about simultaneity, not sequence, about the nerves and the will rather than the intellect. James found the harsh and analytic Calvinist theology of which Edwards was the greatest practitioner, a theology that formed the backbone of New England life, utterly repugnant, a "metaphysical monster";

he devoted a lifetime to freeing its prisoners. The real greatness of America, in James's view, is its "energy" and its "light." Boston and New England are the past; New York, the present and the future.

When Stein became James's student at Harvard in the mid-1890s, the two at once admired and appreciated each other; they continued to do so until their respective deaths in 1910 and 1946. Stein, who thought that *Three Lives* owed much to James, sent him an inscribed copy in 1909, and he responded to the opening pages enthusiastically. "Gertrude Stein is great!" he wrote her. There were important differences between them, of course, but it is their shared, very American, complex cultural optimism that makes them central to my narrative.

Stein tells two stories about working with James in her *Autobiography of Alice B. Toklas* (1933). Presented with the final exam in James's psychology course, Stein decided not to write it; it was, after all, "a lovely spring day." She left the examination hall with a calmly outrageous note of explanation for James penciled in her blank exam book: "I am so sorry but I really do not feel a bit like an examination today." James responded with a postcard —"Dear Miss Stein, I understand perfectly how you feel[.] I often feel like that myself"—and gave her the highest grade in the class. On another occasion, a male student doing an experiment that was designed to explore "subconscious" reactions explained to James that his results were off because one of the subjects he studied showed no subconscious reactions at all. When the student added that the subject was Gertrude Stein, James at once replied: "If Miss Stein gave no response I should say it was . . . normal."

One cannot be sure if these incidents took place exactly as Stein recounted them—she was, after all, intent on establishing her own credentials as James's heir and peer—but they have the ring of truth. James and Stein seem to be running on shared insights, improvising a collaboration. There is in both an instinctive reliance on the conscious life to express and to modify the unconscious one, a trust that what shows up in the light is more important than what may remain hidden in the dark, an implicit insistence that some things are unanalyzable and must simply be believed or disbelieved. Both are quick to privilege a certain kind of feminine intelligence over the note-taking masculine mind, and they are wonderfully willing to drop the rules at the call of experience. Clearly aficionados of James's "will to personate," they fall happily into free performance style. Each adopts a kind of persona or role that highlights a specially American and comic blend of publicity smarts and imperviousness to public response, of intellectual adventurousness and emotional conservatism; they share the knack of delivering a bold insight in the tone usually reserved for an obvious truth, for turning the startlingly new into the comfortably familiar and transforming a competitive situation

into a sheerly stimulating one that exempts the participant from its conflicts but not from its benefits. Both have a gift for transforming possible failure into fresh beginnings.

After studying with James, Stein took some graduate courses in psychology and women's nervous disorders at Johns Hopkins, then went to live in Paris with her adored older brother Leo; together they began to collect the work of Picasso and Matisse. Within the next few years, she broke with Leo, found her "wife," Alice B. Toklas, and established herself in her home at 27, rue de Fleurus as hostess and confidante to the most exciting writers and artists of the day. Never one to underestimate her own importance or the comic efficacy of an outlandish pose, Stein asserted that she had "killed" the nineteenth century much as a "gangster" takes out his victim; she *was*, she said, the twentieth century. She met many American artists during their trips to Paris—Hemingway, the Fitzgeralds, Crane, Anderson, Robeson, and Van Vechten, among others. Even those who stayed at home might read her work in New York's *Vanity Fair*; the magazine branded anyone who disliked her a "philistine." In any case, Stein did not see herself as an expatriate. In her telling, Paris was an outlet for American energies to which America itself could be at times inhospitable. America was her country, she liked to say, Paris her "hometown."

Stein wore her hair pulled back or cropped short, highlighting her direct eyes and strong facial modeling, and she dressed her massive form in simple, rough-textured clothing. Whenever the weather permitted, she went shod in sandals. Some thought Stein's eccentric outfits looked like the habit of a wandering friar, but Hemingway saw her costume as "steerage" wear. His comparison was apt; Stein wrote about the "foreign population" because she belonged to it. Born in Pennsylvania to middle-class German Jewish immigrant parents in 1874, she spent her first four years living in Vienna, speaking German. English was a second language for her, and it fascinated her as only an idiom that is appropriated, not inherited, can do. In addition to the black protagonist Melanctha, the stories in *Three Lives* featured two working-class German immigrant women, and the clumsy, simple yet eloquent language Stein used to tell their tales can best be described as a deliberate free reworking of an immigrant's version, a minority group's translation, of the Anglo-American language. Stein's sense of what happens to a language, what it sounds and feels like as one learns it, as one approaches it from the viewpoint of another language and culture, was the basis for her famed style. Fitzgerald loved her "great stone face," and her huge frame reminded him of an "old covered wagon"; she was a pioneer both literally and figuratively speaking.

Three Lives found no publisher and Stein had the book privately printed.

But, like Hemingway and Eliot, she hungered for a mass-market audience. *Vanity Fair* was all very well, but she, too, wanted to be courted by the big American magazines and published by a major New York firm. She got her wish in 1933 when *The Atlantic Monthly* serialized *The Autobiography of Alice B. Toklas*, a memoir of her early Paris years; Harcourt Brace published it a year later, and it became a best-seller. *Time* magazine put her on its cover, and she made a triumphant lecture tour of America. Disembarking in New York, Stein was at first "upset," then delighted, by the city's bright lights and skyscrapers and noisy crowds. An advertising campaign about her book had preceded her visit, and countless friendly New Yorkers now recognized her and wanted to shake hands and say hello. Stein once described Mary Wilkin Freeman's *Pembroke* (1894), a novel about the repression and loneliness of New England life, as "soul-sickness"; New York's easygoing and democratic ways were her own. An unrivaled if inventive oral historian, she was famous for engaging in long chats with passing strangers who might then turn up as friends on her pages, and she used the pronouns "I" and "everybody" as synonyms; her second memoir, a sequel to *Alice B. Toklas*, was titled *Everybody's Autobiography* (1937).

Stein was on friendly terms with the new American technology of mass culture. When she arrived in New York, Macy's department store, charmed by the brash ring of her *Four Saints in Three Acts*, was advertising its fall collection as "Four Suits in Three Acts," and the electric message running around the *New York Times* building in Times Square read: "Gertrude Stein has arrived in New York, Gertrude Stein has arrived in New York," *ad infinitum*. Stein had built her art, the description of what she called "the continuous present" apparent in her much-quoted line "A rose is a rose is a rose," on just this endless repetition of the average, a trick fast becoming cultural law. *Alice B. Toklas* was full of Stein's exploits in her Ford car, purchased in Paris during the Great War, and she knew her writing had much in common not only with the "serial" form of American movies and the "funny papers," but with Henry Ford's assembly lines; the "continuous present," she explained in *Everybody's Autobiography*, is "a beginning again and again, the way they do in making automobiles." Stein flew for the first time during her American trip; she found airplane travel a source of excitement and curiosity, confirmation once again of her own artistic presuppositions. The world from a plane window looked much like the Cubist paintings she had discovered in the 1900s as the best model for her own prose style. A devotee of what might be called uncritical mass, Stein realized on her first flight that "the air is solid."

Photojournalists followed Stein around on her American tour, and she was in her element in this kind of nonstop, off-the-cuff, on-the-cuff media

attention. But when they wanted to catch her "doing" something in her hotel room, she had to pause. Alice did the real work of their ménage, she explained. Unpacking, cooking, cleaning, even typing Stein's manuscripts —these were all Alice's jobs. Finally, with calm aplomb, she drank a glass of water as they snapped her picture. If some feared the passivity, the "let us do the work for you" spirit that the new mass culture of the day conveyed, she did not. "Martyrs" have to do things, Stein said; "a really good saint does nothing."

Visiting Mabel Dodge Luhan, the American writer and trendsetter, in Italy in 1912, Stein had fallen in love with the miniature alabaster fountains with doves perched on the brink that were mass-produced there as mementoes for tourists; their cheapness and expendability were part of the attraction, for she had a "weakness" for "breakable objects," she noted in *Alice B. Toklas*, and "a horror of people who collect only unbreakable objects." The endlessly reassuring promise of the mass arts that there is always more, and more of the same, found in her its best advocate. "Comfort" was one of her favorite words, and she believed that "there is no pleasure like the spending of money." On her deathbed, she told her doctor: "I was not made to suffer." Immediate gratification was at the root of Stein's persona and art.

In her earliest narrative, the autobiographical *Q.E.D.* of 1903 (not published until 1950), Stein described the unhappy time of her first love affair, whose painful end came in England under London's "smoke-laden" sky with its "dreary weight of hopeless oppression." Filled with "homesickness," Stein's character Adele (a stand-in for Stein herself) flees from England back to America, and New York; "a hopeful spirit resists," Stein wrote. Once in New York, Adele "rejoiced in the New York streets, in the long spindling legs of the elevated, in the straight high undecorated houses . . . It was clean and strict and meager and hard and white and high." What *Q.E.D.* does not tell us is the crucial fact that Stein had begun her career as a writer when she visited New York in 1903; the book was written in a borrowed apartment on Riverside Drive.

Freud came to America only once, in 1909, to deliver a series of lectures on psychoanalysis at Clark University in Worcester, Massachusetts, yet his influence on Americans was incalculably great; the only authority that white American writers seemed to allude to more frequently was the Bible, whose Old Testament was of paramount importance to Freud as well. Freud is not the hero of my book, but he is its most inescapable presence, the would-be critic, line prompter, and dictatorial director of the drama it describes. Born in 1856, he had an extraordinarily long and productive life (he died at the age of eighty-three in 1939); his thinking developed and redefined its premises

as radically between 1913 and 1920, crucial years for the literary and psychological formation of my subjects, as it did between 1897 and 1905, his first great period of discovery. The headline for a review essay about him by Joseph Wood Krutch in *The New York Times* on May 9, 1926, read: "FREUD REACHES 70 STILL HARD AT WORK." He was a participant as well as an authority on the modern scene.

The full flood of Freudianization did not hit America until the late 1930s, but as early as 1918 the Chicago *Daily News* was referring to Freud as "the world-renowned father of psychoanalysis." The movie star Colleen Moore could be seen reading a book by Freud in *Flaming Youth* (1923), the film that packaged "the flapper" for a mass audience. More surprising, she did, in fact, read books by Freud; so did her friend Louise Brooks. In 1925, Samuel Goldwyn offered Freud $100,000 to write a "love story" for his studio. Who better than Freud with his knowledge (in Goldwyn's words) of "emotional motivations and suppressed desires" for such a task? *The New York Times* featured this offer, and on January 24, 1925, reported its outcome: "FREUD REBUFFS GOLDWYN / Viennese Psychoanalyst Is Not Interested In Motion Picture Offer." He had not always been able to afford being so standoffish.

After the long ordeal of the Great War, the Viennese were bankrupt, and Freud was asking to be paid by his patients in potatoes; coal was a luxury, and he worked in a "bitterly cold room," "tired" and "corroded by impotent rage." Help came from his British associates and patients, but most of all from the hundreds of affluent Americans who came yearly to Vienna to be analyzed by Freud or one of his followers. By 1919, 60 percent of Freud's patients were American, and English became the language of his practice. By the time of his death in 1939, *Imago*, the chief journal of psychoanalysis, had been rechristened *American Imago*; it was written in English and based in New York.

At home and abroad, psychoanalysis was developed and practiced largely by urban intellectuals. The modern city, Lewis Mumford and others explained, complicates and psychologizes, even pathologizes, the consciousness of its inhabitants; the city produces both modern pathology and the new science devoted to its alleviation. En route to Worcester in 1909, Freud spent a week visiting New York. Two psychoanalysts, Ernest Jones of Toronto and A. A. Brill, who had emigrated to New York from his native Austria-Hungary, showed him the sights, from the Metropolitan Museum to Coney Island. Although Freud expressed no particular interest in the city, no metropolis anywhere took up psychoanalysis so eagerly as New York. The International Psychoanalytic Society established its main American headquarters in New York in the next few years; over the decades its members

proved more loyal to Freud and his teachings than any other group. By the early 1920s, there were about 500 Freudian or quasi-Freudian analysts of reputable and disreputable credentials in New York. Translations of Freud and articles popularizing his ideas poured from New York presses; Horace Liveright brought out English versions of the *General Introduction to Psychoanalysis*, *Beyond the Pleasure Principle*, *Group Psychology and the Analysis of the Ego*, and *The Future of an Illusion*.

Greenwich Villagers often staked out what would be long-term life-style trends for all of America, and now, gripped by what one observer called *"mania psychologica,"* they spent their time in "Freuding parties," "psyching" and probing each other's motives and dreams. Sherwood Anderson (sometimes called the "American Freudian" because of the Oedipal patterns evident in his fiction), looking back on these days in his *Memoirs* (1942), noted that "it was a time when it was well for a man to be somewhat guarded in the remarks he made, [and] what he did with his hands." He published a story about such giveaway gestures, "Hands," in *Winesburg, Ohio* in 1919. The earnest Illinois poet and homeboy Vachel Lindsay found the New York enthusiasm for psychoanalytic ways torture: "I do *not*," he asserted, have "a matriarchal complex!" But who could stop Freudian-minded readers and observers from drawing their own conclusions?

There were quacks like André Triton, who published *Easy Lessons in Psychoanalysis* (1922) and gilded his toenails for the "psychic teas" he held in Greenwich Village for interested women, but by and large the New York response to Freud was deadly serious. Floyd Dell underwent analysis in 1916 to find a clearer direction for "my love life and literary work," and became, by his own confession, "a sort of missionary on the subject." He was one of Edna St. Vincent Millay's lovers at the time; he subjected what he took to be her fear of intimacy to a psychoanalytic critique which he later published in his autobiography, *Homecoming* (1933). When he urged her to go into treatment for her bisexuality, Millay refused, ever hostile to intellectualizing interlopers, and the relationship ended. In a 1922 piece for *The Nation*, the Village poet Maxwell Bodenheim divided contemporary American writing into five psychoanalytic types of sexuality à la Freud with fair precision. The poet and essayist Conrad Aiken began to read Freud's work in the 1910s, and he knew at once that Freud and his followers "were making the most important contribution of the century to the understanding of man."

Freud's influence was visible on Broadway as well. The audiences who flocked to see John Barrymore's superb production of *Hamlet* in 1922 were electrified not only by his genius but also by his self-consciously Freudian interpretation of the role. Freud had done an Oedipal reading of *Hamlet* in

The Interpretation of Dreams in 1900 (translated into English by A. A. Brill in 1913) and Ernest Jones had expanded the master's views in *Hamlet and Oedipus* in 1910; Barrymore, one might say, fleshed out their interpretation. His Hamlet cannot kill his uncle Claudius because he himself wants to do what his uncle has done: like Oedipus, he wants to kill his father and bed his mother. According to Barrymore, Hamlet's "subconscious" was dominated by one thought: "That bastard puts his prick in my mother's cunt every night!" The attractive actress Blanche Yurka, who played Hamlet's mother, Gertrude, was five years younger than Barrymore and they played their scenes together as tormented love scenes. Barrymore's director, Arthur Hopkins, and his set designer, Robert Edmond Jones, were also avowed Freudians. They had collaborated two years before on an unsuccessful but striking staging of *Macbeth* with Lionel Barrymore in the lead, playing Macbeth as a man-child struggling in the Oedipal web spun by the possessive and childless Lady Macbeth amid vast and eerily lit sets designed by Jones to represent "the power of the unconscious." Preparing for *Hamlet*, John Barrymore had extensive conversations with a New York analyst, Smith Ely Jeliffe, who under the aegis of Brill had become a "convinced Freudian" in 1910; he had published three lengthy psychoanalytic critiques of Barrymore's pre-*Hamlet* roles in the *New York Medical Journal*.

Three of Eugene O'Neill's biggest dramatic hits—*Desire Under the Elms* (1924), *Strange Interlude* (1928), and *Mourning Becomes Electra* (1931)—were sexually explicit dramatizations of mother-son attraction, incest, and murder. And they were not the only theatrical productions that showed Freud's influence. Horace Liveright served as financial backer and producer to *Hamlet in Modern Dress*, a transposition of Shakespeare's story to contemporary Rhode Island. The play had a modest run on Broadway in 1925. Freudian insights fueled New York comedy as well. At *The New Yorker*, Thurber, White, and Benchley elaborated psychoanalytic concepts in sketches whose titles carried a mock Freudian ring: White and Thurber's *Is Sex Necessary?*, Benchley's "Why We Laugh or Do We?," "Do Dreams Go by Opposites?," "All Aboard for Dementia Praecox!," "Dream Complexes," "Phobias," and "My Subconscious." A number of Thurber's cartoon captions worked the same vein: "With you I have known peace, Lida, and now you say you're going crazy"; "You said a moment ago that everybody you look at seems to be a rabbit. Now just what do you mean by that, Mrs. Sprague?" Benchley, Thurber, and White collectively created an insecure and nervous male persona that reached its comic apotheosis in Thurber's Walter Mitty (1939), a figure out of a case study: hovering on the edge of psychosis, furtive and apologetically hostile before all things living or (especially) mechanical,

both fascinated and terrified by the dominant women he seems effortlessly to attract. Like Eliot's J. Alfred Prufrock, the Mitty figure was a comic variant of the Oedipal model as surely as Barrymore's Hamlet was a tragic one.

Avowedly Oedipal struggles were turning up in New York courtrooms, too. On February 2, 1924, the New York *World* chronicled "The Long Loveless Ordeal" of a drama critic and novelist named Ludwig Lewisohn, who was divorcing his wife, the writer Mary Bosworth Crocker, for an odd and striking reason. According to the *World*, Lewisohn "alleged that he was twenty-three when he married and that his wife was nineteen years older and was the mother of four children, the eldest of whom . . . is only three years his junior." Crocker's crime was, apparently, her age and the fact that she already had children when she married him; his wife's "moral obliquity" in trying to bind him to her had filled him with "terror and despair," he said, sounding much like Hamlet resisting with fascinated loathing Gertrude's overripe sexuality. Two years later, he published an autobiographical novel called *The Case of Mr. Crump* that specifically dramatized his "ordeal" as that of Oedipus and Hamlet.

On a cruder and less literary note, in April and May 1927 New York journalists and spectators packed a courthouse in Long Island City to watch the trial of an unprepossessing corset salesman named Judd Gray and his lover, a peroxide-blond housewife called Ruth Snyder. No one denied that Gray had helped Snyder to bludgeon her husband, Albert, to death with a sash weight, but his lawyers, Samuel Miller and William Millard, argued that he was suffering from a "mania for martyrdom" and an "inferiority complex." In their view, Gray, who nicknamed Snyder "Momsie," had acted under an Oedipal compulsion to kill the father (Albert in his forties was a decade or more older than his murderers) and marry the mother. He had been "hypnotized" by a "mastermind." Needless to say, Snyder's lawyers, Edgar Hazelton and Dana Wallace, saw things differently. They painted their client as a victim of sexual thralldom right out of Freud's "Taboo of Virginity" (1918), a "hysteric" who was subject to difficult menstrual periods and fainting spells, trapped in a loveless marriage and sexually frigid until awakened for the first time by her "demon lover," and soon a helpless pawn in his hands.

Gray and Snyder were not able to exculpate themselves; each succeeded only in damning the other. Both went to the chair in January 1928; she was the first woman to be electrocuted in New York State. In the memoirs that they and their unnamed ghostwriters penned on death row—Gray's *Doomed Ship* and Snyder's *My Own True Story*—each stayed in his or her Freudian role. Gray's book centers on his adored mother, Snyder's on her troubled sexuality. This is not to say that a Freudian view of them is not the correct

one; my point is rather that lawyers and defendants saw the case and themselves in a Freudian way, that the Freudian discourse, no matter how simplified or distorted, had by the mid-1920s eclipsed the Protestant pieties sovereign in America's official life until then. It had become *the* explanatory discourse, if not of America, then of New York.

For his part, Freud always acknowledged that America had been the first country to welcome psychoanalysis: "ex-communicated" in Europe, he had been "received [in America] by the best as an equal," and American recognition had removed psychoanalysis from the realm of "delusion" and made it "a valuable part of reality." Despite numerous invitations, however, Freud refused to go back to the United States; indeed, he developed a vehement, even obsessional hatred for all things American. Americans might put their seal of approval on psychoanalysis, but they did not and could not understand it, he insisted. Psychoanalysis, he wrote a friend in 1924, "suits Americans [only] as a white shirt suits a raven." America was "a gigantic mistake"; his "suspicion of its aims" was "unconquerable." At the end of his life, in great peril as a Jew in Nazi Vienna, he refused to go to America for refuge, as most of his friends wished him to do. Stubbornly, predictably, he elected to finish his days in England, where his work had been far less influential and he himself far less revered, and he continued to hope that America would secede, or be expelled, from the ranks of psychoanalysis.

Freud saw only the simplifications and distortions Americans wreaked in his "science." In his view, American versions of psychoanalysis were to the Viennese original what mass culture was to elite art, and he was a bitter enemy of the democratic tendencies endemic in the mass arts that America in general and New York in particular hosted. Further, attached as he was to modes of temporal sequence in his science and in his art, Freud gave his allegiance to the print culture which the mass media were threatening to succeed. Whereas James had responded eagerly to New York's promise that "there was nothing that was not easy," whereas Stein loved the effortlessness and abundance created by the new technology of consumer-oriented mass production and saw her own art as its ally and analogue, Freud prized the arts, not of consuming or absorbing, but of mastering the world. He reified productivity and hard, unrelenting work; *"Travailler sans raisonner"* (Don't debate; work!) was his motto. The flow of curiosity by which James and Stein oriented themselves in a fast-modernizing culture was foreign to him. He rebuffed not only Sam Goldwyn's offer but several others like it, avoided the telephone, seldom listened to the radio, and never, so far as we know, went to a movie.

Throughout his studies of what he called "the pathology of cultural communities" and in his voluminous correspondence, Freud seldom missed a

chance to jab at the values, or rather the lack of values, in popular American culture. He hated the "uncultivated public" that put "quantity" above "quality," intellectuals incapable of "living in opposition to the public opinion as we [Europeans] are prepared to do," the insane "rush of American life" with its worship of the "almighty dollar," its "cheap" and "manic" promises of instant gratification, and its "prudish" middlebrow moralizings. Most of all, he detested the blind "optimism," the "noble intentions" and utter disregard of "facts," of those he took to be America's political and religious spokespersons, those siblings in delusion, Woodrow Wilson and Mary Baker Eddy.

In *Thomas Woodrow Wilson*, a book he wrote with William Bullitt in 1930–32 (it was published posthumously, in 1967), Freud explained that Wilson's lofty ideals were nothing but "Christian Science applied to politics," and he scorned the patent simplifications of this worldview: "God is good, illness is evil. Illness contradicts the nature of God. Therefore, since God exists, illness does not exist." Can anything, one can almost hear Freud snort, be sillier, more contemptible than this? Elsewhere he denounced Christian Science's founder, Mary Baker Eddy, as "mad and wicked," a woman gripped by a "lunatic" frenzy. America, in Freud's view, was incapable of being "honest"; it knew nothing of the stern self-denial, the "instinctual renunciation" he considered man's highest achievement. He rejoiced in the Depression, which he hoped would make quick work of the mirage of "American prosperity" and disprove the claim of "pious Americans" to belong to "God's own country." (In other moods, Freud rather thought God and America deserved each other.) The Declaration of Independence might insist that "life, liberty and the pursuit of happiness" are man's "inalienable rights," but, Freud declared, in *Civilization and Its Discontents*, a Spenglerian study of the hopeless paradoxes of Western culture published in 1930, "the intention that men should be happy is not included in the plan of creation."

Freud's relations with his male disciples were notoriously vexed and conflicted; he demanded an obedience few intelligent men could long supply, and, again and again, the issue that dramatized the rupture was America. En route to America in 1909 on a boat called the *George Washington* Freud had a near-falling out with his young Swiss disciple Carl Jung. For the purposes of mutual dream analysis, Jung wanted to know certain details about Freud's personal life which Freud refused to divulge. "I cannot," he told Jung, "risk my authority." But by coming to America and bringing Jung and Ferenczi with him, he already had. Others in the Freudian ranks followed: Otto Rank, Alfred Adler, Theodor Reik, Hans Sachs, Franz Alexander, Helene Deutsch, Erik Erikson, Fritz Wittels, Sandor Rado, and Karen Horney all visited America, and New York, and most of them loved what

they found. Deutsch thought the new skyscrapers "the most beautiful architecture that one can imagine" and telegrammed her son: "AMERICA IMPOSING REALLY NEW WORLD EVERYTHING GIGANTIC MAD TEMPO." What Freud hated as cheap commercialism she saw as the prosperity and energy of a people "striving forward," exciting evidence of "hope" and "sheer life!"

Some of the émigrés lingered in this "really new world" for months, years, decades, and even life. Both Ferenczi and Rank used trips to New York to signal their attempt to break from Freud. Rank, who fell in love with Harlem dancing and occasionally signed his letters "Huck [Finn]," expatriated for good in the 1930s. Jung stayed in Switzerland, but visited America often and found his biggest following and surest funding there. If there were, as Freud claimed, irreparable differences between the new discourse of psychoanalysis and America, most of his followers refused, if not to see them, to condemn them. Freud charged his American patients higher fees than he asked from European patients and gave them less time and attention; Americans had no value, he insisted, except their "dollarei." But those "dollarei" were critical to his still-fledgling discipline. Psychoanalysis might have originated in Vienna, but it was copied and Americanized, then marketed, and marketed on a scale immeasurably greater than Europe could offer, in New York.

RIVAL AUTHORITIES

If Freud was willy-nilly the European founding father or, rather, stepfather of urban American modernism, James and Stein were its very American biological parents, and there were contacts and visible links among the three writers. James came to hear Freud in 1909 at Worcester and the two men later took a walk together to converse further. James was far better known at this time than Freud, and both Ernest Jones and Jung, who were with Freud in Worcester, revered him. Although there is no evidence that Freud had read James's writings on religion—the work that James considered his most valuable efforts to date, *The Varieties of Religious Experience* (1902) and "The Will to Believe," an essay of 1896—he knew James's earlier work on *The Principles of Psychology* (1890), and James himself made an indelible impression on him. Warm, affectionate, kind, and witty, a cosmopolitan fluent in half a dozen languages (Freud thought James spoke better German than he did), James was just the kind of person to whom Freud was drawn all his life. What he loved, at least initially, in his colleagues Josef Breuer, Wilhelm Fliess, Carl Jung, Sandor Ferenczi, and Lou Andreas-Salomé was, in his own words, their "optimistic" outlook, their "mixture of deep wisdom

and imaginative light-heartedness," their "richer and happier natures" that find "all hearts open" to them; they complemented and relieved, he said, his own "repellent," "narrow," and "somber" temperament.

On the day he spent with Freud, James was suffering from the painful angina pectoris that would kill him the next year, and at one moment during their walk, by Freud's account, "[James] stopped suddenly, handed me a bag he was carrying and asked me to walk on, saying that he would catch up with me as soon as he had got through an attack which was just coming on." James rejoined Freud a few moments later, and continued the conversation as if nothing had happened. Remembering the incident almost twenty years later, in 1925, when he was facing the cancer of the mouth that would eventually end his life, Freud wrote in his *Autobiographical Study* that he hoped to "be as fearless as [James] was in the face of approaching death," and in his own more heavy-handed style he was. Back in 1909, he had recognized James as "a great man," "the only American genius," and added: "He thinks I am crazy." Freud was not entirely mistaken. Although James understood the importance of Freud's ideas about unconscious displacement and repression—he had already welcomed them (the first English-speaking person to do so in print) as he welcomed all bold and innovative work—Freud himself struck James as a "regular halluciné," a man of "fixed ideas," dangerously reliant on "symbolism" for his method.

James was a friend, if an innovative one, to the liberalizing forces that took Protestantism captive in the nineteenth century, not, like Freud, their opponent. He had long conducted a high-spirited campaign against the Hegelian tradition of intellectual monism, with its Hebraic-Calvinist stress on a "reality of realities," its elitist privileging of the isolated male mind struggling to decode a harsh and incomprehensible universe, the tradition of which Freud is so clearly a culmination; and in the last two decades of his life he became an active observer and defender of the popular American religious therapies of the day, the positive thinking Mind-cure practices that produced *Pollyanna* and culminated in Christian Science. James consulted Christian Science practitioners about his own physical and mental difficulties, and he also assiduously attended Spiritualist séances.

Spiritualism—the practice of tapping the resources of another world and contacting the dead, a marketable service performed by paid mediums in séances—was an important predecessor and ally of Christian Science. It had begun in the 1840s in upstate New York with the "rappings" of the young Fox sisters. From there, Spiritualism spread like wildfire across America and into Europe. A number of prominent psychologists of the late nineteenth century attempted to verify these supernatural phenomena, and James put himself at their head; he extensively and sympathetically documented his

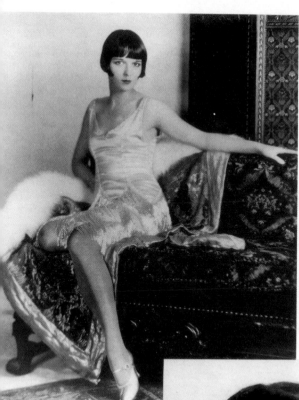

Louise Brooks
(Frank Driggs)

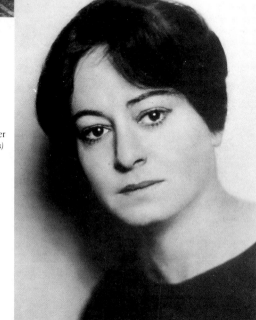

Dorothy Parker
(Culver Pictures)

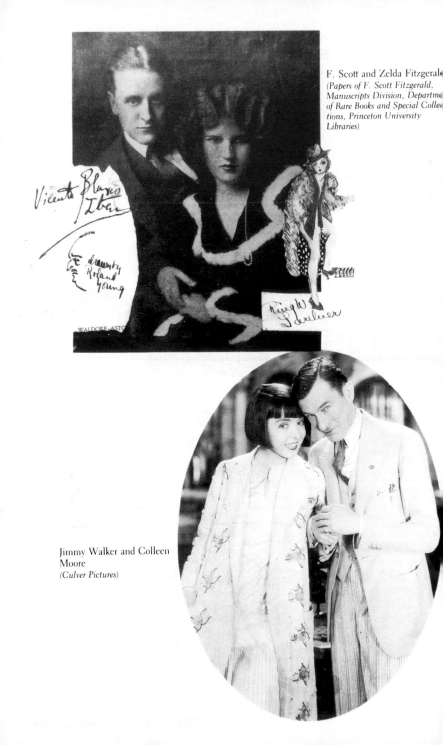

F. Scott and Zelda Fitzgerald
(Papers of F. Scott Fitzgerald,
Manuscripts Division, Departme
of Rare Books and Special Colle
tions, Princeton University
Libraries)

Jimmy Walker and Colleen
Moore
(Culver Pictures)

A Babe Ruth poster
(Transcendental Graphics)

Robert Ripley
*(Billy Rose Theatre Collection,
The New York Public Library for the
Performing Arts, Astor, Lenox, and
Tilden Foundations)*

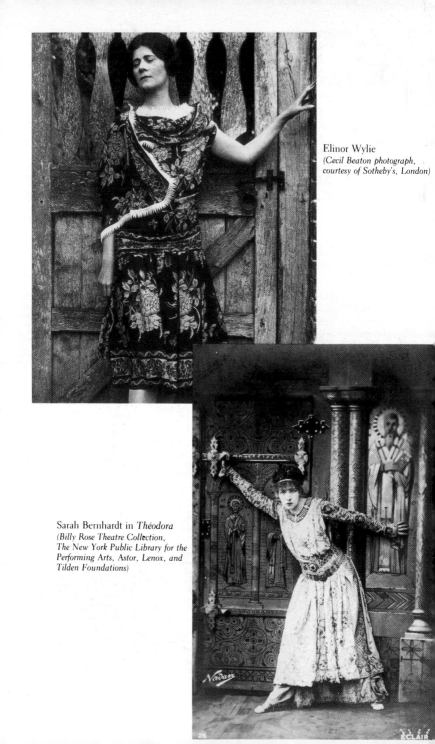

Elinor Wylie
*(Cecil Beaton photograph,
courtesy of Sotheby's, London)*

Sarah Bernhardt in *Théodora*
*(Billy Rose Theatre Collection,
The New York Public Library for the
Performing Arts, Astor, Lenox, and
Tilden Foundations)*

John Barrymore as Hamlet
(Billy Rose Theatre Collection, The New York Public Library for the Performing Arts, Astor, Lenox, and Tilden Foundations)

Edna St. Vincent Millay
(Library of Congress)

Charles Gilpin
*(Schomburg Center for Research in Black Culture,
Photographs and Prints Division, The New York
Public Library, Astor, Lenox, and Tilden
Foundations)*

Young Wallace Thurman
*(Yale Collection of American Literature, Beinecke
Rare Book and Manuscript Library, Yale University)*

Nella Larsen
(Yale Collection of American Literature, Beinecke Rare Book and Manuscript Library, Yale University, Estate of Carl Van Vechten, Joseph Solomon, Executor)

George Gershwin
(Frank Driggs)

John Bubbles
*(Billy Rose Theatre Collection,
The New York Public Library for the
Performing Arts, Astor, Lenox, and
Tilden Foundations)*

Josephine Baker
(Frank Driggs)

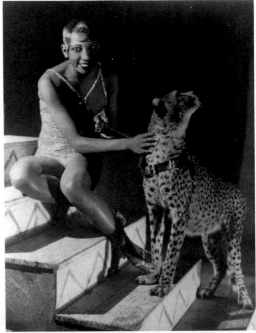

numerous séances with one Mrs. Piper and served as president of the American branch of the Society for Psychical Research. Santayana called his partisanship of this feminine subculture "religious slumming," but James lightheartedly dismissed the charge as the product of Santayana's "white marble mind."

James was a congenitally skeptical man, too much so to reify any philosophical solution, as Freud did the more or less officially atheist and masculinist creed of psychoanalysis, and he did not in any sense "prove" to his satisfaction the claims of Spiritualists or Christian Scientists. But that did not check his conviction of their importance. When he admitted at the end of his life that twenty-five years of "psychical research" had brought him, "theoretically" speaking, "no farther than I was at the beginning," it is well to remember that theory was never what engaged James most deeply. As the founder of the American school of philosophy called "pragmatism," practice was his concern, and practice was where the psychics and healers were strong. In the mid-1890s, James opposed a bill submitted to the Massachusetts state legislature that required Spiritualist, Christian Science, and Mind-cure practitioners to pass examinations set by a state board in order to obtain licenses; this would, in James's opinion, "kill the experiments outright." Were the law in effect, most practitioners would be out of business, and it would then be impossible to learn more about how they got their "brilliant . . . results." While he held "no brief for these healers" on an "intellectual" plane, and found one of their leaders (he is almost certainly describing Mary Baker Eddy) "a rapacious humbug," he also believed that the fact that some healers and mediums were frauds did not mean that all were frauds nor that any was altogether fraudulent, nor could it obviate the clear benefits that they had brought to multitudes of people. He declared that any "science" of the mind that "denies" the "exceptional occurrences" and therapeutic value of these psychic and healing practices "lies prostrate in the dust before me; the most urgent intellectual need I feel at present is that science be [torn down and] built up again in a form in which such things have a positive place." If he faulted the mental capacities of the healers and mediums, he also faulted his own emotional capacity, or incapacity. He thought he overintellectualized; he took religious matters, he said, "too impersonally." James saw, as Freud did not, that impersonality or objectivity is not only a much-touted (masculine) virtue and an indispensable tool in any fair inquiry, but also another form of subjectivity, a particularly dangerous form, since it cannot see its own limits, its own potential for bias.

James, whose "intensely masculine" nature was noted by Santayana and others, supported the view of women that was current in his day—their most sacred function, he remarked on numerous occasions, usually apropos of

his strong-willed and beloved wife, Alice, and their four children, is motherhood—but he also held the very unconventional notion that the most important ideas and experiences may come to those nature or society has marginalized as "[not] complete," as unfit. He was confident—rightly so, it seems, as we look about today's therapeutic society—that the popular religions of the future would come, not from the thought or beliefs of the intellectual masculine elite of his day, but from the largely feminine Mind-cure tradition of concrete therapeutics. At a time when every branch of science was absorbed in efforts to raise its status by masculinizing its task force and theorizing its premises, when the omnivorous diagnosis of "hysteria" relegated claims to special knowledge on the part of excitable women to the realm of disease, and of sexual disease at that, James was advocating what can best be called a feminization and pragmatization of psychological inquiry.

Rather than checking or coopting the feminization process that was the legacy of the nineteenth century, James wanted an alliance of the "feminine mystical mind" and the "scientific-academic mind," of feminine practice and male thought. This might sound like the usual appropriation of female experience for the purposes of male theory that has often been mistaken for a higher form of civilization, and in part it was, but with this important difference: James wanted a collaboration, not an expropriation, and one, moreover, as his early exchanges with Gertrude Stein at Harvard show, in which feminine practice dictated the terms to male theory, not the other way around. Always willing to admit in public as well as private that he sometimes trusted the insights of his wife, his mother-in-law (to whom he dedicated *The Varieties of Religious Experience*), and countless female psychics and healers more than he did the theories of his colleagues at Harvard or abroad, he did not fear, as Freud seemed to, that by associating with women and espousing their practices he would be, as Freud put it in "The Taboo of Virginity," "infected" by their "femininity" and "thus prove himself a weakling." To James's way of thinking, one might reach wisdom by many different routes; he was a self-styled "pluralist" writing about, in the title of his last and greatest work, A *Pluralistic Universe* (1909).

Freud told the Boston press during his 1909 visit that the popular therapies that were James's deepest concern were "dangerous" and "unscientific," mere panderings to the public with its "weakness" for the "mysterious." Psychoanalysis, he boasted, had "absolutely nothing mysterious about it." (James, reading these remarks in the paper, commented succinctly, "Bah!") And Freud was anything but a pluralist. His habit, he wrote to Lou Andreas-Salomé on May 23, 1930, was to "exclude all opinions but one"; he broke with his earliest collaborator, Josef Breuer (the co-author of *Studies in Hys-*

teria) because Breuer, like James and unlike Freud, "unfailingly knows three candidates for the position of *one* truth and abhors all generalizations as presumptuous," as Freud fumed to Wilhelm Fliess on March 1, 1896. Men "crave" a "plurality of lives," he wrote in "Thoughts for the Times on War and Death" (1915), of opportunities and chances, but they never find them; the hope of their attainment is nothing but an "illusion." James disliked what he called "moonshiny optimism" as much as Freud did, but he believed as Freud could not that hope is a very different thing from facile cheer.

To ask what hard proof there is for the proposition that "duping through hope" is worse than "duping through fear," as James did; to suggest, as Santayana thought James did, that "the resources of our minds are infinite," that life is an exhilarating and absorbing drama which may have "no last act"; to insist that there are, in James's words, always "other occasions in reality" and "fresh news" on earth, that the world is "plastic," that men can and do find fulfilling and valid substitutes for lost people and objects; to preach that human beings may sometimes help and heal themselves without the intervention of trained medical aid—that illness, whether physical or mental, may contain within itself antibodies capable, not of checking or eliminating disease, but of transforming it to the ongoing needs of the organism; to believe that the universe is "intimate" with men and "friendly" to their needs, that life does not taunt men with "printed bills of fare" but offers them the "solid meal" they crave; to think that nature is at least as likely to grant extraordinary insight to untutored women as to highly educated men—all this was to Freud's mind simply to deny the obvious reality of a human psyche programmed for pain, conflict, and even self-destruction amid a world bleak in nature and limited in opportunities, a world whose losses Freud knew to be many, important, and final, a world whose stern challenges the weaker feminine psyche was equipped only to evade and deny.

Yet Freud's contribution to the cause of women was not altogether negative. The case studies he wrote of his early women patients are, despite their shortcomings, the first vivid accounts of female sexuality in the modern era; indeed, they could almost be said to have initiated the modern era. Freud welcomed women intellectuals like Lou Andreas-Salomé, Helen Deutsch, and Marie Bonaparte to psychoanalytic circles, and said that women had seemed "intellectually inferior" to men only because the topics of sexual identity and activity most congenial to the sex that bears the children of the species were forbidden to them as subjects of thought and art by Victorian prudery. He even acknowledged in a letter of May 13, 1938, to Ernest Jones, that his own inability to think unless he could think about sex was that of a woman.

Even as Freud identified his interest in sex as a woman's interest, he didn't

make the connection on an emotional level; he didn't own it. He called this trick of springing an intellectual perception clear of its emotional context, this habit of enriching the "thinking process" but not the "person," "negation," and he was a master at it. He seldom acknowledged the contributions of his female patients, and he accepted the ideas of later feminine colleagues like Helene Deutsch and his daughter, Anna, only when their work supported his own or focused on problems—like female masochism and child psychology—of secondary interest to him. Freud's "science" was, in fact, just what James had attacked and put "prostrate in the dust before me": an effort to devalue feminine experience and the religious experience so closely aligned to it.

Freud and Gertrude Stein never met; there is no evidence that he read her work and there are only hints she read his. But she was aware of him as her greatest adversary. Her break with her brother Leo was the result in good part of his decision to enter psychoanalysis and embrace the Freudian viewpoint; "Freud is the man I long ago called for," he announced, but his sister was looking elsewhere for her values and ideas. As Jews, Freud and Stein were both self-conscious outsiders to the world of late-Victorian culture in which they were reared, yet Freud was the culmination of its patriarchal impulse as surely as Stein was the culmination of its equally powerful matriarchal thrust. What Freud loathed above all else in American culture was its "dominating women"; in his view, they treated American men as wolves do sheep and constituted an "anti-cultural phenomenon." Freud did not know New York's popular culture, but he would not have been surprised to learn that it was filled with images of men dominated by women and in the grip of the Oedipus complex; he attacked Prohibition in *The Future of an Illusion* as "petticoat government," depriving the male of "stimulants" and fobbing him off with "piety." Following Marx, who defined religion as the opium of the masses, Freud saw religious beliefs and practices as the earliest form of mass culture, and he identified both religion and mass culture with the self-indulgent fact-blind ascendancy of the matriarch; for him, there was no separating out America's burgeoning popular culture and its cheap catering to the unwitting masses from its feminization.

Others made explicit the links between popular culture, a dominant motherhood, and a too-easy pacification. In *Notes Towards a Definition of Culture* (1948), T. S. Eliot later described mass culture as the "desire to return to the womb." Even Gilbert Seldes said that the lively arts were "opiates" designed to "trick" but not satisfy "our hunger" and let us "sleep." Could it be accidental that the signature song of the "world's greatest entertainer," Al Jolson, was the ragingly sentimental "Mammy"? The Al Jolson fan, Robert Benchley noted, "totter[s] out [of Jolson's show] to send a night letter to his

mother." The scornful 1920s slang term "sucker," meaning a person too easily gulled by false promises of effortless achievement, modernized the old word "suckling"; the "sucker" was not yet weaned from mother's breast. More recently, in *Society Without the Father* (1976), Alexander Mitscherlich has called the world of mass culture a "fatherless" society, a concept Freud found too awful to contemplate. In 1912, Jung, drifting rapidly to open apostasy, wrote Freud that the earliest society was a matriarchy in which "there was no such thing as a father's son," but Freud disagreed in a letter of May 14: "There have been father's sons at all times."

Stein's position about gender roles was very different. She had probably read some of the work of Mary Baker Eddy; Eddy was one of her forerunners as surely as James was, and she loved the best of the Mind-cure fiction of the high Victorian era, Louisa May Alcott's *Rose in Bloom* (1876) and Gene Stratton-Porter's *Girl of the Limberlost* (1909). The problem with the present, she explained in *Everybody's Autobiography*, is "too much fathering . . . there is no doubt about it, fathers are depressing. Mothers may not be cheering but they are not as depressing as fathers." She looked forward to a very un-Freudian, indeed a fatherless, twenty-first century "when everybody forgets to be a father or to have been one"; her last work was the libretto for an opera about the American suffragist Susan B. Anthony called *The Mother of Us All*. While Freud espoused "the reality principle," she explored "the pleasure principle" (both terms are Freud's). If the mass arts are feminine and matriarchal in their implications, themselves perhaps the only real matriarchy now known, it is not surprising that Stein enjoyed them as thoroughly as Freud detested them.

As the term "sucker" suggested, the older matriarchal culture had celebrated an ethos of psychological nurture and oral gratification. Mary Baker Eddy aimed to "banish soulless famine". When she rewrote the "Our Father" prayer for Christian Science and its "Father-Mother God," she amended the line "Give us this day our daily bread" to "Feed the famished affections." Many besides Freud thought Eddy's message an instance of what Fannie Hurst called "fatmindedness." The full title of Lulu Peters's best-seller, *Diet and Health* (1918), the book that made deliberate famine a cultural law for America's women, was *Diet and Health with Key to the Calories*; Peters was mocking the bible of Christian Science, Eddy's *Science and Health with Key to the Scriptures* (1875). Yet, in the age that banned the full-figured woman, discovered calories, and invented the bathroom scale, Stein insisted with James that life should and does offer us, not "a printed bill of fare," but the "solid meal" we crave.

Alice B. Toklas told the world that Stein "was always fond of pigs," and Mabel Dodge Luhan wrote of her bulk—"pounds and pounds and pounds

piled up on her skeleton, not the billowing kind, but massive, heavy fat"—
and her appetite; "She loved beef and I used to like to see her sit down in
front of five pounds of meat three inches thick and, with strong wrists wielding
knife and fork, finish it with gusto." "Yet," Luhan continued, "with all this
she was not at all repulsive. On the contrary she was positively, richly
attractive in her grand *ampleur*. She always seemed to like her own fat anyway
and that usually helps other people to accept it. She had none of the funny
embarrassments Anglo-Saxons have about flesh. She gloried in hers." In her
own eyes and, Luhan suggests, in others' as well, Stein's massive poundage
was part of the "fatness" which the Psalms repeatedly link to God's favor and
blessing.

Gene Stratton-Porter, meeting the charge that her stories were "molasses-
fiction," remarked imperturbably: "What a wonderful compliment! All the
world loves sweets!" Or, as the National Confectioners Union protested in
an advertising campaign of the late 1920s—they were hard hit by the diet
and cigarette "crazes" sweeping American women, who preferred, it seemed,
in the words of the new Lucky Strike ad, to "reach for a Lucky instead of a
sweet"—"Candy Is a Food!" It was a proposition Stein was prepared to
endorse. "Sugar," she wrote in a paean to "FOOD" in *Tender Buttons* (1914),
is "violent luck" and "a whole sample"; sugar is "cuddling." She was neither
Eleanor Porter turning out *Pollyanna*s nor Eleanor Abbott extolling "make-
believe"; like James, she was an avant-garde writer incorporating the older
matriarchal oral ethos into her pioneering aesthetic.

Fannie Hurst believed that dieting psychologizes, even pathologizes, the
dieter. "Frightening mental traits" appear in one engaged in this "newly
developed form of self-torture." In fact, dieting, as Hurst experienced it,
presupposed and instilled the Freudian worldview. Freud declared that our
deepest needs and desires go "forever unappeased," and Hurst, telling the
story in her novel *Back Street* (1930) of a multiply anorexic woman who
finally dies, horribly, of starvation, concluded that "it is as if we get born
with more appetites than we need just in order to spend our lives trying to
curb them." The dieter quickly learns there is "too much" of only one thing
"with you: yourself." In the world of dieting as in the world of psychoanalysis,
self-hatred is a virtue. But distrust of self, lack, failure of satisfaction, and,
above all, the psychologization of consciousness that such a state imposes,
were anathema to Gertrude Stein; as the student who tested her "subcon-
scious" reactions in William James's class had discovered, she often insisted
she had no subconscious at all. She did so, I think, because she wished to
reject the notion, not so much of the unconscious in general, as of the
Freudian unconscious in particular, and the reification of stoic pain that
invariably accompanied it. When her brother Leo turned to psychoanalysis,

she resisted his insistence on their "unhappy childhood." Freud's stated therapeutic goal might be to replace "hysterical misery" by "common unhappiness," but Stein queried, "What is the use of having an unhappy anything?"

Freud disavowed any notion of himself as a "doctor"; his aim, he remarked in *The Question of Lay Analysis* (1927), was not "to help suffering humanity" but to pursue "a theoretical career." The young Freud had at moments believed that psychoanalysis could cure anyone who tried it, but by 1937, when he wrote the gloomy "Analysis Terminal and Interminable," he had concluded that the patients who had tried his method had found no cure and little long-term amelioration of their problems. This provided legitimate fuel, Freud thought, to his deepening pessimism about human nature; patients were "good for nothing," "riff-raff," "rabble." It did not occur to him, apparently, that the fault might not lie with the patients or their nature, that the therapeutic strategy he had devised might simply be unsuited or inadequate to their needs. But it did occur to a number of his most gifted disciples. When Jung, Rank, and Ferenczi distanced themselves from Freud, they did so in good part on the grounds that they were not able to help their patients using his therapeutic techniques. Rank wrote in his last book, *Beyond Psychology* (1941), that Freud, by subordinating "therapy" to "theory," had sacrificed the "souls" of his patients to his own ambition. Jung thought Freud was practicing "vivisection" on human beings; Ferenczi described him as "paternal-sadistic." All three men marked and protested Freud's denigration of women; they believed psychoanalytic therapy a process of enforced masculinization.

Helene Deutsch did not officially break with Freud, but when she went to America in 1930, she found that doctors there were turning to psychoanalysis "*in order to be able to help* [the patient]." The emphasis was Deutsch's, and she was clearly implying that European doctors, Freud chief among them, did not desire above all else "to help" the patient. Perhaps that was why American doctors were "sad and disappointed" when they tried the methods of psychoanalysis. Freudian therapy was not therapeutic, a number of its disciples decided; it did not have, in James's words about American religious therapy, "extensive results." Whatever his quarrels with the medical profession of his day, Freud shared the authoritarian stance of its elite; his loyalty was to the "pure gold" of psychoanalytic theory, not to the "copper" of direct treatment. (The metaphor is from Freud's essay of 1919, "Turnings in the Ways of Psychoanalytic Therapy.") In contrast, Stein and James were by Freud's definition "doctors" very much interested in helping the suffering, including themselves. Their commitment was less to their own insights than to the patient's health, and they believed that the

sick person is the indispensable authority on his own illness and recovery.

The great contribution of the generation of American women doctors, nurses, and health experts who had come of age in the heyday of Mary Baker Eddy—the Civil War years and the decades after—lay in maintenance and preventive medicine. They were interested not in the fast-breaking developments in medical research, psychiatry, surgery, or any form of crisis-oriented medicine but in how people get sick, how they can recover, and how one might keep them from falling prey to illnesses that were preventable or curable or imaginary. These women pioneers of medicine focused on the cure, not the disease, on the pragmatics of treatment, not the master plot of diagnosis. They wanted to help people keep themselves out of doctors' offices through shared and collective lay diagnosis and practice; in their view, half or more of human illness was fabricated by male doctors to give themselves lucrative and prestigious employment, and then imposed on the people least trained or encouraged to diagnose themselves—namely women. Remember the doctor in Pollyanna's town who knows that her Glad Game could put doctors like himself out of business. In some sense, this was indeed the aim of the first women doctors, as of the Mind-cure and Christian Science movements *Pollyanna* popularized, and this aim rested on premises that are not unintelligent, though they can be dangerous.

It is true that the Christian Scientist practitioner might sometimes be trying to sweet-talk a malignant cancer which in fact requires instant and aggressive professional treatment out of existence. This was the picture Christian Science called up in Freud's mind—self-infatuated palaver ludicrously deployed to meet a problem intractable to anything but realistic diagnosis and specialized treatment. The risk in such therapies puts them off limits to most people; when it comes to our health, most of us believe that we have to know the worst. But it must be remembered that for every time the Christian Scientist refused to acknowledge cancer, there were many more times when she was assuming responsibility for her own health, when the problem at hand did not, in fact, require the costly treatment that doctors prescribed for it. This was the picture the loose set of practices included under the rubric of Mind-cure, Spiritualism, and Christian Science summoned to the minds of James and Stein. They trusted the skepticism toward established authority that the Mind-cure tradition suggested; they sensed its radical implications, its not always intended openness to the new, to the outside chance. Like the Victorian doctor and feminist activist Elizabeth Blackwell, though without her sometimes blanket dismissal of science, James and Stein were resolved, in Blackwell's words, to "commit heresy with intelligence."

James sponsored several patients-rights movements in his own lifetime, and the fellowship of Alcoholics Anonymous, founded by a New York stock-

broker named Bill Wilson in 1935 and destined to become the most important self-help group therapy in the world, sprang directly from his thought. (Before the "Big Book," the AA manual, was published in 1939, Bill Wilson used *The Varieties of Religious Experience* as the fledgling fellowship's handbook and bible.) Alcoholics Anonymous's emphasis on group experience, on a maintenance model of lowered but steady psychic expenditure and self-help, and on "spiritual" awakening was vintage James, and the fellowship demonstrated the wisdom of his reliance on "the agency of [the patient's] mind." The medical establishment, including Freud, had long judged alcoholism a disease impervious to treatment, but alcoholics could apparently do for one another what doctors could not do for them.

Stein, too, avoided the crisis model of masculine medical treatment that maximizes human fears and gives privilege to medical expertise. An unrivaled practitioner of antiphobic strategy, she believed that recovery begins when people cease to fear their illness; fear may drive them to heroic feats, but they gather strength before and after such exploits when they feel safe. Just where Freud intended to alarm, Stein sought to reassure. Freud unmasked *The Psychopathology of Everyday Life* (1901), the unnoted "slips" by which the treacherous unconscious sabotages conscious control in the midst of what we think of as our safe and insignificant daily life, but Stein wrote in *Everybody's Autobiography*: "Except in daily living nobody is anybody." Daily life for Stein is not betrayal; living is therapy for life. "If you write about yourself or anybody it sounds as if you are very unhappy but generally speaking everybody . . . has a fairly cheerful time in living." While Freud anatomized the unconscious meaning of "Jokes" (1905) as repressed and violent wishes, Stein wrote audaciously in *Alice B. Toklas*: "Gertrude Stein always laughed and this was difficult."

Freud believed that religion was doomed to defeat at the hands of science, but James and Stein found that the human experience on which all science must rest confirms, not contradicts, faith. "One thing is sure," Stein wrote in *Everybody's Autobiography*, "everybody has a knowledge of gods." Although James knew that the god of our mothers and fathers was dead, that there could be no going back to the discredited pieties of Victorian life, he thought there might just possibly be a going *forward*, a "fresh highway" to a new and free faith that embraced not "God" but, as Stein said, "gods," gods who had something in common with the old matriarchal oral culture of abundance they succeeded. James spoke of "a tremendous muchness suddenly revealed" as if through "an open window," Stein, talking about *Four Saints in Three Acts*, of "a bright filled space."

On May 4, 1924, Romain Rolland visited Freud in his study in Vienna. Rolland found the room a "somber" place cluttered with "a pandemonium

of small gods, fetishes and amulets" (part of Freud's famous collection of archaeological artifacts) that seemed themselves "hallucinated projections of the erotic and religious dreams of humanity." Like most of Freud's friends and visitors, Rolland noted his "stoical pessimism," his "fatalism." "I would gladly end my life," Freud told Rolland. If James's refrain was "Who knows?," Freud's was always, "*I* do." Stein, penning the words "Fathers are depressing," might have had Freud in mind. "Fathers," to extend Stein's thought, may be depressing to themselves as well as to others. But Freud reified, even cherished, his depression; to his way of thinking, it was proof that he had the strength of mind and character needed to look hard at reality's dark design.

In contrast to Freud in his somber study, William James was known on occasion to work in the midst of his busy household, and he liked at unpredictable moments in the classroom to open the window and look out. He struggled all his life with depression, at times suicidal depression—discerning friends sometimes sensed a deep sadness in the man despite his playfulness and celestial gaiety—but he saw depression as more deception than truth, both an actual illness sometimes tenaciously resistant to treatment and the most seductive form of self-indulgence. Where Freud compared himself again and again to those like Faust and Aeneas who have traveled down to the underground to steal the secrets of the demons ruling there, James was attracted to the light and, like Stein, who found that "the air is solid," he said that "air [is] . . . itself an object." Not any "air," however. James wrote often in his letters about the "screeching . . . white luminosity" he found only in America's weather, about "our acrobatic climate," "our glorious quick passionate American climate with its transparency and its impulsive extremes," "our American weather, a strong west wind like champagne, blowing out of a saturated blue sky right in our teeth," a world "whanging with light."

There had been a good deal of pain in Stein's life, too; being fat, German, Jewish, lesbian, and (in her own estimate, at least) a "genius" was not an easy part for a woman to play in late-Victorian America. The epigraph for *Three Lives* ran in part, "*Je suis un malheureux*" (I am an unhappy person). "Why is there so much useless suffering why is there," she asked in *Tender Buttons*; this was not a question Stein, as tough-minded in her way as Freud in his, pretended to answer. "Every room has its gloom," she said; "the great thing is to find the color that will cut the gloom." She does not say "banish" the gloom or "deny" the gloom or pretend it isn't there, but "*cut*" the gloom," splice it with something else, change the "composition" (a favored term with Stein) so as to see it differently. In her view, "Americans have to have . . . optimism because they do know what it is to have disillusion. The land goes

away from them, the water goes away from them[,] they go away from everything and it is all of it so endless." For Freud disillusion always follows optimism; in his telling, optimism *produces* disillusion. For Stein, disillusion precedes optimism and in some real way causes it—at least in America. As Stein began her literary career in New York City in 1903—"here!" as she wrote in a deleted passage of *Q.E.D.*, "in the heart of this high, aspiring, excitement-loving people"—she thrilled to "the empty upper air." In America, "there is no sky . . . There is only air . . . There is no lid on top of them."

Freud, quoting Milton's Satan in *Paradise Lost*, urged that, if we cannot find "reinforcement" in "hope," "let us consult . . . what resolution we may gain from despair," but James liked to remind people, "Nothing is more characteristic of human nature than its willingness to live on a chance." In *Everybody's Autobiography*, Stein asked, "What is hope?" and answered, "Hope is just contact with the facts." James told the modern era what it had "the right to believe," and how to test its beliefs. Freud told the age what it was compelled to disbelieve, what it must analyze, and above all what it must renounce. Stein announced the preposterous as the pleasurable and the "literally true." Champions of the Victorian matriarch, Stein and James believed in adding on, in the amplitude and jostling of inclusion; Freud, decided foe of the Titaness, adhered to the arithmetic of subtraction, to the saving rigors of exclusion.

James died before the American moderns' matricidal aims had become clear; Stein, quite simply, never took them seriously. She was sure, at least, of her own rule. In any case, neither James nor Stein espoused the Titaness that Freud and the American moderns rejected; they had little use for the dewy-eyed deniers of plain fact and the self-righteous reformers who dominated much of the Purity, Suffrage, and Prohibition movements, and drew the ire of Freud and his followers. They championed, rather, the matriarch at her best, a figure Freud dismissed or misread at his peril: the Spiritualists whose séances James attended and investigated, the early women doctors and nurses who questioned male-monopolized expertise, the best practitioners of sentimental fiction, who acknowledged with Gene Stratton-Porter that "all the world loves sweets!," the women led by Mary Baker Eddy who asked the Father-Mother God to "feed the famished affections." Why, Stein and James inquired, throw out the baby with the bathwater? Pluralists drawn to popular culture as a working democracy, no matter how imperfect, they saw the links between matriarchal nurture and popular culture in America; they knew these links would persist whatever matricidal turns the culture took, and they welcomed popular culture as the product and inalienable right of "everybody" (Stein's favored word), regardless of gender, race, or status.

The decades after 1910, the year of James's death, saw the triumph in intellectual circles of the elite, histrionically pessimistic, intellectually severe Freudian tradition over that of the indigenous American pragmatic and optimistic tradition of "religious therapy" to which James and Stein belonged. James's work had dominated American philosophy and psychology in the previous decades, but his stock fell rapidly. Walter Lippmann's changing views about him were characteristic. Lippmann had studied with James at Harvard in the 1900s; knowing him was "the greatest thing that happened to me in my college life," and he "loved" James more than "any very great man I ever saw." But as the world changed and he grew older, Lippmann was attracted to minds more dogmatic and austere than James's, Freud's chief among them. Such minds might be less lovable than James's, but they were "inescapable"; they faced the tough facts as James did not, Lippmann believed. After discovering *The Interpretation of Dreams* in 1912, he "went back and read some of James with a curious sense that the world must have been very young in the 1880s." James was not a realist, Lippmann decided, as Freud was, but "the last of the romantics" writing for a happier, less self-conscious, definitely pre-modern culture, for a vanished America enjoying a "spell of exceptionally fine weather."

As Lippmann had repudiated James, Ernest Hemingway repudiated Stein. She was his mentor and friend in Paris in the early 1920s, and her encouragement, her comments on his work, and the weeks he spent editing portions of her narrative *The Making of Americans* for *The Transatlantic Review* in 1924 left an indelible mark on Hemingway the man and the stylist. Relations between the two became strained, however. Each left very partial accounts of the reasons; neither is reliable. In *Alice B. Toklas*, Stein wrote that Hemingway "smells of the museum," while in his memoir of his Paris years, *A Moveable Feast*, probably begun in the late 1920s but rewritten much later and posthumously published in 1964, Hemingway took her to task. He did not deny Stein's formidable charm and powerful intellect: "She could not be resisted," he wrote. In some way that made him go easier on her than on most of the people he portrayed in *A Moveable Feast*, Stein, too, was lovable. But her vision was nonetheless, to Hemingway's mind, a defective one. She wanted to know, he wrote, the "gay part of how the world was going; never the real, never the bad." For Hemingway, as for Lippmann and Freud, all practitioners of "terrible honesty," the "bad" *is* the "real."

The struggle between the Freudian discourse and the Jamesian-Steinian tradition went on throughout the 1920s, and it hardly came to an end then. Freud's most influential European opponents, Carl Jung and Romain Rolland, drew on James, in Rolland's case explicitly, to rebut and answer Freud in the 1930s and 1940s. During Ferenczi's difficult, partial break with Freud

in the early 1930s, he, too, turned to James's work, and he was also aided and comforted by a former patient, an American therapist named Elisabeth Severn, whose interest in trauma, telepathy, and mediums he came to share. Christian Science and Spiritualism reached their peak of popularity all over the world in the 1920s, though the 1930s would witness their relative decline. Mind cure more broadly speaking, however, the optative therapeutic practices by which mind, avowedly aided by forces larger than itself, influences matter, continued to produce blockbuster best-sellers; Emile Coué's *Self-Mastery Through Conscious Auto-Suggestion* (1923) and Bruce Barton's *The Man Nobody Knows* (1925) were followed up by Walter Pitkin's *Life Begins at Forty* (1932), Dale Carnegie's *How to Win Friends and Influence People* (1936), Norman Vincent Peale's *The Power of Positive Thinking* (1952), and on to today's burgeoning self-help and pop-therapy books. But the prestige, the high intellectual and cultural interest that James and Stein had brought to the Mind-cure tradition was largely a thing of the past by the time of Stein's death in 1946. It had come to be an unwritten axiom that "theory" and "therapy," elite art and professionalized good cheer, were mutually and forever exclusive. Highbrow pessimism assumed lowbrow optimism, and vice versa.

MUTUAL MIND READERS

The developing pattern of Freud's work as it choreographed the exchange and struggle between masculine and feminine elements, between theory and belief, between the elite and the masses, between the "primitive mind" and civilized "hypocrisy," between "terrible honesty" and "religious therapy," provides a blueprint for the 1920s. To use Freud as a paradigm for portions of the larger culture of his day is in no way hostile to his premises; as he wrote Fliess in 1897, "One always remains a child of one's age even in what one deems one's very own." Freud's method was, Lewis Mumford remarked in a late essay, "the art of autobiography carried to . . . exhaustive lengths." He moved seamlessly from his own self-analysis to an analysis of individual case histories, and on still further to studies in the "cultural pathology" of the Western world. In his words (in an essay of 1937 titled "A Disturbance of Memory on the Acropolis"), Freud "began by attempting [psychoanalysis] upon myself, and then went on to apply it to other people, and finally by a bold extension to the human race as a whole." What held true for him held true for others, he was sure; what held true for them held true for all of Western civilization. In *Totem and Taboo* (1913), he christened such acts of "bold extension" "instigations."

In *The Question of Lay Analysis* (1926), Freud predicted that "the use of analysis in the treatment of the neurotic is only one of its applications; the future will perhaps show that it is not the most important one," and in a 1935 addendum to *An Autobiographical Study*, he remarked that he regarded all his work in "the natural sciences, medicine and psychotherapy" as merely a long "détour" around what had originally "fascinated" him and to which he had returned in the 1920s: "cultural problems." Freud believed he had established psychoanalytic modes, not only of individual psychology, but of cultural investigation; somewhere he knew that he was less the scientist he sometimes claimed to be than the greatest cultural critic of an era that gave birth to cultural criticism as we know and practice it today. But he was not, as he thought, discovering absolute or universal truths about the workings of culture; his theories have value not because they are, as he asserted in speaking of the Oedipus complex in his *Autobiographical Study*, "universal law[s] of mental life," but because, like all theories, they are time-bound, a part of a historically specific yet widely shared situation. Freud's writings tell us less about the "universal laws" of human nature than he claimed, but more than he was aware about the man who formulated those laws and needed so urgently to believe them, and, I add, about the white urban American moderns who adopted them so eagerly.

In his hatred of all things American, Freud, by the dynamic of repression he himself explicated, protested too much. We have seen how heavily Madison Avenue borrowed from Freud, but the relationship was not altogether one-sided. His nephew, the public-relations man Edward Bernays, the son of his sister Anna, who had come to America with her husband in the early 1890s, visited Freud and corresponded regularly with him from boyhood on. Freud praised Bernays's book *Propaganda* in a letter of March 2, 1928, as "clear, clever, and comprehensible . . . I read it with pleasure [and] . . . wish you all possible success," and Bernays in turn devoted considerable time and money to publicizing Freud's work in America. In 1920, Freud had asked him to peddle among New York publishers the idea of a popular book to be written by himself. For a title, he suggested the catchy "Scraps of Popular Psychoanalysis"; it sounds like a companion volume to André Triton's *Easy Lessons in Psychoanalysis*. *Cosmopolitan* was interested, but Freud wanted more authorial freedom and money than *Cosmopolitan* was willing to give, so the project was dropped.

On August 13, 1937, Freud wrote to his friend and disciple Marie Bonaparte that he had "an advertisement floating about in my head which I consider the boldest and most successful piece of American publicity: 'Why live if you can be buried for ten dollars?' " Of course Americans, too, liked to spoof American ads. The September 1931 issue of *Ballyhoo* printed a

campaign for "Blisterine Toothpaste." "Don't Buy It!" *Ballyhoo* urged. Why not? With the money you save, you can buy yourself a set of fake teeth and kiss all dental bills goodbye! Freud, just like *Ballyhoo*, was expressing the manic route to hidden and depressing agendas that was characteristic of American advertising, a route as familiar to him as to Madison Avenue.

Freud had once, as a young man in the 1880s, considered emigrating to America, and all his life he likened his discovery of psychoanalysis to that of Columbus, who "changed the world" by discovering America; on the wall of his study he kept a copy of the very Declaration of Independence he mocked in *Civilization and Its Discontents*. So the vehement scorn that characterized Freud's response to America had complex roots: he noted uneasily on several occasions that Woodrow Wilson, whose disregard of "facts" and overinvestment in the "illusions of religion" drew his heavy and sustained fire, was born in the same year, 1856, as he. He had initially greeted Wilson's arrival in Europe in December 1918 for the Versailles negotiations after the war with hopes as high as those the "riff-raff" held. Wilson was to Freud an unwanted twin, a double to be exorcised, and the much despised Mary Baker Eddy, as Freud's friend Stefan Zweig liked to remind him, was a pioneer in the field of "mental healing" he considered his own.

If Americans were "savages," Freud knew, as he put it in a letter of January 2, 1910, to Jung, that the "civilized world . . . regard[s] me as a savage." America might be a "victim of a mother complex" and a "black raven" in a "white shirt," but so was Freud. His adored and imperious mother, Amalia, had called her dark-skinned oldest son Sigmund in his infancy her "blackamoor." Later, she introduced herself to his friends and colleagues with a single stark line: "I am the Mother." One observer likened Amalia's influence on Freud to a "tornado." She died only nine years before he did, and he did not feel "free to die," he noted, until her death. Freud was summoned to his lifework, he tells us in his *Autobiographical Study*, when a professor of his quoted in class a passage then erroneously attributed to Goethe about "Mother Nature," whose "favorite children," longing to be restored to her breast, try to fathom her tantalizing secrets; throughout his life, Freud repeatedly imaged himself as Goethe's Faust trying to gain entrance to the world of the primitive Mothers. With its strained Oedipal reification of the father, psychoanalysis was a long and self-conscious detour around the secrets of "the eternal feminine" (the phrase, a favorite of Freud's, is Goethe's), backhanded but overwhelming evidence of a gigantic mother complex in the man who created psychoanalysis and in the culture that proved to be the most hospitable to its ideas.

Freud once remarked that he had always needed a "friend" to love and

an "enemy" to hate, and that the two sometimes "coincided in the same person." It stands to reason that America, as the chief of Freud's self-declared enemies and the most persistent of his friends (no matter how unwanted), was tied in to the workings of his own psyche and the development of his thought. The proof of this proposition lies not only in Freud's writings but in those modern American writers to whom his work was so crucial. I have discussed the direct and acknowledged effect Freud had on the New York scene, but a powerful kind of like-mindedness is at work here as well, a set of affinities that indicate an influence deeper than conscious assimilation can exercise. Time and again, the modernist writers came up with thoughts and words strikingly like Freud's, and there is often no evidence of direct transmission.

Joseph Wood Krutch, a long-time student and reviewer of Freud's work, apparently modeled his pessimistic best-selling tract on the times, *The Modern Temper*, closely on Freud's *The Future of an Illusion* (1927). Yet, Krutch claimed, no doubt truthfully, that he did not read *The Future of an Illusion* until he had finished his own book. Eliot's line from *Burnt Norton*, written in the mid-1930s—"human kind / cannot bear very much reality"—echoes Freud's remark in *Civilization and Its Discontents* that "life as we find it is too hard for us." Eliot's dictum that "the world of natural science may be unsatisfying, but [it] . . . is the most satisfying that we know . . . and it is the only one we must all accept" has not only the sentiment but the austere and melancholy rhythm of Freud's famous statement made twelve years later in *The Future of an Illusion*: "Science is not illusion. But it would be an illusion to suppose that we could get anywhere else what it cannot give us." As a young man, Freud had vowed he would "gladly sacrifice himself for one great moment"; Eliot announced himself willing "to be damned for the glory of God," and took a vow of celibacy at forty just as Freud had done. Freud's comment in a letter of April 21, 1912, to Jung—"One learns little by little to renounce one's personality"—found its best explication in Eliot's words in his essay "Tradition and the Individual Talent" (1919): "The progress of an artist is a continual self-sacrifice, a continual extinction of personality."

F. Scott Fitzgerald became a student of psychoanalysis in the late 1920s as he struggled to deal with his wife's institutionalization under the care of a series of doctors of the schools of Freud and Jung, and he underwent his own emotional and alcoholic "crack-up." His greatest novel, *Tender Is the Night*, details the deteriorating marital relations between an American psychiatrist and his wife, who is also one of his patients; it reads like an extended explication of Freud's essay of 1915 on "Transference Love." Freud believed that the best men could achieve was "common unhappiness," while Fitzgerald said that the "natural state of the sentient adult is a state of qualified

unhappiness." Dorothy Parker's stated artistic ideal—"the disciplined eye and the wild mind"—was close to Freud's description of his own method as "the succession of boldly roving fantasy and ruthlessly realistic criticism."

These are only a few of the many instances of words and ideas shared by Freud and the white urban American moderns. I have already mentioned many others, and will allude to still more in the course of this book. Their abundance cannot fail to tell us how strong and tenacious this connection was. Freud's theories seem designed to explicate these artists' lives and work, less because they consciously endorsed his views (though they often did) than because they shared the mind-set and mood out of which his theories came. In other words, Freud was connected to modern white urban America less because Americans read him, though they did, than because they did not have to read him. Freud and America in the modern era were not just conversationalists on a common theme, critics working within the same interpretative project, but mutual mind readers at work in an age fascinated with all forms of mind reading and mental telepathy.

The paradoxes that psychoanalysis discovered and contained were familiar ones to Americans. The negative centrality accorded the feminine, the insistent and fearful denigration of feminine capacities that is characteristic of psychoanalytic thought—these were second nature to a culture for which modernism and matriphobia were synonymous. The utopian change-the-world tone of the early writings of Freud and his followers suited the world's most affluent and ambitious nation; the darker, determinist, and elitist but no less imperial side of Freudian thought as it later developed also found echoes in a culture still far from free and, more important, still far from wanting to be free of its stern and histrionic Calvinist heritage. The often violent alternation evident in Freud's work between these utopian and Spenglerian extremes, his sheer fascination with the dynamic of energy conversion by which opposites necessitate each other, had an analogue in the New England Calvinism of Jonathan Edwards, with its dual stress on the horrors of damnation and the transformative radiance of God's grace. On a broader scale, Freud's manic-depressive fascination with "power's script" was not simply congenial to the American temperament; it *was* the American temperament.

America was the youngest of the world's powerful nations, and Freud's followers were the youngest and most adventurous men in the medical ranks of the day. "Everywhere youth is siding with us," Freud wrote Jung in 1907; the conservative Boston psychiatrist Morton Prince, speaking of his Freudian opponents, referred bitterly to the "cocksureness of youth." Thanks to the radical shifting of the balance of world power in the Great War, America took on the role of economic and cultural leader for the first time in its

history in just the years during which Freud, also given a tremendous boost in status and authority by the events and nature of the war, consolidated his intellectual authority. As powerful arrivistes, Freud and America, more specifically New York, shared in its most acute form the adrenaline rush that was modernism.

4

"YOU ARE ABOUT TO

DISCOVER YOURSELVES"

"A KIND OF MAGIC"

Whatever their disappointment at the failure of psychoanalysis to help their patients in the years after World War I, American psychiatrists at first adopted psychoanalysis precisely because it did yield results, amazing results. During Freud's visit to Worcester in 1909, the New England psychologist and writer G. Stanley Hall, a pioneer in the study of adolescence, asked Freud and Jung to examine a "hysterical" girl whom he and his colleagues had been unable to aid. Under their questioning, she confessed her secret—a sexual obsession with a male acquaintance—and her cure was, Hall testified, instantaneous. The distinguished Boston neurologist James Jackson Putnam, a colleague and friend of William James who served as host to Freud at Worcester and, after Freud's departure, tried out Freud's theoretical assumptions and therapeutic practices on twenty of his most difficult long-term patients, told Freud the results in a letter of November 17, 1909: "[Using psychoanalysis] I succeed in obtaining insights into my patients' thoughts and minds of a far deeper sort than I have ever got before"; all twenty patients showed marked improvement. Putnam presented his findings to the American Neurological Association in Washington, D.C., in May 1910 and garnered an "ovation" (the word was that of the skeptical James watching Putnam's newest enthusiasm from the sidelines) over this victory for the Freudian position.

The patient who most concerned the New York psychologist Trigant Burrow was himself. Years of application to the conventional medical standards of the day had brought him only, in his words, "pain and disappointment and embarrassment"; he thought that traditional psychiatry did not share his concern with the "handling of human suffering." But in 1909 he discovered

149

Freud and Jung, then at the height of their collaboration. Jung analyzed him, and Freud instructed and aided him by letter; the result was a "revolution." "I have found my work," Burrow wrote to his mother from Zurich on October 19, 1909. "A new day has dawned . . . judge of my happiness!" Burrow helped to found the American Psychoanalytic Association in 1911 and later served as its president.

About the same time Max Eastman, the elegant socialist and New York intellectual, got equally good results with psychoanalysis, and he described the Freudian method for *Everybody's Magazine* in June 1915 as "a kind of 'magic,' " a magic that is "rapidly winning the attention of the most scientific minds in the world of medicine." "Are you worried?" he asked his readers. "Have you lost confidence in yourself? Are you afraid? . . . depressed, nervous, irritable, unable to be decent-tempered? Do you suffer from headaches, nausea, neuralgia, paralysis or any other mysterious disorder?" Never fear; Freud teaches us that "we have but to name [our] nervous diseases with their true name and they dissolve like the charms in a fairy story." Psychoanalysis can help "hundreds of thousands of people; its power is almost beyond belief."

Eastman knew he was using "the language of the patent medicine advertisement" to describe the effects of Freudian therapy, and the conjunction is a telling one. The patent-medicine industry was doing a thriving business, and its promise-everything language expressed the American tradition of therapeutics at its most disreputable; in other words, Eastman was openly linking Freud to the least credible of the "dangerous" and "unscientific" notions that Freud had specifically and publicly condemned, and he did so with no visible sense of contradiction. In fact, Eastman had tried a New Thought sanitarium (New Thought was a sibling of Christian Science) for relief from nervous fatigue and psychosomatic backache before being "cured" by psychoanalysis. For him, psychoanalysis was less an opponent of Mind-cure than an extension and an improvement of it.

Freud had a specific example in mind when he attacked American therapeutics in 1909, namely, the Emmanuel Movement, a blend of psychiatry and Mind-cure that both James and Putnam supported at its inception. Its leader, Elwood Worcester, however, incorporated large elements of what he took to be Freudian thought into his own teaching, and in his book, *Body, Mind and Spirit* (1931), he praised Freud's "unearthly ability to describe the unseen." Horatio Dresser, one of the founders of New Thought, also paid homage to Freud, in his *History of the New Thought Movement* (1919), for his illumination of "desire, the will and the love nature." To Dresser, Freud was an "optimist," an opponent of "pessimistic" Calvinism, who believed, as he did, that men can achieve mastery over all "sorrow and suffering."

Worse yet from what one supposes would have been Freud's perspective, his American critics used the same words to dismiss his teachings that they used to attack Mind-cure, Christian Science, and Spiritualism: "occult," "meta-physical," and "psychic." The New York neurologist Joseph Collins scorn-fully lumped psychoanalysis with "Christian Science—and all that bosh, rot and nonsense," and Morris Fishbein, an urbane New York writer, declared it one of the "Medical Follies" of the day, along with Christian Science, Spiritualism, crash diets, and over-the-top advertising of all kinds; psycho-analysis was a "voodoo religion," a "cult," not a "science." Freud's attack on American religious therapy had apparently dissuaded neither his American critics nor his American admirers.

The turn-of-the-century humorist "Mr. Dooley," Finley Peter Dunne, once warned the British: "When we Americans get through with the English language, it will look as if it had been run over by a musical comedy," and psychoanalysis, as it was tossed into a potpourri of indigenous quack remedies and casually spliced with the ideas and methods of those Freud declared to be his foes, might be said to have suffered a similar fate. But Freud's American fans and critics did not altogether misapprehend him. Just as James correctly assessed Freud's long-term aims and effects, those who saw Freud and Mind-cure as allies were accurately gauging his short-term ones. Although their paths diverged after the Great War, although they became rivals and enemies, as James had foreseen, for a brief but critical moment the Freudian discourse and a version of the Jamesian-Steinian tradition of religious therapy seemed to run hand-in-hand, to strike the same chord and seek the same exhilarating goal. Freud attacked the Mind-cure practitioners, I think, for much the same reasons he later savaged the admen of Madison Avenue: they broke his cover and highlighted his own preoccupation with the magical and the intuitive, with the quick and miraculous fix.

Not long before his death, Freud told Ernest Jones, "If I had my life to live over again, I should devote myself to psychical research." The term "psychical research" designated the study of all phenomena that seemed to indicate powers in the human mind beyond those science could officially chart; these were the same powers that James explored with such interest in his last decades. Freud's declaration was a smoke screen, for, in private if not in public, he already had.

Describing his own mission, Freud usually sounds more like a shaman dealing in powerful occult mysteries than a medical man bent on establishing scientific truth. "I really am a kind of Midas," he wrote to Wilhelm Fliess on June 12, 1895; "I have seen the whole psyche . . . laid bare." When Eastman claimed that we have but to name the disease to "dissolve" it, he was, whether or not he knew it, simply paraphrasing, and tempering, Freud's

boast in "The Future Prospects of Psychoanalysis" (1910) that the psychoan-
alyst, like the "magicians" of old, could "dissolve the power" of the "demons"
and "evil spirits" of the mind by naming them. "The more we understand,"
Freud promised, "the more we shall achieve." At the start of his career,
Freud had used hypnosis extensively with his patients, and hypnosis as a
historical phenomenon was a form of mental healing closely associated with
the mind-over-matter school of psychic research. Freud's friend Stefan Zweig
began his study of *Mental Healers* (1931) with a discussion of Franz Anton
Mesmer, the late-eighteenth-century Austrian pioneer in the practice of
hypnosis, who effected his cures by riveting his gaze on his patient's eyes
(hence "mesmerize"); Zweig then moved on to Mary Baker Eddy and con-
cluded with Freud. All three thinkers, Zweig said, had a "Faustian" subtext
to their efforts.

Although Freud dropped hypnotism in the 1890s, he became a member
of both the American and English Societies for Psychical Research in the
1910s, and he conducted extensive experiments in telepathy or mind reading
with Ferenczi and the "magician" Jung (as Freud then occasionally addressed
him). He told his friend Nandor Fodor that he did not "reject the study of
so-called occult phenomena as unscientific . . . unworthy or dangerous."
Indeed, he explained in an essay of 1928 on Dostoevsky that psychoanalysis,
by discovering the unconscious and explicating its powers, had "paved the
way for telepathy." Did this mean that telepathy was the goal of psycho-
analysis? Freud's *Lectures on Psychoanalysis* (1933) included one on telepa-
thy, "Dreams and Occultism," in which he confessed, "It may be that I
have a secret inclination toward the miraculous." He never relinquished his
faith in the miraculous; all his so-called science was an attempt to give it
the status of objective truth.

Americans, too, claimed objective status for their "inclination toward the
miraculous." The French pharmacist and Mind-cure guru Émile Coué, who
secularized Christian Science tenets and tactics for a mass audience in the
years just after the war, taught people to repeat his magic formula: "Day by
day in every way I am getting better and better." If people say these words
often enough, Coué promised, they'll believe them, and if they believe them,
they'll make them come true. During his triumphant tour of America in
1923, Coué told his eager audiences that they were naturals for his method:
"You have long used auto-suggestion [self-hypnosis] without realizing it."
Modern America was becoming famous for its technological enthusiasms,
for its cars, planes, radios, and movies, inventions that changed forever the
notion of what was believable and what was not, and by Coué's logic, such
technology was itself proof of Mind-cure claims; none of it could have been
invented unless people had first thought of it, first imagined it, and trusted

that what could be thought and imagined could be realized in fact. American technology dramatized and guaranteed the practical efficacy of the mind-over-matter approach shared, whatever their differences, by Freud and the various practitioners of America's self-help therapies. Was not Freud himself an inventor and a technologist? The Columbia-trained psychologist Wilford Lay explained in his book *Man's Unconscious Conflict* (1917), yet another translation of Freudian thought into Mind-cure terms, that the power of the unconscious as Freud described it was simply another version of "the power in an automobile's [engine]"; Freud was the first "aeronaut" of the mind.

Americans had long privileged and idealized technology. The United States Commissioner of Patents Thomas Ewbank, speaking to Congress in 1849 about the "infinity of work" facing Americans obliged to make the "natural wilderness . . . into a fit theater of cultivated intelligences," asserted that to be human is to be a "Manipulator of Matter"; a new nation with an immense continent to subdue, America "had to be technological in order to survive," as the historian Alan Trachtenberg puts it. The railroad, new in the early nineteenth century, was the first nationally effective agent of technological empowerment; it dramatically increased the accessibility of raw materials to American industry and bound the continent into a system of megaprofits beyond the reach of the physically smaller British and European nations. Not surprisingly, Ralph Waldo Emerson thought the railroad a "magician's rod" wielded by a "sublime . . . Destiny" "friendly" to America, and John Roebling, who later designed the Brooklyn Bridge, called it "a magic wand . . . open[ing] up the slumbering resources and long-hidden treasures of the earth." In America, technology and magic were synonymous, one and the same thing.

Reserved, disciplined, and titanic, John Roebling possessed one of the most distinguished intellects in nineteenth-century America. He had been trained as an engineer in Germany; philosophically, he began as an Emersonian Hegelian with a strenuous faith in the individual's power to master himself and the world, and he ended by what seemed to him a logical progression, as an enthusiastic Spiritualist, a follower of the "Poughkeepsie Seer," the youthful medium Andrew Jackson Davis. In 1867, Roebling participated in a series of séances held in his Trenton, New Jersey, home in which he reached his recently deceased wife, Johanna, who told him about life in the "Spirit Land"; he had long practiced quasi-Christian Science techniques of self-healing. When he did not contract cholera during one outbreak, an observer said, "He determined not to have it." "The great secret," Roebling explained, is "to keep off fear." But in 1869, he insisted on handling his own medical treatment during an attack of tetanus, or lockjaw, and unfortunately it was fatal.

The Brooklyn Bridge, designed by Roebling and finished in 1883 by his son Washington, was the longest suspension bridge in the world—the New York press immediately proclaimed it "the Eighth Wonder of the World" —and Roebling believed that man's ability to master his environment, to build bridges and roads where nature had left none, was "proof positive that our mind is one with the Great Universal Mind"; the changing forms of matter, whether transformed by human hands or divine will, were manifestations of the "evolution of the Spirit." To Roebling, as to Mary Baker Eddy, matter was a form of stubborn recalcitrance destined to be overcome by "mind," or "spirit" (the terms were interchangeable in Mind-cure writing); a technological achievement like the Brooklyn Bridge provided an exact parallel to a successful séance. Both the engineer and the medium forced the material world to yield up its spiritual design, its *élan vital*, to serve the needs of human empowerment. Some of the early users of the telephone in the 1880s thought it a form of mental telepathy, and the first radio users thought listening to the radio was like being in a séance. The mediums of Spiritualism, just as the word "medium" suggests, anticipated the technological media; both produced voices and messages from thin air, from nowhere. Mind and Machine have the same purpose and get the same result.

Freud regarded himself as a magician exorcising the demons of the psyche and calling on the conscious ego to reclaim the wilderness of the id's terrain, and Americans believed themselves to be miracle workers who had summoned up a civilization from a resistant and untamed land peopled by savages. Freud might find inspiration for his work in the words attributed to Goethe about the children of "Mother Nature" who seek to discover her secrets, but Roebling and his fellow Americans knew that they were engaged in the literal conquest of nature; in the words of an Austrian visitor, Francis Grund, writing about *The Americans* in 1837, they had made of the "mother [land] who gave them birth" a "conquered subject." America was the only Great Power of the nineteenth century that produced three new religions, all of global scope, Spiritualism, Christian Science, and Mormonism, and Mormons were as imperial in their claims on the material world as Christian Scientists and Spiritualists were in their claims on the "Spirit Land." The mind-over-matter philosophy was not simply an American product or tradition but the identity, the actual history of a people who patented much of modern technology and conquered a continent in a brief century or two. Freud might see himself as a pioneer, but Americans considered themselves, in Melville's words, "the pioneers of the world."

As a psychologist, Freud was interested in questions of epistemology— why do people do and see things the way they do? What makes them feel one way and not another? What motivates and drives them?—and he con-

cluded early on that human behavior was not primarily a response to the stimuli of the external world. According to Freud, it was not the conscious and adaptive ego that rules the psyche but the unconscious mind, or id, as he called it, and the id makes no distinction between subjective and objective truth; the unconscious acknowledges as reality what feels real to it, not what is real in objective fact. When objective and subjective reality coincide, it is just that, a coincidence, albeit one that can be consciously sought, for the unconscious mind or psyche neither formulates nor deals with "the reality principle"; it has its own darker and deeper truth, and it makes the world in its image. The somatic school that dominated medical thinking at the start of Freud's career argued that the point of origin for all human perception and feeling lay in the body; every psychological state or impulse had a physical cause. The increasingly powerful Marxist school taught its disciples that economic developments dictated the terms to individual consciousness as to society; culture was merely man's "rationalization" of economic forces beyond his control. But Freud declared that everything begins and ends, not in the body, not in the economy, but in the unconscious mind, the psyche itself. The mind may learn some of its language from the outside world, but the mind, not the world, writes the script that individuals and societies alike read and enact.

This was a revolutionary position because of the complex extremes to which Freud drove it and the scientific framework he attempted to provide for it, but it was not an original one. Despite his disavowal of God, of the divine "mind" or "spirit" Roebling and Eddy discerned at work in the world, Freud's notion of causality was close kin to that of Mind-cure, the creed of the country that seized a continent as mirror to its desires. His insistence on no-God where Mind-cure found all-God was a crucial difference of terminology, interpretation, and emphasis, but it was not a difference of logic, epistemology, or structure. Only Eddy among these mind-over-matter practitioners maintained that there was no reality at all outside the mind, but all of them, whatever their differences of opinion about the fact and nature of the outside world independent of mind, agreed that there was no reality outside the mind equal, much less superior, to the mind's power to create its own reality.

"STRIKE THROUGH THE MASK"

On June 28, 1914, Archduke Franz Ferdinand, heir to the Austro-Hungarian throne, was assassinated in Sarajevo. In short order, the imperial ambitions of Germany and Austria-Hungary were pitted against the allied forces of

France, Great Britain, Italy, and Russia; the United States joined the Allies in April 1917. The Great War introduced the unprecedented horrors of modern warfare—technologically sophisticated, tactically brutal, and psychologically disastrous. The immobility of trench fighting, the stunningly high casualties, which made the Duke of Wellington's famous estimate in the Napoleonic Wars—that no army could sustain more than 30 percent losses and survive—seem an antiquated irony, the new technologies of submarines, tanks, barbed wire, airplanes, machine guns, and bullets designed to wound with the maximum of damage and pain, the lethal poison gas banned by mutual agreement at the meeting of nations at The Hague in 1907 and in use nonetheless—these factors defied all previous notions about what military destruction could mean.

The Great War is often considered the first industrial war, the first "total war," and it was fought, Carl Jung realized, not only in the trenches of the front but also in "the shadow side of the mind," in the unconscious. The war's catastrophic slaughter, and the manifest self-interest and shortsightedness of those who engineered it, discredited the official posture of optimism, the belief in man's progressive conquest of matter adopted to one degree or another by both Mind-cure and psychoanalytic practitioners, but it also underlined and legitimated something of far greater importance to them, their common belief in the mind's dominant role in defining and creating reality.

Not long after the fighting began in 1914, soldiers on both sides started to evince signs of severe mental dysfunction, with symptoms that ranged (sometimes in the same person) from hysterical fits and convulsions to extreme mutism or shutdown; doctors dubbed the disorder "shell shock" and, a bit later, "war shock" or "war neurosis." The term "shell shock" came from the belief that the deafening sound of exploding shells caused this form of illness, but the somatic or physiological etiology was quickly discredited; doctors reclassified shell shock as a mental rather than a bodily disorder, a disorder whose origins lay in the mind.

Shell shock was understood to be the psyche's response to the traumatic circumstances of modern warfare, in which soldiers had both to block and to assimilate military conditions that were fast outstripping human powers of adaptation, but it had, apparently, little to do with physical wounds or actual combat; men who had had little experience of actual combat, who had seen relatively little or no action, sometimes manifested shell-shock symptoms more severe than those of soldiers who had served for long periods on the front lines. Most medical observers concurred that shell shock had made irrelevant the long-standing search for some "unknown physiological basis" for mental illness; as Dr. Thomas Salmon put it in *The Care and*

Treatment of . . . War Neuroses ("Shell Shock") (1917), the "psychological factors are too obvious and too important . . . to be ignored." Shell shock proved to the world that the mind on its own, unaided by bodily illness, could make men sick. If the devastation the Great War brought proved man's mind and his motives to be less trustworthy than the Victorians had liked to believe, it also proved the mind to be more powerful, for ill if not for good, than the Victorians had dared to imagine.

All the major forms of mind-over-matter therapy, from Eddy's version to Freud's, achieved their widest popularity in the decade after the war, but Freud's gains outstripped those made by any other faction. His success was predictable, for he made the most radical, interesting, and sophisticated claims for the mind's powers, and he had the least invested in conventional optimism of any kind. If American Mind-cure could be seen as what William James, speaking of the Spiritualist mediums, called "optimistic mediumship," a kind of white magic that nurtured as it rearranged and surpassed human hopes, Freudian thought, with its strident emphasis on conflict and deprivation, belonged to what James described as "demon theory," or "pessimistic mediumship." This is not to say that Freud found nothing to celebrate in modern man's fate as psychoanalysis understood it; psychoanalysis was a form of black magic, as he proudly acknowledged on more than one occasion, a supreme, intoxicating will to mastery masquerading as stoic despair, and it elicited in its followers the heady confidence that attends the sense of omnipotent powers of explanation inexplicably but decisively placed in human hands.

Freud's mood palpably darkened during the war years. In an essay of 1915, "Thoughts for the Times on War and Death," he announced that the collective "all-embracing patrimony" of a united Europe had been destroyed. In the face of the war's "hideous onslaught," its "excess of brutality, cruelty and mendacity," the ideals of the civilized West were disintegrating; the war's staggering body count, as many as "ten thousand [dead] on a single day," had, in Freud's view, invalidated forever the claim that men control their own lives, not to speak of the notion of a caring god or of a world made in his likeness. He summed it up in a letter to Lou Andreas-Salomé just after the war began: "The world will never be again a happy place." But for Freud and his new discipline, this was good news, not bad, and he knew it. The extremes of violence and corruption that the war exposed in those who waged it during the next few years held no surprises for him. People were behaving, he told Andreas-Salomé, "exactly the way we would have expected [them] to behave from our knowledge of psychoanalysis"; the war was simply forcing men to face "the true state of affairs" and "give truth its due." Postwar Europe would still be a patrimony, if one in different hands, under a different

pater. What Victorian idealism had lost, Freudian psychoanalysis had gained.

The old Victorian way of life might have been "happy," but it was, to Freud's mind, a kind of "impoverishment," "hypocritical," "flat," "superficial," and, worst of all, "safe." Thanks to the war, however, life was becoming "significant" and "interesting again"; "risk" and "battle" and "conflict" were, after all, "the essential content of life," and Freud urged his readers to adopt as their motto the words "*Navigare necesse est, vivere non necesse*": it is necessary to sail the seas, to risk and dare, but it is not necessary merely to live. Always eager to disassociate himself from the country that thought itself his most important ally, Freud specifically identified the old order of hypocrisy with America. Life before the war, he remarked in "Thoughts for the Times on War and Death," was like an "American flirtation in which it is from the first understood that nothing is to happen." In contrast, life during and after the war, now that "truth" has been given "its due," was to be like "a Continental love-affair in which both partners must constantly bear in mind the serious consequences."

Throughout his career, Freud analyzed and referred to linguistic habits and practices as the place where the workings of the unconscious most readily reveal themselves to the psychoanalytic mind. For Freud, language *is* culture; a society can only be as honest as its linguistic habits. His attack on the "hypocritical" and "superficial" prewar civilization of the West in "Thoughts for the Times on War and Death" was at bottom an attack on a culture that refused to call things by their right names, and he had already offered a parable about its overpolite and euphemistic ways in 1910, in "The Future Prospects of Psychoanalysis." There his example had been of an imaginary picnic of "ladies and gentlemen of good society." A woman who wishes to excuse herself "to relieve a natural need" in such a gathering will usually devise some polite phrase, he had reminded his readers—"she is [just] going to pick flowers" is the standard line—rather than say that she needs to urinate or defecate. But if some "wicked fellow" prints on the picnic's invitation that "the ladies" are "requested to say that they are going to pick flowers" when they wish to attend to nature's needs, the "flowery pretext" would be ruined. The ladies would then "have to own up to their natural needs and none of the men will take exception to it"; the ladies would "have to be honest," and the gentlemen would respect them for their candor. Freud, clearly the "wicked fellow" of the parable, wished to accomplish a linguistic as well as a sexual revolution, and it is not surprising that he saw America as his special foe in this area; most of Europe felt the same way.

Visitors to the United States over the course of the nineteenth and early-twentieth centuries again and again remarked with an air of superior amuse-

ment that middle-class Americans enforced conventional linguistic notions of purity and censorship far more stringently than their British and European peers did. Such travelers quickly learned that American women would not tolerate, as their English sisters did, the use of the word "leg"; "limb" was the accepted term. The word "corset" was never used in polite company, and "rooster" was substituted for the more sexually charged "cock." Most common English swear words were euphemistically altered—"damn" became "darn" and "dang," "goddam" became "doggone" and "gosh darn," "Lord" became "lawdy" and "lawsy." In 1915, the American National Council of Teachers of English established a "November Better-Speech" week; variations included, "Ain't-less Week" and "Final-G Week," and there was a "tag-day" on which schoolchildren guilty of grammatical lapses like "I have got" and "It's me" were forced to wear derisory signs identifying their crime.

Euphemism, the substitution of a more genteel term for a crude one, is a linguistic practice usually associated with those achieving respectability and cultural responsibility for the first time, those who wish to advertise their new standing in everything they do, those whose notions of linguistic acceptability are by definition borrowed, not innate, and it was second nature to Victorian America, a new nation intent on proving its credentials to a skeptical world. Although America at the turn of the century was the biggest and fastest-growing economy in the world, it was not yet perceived as equal to the other Great Powers in military, diplomatic, or cultural force. The military and diplomatic issues were interwoven. Little diplomatic importance could be ascribed to a country that, in the heyday of the formal alliances of the Great Powers of Europe, was isolationist, even if aggressively aggrandizing at its borders, a country that devoted a mere 1 percent of its admittedly huge gross national product to defense (compared to Germany's 4.6 percent and Russia's 6.3 percent). The United States Navy was more than adequate, but its on-the-ready front-line army was only one-tenth the size of Russia's. Moreover, if America left Europe to fight its own battles, it also let Europe, most particularly England, supply its cultural fare.

When the high-bred young British poet Rupert Brooke visited the United States in 1913, he reported contemptuously that America, culturally speaking, was "utterly dependent" on England; the magazines were devoted to English topics and "filled with English writers." Finding only American architecture, children's clothes, and "the jokes" worthy of commendation, he concluded, "America is still our colony." He had a point. In 1912, America's literary commentators devoted as much time and space to the centennials of Thackeray and Dickens as the English did. Few students read American writers in school. The Modern Language Association of professors

of English in the United States had no branch for Americanists; as late as 1917, only two professors of English in the entire country—Fred Pattee of Pennsylvania State University and William B. Cairns at Wisconsin—specialized in American literature. Mark Twain was America's most popular author, but he was regarded in many quarters as an imprudent if gifted writer for boys; *Huckleberry Finn* and *Tom Sawyer* were on the Restricted List in Brooklyn's public libraries as late as 1906. Walt Whitman was considered a brash and improper renegade, and Herman Melville was remembered, if at all, as a "romancer" of South Seas adventure. America was apparently still too involved in its explosive gestation process to do its own cultural thinking or recognize those in its midst who had already done so.

Although Freud did not write on the euphemisms and coy falsifications of the American language, he applauded those who did. Mark Twain might raise eyebrows at home, but he was the only American Freud included in a list of his ten favorite authors; in *Jokes and Their Relation to the Unconscious* (1905), he praised Twain's comic destruction of the "economy" of "pity" and "piety," the sleights of hand by which he persuaded his readers to endorse an ethos of "hardheartedness." A master of the American vernacular, Twain, like Freud, believed that language told the tale as no other cultural phenomenon could; he once remarked that the difference between the wrong word and the right one was the difference between a "lightning bug" and "lightning," and Mary Baker Eddy was his *bête noir* as surely as she was Freud's. Twain had tried out Christian Science techniques of healing himself; he analyzed what he deemed Eddy's "self-deification" and the euphemistic language that accompanied and accomplished it in a book entitled *Christian Science* (1907). Appropriately, he wrote the first third of it while living in Vienna.

Even William James complained about the "preposterous . . . phrases" of "weak talk," fake Latin, and "gushing" poetry the mediums and healers he frequented were liable to use in their various trances and exercises—at such moments he "hated the whole thing"—and Twain set out, like the "wicked fellow" of Freud's parable, to demystify such euphemistic excess once and for all. Eddy's chief crime in Twain's eyes was that she had "no ear for the exact word," and his book is a case study of a Titaness and her language, a not-so-mock trial in which all the damning evidence against the accused is supplied by herself. As Huck Finn wrestled with the sickly verse of Emmaline Grangerford, Twain struggles valiantly, hilariously, to make sense of Eddy's strangely private but "oracular" pronouncements, her "unknown tongue" of "insane metaphor" with no "traceable meaning," her pretentious "verbal discharges" redolent with unearned "serenities of self-satisfaction."

Contemplating a couplet by Eddy about a rural paradise where "Palm, Bay and Laurel in classical glee, / Chase Tulip, Magnolia and fragrant Fringe-tree," Twain remarks in mock admiration, "Vivid? You can fairly see these trees galloping around!" Surely, he suggests, Eddy's own description of her new language in her memoir *Retrospection and Introspection* was the give-away evidence of her incoherent but imperial linguistic mission: "Grammar was eclipsed; etymology was divine history voicing the idea of God in man's origins and signification. Syntax was spiritual . . . prosody the song of angels"; her declared fondness was for the "spiritual noumenon and phenomenon [that] silence portraiture." Twain greatly admired some of Eddy's prose, in particular the first version of *Science and Health*, but he and others assumed that anything published under her name that gave evidence of literary talent was probably ghost-written or plagiarized; he was compelled to strip her of her power to make language, bad or good.

In Twain's view, Eddy's heightened and obscure language was nothing but a decoy device used to distract attraction from her real aim, that of acquiring worldly power and making money on a scale unbelievably immense. Stefan Zweig called Eddy a "conquistador," the word Freud liked to use to describe himself, and Twain saw her as a Napoleon, "the only really absolute sovereign that lives today in Christendom," a shrewd dictator who had usurped, if not destroyed, male prerogatives; in his phobic metaphor, her "spiritual X-ray" can "pierce the dungarees" of the most "blameless . . . member," find his secret fault, and order him "to the block." Eddy could outwit "Satan himself." Twain spent much of his life pursuing get-rich-quick schemes, none of them successful, and his envy of Eddy's business genius is palpable on every page he wrote about her; he marvels that she started out with "nothing," took what had been a "sawdust mine" and "turned . . . [it] into a Klondike."

In actual fact, Eddy was one of the most astonishing success stories of a nation and a century that boasted of nothing else. Born Mary Baker to a modest New England family in 1821, her girlhood was scarred by struggles with various nervous disorders and painful efforts to free herself from the relentless Calvinist theology of her father; she aligned herself with the gentle creed of her adoring mother and began to develop what she called in *Retrospection and Introspection* her "daydream" of a better faith. As a young woman, she found nourishment for her messianic ambitions in the best-selling melodramatic novels of Mrs. E.D.E.N. Southworth about womanhood beset, indomitable, and triumphant, but she found no adequate field in real life for self-expression.

After decades of ill health, several unsuccessful marriages, and long weary years of scraping a living in the feminine subculture of New England board-

inghouses and Spiritualist activities, Eddy, then in her forties, found her savior in a New England lay healer called Phineas Quimby, who restored her to health and gave her, at last, her lifework. After Quimby's death in 1866, Eddy adapted—or, as many, Twain among them, charged, stole—his secular techniques of healing and joined them in a stroke of genius to the tradition of faith healing established by Christ and his Apostles. A self-proclaimed worker of miracles, a driven talent, Eddy went on to write the Christian Science bible, *Science and Health with Key to the Scriptures* (1875). The book was lucrative, since several hundred revised editions of it were issued in the course of her lifetime, and all Christian Scientists were required to read only the most recent one.

After the initial publication of *Science and Health*, Eddy founded a series of "colleges," as she liked to call them, to teach *Science and Health* and Christian healing; then she established her Mother Church in Boston and instituted, a bit later, two journals and a publishing house, all organized effectively into a commercial empire dedicated to spreading her new faith and building up her own power within it. By the 1900s, when Twain wrote *Christian Science*, Eddy's church had branches throughout the United States and Europe: it boasted more adult women, more urban residents, and more wealth among its members than any other sect in America. Twain predicted that, by 1940, Eddy's church would be the ruling power, sacred and secular (if such a distinction could persist in the Christian Science state he saw coming), in the United States. He was mistaken—Christian Science's growth rate slowed, then more or less stopped in the 1930s—but he accurately described the momentum of Eddy's meteoric rise.

Twain couldn't have known the full story of Eddy's last years, for she spent them locked away from an inquisitive press eager to report on just how well America's chief exponent of the mind-over-matter school of popular therapeutics was withstanding the deterioration of body and intellect old age brings to less elevated mortals. Eddy and Twain died, fittingly, in the same year, in 1910 (she was eighty-nine, he seventy-five); her end was prolonged, histrionic, and gallant. Despite extreme age, poor health, and undoubted mental illness of a hysterical and paranoid nature, despite continuous lawsuits and accusations, far more vicious than Twain's, brought against her of "witchcraft" and "insanity"—"If I were a man they would not treat me so," she remarked in an impressive moment of understatement—Eddy kept her position intact until her death. On one occasion, when Calvin Frye, the most loyal of her several male handmaidens, seemed to be at the point of death, she ordered him out of his coma—"Calvin! Wake up! Disappoint your enemies!"—and he did. In 1927, seventeen years after Eddy's death, the New York *World* printed the testimony of Carl Gluck of Oakland, California,

that she had been born again and "was, in fact, now twelve years old, living as a little girl, unaware of her future mission, in the western part of the United States." Twain, for one, would not have put such a feat past her; he debunked her language but never her ambition or her power. Freud found in Eddy a rival authority as well as a "wicked" and "insane" enemy; Twain thought she might be "the most interesting woman that ever lived."

With his keen and jocular insights into the emerging consumer society of his day, Twain was frequently invoked as a patron saint of Madison Avenue, and a version of Eddy's euphemistic practices found an outlet there as well. In a study titled *Advertising to Women* (1928), an advertising man named Carl Naether advocated dropping into "woman's own language" to entice female buyers. Women should be sold, not plain hot-water bottles and electric heating pads—far too "impersonal" in Naether's view—but "cuddly and comforting" ones; not window shades, but "such sweet shades!" Feminine exile, or liberation, from exact language was to meet the needs, not, as Eddy hoped, of women, but of the male advertising industry designed to exploit them.

Nor was American euphemism, its critics charged, restricted to the female sex; Freud was not the only one who sensed an affinity between Eddy and Woodrow Wilson. Wilson went to the postwar peace negotiations held at Versailles in December 1918 an international hero, hailed by Americans and Europeans alike as "superhuman," "shining!"—in the words of William Bolitho. A complicated, learned, and at times insightful man, he saw a "tragedy of disappointment" ahead. "Wait until they turn," he warned, and turn they did. Indeed, the Wilsonian ideals propounded at the peace talks seemed to most observers to be fraudulent from the start. Wilson came to Versailles publicly pledged to nothing less than "the establishment of the eternal principle of right and justice"; in his own grandiloquent words, "We Americans have no selfish end to serve." In Ben Hecht's eyes, Wilson, trying to impose on wily and sophisticated European statesmen what he thought to be American ideals, resembled "a virgin in a brothel sturdily calling for a glass of lemonade."

Congress refused to support the League of Nations, which represented all Wilson had been able to salvage from the Versailles Conference. Driving himself mercilessly on an odyssey of speech-making across the country in a last-ditch effort to rally the people to his side, he suffered a mysterious series of official "nervous breakdowns" and less official strokes that made his remaining year in office a nightmare for himself, his supporters, and much of the nation. Wilson was a man of public piety, a "mama's boy" (in Freud's phrase) compulsively in need of feminine company, and when he was incapacitated by illness, some thought his second wife, Edith Bolt, was running

the country; people other than Freud talked of America's "petticoat govern-ment." Still in his own eyes a model of rectitude, Wilson retired unhappily in 1920, relegated to the junk heap of history with Pollyanna and Molly Make-Believe. Mencken called him "the perfect model of the Christian cad," and some thought, or hoped, he had taken respectable Protestantism down with him.

In 1920, during Wilson's disastrous last year in office, a public-relations man named William Hale, a disillusioned Wilson supporter and campaign biographer, published a scathing indictment of Wilson's rhetoric, *The Story of a Style*. The book reads like a self-conscious continuation into masculine territory of Twain's attack on the language of Christian Science. According to Hale, there was not one fact or sincere belief in any word uttered or penned by Wilson; his language is compelling not for the truths it contains but for the secrets it gives away. Hale sent a copy of his book to Freud, and Freud told him that it exemplified "the true spirit of psychoanalysis." He, too, Freud confided, held Wilson as "responsible" as any one person could be for the present "misery of the . . . world."

As Hale paints him, Wilson is a man "infatuated" with words, basking in a state of "fascination" and "fetishism" with his own grandiose language, a vain, insecure man turning language into a self-involved dalliance to assuage his own doubts and fears. Hale notes Wilson's fondness for adjectives, which retard, and his avoidance of verbs, which activate, and details what he sees as a habitual overuse of linguistic forms that stave off the hard work of realistic analysis: epithets ("fateful days," "quiet days," "spreading Delaware," "broad Delaware"), prefatory assurances ("I feel constrained to say"), inten-sifiers ("veritable," "surely"), meaningless but attractive abstractions that res-onate with purposeless nobility ("it was the stuff of his character"), and leisurely anachronisms ("perchance," "for the nonce," "a whit"). Wilson's verbal tricks comprise an elaborate window display of goods that are not in stock. Hale's point, like Twain's in *Christian Science*, is (to appropriate the title of a recent book by Paul Slansky on the Reagan era) that these "Clothes Have No Emperor."

We need not push too far the parallels between the language of Eddy and that of Wilson. Eddy's strange inventive idiom, with its refusal of conven-tional logic, was the language of a subculture whose day of power had come attempting to refashion standard mainstream speech. In contrast, Wilson's language was that of the dominant power block in his culture, white Prot-estant men of good birth and high education, a language once brought to extraordinary heights but now far gone into obsolescence. Wilson played not, as Eddy did, with new and private phrases but with hypnotic clichés. But the similarities are at least as compelling as the differences. They both

specialized in what Edmund Wilson called "the development of language beyond its theme." The "addiction . . . to the mimic fray of words" which Hale exposed in Wilson is close kin to the "serenities of self-satisfaction," the self-love gone pathological, that Twain condemned in Eddy. Both seemed to seek what Stefan Zweig, describing Eddy's goal in *Mental Healers*, called "the castration of reality." And they both appeared regressive: Twain had concluded that Eddy's narcissistic prose was "not grown-up English" but "nursery" talk; Wilson's linguistic habits were, to Hale's mind, infantilism masked as pious platitude.

Freud's picture of America as the home of pale imitation and florid euphemism dominated by "an astounding mother fixation," as Gilbert Seldes called it in *The Stammering Century*, was, of course, too simple. Rupert Brooke and Freud alike noted the power and originality of the American joke, but both missed it. America might be the country where people talked of "limbs" instead of "legs," but it was also the country, Mencken told the readers of *The American Language*, where people said "vomit" instead of "get sick," the phrase preferred in England. America became the source of much of the English-speaking world's slang in the twentieth century, and slang is dysphemism, the substitution of a more brutal and graphic word for a conventional or polite one. The attacks by European visitors on America's euphemistic excesses notwithstanding, the struggle over the American language was waged largely by Americans; it was a civil war.

America specialized not only in prohibition (with or without the capital letter) but also in defying it, and the logic behind this apparent contradiction was precisely the one Freud enunciated in "Thoughts for the Times on War and Death." The repressed but uninhibited "primitive mind" always returns, he wrote; the more violent and complete the attempted repression, the more violent and complete the return. According to this line of reasoning, America, as the most imitative, hypocritical, and feminized nation among the world's major powers, might also be the one most clearly marked and ready for an explosive and masculinized liberation into cultural originality. If America was a "raven in a white shirt," a land of savages masquerading as a civilization, by Freud's own logic it would sooner or later show its true colors, and several of Freud's followers, more sympathetic to America than their mentor, saw the picture he drew but refused to read aright.

Carl Jung, in New York on his third visit to the United States in 1912, gave an interview to *The New York Times* which was published in the Sunday magazine section on September 19 under the heading "America Faces Its Most Tragic Moment." Jung's message to America was a bold one. "You are about to discover yourselves," he announced; "you have discovered everything else." Americans had conquered a continent and built a business empire

that was the talk and envy of the world, but Jung reminded them that they played no part in forming the world's art and literature, and he told them why: their pseudo-Victorian culture was a hypocritical and dishonest one that had nothing to do with the realities of the American psyche. In his view, this intense "prudery" came from dissatisfied women, who had been given cultural control instead of the sexual fulfillment they craved, who were venerated but neglected by men afraid to meet the challenges of adult sexuality; the American man, in Jung's words, wants "only . . . to be the obedient son of his mother-wife." Ruled by unhappy and vindictive women, America is torn between the "great abstractions" of its Puritan founders and the primitive "unconscious" of its Negro underclass. "The Negroes," he half warns, half exults, "are really in control." Americans must "analyze" their overdeveloped need for "self-control" and "admit that you have been hiding from yourselves." As Twain saw Eddy's euphemistic language as nothing but a mask for her aggressive ambitions, Jung believed that American prudery was simply "the cover for brutality." The nation would have the great future it deserved only if it had the "courage to face itself."

Eleven years later, D. H. Lawrence brought this picture of American culture as pious platitude masking primitive ferocity to its most incendiary realization in his pathbreaking *Studies in Classic American Literature*, a freewheeling presentation of America through its literary masters from Benjamin Franklin to Walt Whitman. According to Lawrence, America was founded by men who, whatever their conscious intent, were in reality fleeing the "cul de sac of . . . liberal Europe" in order to "slough the old consciousness off completely." The "essential American soul," he proclaimed, is "hard, isolate, stoic" and a "killer"; America is full of "vampires," the "terrible . . . ghosts" of the black and red men the white settlers had exterminated, exploited, and, unbeknownst to themselves, envied and assimilated. For Lawrence, America was a King Kong figure—King Kong's cinematic debut was only a decade away—careening amid the wasteland of the West, and he was King Kong's prophet.

Lawrence called the American literature he was writing about "classic"—recognized and revered, in other words, by those acknowledged to be best able to judge the matter—but next to no one knew it. Using the term was, in fact, a publicity stunt, Lawrence's bold bid to canonize a group of authors who were largely ignored, forgotten, or misread. Writing brilliantly, inventively, of Melville and Hawthorne, of Cooper, Poe, and Whitman, he established their reputations, still good today, as great modernist writers far ahead of their time, and he did this by demonstrating their uneasy, uncontrollable, and profound expertise in the life of the unconscious.

Lawrence's watchword in *Classic American Literature*—"Trust the tale and not the teller"—is an example of the Freudian ethos of aggressive over-interpretation at its most imperial; he intended to "out," as we say today, the real America from its closet of pseudo-gentility. According to Lawrence, the reader of classic American literature should ignore the professed concern for piety, the feminized notions of good taste, the bogus tributes to the ideals of American democracy and domesticity that, he freely acknowledges, one finds on every page of Cooper and Hawthorne and Whitman, that even Melville is not free of. The reader must go through such superficial material—the "tellers" have put it there merely as a front—to the real meaning of the American "tale." Despite his lover's quarrel with Freudian thought, Lawrence was a self-confessed victim of the Oedipus complex, a tortured pilgrim to the sites of archaic culture, and he discovered in classic American literature a map of the repressed "primitive" psyche of the Western world, a psyche filled with images of black and red men, with incest fantasies, Oedipal and matricidal motifs, Satanism, the "death impulse," and all that lies "beyond pain or pleasure." It was time to end American "duplicity" and eliminate the "tame wolves," he believed, to "pull [off] the . . . idealistic clothes" of American utterance and "see . . . the dusky body" beneath. His injunction had been anticipated by Melville's Captain Ahab: "Strike through the mask!"

As Lawrence and Jung saw it, America was a test case of gigantic proportions. Because America's repression had been more complete than that of any other country, its inner nature of "brutality" more extreme and more at odds with its public mask and voice than was the case anywhere else, its liberation would be correspondingly more powerful and influential than what any other nation could hope to experience. Indeed, America might be the only country capable, if uncensored and unchecked, of flooding the civilized world with what William Carlos Williams called in his self-consciously Lawrentian study, *In the American Grain* (1925), "rich regenerative violence." America stood to lose, not an identity, but a disguise. "In America," Jung told the nation in 1912, "you can be anything"—even, perhaps, yourself.

MODERN MANIA

The optimistic mood of the years before the Great War was not sustained. This was particularly the case with Freud and his followers; Freud himself retracted the promise-anything language of "Future Prospects of Psychoanalysis" and the dark hopes of "Thoughts for the Times on War and Death."

The war did not shatter cultural resistance to psychoanalysis, as he had said it must; nothing, he came to believe, could or would eradicate the world's unwillingness to acknowledge what he took to be truth and reality. In the United States, too, millennial expectations were put away. Max Eastman, distressed and put off by the violence of Freud's distaste for America, qualified his own enthusiasm for Freud. And Putnam, Burrow, and Hall, like Freud's disaffected European followers, began to realize that psychoanalysis neglected, in Burrow's words, the "moral values" of "the unconscious personality," or, as Putnam put it, the "fundamental[ly] social character of all psychic processes." Putnam died in 1916, before he could fully formulate the modifications of Freudian theory he thought necessary; Hall turned to the ever more mystically minded Jung; and Burrow became, to Freud's visible displeasure, an exponent of the "Nest Instinct," of the "primary identification with the mother," and one of the founders of that most American of therapeutic practices, group therapy.

Retractions like these seem natural responses to overconfidence, to elated states of mind that appear in retrospect to have been unfounded, even delusional; the swing down always succeeds the excessive swing up. The heady belief that mind could and did control matter, not the other way around; Freud's conviction that the Great War would "force" men to "give truth its due"; the sense of revelation that Putnam, Hall, and Burrow had experienced in their first encounters with Freud and his new discipline; Eastman's excitement about psychoanalysis's "magical" powers; Wilfred Lay's unthinking reliance on the marvels of American technology as indicators of a new and wonderful Freudian world order; the apocalyptic tone Jung and Lawrence adopted as they urged America toward self-discovery—all these seem to qualify as signs of "mania," as instances of magical thinking, the belief that willing or wishing makes it so, the dangerous conviction that revolutionary change can be unimpeded or altogether beneficial. In all these exhortations and prophecies, something is too high-pitched, too strident. Freud called it denial or "negation"; Constance Rourke, speaking of the American character in *American Humor*, spoke of the "blind wish to exhibit power." Something crucial is missing: the price tag. What will this revolution in consciousness cost?

I do not wish to downplay the obvious manic-depressive pattern in modern American culture. The economic boom of the 1920s was followed by the Depression of the 1930s; Frederick Lewis Allen, writing in 1931, said, "Action and reaction; the picture was now complete." Similar turnarounds have characterized American culture past and present. But the evidence of this mania as we see it just after the Great War must be assessed historically before it can be diagnosed clinically or psychoanalytically; that hyperbolic

thinking is later retracted does not mean it was altogether false to the circumstances that engendered it. Sometimes history hands people more reality, more bad or good events, than they can fully assimilate. In the best as in the worst of times, when more is happening than people can process, they jump past the mind to the instincts, and this jump is itself a source of adrenaline, the chemistry that makes quick sense of what baffles the mind.

The psychiatrist Ronald Fieve, an expert on manic depression or, as he prefers to call it, "moodswing," has distinguished between sheerly pathological "mania" or "grandiosity" and "grandiosity with a basis in fact"; this distinction offers, I think, a key to understanding the American cultural scene after the Great War. Eastman's notion of indisputable "magic" endorsed by "the scientific mind" contained an important truth: the human mind *was* accomplishing marvels with the hitherto intractable material world; Freud *was* making discoveries that would alter people's perceptions of themselves forever. The Great War did indeed usher in an era of unprecedented, shocking, and masculinist truth-telling; America on the eve of the war was in plain fact flush, powerful, poised for a breakthrough as momentous as victory. As Freud's "Thoughts for the Times on War and Death" testified, even a moment of historical upheaval like that of the Great War offers its own brand of intoxication. This does not mean that the moderns' elation was an adequate response to the new facts of the day, but it may well have been the only response that was humanly possible.

Young John Dos Passos, a volunteer during the war, wrote home from France that it was "hell," but, he added, in a phrase that could stand as an epigraph for the ethos I am describing: "Hell is a stimulus." Many minds, some of them very different from Freud's, acknowledged this truth. In fact, Freud's ablest adversaries, William James and Gertrude Stein, saw modern life in similar terms. One of the last essays that James prepared for publication before his death in 1910 had been "The Moral Equivalent of War." On the face of it, James's essay seems very dissimilar to Freud's "Thoughts for the Times on War and Death." James was proposing to abolish war in its lethal form and replace the world's armies with a global task force of youth dedicated to providing services rather like those John Kennedy's Peace Corps of the 1960s was intended to offer. James's premise was that men cannot, indeed should not, abolish war without finding another outlet for the energies that war taps and incites. War is, James thinks, part of civilization and an invaluable part. Freud wrote in "Thoughts for the Times on War and Death" that men are all "murderers at heart," who go brutally to brutal wars, and James, too, knew that "history is a bath of blood." In an essay of 1903, protesting lynching, he had written of men's "aboriginal capacity for murderous excitement"; the "carnivore" within is contained by "artificial," not

"organic" means. He did not underestimate the destruction man's darker side can wreak, the wars and savage violence it precipitates, but he acknowledged that it was the "horrors" of war, the fact that it was "life in extremis," that made it compelling and fascinating.

James didn't write of "civilized hypocrisy" as Freud did; he didn't see the individual's conscious life as mere deception, but he, too, believed that "civilized man" had developed a "double personality." "Civilized man" may espouse peace and justice, but at bottom he scorns the "sheep's paradise" his ideals, if carried into action, would institute. He railed at the "atrocious harmlessness" of American middlebrow culture (very much including its Mind-cure elements), and he thought, as Freud did, that the conversion to a "pleasure economy" or anything like a full-blown consumer society could be "fatal" in its "disintegrative influences." Although he hoped that the "Fear" (the capital letter is his) from which war springs was "not . . . the only stimulus . . . for awakening" men's fullest "energy," he, too, said that it was the chief one. For James as for Freud, "hell is a stimulus."

Gertrude Stein viewed the Great War as a lucky break for herself and her brand of experimental modernism; her life passed in the midst of what looked in retrospect like continuous warfare, and she acknowledged this happily. Born less than a decade after the Civil War ended, a war Stein considered the most important event of the nineteenth century, she liked to describe herself as a Civil War veteran, and her adult life was spent surviving and explaining two world wars. *The Autobiography of Alice B. Toklas* centered on the Great War; its sequel, *Everybody's Autobiography* (1937), was filled with her awareness of aggressive Fascist dictators looming large and ominous; and her third and last autobiography, *Wars I Have Seen* (1945), told the story of her life as an imperiled Jewish civilian in occupied France in World War II. The history of modern war was Stein's autobiography.

One must remember that the counterphobic strategies of which Stein was a past mistress have meaning only in a world where there is much, perhaps everything, to fear, where "Fear" with the Jamesian capital letter calls the shots. "There is so much to be scared of," Stein remarked; "so what is the use of being scared[?]" When everything is terrifying, fearlessness becomes the only option if one is to live at all. Stein's pose of preternatural calm, her comfortable air of ironclad common sense, gains its full value only on the assumption that the rest of the world is given over to fearful frenzy; her humor gets its edge precisely from the failure of the rest of the world to see the joke. Having cornered the market on showy serenity, she sits, immense and heavy, on a mother lode of scarce supplies. Only disasters of world magnitude could create a composure so self-conscious and implacable.

World disasters were Stein's cue; their energy was her placidity. She was not, however, extolling or minimizing the casualties of war but, rather, celebrating the human power to persist through calamity, and advertising her own abilities to utilize the extreme energies that war unleashes for her own purposes.

Stein's writings about World War II—"The Winner Loses: A Picture of Occupied France," published in *The Atlantic* in November 1940, and *Wars I Have Seen*, a big seller in the United States—read as the culmination of her experimental art of concrete therapeutics. What becomes clear is that Stein's program for living—learning how "not to think and not to plan" and relying on "everybody," on the "comfort" that one's fellow human beings, whether they be friends, acquaintances, or strangers, bring as partners in the business of daily life—is, in fact, the program that wars and other major emergencies automatically put into operation. In the face of overwhelming common danger, acquaintances become, if only for the moment, allies; not worrying about the larger and darker picture becomes the strategy of survival. Stein tells us that only those in desperate straits know the miracle of relief; only for the hard beset can sheer breathing be pleasure, excitement, and comfort. Only they know the value of "life, dear life." War made sense of Stein's aesthetic because that aesthetic was created by and for something like wartime conditions; her aesthetic worked best, in other words, in the wartime zone that passed for modern life.

Freud had hoped the Great War would destroy the nineteenth century's belief in that bogus notion called "progress," and Stein rejoiced at what she took to be its final demise in World War II; the nineteenth century was at last "dead, stone dead." As Freud found that the Great War had made life "interesting again," Stein noted in "The Winner Loses" that habitual activities that had become "a bit of a bore" in peacetime were now, when they could be pursued only at odd moments and unexpectedly, "most exciting" again. People have become "more wide awake than they were"; "they feel alive and [they] like it." Different as her celebratory ethos was from Freud's histrionic stoicism, for Stein, too, hell was a stimulus.

The Jamesian-Steinian version of the Mind-cure discourse and the Freudian one seemed for a brief but critical period of time to work together, to seek the same goal, and they did so in good part because of their common valorization of energy. Freud called the energy principle the "id," or the "unconscious," or the "instincts." James, following his friend the French philosopher Henri Bergson, called it the "*élan vital*" or the "subliminal self." Stein knew she belonged to an "excitement-loving" people, and the word "excitement" in all its forms orchestrates the last section of *Wars I Have Seen*, "The Coming of the Americans." Whatever definition they gave to

it, these three all knew that energy could be potent for ill as well as for good, but nothing, to their mind, altered energy's status as the premier commodity, ethos, and aesthetic of the modern era.

Energy of every kind, from calories and vitamins to atoms and X-rays, from technological forms of acceleration to the drives of the unconscious, from gasoline to electric light, was being newly corralled and calibrated. At the simplest level, energy is a more or less neutral flow of life and power, the fuel of any enterprise, whether an automobile or a human psyche. But energy can be put to widely divergent uses. The airplanes that were beginning to carry the world's mail from one place to another in the 1910s, for instance, were quite different in purpose and connotation from the lethal bombers that first appeared over Europe's skies during the Great War. The energy of the psyche can be channeled into very different enterprises, too; the psyche's energy, even in excess, may result in highly creative achievements, but it can also manifest itself as unexamined and irresponsible acting out. Channeled super-energy constitutes something like what Fieve calls "grandiosity with a basis in fact," what Gilbert Seldes called the "surcharge of genius"; it is high energy running on real resources to effective ends. But when the energy flow is unchecked and unresponsive to the needs of the organism, it becomes pathological, a self-destructive drive to power, a form of clinical "mania," what Jack London termed a "nerves marathon," an energy spurt that exceeds the organism's powers of absorption, direction, or renewal.

"Mania" was a topic of great interest to Freud; in *Civilization and Its Discontents* he defined it as "a pathological state in which a condition similar to intoxication arises without the administration of any intoxicating drug." Despite his comparison of the "flat" and "superficial" prewar era with "an American flirtation," he knew that America spelled extreme energy, but he insisted that it was a "pathological" if seductive "mania" bred by the cheap and uncritical profusion of American wealth and opportunity and the hysteria of American women, a mania doomed to short-circuit and produce America's extinction. Trigant Burrow, too, believed that cultures fall ill just as individuals do, and on the subject of American mood swings, he was squarely in Freud's camp. He described America's economic "inflations and . . . depressions" in the mid-1920s as "compulsive reactions . . . the fluctuating mental states . . . of an unstable social cyclothymia." ("Cyclothymia" was a medical term for manic-depressive insanity.)

William James was hardly a mindless fan of American energy. Freud, situated in the heart of an increasingly aggressive Austrian-German empire, had few specific condemnations to offer of his own world, but James turned a sharp eye on such tendencies in his own country. He saw America's aggrandizing imperialist activities dramatically played out in the conquest of

the Philippines, and the extirpation it spelled of what he termed (in an essay of 1899 on "The Philippine Tangle") "the precious beginnings of an indigenous natural life," as ominous signs that America was indulging in "a wayward spree of power." He cautioned his fellow citizens to beware of the notion that democratic America was somehow better than other nations; such a notion was, in James's words, an "idle dream! Pure Fourth of July fancy." A decade before Jung made the same point, James was urging Americans to "rid [them]selves of cant and humbug, and . . . know the truth about [them]selves" lest the "American soul" suffer "perdition."

But by the same token, James did not see America as worse than other countries, as Freud did; its ugly imperialist tactics abroad and racist practices at home alarmed him precisely because he felt it had so much to lose, because he saw its greatest strengths feeding its most hideous defects. That his country was hardly exempt from the faults of other nations did not to his mind mean that its virtues were not precious, even unique. He apprehended America at its deepest reaches as a religious and psychological entity rather than as a political one, and he felt, as Stein did, that there its energies were in some sense to be trusted, that the risks it ran were necessary and creative. Without sanctioning America's imperial excesses, without thinking it exempt from the problems common to all nations, he recognized that, under the right circumstances, acting out can be working out. Where Freud insisted that America could not control its energy flow yet must do so in order to survive, James and Stein believed that, in the words of Marianne Moore, another of James's disciples, "one need not know the way to be arriving."

The difficulty of diagnosis in the American case arises from the fact that the two kinds of mania, healthy and pathological, overlap in their place of origin and their mode of operation. Much of American—as of European—modernism, with its reification of the future and of the drives and instincts, its investment in form breaking and convention smashing, falls in the area, difficult to chart, that lies between exhilaration and hysteria, between "grandiosity with a basis in fact" and pathological mania insufficiently grounded in fact, between a trust in energy as surplus life and a worship of energy as force. Both forms of energy spell an excess of the will to appropriate and aggrandize; both represent an extreme excitation of the belief system, a state in which the mind entertains notions "almost beyond belief" (Max Eastman's words about the power of psychoanalysis). Whether healthy or ill, the manic person believes everything that he wants to believe and nothing that he doesn't. Both forms of mania allow their possessor to make feats into facts, to live more vividly and to accomplish more, much more, than people can usually do in the normal course of things. Both hold out the giddy promise

of a "bonanza," as Fitzgerald termed the astonishing good luck that some-times seems to attend the energy freak, of getting something, if not for nothing, for what feels and looks like next to nothing.

One might say that self-knowledge, the awareness that stops people, and nations, from spending money they don't have, from making promises they can't keep, is the key to distinguishing healthy mania or excess energy from unhealthy. But this definition, too, leads to problems, for certain kinds of energy clearly operating outside the realm of conscious knowledge and control nonetheless feel like something close to self-knowledge, getting the job done faster and better than self-knowledge ever can. Peak energy—the kind Fitzgerald felt that afternoon in New York in the early 1920s riding in a taxi between tall buildings under a "mauve and rosy sky" and "bawling" because he knew he would "never be so happy again"—feels like knowledge, not just of the self, but of the cosmos. Peak energy, the special vitality that the historian Paul Kennedy, analyzing America's meteoric rise to world prom-inence, has called the "indefinable 'plus factor' of self-confidence and will-power in a people whose time has come," peak energy of this kind can feel like destiny, and what more powerful form of self-knowledge is there than the sense of fate backing one's enterprise?

In *The Psychopathology of Everyday Life*, Freud wrote that all "the great and important decisions of the will" feel "fated, blind and impulsive." To illustrate his point, he quoted Martin Luther's declaration (one crucial to Freud and often cited by him) as he kicked off the Protestant Reformation at the Diet of Worms in 1521: "Here I stand; I can do nothing else" (*"Hier stehe ich, ich kann nicht anders"*). As we make such choices, Freud contin-ued, we feel we are acting from "psychical compulsion," and we feel this way because our "motivation" is really coming from our "unconscious" rather than our "conscious" self. Freud was describing his own version of "gran-diosity with a basis in fact," I think; this is what he meant by an "instigation." As Freud saw it, an instigation is a way of betting everything on one's energy flow; it's a decision to go with one's instincts as being more accurate than the conventional evidence of available facts, a raid, conducted in charged and elated moments of intuitive breakthrough, on the unknown, perhaps the unknowable.

Freud claimed to do vast amounts of research and "laborious work on other people" in preparing his books and essays, but he confessed that he disliked every minute of it. In the midst of writing *Totem and Taboo* in 1912, he told Ernest Jones that he was "reading thick books" but they had little to offer him because "I am already in possession of the facts I am trying to prove." When Freud lectured, he spoke without notes; "I must," he said, "leave it to my unconscious." This was the age of the brilliant hunch, the

age when people made and lost fortunes daily on the stock market, when gossip columnists, admen, and psychoanalysts alike knew more about people than they did about themselves, when Paul Poiret, the Parisian "King of Fashion," announced: "I stand before you equipped not with an iron ruler but with a pair of antennae . . . I respond to your hidden intentions by anticipating them." Fitzgerald called such ESP "guess work and prophesy"; the publisher Donald Friede, discussing Horace Liveright's uncanny instinct for a best-seller, spoke of "second sight."

If Freud linked himself with Luther's moment of instinctive volition at the Diet of Worms, America, too, had historical and temperamental ties to this moment. In "The Origins of the American Mind" (1926), Lewis Mumford wrote that the "unsettlement" of Europe was the "settlement" of America: the Reformation Luther helped to start led to the colonizing of the American continent and began the process that resulted in the transfer of global power from Europe to America. The English author Mary Borden wrote in *The Spectator* on June 30, 1928, that "the scaffolding of the world of the future is reared against the sky of America"; Fernand Léger saluted "audacious America which always acts and never turns to look behind." America's rise to power was an instigation, a gigantic and dramatic process of acting out masked as history. America could (I appropriate Luther's words) "do nothing else." Acting out in a spirit of mania or grandiosity may be the only possible response to overwhelming circumstances; when history is on overload, risk taking, even recklessness, may be the only creative option.

What made for the dramatic successes that early psychoanalysis could count to its credit was that Freud was breaking through a centuries-long taboo; in the words of Nathan Hale, Jr., our most distinguished historian of psychoanalysis, he "repeal[ed] the reticence" of Victorian culture. And what explained the fans that modern metropolitan America attracted around the globe was the sheer verve and energy that attends pent-up, long-delayed self-discovery and expression. Liberation or release after intense and protracted repression, liberation in its early phrases, not only feels like cure, it can *be* cure.

William James had his own version and moment of instigation, of access to unconscious powers. The germ of his masterpiece, *The Varieties of Religious Experience*, came to him in a charged moment of dense inspiration on a "Walpurgis night" in July 1898 in the New England woods when the Gods of nature and "the inner life" held a "meeting in [his] breast," an experience, as he wrote his wife on July 9, of "intense inhuman remoteness" and yet of "intense appeal." James found he couldn't fully articulate or understand what had occurred, but he knew it to be "utter Americanism," replete with "every sort of patriotic suggestiveness." In a similar spirit, in

Djuna Barnes's novel *Nightwood*, an expatriate named Matthew O'Connor explains his exaggerated hopes and fears by remarking: "Because I'm American, I believe anything." Barnes, like James, was suggesting, I think, that a certain kind of overextended credulity was not only an American preference, habit, and quite possibly folly, but also an American *right*; if it takes "a kind of genius to believe anything," as Eliot said, that form of genius flourished on American soil. Fitzgerald called it a "willingness of the heart" and thought it the distinguishing mark of the national character.

Americans after the Great War had good reason to believe in themselves more than their European counterparts did. The American imagination was racing less to accelerate reality than to keep up with a reality already moving at speeds hitherto unknown. That this imagination, once geared to such high velocities, sometimes overshot reality's mark was not simply evidence of mass neurosis or psychosis, though many of the people involved would later think so; it was also the inevitable result of a world in an unprecedented state of acceleration. Constance Rourke remarked in *American Humor* that America had "little to draw upon except its own momentum," but momentum, the dynamic by which the force a body exerts increases with its velocity, can be, at least for a while, everything.

WAR AND MURDER

≡

THE CULTURE OF MOMENTUM

ENDING CULTURAL LAG

In the 1900s, Alfred Stieglitz took picture after picture of New York's audacious new Flatiron Building. Arguably the city's first skyscraper, the Flatiron, designed by Daniel H. Burnham in 1902, rose for twenty-three floors, a breathtakingly unbroken and slender wedge of matter slipping gravity's laws. Stieglitz thought that the Flatiron was "to the States what the Parthenon was to Greece," and during one snowstorm he had something like a vision: "The Flat Iron impressed me as never before. It appeared to be moving toward me like the bow of a monster ocean steamer—a picture of new America still in the making." The Flatiron, like the nation it emblematized, was to Stieglitz both a wonder of civilization and a "monster" whose course could not be known. All that was certain was its power, its grip on the future, its implacable advancing motion. Stieglitz's prophetic tone was soon justified by historical fact; America emerged from the Great War the most powerful nation in the world.

Gertrude Stein still affords the best commentary on the relationship between the Great War and America's rise to world dominance. If America *was* the modern, as she claimed, it could not be fully recognized until the modern spirit in culture at home and abroad had found its audience and received its due. Stein knew that the problem in the prewar decade did not lie with modernism itself; in fact, most of the avant-garde artistic achievements we associate with the modernist impulse, from Cubism and the Ballet Russe to skyscrapers and obtrusively dissonant music, were in place or in the works by 1913. The problem lay rather in a lack of centralization and momentum, in slow, uneven distribution and assimilation, in limited public receptivity and resistance. Stein was herself, of course, a victim of this cultural

lag. She had been forced to have *Three Lives* privately printed (in 1909), and by the time the war began, she had written several more book-length manuscripts, including her pioneering masterwork, *The Making of Americans*, for which she found no publisher; they lay, unread, in a cabinet at 27, rue du Fleurus. Alfred Stieglitz's father, Edward, a successful businessman, couldn't understand his son's enthusiasm for the Flatiron, which he thought a "hideous building"; this new and daring artwork had found its greatest interpreter in his son, but the broader public which the older Stieglitz typified could not as yet see its beauty or importance.

Stieglitz held pathbreaking exhibitions of contemporary art in the Little Galleries of the Photo-Secession Group, as he christened his movement, at 291 Fifth Avenue—both Matisse and Picasso had their first American shows there—but few people saw them. The big New York galleries promoted the classics and those newcomers who were loyal to them. The *Times* pronounced the famous exhibition of Post-Impressionist and Cubist art at the Armory in 1913 "pathological"; another startled critic called it "unadulterated cheek." Literary modernism found its only outlets in "little magazines" like Harriet Monroe's *Poetry* and Scofield Thayer's *Dial*, with small publishing houses like Mitchell Kennerley's and B. W. Huebsch's; its practitioners clustered in specialized small enclaves, sometimes far apart. Many of the writers we think of as 1920s New Yorkers—including Ring Lardner, Ben Hecht, Harriet Monroe, Charles MacArthur, and Edna Ferber—lived in Chicago in the prewar years.

Within New York, the modern movement was largely conscribed by Greenwich Village and the area around it, where one could find not only Stieglitz's 291 but the theaters and meeting places of the Provincetown Players and their star playwright, Eugene O'Neill, Mabel Dodge Luhan's chic salon, and the offices of the eclectic socialist journal *The Masses*, all important but small-scope enterprises. Big publishing firms like Doubleday's and Scribner's maintained ultra-conservative back and current lists. Scribner's turned down Van Wyck Brooks's searing study of *America's Coming-of-Age* in 1914 (Huebsch took it); only the editor Maxwell Perkins's threat to resign forced Scribner's to accept Fitzgerald's first novel, *This Side of Paradise*, a book that seemed daringly explicit in sexual matters to most of the Scribner's staff. As Stein and others saw it, the artists of the 1900s and 1910s were not ahead of their times so much as the public was behind them; their art was ready, but the market wasn't.

It took the violent facts of the Great War to centralize and circulate the modern spirit, Stein asserted, to make all the people less creative than herself catch up with the pioneering developments of early modernism. In her reading, the war was not the cause of modernism but, rather, its ablest

publicist and campaign manager; she knew that modern publicity would often usurp what had been causality's role. By accelerating experience to crisis proportions, the war abbreviated the period of cultural lag, established instant assimilation as a self-protective necessity, and made the avant-garde, whether in the arts or technology, the mainstream. Freud said that the war was at last forcing people to "give truth its due," and Stein wrote in her essay "Composition as Explanation" (1926) that the War had "forced . . . everyone [to be] . . . contemporary in act . . . contemporary in thought . . . in self-consciousness." The war made people acknowledge the importance of the nascent modern movement whose products and practices had seemed "ugly" only because they had not been accepted, much less assimilated; it "may be said to have advanced a general recognition of the expression of the contemporary composition by almost thirty years."

Stein's reputation profited by the war almost as much as Freud's did; what once was deemed eccentric or marginal now commanded center stage. And of course her country benefited also. After all, the Great War did not accelerate the experience of all peoples and nations equally. The rate of assimilation might have speeded up for everyone, but who had to assimilate what was still a question of power politics, and the war had massively changed the balance of power. Quite simply, what Europe lost, America gained.

America's part in the war was privileged and relatively pain-free. Congress did not declare war until April 6, 1917, more than two and a half years after hostilities had begun, and the war ended only a year and half later, on November 11, 1918. By April 1917, almost all the most devastating battles were over and more traditional military maneuvers had resumed. Ernest Hemingway, who served in the Italian Army, getting wounded and decorated for bravery in the summer of 1918, always maintained that a little war experience invigorated a man; as he wrote to Fitzgerald on December 15, 1925, echoing Stein, "War . . . groups the maximum of material and speeds up the action." But he also knew that too much war could be destructive, sapping the soldier's strength and poisoning his memory. By this criterion, America got exactly as much of the Great War experience as could benefit its own interests and no more. In a letter of April 11, 1917, from London, T. S. Eliot told his mother back in St. Louis, "You [Americans] will be having all the excitement and bustle of war with none of the horrors and despairs."

The war organized and mobilized America's productive capacities on every front, from the steel interests and the auto business to the fashion, advertising, and movie industries, and it did so at no apparent expense to America. America knew nothing of the costly on-the-home-front combat that sapped the economic strength of Europe, Britain, and Russia. The over-all cost of

the war, by Paul Kennedy's calculation in *The Rise and Fall of the Great Powers* (1989), was in the neighborhood of an extraordinary $260 billion; from its inception, the Allies depended on American loans, trade, and investments to keep themselves going. By the spring of 1917, they had borrowed over $2 billion from the United States, which put them at the mercy of American priorities. The British Chancellor of the Exchequer warned his countrymen in October 1916, "By next June or earlier, the President of the American Republic [will] be in a position, if he wishes, to dictate terms to us." Between 1914 and 1916, American trade with the Allies jumped from $825 million to $3,214 million, a gain of roughly 400 percent. Between 1916 and 1918, exports of steel, iron, and foodstuffs doubled; exports of explosives alone went from $6 million to $467 million. Imports dropped dramatically, but the economy, stimulated by the demands of foreign nations at war, filled its own needs effortlessly. This imbalance between American and European accounts was one of the precipitating causes of the Crash of 1929, and it persisted long after the Depression was over.

In the Civil War, the nation had lost 600,000 men out of a population of 35 million, but in the Great War, it lost only 126,000 men out of a population of 100 million, by James Truslow Adams's tally. In contrast, Great Britain lost 908,000 men, Austria-Hungary 1,200,000, France 1,763,000, Germany 1,773,000, and Russia (the only country with a population comparable to that of the United States) 1,700,000. Kennedy estimates the total number of men killed or rendered dysfunctional by war injuries at 30 million, and this figure does not include the wartime "birth deficits," the decline in population growth that results when most young men are not at home. The loss of work time and manpower that the European nations sustained is incalculable, but its consequences are not. By Kennedy's figures, the European economy as a whole was put back eight years by the war; the American economy, in contrast, gained six years. This gain was a matter not simply of more sales of more American products and more dollars in American coffers, but also of the American method and pace of production and consumption, for the war made the American economy and the way it worked not *a* model but *the* model for the rest of the world.

The Great War did not in and of itself bring about America's economic hegemony. Kennedy calculates that America would have assumed the leadership position by 1925 even without the war. Just as modernism as an artistic phenomenon was in place when the war began but needed a stimulus to be widely felt and broadly marketable, America's economic leadership was clearly in the cards by the late nineteenth century, though few anticipated the speed with which it would be achieved or the all-encompassing aspect it would assume. In 1880, according to Kennedy's figures, Great Britain had

the highest industrial output and capacity in the world; America was a distant second. In 1890, the nation led the world in only one major economic category, that of energy consumption; that superiority, however, held the clue to its coming dominance. If energy supplied the ethos of the modern age, energy as productivity potential, as natural resources and available labor, as technology and hydroelectric power, as consumer receptivity and wealth, as a market geographically vast and psychologically manic, energy, in short, as the fuel of acceleration was America's salient characteristic and greatest strength.

Great Britain's industrial potential did not stand still while America pulled past it; in fact, it almost doubled. But America's potential multiplied thirteen times and went on accelerating; by the 1920s, it was greater than that of all the other Great Powers—England, France, Germany, Russia, Italy, and Japan—combined. Hydroelectric power alone grew faster in the 1920s than in all the years before. The growth, and pace of growth, in the American economy was the master "Believe It or Not" item upon which all the others Ripley published depended, which set the style for all, which made the others look at once logical and paltry. The war benefited America, not because it caused or created America's economic superiority, but because it speeded up its economic operations and hastened their recognition. The war revved up the dizzying pace of change and reinforced acceleration itself, the trademark of American life, as the most valuable asset any society could possess, at least in modern times.

Consider America's wartime mobilization. American industry and food supplies were critical to the exhausted Allies, but American troops, once in combat, depended on Allied technology. Even the United States could not produce in the short span of a year enough artillery, airplanes, and tanks—all new or newly modernized—to arm its own soldiers. All that navy-strong America could contribute technologically to the war effort was its destroyers. But what made its troops decisive for the Allied cause despite this technological gap was the speed with which men, men fresh to the struggle and not demoralized by protracted exposure to modern warfare, were conscripted, equipped, transported, and sent into action.

In April 1917, Germany had initiated unrestricted submarine warfare, against President Wilson's strongest prohibitions, thus putting all American vessels, no matter how neutral their declared mission, at risk. The German high command was aware that this decision would force America to enter the war; their strategy was based, not on any overestimation of America's declared pacifism, but on the not unreasonable assumption that German submarines could end the war before large numbers of American troops were mobilized to wage it. After all, it had taken Great Britain two full years to

get a million men into action. And in 1917 the Germans seemed to have the edge: Russia was on the eve of the Bolshevik Revolution, which would shortly take it out of the war; France and England were losing against German technology, manpower, military leadership, and sheer aggressive energy.

By turning to out-and-out unrestricted submarine warfare, the Germans were betting on their own capacities of acceleration over those of America. The bet cost them the war. Within a year of America's entry, American business was mobilized by the new War Industries Board under the Wall Street speculator Bernard Baruch. America built its destroyers in the "astonishing" (the word is Paul Kennedy's) time of six months, and its powers of acceleration here were prophetic of its speed in raising troops. Hundreds of thousands of American soldiers were in combat within six months of America's declaration of war; between March and November of 1918, the number of American soldiers on active duty in France increased by 700 percent. The nation had instituted an official draft, the first in its history, and sent 2 million men to Europe in the space of eighteen months.

The more or less unarmed prewar America might have commanded limited respect in European diplomatic circles, but the Versailles peace-treaty discussions in late 1918 were initially seen as an American triumph. In a letter of December 18, 1918, to her husband's family in St. Louis, Vivienne Eliot wrote that "we all follow American politics now," though no one, she noted, had been interested in them before the war. *The* (London) *Times* trumpeted Woodrow Wilson's visit to France as "one of the greatest events in our own and American history." Versailles witnessed the defeat of most of his Fourteen Points, but it was Wilson who had lost command, not America. Although isolationist America did not choose to exercise its new diplomatic powers for another decade or two, Versailles nonetheless marked the first negotiations of world importance in which all the nations involved granted, even assumed, America's right to set the terms of discussion, a right it has not willingly relinquished even today. With the hindsight supplied by the Great War, America in the prewar years was seen to have been, not a "colony" of Britain, as Rupert Brooke would have it, not a second-rate power, but, in the famous phrase of Admiral Yamamoto, a "sleeping giant." In 1919, the giant was awake and his actions, his *modus operandi*, had revolutionary consequences.

A NEW IMPERIALISM

A nation's economic power had not always entailed the reification of its acceleration or takeoff. For a nation to extend its geographical empire, as

Rome did in the centuries before and after Christ's birth, as Spain and Portugal did in the fifteenth and sixteenth centuries as Great Britain and France did in subsequent centuries, was first to widen that nation's economic resources and to complicate the process of controlling them. The first goal of geographic expansion, in other words, was to broaden and diversify the aggressor nation's economy, and only secondarily to rev up its tempo, to speed up its rhythm and pace. Nineteenth-century Britain represents the fullest expression of this form of geographical imperialism or territorial take-over; although the larger land masses and more diverse and numerous populations that England came to control called for and brought about accelerated communication and transportation among the empire's far-flung parts, the acceleration was not England's primary aim but, rather, a consequence of it. If momentum is the dynamic by which the force a body exerts increases with its velocity, one could say that pre-twentieth-century imperialism did not wholly embrace the principle of momentum; its first priority was on increasing not the speed of the body but its mass. But for the emerging imperial American economy the emphasis was on speed, not mass; the pace was the content, and momentum was law.

Unlike Rome or Spain or England, modern America had from the get-go a continent at its disposal, a potential empire at its doorstep, an empire whose native occupants were quickly bought off or annihilated by European pioneers shackling the resources of the land for their own purposes of development. In 1837, Francis Grund noted that Americans had transformed the world they discovered so rapidly and extensively that it could not serve them as "home." "They live," Grund wrote, "in the future and *make* their country as they go along." Walt Whitman's pre-Civil War persona in *Leaves of Grass* (1855), who "skirts sierras, whose palms cover continents," was the voice of omnivorous America conquering its continent in imagination as in fact.

By the end of the Civil War, America's continental borders had been more or less established; although the acquisitions of the Philippines, Hawaii, Cuba, and the Panama Canal Zone between 1898 and 1904 were crucial, by and large one can say that, over the course of the half century after the Civil War, America acquired power less by outright territorial expansion than by colonizing the future, defining, monopolizing, and selling at steep rates the modernization process itself. The old European method of overt territorial imperialism did not collapse conclusively until after 1945—Russia held out, as we know, through the 1980s—but by the late 1920s it was clear to many that the cost to the imperial powers, most notably England and France, of the day-to-day policing of the foreign lands and peoples in their empires was prohibitive. Whatever defeats it suffered at Versailles,

Woodrow Wilson's "new diplomacy," with its emphasis on liberation and self-government for colonized peoples, and its animus against traditional geographic imperialism, was the way of the future.

Back in 1885, the American economist David Wells had congratulated American industry on its ability to accelerate by abandoning the obsolete, on its refusal to expend precious capital and time in the effort to modernize the passé; unlike their European contemporaries, Americans know that top efficiency means destroying, not remodeling, equipment that is outdated. In Wells's words, "Abandonment of large quantities of costly machinery [is] a matter of absolute economic necessity"; "The destruction of what has once been wealth often marks a greater step in the progress of civilization than any great increase in material accumulation." Decades before Wilson's Fourteen Points America, according to Wells, had repudiated the principle, if not the practice, of traditional imperialism—"material accumulation"—for a strategy that centered on energy acceleration, destroying the old to power the new. American-style imperialism openly based itself on what Alan Trachtenberg has called "the symbiotic relation between destruction and production" needed to achieve, not just top "production," but top "productivity"; this was an ethos not of accumulation but of adrenaline and speed.

One must remember that turn-of-the-century America had fewer skilled laborers in its work force and fewer and less powerful labor organizations to protect them than did the European countries, with their long tradition of craft guilds and artisan leagues and their more recent big, sometimes Marxist-oriented unions. Put another way, America had fewer prohibitions against rapid technological change than any other Western nation, in part because its skilled laborers did not have the strength or the incentive to resist the technological advances that by definition eliminate more jobs than they initially create. Paul Poiret, visiting America in 1913, found that futuristic science fiction of the sort written by Jules Verne and H. G. Wells was "surpassed by the reality," and he concluded that "an unschooled person" would adapt to the fast-changing American scene better than an elaborately trained and expert one could. Poiret saw that an extensive knowledge of traditional skills could attach one retrogressively to the past; to be apparently unprepared, untrained, might be, in some circumstances, to be the best trained, the best prepared. It's another form of discarding or skipping obsolete practices to power and speed the assimilation of the new, a way of dropping the empire to concentrate on the rule. As Gertrude Stein pointed out, in a period of immense change like that of the Great War, fast assimilation is a prerequisite for power; the country least hampered by past conventions and traditions, least subject to cultural lag, most oriented toward the future, most

alert to incentives to modernize, will dominate. America, the youngest major nation on the globe, the home of Thomas Edison and Henry Ford, fit the bill.

Thomas Edison, born in Ohio in 1847, the inventor of the electric light bulb, the quadruplex telegraph, and the phonograph, opened the world's first "invention factory," or research lab for technological development, in Menlo Park, New Jersey, in the centennial year of 1876, and he helped to make America the leader, not just in technological innovation, but in planned technological acceleration. Some forty years later, in 1914, Henry Ford, Edison's friend and admirer, installed the first moving assembly line fed by an endless chain conveyor in his Detroit factory. Ford's new procedure was typical of the acceleration tactic of the modern American economy as David Wells had described it, for the assembly line revolutionized, not what Marx called "the means of production," the technology or machinery of production, but productivity itself, the pace at which production occurs. The assembly line meant that Ford's workers no longer had to move among various bins to collect and put together an automobile's parts; all the parts were automatically brought or "fed" to them with maximum efficiency. (Ford was also a disciple of America's premier efficiency expert, Frederick W. Taylor.) The results were astonishing.

In 1913, it had taken Ford's men 14 hours to assemble a car down to its last details. By the end of 1914, it took 95 minutes. By 1925, the factory was turning out a car every 10 seconds. The speed of assembly on the new plan allowed for a breathtaking drop in the price of a Ford car, from $950 in 1910 to $290 in 1924. "Every time I reduce the charge for our car by one dollar," Ford said, "I get a thousand new buyers." Everyone could now afford a Ford. In 1905, when the automobile was still in its infancy, half the 5,000 cars in America had been of foreign make—the word "automobile" was itself a tip-off to their French origins—but by 1929, almost all the 32,121,000 cars in America were made at home. One of every five Americans had a car (as opposed to only one of thirty-seven Englishmen, one of forty Frenchmen, and one of forty-eight Germans). What cars Europe boasted were largely American; every second car in the world was a Ford.

It was in good part thanks to Ford's assembly line that American industrial production doubled in the years after the Great War and "without any expansion in the labor force," as the historian William Leuchtenberg notes. Manufacturers made more money, yet employed the same number of men as they had in 1919, and whatever the fate of the men they did not employ, those they did were better off than their predecessors had been. The pay of the average worker increased (Ford instituted the $5 day in 1914), his standard

of living went up, yet his work hours were reduced. In 1923, U.S. Steel shortened the worker's day from twelve to eight hours; in 1926, Ford went U.S. Steel one better by moving from a six-day to a five-day week.

The assembly line meant more products and more profits in less time at less cost for less work, and made possible, in Stein's phrase, the "Americanization of everything." This was, like all America's gains in and just after the war, to get something apparently for nothing; obstacles seemed to vanish before American affluence and technological genius. As Ford boasted in 1914, "Nobody can stop me now. From here on the sky's the limit!" Predictably, industry abroad, with its strong labor unions and long craft traditions, resisted the kind of instant change the assembly line represented; in any case, the Great Powers of Europe, engaged in the most costly war in their history, had no funds to spare for the expensive modernization process. But American industry and cultural enterprise on all fronts quickly adopted some version of Ford's new mass-production techniques in a blaze of self-conscious publicity.

Take the clothing industry. In the early years of the twentieth century, a woman who wanted a new dress did not go to a department store or boutique and pick out a ready-made, standard-sized dress from the rack, as we do today. There was, in fact, no ready-made accurately sized clothing; the woman who wanted a new dress either sewed it herself or ordered one "made to measure," to fit, in other words, her particular body, from the seamstress she patronized. In the mid-nineteenth century, the London fashion king Charles Worth had instituted a salon of *haute couture* where a dress designed by him could be, for the first time, "repeated" or duplicated (largely by hand) and sold in select shops, but this practice was a limited operation that had little effect on the fashion needs of most women. The only ready-to-wear clothing women could purchase before 1900 was utilitarian, outside any notion of fashion, and it came, if sized at all, in crude "stock sizes"; most catalogues did not even list size. Although the American Isaac Singer had invented the sewing machine in 1851, women's clothes of that time were too detailed, too complex, to allow designers and tailors to make wide use of it. Only the simpler clothes worn by men lent themselves to rudimentary proto-mass production.

The Great War, with its demand for millions of standard-sized men's uniforms made to government regulations, was a godsend to the American clothing industry; by the end of the war, full-scale mass-production techniques were being applied to civilian clothing and America had taken the lead in the world's clothing market. In turn, the new possibilities of mass marketing that this opened up dictated simpler styles and cheaper fabrics for Europe's couturiers. In Paris Coco Chanel pioneered in elegantly plain

designs made of inexpensive jersey and other cotton fabrics; Americans pirated and mass-produced her fashions more extensively than those of any other designer. There was no copyright on clothing designs until the 1950s, but Chanel got a lot of free publicity from her American fans, if little hard cash. Americans also made quick, wide use of new powered cutting shears; by the early 1920s, they were doing accurate sizing of all kinds of clothing, though Britain did not do so until 1933. "Culture," in Fitzgerald's words, "follows money"; by the early 1930s, not just clothing production but fashion design was shifting its headquarters from Europe to New York and Hollywood.

Hollywood had its own love affair with mass-production methods. Movie magnates dealt with as broad a spectrum of the American public as Henry Ford did, and they took what he called the "great multitude" with the utmost seriousness. An ex-glove-maker, Samuel Goldwyn, the founder of what became Metro-Goldwyn-Mayer, explained: "If the audience don't like a picture, they have a good reason. The public is never wrong. I don't go for this thing that when I have a failure, it is because the audience doesn't have the taste or education, or isn't sensitive enough. The public pays the money." Intent on creating a seamless weave of predictable profits, Goldwyn and his peers combined big-name stars, genre or formula pictures, and interlocking production, distribution, and exhibition arrangements in one slick package, and they proudly acknowledged American business in general and Ford in particular as their model.

Marcus Loew, who headed New York's largest movie-theater chain, claimed, "Chain store methods in the movies are just like what you have in railroads, telephones, and automobiles." He was known as the "Henry Ford of vaudeville." Later, in the talkie era, the Warner Brothers, notorious among overworked actors for their factory-like, super-quick production methods, were dubbed the "Ford of the movies." These early movie entrepreneurs were often careless, in our view criminally careless, about preserving their celluloid products. Many of the early silent features of Mary Pickford and D. W. Griffith have either disintegrated or vanished. The carelessness makes a certain sense, however; the movie business was just imitating the destroy-to-accelerate tactic of American industry. "All the Stars While They're Stars" was the lead for one celebrity column. It was the next hit that mattered, not the last.

Movies, of course, were not only part of the technology of mass production but part of the media, and the media were largely American in development if not origin. Why? In part because America needed the media for the same reason it favored all technological developments. England and France might over the course of their history acquire empires that mandated communi-

cation among their parts, but America—with its geographic sprawl, divided and interrupted by mountain ranges and rivers that obstructed the free flow of goods and people from one part of the country into another—started with this mandate; indeed, the national identity, as advertised in its name, the *United States* of America, depended on fulfilling it. Europeans, dividing a continent among themselves, utilized and guarded nature's obstacles as their official geographical boundaries, but America from East to West desired and recognized no boundaries except the Atlantic and Pacific Oceans.

Little wonder that Americans seized on the railroad, first developed in coal-mining England, as part of a divine plan for their nation. Little wonder that they coopted the infant auto industry from its French proprietors and the fledgling radio from its Italian inventor (Guglielmo Marconi patented a radio set in 1897; the earliest radios were sometimes called "Marconi sets") and made the movies their own personal looking-glass. The acceleration of precise information conveyed via telegraphs, cameras, telephones, big daily newspapers, advertising, movies, radios (and later television)—in short, the phenomenon of media and proto-media that palpably speed up not just our work but our minds, our very consciousness, the acceleration of culture itself—was an American obsession, if not an American monopoly. Only the media could make America instantly transversible. Only the media, one might add, could make it fully exportable; wherever the media are found, the real American language is being spoken.

America's lead in media development was not, however, the work solely of its general incentives to technologize culture. Crucial to American success was that only America had the economic assets to capitalize fully on the new media. Look again at the movie industry. Edison invented the movie camera in 1889, but he had serious rivals in the Lumière brothers, Louis and Auguste, in France. In 1910, when the film industry was only about a decade old, more than half the 4,000 movies released annually across the world came from France, Germany, and Italy, and a number of them set the cinematic fashion. In 1913, an Italian biblical epic, *Quo Vadis*, opened in New York. At the then unprecedented length of eight reels, with tickets priced at the new high of $1, it drew full houses for twenty-two weeks at a top Broadway theater, also a first for the movies, not yet far from their humble nickelodeon origins, and went on to enjoy comparable runs in other American cities. Within the year, however, D. W. Griffith topped *Quo Vadis* with his own biblical film, *Judith of Bethulia* (not released until 1914). His Civil War epic, *The Birth of a Nation*, which appeared in 1915, ran 2 hours and 40 minutes, drew huge audiences, and advanced cinematic art, whatever one thought of its racist politics, by light-years.

By 1918, America was putting out close to 700 full-length features a year and shutting out foreign competitors for the domestic market; by 1926, American films had captured 95 percent of the British market and 70 percent of the French market; three-quarters of all the films shown in the world were American. The English observer Arthur Weigall bemoaned the trend in 1921: "To the remotest towns of England . . . [American] films penetrate . . . Gradually the world from end to end is being trained to see life as it is seen by . . . the United States . . . The world is being Americanized by the photoplay." Although Great Britain tried to impose an import quota on American films in 1927, France in 1929, neither was successful; as Gilbert Seldes insisted in a book title of the 1930s, "The Movies Come from America!" But the victory had not been that simply of a superior product. Because explosives and celluloid were made from some of the same ingredients, the European countries cut back on filmmaking in 1914, while the United States surged ahead; by 1918 America had gained a lead in the movie business that it has never since surrendered.

A combination of the two developments, mass production and media transmission, made America synonymous with acceleration; what mass production did for the rate of material production, the media did for the speed of perception. Together they delivered more for less to a degree and at a rate literally unbelievable before their existence; together they made the phrase "instant gratification" a fact. Fittingly, the terms that we still use today— that I have been using in this book—to describe the acceleration of production and consumption and the strategies by which we facilitate and enforce it, to describe mandated and instant change, were either coined or first popularized in the 1920s; and Americans played a large part in their widening use and sometimes in their invention.

The term "acceleration," which dates back to Sir Isaac Newton and bespeaks the quickening of a rate of speed, motion continually increasing in velocity, entered the American mainstream via Henry Adams's posthumous best-seller of 1918, *The Education of Henry Adams*; James Truslow Adams also helped to popularize the term in his influential essay "The Tempo of Modern Life" (1931). The term "cultural lag," which designates the delay, the conflict, between a society's means of material production and the modernization of its sensibility, between what is available in a society and what is actually endorsed or consumed by it, the phenomenon that Stein believed the Great War had suspended, was coined by the sociologist William Osborn, then at Columbia University, in his book *Social Change* (1922).

The "installment plan," buying on credit rather than paying in full and at once in cash, the buy-now, pay-later plan that enforces an acceleration of

consumption to match the limitless acceleration afforded by mass production, came in with the automobile boom of the 1920s, when the car industry created security companies to help its customers arrange delayed payments for their new cars. By the mid-1920s, 60 percent of all cars and furniture and 75 percent of all radios were purchased on the installment plan. "Planned obsolescence," the practice by which products are designed, not to give the longest possible use to the buyer, but to become quickly unusable or un-acceptable through technological failings or fashion's dictates, was officially adopted in 1927 under the euphemistic phrase the "yearly model," by General Motors president Alfred Sloan, a pioneer in diversifying the standard automobile to suit a society fast becoming hyper-consumer-minded.

Frederick Lewis Allen assembled the evidence of these new changes in his popular history of the 1920s, *Only Yesterday* (1931). He began his account with a series of pointed comparisons between the daily habits and appurte-nances of a typical white middle-class American family in 1919 and those of a similar family in 1930. Allen's title was itself a "Believe It or Not" tactic. Could it really be "only yesterday" that the majority of Americans did not live in cities? "Only yesterday" that most Americans had never heard of Freud? "Only yesterday" that there were no radios, no talking pictures, no domestic plane service, no short skirts, no vitamins, no interest in "sex appeal," and no jazz saxophonists? Allen was surely aware that most of his readers were at least in their twenties, probably in their thirties or forties; they would have been teenagers or young adults in the hopelessly benighted world of 1919. Fitzgerald, for instance, turned twenty-three, Hemingway twenty, in 1919. Yet Allen clearly expected his readers to find his picture of 1919—a world without "automatic traffic lights," "cross-word puzzles," and "Al Capone"—"strange," even incomprehensible; he assumed, in other words, that his readers would barely remember or credit the culture of their own youth, that they would find it as alien, unrecognizable, and unbelievable as one might ordinarily think people would find the mores of a century, rather than a decade, ago. The word Allen used to describe what had hap-pened in America was not "change" or "development" but "transformation."

Allen could not know that the pace of change had not only accelerated but *peaked* in the 1920s: the consequent transformation of American culture was not followed by any cultural change so wide or drastic. The modern world as we know it today, all the phenomena that to our minds spell the contemporary, from athletic bodies and sexual freedom for women to air-planes, radios, skyscrapers, chain stores, and the culture of credit, arrived on the scene then, and although these phenomena have been extended and vastly empowered in the decades since, they have not fundamentally altered. Only the computer, developed in the 1940s from the electric calculator, can

claim a revolutionary effect comparable to those brought about in the first decades of the twentieth century.

When World War II began, President Franklin D. Roosevelt solicited suggestions for a title for the combat less imitative and derivative than "World War II," which seemed to make it a mere and obvious successor, a kind of clone, to the "Great War" or, as it was now called, "World War I." But no more original terms were found. In a similar fashion, the generations since the "modern" era, an era usually thought to have changed direction, if not ended, in 1939–45, have thought of no better designation for their own period than "postmodern." All that is clear, apparently, about the decades since 1945 is that they chronologically succeed or follow the "modern" ones; what they contribute that is original, their own, is not yet clear enough to generate a distinct label. The 1920s generation felt immeasurably distant from its recent past—the very word "Victorian" had a pejorative ring—but we in the 1990s still live in good part in the world that the 1920s put in place; our culture has changed far less in the last sixty years than it did in the preceding twenty.

In their study of American modernization, *Middletown* (1929), Robert and Helen Lynd reported that a boy in Muncie, Indiana, asked by his Sunday-school teacher to "think of any temptation we have today that Jesus didn't have," answered at once: "Speed." Increased speed could be a temptation because it was not only a material development but an ethos, a peculiarly modern ethos of instant power and instant assimilation, an ethos fueled by the Great War and destined to govern every aspect of American development in the war and early postwar years. As the modern period began, America had a headstart.

LITERARY INDEPENDENCE

America might be the world's youngest country in terms of history and chronology, but in terms of modernity, it was the oldest; it had been modern long before modernism existed anywhere else. Stein explained the phenomenon in *The Autobiography of Alice B. Toklas*:

America [is] the oldest country in the world because, by the civil war and the commercial conceptions that followed it, America created the twentieth century, and, since all the other countries are now either living or commencing to be living a twentieth century life, America, having begun the creation of the twentieth century in the sixties of the nineteenth century, is now the oldest [modern] country in the world. [punctuation added]

In other words, due to specific historical conditions that made the fast development of innovative, aggressive capitalism the only logical mode of economic development, nineteenth-century America initiated, not nineteenth-century culture as it was conceived and on view in Europe and Britain, but twentieth-century culture, a culture as yet only in Europe's future. By Stein's logic, once the Great War had precipitated the rest of the Western world, willy-nilly, into the modern era, America as the world's "oldest [modern] country," was inevitably recognized as supplying the leadership. America's past might be short, but it was all-important, for the nation apparently specialized in exactly the commodity the whole world now needed: modernism itself.

Karl Marx wrote of the determinative influence that a society's economic "base" or "means of production" exerts on its cultural "superstructure" or self-expression. This was the rule Fitzgerald summed up, and Americanized, as "culture follows money," and it meant that, if American industry in the nineteenth century was already modern, so was the art that accompanied it, no matter what attitude those making the art ostensibly took toward their fast-modernizing industrial age. D. H. Lawrence, celebrating the American writers of the nineteenth century as moderns before the fact, as a posthumous avant-garde of twentieth-century literary art and psychoanalytic thought, was making the same point. Nineteenth-century America was a modern nation thinly disguised as a Victorian one, and it produced a culture both more repressed and more extreme, more archaic and more modern, than its counterparts abroad, a culture in which the future was already far developed, a culture fabulously equipped for the modern era and fast getting ready to advertise the fact.

A host of American writers, almost all of them New York–based, including Van Wyck Brooks, William Carlos Williams, Lewis Mumford, Carl Van Doren, Carl Van Vechten, Columbia professor Raymond Weaver, and psychologist and critic Henry Murray, joined Lawrence's literary reclamation project in the 1920s. By the decade's close, Americanists had organized their own division of the Modern Language Association. Melville and Whitman were now treated as among the most important writers in the world. The Great War aided and accelerated the recognition of America's literary past as decisively as it benefited the American economy. Unlike the other Allied nations, America discovered that it had lost to the war, not cherished possessions but borrowed goods, not reality but pretense.

e. e. cummings, looking back on his stint as a volunteer ambulance driver, concluded that "World War One was the experience of my generation; no-one wanted to be 'out of it.' " This was the first literary generation in America to include a significant number of veterans. In addition to cummings, John

Dos Passos, Alexander Woollcott, Laurence Stallings, Raymond Chandler, Harold Ross, Robert Sherwood, Herman Mankiewicz, Gilbert Seldes, Heywood Broun, Thomas Boyd, Charles MacArthur, Damon Runyon, and Ernest Hemingway, among others, fought or served as correspondents in the war. Dozens of others, like Fitzgerald, Faulkner, and Dashiell Hammett, enlisted only to have the war end before they could see active duty.

Most of the writers who participated in the Great War quickly formed and publicly expressed the view of it that increasingly prevailed in its aftermath in intellectual and artistic circles everywhere: that its corrupt beginnings in imperialist power struggles were matched in ugliness and senselessness only by the unprecedented brutality of combat conditions and the indifference of those in charge to the welfare of the soldiers who were the war's real victims, though the same writers admitted freely in private, as Stein repeatedly did in public, that the war had given them the time of their lives. Dissident John Dos Passos banished enthusiasm from his bleak novels and official pronouncements about the war, but elsewhere he revealed the exhilaration he experienced near the front. "I feel more alive than ever before," he wrote in his journal. Why had he joined up? "I wanted to see the show." Harry Crosby, destined to become a flamboyant expatriate poet with close ties to the New York scene, had volunteered in 1917, when he was nineteen. After the devastating Battle of Verdun, he wrote his parents from the front in a tone of high elation: "This is war all right. I've never been so impressed in all my life . . . There isn't a square yard out there that isn't pockmarked with shell craters. The Valley of Death I should call it. It is thrilling living amidst such surroundings."

Volunteers like Crosby and Dos Passos were not fighting to defend their homeland, of course, nor were they there to save Europe. Although a number of them entered action before their country did, their appreciation of Europe was more likely to be a consequence than a cause of their military service. Dos Passos was franker than most in his confession that he hoped to get a "great novel" out of the war, one that would capture "all [its] tragedy and hideous excitement," but the literary motive was equally obvious in cummings, Faulkner, and Hemingway, who, like Dos Passos, found in the war the subject matter of their first book-length work: cummings's *The Enormous Room* (1922), Hemingway's *In Our Time* (1925), and Faulkner's *Soldier's Pay* (1926). Harry Crosby, diagnosed after the war as a shell-shock victim, wrote in his journal on February 1, 1925, "We who have known war must never forget war." "That is why," he added, "I have the picture of a soldier's corpse nailed to the door of my library."

Hemingway is the most famous example of the impact of the Great War on American literature. Unlike Dos Passos, cummings, and Faulkner, he

continued to write about war for the rest of his literary career, and most critics agree that he wrote about it not only better than any of his American contemporaries but better than his British peers as well. To read Hemingway's stories about the Great War and its civilian analogues in *In Our Time* in conjunction with two of the best British memoirs of the war, *Sherston's Progress* (1928–36) by Siegfried Sassoon and *Goodbye to All That* (1929) by Robert Graves, both of high quality, both admired by Hemingway himself, is to discover that only Hemingway integrated the experience of war into the style, the form, the narrative consciousness of what he wrote.

Sassoon and Graves were very different as writers, and they memorialized the war differently; while Sassoon's account was partly fictionalized, Graves's was straight reportage. But they faced a common challenge—how to write of modern warfare—the same challenge that confronted Hemingway, and it was one they could not fully meet and he did. Although both the English writers knew the war at intimate firsthand, although both went to the front and served for the duration, although their books contain much accurate information and intelligent reflection about the war and its context and consequences, they seem everywhere to be self-consciously using older narrative modes and language to deal with material that eludes such conventional strategies of expression. Their stated goal was to get at the "mood," to tell, in Sassoon's words, "what [they] felt like" in the war, but they were not, as writers, quite up to the task, and they seem aware of the fact.

Graves uneasily explains that he started his book as a novel, then decided on a memoir. Sassoon alternates between obvious fiction and equally obvious autobiography; he tests out traditional words—"lifetime (the word was one which had seen better days)"—and expresses puzzlement at the inadequacies of his traditional autobiographical first-person posture: "I am beginning to feel a man can write too much about his own experience, even when 'what he felt like' is the nucleus of his narrative." Graves and Sassoon both published some poetry about the war in the late 1910s, but they waited until the late 1920s to publish their war memoirs. In contrast, Hemingway's *In Our Time* was out by 1925; *The Sun Also Rises* was published in 1926, and his second novel, *A Farewell to Arms*, a romance set against the background of the Great War, appeared in 1929. Sassoon and Graves may have been uncertain about the success of their literary endeavors, but Hemingway was at bottom doubt-free. He knew exactly, *exactly*, what he was doing.

Hemingway's confident superiority as a delineator of the Great War is all the more startling in light of the evidence at hand of his apparent unfitness for such a task in terms of military and literary experience. Hemingway worked for three weeks in July 1918 in the Italian Army as a Red Cross volunteer, picking up the wounded and the dead; he then asked for a transfer

to canteen duty near the front and was wounded within the week. His wounds, like his courage under fire, were undeniable, and he spent months in hospitals, but this brief if intense record could hardly content one who believed, as Hemingway did, that the war had given him instant access to his own talents; he needed more substantial evidence to back up the authority he knew was already his. Soon he was claiming that he had served in the war for years, not weeks, and fought in some of its most difficult battles. As a reporter on the Toronto *Star Weekly* in 1920, he advised "Slacker[s] at War" "How to Be Popular in Peace": change towns, wear a trench coat, whistle war songs, talk seldom about the war on the pretense that the wounds are too deep and fresh to bear examination, and read a good history of the war. "Study it carefully . . . [and] you will be more than able to prove the average returned veteran a pinnacle of inaccuracy if not unveracity." These had been his own tactics, in fact, and his ruse was not fully exposed until after his death.

Why, one wonders, did Hemingway's falsifications go so long undetected? Surely the main reason people believed his story was that the prose he created to convey (or fabricate) it was so new, so eloquent, so factual, that readers assumed it could have come only from the extensive war experience he claimed; in other words, it was Hemingway's greatness as a stylist that accounted for the success of his impersonation as a vet. His achievement as a writer is not in doubt, yet a case can be made that the famous Hemingway style was as unearned as his vaunted veteran status. When Sassoon entered the war, he was a published and accomplished author in his early thirties; Graves, a decade younger, began publishing during the war. But though the eighteen-year-old Hemingway was sure he would be a writer, he had in fact written little before the war save some heavy-handed Ring Lardner imitations for his high-school paper and a few apprentice pieces for the Kansas City *Star*. Moreover, the letters he wrote during his period of military service show that he possessed no adequate language, no reliable or discerning sense of the literary medium he planned to master.

The letters Hemingway wrote home from the front and the hospital are full of Victorian clichés and sentimentalities that could be straight out of the idealistic, overblown writings of Alan Seeger, the Harvard poet and Great War hero best known for his war poem "I Have a Rendezvous with Death." Seeger, whose dispatches and poems were published in *The New Republic* and the New York *Sun*, had written to his devoted mother in June 1915 that, should he die, "you must be proud, like a Spartan mother." When he was killed in the battle of the Somme on the emblematic date of July 4, 1916, his patriotic martyrdom was complete. In a letter of October 18, 1918, Hemingway, too, claimed "a rendezvous with death"; he told his mother,

Grace, that he planned to return to the front (he didn't), and reminded her that "the mother of a man who has died for his country should be the proudest woman in the world, and the happiest."

At other less elevated moments, Hemingway's letters read like exercises in Babbitry à la Sinclair Lewis, replete with boisterous misspellings, crude nicknames, lame slang, and joshing foreign phrases; their salient characteristic is their author's clumsy and incessant obtrusiveness. The young Hemingway apparently preferred to bungle his idiom—"Dats de way tings are" or "Laid non-hearage from you to some form of displeasure with the Enditer"—than to use it straight. Even describing his shrapnel wounds in August 1918, he can do no better than to say: "So we took off my trousers and the limbs were still there but gee they were a mess." Convalescing, "Ernie" (as he signed himself) complains: "I ain't got no pep!" Such language was nothing but a clumsily masculinized version of the euphemistic, feminized tendencies that foreign observers deplored in the American language; one should note that Ernie uses the genteel "limbs" instead of the forthright "legs."

Just a few years later, however, Hemingway, describing a clearing where the war veteran Nick Adams makes his camp in "Big Two-Hearted River" (the closing story of *In Our Time*), was writing like this:

> There was no underbrush in the island of pine trees. The trunks of the trees went straight up or slanted toward each other. The trunks were straight and brown without branches. The branches were high above. Some interlocked to make a solid shadow on the brown forest floor. Around the grove of trees was a bare space. It was brown and soft underfoot . . . The trees had grown tall and the branches moved high, leaving in the sun this bare space they had once covered with shadows. Sharp at the edge of this extension of the forest floor commenced the sweet fern.

This is matchless prose, prose that will not, in Hemingway's phrase, "go bad." He is still writing about the wounds of war—the trees which have lost their lower branches are emblematic of Nick himself as he tries to recover from his wartime trauma—but he does not for a moment tag or manage the reader's response. He has moved magically, it seems, from the Sinclair Lewis language of Rotarian English to a seamless, tough, elegant prose style. This is more than growth; it is, to recur to Allen's term in *Only Yesterday*, "transformation."

It is important to be clear here. Hemingway's military experience was real, even traumatic. He saw the horrors of modern warfare at firsthand, and he probably did suffer, as he claimed, from some form of shell shock. The war

did indeed have a crucial impact on his writing style. What is most interesting about his postwar stylistic transformation, however, what Hemingway could not bring himself to acknowledge, perhaps did not even understand, was that he had been so ready, so primed for the Great War experience, that it had taken him only weeks, not years, of participation to get its feel and meaning. In the enterprise of finding an adequate language with which to convey the war, the way was cleared for Hemingway as it was not for Graves and Sassoon. Something came easier to him. It did so, I think, not just because he was an original, a genius as neither Sassoon nor Graves was, or even because of the apprentice years he spent in Paris in the early 1920s absorbing Stein's style, rereading the Bible, and writing newspaper dispatches in "Cablese" (as Malcolm Cowley dubbed the laconic style of journalistic urgency that Hemingway learned as a correspondent), though these factors played their part. Hemingway also had an edge, as Stein knew she did, as an American; he had both more and less to draw on than an English writer did.

Just as, in Paul Poiret's opinion, the person uncluttered by traditional knowledge fared best in the New World, just as America's economic success came from its decision to abandon, not modernize, obsolete machinery and methods, Hemingway had an advantage because of the luggage he did *not* carry; his inadequate language was, paradoxically, not a drawback but an asset. In the face of the horrors and thrills of the Great War, the writer who was already trained and skilled in a sophisticated idiom, as Sassoon and Graves were, an idiom developed, moreover, on the premise that realities like those the war presented, did not, could not exist, and should not be mentioned if they did, found himself committed to a sensibility as inadequate and passé as the old industrial equipment Americans habitually destroyed. The war turned the British writers' prewar superiority in literary skill, experience, and accomplishment into a handicap. Their idiom was too good and too ingrained to be simply cast aside in the face of the Great War, but it couldn't get the job done. The culturally impoverished Hemingway, in contrast, starting in some sense from scratch, less freighted with cultural baggage, could fashion with little resistance or waste the new literary tools the modern experience demanded.

Hemingway's natural advantage as an American was not entirely a negative one; it came also from the baggage he *did* carry as an American, even if he carried it unawares. The shell shock he suffered was not as new to America as to Europe; his country had a prior historical claim on the medical and military enterprise that was the Great War. The highly industrialized American Civil War, fought in part in trenches, was a forerunner of the combat style of the Great War. In the late 1860s and early 1870s, American doctors,

with Philadelphia's S. Weir Mitchell at their head, did pioneering work with Civil War veterans suffering from what was then termed "battle fatigue"; over the next four decades, Mitchell studied and wrote about the related nervous disorders that seemed peculiarly to afflict America's civilian population.

When Carl Jung described America in 1912 as "the country of the nervous disease," he was not advancing a new idea. In 1881, sixteen years after the Civil War ended, a New York doctor named George M. Beard published a popular study of the state of the American psyche entitled *American Nervousness*, which anticipated Jung's diagnosis and dramatically expanded Mitchell's assumptions and findings about "battle fatigue" and nervousness more generally speaking. Beard's title was intended, like Mencken's *The American Language* four decades later, to strike a proprietary, imperial note; his aim was to show his readers that they were more prone to "nervousness" than the people of any other country because American life, by its very nature, overstimulates and taxes the nervous system. "Modern nervousness," he wrote, "is the cry of the system struggling with its environment." Protestant individualism, urbanization, industrialization, unprecedented social mobility and economic competition, hectic pace and noise, rapid dissemination of ideas by an omnivorous national press, and the (to Beard's way of thinking) excessive "mental activity" of American women—all the phenomena associated with a rapidly modernizing culture—make Americans automatic targets of nervous stress, at once overexcited and depleted. Modernization, in sum, "inevitably" increases nervous tension; technological and cultural acceleration is matched by a speeded-up psyche.

Europeans might not as yet consider America to be the full equal of the other Great Powers, but Beard was confident that America was twenty-five years ahead of all other countries in terms of economic progress. As Europe adopts America's technological methods of modernization, as it must, it, too, Beard believed, will fall victim to "American nervousness," and since Europeans have fewer coping mechanisms for handling nervous illness than do Americans, already habituated to the disease by protracted exposure, Europe, in Beard's words, "must die before America"; the cross-stimulation or cross-infection between American nervousness and the European psyche is part of the foreordained "Americanization of Europe." When Beard wrote that "no age, no country and no form of civilization, not Greece, nor Rome, nor Spain, nor the Netherlands, in the days of their glory, possessed such maladies," he was not complaining but boasting. It never occurred to him that a return to earlier and simpler days was possible or desirable; America had to seek new inventions and new sources of power, and Europe had no

recourse but to follow the American lead. "Nervousness" was proof of America's status as a chosen nation.

According to Beard, the more modern a country is, the more nervous it will be, and the more modern and nervous a country is, the more its conditions will approximate those of wartime. The highly industrialized Civil War had expressed the American way of life as it was in peacetime as well as in wartime; Beard, living in the more or less peaceful America of the 1880s, could pick up seamlessly on Mitchell's work on Civil War "battle fatigue" because, to his mind, modern American life, truly modern life anywhere, is industrial battle. Shell shock was the heir of the Victorians' nervous disorders, the pathological offspring of modern technology deployed to military purpose. The Great War as a military, industrial, and psychological force was already in America's history, one could say, before it broke out in Europe in 1914. Hemingway had been to boot camp without knowing it, and he had the literary credentials to prove it.

When 2 million American soldiers went to Europe in 1917 and 1918, a number of the writers among them saw that their new literary material was the war experience itself, experience *in extremis*, violent, terrifying, meaningless, but implication-laden and symbol-drenched experience whose outer terrain was no man's land, in Harry Crosby's words, "the Valley of Death," "pockmarked with shell craters" and inexpressibly "thrilling," and whose inner terrain was, to recur to Jung's words, "the shadow side of the mind, the unconscious." Imagine their excitement when the fledgling American writers who joined the war effort intuited that this war was something they already knew a great deal about, not from Thackeray or Dickens, but from classic American literature and the immense expanse and violent mood swings of the country that produced it.

I am not arguing that classic American literature directly influenced the writers of the Great War era. Few if any of them had read Melville, much less Charles Brockden Brown, and those of them who knew Poe or Whitman or Hawthorne (Van Wyck Brooks wrote brilliantly of all three in 1915 in *America's Coming-of-Age*) probably did not interpret them in the charged hyper-readings that became fashionable after the war. But I do believe, with Freud and Fitzgerald and many of their peers, that history works as much by something like telepathy as by cause and effect, as much by the apparent coincidences of what Hegel called the Zeitgeist as by calculable economic or cultural influences; in an important essay of 1893, Twain christened this view of history-as-mind-reading "mental telegraphy." History may operate less by laws of sequence than by simultaneity; its only detectable design may lie in what groups together in a proliferation of resemblances that extend,

alter, and expand objects and events. As Stein's title "Composition as Explanation" was meant to suggest, composition may be as close to explanation as we are likely to get.

I think that writers absorb the special literary atmosphere they live in whether its products are known or unknown to them, as surely as people take in the air they breathe, whether or not they know its specific composition, its levels of pollution, its pollen count or humidity. In Stein's words in *Wars I Have Seen*: "Anybody is as their land and air is. Anybody is as the sky is low or high. Anybody is as there is wind or no wind there." "Everyone is as their . . . climate is." I do not wish to slight the various theories of historical causality, most importantly, the almost comprehensive Marxist schema whose main tenets seem to me simply common sense; I only wish to acknowledge that such theories stop short of full explanation, that the road ends before we do, that we make our way nonetheless, traveling through the dark by some other form of knowledge. If this view puts history and cultural production in part into the realm of the recalcitrantly mysterious, that may be where they belong. History may be closer to weather than we care to admit. Perhaps, in Wallace Stevens's words, "it is enough to believe in the weather."

Serious reconsideration of Twain—Hemingway's, as Freud's, favorite American author—began when Twain's darkest tale, "The Mysterious Stranger," was posthumously published in 1916. The Melville renaissance was initiated in this country in 1921 when Raymond Weaver published *Melville, Mariner and Mystic*. (England had taken the lead; the poet Viola Meynell wrote a pathbreaking introduction to a new edition of *Moby Dick* in 1920 in which she praised Melville as a "genius" of "wildness," of "imagination escaping out of bounds.") But, on another level, one can say that the rediscovery of classic American literature, whether at home or abroad, actually began with the Great War in 1914. To go to this war was in some not altogether fanciful sense to read Melville and Twain and their peers. The war presented as fact the fictive world of classic American literature and made its formal rediscovery and critical recognition inevitable.

A WORLD OFF-TRACK

D. H. Lawrence found in classic American literature a map of the primitive mind whose return Freud had heralded in "Thoughts for the Times on War and Death," but the connection between the Freudian discourse and the American narrative tradition was closer still; indeed, the terms Freud used

to describe the Great War can be used without the slightest modification to describe classic American literature. If the war broke all the rules of "civilized hypocrisy," as Freud hoped, if it had blazoned man's repressed capacities for "an excess of brutality, cruelty and mendacity," and discredited the argument for God's providential design and man's progress to the higher stages of evolution; if it forced people to acknowledge the Satanic drift of the universe without and the "blind fury" of the psyche within, it had merely supplied classic American literature with its proof and its cue.

Nothing is clearer about the most important novelists of the post-Great War decades than that they abandoned plot as the indispensable framework, interest, and credential of the novel form. Human beings cannot live without stories, but in the postwar era, they were increasingly forced to turn to less prestigious forms of fiction and media fare to satisfy their hunger. In elite modern fiction, American and British, a successful plot seems to be an inexplicable accident. Why is *The Great Gatsby*, for example, the only superbly plotted, or even well-plotted, novel among Fitzgerald's five? *Gatsby* is not a better book than the sometimes ill-organized *Tender Is the Night*. Elsewhere plot is downplayed, occasionally to the point of suspension or outright omission. What really happens in Virginia Woolf's moving meditation *Between the Acts* (1941) or Hemingway's equally reflective if less successful *Across the River and into the Trees* (1950)? Moving to more recent times, one finds novels like Thomas Pynchon's *Gravity's Rainbow* (1973) and John Barth's *The Sot-Weed Factor* (1960), in which plot is articulated to the point of conscious absurdity, a filigree that calls attention to its own artificiality. In all these modern and postmodern works, plot is no longer the necessary handmaiden of the characters' lives, nor does it supply the narrative's beat; it has either been dismissed from the narrative or usurped the narrative's life. Few if any writers of self-consciously major status in the last seventy years have placed a high priority on storytelling. Conventional literary strategies of plotting were apparently among the casualties of the Great War.

To fight in this war was to be engaged in an action that no one understood. The technology and military strategies involved were so new and unfamiliar that the outcome of any given engagement could not be predicted; commanders and troops spent more time in preparation to less purpose than in any war in history. The British lost a catastrophic 60,000 men at the Somme on July 1, 1916, many of them in the first eleven minutes of battle. As the historian John Keegan recounts the events in *The Face of Battle* (1976), the generals had not been able to assess the action before it took place, or even to perceive it as it happened. Because of the extreme vulnerability of

participants in such technologically sophisticated combat and the record-high casualty rates, the commanders deemed it inadvisable to expose themselves in battle. At the Somme, they had to wait for news to come to them, news that was difficult to collate on a big, chaotic field of battle; they never caught up to the action. And the action at the Somme and elsewhere wasn't pretty. In "A Natural History of the Dead," collected in *The Green Hills of Africa* (1935), Hemingway reports bodies blown apart by explosives "along no anatomical lines but rather divided as capriciously as the fragmentation in the burst of a high explosive shell." Others "die like cats; the skull broken in and iron in the brain, they lie alive two days . . . and will not die [unless] you cut their heads off." Corpses turn color and take on "a visible tarlike iridescence"; they swell and blow up until "they become much too big for their uniforms."

Faced with the constant and imminent prospect of such meaningless and horrible death, soldiers in the Great War did not turn to God. According to Robert Graves in *Goodbye to All That*, "hardly one soldier in a hundred was inspired by religious feelings of even the crudest kind." The American Methodist chaplain Ernest Fremont Tittle confessed that he "found it very difficult even so much as to think of God" amid the "infernal business" of the war. Soldiers forgot the "prayers prattled at mother's knee," in the words of a British veteran, Philip Gibbs, and noted instead the bitter jokes of wartime. Graves reported that one officer found "two rats on his blankets tussling for the possession of a severed hand. The story circulated as a great joke." Sassoon remembered the sight near the Hindenburg Main Trench of "a pair of hands (nationality unknown) which protruded from the soaked ashen soil like the roots of a tree turned upside down; one hand seemed to be pointing at the sky with an accusing gesture."

Participants expressed again and again their sense that the war baffled narration and refused to precipitate itself as recordable history. One of the most popular songs among soldiers went, "We're here because we're here because we're here," repeated *ad infinitum* and sung, with obvious ironic intent, to the tune of "Auld Lang Syne"; "because," the causal word, the conventional tip-off to meaning, is here emptied of content. In a poem entitled "Exposure," the British poet and soldier Wilfred Owen, who suffered shell shock and finally death in the war, wrote:

> The poignant misery of dawn begins to grow . . .
> We only know war lasts, rain soaks, and clouds sag stormy,
> Dawn massing in the east her melancholy army
> Attacks once more in ranks on shivering ranks of grey,
> But nothing happens.

How to tell a story where "nothing happens," where nothingness itself *is* the story?

If the Great War put traditional story or plot out of fashion, British literature stood to lose more than American literature did. When Owen wrote in his journal of no man's land as "the face of the moon, chaotic, crater-ridden, uninhabitable, awful, the house of madness," he could not possibly be speaking of the favored sites of British fiction, the arenas of social conflict and accommodation provided by Jane Austen's country estates or Anthony Trollope's Barsetshire or George Eliot's Middlemarch or even Dickens's ravaged, corrupt, but still definable London; he could easily, however, be talking of the somnambulistic ordeals of geography that engulf narrative time in Brockden Brown's *Edgar Huntley* (1799), the arctic wasteland of Poe's *Narrative of A. Gordon Pym* (1838), or the inscrutable "whiteness" of Melville's emblem of universal disorder, Moby Dick. The war's strange pacing, reluctant and violent by turn, as Owen and others described it; the flickering, hallucinatory sense of place, purpose, and identity; the plotlessness that substituted for narrative coherence, was the everyday fare of classic American literature.

English narratives of the nineteenth century, the works of Austen, Eliot, Dickens, Thackeray, Gaskell, the Brontës, and Wilkie Collins, were often irregular but greatly plotted novels. Plot or story in the nineteenth-century British novel, however shapeless or strained, was an affair of fidelity, one that seldom, if ever, abandoned its commitment to the revelation and development of its chief protagonists. Dickens had a fondness for entitling novels by the name of the story's main character: *Nicholas Nickleby, Oliver Twist, Martin Chuzzlewit, Dombey and Son, David Copperfield, Barnaby Rudge, Little Dorrit, The Mystery of Edwin Drood.* George Eliot wrote of "Amos Barton" and "Janet's Repentance" (in *Scenes from Clerical Life*), of *Adam Bede, Felix Holt, Romola,* and *Daniel Deronda.* Charlotte Brontë told the stories of *Jane Eyre* and *Shirley*; Thackeray, of *Pendennis* and *Henry Esmond.* In the British tradition, story and character were working, if loose, synonyms. Among authors of classic American literature, however, only Charles Brockden Brown shared this habit as a widespread practice. He wrote *Wieland, Arthur Mervyn, Ormond,* and *Edgar Huntley,* but these titles, once one has read the novels they head, suggest not a recognizable or familiar person or character but, rather, the strained and disturbed psychological states that Brown's protagonists seem to exist only to personify.

Twain wrote of *The Adventures of Tom Sawyer, The Adventures of Huckleberry Finn,* and *Pudd'nhead Wilson,* but he severed character from story and moral purpose apparently at will. Hemingway thought that *Huckleberry Finn* was America's greatest novel and the most important predecessor to his

own work, but he advised modern readers to ignore the last part of the book, in which Huck and Tom, caught up in a childish and cruel game, re-enslave Jim; in Hemingway's view, Twain had betrayed his hero and his book. In fact, Huck signs off, in the novel's last lines, a fugitive headed for the "territories," with no better sense of right and wrong than he had at the start of his adventures; he knows only that he wants to resist colonization, to escape being "sivilised." The false series of juvenile pranks and intrigues that end the book and antagonized Hemingway may have a point: *Huck Finn* is a *Bildungsroman*, a novel of education, in which Twain sees to it that nobody gets educated.

Melville's books, like Twain's, move forward when he is in close connection with himself, in the grip of his daemon; when he is not, matters stop and muddle, if in fascinating ways. Plot doesn't develop in *Moby Dick*, but rather happens, sporadically, jerkily. Melville seizes upon an incident —a chance encounter between Ahab's *Pequod* and another whaling vessel, an episode in the intermittently glimpsed relationship between Ishmael and the cannibal harpoonist Queequeg—exhausts its significance, and abandons it. The unifying principle of *Moby Dick* is not story or character but Melville's changing and brilliant need of his material. *Moby Dick* is on the page before us, on the successive and many pages before us, because Melville must have it there; it emanates not from any sense on his part of an outside literary structure but from his private necessities and cultural possibilities. He writes *Moby Dick* because, in Luther's words, he "can do nothing else," and his allegiance to his inhuman protagonist is far greater than his interest in his human ones.

The title *Moby Dick* is the name, of course, not of any character in the book but of the leviathan who destroys everyone in it except Ishmael, and important as Ishmael's survival is, it is not Melville's final concern. A German veteran Rudolf Binding, noted in his memoir *A Fatalist at War* (1929), that "only the War had its way," and Melville closes *Moby Dick* with "the great shroud of the sea roll[ing] on as it rolled five thousand years ago"; in *Moby Dick*, only the ocean gets its way. Edwin M. Eigner has argued that the English writer was concerned with the effects of experience on his protagonists, while the American writer focused on the nature of experience itself. He was interested in psychology more as a branch of physics than as an aspect of the humanities or social sciences, and for the British novel's traditional task of empathy and therapeutically shared experience, he had almost no interest at all.

Melville's Pierre does not love his fiancée, Lucy, or his half sister and wife, Isabel, as Adam Bede loves Hetty and Dinah in Eliot's *Adam Bede* (1859), nor even as Jude Fawley loves Sue Bridehead in Hardy's *Jude the*

Obscure (1895). Heathcliff's mourning of his dead love, Cathy, in Emily Brontë's *Wuthering Heights* (1847), frantic and obsessive as it is, is something different from the cold-blooded, fixed attentiveness Poe's male protagonists devote to their "posthumous heroines" (the phrase is Harry Levin's), their dead or apparently dead Ligeias, Bernices, and Madeleines. While Cathy and Heathcliff's tortured love outlives them and finds a happier expression in their children, Poe's couples are irrevocably childless and loveless. What English novelist of the Victorian era spoke of needing "a pen warmed up in hell," as Twain did while writing *A Connecticut Yankee in King Arthur's Court* (1889), or of "writing a wicked book" and feeling as "spotless as the lamb," as Melville did upon finishing *Moby Dick*? Utterances like these are the words of "conquistadors," to recur to Freud's favored word of self-description, and they supplied, just as post-Great War pessimism did, not depression, but top exhilaration to those who trafficked in them. The nineteenth-century American writer was not downcast but jubilant as he refused all consolation, all grief; he was engaged in an instigation rather than, like his British counterpart, a therapeutic process.

Classic American literature awards little time to the victim. Ahab may deform and destroy his life, but he does not miss out on it. Like Oedipus, in whom Freud found both his riddle and his answer, the hero of classic American literature has the energy, the power, and the strange, ludicrous dignity of the self-tormented. Who forces Roderick Usher, or any other of Poe's apparently weak and passive characters, to madness? Who compels Ahab to his insane chase of the whale? Even Hawthorne, obsessed with the sins of the fathers, is attracted to those who make their lives and pick their sins. Hester Prynne will not repent her adultery; Zenobia's suicide in *The Blithedale Romance* is designed to torment the man who rejected and outlives her. Miriam, the heroine of *The Marble Faun*, tries to avenge herself on her persecutors. The pessimism of the authors of classic American literature, like that of their descendant Hemingway, has gained more in energy than it lost in hope; in the words of Juliet Mitchell, summing up the Freudian ethos, this tradition enforced "pessimism of the intellect and optimism of the will."

The English novel had specialized in the very things the war seemed to render null and void, in the art of mimesis, the commitment to a faithful description of a social landscape, an intelligible world filled with knowable people and familiar places, but this was a world for which the practitioners of classic American literature had found but little use and for whose depiction their skills were sometimes rudimentary. This is not to say that mimesis, the art of exact description, is altogether absent from classic American literature; one need think only of Hawthorne's description of "the Custom House" and

its denizens in the prologue to *The Scarlet Letter* or Twain's depiction of the river pilots in *Life on the Mississippi* or the sailors and captains of Melville's early fiction. But mimesis in classic American literature is a guest, not a host, and it sets none of the rules; it never controls the narrative enterprise, as it habitually does in the British tradition.

In *Dora*, a case study of 1905, Freud used the word "switched" to describe the breaks and ruptures that occur in the stories of neurotics, and one can say that, in classic American literature also, mimetic representation has been "switched," tampered with, pushed one crucial step off track. It is as if a train had veered off to a new track or a ship at sea had gone off course. Everything may at first seem the same to the passenger; the interior of the vehicle, the sound of the engine, the other passengers, the motion—all are unchanged. But the aim, the direction of the vehicle, and hence, sooner or later, the mood of the passenger are irretrievably, ominously altered; fear, William James's "Fear" with its capital letter, fear as a stimulant and an incentive, is as constant a presence in classic American literature as it is in that extended explication and solicitation of terror the Freudian discourse.

In the American tradition, mimesis is displaced to what the critic Richard Poirier, speaking of American narrative and borrowing a term from Shakespeare's *Coriolanus*, has called "a world elsewhere." Forced into exile, Coriolanus turns the tables on those who exile him by telling them, "I'll banish *you*. There is a world elsewhere." This willed conversion of exile from the known and familiar world into an enhanced power of exploration and vision in another unknown but compelling world, this exchange of the recognizably real for a place or mode defined as more insistently real, a place where provincials are recognized as sovereigns, was the central strategy of classic American literature.

With the Great War, America's "world elsewhere" became the here and now. People always ask from literature the description of their world as they know it; they always want to see their image in the mirror, as Henry James remarked. But the Great War showed much of the West that what the world had seemed to be just prior to the outbreak of the war, the world people still saw out their windows in the postwar decade, the world the English narrative had described with matchless fidelity, inventiveness, and depth, was not, somehow, the "real world" at all. The indescribable "world elsewhere" that the American narrative tradition was concerned with was, however unfamiliar or displaced it seemed, the real "real world." When the world seems itself to be "switched" or displaced from its course, the funhouse mirror reflects most accurately the object; or the person, as it really is. Officially to devalue conventional mimesis, as the Great War did, was to create a critical atmosphere in which, though the narrative preferences of Melville and Twain

—their refusal or inability to play conventional storyteller, coherent plotter, and consistent delineator of place and character—might still feel like limitations to readers of their work, they could no longer disqualify them from the front ranks of authorship.

Lewis Mumford, explaining the character and delineation of Ahab in his study of *Herman Melville* (1929), remarked that Ahab seems "incredible" if considered on the customary "plane" of "realism," but Mumford knows this is not the plane *Moby Dick* operates on; it is, in Mumford's phrase, "projected" onto another plane, and the characterization of Ahab follows "another and equally valid convention." On this plane, Ahab "ceases to be incredible because he is alive." Vitality, not verisimilitude, is the criterion of classic American literature; it offers a portrait of energy itself, of the adrenaline of the psyche, a portrait in which the external landscape is never separate from the landscape within. Mumford found Melville's closest kin in Freud and his great rival, the French psychiatrist Pierre Janet; Melville, too, "x-rays the very organs" of his characters. A consistent representation of their surface appearance holds little interest for one who means to depict a "psychological mood."

When Jung compared no man's land to the "shadow side," the "unconscious" of the mind, he defined the Great War as a vast analogue to the unseen psyche. Sassoon and Graves, like Hemingway, wanted to convey this extension and pathologization of consciousness, the "mood," the sense of "what [they] felt like," in their narratives, but they fell short of the mark as he had not. Their failure and his success, seen in the light of the classic American literature before Hemingway, is not surprising. America may not have a character in the same sense that the older European countries do, but it has always had a psyche. It means something, if something far from conclusive, to talk of a "Melville complex" (the impulse to grandiosity), or a "Hawthorne complex" (the psychology of guilt), or a "Poe complex" (the mechanisms of paranoia), or, one might add, moving to the moderns, a "Fitzgerald complex" (the stress of social and psychological mobility) and a "Hemingway complex" (the coping rituals of the self-consciously tough). It means less, I think, to speak of a "Dickens complex" or a "Thackeray complex" or even a "Woolf complex." Lawrence can be talked of in terms of a complex (the obsession with potency)—perhaps that is why he is still American literature's most important commentator—but he was self-consciously breaking with the traditions of the Anglo-European past.

If the subject of the English novel had been society, that of the French narrative tradition the mind, that of the German school the metaphysical sensibility, that of Russian literature the soul, the central preoccupation of classic American literature lay in the mood and the psyche where it originates:

the abrupt fluctuations and disturbances of people's perceptions of life and themselves, as vague as a malaise and as sharp as a gambler's hunch, the troubling traces of something that leaves many footprints but no trail, that is all clues and no substance, something people know as well and as little as they know themselves. Classic American literature springs from the illegitimate emotions possessed of a powerful dynamic but no stable content, the vulgate of the psyche where consciousness and unconsciousness find their life in symbiosis, a vulgate whose authentic self-expression must be, not in the constructs of story or character, but in that most fluid and intractable of the narrativist's resources, language itself, a language pushed to deliver all its resources.

The American language, expert in both euphemism and dysphemism, in pale imitation and bold originality, offered its heirs a double legacy, and some of them knew it. Philip Rawlings, the transparently autobiographical hero of Hemingway's play about the Spanish Civil War, *The Fifth Column* (1938), says that he can "talk either English or American, was brought up in the one, raised in the other," but he knows he "can lie so much easier in English." Hemingway sensed that he somehow spoke two languages: one, the English language, acquired or consciously taught to him; the other, the American language, a more instinctive tongue, an undefined but insistent part of the half-seen world of broader influences at work on him. In plain fact, Hemingway did speak two languages. He naturally, one might say, used the euphemistic jocular Booster tongue, the language we saw him employing in his letters home during the Great War, full of false goodwill and real bad manners, a language uneasily attempting to prove its familiarity with polite Anglo-American speech by roughing it up. This idiom was the hard-core, middlebrow, middle-class American-speak of Hemingway's hometown, Oak Park, Illinois, and he used it throughout his life, in his letters. But he also drew on the very different linguistic resources of classic American literature, and he wrote his published fiction in his own version of that idiom.

Classic American literature anticipated the themes and mood of the Great War, and it did so in a language more diverse and inventive than that seen in any other contemporary branch of the English language. It was a language that had heard the pungent, spare, biblically nourished idiom of Lincoln's addresses and Emily Dickinson's poetry, and listened to the free and sharp turns of the frontier vernacular; it had incorporated the black-and-white slang of nineteenth-century minstrelsy and variety entertainment, and the ambitious metaphysics of the sublime style. Sassoon and Graves were monolingualists; although their tongue was sophisticated and resourceful, no experience could summon forth a new parlance. But Hemingway possessed an instinctive sense of a complex language different from the one he normally

used. Unwittingly bilingual, he had a conscious language, pidgin-American shading into pseudo-Anglophilism, and an unconscious language, the resourceful eloquence of classic American literature. The war brought the needed style to the surface, a fusion of guts and grace, fresh, antique, and bare, as his conscious craft.

Go back to Wilfred Owen's lines about the war's refusal to precipitate itself as event:

> *The poignant misery of dawn begins to grow . . .*
> *We only know war lasts, rain soaks, and clouds sag stormy,*
> *Dawn massing in the east her melancholy army*
> *Attacks once more in ranks on shivering ranks of grey,*
> *But nothing happens.*

Like Graves and Sassoon, Owen is doing more describing here than creating, more "telling" (to use the critic Wayne Booth's distinction) than "showing." Hemingway would never have used the overpurposive, distracting, and vague "only" ("We only know"), nor would he have relied on the sodden profusion of adjectives Owen musters ("poignant," "melancholy," "shivering"), nor made nature empathize, as Owen does, with the problems of men ("clouds sag stormy").

In "Thoughts for the Times on War and Death," Freud had explicitly looked to the war to end the literature of empathy and vicarious experience. He had scant patience with what he considered the rank sentimentalism of late-Victorian literature, with fiction that allowed its readers "to die in the person of a given hero, yet . . . survive him . . . ready to die again with the next hero just as safely." Hemingway, too, detested such easy habits of identification and the "plurality of lives," in Freud's phrase, they seem to offer; to his mind, this kind of identity transference and expansion gave privilege to evasion and served only as "alibis." "You can depend on just as much as you [yourself] have actually seen or felt," Hemingway taught. Descriptive language like Owen's was for Hemingway language narcissistically infatuated with its own connotative possibilities, language that overinvests in the remembered and anticipated responses of others. Descriptive language, in sum, depends not on "what *you* have actually seen or felt," but on what *others* "have actually seen or felt." And Hemingway never, never states his theme as obviously as Owen does here ("nothing happens").

Hemingway was writing prose, of course, Owen poetry, but his dense and elegant style seems to invite such comparisons. My focus in this discussion of the Great War's destruction of traditional modes of mimetic presentation has been on prose, for it is prose that has traditionally relied most heavily

on narrative coherence, not poetry, with its innately looser allegiances to realistic representation. But it should be said that the Great War benefited the more eccentric and irregular American poetic tradition of Whitman and Dickinson as much as it did the heretical prose tradition of Poe, Melville, and Twain. Although prewar England, with Byron, Keats, Shelley, Wordsworth, Coleridge, Tennyson, and Browning to its credit, had engrossed all the popularity and prestige on the Anglo-American poetic scene, postwar England had no match for America's formidable array of talents, talents that included Eliot, Stevens, Frost, Williams, Hughes, Moore, Millay, and Crane. Hemingway tried poetry in his apprentice years; the result was hopelessly mediocre, but his best prose, with its uncanny powers of ultraclarification, has, in Edmund Wilson's words, the "hard" and "disturbing" quality of "a great lyric."

Yet, while Hemingway's prose has some of the virtues of poetry, it lacks many of the virtues traditionally associated with prose, especially with quasi-reportorial prose like that In Our Time purportedly offers. Indeed, In Our Time, unlike the memoirs of Sassoon and Graves, provides no hard-core information about the war at all. Look at the opening lines of the first chapter, "On the Quai at Smyrna":

> The strange thing was, he said, how they screamed every night at midnight.
> I do not know why they screamed at that time. We were in the house and
> they were all on the pier and at midnight they started screaming. We used
> to turn the search light on them to quiet them. That always did the trick.

The scene is powerfully and sharply rendered, but the specific details are omitted. Clearly some civilians are being detained by an enemy army, but we don't know when, where, or why. Nor are we told what the screaming sounded like or how the narrator felt about it, what associations it conjured up. Metaphor, imagination's best bridge to mimetic reality, is here taboo. Who exactly are "they" and "we" anyway? Who is the "he" of "he said"? Who, for that matter, is "I"?

This failure of specificity, this confusing exchange of pronouns, forces Hemingway's readers to focus not on the distinctive traits of the persons supposedly being designated but on their interchangeable qualities. Put another way, one might say that Hemingway's personal pronouns aspire to the condition of the neutral third-person pronoun, "it." Kafka, too, liked to substitute "it" for "I" or "he"; he revised Descartes's famous syllogism "I think therefore I am" to read "It is, therefore I am not." "It" is the minimalist, featureless pronoun. With its sinister seepage, its excision of the human, "it" is the pronoun most appropriate and effective in descriptions of modern

technological warfare, and it came to Hemingway's hand as naturally and forcefully as the required instrument is slapped into the palm of a surgeon by an expert aide.

"I have the nightmares and I know the ones that other people have," Hemingway said in a *Paris Review* interview of 1954. "But," he continued, "you do not have to write them down. Anything that you can omit that you know you still have in the writing and its quality will show." Note the ominously unspecified, "*the* nightmares": language can advertise its resources, not only by flagrantly deploying them, but also by conspicuously sinking and stockpiling them. Hemingway never tells the readers of "Big Two-Hearted River" that the trauma Nick Adams is trying to cope with is that of his experience in the war. But we know; somehow, in Hemingway, we always *know*.

Sassoon's puzzled conclusion that "a man can write too much about his own experience even when 'what he felt like' is the nucleus of his narrative" is the place where Hemingway's aesthetic begins. He understood, as Sassoon, Graves, and Owen apparently did not, that what the writer knows but omits will show up in what he writes as a sense of unstated depth that is more powerful than any attempt to describe the undescribable can be. Good prose, Hemingway insisted again and again, must be like an iceberg, seven-eighths submerged; like dynamite packed under a bridge, the Hemingway biographer Kenneth Lynn has said; like Moby Dick, one might add, masking his gigantic bulk in the ocean. Think of Stieglitz's vision of the Flatiron Building "moving toward me like the bow of a monster Ocean Steamer—a picture of new America still in the making." Good prose, as Hemingway understood it, is like the Flatiron in Stieglitz's vision; it is fueled by the powers of latent, uncheckable momentum. As Hemingway once put his aesthetic credo: "Let the pressure build."

AMERICAN REPATRIATION

In their war memoirs, Sassoon and Graves dramatized the shock the war had brought to a more or less normal if gifted sensibility; it was, nonetheless, a shock from which the self could and should recover, in their view, although forever altered by its wartime experience, to return to a social order, equally shaken, equally in need of rehabilitation, but still possessed of meaning. Sassoon labeled his post-battle self a "convalescent"; like their British predecessors, like, in a sense, the authors of *Pollyanna* and *Molly Make-Believe*, Sassoon and Graves were interested in regaining and maintaining a state of health. They wanted to normalize what had become abnormal, to recon-

textualize the incurable text of war and shell shock in the therapeutics of the English mimetic-narrative tradition. But, as they themselves knew, mimesis was inadequate in the wake of the Great War; even if it constitutes some kind of psychological health, it is regressive on the artistic level.

Graves tells the reader not just about his war experience but also about his prewar boyhood and school days, and his postwar life, his marriage, his desire for children, and his return to college, where he wrote a thesis (interestingly enough, on "The Illogical Element in English Poetry," on the "direct opposition" between "the obvious prose sense" and the "latent content"). For the veteran Graves, life goes on, if painfully. Sassoon, recuperating from the war on the rural estate of an obtuse, if benevolent, noblewoman, stresses his determination not to communicate, not to respond to the customs and rituals of civilian life; "I wasn't going to be bluffed back into an easy-going tolerant state of mind." Wandering around the grounds, however, he forgets "the military machine" and " 'take[s] sweet counsel' with the countryside," noting brooks, hedges, and apple blossoms with intense pleasure. As the citation "take sweet counsel" shows, poetry's lessons of pastoral trust still have validity for him, and "the pleasant-mannered neighbors" who drop in to tea are, he confesses, difficult to dislike. Sassoon can enjoy a temporary reprieve, a time-out period; natural scenes, other people, even—or especially—scenes or people who have not known the war, are potentially restorative to the shell-shocked convalescent.

Sassoon uses the Victorians' favored word, "progress," in his title Sherston's Progress, a word he meant ironically to infuse with its older Bunyanesque connotations, as in The Pilgrim's Progress, of the religious quest; the word does not and could not appear in the title of any Hemingway book or story. "Progress," he might ask; "to what?" A more complete ironist than either Sassoon or Graves, Hemingway usually preferred the radical irony of omission. Just like the American economy in David Wells's description of it, he, too, practiced the excommunication of the outdated, the deletion of the criminally obsolescent word or term and the ideas and feelings it had traditionally evoked; he permitted himself no trafficking with the deposed but still dangerous enemy. In A Farewell to Arms, Hemingway explained that the only words that retained meaning were the "concrete" words, the names of particular places, persons, and things. He did not consider going to college after the war, as Graves did; he knew he had nothing to learn that school could teach.

Hemingway's postwar return to his family was a troubled one, but when he went to Paris in the fall of 1921 he was entering the best, most productive years of his life, the times he remembered, as his days lengthened and darkened, with heartbreaking nostalgia and regret. By all accounts, the young

Hemingway simply radiated vitality and happiness; everyone wanted to be near him, to share in the excitement. The writer Nathan Asch reminisced about the power of his presence in Paris to Malcolm Cowley, who told it to Denis Brian for his "Intimate Portrait of Hemingway," *The True Gen* (1985):

> It was an event when [Hemingway] passed the sidewalk tables at the [Café] Dôme. Arms waved in greeting and friends ran out to urge him to sit down with them . . . Hemingway would be striding toward the Montparnasse railroad station . . . and he wouldn't quite recognize whoever greeted him. Then suddenly his beautiful smile appeared that made those watching him also smile . . . He put out his hands and warmly greeted his acquaintances, who, overcome by this reception, simply glowed and returned with him to the table as if with an overwhelming prize.

It is not hard to see why Ronald Fieve considers the young Hemingway a prime example of "grandiosity with a basis in fact"; in his early days in Paris, he was effortlessly packing two or three lives into the confines of one and transforming everything he touched. He was married to Hadley Richardson, whom he always believed the finest, the most gifted, the kindest and strongest and most generous of his four wives. "I wish I had died," he wrote in his memoir of Paris, A *Moveable Feast*, "before I ever loved anyone but her." Although he left her in 1926 to marry Pauline Pfeiffer, Hadley continued to see herself as his beneficiary. She'd been an unhappy young woman when they met in 1920, burdened by the suicide of her father, the death of her sister, the tyranny of her mother, and a series of "nervous" disorders, and Ernest, with his enthusiasm, self-confidence, and love of adventure, had set her free; he gave her, she said, "the key to the world." In 1923, the couple had a baby boy, "Bumby," to whom Hemingway devoted intermittent but real attention. He was also helping to edit *The Transatlantic Review*, traveling all over Europe as a journalist and tourist, fishing, hunting, skiing, studying, and betting on horse races, learning to bullfight, acquiring new expertise in wines and food, forming a dozen new and intense friendships, and, best of all, forging the prose style that he knew would put him in the front ranks of the world's great writers.

When Hadley, in transit on a train in 1922, accidentally lost the typescripts of all the stories Hemingway had been working on in his long and much-vaunted training sessions as a novice writer, he was devastated; in later years he liked to recount the horror and despair the loss had occasioned him. Yet there is no evidence to suggest that what he lost was anything more than apprentice work. He wrote most of the stories that became *In Our Time* in a few short months of elation in the winter of 1924. The loss of his manu-

scripts was, whatever his claims, no tragedy; he had only once again ex-
emplified David Wells's imperative to destroy the old in order to give birth
to the new. This is not to say that Hemingway's years of apprenticeship were
not important ones but, rather, that when the harvest of his efforts came, it
came in a burst. He posed on the page and off as a seasoned vet, though
he was but a summer's participant in the struggle, and he did so, at least
initially, I believe, with an immense and justified sense of clarification,
release, and excitement. The Hemingway who wrote *In Our Time* was not
lying as he was, by his own account, in speaking "English"; or rather, in
telling this lie, he was telling, perhaps for the first time, something like the
truth. The costume fit, he knew the part by heart; the stage was home. In
the title of Philip Gibbs's war memoir of 1920, a best-seller on both sides
of the Atlantic, *Now It Can Be Told*.

For the writers of the 1920s, the Great War provided an ambivalent but
powerful form of repatriation. I have already suggested that Hemingway and
other American artists lived abroad in the 1920s, less to escape their country
than to be able to write more effectively about it; "I am," Philip Rawlings
remarks in *The Fifth Column*, "an American before everything else." Dos
Passos had spent much of his prewar life abroad, but after the war was over,
he went back to the States, he thought, to stay. Shortly before his return,
he wrote a friend that "for us barbarians, men from an unfinished ritual,"
Europe, now that it was settling back into the "ceremony" of life disrupted
by the war, was too "gentle"; brutality, as Jung told the nation in 1912, was
America's style. The most important change the war fostered in the cultural
life of America, a change, I would argue, as profound as any comparable
one in war-ravaged Europe, was that it allowed the country to shed its
borrowed past, to be itself. America, not Europe, offered the long-standing,
on-going exemplar of the violent reality the Great War personified and
unleashed, and there could be no going back.

THE "DARK LEGEND"

OF MATRICIDE

MATERNAL REBUKE AND FILIAL REVOLT

As the nation, nerved by the stimulus that only hell can deliver, headed into the Great War, its feminine forces gathered to condemn the "hideous excitement," in John Dos Passos's exultant phrase, the war brought to some of its masculine participants and observers. A Mind-cure practitioner named Annie Payson Call, an intelligent single woman of New England stock, constituted herself moral advisor to the boys soldiering in no man's land, and in her book *Nerves and the War* (1918) she warned them: "Don't take the war into your mind!" Uneasily aware that history was slipping her leash, Call claimed that shell shock was a figment of the imagination, the product of negative thinking, something that Mind-cure tactics should and could dispel. She urged soldiers to "rouse the will to direct the brain into wholesome channels," to avoid "levity" and remember the "great purpose" for which the war was being fought.

On a more private note, in early 1918, a playwright-to-be named Sidney Howard, then a volunteer serving in France, received a letter from his mother reproaching him for the "unhealthy thirst for excitement" his letters home betrayed. He responded with his own protest and a declaration of independence. How could his excitement be unhealthy? "[I'll] be young only a little time longer! and the place to be young is the dangerous place!" Sidney was in the air corps, one of the breed of ace pilots new with the Great War, and he found flying "sport, and by God . . . poetry!" But his mother's surveillance was not to be dodged so easily. In the summer of 1923, shortly after his father's death, Howard and his new wife, the actress Claire Eames, traveled in Europe, hoping to shake Mrs. Howard, who had "pursued" them (it's his word) to the Continent; in 1926, he dramatized his feelings in a play titled

The Silver Cord. Reviewing it for the New York *Sun*, Gilbert Gabriel described it as "a play for the mature . . . full of excitative truths." Howard was talking about the umbilical cord that attached mother to son; *The Silver Cord* is an impassioned, distended, and palpably phobic attack on pious and "diseased" mothers and their "superabundant vitality." In Howard's view, it was the high pitch of self-righteous matriarchal intrusiveness that was unhealthy, not his own attraction to "the dangerous place."

This contest between mother and son spelled another quarrel over the interpretation and use of the energy rush that the Great War triggered, a homefront, gendered version of the struggles and shifts in power among nations after the war. Whose engine, so to speak, was this new source of fuel going to supply, the mother's or the son's? The quarrel was not over excitation itself; both sides, the matriarchal and the masculine, the Victorian and the modern, openly acknowledged their commitment to charged experience. Gilbert Seldes, looking at the feminine leaders of America's Purity campaigns, was struck by their "demonic energy," and Carrie Chapman Catt, president of the National American Women's Suffrage Association (NAWSA), spoke frankly of the way her sense of mission "filled the days and rode the nights." A number of the most prominent domestic reformers—including Clara Barton, Dorothea Dix, Harriet Beecher Stowe, Catherine Esther Beecher, Jane Addams, and, of course, Mary Baker Eddy—were victims of early physical or "nervous" ailments of one kind or another. All of them were expected to die relatively young; all of them took hold upon discovering their mission and led busy and phenomenally productive lives well into their seventies and eighties. A career in reform activity could apparently add years, even decades, to one's life. Those who supported American entry into the Great War saw it as the biggest and best manifestation of this highly energized crusading matriarchal ethos, its culmination and justification; in fact, the two most important feminine reform movements, Prohibition and Suffrage, rode to victory on the war's coattails.

America's declaration of war turned Prohibition's enemies into the nation's enemies. Temperance crusaders denounced the German-dominated beer industry as a hotbed of treason, and they slipped a "dry" provision forbidding the "waste of food stuffs in the manufacture of beer and wines" into wartime food legislation. What was known as "Wartime Prohibition" was passed into law in December 1917, only six months after America entered the war. President Wilson opposed the final Prohibition amendment on constitutional grounds, but Congress overrode his veto, and the states ratified the Eighteenth Amendment in January 1919. The "wet" or anti-Prohibition interests opposed suffrage reform almost as fiercely as they fought temperance legislation, for the two movements were connected, even at moments interchangeable;

temperance work convinced many otherwise moderate-minded women that they needed the vote if they were ever to beat the liquor industry, and the war gave them their best opportunity to date.

The labor force was depleted by the wartime draft, but women by the thousands took their men's places, not only in clerical and secretarial occupations, but in hard-core, males-only, industrial enterprises like steel production and auto manufacture. NAWSA's membership doubled during the war, going from 2 to 4 million, and suffrage leaders were soon visible in high places, sitting on prestigious national war commissions, staffing and expanding the Red Cross, and proselytizing for Liberty Bonds. Under wartime pressures, England and Canada had already given women the vote, and America now followed suit. Congress passed the Nineteenth Amendment in 1919.

Although President Wilson was not initially a friend to the suffrage cause, Carrie Chapman Catt's strategy in 1916 and 1917, her bold and top-secret "winning plan" for a national amendment, centered on making him her ally. Alice Paul, the leader of the Woman's Party, the more radical wing of the suffrage movement, campaigned for the Republican candidate Charles Evans Hughes in the 1916 election as a way of rebuking Wilson for his lackluster record on suffrage, but Catt and the conservative majority she headed remained loyal to him. In 1917, Catt backed Wilson's decision to bring America into the war, and she capitalized shrewdly on the affinities between his declared purposes and suffrage goals. If Wilson was fighting a "war to end wars," suffragists claimed that to enfranchise women was automatically to achieve world peace; in the words of the suffrage leader Alice Stone Blackwell, "to hasten the day" when "mothers" can vote is "to hasten the day when war shall be no more." Catt later lobbied, as Wilson had, for American recognition of the League of Nations. When Wilson spoke before Congress on September 30, 1918, on behalf of woman suffrage, he explained that "early adoption of this measure is necessary to the successful prosecution of the war"; without the "direct and authoritative participation of women in our counsels, we shall be only half-wise." Catt gave Wilson her support for the war in exchange for his support of suffrage; to her mind as to his, it was all somehow a single enterprise, a perilous and charged opportunity for moral and cultural uplift.

Catt, too, believed in "war[s] to end wars," in obtaining peace with forcible means. She began her career in reform activity as a teacher, and on her first day of classes in Mason City, Iowa, in the early 1880s, she whipped nine startled and truant boys with a tug strap; in the words of her biographer Mary Gray Peck, "The era of moral suasion was over." Clear-eyed and hard-headed as she was, Catt, like Wilson, tended to see her role in history as a matter

of revelation. She found her life's work when voices spoke to her of suffrage and announced: "This is what you must do." She, too, felt "impelled to pass [her] knowledge," her vision, "on to others." If Wilson viewed woman's role as one, in his words, of "inspiration," of providing "sympathy and insight and clear moral instinct," of acting as a "spiritual instrument," Catt believed, in her characteristically more stringent phrase, that women exerted a "corrective influence" on the morally inferior male of the species. Although Catt's dry, dull prose was free of the euphemistic excess that William Hale condemned in Wilson's style, both President and suffragist were passionate monologuists who spoke no language save that of Victorian idealism, and they lived high off its considerable supply of adrenaline.

It was, however, exactly this self-infatuated sense of idealistic purpose that the young veterans, or at least the writers and would-be writers in their midst, rejected. The Great War had taught them that the missionary crusade could be thrilling to one—even, perhaps, especially to one—who unlike Catt fighting for woman suffrage or Wilson campaigning for his Fourteen Points, had no belief in its declared moral purpose. In *Exile's Return* Malcolm Cowley, who had served as an ambulance driver in the French Army, wrote that he and his peers, faced by the horrors of the war, "lost our ideals at an early age and painlessly." "We had fought for an empty cause"; the war was not a great crusade but a "great show," one whose excitement left its participants afraid of nothing but boredom and "thirst[y] for abstract danger, not suffered for a cause but courted for itself." They discovered that they could enjoy what purported to be a moral crusade without believing in it, and get something, even possibly great art, out of destruction and chaos without idealizing them. They could take the adrenaline rush that fills the days and rides the nights, and leave the Victorian content and bogus rhetoric behind. The writers who fought in the war threw off, in its name, all efforts to check their development or define their aims; open disillusion was the sharpest weapon they had in waging the real war, the war against Mother.

Ernest Hemingway, writing letters home to his mother, Grace, from his hospital bed in Milan in the summer of 1918, called her "my best girl" and signed himself, "I love you, Ernie." A few years later, however, he was insisting that his deepest ties were to his reticent, henpecked, and unhappy father, doctor and sportsman Clarence Edmounds Hemingway, and telling everyone how much he hated his dominating mother; "that bitch" was his usual way of referring to her. He also more or less ceased to use his first name in the years just after the war, encouraging friends to call him by jocular nicknames like "Wemmedge" and "Waxy" and "Papa," or by variants of his last name, like "Hemingstein" and "Hem." For Hemingway, "Ernest" summed up the worst of the Victorian legacy of pious feminization he meant

to repudiate. Grace had, in fact, taken the name "Ernestine," in honor of her adored father, Ernest Hall, when she briefly tried a professional singing career before marrying Ed Hemingway in 1896. No wonder "Ernie" rebaptized himself "Hem": "Hem" was closer to "him" than any variant of "Ernest" could ever be.

Denis Brian has speculated that Hemingway took as his motto the phrase "grace under pressure" because he had learned a lot about "pressure under Grace" during his boyhood in Oak Park, Illinois. Woman suffrage was a congenial issue to the solidly middle-class and liberal Oak Park mind; women could vote on local issues by 1911, eight years before national suffrage became law, and they were active voters, sometimes outvoting men two to one. Grace herself was a committed suffragist, an ebullient amateur singer and painter, and a stout, full-figured, and tirelessly energetic proselytizer for what Norman Vincent Peale later popularized as the "power of positive thinking"; her sense of matriarchal mission and prerogative was immense.

On July 26, 1920, some eighteen months after he came home from the Great War and a few days after his twenty-first birthday, Hemingway, plus sisters and friends, snuck out of the family's summer home for a secret midnight picnic that went on all night. Grace discovered their absence, and when they returned, they found the air "*blue* with condemnation," in the words of Ursula Hemingway, Ernest's favorite sister. When Ernest refused to apologize, the outraged Grace threw him out of the house. As he left, she handed him a letter, addressed to "my dear son Ernest." In it, she told him that "a mother's love [is] a bank." Each child is born with an "inexhaustible" account; the mother is a "a *body* slave to the infant's every whim." But, as the years go by, she begins to expect a flow of cash into the account as well as out of it. Since Ernest has contributed nothing, he will have no more funds deposited to his credit: "*You have overdrawn.*" To Grace's mind, her son was "lazy and pleasure-seeking," with no real "aim in life," "neglecting your duties to God and your Saviour Jesus Christ." He had failed —this was Grace's closing and most serious charge—to live up to his namesake; unlike Ernest Hall, her son was not a "gentleman."

Grace signed her rebuke as "Your still hoping and always praying Mother," and promised that "when you have changed your ideas and aims in life, you will find your mother waiting to welcome you, whether it be in this world or the next, loving you and longing for your love." The son's debt to his mother is love, and it can never, in this telling, be fully paid. Ernest appealed to his father, but as usual Ed sided with Grace. He had recently reprimanded Ernest for his irresponsible ways, and now he wrote Grace in a mood of sorrowful sternness that "suffering alone will be the means of softening his Iron Heart of selfishness." Hemingway chose to forget his father's part in his

rejection—"dad has been very loyal," he later said—but he never forgave Grace, nor did he ever forget her letter. All his writings can be seen as an answer to it.

Ernest's account as a baby was indeed a lavish one. His biographer Kenneth Lynn, drawing on Grace's scrapbooks, letters, and journals, has revealed that she kept him in bed with her every night for the first six months of his life; she breast-fed him and fondly noted that "he is content to sleep with Mama and lunches all night." Ernest grew up with his sisters Marcelline, Madelaine, and Ursula—his only brother, Leicester, arrived in 1915, when he was almost sixteen years old; yet another sister, Carol, had been born in 1911—and Grace dressed him as a girl past the age when most boys were given obviously masculine attire. She reported that he called her "Fweetie" and "loves to sew." There were moments of real confusion for the little boy, however. On one Christmas Eve, Grace observed that "he was quite fearful . . . as to whether Santa Claus would know he was a boy, because he wore just the same kind of clothes as his sister." There were even moments, rare but emphatic, of outright revolt. Responding to Grace's usual name for him, "Dutch Dolly," Ernest once retorted: "I not a Dutch Dolly, I Pawnee Bill. Bang, I shoot Fweetie!"

Hemingway's matricidal impulses toward Grace surfaced in a story titled "Soldier's Home," a transparent fictionalization of their last angry confrontation, strategically placed at the very center of *In Our Time*. The smotheringly pious, solicitous, and manipulative Mrs. Krebs is trying to break through the alienation and apathy of her son, Harold Krebs, who has just returned from fighting in the Great War. Before the war, Krebs had been a joiner, a Methodist college student who belonged to a fraternity and wore the same collar his frat mates favored, but the war has changed him. Indeed, the war is the best thing that ever happened to him, though he has no idea what it was about or who the enemy was; he had considered settling in Germany after it was over. Now, back home in the small Midwestern town of his origin, Krebs is fighting to keep alive whatever autonomy the war gave him; his mother is fighting to extinguish it.

Mrs. Krebs begins by coaxing her son to pray with her as he used to do before the war. "God has some work for everyone to do . . . There can be no idle hands in His Kingdom." But Krebs sullenly insists, "I'm not in His Kingdom." "I can't pray," he says. When she pleads with him, "Don't you love your mother, dear boy?" he replies, "I don't love anybody." She gets upset. "I'm your mother," she tells him, as if that explained everything, and reminds him, as Grace did Ernest, that she had breast-fed him as a baby. With a characteristic lunge for the humiliatingly physical

and intimate note, Grace had referred to being Ernest's "*body* slave," but Mrs. Krebs puts it more euphemistically: "I held you next to my heart when you were a tiny baby." Feeling "vaguely nauseated," Krebs gives in: "Mummy," he promises, "I'll try and be a good boy for you." He puts his arms around her and kisses her hair, then he gets on his knees and they pray together, but he hates the "lies" she has "made him [tell]." Krebs is one of John Watson's abused children, sickened by maternal overstimulation, and he makes plans to leave home forever.

Like Twain's attack on Eddy, Hemingway's attack on Mrs. Krebs turns on the issue of language. The scene between Krebs and his mother occurs while she is serving him breakfast. As she closes in on him—"I pray for you all day long, Harold"—he looks at "the bacon fat hardening on his plate"; he is seeing, and hating, his mother's body, as well as her talk. The link he makes, aware or unaware, between his mother's speech and her body is natural: to speak the same tongue is to share the same blood, draw nourishment from a common source; that's why we talk of our "mother tongue." First names are at issue here, as they were in Hemingway's real-life situation. Mrs. Krebs always calls her son "Harold"; Hemingway, as authorial voice, just as stubbornly refers to him as "Krebs." Krebs wants to speak like a Hemingway hero, stark, tough, bold, affectless, and at moments he does: the lines "I'm not in His Kingdom," "I don't love anybody," "I can't pray" are trademark Hemingway. But once he says, "Mummy, I'll . . . be a good boy," it's all over; she has forced him back into her own realm. Now we understand why he wanted to settle in Germany; a foreign language is at least a neutral medium. Krebs needs a buffer. His father, of course, should supply it.

Mr. Krebs is constantly referred to by Mrs. Krebs—"I had a talk with your father last night," "Your father has felt for some time," "Your father is worried too." "[Your father] thinks," and so on—but we never meet him. All we really learn about his responses to his son—what we find out, in other words, through Hemingway's narrative voice rather than through Mrs. Krebs—is that, while his mother tries to pry into his feelings about the war, "his father was non-committal"; he seems to have some of the impartiality that Mrs. Krebs so utterly lacks and that Krebs so sorely needs. But Mr. Krebs is as unprotected and manipulated as his son; Mrs. Krebs invokes his authority simply to camouflage and augment her own power. When she says that Mr. Krebs suggested that she hold this tête-à-tête with him, Krebs replies: "I bet you made him."

It is his father, not his mother, that Krebs consciously plans to leave without even a goodbye. "He would miss that one," he decides. He is, however, not

rejecting his father so much as protecting him from firsthand scrutiny, sparing him a test he would undoubtedly fail; Mr. Krebs has been put into storage, not exile. Krebs's attempt to evade him is a safety measure, a feint, and a decoy device, but his hostility toward his mother is the real thing. Nick Adams's very similar mother, who appears in the second story of *In Our Time*, "The Doctor and the Doctor's Wife," is specifically identified as a Christian Scientist, and Mrs. Krebs seems to be a Mind-cure exponent, too. She is palpably a stand-in for some kind of self-appointed mother-deity, and it is not "*His* Kingdom" but *Her* Kingdom that Krebs wants to flee.

Hemingway drew the name of Krebs from an acquaintance, a veteran and journalist named Krebs Friend; Friend had married a wealthy and domineering woman forty years older than himself, and when Hemingway met him just after the war, he was still suffering from a severe case of shell shock. Harold Krebs, too, is a casualty of matriarchal power and a shell-shock victim, but he finds in the malady's chief symptom, mutism, the refusal of reactive response, a perfect excuse to shut out the mother and the matriarchal deity she typifies. The veteran's muteness rebukes and dodges, though it cannot silence, the endless chatter of moral imperatives with which the mother conducts and conceals her business.

After the blow-up over the fateful picnic, Grace Hemingway reported to her husband that Ernest had told her that she read only "moron literature." She in turn disliked her son's writing, objecting on several occasions to the darkness of his themes and his penchant for four-letter words. After reading *The Sun Also Rises* in 1926, she wrote Ernest that she considered it "a doubtful honor to produce one of the filthiest books of the year"; the novel filled her with "sick loathing." Ernest saved this letter, and he kept it in the same place he kept her protest of July 1920; to save them was to keep his ammunition handy. Even setting aside her prudery, Grace's distaste makes sense, for her son's literary style was at some level nothing but the denial of hers. The stripped prose style he perfected, with its phobic avoidance of words like "sacrifice," "glory," and "honor"—its omission, in sum, of all the terms associated with "Mummy"—was his most effective protest against her high-minded idiom. Hemingway's artistic breakthrough, the stylistic transformation he achieved in the 1920s, depended for its incentive, vitality, and focus on a symbolic but potent act of matricide.

The moderns' revolt against the matriarch was always an ambivalent one. The theme of failed prayer, not of forced prayer à la Mrs. Krebs, but of prayer desperately needed but punitively off limits, runs throughout *In Our Time*, and it grew ever more insistent in Hemingway's later work. Grace liked to claim that Ernest was the most like her of all her children, and

somewhere "Hem" knew he needed "Grace." His last wife, Mary Welsh, was herself a Christian Scientist, and the first two women with whom he fell in love, Agnes von Kurowsky and Hadley Richardson, were both eight years older than he. Agnes was a nurse, and he called Hadley "dear sweet Mummy" and insisted that she breast-feed their son Bumby even after it became clear that her milk was insufficient. But in "Soldier's Home," in a scene that was to echo throughout the fiction and drama of the decade, Harold Krebs has refused the maternal teat. The supply of public piety and hopeful idealism, the mother's milk of Victorian America, had officially run out; the old oral culture of the matriarch was, if not finished, repudiated and discredited.

DISMEMBERING THE MOTHER

As Hemingway possessed the greatest prose talent of his generation, Hart Crane was the era's most intensely gifted poet, and though the two did not meet, the parallels between their lives are uncanny. Like Hemingway, Crane was born on July 21, 1899. He, too, had a father named Clarence and an artistically minded, powerful, and possessive mother named Grace. He, too, was a Midwesterner, growing up in Cleveland, Ohio; his mother came from Hemingway's hometown, Oak Park, where she returned toward the end of her life. Like Hemingway, Crane was raised in the thick of the culture of feminization; Grace Crane and her mother, Hart's beloved grandmother Elizabeth, were Christian Scientists, and he attended Christian Science Sunday school regularly as a boy. Both Hemingway and Crane left home at the age of eighteen.

But Crane did not repudiate his feminine influences as strenuously as Hemingway did. Although he came to dislike what he considered the Christian Science denial of pain and evil, he displayed his familiarity with Eddy's teachings and writings throughout his life. Sometimes the influence was a conscious one—he closed a letter of 1926 with the line "God is love, as Mary Baker Eddy says!"—but more often, the influence ran deeper than conscious assimilation. One sees it in his push toward affirmation; he "cried," in his words, "for a positive attitude." He had been a musically gifted child, composing on the piano before he was ten; on one occasion, asked by his aunt what he was playing, he looked up and said, "I call it 'the lamb's first morning.' " This sense of undefiled beginnings still visible in later times, even in tormented and conflicted later times, of light glimpsed and possibly prevailing amid the dark, never left him. Crane claimed that the chief model,

analogue and inspiration for his poetry had been the ecstatic rush of Melville's language in *Moby Dick*, but he did not read *Moby Dick* until 1921, when his characteristic style was fully formed, if not altogether mastered. The Romantic poets he read in his teens played their part, but his special inventive, abstract, and expressive idiom, half sensation, half displaced conceptualization, owes more to Eddy than to either Melville or the Romantics.

Christened Harold Hart Crane, Crane was called Harold during his childhood and early adolescence, but when he decided to become a poet, he took his mother's suggestion and dropped the Harold to become simply Hart Crane. Highlighting the Hart was a way of marking his dedication to the affects of the heart stressed by his Romantic predecessors, but it also underscored his alliance with his mother; Hart was her maiden name. Hemingway rejected the name Ernest with its awful hint of Ernestine, but Crane chose to reinforce, not deny, his own matriarchal lineage.

Grace Hart had been a charismatic and striking beauty, and her marriage to Clarence Crane was a wild love match, but conflicts quickly developed. "C.A.," as intimates called him, was a candy manufacturer of the Babbitt booster type with a limited imagination and explosive failures of tolerance; he found it ever more difficult to cope with Grace's high-strung temperament and penchant for pathologically histrionic scenes. Hart was their only child, and he later described his youth in a letter to his mother as a "bloody battlefield for yours and father's sex life and troubles." But whatever his problems with his mother, when the couple divorced in 1917, Hart threw in his lot with hers. While C.A. insisted that Hart's poetry should be no more than a diversion or hobby, that his first obligation was to hold a paying job, quite possibly in one of his own candy concerns, Grace encouraged his poetic aspirations and recognized them as paramount. Hart was homosexual and "out" to most of his friends by his late teens—the closet style held scant appeal for him—and if his mother closed her eyes to his sexual activities, her willful ignorance was better than the rejection he knew he'd meet at his father's hands if C.A. ever learned of his sexual preferences.

The conflict between Hart and his father eased as he grew older. By the late 1920s, his poetry had begun to garner prestigious praise (though not a wide readership); C.A. had remarried, very happily, and he proved to have a fund of goodhearted if reserved feeling for his son. A father and son photograph taken in 1930 during one of Hart's extended visits to C.A.'s Ohio home speaks volumes about their new intimacy. The two looked alike, and both are here dressed alike, in conventional suits, overcoats, and hats, hardly usual attire for Hart, who favored sailor garb and flamboyant Mexican capes

and sombreros. C.A. holds a cane, Hart a cigar. Both men look like model members of the bourgeoisie, and the look of shy pride on Hart's face tells the observer that he is not simply indulging in strategic camouflage; he wants to be his father's spitting image. C.A. always addressed his son as "Harold," not "Hart"; despite his quick temper, he had a touch of that noncommittal impartiality Hemingway sensed in his own father. His death in 1931 contributed to the growing despair of Hart's last year.

It was not C.A. but Grace who proved the intractable problem. Indeed, Grace Crane makes Hemingway's mother look like a novice in the ways of manipulative excess, and she was for periods of time mentally ill, as no one but Ernest ever considered Grace Hemingway to be. Hart had moved to New York in 1917, but all observers agreed that his mother continued to run his life. Sometimes sending money, other times withholding it, barraging him with letters and visits and then punishing him with protracted silences if he failed to respond to her satisfaction, writing and interrogating his friends, systematically, it appeared, indulging and depriving him, Grace lived off her obsession with her only child and roped him back into it every time he took a step away from her. None of Hart's friends doubted that she loved him, or even that he loved her as he did no one else, but all knew the connection was poisoning him.

In the summer of 1928, mother and son made a joint visit to Los Angeles; Grace, now twice divorced, had acting ambitions for Hart and herself. The situation soon became explosive. Hart's homosexuality grew stridently public and desperate in the libertine atmosphere of L.A.; Grace could no longer deny her son's sexuality, and it seems (Hart never talked of their final days together) that she reacted as one might expect Grace Hemingway to have reacted. Horrified by his mother's accusations and reproaches, Hart left her house one night without a word and fled back to New York; the city had been, he claimed, a better parent to him than either of his biological parents. Grace's subsequent refusal to send him his small but much needed inheritance from his recently deceased grandmother pushed him past whatever love he still felt for her into anger, hatred, and sheer fear; denouncing her "hysterical" and "destructive" character and influence, he broke off all contact with her.

Whatever pain the disclosure of Hart's homosexuality brought Grace, it was nothing next to the pain of losing him, and she never gave up her hopes of reconciliation. Convinced that he would die without her love, she pursued him by letter and in person; he became an expatriate, a fugitive, he told friends and strangers, from his "fury" of a mother. He, too, had discovered that behind the skirmish with the father lay the battle with the mother; Father

was shadowboxing, but Mother was the match. Like Hemingway, Crane was an alcoholic and a suicide; on April 27, 1932, coming back by boat to New York after a year in Mexico on a Guggenheim fellowship, he jumped, a dead-drunk Icarus, into the sea. His remains were never found; his name was inscribed on his father's tombstone in Garretsville, Ohio.

Grace's gallant, pathological pursuit was not over. She stayed in touch with any of Hart's friends who would talk to her and deluged his early biographers with requests and information. Now a Spiritualist, Grace believed she was in communication with her dead son, and claimed that he was dictating poetry to her from the other world; she sought, in vain, to find a publisher for Hart Crane's "Posthumous Works." She had progressed seamlessly, inevitably, from the role of his muse to that of the author of his poetry. In her final illness at Holy Name Hospital in Teaneck, New Jersey, Grace came out of a coma to utter her last words: "Poor boy." The words were the same ones Grace Hemingway used in a letter to her son in early 1929 to describe her husband; Ed Hemingway had just shot his head off, an act for which Ernest held his mother responsible, an act which he himself duplicated three decades later. Grace Crane died on July 30, 1947.

In the fall of 1928, just a few months after his break with his mother, Crane entered an informal psychiatric relationship with the lay therapist Solomon Grunburg. (He eschewed formal Freudian analysis because he thought it would destroy his creative gift and prevent him from finishing his protracted *magnum opus*, *The Bridge*.) Within weeks, he reported a dream of terrifying intensity. In it, he found himself in a dark attic, rummaging through a trunk of his mother's clothes. He's not sure what he's looking for; he only knows it's somewhere in the trunk. The trunk is crammed full, and as he pulls various articles of dress from it, he comes across first a hand, then another hand, then part of an arm; he pulls, piece by piece, what is clearly a dismembered body from the trunk, all of it covered with bloody clothes. It is his mother's body.

Crane's poetic was something he called, in "Voyages III," a poem published in *White Buildings* (1926), "the silken skilled transmemberment of song." "Transmemberment" is a Crane, and an Eddyesque, coinage, not to be found in the dictionary; in the context of "Voyages III" it suggests a kind of reversal or recasting of the act of dismemberment at the center of his dream. The literal text of much of Crane's finest short poetry is an undisguised if enjambed account of gay lovemaking, and "Voyages III" describes physical love at its peak. The two men's interaction is figured as a kind of underwater feat, occurring at the bottom of the sea and yielding superhuman delights compacted and multiplied by the oceanic pressures of impossible limits magnificently transgressed. The poem concludes with these lines:

> . . . *death, if shed,*
> *Presumes no carnage, but this single change,—*
> *Upon the steep floor flung from dawn to dawn*
> *The silken skilled transmemberment of song;*
>
> *Permit me voyage, love, into your hands . . .*

Crane is apparently using the word "transmemberment" to signify a regrouping of what has been separate, fragmented, even dismembered, lost to "carnage" and "death," into a single act of sexual love and poetic consciousness. The word "*trans*memberment" has been created out of the necessity of countering the idea and act of *dis*memberment; it's a transformative word, an angel's wand dispersing the demonic implications of dismemberment, an exorcism of black magic by white. Transmemberment is the reincorporation of the scattered self into an electric matrix.

The logic that made Hemingway's style the repudiation of his mother's was not Crane's. "Voyages III" is the poetry of a full-scale masculine genitality that has strangely fulfilled rather than rejected or outgrown its infant sources, an adult sexuality at one, no matter how briefly, with what the feminist critic Patricia Yaeger calls the "pre-Oedipal sublime," and its language is that of a poetry of flux and suffusion very close to its maternal origins. But what Crane's poem rewove, his matricidal dream has undone. His dream is very much about the "carnage" and "death" he overcame in "Voyages III," and it suggests that the dismemberment of the mother and the mother tongue that the maternal body emblematizes, a dismemberment which his poetry retrieves and reknits, is the necessary precondition to his art. Crane the poet must transmember, or reconstitute, what Crane the dreamer has dismembered; the dreamer has murdered the mother that the poet will restore and re-create. Crane's poetry is a delayed act of atonement to the murdered mother, but the murder must precede the art. As Freud put it, quoting Goethe's *Faust* in the last line of *Totem and Taboo*, his own elated and dark study of murder and re-creation, "In the beginning was the Deed."

Writing *Totem and Taboo*, Freud felt "all omnipotence, all savage." He believed it "my greatest, best, perhaps my last good work. Inner confidence tells me that I am right." With that uncanny instinct for cultural timing that was his specialty, he published it in 1913, the year before the Great War began; he had his own battles to fight. In this text Freud talked of "instigations," and it is itself his boldest act of instigation. *Totem and Taboo* is purportedly an account of an act of patricide; despite its apparent patriarchal focus, however, or rather in some sense because of it, it powerfully anticipates both the theme of the matricidal wish to be found everywhere in the lives

and works of the American urban moderns and the manner, the method, of partial displacement in which they carried it out. *Totem and Taboo* is the central expression of the era's matricidal impulse, but like its American analogues, it is not an open expression of that impulse. As Crane discovered that the fight with Mother underlay the apparent fight with Father, as Hemingway in "Soldier's Home" veiled the story of the flight from the cannibalizing mother with the story of the flight from the cowardly father, *Totem and Taboo* offers the tale of the murdered father as a front behind which Freud can accomplish the murder of the mother.

Freud's matricidal script was never published or even fully written; it was a script denied, vehemently denied. At key points in his writings, against all the logic of his own argument, Freud tries to exempt the mother-son relationship from the lethal hostility that constitutes intimate relations in the Freudian discourse; he knew, as he made clear in his essay on "Goethe's *Dichtung und Wahrheit*" (1917), one of many unacknowledged addenda to *Totem and Taboo*, that nothing is more forbidden or dangerous than defying the mother. Freud evidently could not allow the matricidal text to appear in its entirety in one place—the risks were simply too great—so he exposed only one facet of it, a mere fraction of the whole, in one place at one time; it is dismembered, deceptively scattered, and camouflaged amid separate works very much in the manner that the body of Crane's mother is broken up and swaddled in separate pieces of bloody clothing in his dream. Freud had a habit of suppressing the figure of the woman in one text, only to have it appear, in fragments, in the next; he left behind not a single coherent matricidal script but the pieces of one, strewn in different spots, at separate sites, in his work. He told a part of the story here, a part there; no one can put it together from any single text isolated from the other texts that he wrote. Reading Freud with this buried matricidal script in mind is an act of reconstruction; one is playing hide-and-seek with the parts of a picture puzzle tantalizingly fallen into a hundred parts and, little by little, reassembling the scenario, the body these *membra dejecta* once formed.

Totem and Taboo is a quasi-anthropological study of taboos in primitive cultures, and it climaxes and ends in a myth of origin, the story of the murder of the first father by a "horde" of his sons in the earliest society. The father has been an absolute despot, and the sons' revolt is motivated in good part by their desire to gain access to the wives he has jealously reserved for his use only. They kill, then eat the father, but after his death, they are overcome by guilt and begin to worship him as God in an act of what Freud calls "deferred obedience." *Totem and Taboo* was Freud's most dramatic attempt to prove the Oedipus complex a "universal law" of human life. He had grounded it in fact, or so he would have us believe, and vastly enhanced its

explanatory powers; in Freud's words, "The beginnings of religion, morals, society and art converge in the Oedipus complex."

Freud's Oedipal theory took its name from Sophocles' play *Oedipus Rex*, the first of three plays about the royal house of Thebes. Eliciting and analyzing his patients' confessions about their sexual secrets in the 1890s, Freud became convinced that Sophocles' drama was being re-enacted again and again, as wish, if not deed; as Oedipus had killed his father, Laius, and married his mother, Jocasta, all men want to murder their fathers and bed their mothers. Predictably, in Freud's reading of Sophocles as of his patients, the family romance, whether the saga of a nuclear unit or that of an entire civilization, is chiefly an arena of masculine struggle; in *Oedipus Rex* as Freud understands it, father and son compete *for* the mother, not *with* her, and in *Totem and Taboo*'s myth of origins as well, everyone of importance is male. Since the father's wives are also the sons' mothers and their sisters, the sons have no real feminine peers; *Totem and Taboo* furthers masculine cultural hegemony by hypothesizing the origins of history and religion in an altogether patriarchal story, a world of, to borrow a title from Hemingway, "Men Without Women." What is apparently at issue in *Totem and Taboo*, as in *Oedipus Rex*, is male authority and male conflict, male transgression and male retribution.

But there is another possible and equally plausible reading of the Oedipus legend and the gendered cosmology behind it, a nonpatriarchal one, and it changes our interpretation of both *Oedipus Rex* and *Totem and Taboo*. Never forget that Freud was extrapolating theories largely about male development from a largely feminine clientele; this imperial graft of masculine theory onto feminine data, this insistence on isolating and reifying the masculine element in what is plainly a bi-gendered or even a female-dominated text or situation, gives us the key to the innermost dynamic of *Totem and Taboo*.

Even Freud could not claim that all the major gods in human history had been male. Following Greek legend and its modern explicators, particularly the influential anthropologist-mythologist J. J. Bachofen, Freud posited an era in which women were the rulers, in which women were worshipped as matriarchal deities who were themselves the sometimes successful rivals to the father gods. But in *Totem and Taboo* he did not discuss directly the wives whom the father now monopolizes and the sons covet, nor did he fix the place and time of their presumed prototypes and allies, the female or mother goddesses; he could not say if the first matriarchal period succeeded or preceded the slaying of the father which *Totem and Taboo* dramatized. He could not, in sum, place the mother. Freud was, of course, indulging, with many of his more anthropologically expert contemporaries, in speculation on topics and times more or less lost to view, but one should note that in

Totem and Taboo and elsewhere, he willingly hypothesized as fact, then asserted as gospel truth, his fantasies of the origins of patriarchal power; it was only matriarchal rule that Freud could not bring himself to specify.

Freud cited again and again the folk wisdom that one's maternal descent is *"certissima,"* absolutely certain. Everyone comes, after all, straight from the mother's body; she has been one's, in Grace Hemingway's phrase, *"body* slave." In contrast, the paternal line is an affair of purely circumstantial evidence; one's father is, finally, the person that one's mother says is one's father. Yet it is this certainty about the mother that Freud's chronological imprecision sought to undo. Remember how sternly he rebuked Jung's matriarchal leanings on May 14, 1912: "There have been father's sons at all times." Freud was at work on *Totem and Taboo* when he wrote these words, and it was his real answer to Jung's heresy. In *Totem and Taboo* it is the father who is *certissim*[us], the mother who can't be located.

Freud's declaration about man's need for the lost or murdered father is central to the historical argument of *Totem and Taboo*, and he made it a forthright and all-inclusive statement: "unappeased longing for the father" is at "the root of every form of religion"; "at bottom, God is nothing other than an exalted father." While Freud could not deny that man's desire for the maternal presence is also ineradicable, also "forever unappeased," in his own words, he spoke of it in a very different context, in an essay on "Female Sexuality" (1931), a clinical rather than historical or anthropological piece, where he treated it not as a part of collective human history but as an ahistorical, psychological, and biological longing for the maternal teat whose withdrawal marks the end of blissful infancy. Freud was well aware that to historicize is to honor, and despite his lip service at the maternal shrine, he could not bring himself to pay the mother this tribute. When we don't know when or how something happened, we don't know what happened or if anything really happened at all, and it is just this state of confusion that Freud aimed to induce; he presents the male past as history, the female past as fantasy.

In the first section of *Totem and Taboo*, entitled "The Horror of Incest," Freud discussed the pervasiveness and tenacity of the taboo in primitive cultures on sexual interaction between mother and son, and even, in some cases, on what one might think of as routine contact between them, but his culminating fable of origins illustrated that taboo rather than analyzing or breaching it; like the savage people he described, Freud could not place the mother because he literally could not face her. *Totem and Taboo* is a matricidal, not a patricidal text in part because, in it, Freud denied, demoted, and obscured, not the father, but the mother. Yet like the vampire figure to whom he compares the father, she will not stay in her grave.

THE MOTHER'S RETURN

Freud's use of the same hauntingly ferocious word, "unappeased," to describe, on the one hand, the drive to deify male power and, on the other, the need to worship the female principle, was his half-unwilling acknowledgment of the parity of the sexes in power. Mothers and fathers, matriarchal and patriarchal gods, Freud knew, were equals and opponents, however he chose to rescript their interaction, and this conflicted equality forms the subtext of *Totem and Taboo*. In the course of his writings on the primitive act of patricide, from *Totem and Taboo* to his study of *Group Psychology and the Analysis of the Ego* (1921), and on to his final anthropological fable, *Moses and Monotheism* (1939), Freud hinted at a matriarchal and matricidal scenario, one he constantly rearranged and buried but never altogether omitted.

In Freud's alternate scenario, the mother plays an active role. The chief among the paternal tyrant's wives, she goads and possibly seduces the youngest of her sons into killing the father. Using her son as proxy and tool, the mother is the chief engineer of the father's murder; she, not the son, is the real killer. After the father's murder, in Freud's telling, the patriarchy gives way to a matriarchy, but it succumbs in turn to the new male "heads of family," who have somehow emerged in the course of matriarchal rule; the actual matricidal "deed" necessary to end it is one to which Freud does not wish even to allude. The "heads of family" then establish a stable and lasting patriarchy that marks the start of known and recordable human civilization. In this version of the *Totem and Taboo* story, the first matriarchy presumably came before the first patriarchy; the most logical explanation for the mother's murder of the father is that she was avenging her own loss of superior status. The earliest god, in other words, was a mother god, who was subsequently vanquished by the chief of the male gods; she retaliated by using their youngest son to murder him, and established herself in her old supreme position, only to be once again deposed and, presumably, like the slaughtered father in *Totem and Taboo*, mourned, if not deified, in an act of "deferred obedience."

I say "presumably" because, just as Freud quarantined and trivialized the "forever unappeased" longing for the mother, he severed the account of the sons' "deferred obedience" to the murdered mother from the veiled narrative of the matricidal deed he provided in *Totem and Taboo* and subsequent works. Only in another context, a deceptively different one, in an essay of 1920, "A Case of Homosexuality in a Woman," does Freud speak of "retir[ing] in favor of the mother." But he himself illustrated the pattern of retirement before the mother, of deferred obedience to the murdered mother

god, even if he could not describe the phenomenon fully in print. I argued earlier that Crane the poet atones for the matricide which Crane the dreamer has committed; so Freud was compelled to include the female figure excised in one text in the next, and so, after his mother's death in 1931, he turned in an act of atonement for his own matricidal impulses to a study of the early "pre-Oedipal," mother-dominated stages of human development. "Post-Oedipal" might be a better way of describing this constellation of feelings and motifs, at least in terms of where they come in Freud's own development, for sketchy and incomplete as this work is, it nonetheless constitutes a partial retirement of his treasured Oedipal theory before the mother's claim to center stage.

In all Freud's speculations about the earliest human society, a half-suppressed but visible and ongoing struggle occurs between male and female deities of at least equal power, in which matricide is as important as patricide and the female gods are as punitive to the male gods as the male gods are to them. The Greeks left a play about this struggle, about matriarchal rule and the deed of matricide that ends it, in the tragedy known as the *Oresteia*, a trilogy by Aeschylus that predates the *Oedipus* cycle by several decades (the *Oresteia* was put on in Athens in 458 B.C., the last of the *Oedipus* plays in 405 B.C.). The *Oresteia* lays bare the matricidal scenario that Freud hints at but cannot bring himself to detail or historicize: a matriarchal avenger, aided by a youngest-son figure, slays the ruling patriarch, who is also her husband, only to be murdered in turn by the representative of a new patriarchal order. The Greeks apparently found the matricidal scenario more important and compelling that the patricidal one, for they left more versions of Orestes' story than of Oedipus'.

Ambitious and sharp-tongued Clytemnestra is wife to the warrior-king Agamemnon, ruler of Argos and a leader in the Trojan War. While he is away in Troy, Clytemnestra betrays him by taking Aegisthus, Agamemnon's birthright enemy, as her lover; Aegisthus is very much a youngest-son figure and completely in her sway. When Agamemnon returns from Troy, Clytemnestra murders him by stabbing him in his bath. Her justification is that she is avenging their innocent and docile daughter, Iphigenia, whom Agamemnon had sacrificed to the gods in order to get a favorable wind to set sail for Troy, but Aeschylus makes it clear that Clytemnestra is simply more talented, intelligent, and commanding than her unfaithful, vain, and shallow spouse; she deserves to be in charge, and after she murders Agamemnon, she marries Aegisthus and establishes herself as the ruler of Argos. A decade later, however, she is murdered by her son, Orestes, who, spurred on by his bitter and neglected sister Electra, feels honor-bound to avenge his father's

death. Feminine patricide has been met by masculine matricide, but matricide, too, is a crime, and Orestes must be judged for it.

The *Oresteia* closes with Orestes' trial; his accusers are the Furies, the most ancient of the gods, fierce mother goddesses who have pursued him, hell-bent on avenging Clytemnestra's death. The question before the court is all-important to the gender politics that obsessed Freud. Matricide is a crime, but is it as grave a crime as patricide? Is it possibly, as the Furies claim, a worse crime? Athena adjudicates the case, and her presence is ominous for the matriarchal gods. Born straight out of Zeus' brain, and herself a virgin, she has no ties to child-bearing; she disdains women and prides herself on being, in her own cool words, "always for the male and strongly on my father's side." She decides to exonerate Orestes (though not without imposing further penance on him) and suppress the Furies.

Her decision takes the form of a crucial act of renaming. The name of the Furies in its Greek form, "Erinyes," was an all-powerful one that had no synonyms or linguistic kin; signifying only itself, the word "Erinyes" by definition could not be qualified, altered, or euphemized. But Athena abolishes the name "Erinyes" and rechristens the Furies the "Eumenides," or "the Kindly Ones." In a stroke, she has blanketed them in subservience, in much the manner that a woman's maiden name is canceled by that of her husband— as Ibsen's willful and violent Hedda Gabler, to take a famous instance from the hand of one of Freud's most like-minded contemporaries, becomes, at least on paper and by law (though not in Ibsen's title), the tame "Hedda Tesman." Athena consigns the Furies to limited and benign, if lucrative, functions in the new masculinized state being established among gods and men, and when, mollified by her bribes, they say that their "hate is going," Clytemnestra has indeed been annihilated. The moral is apparently that the mother's murder may sometimes be forgiven, the father's never. The patriarchal conclusion of the *Oresteia* is that of Freud's overt text in *Totem and Taboo*, but the route to that conclusion is a powerfully different one, for here the mother is both the murderer and the murdered, the patricide and the person punished for patricide.

Freud never discussed the *Oresteia*, although many of his contemporaries—Bachofen chief among them—and disciples did. When Otto Rank presented a paper on the *Oresteia* from what became his *The Incest Motif* (1912), before the Psychoanalytic Society in Vienna on October 19, 1906, Freud insisted that all that was important about Aeschylus' play was its culminating representation of the transfer of power from the matriarchy to the patriarchy, and claimed that Orestes and Clytemnestra might have been omitted without loss to Rank's project—a willfully obtuse comment, given

Rank's subject matter. Freud was nonetheless fully conscious, if not of feminine deities, of what he considered universal feminine claims to divine sanction, and he regarded them with fascinated disapproval.

In the mid-1910s, Freud and his friend and disciple Lou Andreas-Salomé engaged in an important discussion about the matriarchy and the patriarchy. In a journal entry of 1916, Andreas-Salomé speculated that perhaps the female gods are hard to place historically because "gods did, in fact, arise [as Freud had said in *Totem and Taboo*] through male belief" rather than through female belief. God is figured as male, she thinks, not because god is male or because the patriarchy preceded or vanquished the matriarchy, but because the patriarchy *needs* gods. In contrast, " 'the matriarchy' had no need of them." Why not? Because, as Freud had argued in his influential essay on "Narcissism" (1914), another unmarked but important companion piece to *Totem and Taboo*, the matriarchs, like women in general, worshipped and deified themselves.

Freud argued in *Moses and Monotheism* that the male sex feels a "compulsion to worship a God which one cannot see"; men honor abstraction and deferred satisfaction. Women, however, in Freud's view, deify the concrete, the material, everything and anything that yields instant self-gratification. While men magnify themselves, paradoxically, through what appears to be a form of self-denial, even self-hatred, women magnify themselves through open self-love. Freud called masculine self-abnegation "instinctual renunciation" and thought it the supreme value of civilized man, but he diagnosed feminine self-love as "narcissism" and thought it pathology. Men prove that they are men by rejecting the feminine practice of self-love; men become men, and even gods, by repudiating women. Masculinity, according to Freud, is nothing but the avoidance of the feminine, the attack on the female principle, whether external or internal. In the "Taboo of Virginity" (1918), yet another addendum, as its title suggests, to *Totem and Taboo*, Freud called the male's reluctance to identify with his feminine or maternal origins "a dread of woman"; men fear "becoming infected with her femininity and thus proving [themselves] weakling[s]."

In a late essay, "A Disturbance of Memory on the Acropolis" (1937), Freud acknowledged that in his own personal history it had been surprisingly easy for him to separate from his father. Since one was never biologically a part of the father, the trick is not losing him but finding him. But how does one free oneself from the mother, the "*body* slave" who bears her offspring in her womb and nurses them at her breast? To find the father is in itself an achievement, but the mother has anticipated and absorbed her offspring's achievements simply by producing them; she has given birth to her offspring and, by extension, to their accomplishments. As Amalia Freud put it, when

introducing herself to her son's colleagues and friends: "I am the Mother."
According to Freud in his essay on "Narcissism," women "compel [mas-
culine] interest [precisely] by the narcissistic consistency with which they
manage to keep away from their ego anything that would diminish it." "It
is as if we envied them," he continues, "for maintaining a blissful state of
mind—an unassailable libidinal position which we ourselves have long since
abandoned." By this reading, male gods may be simply a sign of male envy,
male discomfort at the plain fact that only the female of the species gives
life, only she is *certissima*, only she has full title to self-approbation. In
Freud's hidden matricidal scenario, the mother's crime is not so much the
act of patricide as the self-love and self-deification that prompts it.

If Freud's work can be read as a detour around his compulsive interest in
the secrets of the mother by way of an induced obsession with the father,
the Oedipus complex was, long before its partial retirement in favor of the
pre-Oedipal motifs in the psyche, itself a smoke screen, a detour fraught, in
Freud's telling, with difficulty and danger and conferring top honors on those
who successfully undertake it, a detour around the shamefully incomplete
struggle for individuation from the seductively all-sufficient mother. More-
over, just as Freud claimed to be talking about men while in fact studying
women, as the Oedipus complex was a cover for the mother complex, as
the theory-prone male might be inferior to the life-bearing female, his only
sure parent, so *Oedipus Rex*, the play on which Freud's Oedipal theory
rested, may itself be a successor text, a postscript and a patriarchal cover-up
of its more powerful matriarchal predecessor, the *Oresteia*. Freud refused to
scrutinize the *Oresteia*, in part, I think, because he feared to find there an
earlier, truer, and more powerful version of *Oedipus*; as matricide is the
sub- or ur-text of the patricidal text of *Totem and Taboo*, the matricidal
Oresteia may be the covert text of the patricidal *Oedipus Rex*.

Unlike Oedipus, Orestes is in no sense a patricidal son; he murders his
mother and grieves for his father. But so, when one looks more closely than
Freud cared to at Sophocles' play, does Oedipus. The only parent Oedipus
wants to kill is not his father, Laius, but his mother (and wife), Jocasta.
Oedipus had not known that the old man he struck down at the crossroads
was his father; his patricidal deed was unintended, performed in ignorance,
and it will be bitterly lamented. But his matricidal impulses are conscious
ones. After he learns the truth about his parentage and his crime, Oedipus
quickly shifts from self-accusation to an attack on Jocasta: "Give me a sword,
I say, / To find this wife, no wife, this mother's womb!" Like Orestes, he
wants to kill the mother he somehow holds responsible for his father's death
and his own disgrace. Sword in hand, he bursts into her quarters, only to
find that Jocasta, upon discovering that she has unwittingly proved a sister

to Clytemnestra, an accomplice in her husband's death who has married his murderer and borne his children, has hanged herself. Oedipus is saved from further bloodshed, though not from self-mutilation; he gouges out his eyes, whether as penance for beholding his mother's death or his father's is unclear. One could say that Sophocles has murdered Jocasta on Oedipus' behalf, leaving the patricide innocent of a further, perhaps a worse, crime.

Freud thought of Hamlet as close kin to Oedipus, and he was the Shakespearean hero most congenial to the modern artists of the 1920s and most often cited by them, but here again we discover that the only person Hamlet really wants to kill—indeed, has to stop himself from killing—is not his father, whose ghost he both resists and obeys, or his stepfather and uncle Claudius, whom he vows to kill yet can't, but his mother, Gertrude. Hamlet, too, blames his mother for his father's death. Gertrude is a Clytemnestra figure, albeit an absentminded, plump, and complacent one; she has countenanced, if not commanded, her husband's death and taken his murderer to her bed. Hamlet, planning to upbraid his mother for her treachery, vows, "I'll speak daggers but use none," but Gertrude is not deceived. She feels his words as real "daggers" and cries: "O Hamlet, thou has cleft my heart in twain!" Although her death is camouflaged among the deaths of all the major characters in the last act, she dies of the poison Claudius intended only Hamlet to drink; Hamlet's matricidal wish has been carried out, accidentally, by Claudius. Hamlet and Claudius, the two most powerful men in the play, the apparent rivals for Gertrude's favors, actually collaborate, and they do so in the Deed, in the act of matricide.

Freud was always half aware of the matricidal story he suppressed, of the mother as the murderer and the murdered; he once referred in passing to "the dread of being killed by the mother," and *Totem and Taboo*'s companion piece "The Taboo of Virginity," is a quasi-anthropological essay about the deflowered virgin as potential killer. Compelled to record in the next text, even if in obscure form, what he had excised from the last, Freud turned shortly after finishing *Totem and Taboo* to a study of *Macbeth*, a play that had, in his words to Ferenczi on July 17, 1914, "long been tormenting me." The result was "Some Character-Types Met with in Psycho-analytic Work" (1915).

Freud sees Macbeth and Lady Macbeth as a single character "split up . . . into two personages," but he focuses largely on the fierce and ambitious Lady Macbeth, who persuades her husband to murder the king and take over his throne. Her will to power falters; she cannot herself kill the king because he reminds her of her father; and after his murder, uncontrollable remorse seizes her. A victim of the "deferred obedience" syndrome, Lady Macbeth goes mad and kills herself, but she is nonetheless a Clytemnestra

figure, a version of the primitive female goddess who brings down her male rival via a son-figure proxy, not one of the Eumenides, but one of the Erinyes. This is once again the scenario hinted at in Freud's sketch of the conflict between the patriarchy and the matriarchy, but although he has assembled all the evidence for this reading, he refuses to see it: Lady Macbeth's "motives" are, he concludes, "impossible to divine." Whatever his own impulses toward "retiring in favor of the mother," Freud insisted on the patriarchal and patricidal origins of human culture right through his final retelling of the Totem and Taboo myth of origins in *Moses and Monotheism*.

FOUNDING FATHERS AND TITANESSES

Few scholars in Freud's day or since have believed that *Totem and Taboo* is an accurate re-creation of any primitive society, as Freud claimed it was, but fewer have realized that it does offer a fairly accurate picture of the society and era in which Freud lived, a picture, moreover, with specific relevance to America, his least welcome but most assiduous and powerful ally. Gender relations in America have always been cast as power relations; as America's language is exceptionally rich in both euphemisms and dysphemisms, its society has entertained extremes of feminization and masculinization seen in no other Western nation.

The nineteenth-century European travelers who routinely commented on the American male's extreme subservience to his women also noted how little time he actually spent with them. His deference to his mother or (in Jung's term) "mother-wife" was, however grotesque, severely limited in time and place, for he passed most of his waking hours with other men. Visitors agreed that, in America, the sexes appeared to have nothing to say to each other, no shared activities, and few shared interests. Women might be supreme in their own "sphere," as it was called, in the home, the church, and the patronage of the fine arts, but men ruled the marketplace, the frontier, and the city streets, and they developed their own highly masculinized cultural enterprises there; the stock market, the Western, and the urban detective thriller, all new in the nineteenth century, were largely American in origin and development.

From its beginning, American history was marked by a polarized gender dynamic of action and reaction not dissimilar to the one Freud sketched in his anthropological fables: eras of masculinization engendered eras of feminization and vice versa, in an apparently endless series. Although no period offers a pure and distinct paradigm of either matricidal or patricidal impulses—masculinizing and feminizing tendencies shade over and spill

into one another—one or the other had been visibly dominant at a given time. The Puritan "Fathers," as nineteenth-century Americans usually called New England's first settlers, came to America in the seventeenth century to escape, or so they claimed, the degeneracy of England and Europe, and to protect a highly masculine theology from corruption. In the course of the next century and a half, their heirs developed that theology into its most exacting form; American Calvinism as exemplified by Jonathan Edwards was stricter than most of its contemporary English and European analogues. Eighteenth-century Americans also engaged in the collective act of parent killing known as the American Revolution; England was the "mother" country. "Deferred obedience," in Freud's phrase, the delayed reaction to the matricidal Deed, took the form in the Victorian era of a courted susceptibility to sentimentalism, nostalgia, and guilt, and an unprecedented transfer of cultural power from masculine to feminine hands.

According to Gilbert Seldes's account in *The Stammering Century*, an "anatomy" of nineteenth-century American culture, the heart of the matter was theological: Calvinism, with its reification of a "sublime and awful" God, its "acute" theology and its dilemmic religious sensibility, had suffered "the most spectacular defeat in the history of American religious life." The God of Jonathan Edwards, even that of the early-nineteenth-century Connecticut revivalist Lyman Beecher (Harriet Beecher Stowe's father), had been a magnificent and cruel despot arbitrarily deciding who were the "elect," the few chosen to know God's grace on earth and in heaven, and who were the lost, the many deemed unworthy and sped to hell. But the Calvinists' liberal nineteenth-century descendants insisted that God was less a father than a mother, not a despot but an "indulgent Parent" (the term is that of the clergyman Noah Worcester), offering love, forgiveness, and nurture to all who seek Him. The Connecticut theologian Horace Bushnell, known as the "American Schleiermacher," explained that true religious experience meant falling back "into God's arms," pressed to the divine breast, "even as a child in the bosom of its mother." The "gates" of heaven, in the title phrase of a best-selling novel of 1868 by Elizabeth Stuart Phelps, were not shut but "ajar," even wide open. God had repudiated his alliance with the demons and become benevolent, well behaved, even domestic.

The Americans who fought for their independence refused obedience to the mother country, but their descendants invented Mother's Day and made the matriarch a national figure of worship. Although the authors of the Constitution did not "remember the ladies," as Abigail Adams asked her husband to do, the ladies themselves, nerved by their exclusion and the ebullient prosperity of the land from whose full promise they were banned, took over not only the churches but also the elementary schools and the

literary profession, cultural arenas dominated by men in the preceding two centuries, and, in Seldes's words, "inscribed their purposes in the law of the land"; in contrast, Seldes said, their most gifted male peers, men like Melville and Poe, went "bankrupt" or "crazy."

From this viewpoint, the liberal clergymen, the non-evangelical Unitarian and Universalists who constituted the newest sects in the Protestant ranks and whose congregations included far more women than men, played the role that Freud had ascribed to the youngest son, favored and seduced by the mother, who carries out her plan to annihilate the father; so did the male reformers who engaged with their sisters in the Purity campaigns of the era, and the genteel poetasters and essayists whom Constance Rourke deplored in *American Humor*, the people involved in creating the early stages of consumer culture, a culture whose first and best customers, beneficiaries, and models were white middle-class women. But just as, overtly in the *Oresteia* and covertly in *Oedipus* and *Totem and Taboo*, the matriarchy ousted the patriarch, only to be itself overturned and subordinated to a newly empowered patriarchy dedicated to the cult of the father, the Victorian matriarch successfully attacked the Calvinist patriarchy, only to be hunted down in the twentieth century by the forces of masculinization bound together in that backlash we know as modernism.

Following the Greeks, Freud translated human gender politics into divine gender struggles, and the American urban moderns, too, liked to flirt with notions of the godlike status and power of the Victorian matriarch and patriarch. The title the "Titaness," bestowed by a studiously flippant Thomas Beer in *The Mauve Decade*, was telling. A Titaness is presumably the female complement of, the feminine companion to, a Titan, and Beer, a Yale graduate and an erudite man, surely knew that the Titans were, in Greek mythology, the oldest and darkest of the gods, kin to the Cyclopes, the Harpies, and the Gorgons, ancient incarnations of the monstrous, primal powers that created the universe. The Furies themselves were female Titans who sprang from the blood of the Titan ruler Uranus at the moment when his son Kronos, acting for his mother, Gaia, in a *Totem and Taboo* scenario, castrated him. "The Titaness," then, signified a race not of mortals but of gods, the earliest gods, gods specifically connected to the vengeful Furies, themselves born in the castration of the Father; it was a title, moreover, that America's Titanesses had actively sought. They claimed on occasion something like godlike powers, and repeatedly cast themselves as star players in cosmological gender scenarios much like those seen in Greek myth and in Freud's anthropological fables.

In 1895, the suffrage pioneer Elizabeth Cady Stanton and a select committee of like-minded, white middle-class and upper-class women published

a book called *The Woman's Bible*. Angered by a revised edition written by an all-male group of scholars and published in 1881, Stanton and her feminist colleagues rewrote and reinterpreted those parts of the Bible they thought most offensive and demeaning to women; the beautiful, vivacious Lillie Devereux Blake, a New York lecturer and author, undertook the revision of the portion of Genesis that deals with Eve and Adam's fall. A descendant on both sides of Jonathan Edwards, Blake was a birthright theologian of sorts, and her purpose was to reverse the Old Testament's judgment on Eve as the temptress whose punishment for sin is to serve man; according to Blake, Eve was, rather, "the first representative of the more valuable and important half of the race," the sex that once constituted a "matriarchy," later overthrown by the now-incumbent "patriarchy."

Stanton had spelled out this gender war in an important essay entitled "The Matriarchate" (1891). In her telling, women had reigned supreme "from the start of human history until the sixteenth century." The basis of their power was Freud's the-mother-is-*certissima* principle, the fact that only women, biologically speaking, can establish and claim clear lines of descent. Indeed, Stanton tells us, men in the matriarchal era were sometimes driven to the "ridiculous" length of going to bed themselves while their women gave birth, pretending that they had "shared the period of labor" in order to prove that the child being born was their own. The shift from the "mother age" to the "father age" was long and bloody, for these matriarchs were apparently quite literally Titanesses, "women of gigantic stature," full of "physical and mental vigor," in Stanton's words, close kin to "Clytemnestra and Medea," but finally the patriarchal forces triumphed. It is, once again, the covert text of *Totem and Taboo*, but with a different ending, for the patriarchy, in Stanton's telling, was soon to give way to an "Amphiarchate," an Eddyism not in the dictionary that seems to signify a new and benevolent matriarchy.

Mocking the grandiosity of such matriarchal claims, Beer explained that the Titanesses, "if it is fair to quote their own words . . . were not people; they were 'women trained by the essence of our nature to deeds of moral elevation, education and the work of God!' " Beer was quoting a speech given by Frances E. Willard in 1892, and however gross his caricature, he had isolated the crux of the Victorian matriarchal identity: its insistence on the female sex as, in Blake's words, "the more valuable and important half of the race," its assertion of some rough equivalency between, as Willard put it, "the essence of [its] nature" and "the work of God."

Clara Barton, founder of the Red Cross, was worshipped by the wounded soldiers she tended during the Civil War for the magnetism and mercy of her maternal influence, but Barton, like Carrie Chapman Catt, was not

herself a mother, or even (unlike Catt) a wife. For Barton, as for a number of her peers, motherhood was less a practice than a highly politicized ideology: to their mind, motherhood was not a factually specific condition but an innate, quasi-divine feminine attribute. Willard, whose followers were said to pray "God or Frances E. Willard help me!" was also childless and unmarried (even possibly gay), but she dubbed the Women's Christian Temperance Union (WCTU) "Organized Mother Love" and referred to her cause as "Enlarged Housekeeping," a phrase which the unmarried social worker Jane Addams adopted for her own work. This claim to instant and broad powers, a claim based on a putative, even fictive maternal identity, this trust in the feminine "essence," is what Freud labeled feminine "narcissism" and what gender and feminist scholars today call "essentialism" —the belief that one's own sex is by nature and even divine ordinance superior to the other sex, that the view one sees out one's particular window is *ipso facto* the world, that one is equipped to speak *ex cathedra* for the rest of mankind— and it was the Titaness's creed and strategy.

The moderns took the matriarch at her own evaluation; their matricidal scenario is, like *Totem and Taboo,* a study in superstition less analyzed than believed and courted. The women whom they criticized most savagely were dead and buried by the 1920s: Mary Baker Eddy had died in 1910, Willard in 1898, Stowe in 1896. Why, one might ask, flog a dead horse? But if the middle-class Victorian woman was indeed a Titaness, that meant she was immortal, whether god or demon. In this reading, the Titaness, like the monster in a horror film, always has one last gasp of violent life left in her even after she has been riddled with bullets, a gasp that may cost anyone insufficiently wary his life; the moderns' world is one in which it is never safe to deal with the enemy, even when that enemy is on her deathbed, even when she is in her grave. To accomplish her demise, one had to drive the proverbial stake through her heart, not once, but again and again.

Really to kill such a god, to finish her off for good and all, the moderns needed another god; to free themselves from the devouring, engulfing mother god, a savage and masculine god was required, and for this purpose they reinstated the punitive god of their Calvinist forebears, a god operating by inscrutable and malign laws and recast in the image of Calvin's heir Freud. The much-heralded death of God was in part a historical phenomenon, the conclusion to the century-long establishment of a new scientific Darwinian worldview whose worst intimations about human nature seemed to be confirmed by the unprecedented brutality of the Great War, but it was also a ploy, a publicity stunt designed to advertise less the patriarchal God's disappearance than his reappearance in a revamped and augmented starring role.

To rebel against God on the grounds of His injustice, to accuse Him of indifference and calculated absenteeism, to figure Him as Fitzgerald did, as "T. J. Eckleberg," a cold and cruel ironist playing cosmic games for his own amusement, to see Him as Hemingway did, as a macho mega-stylist who played it rough and talked it short and cryptic—all this was but to modernize Calvinism by shifting the blame for divine inaccessibility from the shoulders of man to those of God. Not-existing was but the newest prank of a deity who had long delighted in paradox and punishment. In a modish essay on suicide as a "Decadent Art" published in the January 1921 issue of Mencken's *Smart Set*, Joseph Wood Krutch announced: "There is no God and I am his prophet." "No-God" apparently required a prophet as surely as Calvin's God did.

The title of Hemingway's first (and never published) story about Nick Adams, the autobiographical protagonist of *In Our Time*, was a characteristically, ominously, unspecified "Did You Ever Kill Anyone?" The new masculine ideal, as attractive to Freud as to Hemingway, was that, in Lawrence's words, of a "hard, isolate, stoic" "killer" who dared to come up *mano à mano* against the Father and was now suffering the consequences. In the age that legalized boxing and established it as America's premier blood sport, the biggest and longest running match was between No-God and his belligerent prophets. In "Psychopathic Characters on the Stage" (1904–5), Freud said that "heroes are first and foremost rebels against God." A *New York Times* headline of 1927 blazoned the K.O. when God went down for the count: "RELIGION DOOMED, FREUD ASSERTS." But this was a fixed fight, a dummy contest; the underlying reality, the suppressed scenario, was that of matricide and feminicide—in the words of Eliot's Sweeney, "Any man has to, needs to, wants to / Once in a lifetime, do a girl in"—a mother murdered because she had murdered the father. It was, not surprisingly, a story given its most powerful presentation in Freud's day by an American author.

Ludwig Lewisohn's novel *The Case of Mr. Crump* (1926), the dramatization of his own unhappy marriage, tells the story of a man who marries a woman old enough to be his mother; she rules and debases him by manipulation, blackmail, and outright force. Crump paints himself as Oedipus, as Hamlet, as Orestes, and sees his wife as a "fury," a monstrous "Mrs. God" blocking his hopes of artistic and sexual fulfillment. Since she will not divorce him, he beats her to death with a poker, then calmly calls the police and prepares to go to prison. It has been worth it; terrible in "her malevolence and her ferocity, her lusts and treacheries" as she had been, "strong and unvanquishable" as she had seemed, he has at last reduced "Mrs. God" to a "huddled, shrunken, sack-like bundle on the floor." Freud read Lewisohn's matricidal tale and pronounced it, in a lunge of overpraise, "an incomparable

masterpiece"; perhaps he appreciated the full rendition it offered of the *Totem and Taboo* ur-text that he could not bring himself to write.

It was common knowledge in psychiatric circles that American analysts were apt to deviate from received Freudian doctrine by switching the focus from the father to the mother, if only because the mother usually appeared by far the more significant figure in the minds of the patients they were treating. Freud's English translator, the New York analyst A. A. Brill, had spent his childhood in Hungary under the tyrannical discipline of his strict and military-minded father; one suspects that he found psychoanalysis compelling and congenial in good part because Freud's authoritative persona and his stress on the father's central role in the child's development fit his own experience. But after decades in America, faced by the overwhelming evidence of his patients' stories, Brill, too, began to recast his thinking along matriarchal lines. This matriarchal focus among American psychiatrists received its fullest explication in a book by the New York psychiatrist Frederic Wertham, *Dark Legend: A Study in Murder* (1941), the story of an act of matricide that took place in New York sometime in the late 1920s or early 1930s. The murderer, who became Wertham's patient, was an Italian-American youth who had killed his promiscuous mother to avenge his deceased father's honor, but *Dark Legend* is also a study of what Wertham called the "Orestes" or "Hamlet" complex more broadly speaking, a pattern of neurotic thought and behavior that centered on the mother rather than the father, a complex which he believed more prevalent and more important than Freud's Oedipus complex; Ernest Jones cited *Dark Legend* respectfully in later editions of his own book on *Hamlet*.

Wertham was Americanizing the Orestes-Hamlet complex. All the matricidal scenarios I've been discussing—whether the Greek, Shakespearean, or American versions—highlight the mother's unruly, displaced, and problematical sexuality and her patricidal deeds or wishes, but where the Greek and Shakespearean versions focus on the mother's neglect of her maternal duties, Wertham's larger matricidal scenario, like Hemingway's and Crane's, depicts the mother, not as too little a mother, but in some senses as too much of one; in this version of the Orestes-Hamlet story, the mother is not indifferent to her male offspring but overinterested in them. To make his point, Wertham recounts a little folktale about a young man who is the fond and sole object of his mother's love. When he falls in love, his sweetheart demands that he kill his mother, cut out her heart, and bring it to her. Without a moment's hesitation, he does what she asks, but as he is running with his mother's heart in his hand to his beloved, he trips and falls. The heart, fallen from his grasp to the ground, asks: "Did you hurt yourself, my child?"

It is the mother's infernal overattentiveness, her grotesque solicitude, what

the feminist critic Madelon Sprengnether calls "the threat of castration imminent in her overwhelming love," her conviction that her child cannot live in the world without her guidance and pity, her self-serving, self-sanctified efforts to keep her children out of what Sidney Howard called "the dangerous place[s]," where young people take risks and experience adversity and pain, and, perhaps, grow up—it is all this that drives men to matricide, Wertham implies. This is the cannibalizing impulse that lay behind Grace Crane's dying words, "Poor boy," and Grace Hemingway's pledge to Ernest in her letter of 1920 that, once he has mended his ways, he will find her waiting and praying for him in this world and the next. "Mother Love," to recur to Willard's slogan, is in this view always "Organized"; it is, finally, the *only* Organization.

Fitzgerald was, like Hemingway, the child of a doting and solicitous mother, the overblown, uncouth, and ill-controlled Mollie Fitzgerald. No matter how much he misbehaved, he later told Sheilah Graham, his mother saw him simply as her "bad brownie." When she died in 1936, he said it was quite within her character to have decided to die in order to leave him a much needed inheritance. In his last completed novel, *Tender Is the Night*, he included a sustained and eloquent elegy to his father, dead in 1931, the kind, disappointed, alcoholic, and remote Edward Fitzgerald, that ends "Good-bye, my father, good-bye, all my fathers," but he dismisses mothers as those who "croon falsely" to their offspring "that there [are] no wolves outside the cabin door." The novel, the portrait of a man's self-destruction amid a pack of carnivorous women, tells us that the wolves are real, and female, and Fitzgerald originally planned it as a study in matricide. Wertham called this explosive protest against maternal suffocation and infantilization a "catathymic crisis," and described its central symptom as "the development of the idea that a violent act against another person or oneself is the only solution to a profound emotional conflict whose real nature remains below the threshold of . . . consciousness." Matricide is always suppressed, and made inevitable by its suppression. "In the beginning was the Deed."

GENDER COLLABORATION

Freud had little to say about the daughters of the father, and he refused to use the term "Electra complex," a term coined by Jung to designate the sister figure who plans and abets the matricide the son commits, but he attracted matricidal daughters in real life. For a number of his female disciples, Anna Freud included, choosing psychoanalysis as a vocation spelled a "revolution," in Helene Deutsch's words, because it meant "liberation from the tyranny

of my mother." Americans, too, found the Electra story compelling. O'Neill, who devoted a trilogy to it, *Mourning Becomes Electra* (1931), thought her "the most interesting of all women in drama," and the Hemingway heroine is often a muted Electra figure, one who seems more like the hero's sister, and a twin sister at that, than his lover. In "Soldier's Home," the only person Harold Krebs cares about is his sister, Helen, a tomboy who likes to play baseball and boasts: "I can pitch better than lots of the boys. I tell them all you taught me." "The other girls," she adds proudly, "aren't much good." Helen has no time for her mother, but she hangs on her brother's every word. When she asks him, "Do you love me? . . . Will you love me always?" Krebs, who initially refuses to answer a similar question from his mother, answers easily, "Sure." In the story's last line, in the midst of planning to beat it to Kansas City, he decides to "go over to the schoolyard and watch Helen play indoor baseball." This, somehow, is not altogether a compromise: she's on his side.

The daughters of the Titaness were as instrumental in overthrowing her as her sons. The modern American women who aided the male writers, psychologists, and theologians in the masculinization process were at least as eager as their male peers to seize the liberties of adventurous autonomy, creative and rigorous self-expression, sexual experimentation, and full exposure to ethnic and racial diversity, liberties that had been even harder to come by for women than men, liberties against which the Victorian matriarch had, as her descendants saw it, ruthlessly campaigned. In an article entitled "Flapping Not Repented Of" in *The New York Times* of July 16, 1922, the flapper was celebrated for her ability to "take a man's view as her mother never could." A proprietor of a tobacco store, interviewed by the *Times* for a February 29, 1920, article on that new breed "Women Smokers," explained that, although he tried to sell his feminine customers the dainty cigarettes the tobacco industry was turning out especially for them, they were uninterested: "They want a man's smoke every time."

This was the generation of women whose leaders, asked to contribute to a feminist symposium in *The Nation* in 1926, wrote pieces with titles like "Confessions of an Ex-Feminist," "The Autobiography of an Ex-Feminist," and "The Harm My Education Did Me," and complained about the "injurious strain of my mother's devotion," the "bitterness" of maternal rule, and "selfish and deceitful" "Mother Nature." One of them wished "I had been born a man"; another insisted, "I *was* my father." Louise Bogan once refused to undertake an anthology of earlier American women poets because, she explained, she had trouble enough putting up with "my own lyric side"; she wanted to take all the "punk poetesses"—a group in which she sometimes included herself—line them up against a wall, and gun them down. While

the Titaness's gender-creed was narcissism or self-love, her daughter's was stylized self-condemnation, an exhilarating foray into the so-called masculine virtue of self-hatred in the interests of feminine liberation.

Although women did not fight in the Great War, postwar styles suggested they wished they had. Flappers wore "helmet" or cloche hats that hugged the head and partially covered the ears and loose-belted trench coats, both modeled on Great War gear. Helmets had protected the soldier from a literal version of shell shock. Trench coats, as the name suggests, had been designed to help him endure the cold, fog, and rain that made trench warfare a palpable hell. Michael Arlen's runaway best-seller *The Green Hat* (1924) set off a craze for cloche green hats and a gaunt, glamorous Katharine Cornell, who played its heroine Iris March on Broadway, modeled the "Green Hat" for a *Vogue* layout in 1925. Garbo was Iris in the film version, *A Woman of Affairs* (1928); she took the trench coat look as part of her haunting and enigmatic signature. In that rhythm of repeated cross-gender appropriation that characterized the modern era, Humphrey Bogart refashioned the trench-coat style for men a decade later.

Shell shock showed up in beauty treatments and feminine hygiene. Depilation of the female body, a practice always more prevalent in America than elsewhere, became *de rigueur* and extreme in the 1920s; legs, underarms, even arms, were hairless. In their 1934 exposé of advertising, *1,000,000 Guinea Pigs*, Arthur Kallet and F. J. Schlink reported that some depilatory creams contained rat poison and were likely to produce "neuritis" and "nervous breakdowns" in those who used them; according to their study, the new X-ray treatments that burned off unwanted hair sometimes led to premature aging and cancer. Kotex advertised its product briefly in the *Ladies' Home Journal* in early 1921 as made of "cellucotton," the "sanitary absorbent" perfected "for the use of airmen and allied soldiers wounded in France"; wartime nurses had apparently discovered this new use.

Women were supposed to be almost as angular as the cars they drove. The writer Brenda Leland, looking back in 1930 at her pre-diet self, felt "shame" and "disgust" at the thought of her "beetling hips" and "hard-shell matronly appearance." Waists and breasts disappeared; long hair was banished along with the old-fashioned corset. Frills were out; sports clothes, crisp suits, and Coco Chanel's classic "little black dress" were in. Legs were bared to the public gaze, and glittered in silk stockings. If décolleté was passé, drastically V-shaped dresses focused attention on the back; night frocks were sleeveless. Women wore abbreviated swimsuits and participated in once-taboo public displays of beauty; Atlantic City began to hold its contests in 1921. Heavy eye makeup and dark red or maroon lipstick were in vogue; one popular brand, favored by the American heiress Peggy Guggenheim,

was called "Eternal Wound." Over in Paris, Paul Poiret, a veteran of sorts, favored violent red colors for his fashions because, as the English heiress and poet Nancy Cunard wrote in her diary in 1919, "he has seen so much blood in the trenches he can think of no other color!" Poiret wanted his fashions to deal "a blow to the head." Chanel said that style was "a slap in the face." Feminine fashion had nothing to do with one's mother's taste; fashion was trauma.

Urban women writers of the 1920s specialized in matricidal texts as surely as their male peers did, and they, too, worked by blatant displacement and disguise. In 1923, a popular novelist named Olive Higgins Prouty published her biggest best-seller, *Stella Dallas*, which later spawned a radio series with the same name, a pioneer soap opera. The novel, set largely in the seedier sections of New York, told the story of Stella, a helplessly vulgar, self-sacrificing, working-class mother, and her well-bred and delicate daughter, Laurel, the product of a misalliance that brings Stella momentarily but disastrously into the orbit of high society; Stella gives Laurel up so that her daughter may climb social heights she can barely sight, much less scale. Predictably, New York's critical establishment scorned the novel as an execrably written cheap potboiler; its apparent theme, the tragic grandeur of selfless mother love, was repellent to the modern metropolitan mind.

Broadway claimed it could do nothing with the story—a planned play adaptation with the aging Mrs. Leslie Carter, the "American Bernhardt," in the lead never came off—and the book went to Hollywood, where the first film adaptation was made in 1925. (There have been two others, the most recent, *Stella*, with Bette Midler, in 1990; the best, *Stella Dallas*, with Barbara Stanwyck, in 1937.) Prouty's only claim to fame today is apparently the fact that in the early 1950s she put the disturbed and gifted poet Sylvia Plath, a matrophobic mother's girl who used her poetry to demonize and worship her dead father, through Smith College (Prouty's alma mater). Prouty was herself the survivor of a severe nervous breakdown, and she served as Plath's sympathetic patron until the end of Plath's short life; Plath was a suicide in 1963 at the age of thirty. The pairing of Plath and Prouty is not so incongruous as Plath's biographers sometimes seem to think; *Stella Dallas* was very much a part of the moderns' *Totem and Taboo* scenario, which Plath inherited and refurbished.

Stella's daughter, sweet and cultivated little Laurel, the exclusive object of her mother's affections, is curiously affectless and "blank"; one of her many admirers says that she's like a book whose "pages white as snow have never been written on." Innocent, unsuspecting Laurel loves her garish and crude mother, oh so much! *She* doesn't consider her mother a "ball and chain around her ankle," as one observer describes the situation; *she* doesn't

prefer her dignified, upper-crust father, Stephen, who can open every door for her. Oh no, not Laurel, the blameless and blank! But her anesthetized air is more cunning than conscience; she's closer to Electra than to Iphigenia. Laurel *has* to be blank for the requirements of Prouty's covert matricidal plot; that way she needn't own her secret wish to get her mother out of the way, or be responsible when Stella ever so nobly disappears from her life without consulting or implicating her at all.

Feminine fashion is very much at issue in *Stella Dallas*. It is the godawful way Stella looks and dresses that condemns her, that makes Laurel appear a changeling and a victim. Stella has exquisite, impeccable taste when it comes to dressing her precious daughter. So why can't she simply redo and upscale her own gaudy, outdated appearance? Why not recosmeticize? Get rid of the bleached hair, the outlandishly loud print outfits, the heavy blotched makeup? It is the deepest logic of the story that Stella can't do any of this because her bad taste is but the symbol of her deeper, chronic, and incurable crime, one that nothing can change: she is the oversolicitous mother who blocks her child from the larger, more exciting, and prestigious world of the father. All that's open to Stella is repentance and self-punishment. She acknowledges her own status as "freak," admits that Laurel somehow isn't really hers at all—"Honestly, I can't see a trace of me in Laurel. Nobody can"—and engineers her own execution.

At the novel's close, Laurel is living happily with her father and his well-bred second wife. As far as she knows, her mother has vanished, but, in fact, Stella is standing at this very moment in the rain, poor, lonely, and radiant, watching Laurel from the street through the window of her daughter's posh new home. Laurel is preparing for her coming-out party, completely unaware, as she has somewhere always longed to be, of her mother's presence. A cop brusquely moves Stella along. "Yes, Sir," she says meekly in the novel's last line; "I'm going. I was only seeing how pretty the young lady was." Stella has found her only acceptable role vis-à-vis her daughter, as slave and fan; she has done Laurel's dirty work for her, somewhat in the fashion that Sophocles and Shakespeare killed off Jocasta and Gertrude without implicating Oedipus and Hamlet, the men who wished them dead. In *Stella Dallas*, new-style matricide is sentimentalized as old-style feminine self-sacrifice; it's matricide by spontaneous maternal combustion.

In the fall of 1928, Sophie Treadwell's play *Machinal* opened on Broadway to good reviews and a modest run. Treadwell had been an actress, a protégée of Helena Modjeska, and a journalist; she based *Machinal* on the recent Ruth Snyder–Judd Gray murder case. Like Ruth Snyder, Treadwell's Young Woman (the characters are largely nameless) is a working-class secretary who marries her older, well-to-do boss, only to fall in love with another man;

like Snyder, she murders her husband and she, too, is electrocuted for her crime. *Machinal* is overtly a story of *Totem and Taboo*-style patricide but written by a woman not a man, a story of the "Deed" carried out not by a son but by a daughter and a wife, a woman whom the author paints as a lost but strangely honest, pure heroine. The father is not, in any case, the real villain of this piece.

The most significant change Treadwell made in the material she was using involved the Young Woman's mother. Everyone following the Snyder-Gray case (and everyone did) knew that Snyder's only ally in life, the one person who really loved her and whom she trusted and cared for in return, was her overworked and inarticulate Swedish immigrant mother, Josephine Brown. "If ever a wretched sinner had a wonderful, loyal, true-blue mother," Snyder wrote in *My Own True Story*, "I have." At her trial, in a moment of real if calculated pathos, Snyder said that she fell for Judd Gray because he had touched her gently as he was fitting her for a corset; no one but her mother, she claimed, had ever been kind to her. But in *Machinal*, the Young Woman's mother is a cold and manipulative monster who pressures her daughter into marrying an ill-mannered, self-infatuated, incurably middle-aged man so that she can enjoy financial security in her old age. In the play's most poignant line, the Young Woman, a neurotic and unhappy person unsure of her rights, uncertain if she has any rights at all, cries: "Is nothing mine?" She's been incessantly violated from the day she drew breath.

Mother and daughter live together; there is no father and no mention of him. The Young Woman works at a job she hates to support them, and her mother criticizes everything she does. Browbeating her daughter into marriage, the mother tells her that the fact that she has no feelings for her prospective husband doesn't count; life, as this mother describes it, is a death sentence in any case. "You can count that you've got to eat and sleep . . . that you got to get old and that you got to die. That's what you can count on! All the rest is in your head!" The Young Woman tries to resist: "But I can't go on like this, Ma . . . It's like I'm all tight inside—sometimes I feel I am stifling." But her mother cuts her off: "You're crazy." When she repeats the charge, more emphatically—"You're crazy!"—the daughter, for a second, revolts: "If you tell me that again, I'll kill you! I'll kill you!" This is the Mrs. Krebs–Harold Krebs, mother-child scene of "Soldier's Home" played over with a daughter, and as Krebs backed down before maternal blackmail and tears, the girl, once her mother starts to cry and reproach her in the tried-and-true fashion of a *"body* slave"—"I brought you into the world!"—at once apologizes: "I know, ma, I know."

In the play's final scene, the Young Woman is waiting in her cell to be taken to the electric chair; her mother is announced by the guard, but the

girl says: "She's a stranger—take her away." Once again she recants, and embraces her mother through the bars, but in her last words, she implores her mother to look after her own unwanted little daughter: "Let her live! Live!"—as, the unspoken part of the request goes, you did not let me. I do not wish to ignore the more conventionally feminist elements in *Machinal*. The play is meant to be an indictment of an industrial patriarchy that pays homage to a cold and unconcerned male deity, an indictment that climaxes in what Treadwell depicts as a noble act of homicide; in any case, the 1920s revolt against authority in which Treadwell took part was too pervasive and vehement not to include the father as well as the mother. But men aren't all bad in *Machinal*; far from it. The Young Woman's lover (played on Broadway by the young Clark Gable), with whom she briefly finds sexual fulfillment and an almost celestial intimacy, is a masculine hipster, a California-born, free-spirited proto-Beat who's been bumming around Mexico, loving the ladies, dark-skinned as well as white, "moving on" whenever the open road beckons, and casually killing some "bandits" to get "free."

Treadwell's career had obvious affinities with the life-style of the Young Man. She, too, was a native of California; transgressing the usual restrictions on women journalists, she, too, traveled to Mexico, where she interviewed the rebel leader Pancho Villa during the Mexican Revolution. (She was also one of the few women journalists to cover the Great War in Europe.) Her alter ego in *Machinal*, in other words, is not only the Young Woman but the Young Man. The suffocated Young Woman wants her lover's free, easy version of the father's world, and kills, as he did, to get it; she very specifically takes his act of homicide as the model for her own. Her tragedy is that the person she murders is not her real, her worst enemy. In the last scene, as she begs her mother to "let [my daughter] live!," there is no escaping, I think, the sense that the wrong woman is going to the chair, that the patricidal deed was in part the deflected but justified matricidal wish. Once again patricide is but matricide-in-disguise; in the 1920s, feminism meant feminicide. American modernism was not an affair of a horde of sons but a bi-gendered venture of siblings intent on decimating the mother and reinventing the father.

The slaying of the Titaness, the Mother God of the Victorian era, was the most important instigation of the modern urban era, and the basis for its central ethos, "terrible honesty." Gods deposed become demons, Freud told his readers again and again, and they do so presumably whether the gods in question are male or female; if deposed male gods become devils, deposed female gods become Furies. These dark female gods haunted modern American urban culture, and they afflicted the sexes in different ways and to different degrees. But that belongs to a later part of this story. In the 1920s,

the moderns bet everything on their powers of denial and negation, on their ability to take the adrenaline rush which an instigation always brings and leave behind, or for the future, the emotional apprehension of the consequences, the kickback, that instigations entail. They went for the excitement and ignored the damages. The full bill for this instigation would not come due till the 1930s and 1940s, and its immediate profits and rewards were immense. Cultural matricide gave fresh access to an adventurous new world of uninhibited self-expression and cultural diversity, a world the Titaness's bulk had seemed designed expressly to block.

"BLACK MAN

AND WHITE LADYSHIP"

WOMAN SUFFRAGE AND THE BLACK VOTE

It is no accident that the Harlem Renaissance, the first extensive, self-conscious, and acclaimed movement in African-American arts and letters, took place in the midst of the demise of the Titaness; Negro and matriarch could not be front stage at the same time. Carrie Chapman Catt—like most of her peers in the suffrage movement middle-class, well educated, and Wasp, the descendant of Englishmen and women who had arrived in Massachusetts in the seventeenth century—liked to boast that woman suffrage was an "altogether bourgeois movement with nothing radical about it," and nowhere was that clearer than in NAWSA's relation to what was called "the Negro question." The ugliest part of the suffrage crusade was its opportunistic racism and ethnic prejudice. As Aileen S. Kraditor has demonstrated in *The Ideas of the Woman Suffrage Movement* (1965), white women won the vote by playing to the nation's anti-Negro sentiments.

NAWSA's crucial victories took place between 1890 and 1920, the decades that witnessed the brutal undoing of post-Civil War Reconstruction and its Freedman's Bureau. Finalized by *Plessy vs. Ferguson*, the Supreme Court decision of 1896 upholding the doctrine of "separate but equal" status for Negroes, Jim Crow laws in the North and South assigned separate and unequal accommodations to Negroes in railroads, trolley cars, rest rooms, hospitals, parks, sports arenas, theaters, housing, and cemeteries. The same decades witnessed a nationwide re-emergence of the Ku Klux Klan and the forcible disenfranchisement of the but recently enfranchised black population; steep literacy and property requirements, the poll tax, and clever manipulation of the new primary system of national elections kept Negroes out of voting booths. In Louisiana, for instance, there were 130,334 registered

Negro voters in 1896; in 1904, only 1,342. Negro bishop Henry McNeal Turner of Georgia concluded, "Hell is an improvement upon the United States when the Negro is concerned."

The suffragists promised to make the Negro's disenfranchisement permanent. Frances Willard dedicated herself to suffrage as well as to temperance—*woman* suffrage, of course, not Negro suffrage. In the late 1880s, she made a tour of the South that moved her to offer her "pity" to white Southerners, saddled with the "immeasurable" problem of "the colored race," a debased and unrestrained race, to Willard's mind, "multiply[ing] like the locusts of Egypt," whose male members were mainly, it seemed, rapists looking for white victims, "menac[ing]" the "safety of women, of childhood, of the home." For her part, Catt confessed publicly that the North had acted unwisely in legislating "the indiscriminate enfranchisement of the Negro in 1868" during the carpetbagger days of Reconstruction; now that Negroes were beginning to migrate in increasing numbers to Northern cities, Northerners like herself, she said, could understand, share, and even further the South's anti-Negro suffrage position. After all, as another suffrage spokeswoman pointed out, "there are more white women who can read and write than [there are] Negro voters." Women, once enfranchised, would end what Catt called "rule by illiteracy" and "insure immediate and durable white supremacy, honestly attained," as the Southern suffragist Belle Kearney boldly put it in 1903.

It should be noted that Catt fought first and last for a federal amendment granting women the vote, and she consistently resisted the preference of NAWSA's Southern constituencies for working at the state level, more sensitive than the federal government, they believed, to local issues like Negro rights or lack of them. But Catt also emphasized that, once suffrage was gained, individual states would still have the right to set qualifications on the right to vote; she herself favored a literacy requirement that would disqualify the majority of Negroes. This anti-Negro position did not change, even when, in the last years of the suffrage crusade, NAWSA made significant gestures toward the urban ethnic and immigrant vote—though Catt, who was pledged to "cut off the vote of the slums," found such work distasteful —in hopes that the Americanization tactics in favor among Progressives of all persuasions could make a homogeneous polis out of the too-heterogeneous American people.

Jane Addams, suffrage leader and spokesperson for immigrant America, had been an early member of the NAACP who had fought to integrate Chicago's elementary schools, but in 1912 she supported Theodore Roosevelt's Progressive Party when it upheld the idea of woman suffrage despite its refusal to include a Negro-rights plank in its platform. One anonymous

African-American correspondent admonished her: "I thought of the breaking hearts of my people . . . and I shudder at the blasphemy of the farce . . . Is woman suffrage more important in [God's] sight than the right of the Negro to be treated like a man?" He pleaded with her "not [to] identify yourself with those who have joined hands to crush the poor African." Such reproaches surely troubled Addams, but they didn't alter her stand; she rationalized her decision to support Roosevelt in Du Bois's periodical, *The Crisis.* Although she strongly opposed lynching, Addams, like Willard, believed that black men did, in fact, have a proclivity for raping white women, and over the next twenty years (she died in 1935), she gave most of her energies to whites-only reform activities.

Catt's plan to enlist Woodrow Wilson's support was feasible in good part because their views on race were similar. By the end of his first term in office in 1916, when Catt turned her attention to him, Wilson was thoroughly disliked by most black Americans, and for good reason. After his 1912 promise to the "colored people" that "they may count upon me for absolute fair dealing," a promise that lured Du Bois and 100,000 Northern Negroes from the Republican fold, Wilson, once elected, had gone on to fire several of the handful of blacks who had found federal positions under Teddy Roosevelt. James Weldon Johnson was eased out of the consular service in South America when Wilson took office; he campaigned against what he called Wilson's "Southern oligarchy" in 1916.

Wilson, born in Staunton, Virginia, came to office in 1912 on a campaign run by openly supremacist white Southern Progressive politicians; as Gilbert Osofsky comments in *Harlem: The Making of a Ghetto* (1971), political progressivism "bypassed the Negro." Wilson appointed Josephus Daniels, one of the most virulent of this Southern lobby, to his cabinet as Secretary of the Navy, and in 1915 he pronounced the Ku Klux Klan version of America's recent past, dramatized in D. W. Griffith's *The Birth of a Nation,* "history written with lightning!" When his Postmaster General, Albert S. Burleson, enforced stricter segregation policies in the dining and toilet facilities of federal buildings, Wilson made no objections. He tacitly and not so tacitly encouraged the attitudes that resulted in the massacre of blacks in a riot in East St. Louis in the summer of 1917, and a year later, he presided over the series of betrayals that constituted the government's response to the extraordinary contribution of Negro soldiers in the Great War. Wilson and Catt, one might say, deserved each other's support.

William Lloyd Garrison, Jr., son of the famous abolitionist, had publicly rebuked NAWSA in 1903: "To purchase women's suffrage at the expense of the Negro's rights is to pay a shameful price." And Du Bois, a supporter

of woman suffrage who tracked the movement's progress in *The Crisis*, accompanied his account with a running commentary on NAWSA's conspicuous lack of interest in Negro rights. Du Bois believed that "the negro race has suffered more from the antipathy and narrowness of [white] women both North and South than from any other single source," and in an essay on "Votes for Women" in the August 1914 issue of *The Crisis*, he had sadly concluded, "It is the awful penalty of injustice and oppression to breed in the oppressed the desire to oppress others." In 1919, the novelist Walter White, a leader in the NAACP, commented indignantly that "if they [NAWSA] could get the suffrage amendment through without enfranchising colored women, they would do it in a moment." His point was well taken. Black women's groups increasingly supported woman suffrage—indeed, the historian Nancy Cott tells us that after the passing of the Nineteenth Amendment, in the areas where measures were not taken to keep Negroes from voting, black women turned out in larger numbers than did their white sisters—but they received scant attention from NAWSA.

In 1899, the National Suffrage convention had refused to pass a resolution put forth by black suffragists opposing Jim Crow cars on the railroads; in 1913, black suffragists were asked *not* to march in the suffrage parade in Washington. In 1919, a group from the Colored Negro Women's Clubs seeking membership in NAWSA was politely but firmly discouraged. In the 1920s, after the vote for women had been gained, black women were unwelcome in the women's peace movement, which absorbed much of the old suffrage organization and provided fresh outlets for feminist reformers like Catt and Addams. When the International Council of Women for Peace met in April 1925, black delegates walked out after they discovered that the seating arrangements were segregated. The National Association of Colored Women fought lynching throughout the 1920s with little help from the large white women's organizations.

Ironically enough, the suffrage movement had its origins in the abolitionist movement of the late 1840s. The suffrage pioneer Elizabeth Cady Stanton, editor of *The Woman's Bible*, began her political life as an abolitionist activist in the 1840s; both the white abolitionist leader William Lloyd Garrison and the black anti-slavery leader Frederick Douglass were committed to women's legal and social rights as well as to the emancipation of the slave. But in 1870 Stanton and her strong-minded colleague Susan B. Anthony refused to lobby for the Fifteenth Amendment, granting the Negro male the vote, on the grounds that it did not include female suffrage; Stanton, too, saw the black man as a rapist waiting for his cue, and she was sure that the vote would supply it. She predicted "fearful outrages on womanhood" if the black

man was enfranchised. In 1867, Stanton and Anthony joined forces with a wealthy Democrat and suffrage supporter, George Train, whose public motto was "Women first, and negro last."

By the 1920s, NAWSA's amnesia about its abolitionist origins was complete. In her polemical history *Woman Suffrage and Politics* (1923), Catt did not discuss slavery. Instead, she wrote briefly of an "anti-slavery movement" on a par with the "anti-liquor movement"; its main importance seemed to be that it "appealed to the humanitarian sympathies of the better-educated women" and provided them with a training ground for the more important work of suffrage reform. There were some troubled consciences in NAWSA ranks—Addams's colleague the social worker Florence Kelly, for one, knew the party had "welshed on the Negro"—but no NAWSA leader seriously criticized the organization's racist policies. White middle-class American women had once learned about their own rights in fighting for those of the enslaved Negro, but by the turn of the century the Negro's rights had become, in NAWSA's telling, their wrongs, the Negro's wrongs looked to be their rights, and the perpetuation of those wrongs their goal.

NAWSA's racism was an almost inevitable corollary to its credo of feminine essentialism. Historically speaking, essentialism of gender and essentialism of race or nation have gone hand in hand; the one set of prejudices seems to attract and require the confirmation of the other. Put another way, one might say that once a group of people starts thinking of themselves as innately qualified for power, it's pretty hard to stop. Why not exalt your race as well as your gender? You've already junked the hard thinking of self-criticism for the aggressively blind pleasures of narcissistic flight. Hitler's Nazi Party, with its fanatical insistence on Aryan blood purity and ultra-masculinity, is the most extreme and notorious example of interlocked gender-and-race essentialism, and African and African-American art was as distasteful to the Third Reich as Jewish art. When Catt wrote, "American women who know the history of their country will always resent the fact that American men chose to enfranchise Negroes fresh from slavery before enfranchising American wives and mothers," she was suggesting to her readers that "Negroes" were somehow not "American men" or "American wives and mothers." White suffragists excluded black women from their meetings and their thoughts because black women weren't, to their minds, truly "women." "Women" are—need it be said?—*white* women.

Catt to the contrary, however, there was a black middle-class, reform-minded matriarch as well as a white one. As the historian Paula Bennett describes them in her book *When and Where I Enter* (1984), the Negro suffrage and club groups that NAWSA excluded shared many of its aims and values. Josephine St. Pierre Ruffin, a friend of Stanton and Anthony,

who edited the first black women's newspaper, *The Woman's Era*, helped to found the National Association of Colored Women (NACW) in 1896; she called for an "army of organized [black] women standing for purity and moral worth." By 1916, NACW claimed 50,800 members. Mary Church Terrell, herself from a wealthy black Tennessee family and a leader in the NACW, advocated the "elevation of black womanhood" and started "Mother Clubs" for black women so that they might learn to protect and improve Negro home life. Mary Morris Burnett Talbert, another prominent Negro club woman and activist, helped orchestrate the Liberty Bond crusade of the war years. The members of NAWC and the Colored Women's Clubs, as of their white sister organizations, were largely middle-class, Protestant, and pro-temperance. Positive thinking was their watchword, too; as the educator and NAWC leader Mary McLeod Bethune put it, "Neither God nor Man [can] use a discouraged soul." To their mind, black women were "the fundamental agency under God in the regeneration . . . of the race," in the words of the black educator Anna Julia Cooper, and the best hope of black men, a group whose political instincts and behavior one black reformer named Mrs. Robert M. Patterson described in 1922 as "foolish," even "abominable."

In his novel of black life, *Not Without Laughter* (1930), Langston Hughes portrayed a black Carrie Chapman Catt figure. The proper, stiff, resolutely middle-class Tempy subscribes to the racially conservative if not racist *Ladies' Home Journal*, attends conventions of the Midwest Colored Women's Clubs, works for the Red Cross, and believes all Woodrow Wilson's promises. Tempy has custody of Hughes's autobiographical hero, her young nephew Sandy; she is always trying to improve his manners and taste, rebuking his fondness for black music and his loyalty to the lowlife branch of the family, and urging him to acquire an upwardly mobile, white education. It's a scenario familiar from the annals of white feminine reform and those of its opponents, a black version of the Mrs. Krebs–Harold Krebs confrontation, the old vignette of the recalcitrant male besieged by females bent on uplift. There were, in fact, chronic gender tensions among African Americans, most of them to do with the fact that black women tended to be marginally better off than black men.

Black women found employment (usually as domestics) more easily than their men, and in the cities they outnumbered them; the percentage of female-headed households was far greater among blacks than whites. Black women also constituted the majority of Negro church membership, and they tended to be better educated, and to place a higher value on education, than their male counterparts. Black women retained at least one of their traditional feminine functions under slavery, if in harshly debased form, that of child breeding, but slavery had obliterated the traditional prerogatives and duties

of the black male as impregnator, householder, breadwinner, and protector of the family, and this imbalance had consequences for the post-Civil War black family. Negro men were often heard complaining that their women understood nothing of "the spirit of subordination to masculine authority," as the black sociologist E. Franklin Frazier put it in *The Negro Family in the United States* (1939); some of them claimed that "domestic tyranny," the subordination of the black male to his women, was servitude, too.

Yet Tempy and the dominating black women she typified were not altogether villains in Hughes's eyes. Surprisingly, Sandy's least reputable relative, the blues-singing and free-living Harriett, agrees with Tempy about the importance of education. She says, "All of us niggers are too far back in this white man's country to let any brains go to waste!" and as the novel ends, Sandy is headed for a thorough schooling. Hughes himself attended predominately white schools until he went to Lincoln, a Negro college in Pennsylvania (whose faculty was, however, all white), in 1926, and he found a devoted friend and patron in Mary McLeod Bethune, who within a few years was to serve with distinction as one of Franklin Roosevelt's advisors in the New Deal. Such a friendship is unimaginable in white circles. Carrie Chapman Catt as the confidante of Hart Crane? Hemingway relying on the support and guidance of Jane Addams? In any case, as Hughes paints her, Tempy in her least attractive manifestations is just imitating her white employer, Mrs. Barr-Grant, who "travelled a great deal in the interests of woman suffrage and prohibition" and wrote "pamphlets on the various evils of the world standing in need of correction"; behind the black matriarch stood the far more intrusive white one. The Negro matriarch in all her guises, from the club-woman model to the mammy figure, commanded more tolerance, respect, and affection among her offspring than the white one did among her descendants, for the simple reason that her powers of uplift and opportunities for self-congratulation were, comparatively speaking, limited.

The motto of NACW, "Lifting As We Climb," with its message of labor doubled and overburdened, of an impossible task gamely undertaken, dramatized the fundamental difference between black women reformers and white; as the Negro club woman Fannie Barrier Williams remarked, the white women's clubs were "the onward movement of the already uplifted," but for black women, "the club is the effort of the few competent in behalf of the many incompetent." Most American black women were working-class, not middle-class; the mothers of several of the most distinguished leaders of the colored women's organizations, including Mary Church Terrell and the great muckraker and reformer Ida B. Wells-Barnett, had been slaves. Inevitably, the black women's clubs and reform movements were closer to the lower classes than were their white equivalents, and far more concerned

for their well-being. Wells-Barnett, who led the crusade against lynching, had socialist, even Garveyite sympathies, but all her more conservative black women peers joined her in protesting Jim Crow laws, lynchings, and the incessant infractions of Negro rights.

When Josephine St. Pierre Ruffin said that the goal of the colored women's clubs was to prove to "an ignorant and suspicious world that our aims and interests are identical to those of all good aspiring women," she was not claiming genteel status so much as she was rebuking the white men who assumed that Negro womanhood was an easy mark, a pool of prostitutes, and reproaching the white women's groups that excluded their black sister organizations. Rejected by the white reform movements, discriminated against by the national government, the black matriarch, whatever her temperamental or class preferences and allegiances, was perforce an outsider, even a radical and a dissident, in the larger context of American society.

The principal reason, after race prejudice, that white suffragists refused to welcome black women into their organizations was that black suffragists were publicly committed to re-enfranchising the black man; the only man they wanted to render voteless was the white lyncher. Their pitch for suffrage, their explanation of why they should have the vote, was, in other words, exactly opposite to that of the white suffragists: white women promised to make the black men's disenfranchisement permanent; black women were pledged to end it. During the congressional debates on the Nineteenth Amendment, Senator Ellison Smith of South Carolina summed up the opposition to enfranchising black women with brutal frankness: "If it was a crime to enfranchise the male half of this race, why is it not a crime to enfranchise the other half?" It was bad enough, to Smith's mind, that black men could, in theory if not in practice, vote; why make it worse? Men like Smith opposed woman suffrage precisely because, however lily-white NAWSA's declared aims, however often it assured its foes that enfranchised white women would outnumber and outvote male and female black voters combined, woman suffrage would give the vote to black women as well as to white ones. For black women, racial essentialism was hardly an option, and this sharply limited their forays into gender essentialism. Essentialist ideology did not take firm hold among black women reformers because black men were more their peers, their co-sufferers in a racist society, than their moral inferiors.

Late-nineteenth-century black women supporting the temperance movement, led by the poet, lecturer, and novelist Frances E.W. Harper, had to spend as much time fighting the anti-Negro rhetoric and tactics of Willard's WCTU (not altogether closed to black women but strictly segregated) as they did crusading against demon rum. Willard thought the Negro male's sexual

depravity stemmed from his addiction to the "grog shop," but Harper took such descriptions to be evidence, not of black male alcoholism and sexual savagery, but of white feminine racism, part of the national habit of scapegoating the black man for the nation's problems, one more attempt to prove him unfit for the vote. In temperance ranks as in suffrage ones, the black woman was willy-nilly the black's man's defender and champion. Although she was an ardent suffragist, Harper had supported the Fifteenth Amendment granting the black man the vote because, in her words, when "it was a question of race, [black women] let the lesser question of sex go." She was not sure in any case "that women are so naturally much better than men that they will clear the stream [of political life] by virtue of their womanhood." Another reason, then, that the black male did not repudiate his matriarchal ties, a corollary to the first, was that what little power the black matriarch had, she used in good part for him. Once enfranchised, black men returned the favor by lobbying for woman suffrage, and they did so with a tenacity seldom seen in their white male peers.

I do not mean to underestimate gender tensions among African Americans; the African-American feminist theorist bell hooks has ably documented the historical roots, intensity, and constancy of black male sexism in *Ain't I a Woman?* (1981). In black ranks as, on like occasion in white, male indebtedness to feminine support did not always generate gratitude; a backlash was inevitable, but it did not become a dominant factor in national black politics until the 1960s, the era of the Black Muslims and the Moynihan Report, the time when the SNNC leader Stokely Carmichael told women that their position in the new protest movement was "prone," and Eldridge Cleaver, a Black Panther who thought black women "subfeminine," advocated rape as a form of protest. Cleaver's main target was the white woman, but he recommended "practicing" on black women.

Both the historian Paula Giddings and the critic Hazel Carby have demonstrated that the reform-minded black matriarch largely avoided essentialist ideology, but this did not mean she was morally better than her white peers or intellectually superior to them. Once full-blown gender essentialism became a cultural possibility for black women, if only for a tiny handful of them, it proved as irresistible as it has always been to privileged white women. One thinks of the moments of self-aggrandizing sentimentalism, of nearworship of the black woman as life force in the work of contemporary black writers like Alice Walker, Gloria Naylor, and Maya Angelou, and of similar moments in the various television productions of Angelou's "spiritual daughter," the television talk-show host Oprah Winfrey. But the situation of the middle-class black woman at the turn of the century was very different from that of her most successful black feminine descendants and, more important,

from that of almost all her white middle-class contemporaries. The black matriarch was saved from some of the faults of her white counterpart not by her innate moral or intellectual advantages but, paradoxically, by her economic and social *dis*advantages.

The state of oppression has very little to recommend it—who would oppose it if it did not damage and limit its victims?—but among its few rewards is that those who are oppressed cannot fully appropriate the oppressor's vices, if only because those vices are inevitably linked to the possession of exactly what the oppressed lack—in a word, power. The truth that power always corrupts, and sometimes corrupts absolutely, is the best available argument for an ongoing, even endless, process of power transference and redistribution. No party, no race, gender, or class, should be in control indefinitely. This principle, both pragmatic and religious in its implications, is a version of William James's notion that the most important ideas are sometimes given to those who are marginalized as unfit; only the insights of the outsider can rectify the insider's inevitable errors. By any measure, the gap between the power of black women and that of white women in late-Victorian America was greater than the gap between the power of white women and that of white men; the black matriarch was better qualified for real political power (though she did not get it) than many of her white peers, in good part because she had had so little of it.

Black middle-class women maximized their ties to their male peers and to those socially and economically below them as their white counterparts did not for the simple reason that those who are entitled members of a ruling class, as both white middle-class men and women were in late-Victorian America, are always in some sense rivals, but those they rule of necessity value the broadest possible collective expression and action, for therein lies their chief hope of bettering their condition. Negro men and women usually supported each other publicly, whatever their private conflicts, because there was no one else's support they could count on. Who was going to work for black woman suffrage if black male voters didn't? Who was going to fight the black male's disenfranchisement if black women didn't? Essentialism is a weapon best used by those who have a measure of real power and want more; it's a way of parlaying the authority granted by one's acknowledged virtues or advantages into fields in theory and practice closed to them. The successful essentialist must be ahead of the game before she starts, for essentialism as a psychological and political strategy operates on a principle much like the one that underlay the new property and literacy restrictions on the vote in the 1890s; it's a game not even open to those without a strong hand to play.

The pragmatics of the white matriarchal reform tradition involved a stren-

uous but logical extension of well-established feminine prerogatives, a deployment of acknowledged entitlement in domestic and religious terms to strategic political ends, an attempt to translate women's recognized moral superiority into nothing less than national law. The black women's movement could adopt this tactic only as an ideal, however, not as a working assumption or a course of action. In the first decades of the twentieth century, twice as many black women (39 percent) were gainfully employed as white ones (20 percent). The black matriarch could hardly claim, as the white one did, that her protected status had allowed her to serve as incubator for all the virtues that a too-busy masculine world chronically neglected, for black women had never been shielded from the world's harshest realities.

From the start, unremunerated and forced labor and sexual exploitation had been the most striking characteristics of black feminine experience in America, and most whites after the Civil War believed black women were cut off from any hope of moral elevation. To their mind, the Negro woman started out as a barbarian from a benighted continent, and after the brief reprieve offered by slavery (seen, strangely enough, in this view as a civilizing influence), she had gone downhill fast. A typical white commentator on Negro womanhood wrote in the *Independent* in 1902 that the black woman was "steeped in centuries of ignorance and savagery"; he could "not [even] imagine such a creature as a virtuous negro woman." If black middle-class women wanted to market themselves as exemplars of uplift, the audience they could command for such a project was not only skeptical but incredulous and hostile.

The slogan of "Organized Mother Love" adopted by white middle-class women reformers seeking to extend their rule into hitherto all-male territory was also problematic, if not impossible, for black women activists. If white women reformers like Addams, Willard, and Catt were not themselves mothers, they belonged to a class and race for whom motherhood was in some real sense a valued, safeguarded, and reinforced role. But for black reformers like Harper, Wells-Barnett, and Ruffin, who were mothers (in fact, devoted ones), it was something they had achieved against enormous cultural odds. Weighing against them was the recent slave past, in which the black woman was forced to bear her white master's progeny to beef up his work force and often was separated from her children; after the Civil War, the black man who wanted to undo slavery's obliteration of his traditional masculine role by supporting a stay-at-home wife and full-time mother faced formidable economic and social barriers. Motherhood, as white middle-class America defined it, was hardly a universally acknowledged and divinely sanctioned prerogative for black women; if it was even their right, it was often denied them. A survey of families in Rochester, New York, in 1930 showed that

twice as many black couples were childless (50 percent) as white ones. In the 1920s, as in the 1870s, black women had scant reason to believe that they could, as another WCTU slogan had it, "Do Everything!"

Frederick Douglass, writing in 1868 to a white suffrage leader about why he backed Negro manhood suffrage though woman suffrage had made no headway, explained that, while woman suffrage was as "sacred" as black suffrage, it was not as "urgent." The American Negro faced a "life and death" situation in which he could be and often was "mobbed, beaten, shot, stabbed, hanged [and] burnt"; without the vote, he had no redress. The white American woman, however, while "abused," was relatively protected, for she had found "a thousand ways to attach herself to the governing power of the land and already exert[ed] an honorable influence on the course of legislation." Douglass acknowledged that, by this logic, a black woman was in double peril, liable to be "abused" as a woman *and* "beaten" or "shot" as a Negro, but he was sure that the first and greatest of her problems was race; she was belittled and attacked, he said, "not because she is a woman but because she is Black!"

In *Slavery and Freedom* (1982), the historian Willie Lee Rose has argued that, beginning in the 1830s, the South tried to make the system of slave labor permanent by depicting and rationalizing it, not, of course, as a manmade, unjust but profitable system of economic exploitation, but as the benign result of nature's law and God's will. Certain of slavery's harshest practices were ameliorated, and it was officially mythologized as part of that idealized institution the Southern family, which now became, in the phrase of many slaveowners, "my family, white and black." In *The Planter* (1853), a Northern visitor, David Brown, noted that in the South the word "household" was used "in the Scripture sense, including slaves but not hirelings"; in this euphemistic usage, those who were owned, those who were forced to work without pay, not those who were employed for wages, belonged to the Southern household and family. Rose rightly sees slavery's ideological familial status among Southern whites as part of a patriarchal rather than a matriarchal order, but Elizabeth Fox-Genovese has shown in her pathbreaking and authoritative study, *Within the Plantation Household* (1988), that women slaveholders and wives of slaveholders domesticated, enforced, and abused the slavery system as thoroughly as men did. Almost none of these women became abolitionists or saw blacks as in any sense their equals; indeed, Fox-Genovese finds herself compelled to testify that the women "were more crudely racist than their men."

Insofar as nineteenth-century Southern and Northern white women were themselves oppressed by white men, it increased rather than lessened their desire to bond with blacks. One might say that the white middle-class Vic-

torian woman was more susceptible than the members of any other group to extremes of self-serving and inaccurate thinking, to the overvaluation of what Constance Rourke called the "false feminine" tactics of essentialism, and she was so not because of any inherent depravity or weakness but because of her historical situation. Insofar as she had less power than her comparable male peers did, she saw more; she understood them better than they understood her. But unlike them, she had not exercised power broadly or continuously enough to attain a full sense of its limits and responsibilities. Unlike her black peers, however, she had had just enough power to want more and to have available to her ethically suspect but widely sanctioned ways of attaining it. She could hardly afford, as she saw it, to compromise her biggest asset, her acknowledged if largely bogus moral superiority, by associating with those considered in social and moral terms vastly her inferiors. As Du Bois had commented, "Oppression . . . breed[s] in the oppressed the desire to oppress others," and blacks provided just the scapegoat the middle-class woman needed. Like their male peers, if for slightly different reasons, white women had a vested interest in seeing Negroes as, in Rose's words, "children never expected to grow up."

In *Woman Suffrage and Politics*, Catt argued that Negro men had proved unworthy of the vote; their votes could be bought, and sometimes were, by the anti-suffrage party. Yet Catt didn't blame the Negro for his complicity with her enemies, for in her view Negroes were only as good as their masters. Negroes don't fight for the vote and win it on her pages; instead, the vote is forced on them by "whip and bayonet," and presumably withdrawn, though Catt of course doesn't say so, by the same methods. What blacks clearly need, in Catt's telling, is not the vote but better masters or mistresses. New Negroes, men and women, did not attack their maternal authorities with anything like the intensity and simplemindedness that the white moderns brought to the demolition of their matriarchs, because they had a far more influential would-be white parent to contend with. Whites cast blacks in the Oedipal family romance of America itself; collaborating and contending white master and white mistress were long the Negro's self-appointed and powerful parents.

THE FAMILY ROMANCE REWRITTEN

What attracts the Young Woman in *Machinal* to her lover, a man who casually crosses the borders between the white nations and the dark, is his freedom from bias and convention. At the end of the play, as she prepares herself for her execution, she finds her only comfort in a black man, also

on Death Row, who can be heard singing spirituals in his cell. The Young Woman "understands him," for he, too, is "condemned"; her mother is a "stranger," but the Negro is a friend. "He helps me," she says. Treadwell's heroine is tentatively, even unwittingly, re-establishing the alliance between white women and blacks that NAWSA had sundered, and her act is indicative of a new cultural mood, a shift in the national psyche, in America's family romance, black and white.

Hart Crane's dream about discovering his mother's dismembered body had a companion, an equally powerful dream that centered on the Negro, which he also told to his therapist, Solomon Grunberg. In it he finds himself floating in a small boat toward a waterfall, with a growing sensation of terror; as the boat reaches the waterfall, he sees a gigantic naked Negro standing on the shore nearby. Despite his imminent danger, Hart cannot take his eyes off the Negro and his huge penis; he is agonizingly aware that his own genitals are insignificant by comparison. This moment of recognition concludes the dream. What is most important about this dream for my purposes is its conjunction with Crane's matricidal nightmare. He dreamed the two dreams only weeks apart, if that; it's as if they're linked, though the causal connection is suppressed. The exaltation of the Negro must be preceded by the murder of the white mother; the matricide must be undertaken to find the Negro, and the Negro must be found in order to destroy the mother. Negro and mother cannot both be authorities in the same dream at the same time.

Crane's intimidation before the Negro phallus is significant, I think, less for its predictable exaggeration of black sexual prowess, less for its obvious homoeroticism, than for its classical Oedipal structure. The dream offers a variant of the family scene adumbrated by Freud in which the male child sees his father's genitals, so much larger than his own, for the first time; not understanding the laws of maturation, the little boy assumes that his own equipment is inadequate, that his father will always dwarf him. According to Freud, this moment is tied to the young boy's castration anxiety, whose working through is a central part of the Oedipal phase of development. One could say that Crane's dream about the gigantic and potent Negro is a classic version of the way male children read their fathers; Crane is in some sense reparenting himself, shifting his genealogy, blocking out the mother and recasting the father.

Early in Crane's career, in February 1921, he wrote a poem titled "Black Tambourine" about "a black man in a cellar," another version of the condemned Negro in *Machinal*. As Crane describes him, the black man is a figure for the Negro artist, faced by "the world's closed door" and trapped in a "mid-kingdom" between an obsolete minstrel tradition and an Africa

that had once fostered great Negro writers like Aesop but is now so remote in time and space as to seem "a carcass quick with flies." Crane was also talking about himself. As a homosexual, he, too, faced a "closed door"; he, too, felt displaced between two artistic modes, in a "mid-kingdom" between the older and more congenial romantic tradition and the modern mode of aloofness and irony that seemed to invalidate the poetic license he needed in order to create. Crane considered "Black Tambourine" a rite-of-passage poem, one of the first to be "definitely my own"; in it, he wrote, "I am getting closer to whatever I have."

Crane had been prompted to write "Black Tambourine" by his experience working in one of his father's restaurants in Cleveland. Assigned to the basement kitchen, the "cellar" of his poem, Crane found a sanctuary; he made friends with the Negro cooks and dishwashers who worked there and joined in their singing and jokes. C.A. had, however, discharged a black handyman to make room for his son, which Grace Crane took as an affront: C.A. was showing he considered Hart no better than a black porter. "Black Tambourine" is about the fired Negro, and it marks Crane's assertion that he is not better than the man he has inadvertently wronged, that the dis-charged Negro has been mistreated, not he. "Black Tambourine" remembers what Grace Crane has forgotten; it is meant to rectify the wrong C.A. committed. The "black man in a cellar" is an emblem of the white world's sin, and of its denial of that sin; he represents, in Crane's phrase, a "tardy judgement" on the world that excludes him.

The amnesty that C.A. offered Hart was real but qualified, a peace treaty that ignored the war that preceded and necessitated it. If C.A. accepted that Hart must go his own way, that he was not a businessman but a poet, Hart knew that his father would never accept the conditions of his being: his homosexuality, the Dionysian sensibility that prompted his art, the alco-holism that first liberated, then destroyed him. On his visits to his father in the early 1930s, he did not cruise or drink or write, and at one bad moment he wrote a friend: "If abstinence is clarifying to the vision as they claim, give me back the madness of my will!" So-called sanity, moderation in any form, was not for Crane the prerequisite for creativity. In this context, C.A., a Booster businessman who gave no thought or credence to America's sins, who was oblivious of his son's tragedy and his art, was only in small part his father at all. The "black man in a cellar" was not just Crane's disguised double but in some sense his source, the one who represents the mystery of Origin and the meaning of the Law, the father he never had.

After leaving home in July 1920, Hemingway moved to nearby Chicago to work as a journalist; there, in January 1921, just one month before Crane wrote "Black Tambourine," he wrote a poem entitled "To Will Davies,"

published in *The Double Dealer* in June 1922 and based on the double execution on October 15, 1920, of two murderers, one black, one white. As the *Chicago Tribune* told the story, the hanging offered an unsettling parable of racial character. "The craven white man," an Italian named Campione, collapsed on the scaffold, sobbing, "Let me go," but the black man, a Negro named Reese, stood "tall" and "jubilant." "I am going to rest," he said.

In his version of the event, Hemingway heightened the contrast still further. His white man is abjectly slobbering and falling all over the priest who accompanies him; the poet-narrator is "glad when they pulled the black bag over his face." But his Negro stands "Straight and dignified like the doorman at the Blackstone." When asked if he wishes to make a final statement, he replies: "No Sah—Ah ain't got nuthin' to say." The narrator tells us that his execution "gave me a bad moment, / I felt sick at my stomach. / I was afraid they were hanging Bert Williams." Hemingway had probably seen the black *Follies* star in New York or on tour in Chicago; as an aristocratic master of minimalist form, Williams was a possible progenitor to his own developing aesthetic of understatement. Even without this information, however, one can see the Negro here as an early example of the Hemingway hero; he passes up the chance to apologize or justify himself, just as Krebs wanted to say nothing, as the laconic killers and stoic bullfighters Hemingway depicted and admired say nothing, as Hemingway the stylist sought to say less rather than more, to leave the obvious, the self-consciously important thing, unsaid.

Hemingway met Sherwood Anderson, his first mentor, in his Chicago days; Anderson, whose celebration of Negro life, *Dark Laughter*, was published in 1925, was then formulating his sense that in America, the Negro, who "above all men knows song physical, alone is not lost." These words are from a letter of 1921 that Anderson wrote to Crane, also at this time his disciple. Anderson was criticizing "Black Tambourine" for its depiction of the Negro as beaten and trapped, and Hemingway's poem reads as if written to illustrate Anderson's point. His Negro, too, is condemned, but unlike Crane's, he is hardly lost; he is palpably a king in exile, one whose authoritative air of self-possession puts to shame the rootless pseudo-civilization that has momentarily superseded his own.

Reese, the real-life progenitor of Hemingway's Negro, was executed for the murder of his wife; in the *Tribune*'s phrase, he was a "wife-slayer." Although Hemingway doesn't specify his Negro's crime, matricidal elements enter his poem as surely as they do Crane's. Pressing behind it is another retelling of the old myths about male and female gods who struggle for power in Freud's matricidal subtext, but here the masculine deity has openly destroyed his female opponent and done it guilt-free. It is important to re-

member that Hemingway wrote this poem less than six months after Grace threw him out of the house. The cowardly white man put to shame by the black one may figure his real-life putative role model, his depressed and submissive father, Ed Hemingway, who had failed to defend Ernest against his mother's wrath. Hemingway might well have associated his father with Aframerica, for the doctor had often taken his little son to Chicago's Field Museum of Natural History, where Ernest's favorite room was the Hall of African Mammals. The Negro in "To Will Davies" is an exemplar, however, not of Ed Hemingway's strengths, but of all that he lacked; Hemingway, too, is shifting his lineage from the white race to the black.

Inventing genealogies was a modernist specialty. Aiming to obscure the overaccessible feminized culture of the recent past, T. S. Eliot ignored the Victorians and the Romantics, and declared his new school of poetry the direct descendant of the difficult and all-male metaphysical poets and Jacobean dramatists of the late-sixteenth and seventeenth centuries. Gertrude Stein sidestepped literature altogether and positioned herself as a modern painter, a Picasso of the prose medium; Marianne Moore learned much of her craft from scientists and admen. But no act of cultural repositioning was more crucial and emblematic than Crane's and Hemingway's relocation in 1921 from the white race to the black, their turn to the figure of the Negro as a peer, exemplar, even father figure. Although neither man took the Negro as a central character in his later work, Crane ended his days as an excited and self-destructive explorer of the primitive mysteries of Aztec culture in Mexico and Hemingway returned repeatedly to the "Green Hills of Africa" (a title of 1935) to prove his status as brave hunter and dominant "Papa."

"Black Tambourine" was an influence on Jean Toomer's *Cane*; Crane and Toomer were close friends at the time, and *Cane*, too, centers on a "black man in a cellar." Like Crane, Toomer had strongly and sometimes painfully bi-gendered and bi-racial impulses and needs. He displayed a life-long dependency on women and a fascination, much like Crane's, with the Eddyesque language of the pre-Oedipal sublime. His first wife, a white writer named Margery Latimer, was a Christian Scientist who died in childbirth in 1932, when she refused to call in a doctor despite a heart condition. His second, Marjorie Content, a white photographer who had taken the American Indian as her subject, followed him into his later experiments with telepathy and psychic phenomena. Toomer demanded a fanatic loyalty from his wives and lovers; he increasingly saw himself as the central figure in a cult, and he wanted to be to his women the figure he himself needed to find, for he, too, sought revitalization through contact with an authoritative male.

Toomer had not known his own father, Nathan, a mulatto who often

passed for white and abandoned his family before Jean's conscious memories began. Though he briefly called himself "Nathan" instead of "Jean," he thought he had found his real father in the early mid-1920s in the Russian guru and entrepreneur Georges Ivanovich Gurdjieff. "Every one of my main ideas," he later remarked, "has a Gurdjieff idea as a parent," and in the years after *Cane*'s publication in 1923, he devoted himself to explicating Gurdjieff's tracts about ascension to the spiritual life written in an abstract idiom that seems to owe something to Eddy's prose. (Crane was also at first a Gurdjieff enthusiast, but the Russian's blatant opportunism led him to drop out of Gurdjieff circles, and hence from Toomer's life.) One could argue that, in choosing a white father instead of a black one, Toomer was simply another modernist rewriting genealogies. His later claim that his maternal grandfather had been a white-passing-for-a-black, his extended attempt to pass for white himself, his insistence that he was not a "Negro" but an "American," whose possible bi-raciality made him the first of a new breed or the last of an old, bespoke not simply his denial of his Negro ancestry but also a black version of the rescripting of racial origins we have just seen in Crane and Hemingway.

Genealogical and racial recasting is, however, far more costly to a black man than to a white one. This is so, I think, not because black men are innately more "black" than white men are "white," but because to deny the most painful and conflicted material in one's assigned identity, whatever it may be, is to block, even forbid, psychological coherence; in America, if one is black, that painful material is by definition associated with one's race. *Cane*, written the year before Toomer encountered Gurdjieff, is evidence of how deeply he understood this psychic law. Toomer was also in close contact at this time with Sherwood Anderson—Anderson pioneered in the ambiguities of racial and gender identity that impelled Toomer, Crane, Hemingway, and many other modern writers—though he saw himself as Anderson's teacher rather than his pupil, and in a letter of December 29, 1922, he explained that *Cane* illustrated the "Negro's curious position in Western civilization"; the novel was meant to "aid the Negro in finding himself."

"Kabnis," the last and most important section of *Cane*, centers on the son's search for the father, and the father here is Toomer's version of Crane's "black man in a cellar," an ancient ex-slave called Father John who literally lives in a cellar, where he is tended by one of his descendants. Like Crane's Negro, Father John represents a judgment on America's racial transgressions. Sunk in the silence of lost wisdom, he breaks his mute vigil in the book's last pages to speak of the "sin" of slavery, which has, in *Cane*'s telling, not only afflicted but enriched all its victims could they but face its reality and

accept the splendid shame of their birth from its terrors; in this view, black denial of the slavery past has been complicit with ongoing white violence. But Kabnis, the son figure and the main male protagonist in *Cane*, is a Northern visitor to the South, a would-be poet, an intelligent, well-educated, and corrosively doubtful young man always harping on his largely white ancestry; he cannot accept Father John, for it is his fate, a painful prefiguration of Toomer's own, to believe in his white parents and not his black ones. Daughters, however, can apparently do what sons cannot. Carrie, the young black woman who looks after Father John, knows that he has "a way of seein' things." In an act of cross-gender empathy, Toomer expresses himself through Carrie as well as through Kabnis, and *Cane* ends with Carrie on her knees before the old slave, circled by the light of the rising sun.

Whatever Toomer's conflicts and divisions, in *Cane*, as in *Machinal*, "To Will Davies," and "Black Tambourine," the Negro, assigned the role of infantalized and brutalized child in the family romance of Victorian America, has become the father, even a Founding Father, of modern American culture. Neither Toomer nor Crane nor Hemingway, it seemed, could begin his career without finding access to his full history, white and black, a history whose point of origin was the American sin of slavery; like Lawrence, they knew they must strip off the "idealistic clothes" of conventional American utterance and see themselves in "the dusky body" beneath.

Cane shared its publication year, 1923, fittingly, with Lawrence's *Studies in Classic American Literature* and, more ironically, with Catt's *Woman Suffrage and Politics*. The conjunction of *Cane*, with its focus on the national sin of slavery, its attempt to recentralize that sin in the modern consciousness, and *Woman Suffrage*, with its amnesiac erasure of slavery, marks the passing of the old order and the start of the new. The cell of the condemned Negro in *Machinal*, Father John's cellar in *Cane*, Crane's "mid-kingdom" in "Black Tambourine," the scaffold on which Hemingway's Negro magnificently meets his end, is the place where slavery, the tragic nexus of black and white, had been consigned with all other signs of cultural miscegenation to a death sentence of oblivion and denial, and it was the birthing place of the American urban moderns, black and white, male and female.

"TAKING UP RESIDENCE IN THE BLACK BELT"

Nancy Cunard, a glamorous, alcoholic British heiress, poet, rebel, and profligate, was one of the most formidable and eager members of the white welcoming committee that greeted the Negro in the Jazz Age. Like Louise Brooks, Cunard knew how to "be cool and look hot"; she favored heavy eye

makeup, slash-red lipstick, and dramatic frocks by Paul Poiret, though she was also fond of turning up at posh parties in male garb crowned by her father's elegant black top hat. Photographed by Man Ray and Cecil Beaton, drawn by Wyndham Lewis, painted by Alvaro Guevara and Eugene MacCown, sculpted by Brancusi, fictionalized by Aldous Huxley and Michael Arlen (she was the model for Iris March in *The Green Hat*), Cunard was an international icon, and in the late 1920s she dedicated herself to the Negro cause; she made two extended and highly publicized visits to Harlem, contributed to its magazines, studied its art, and pursued its men.

Cunard was British by birth but not by descent; she could best be described as someone paradoxically born an expatriate American. Her mother, Lady Emerald Cunard, née Maud Burke, was American; her father, Sir Bache Cunard, though born in England, was from American stock. His grandfather was a Philadelphia engineer, Samuel Cunard, who founded the shipping line that made the family's fortune and settled, in his old age, in England, where Queen Victoria made him a baronet. Sir Bache's mother, Mary McEvers, was a New Yorker. Jung claimed that the subconscious of Americans, even of those but recently patriated there or long expatriated from there, were filled with the dark images of the Indian and the Negro, that this is what makes the American psyche instantly recognizable. "The Negroes," Jung had insisted, "are really in control!" Cunard came by her appetite for Negritude naturally.

Only one passion in Cunard's life preceded and exceeded her commitment to Aframerica. Asked as a young woman what she most wanted, she instantly replied, "Lady Cunard dead"; she was an Electra figure as surely as Hemingway and Crane played versions of Orestes' part. Her motive was not the same as theirs, for she received scant attention from her mother. The product of too little nursing rather than too much, of too soon and too complete a weaning, Cunard wore her starvation like a badge of honor. Skeletally thin and anorexic to an extreme, she told her friend John Banting that "she had always hated food," and another of her admirers remarked that "thinness . . . reaches a sort of thing-in-itself for her. She is the only woman who can be *really* impassioned about ideas almost continuously." A tortured paragon of what Freud called "instinctual renunciation," as intent on subduing feminine matter to masculine theory as any Oedipal hero, her very "profligacy," as William Carlos Williams saw it, an assertion of "a terrible chastity of mind," Cunard lived, it seemed, on ideas and obsessions. Her alcoholism, like that of Hemingway and Crane and many others among her modern peers, was in part an inevitable backlash against a willful, matricidal determination on a course of extreme oral deprivation on every level.

Nancy's father, Sir Bache, was kindly but remote, lost in his preoccupation

with hammering silver and other handicrafts, a man who loved "making things with his capable hands," as Nancy put it. He died in 1925, when she was twenty-nine, but she had never seen much of him. Lady Cunard had long kept a separate establishment, and there were rumors, persistent ones, that Sir Bache wasn't Nancy's father at all; many thought that the writer George Moore, long in love with Lady Cunard, was her actual sire, and Lady Cunard did little to set the record straight. Nancy had not always hated her mother. In her reminiscences of her childhood included in G.M., *Memories of George Moore* (1956), she spoke of her mother's gift for music, her "outbursts of airy fantastic wit," and seemed to have seen both her parents through the same clear lens, "admiring and critical of them by my own standards." The serious trouble between mother and daughter apparently began sometime around 1910, when Lady Cunard fell deeply, decisively, in love with the British conductor Sir Thomas Beecham.

Nancy was then fourteen, just approaching womanhood. Insofar as she was a young woman, she was upstaged by a more experienced rival for masculine attention; insofar as she was still a child, she was betrayed by her mother's affair, ousted from what little place she had held in Lady Cunard's affections, and conclusively denied any visible evidence of her paternal origins. As Freud said, the mother alone is *certissima*, or, as the black feminist scholar Hortense Spillers has rephrased the matter, "Mama's Baby, Papa's Maybe." With little interest in her own maternal role, Lady Cunard nonetheless made Nancy forever a fatherless child; she was somehow nothing and no one but her mother's daughter. Lady Cunard had satisfied her ambitious nature in marrying Sir Bache and she never considered divorcing him; instead, she clothed her liaison with Sir Thomas, which lasted thirty years, in sophisticated but implacable discretion. Everyone knew the two were lovers; no one spoke of it. No one but Nancy. For her, suffocated and obscured as she was in maternal lies, identity could be achieved only by exposing her mother's evasions and deceit with inflamed outspokenness; only the blow that eviscerated Lady Cunard could give her daughter birth.

By all accounts, Lady Cunard was an alluring beauty and a skillful, snobbish, and sought-after London hostess. Those closest to her found her a charming, witty, and loyal friend and a disciplined woman of considerable integrity, but Nancy painted her as a wicked stepmother out of a nightmare fairy tale, an intrusive and sensual society queen, "petite and desirable as per all attributes of the nattier court-lady." "Intelligent, falsely understanding and very wicked," Lady Cunard, according to Nancy, destroyed all she touched. It was her "stultifying hypocrisy," her smug implacable air of patronage that enraged her daughter. "She likes to give," in Nancy's words, "and to control. It is unbearable for her not to be able to give someone

something. But suppose they don't want it?" The title of Nancy's first volume of poetry, published in 1921, was *Outlaws*; she longed to cast in her lot, cast it in, flagrantly and decisively, with people who didn't want what Lady Cunard had to give, people who refused to "be reformed in [the] dreary image" of white Anglo-Saxon respectability.

Nancy later claimed that as a child she'd had a recurring dream of herself dancing surrounded by Negroes, "one of them though still white," and in the late 1920s, she set about making her dream come true. In 1928, she began an important affair with the Harlem pianist and singer Henry Crowder. With his help, she started work on *Negro*, published in 1934, an ambitious, striking, and uneven anthology of essays on all aspects of the African-American and African experience. Claude McKay, very definitely not one of her admirers, called Crowder "the Negro stick [used] to beat the Cunard mother," and he was soon but one of a host of Negro lovers in Nancy's stable, many of them, in his words, "uneducated" and "low-class," most of them very dark-skinned. Crowder was dark-skinned himself, but he was not black enough for Nancy's taste; she often told him, he reports in his memoir, *As Wonderful as All That?* (1987), that she "wished I was darker." In Harlem, Nancy wagered, she had found a way to bring disgrace, disgrace that couldn't be camouflaged or ignored, to Lady Cunard's imperturbable life of licensed indecency; surely her mother's maddening air of sophisticated tolerance did not extend to questions of race.

Lest her mother miss her message, Nancy spelled it out in the press. In 1931, she published an article in *The Crisis* that took its title from a query she claimed her mother had made: "Does Anybody *Know* Any Negroes?" "Who receives them?" Cunard continued, still quoting her mother: "You mean to say they go into people's houses?" A few months later, she circulated her privately printed, no-holds-barred denunciation of Lady Cunard, provocatively titled *Black Man and White Ladyship*. There she said that her mother would like to "kill or deport" all Negroes, but Nancy reminds her that even she doesn't have this power. So, Nancy gloats, "the hefty shadow of the Negro falls particularly and agonisingly over *you*." Lady Cunard is sterile, dead, "alone" in a claustrophobically "unreal" world where there is endless socializing and "no contact." In her essay "Harlem Remembered" (collected in *Negro*), Nancy wrote that "whites are unreal; they are *dim* but the Negro is very real; he is *there*," and he embodied for her everything her mother lacked, the "gorgeous manifestations of the *emotion* of a race."

Whatever her infidelities, Nancy stayed with Henry Crowder longer than she did with any other lover. She liked to call him her "tree"; it was her way of saying that he'd been an anchor, a mainstay in her turbulent life. The nickname makes full sense, however, only when one supplies the missing

word "family," as in "family tree." When she summed up Crowder's influ-
ence on her life by saying that "Henry made me," she meant, of course,
that he was the making of her and perhaps, more colloquially, that he had
"made" or had her sexually, but she was again using genealogical, even
biblical language; Henry "made" her as God "made" Adam in His own
image. Nancy always justified her compulsive promiscuity by alluding to her
mother's long-standing affair with Beecham; it's a version of the sins of the
parents being, if not visited on their children, courted by them. With such
a mother, Nancy liked to insist, "I can do as I like." But she seemed anything
but free. Crowder reflected less Nancy's sexual passion (which various lovers
testified to as problematic) than her need to resituate herself, as Crane and
Hemingway had done, in a darker ancestry, in a patrilinear genealogy that
irrevocably excluded her mother.

Lady Cunard's only known comment on *Black Man and White Ladyship*
was the dignified "One can always forgive someone who is ill," but forgiving
"someone who is ill" was one thing, publicly countenancing her daughter's
behavior quite another, and she cut back Nancy's allowance, then disin-
herited her. As one New York newspaper, reporting on Nancy's second stay
in Harlem in the spring of 1932, headlined the story: "Disinherited by Her
Mother for Her Unconventional Conduct the Heiress of the Famous British
Steamship Fortune Takes Up Residence in the Harlem Black Belt." Nancy
was never again received in Lady Cunard's world, the world in which she
had been raised.

Cunard ended her relationship with Crowder abruptly in the spring of
1935; she was intimacy-phobic with men—her most enduring friendships
were with gay women—and sooner or later she walked out of all her affairs,
but she never abandoned her commitment to his race. She moved on with
unbroken intensity to more lovers, more protests, fewer triumphs, and
mounting losses, and she died broke, alcoholic, alone, half-crazed, and
incredibly brave, in 1965. It cannot be too much emphasized that Cunard's
concern with white-black relations was genuine, permanent, and informed.
Unlike many of the Negro's white admirers, she never romanticized the
harsh realities of black experience. The Harlem she found in the early 1930s
was not, despite its still-flourishing nightclubs, the Harlem of the 1920s, and
in her essay on it published in *Negro*, she presented, among other things, a
valuable commentary on the effects of the Depression on black Manhattan.
However much she drank, however much she played the whore, however
driven she was to emotional violence, Cunard was always, a friend remarked,
"compellingly respect-worthy." Everything she did was at some level not
personal but political; every blow she struck at her mother exposed real
pathologies, real sins in her world.

When Cunard picked the title "Black Man and White Ladyship" for her matricidal pamphlet, she was well aware of the Ku Klux Klan scenario of brute black rapist and delicate white flower it summoned up in many quarters, and she meant to ironize and reverse its implications. *Black Man and White Ladyship* included an impassioned defense of the Scottsboro Boys, the nine ill-educated and dirt-poor young black men sentenced to death in Alabama for the alleged rape of two white women on a train in March 1931. By the time Cunard wrote and circulated her pamphlet around Christmas 1931, investigations conducted by the defenders of the Scottsboro Boys, led by the Communist International Labor Defense (ILD), the American Civil Liberties Union, and the Commission on Interracial Cooperation, had revealed that the women who accused them, Victoria Price and Ruby Bates, both unemployed mill hands, were anything but the virtuous damsels in distress the white Southern press had painted; they were, in fact, prostitutes who included black men as well as white men in their regular clientele—one colored man claimed he had heard Price ask another Negro about "the size of his privates"—and both of them had had sex on the eve of the alleged rape, not with the Scottsboro Boys, but with some white men riding the rails with them.

Price had a prison record. Always the more virulent and persistent of the two, she screamed for blood, telling reporters that she wanted to see her alleged attackers "burned to death," "fried" in the electric chair, but the ILD believed she had made up her story to divert attention from charges that might otherwise have been pressed against her for various misdemeanors in her recent past. Bates recanted in 1933, because, in her words, she knew "it was wrong . . . to let those Negroes die on account of me," then joined the Scottsboro Boys' defense. Price did not retract her charges, though there is ample evidence she would have been glad to do so for the right price. The case dragged its way through the courts for the next six years; none of the Scottsboro Boys was executed, but the last of them did not leave prison until 1950.

Cunard's longest contribution to *Negro* was her scorching and closely researched account of "Scottsboro—and Other Scottsboros." As she saw it, Scottsboro signified not only the breakdown of the so-called liberal capitalist establishment, "colored" as well as white, but "the lie of the 'rape' of white women by black men." Scottsboro was another instance of the White Ladyship's homicidal treachery vis-à-vis the Black Man; to drive her point home, Cunard specifically described her mother in *Black Man and White Ladyship* as an upper-class, Anglo-American ally of the "lynchers" in the "cracker southern states of [the] U.S.A." A subscriber to Freud's declaration of war between feminized "hypocrisy" and the "primaeval men within us," Cunard's

aim was to expose the ugly racism of the Victorian matriarch, her White Ladyship in all her guises, from sophisticated court lady and high-minded reformer to white-trash prostitute and Southern lyncher. She never betrayed the slightest sign of remorse over her treatment of her mother; she was guilt-free somewhat in the way an assassin of a Fascist dictator might be. Nancy Cunard was serving, to her mind, the cause of justice and freedom.

But the story is more complex than she would have it. Her lover Henry Crowder proved less Negro, less indifferent to the values of the Lady Cunards of this world, than Nancy would have liked. She believed heart and soul in his musical gifts, his presumed legacy from his creative race, but all the evidence suggests that he was a skillful musician of far less than genius, whose ambition was fitful if not weak, and he held views on society and race far more conservative than those held by most of Nancy's white lovers, not to speak of Nancy herself. In Crowder's memoir, As Wonderful as All That?, written in 1935, he hardly figures as the avatar of the "primitive mind" of Freud's and Nancy's fancy. In his pages, it is Nancy who plays the savage, Crowder the civilized role; she's the aggressor, he's the victim.

The two met in the summer of 1928 in Venice, where Crowder was playing piano in a jazz quartet of black musicians called the Alabamians. As their affair began, he was, in his words, "infatuated beyond all reason," but reasons were not lacking. Impressed that here was "no ordinary person," Crowder was drawn forcibly to Nancy's intelligence and independence of mind. He believed that he had much to learn from her and much to teach her; she might contribute to his "progress" and that of his race. By his telling, Crowder saw Nancy as an opportunity, not for sexual transgression, but for racial uplift; however, almost from the start, he was uncertain whether she shared his aims.

To his way of thinking, Nancy was slumming, not just in her liaisons with the uneducated ultra-black Negroes she preferred and to whom he felt invincibly superior, but even in her affair with him; she was betraying her white heritage, for which he had considerable respect. Her matricidal impulses were anathema to him—"I never could understand," he said, "how anyone could feel as she did toward her own mother"—and when he writes that Nancy wasn't "raising the lowest of the black race to her level" by consorting with them but, rather, "lowering herself to their level," he sounds much like Lady Cunard herself. Little wonder that Crowder gave Nancy a sense of security; by the ironic pattern of race and gender reversals that characterized this love affair, he offered her, not just the possibility of racial repositioning, but the familiar face, if in darker hue, of her mother's convention-bound world.

Crowder's infatuation was short-lived. He reminded Nancy early on that

"colored men" who find white women seeking them out generally expect to get money in the process and he was no exception. It was a "game," and he was, he thought, in a "strategical position"; he says that he never really loved her. Crowder was married to a black woman when he met Nancy and he did not get a divorce, though he did take a "colored girl-friend," someone he cared for, he assures us, far more than he did for Nancy. Despite his protestations, however, I do not think that he stayed with Nancy as long as he did solely or even primarily for the money. Crowder called their relationship "one of the strangest . . . that has ever taken place between a black man and a white woman," and Cunard's part was pre-scripted in his life as surely as his in hers; long before Nancy, he was dry wood waiting for the flame.

Crowder, born in Georgia, describes himself as a childhood "goody-goody," the fond son of a loving and devout Baptist mother, anxious to please, to be thought "perfect," but unable to internalize any principles save a dogged passive resistance. He's the well-intentioned but weak person unable to keep his "resolutions," to follow "the path my mother pointed to me." Like many black musicians of the day, he got his start playing piano in various Washington and Chicago brothels, and he soon found himself in the wrong places, the wrong love affair, the wrong marriage; but the tale he tells is oddly depleted and colorless. His only progression is from duped innocent to cautious and cynical pragmatist; his favorite expression is "opinion reserved." He is never, however, cautious enough. Failing to meet his own standards had apparently become a habit with him. With Nancy, he writes, "I was doing practically everything I had vowed I would never do."

She flew into drunken rages, humiliated him in public, and flaunted her lovers in his face, but he couldn't seem to tear himself away. Sometimes he bore bruises on his face. "Just bracelet works," he told one solicitous inquirer, and the ironies were as brutal as they looked. Drunk, Nancy hit him with hands and arms studded with her trademark heavy African slave bracelets. Drinking more and more himself, unwilling, numb, but strangely faithful, he knew he was drifting toward bottom. If Crowder represented to Cunard downward social mobility in the interest of a Promethean strike for a more daring and honest life, by his account she spelled nothing to him but degradation. It's not that he was better than she; he was simply, by temperament and situation, more defeated. Degradation was his destination.

Crowder outlined Nancy's capricious ways with him, economic as well as sexual, in some detail. He would leave her, sometimes for weeks, even months at a time, and find some paying job working at his métier, only to have Nancy bribe him back to her side, then put him on a meager allowance, which she interrupted at will. When he asked her to buy him an expensive

new car, she did so, but he quickly discovered that she expected him to use it to chauffeur her around. Others might be impressed by her anthology, *Negro*, but Crowder was not; the idea was splendid (it was, after all, partly his own), but Nancy didn't know enough to pull it off. In Crowder's opinion, *Negro* was "shallow and empty. It makes a big noise but like a big drum it has little inside."

Crowder also resented Nancy's insistence that he accompany her to places where black-white interaction was forbidden, and he hated the hostility he encountered as a result. Other blacks made similar protests. During her April 1932 visit to Harlem, Cunard solicited a contribution to *Negro* from a young black journalist named Eugene Gordon. The two met to talk, and Nancy, still deeply committed to the Scottsboro Boys, told him of her plan to visit the South, to see "Negro workers [in their] natural habitat." Gordon later said that he was barely able to stop himself from bursting into "an impassioned protest: let her begin considering the Negro's interest if she didn't consider her own!" A visit like the one Nancy proposed, Gordon knew, could only inflame the racial tensions already taking a heavy toll on Negro lives. Reporters covering Cunard's stay in Harlem in 1932 testified that her black neighbors filed petitions with her landlord, urging, commanding her, in vain, to leave.

One can see such reactions simply as predictable discomfort before the unconventional face of change, and there is some truth in such a view. No other white notable of the day lived so intimately with the Negro or so openly breached the sexual taboo; the antagonism she met was inevitable. Moreover, a number of the blacks with whom she associated admired her enormously. After watching her in action, Eugene Gordon became an ally, and the ever-generous Langston Hughes, who contributed to *Negro* and joined Cunard in protesting the Fascist regime in Spain, thought her a "wonderful woman"; she possessed "a grace in giving that was itself gratitude." But whatever the reactions she elicited, it is disturbing to realize that Cunard seldom paused to consider the wishes and needs of those she intended to benefit.

Cunard later told Hugh Ford (who edited a volume of her writings after her death) about a black man who'd asked to repay her for all the help she'd given him. She had instantly replied, as if out of some unsuspected reserve of instinctual conviction, "I am your mother. There is no payment due." She never had children; her biographer, Anne Chisholm, has established that she had a hysterectomy in 1920, for unknown reasons. Perhaps venereal disease or a botched abortion had made it necessary, or perhaps it simply expressed her stern resolve never to be a mother. In any case, all Nancy knew of motherhood was what she had learned from her own mother. If she was, as she claimed, somehow the mother of the Negroes she sponsored, it

was an ominous role in terms of both her personal history and the public posture of her late-Victorian feminine predecessors. Back in 1922, *The Sketch*, a London society sheet, had remarked archly and (from Nancy's point of view) unkindly, "Lady Cunard's daughter . . . is almost more like Lady Cunard than Lady Cunard herself!" It was a prophecy.

Nancy's compulsive need to buy people—Crowder repeatedly remarked on it—suggests that she, too, found it "unbearable" not "to give someone something" even when "they don't want it." She forced her gifts on people, just as she said her mother did, while withholding what they really wanted: love, respect, autonomy. She, too, liked to endow and disinherit people, especially black men. Despite her good intentions and very real achievements, Cunard played out a variant of the White Ladyship–Black Man pairing, and as she rejected her own White Ladyship, so Crowder, poor excuse for a Black Man as he might be by her standards, rejected his. If degradation had been his goal, by 1935, when he wrote his memoir, his need to punish himself, to do time in the salt mines of humiliation, had apparently been satisfied. He wanted, not so much success—it's too late, he's sure, for that—but something like control or copyright on his own defeat. Crowder's is a tale of abuse and addiction, but it is also one of recovery, no matter how muted. His autobiography was not published until 1987, more than thirty years after his death; perhaps fearing reprisals from Nancy's family, he never submitted it for publication, but he clearly had a particular audience in mind, that of his black male contemporaries, all those who might be tempted, as he had been, by the wiles of a White Ladyship.

Cunard was hardly the first person to try to subvert the usual connotations of the inflammatory Black Man–White Ladyship pairing. Forty years earlier, Ida Wells-Barnett, attacking lynching in her pamphlet *U.S. Atrocities* (1892), had dared to suggest that if the black men lynched for assaulting white women had had any sexual contact with the women who accused them, it had been at the women's solicitation. Black men were being killed, she protested, only because they were "weak enough" to accept the favors of white women; they were "Afro-American Sampsons who suffer[ed] themselves to be betrayed by white Delilahs." The cruelest irony in the tangled complexities of the Crowder-Cunard affair was that Crowder ended by seeing it as another version of the scenario that Wells-Barnett had exposed as the truth behind the lyncher's black rapist–white victim scenario. He was a "Scottsboro Boy," too, another "Afro-American Sampson . . . betrayed by [a] white Delilah." *As Wonderful as All That?* is an updated version of Nancy's *Black Man and White Ladyship*, a cautionary tale for "colored men" who are tempted to sacrifice their chance at a self-supporting career because they have become "enamored of white women."

After Nancy broke off the affair in 1935, there were a few chance meetings, occasions that Henry deliberately did not pursue, he tells us, and some letters exchanged years later, but their paths never really crossed again. Crowder went back to Harlem, where he worked without much success as a musician, then became a postal clerk for the Coast Guard in Washington, D.C., where he died in early 1955. In 1935, finishing As Wonderful as All That?, he was "content," he said, because his hopeless attempt to "follow the flash of a . . . [white] woman's fancy" was at last over. He felt "not happy, not sad," "going through the motions of life without any special interest," but glad to put the nightclubs behind him—"never cared much for them anyway." He had "returned," in his words, "to my own [people]."

WHITE GODPARENTS, BLACK AUTHORS

Cunard was not the only white woman patron on the Harlem scene in the 1920s and early 1930s. Mrs. Charlotte Mason, a wealthy and manipulative widow domiciled in a Fifth Avenue penthouse, appointed herself "godmother" to select black artists, most notably Zora Neale Hurston, Alain Locke, and Langston Hughes. Although then in her seventies and plagued by ill health, Mrs. Mason immersed herself in Harlem's cultural activities, collecting Duke Ellington recordings and occasionally attending Negro revues with Hughes as escort. Mrs. Mason displayed little of Cunard's political intelligence and none of her passion for justice, but she had the same intense personal charisma and the same intense focus on race.

When the Harlem Renaissance began, Mrs. Mason was already a long-standing champion of the primitive and an expert in American Indian culture. Her husband, Rufus Osgood Mason, had been a surgeon and an authority on psychic research and healing; he published monographs with titles like "Telepathy and the Subliminal Self" and "Hypnotism and Suggestions in Therapeutics," in which he explained the mind's "influence" over the "organs and functions of the body." He thought of his method as a scientifically more rigorous form of "Eddyism," and his wife was an Eddy look-and-sound-alike who claimed preternatural powers; she adopted his notions of psychic healing and saw the "child races" of Africa as central to their promulgation. Only black culture and its collective life of "pagan" rituals and "spiritual" consciousness could save or succeed the sterilities of white civilization now "in the throes of death." Echoing D. H. Lawrence, Mrs. Mason wrote Alain Locke that she wanted her Negro protégés to "slough off white culture" and be their "savage" selves. To her way of thinking, as to Cunard's, it was crucial that blacks be very black. Primitivism as she

practiced it was a form of racial essentialism, one that served her as an exotic extension of Mind-cure tactics; blacks were to provide therapeutic healing for whites.

But if primitivism in this instance was exploitation, the exploitation was not altogether one-sided. Hurston played shamelessly to Mrs. Mason's fantasies of herself as medium and patron of black vitality, calling her "the true conceptual mother," writing to her of "your radiating spiritual self" and sometimes signing her letters as "Your Pickanniny, Zora." She did so not simply because she was an opportunist of legendary and sometimes disturbing guile, but because she shared Mrs. Mason's belief in the regenerative richness of Negro life and culture. No member, in her words, of that "sobbing school of Negrohood who hold that nature somehow has given them a lowdown dirty deal," Hurston believed that she herself possessed something like mediumistic powers, and she had her own brand of essentialism. "I love myself when I am laughing, and then again when I am looking mean and impressive," she wrote a friend in 1934; she spent a lifetime elaborating her pride in being, as she put it, "Colored Me." In the 1950s, Hurston fought desegregation in the public schools of the South because she saw integration as a threat to the survival of an autonomous black culture, plain evidence of an insulting assumption that blacks could learn only if taught by white teachers and led by white students. Negroes imitating whites were, to Hurston's mind, perpetrating an "intellectual lynching" on themselves.

Mrs. Mason was Hurston's sponsor and friend till the older woman's death in 1946, and in her memoir, *Dust Tracks on a Road* (1942), Hurston claimed to find in her a fellow primitive and pagan. Mrs. Mason delighted to have Hurston tell her everything she had observed on her anthropological forays into "the raucous sayings and doings of the Negro furthest down"; she had infinite "sympathy" with these people, Hurston writes, "because she says truthfully they are utterly sincere in living." There is no irony here; Hurston is always doubling, always armed, but irony was not one of her weapons. Mrs. Mason was not, in any case, a mother figure to her; Hurston was too aware of what was going on between them, and she was, I think, uninterested in such a prospect in any quarter.

If Hurston made anyone a parental figure during her New York years, it was her anthropology teacher at Barnard College, Franz Boas, and even there she was half in jest and all in play. Boas's students, all but Hurston white, called him "Papa Franz"; they did not do so, however, to his face. When Zora, with characteristic bravado, casually asked Boas's secretary one day for "Papa Franz," the secretary retorted that she'd "better not let him hear me say that," but this rebuke served only to spur Zora on. She approached Boas at a party and asked him outright if he were not her "papa."

A complex, occasionally witty man, Boas told the company: " 'Of course Zora is my daughter. Certainly!' " he said with a smile. " 'Just one of my missteps, that's all.' " When Zora mixed racial genealogies, it was folklore, not psychology or the family romance. She resisted Freudianizing as strenuously as Gertrude Stein did, and for much the same reasons.

Boas demanded of his students "facts, not guesses," and he'd "pin you down," Zora writes, "till you delivered." Mrs. Mason, in contrast, specialized in guesses as facts, and Zora, content by her own admission to pull B grades under Boas, intended to be her rival, not her apprentice, in the field. Mrs. Mason could read her mind, Zora reports, even when she was thousands of miles away: "There was and is a psychic bond between us." In fact, Godmother could read the minds of all her protégés, but only Zora, we learn in *Dust Tracks on a Road*, "could read *her* thoughts" in return. Herself a serious and accomplished student of voodoo practices, Hurston met magic, not with disbelief, but with stronger magic. Although Mrs. Mason stipulated that none of her protégés identify her in public or in print, Hurston brazenly called her by name in *Dust Tracks on a Road*.

Mrs. Mason could be, in Zora's words, "as tender as mother love when she felt you had been right spiritually," but if she detected the slightest negative or unworthy thought in one of her protégées, she was merciless. "That is nothing!" she would say: "It has no soul in it. You have broken the law!" Mrs. Mason funded the research and writing of *Mules and Men*, begun in the late 1920s and published in 1935, Hurston's anthropological treasure trove of black Southern folktales and magic. She praised the book as a "lasting monument," but she made Hurston turn down an offer to dramatize it because she thought such a venture too commercial, certain to involve a prostitution of Hurston's authentic black material. Like a number of Mrs. Mason's protégés, Hurston had agreed to accept her as sole manager of any work she did while funded by her, and this time Mrs. Mason's refusal cost her a chance to win the broader audience her books did not bring her. Mrs. Mason had begun, however, to withdraw her financial support, though not her friendship, from Hurston in the early 1930s; it is worth remarking that Hurston's best-remembered and most highly regarded work, *Their Eyes Were Watching God* (1937), was written when she no longer had to answer to Godmother's demands.

Like Hurston, Langston Hughes shared many of Mrs. Mason's ideas about race, and he responded far more deeply and unguardedly than Hurston did to her charm and exalted seriousness of purpose. Their relationship began in the spring of 1927; though platonic, it was at least as charged with the erotics of displaced power and cross-race seduction as the affair between Cunard and Crowder. Hughes never names Mrs. Mason in his portrait of

her in *The Big Sea* (1940); till the end of his life, unlike Zora, he still obeyed at least this one of her commands.

Mrs. Mason told Hughes that he was "a golden new star in the firmament of primitive peoples," and in turn he found her "an amazing, brilliant and powerful personality," a queen whose "power filled the rooms" of her sumptuous apartment. "No one else," he felt, "had ever been so thoughtful of me, or as interested in the things I wanted to do, or so kind and generous to me." Mrs. Mason gave him a monthly allowance, a full-time secretary, elegantly monogrammed stationery, and an open account with New York's best tailors. When he wrote his novel *Not Without Laughter*, she talked him through the ups and downs of the creative process in letters heavy with Mind-cure therapeutics, urging him to resist overexcitation, to think of his "nervous condition as stored energy . . . [and] take deep breaths, willing yourself mentally to keep the spiritual urge throbbing and [restore] complete relaxation of the nervous system." Hughes had long felt himself an unwanted child, but the white parent had apparently compensated for the failures of the black. "I was fascinated by her, and I loved her," he tells us.

In the midst of all this mutual devotion, however, Hughes half-sought the parting that almost destroyed him. As their strange alliance progressed, Godmother exacted ever more particularized accounts of every penny she gave him. She demanded a letter a day—indeed, she urged him to answer no letters but hers—told him what music to listen to (Negro spirituals were always to be preferred to German lieder), and policed not just his writings but his innermost thoughts. One of his friends felt that she talked to him "the way a woman talks when she is keeping a pimp: 'I bought those clothes you are wearing! I took care of you! I gave you this! I gave you that!' " Mrs. Mason's passion for things African did not include supporting the NAACP or hiring black servants, and with the advent of the Depression, Hughes's populist sympathies made it more and more painful for him to take her money, to be driven around as he sometimes was in her limousine by her white chauffeur—who "*hated* to drive me," Hughes recalled, not without pleasure—and eat at her fastidiously lavish table, while his black brothers and sisters lost their jobs and begged, starving, right next to him on the streets of Harlem.

Hughes began to flirt with the Communists and to write protest poetry, and his protest included not only political tyrants but domestic ones, all those who try to "control [other] people's lives." One poem, "Pride," explains that he will no longer "eat quietly the bread of shame," and ends with the defiant lines: "My fist is clenched / Today— / To strike your face." Not surprisingly, Mrs. Mason pronounced what he let her see of his new poetry "powerful," but "not *you!*" It lacked, she said, the "negro warmth and

tenderness" she felt to be his gift, but he knew with ever greater conviction: "I was not Africa. I was Chicago and Kansas City and Broadway and Harlem," and he begged Mrs. Mason to let him go, "or rather to release yourself," as he wrote her in a supreme moment of willful confusion, "from the burdens of my own lack of wisdom." Although he wanted no more of her money, he fervently wished to keep her friendship and goodwill, but he soon discovered that the money was "the only . . . thread binding us together"; once it snapped, everything collapsed.

"Godmother" was the right title for Mrs. Mason. Like Hemingway's Mrs. Krebs and Lewisohn's "Mrs. God," she figured as a kind of mother deity, and when she shut her doors to Hughes in December 1930, he felt abandoned, excommunicated. Like Krebs, who first defies his mother, then caves in to her, Hughes, after losing Mrs. Mason, was overcome by "nausea," weak and sick, he tells us, for weeks with an illness that baffled the doctors he consulted. Describing his condition, Hughes sounds like someone who believes himself suffering under a hex or curse, and he was not altogether mistaken. Over the next decade, Mrs. Mason pursued him like a fury, bribing his friends (Hurston and Locke included) and plotting clandestinely with them to punish and disgrace him.

The Negro poet Sterling Brown criticized Hurston's *Mules and Men* because it whitewashed the "bitter[ness]" of "the total truth"; in her account of the black South, there were no lynchings, no race riots, no trace of the world that prosecuted and imprisoned the Scottsboro Boys. But Hughes identified himself with the Scottsboro case as soon as it became public news in late March 1931, only a few months after his break with Mrs. Mason. He wrote a dozen or so poems and essays about it and a play titled *Scottsboro Limited* (1932); in early 1932, he visited the defendants in their jail in Montgomery. For Hughes, the matter was one of "8 black boys and one white lie," of "white prostitutes" putting the blame for their own promiscuity on innocent black victims. He saw the women as victims, too, exploited by a corrupt capitalist system, but he understood as well as Wells-Barnett or Crowder did how thoroughly white ladyships, whatever their provocations, could destroy black men. A friend spoke of the look of "agony" on Hughes's face as they set out for a meeting of the Scottsboro Boys' supporters in late 1931—"It seemed that his life depend[ed] on getting to that meeting"—and he paraphrased Hughes's message: *"They are innocent. They must go free."*

Real release from Mrs. Mason's spell began in 1933, during Hughes's first visit to the Soviet Union. (He had been asked to collaborate in a Russian film about the Negro which was never made.) There, spurred by the discovery of Lawrence's matricidal tale "The Lovely Lady," Hughes began the stories published in 1934 as *The Ways of White Folks*. A number of these stories,

particularly "The Blues I'm Singing" and "Rejuvenation Through Joy," reflect his effort to disentangle from Mrs. Mason, but his most resonant verdict is contained, I think, in "Slave on the Block," a story that chronicles the patronage of Luther, a beautiful and streetwise young black man, by the Carroways, a trendy white Greenwich Village couple full of avid pretensions to understanding "primitive" culture.

Anne Carroway soon has Luther posing without his shirt for a painting titled *Slave on the Block*, but Luther gets involved with Mattie, the Carroways' middle-aged black cook, who lays franker sexual claims on him than Anne can admit; the black matriarch is always preferable on Hughes's pages to the white one. As he senses his power, as he realizes that the Carroways will pay him good wages for doing nothing, Luther grows more and more casual, insouciant, lordly. The story comes to a climax when Michael Carroway's ultra-respectable if hardly well-bred mother comes to visit. Mrs. Carroway is a "mannish old lady, big, tall" and "bossy," a Titaness and a Mind-cure exponent. Mattie, contemptuous of Anne, treats Mrs. Carroway mère with considerable respect, but Luther is fearless before her. One morning, when Mrs. Carroway is reading her "scripture," *Health and Life*, an obvious stand-in for Eddy's *Science and Health*, Luther asks her rudely: " 'How long . . . you gonna stay in this house?' " Mrs. Carroway reproves him—"I never liked familiar Negroes," she says—but he answers, quick as a shot, " 'Huh! . . . I never liked poor white folks!' " He has precipitated his own dismissal, and he leaves the house with Mattie, still shirtless, the Black Man triumphantly junking the "idealistic clothes" in which her White Ladyship liked to clothe, and unclothe, his "dusky body."

Hughes had a white male patron, too, the foppish New Yorker Carl Van Vechten, or "Carlo," as he liked Harlemites to call him. One of the most influential and well-connected writers in the city, Van Vechten was a music, dance, and literary critic of real distinction, as well as a gifted photographer and a witty and urbane novelist of contemporary manners. The year 1924 marks the official opening of the literary renaissance in good part because it was in that year that Van Vechten immersed himself in Harlem life, and he did so, as Hughes's biographer, Arnold Rampersad, has observed, more completely than any prominent white man in New York had ever done; in turn, Harlem welcomed Carlo's presence. Van Vechten later remarked that he was drunk for most of the decade; he also noted that every time he lost his silver flask during some excursion to the wildest parts of Harlem, it was invariably returned to him the next day. Attending countless Harlem parties and events, he met hundreds of Negroes (so he boasted), and he held a sustained open house at his elegant apartment at 150 West Fifty-fifth Street for a daringly mixed crowd of black and white notables and hopefuls.

Born in Iowa in 1880, Van Vechten was several decades older than most of his protégés; he was a parental figure of sorts, and he served as agent, PR man, banker, and confidant to a host of talented Harlemites, including almost all Mrs. Mason's protégés and others, like Paul Robeson and Wallace Thurman, invulnerable to her appeal. Robeson's wife, Essie, called him "godfather," and, in a tribute of October 13, 1925, "This Young Spade," the *Herald Tribune* dubbed him "the beneficent godfather of all sophisticated Harlem." Within three weeks of meeting Hughes, Van Vechten persuaded Alfred Knopf, his own publisher, to publish Hughes's first volume of poems, *The Weary Blues*, and made himself responsible for every detail of its production; he also opened the pages of *Vanity Fair* to Hughes's poetry. Little wonder that Hughes christened his new friend "my good angel"!

Van Vechten's motives were hardly above reproach. He shared Mrs. Mason's fervor for the primitive, and he later remarked that his interest in Negroes in the 1920s had been "violent," "almost an addiction." His favorite caricature, a genre of which he was a connoisseur, was one done of himself by the Mexican artist Miguel Covarrubias (a protégé of both Van Vechten and Mrs. Mason) in which he was drawn as a Negro; the caption reads, "A Prediction." Though married, Carlo was gay, flippantly fastidious to the point of triviality, and a voyeur. Playing plump and white-haired host, he sometimes affected the elaborate cerise and gold Mandarin costume of (in a friend's words) "the Dowager Empress of China, gone slightly beserk"; he had affairs with talented Negroes like the man-about-town Harold Jackman and kept a growing collection of photographs of nude black men. One might say that he took literally D. H. Lawrence's injunction to strip off the "idealistic clothes" and see "the dusky body" beneath.

Lawrence disliked Van Vechten's flamboyant novel of Harlem life, *Nigger Heaven*, as much as Du Bois did; he thought it merely the "usual old bones of hot stuff, warmed up with all the fervor the author can command—which isn't much," a cheap and easy romanticization of the primitive with no awareness of the painful aspects of black life. Lawrence's take on Harlem was very different. He found that the streets "echo[ed] with dismalness and a loose-end sort of squalor," and the New Negro was a disappointment, too: "He's an absolute white man, save for the color of his skin." Lawrence was presumably thinking of Harlem's middle-class pretensions, a side of black Manhattan to which Van Vechten had devoted much praise and most of *Nigger Heaven*, though the genteel characters of his dull middle-class plot were understandably neglected or forgotten by critics, like Du Bois, inflamed by the more lively antics of his lowlife minor protagonists. In truth, much of Harlem's "Talented Tenth" and a sizable portion of its less-talented nine-tenths had no ostensible interest in the negritude which Cunard, Mrs. Mason,

Van Vechten, and the *Fire!* crowd led by Hughes and Hurston publicized and promoted.

Black and white commentators pointed out that one reason Harlem's business community failed to prosper was the preference of Negro shoppers for white-managed stores over black-run ones, even when the white shop in question openly discouraged Negro patrons. The wealthiest person in Harlem was Madame Sarah Breedlove Walker, who made a fortune from her patented hair straightener. The formula was divulged to her in a vision while working as a laundress in St. Louis, and she never shared its contents. Moving to New York in 1913, Walker was soon making $50,000 a year from her preparation alone; by the time of her death in 1919, she had her own townhouse, a school of beauty culture (both on 136th Street), and an elaborate Italianate palace on the Hudson River worth $250,000. Dozens of lesser entrepreneurs competed for Walker's color-conscious market. Harlem newspapers carried ads for Wonder Uncurl and Kink-No-More pomades, Magnetic-Metallic Combs guaranteed to straighten the hair, and skin lighteners like Black-No-More, Cocotone Skin Whitener, Complexion Wonder Creme, and Fair-Plex-Ointment.

Nancy Cunard thought the well-bred Harlem of Strivers Row represented "society with a vengeance! A bourgeois ideology with no horizon," and middle-class black New Yorkers were as disturbed by the craze for "nigger dances" as were their white counterparts downtown. The Reverend Adam Clayton Powell, Sr., pastor of Harlem's Abyssinia Baptist Church, protested in 1914 that "the Negro race is dancing itself to death"; thanks to the "turkey trot, the Texas Tommy, and ragtime music . . . grace and modesty are becoming rare virtues." Edward Waller, the resolutely respectable and middle-class father of Fats Waller, was a deacon in Powell's church, and he steered his son toward classical music and away from jazz as firmly, and as unsuccessfully, as the white parents of Bix Beiderbecke, pillars of the Presbyterian Church in Davenport, Iowa, discouraged their offspring in his pursuit of a career as a jazz cornetist. Fats later tried to make his own son play Mozart and Beethoven instead of Waller. Black writers like Sterling Brown and Wallace Thurman sometimes despaired of the black middle class's flagrant lack of interest in new black fiction. Brown said they lacked "mental bravery"; Thurman concluded that the "best [Negro] . . . people do not think at all."

Without underestimating the debilitating effects of racism evident in such distrust among Negroes of their own art and natural appearance or the tenacity of what could be called the colored women's club uplift mentality in Harlem, one must remember that the Negro aping the ways of his betters was also engaged in impersonation and role-playing. When *The New York Times*

unctuously inquired in 1908 how one could "respect" the Negro when he seems "ashamed of [his] own features" and "mask[s]" [himself] into some resemblance of the Caucasian race," it was apparently unaware that "wear[ing] the mask," in Paul Laurence Dunbar's phrase, was the aesthetic of black Manhattan, low and high. Lawrence, too, missed the joke; his disillusion with Harlem, his disappointment at finding beneath the "idealistic clothes," not the "dusky body," but more clothes, is, I think, at least as suspect as Van Vechten's addiction to negritude. What separated Lawrence from many of his modernist peers and allied him, despite his protests, with the Mrs. Masons of the day, was his limited theatrical sensibility. His interest was always in stripping off the disguise rather than in reading or elaborating it, and this put him at a considerable disadvantage when faced by the complex masks, whether whiteface or black, that the New Negro habitually assumed.

In contrast, as a married homosexual, Van Vechten knew a good deal about "passing" for something he wasn't; his modish fiction, with its "tattooed countesses" and exaggeratedly clever poseurs, bears witness that he understood masks as he understood nothing else. Nor was he a Johnny-Come-Lately to Negro affairs. His father had been the co-founder and mainstay support of Piney Wood, a school for African-American children in Mississippi, a post Van Vechten took over after his father's death. During his student days in Chicago at the turn of the century, he discovered black ragtime entertainment; he was bringing black artists to Mabel Dodge's salon back in 1912. He also became a supporter of the new NAACP and a regular and early subscriber to Harlem's radical weekly *The Messenger*. If Van Vechten was more of an outsider than he wanted to admit, at least he stuck around, in fact, for a lifetime, and unlike Mrs. Mason or Lawrence, he took Harlem more or less as he found it.

In 1940, when Hughes was preparing to publish *The Big Sea*, Blanche Knopf asked him to drop his recent Marxist poetry (the poetry that Mrs. Mason found "not you!"), but Van Vechten sided with Hughes; he disliked the radical poetry, too, but he considered it an essential part of Hughes's developing story. Despite accusations to the contrary, Van Vechten was not a mindless enthusiast for Negro culture. Right or wrong, he let Hughes know his opinion of his new poetry, and he gave the Knopfs and Otto Kahn, a leading patron of the arts who funded both Paul Robeson and Hart Crane, honest and helpful assessments of the Negro artists he sent their way. Van Vechten told Essie Robeson how bad her early literary efforts were, but he also assured her: "Reject [the advice] when it does not meet your approval. The friendship will remain." Whatever his sexual tastes, there is no evidence that he thrust his attention on black men like Robeson and Hughes, who were obligated to him but sexually uninterested in him.

Hughes used his break with Mrs. Mason as the climax and penultimate chapter of his memoir, *The Big Sea*, and he made it a parable of maturation. Ejected from her Fifth Avenue apartment into the street, dazed with pain, he still feels the sunshine and the wind on his face as he walks toward the subway; like Henry Crowder a few years later, he is heading home to Harlem, and he has resolved to become what he has not yet, he acknowledges, been, what Crowder never quite became, a fully "professional" artist, a writer who depends on no one but himself, who "makes [his] living from writing." Hughes dated his literary independence from the day he broke with Mrs. Mason, but he remained Van Vechten's devoted and intimate friend until the older man's death in 1964; Hughes himself died on May 22, 1967, of complications attendant on prostate surgery. The white godfather, unlike the white godmother, did not forbid his protégés' maturation or act as an assassin to their autonomy. Van Vechten had something of that neutrality, that spirit of disinterested concern, for which this generation, black and white, hungered.

Hughes does not tell us in *The Big Sea* that when the white godmother dropped him, the black one picked him up. It was Mary McLeod Bethune, "a jet-black woman who had risen from a barefooted fieldhand . . . to be . . . a leader of her people," with her "wit and wisdom" (Hughes's words in *I Wonder As I Wander* [1956], the sequel to *The Big Sea*), who suggested to him, only months after his break with Mrs. Mason, that he try to make a living by touring the South lecturing and reading his poetry—an activity that proved Hughes's first and most long-lived means of real self-support.

Hughes never lacked for sponsors, and he had another older white woman patron, a more benign one than Mrs. Mason, in a wealthy New Yorker named Amy Spingarn. Spingarn preceded Mrs. Mason in Hughes's life, financing his first semester at Lincoln in 1926; with her husband, Joel, and her brother-in-law Arthur, she contributed a good deal of money and intelligently informed support to the Harlem Renaissance, and Hughes was genuinely devoted to her. Yet it must be noted that the Spingarns were Jews, a group that often saw in the Negro's problems their own difficulties in finding acceptance in elite Protestant circles. Although he alludes to Spingarn gracefully (and anonymously) in *The Big Sea*, Hughes chose not to make her a character in his memoirs, as he did Mrs. Mason, Van Vechten, and Bethune. He did not, in other words, write her into his drama of patronage and reparentage; a white matriarch, even if a Jewish one, even if, especially if, a beloved one, could not hold center stage in his story. It is the malign Wasp would-be mother, whose tentacles go deepest, who must be publicly uprooted and overcome.

To say that Van Vechten and Bethune came through for Hughes where Mrs. Mason failed is not entirely a matter of blame, however, of intentions

good or bad. The options that history provides are sometimes severely limited ones. In modern black-and-white America, the black man could serve as a symbolic father figure, as an artistic forebear and a pioneering expert in the popular arts; the white father and the black mother still had viable roles to play as well, but the white mother did not. The only role models fully available to this generation, men and women, black or white, were either male or Negro.

THE BENEFITS OF MATRICIDE

White feminine reformers and their male cohorts in America expressed on more than one occasion a supreme confidence that their divinely inspired and God-backed goals, once passed into law, would implement themselves and automatically bring in a golden era. The revivalist Billy Sunday summed up their hopes on the eve of Prohibition's enactment: "Hell will be forever for rent!" But, as everyone knew by the mid-1920s, hell remained well occupied; the millennium had not arrived. Suffragists, in their eagerness to get the vote, had neglected to plan how to get the vote out; in their enthusiasm for legislating Prohibition, temperance supporters devoted little thought and allocated few resources to enforcing it. The proponents of uplift had forgotten the resistance sure to attend their efforts to boss a nation; the only thing as conspicuous as the crusades they headed was their failure, once made law, to work.

Fiorello La Guardia estimated that it would "require a police force of 250,000 men [to enforce Prohibition]" and, he added wryly, "a force of 250,000 men to police the police." But the enforcement division of the Prohibition Bureau never rose above 3,000 men, and it usually stood at around 2,200; in 1923, the country as a whole spent less than $500,000 to implement its dry laws. Most Western nations tried some version of Prohibition in the 1920s, and all of them eventually modified or repealed it, but nowhere was it so brutally canceled as in America. The Eighteenth Amendment is to date the only constitutional amendment ever rescinded by the American people.

No one in the 1920s talked of rescinding the Nineteenth Amendment, but that may have been because no one thought it was necessary. According to *Non-Voting*, a study written by Charles Merriam and Harold Gospell and published in 1923, newly enfranchised women voted only half as often as men, and their votes did not visibly alter the political, economic, or social priorities of the nation. One ad in *The American Mercury* in 1932 said: "When Lovely Women vote," they vote for—"Listerine Tooth Paste!" In this view, women cast their real votes, not in voting booths, but in stores.

Although the enfranchised white woman was pledged to outvote if not eliminate the Negro, the Negro did not sink from sight when suffrage became law. Quite the reverse. Reality itself had, it seemed, kicked back. If the Great War had furthered the emancipation of modern America from the Titaness, the emergence of the New Negro, and his reception by significant portions of the white world, had proved her demise a fact.

I do not mean to suggest that NAWSA and its allies were the originators or even the chief culprits in the disenfranchisement and Jim Crowing of the American Negro in the decades between 1880 and 1920. The Jim Crow era was the product of long-standing, widespread national prejudice that was fast developing into officially sanctioned ideologies of race, of animosities between the black and white working classes, animosities painfully visible in the labor unions of the North and the Populist movement of the South. NAWSA hardly caused Negro disempowerment, although NAWSA backed it. A fuller account of NAWSA's role in the Jim Crow era would also put its prioritizing of women's rights over those of the Negro in the context of a long-standing historical situation in which the white middle-class woman was told again and again that her rights were less important than those of someone else. When was she ever to be allowed to insist that she came first?

Nineteenth-century white middle-class women contended with masculine essentialism, the notion that any-man-is-better-than-any-woman, and this underlay, in NAWSA's view, the denial of suffrage to the white woman but not to the black man. It is understandable that they countered this masculine essentialism with feminine essentialism, with the idea that any-woman-is-better-than-any-man. It is even understandable, if regrettable, that they used racism to buttress their claims; they were embattled, and they chose a weapon that was common in their world and close at hand. The matriarch exaggerated her claims and overestimated her powers, but it is well to remember that those who have been long pressured into self-hatred may end by placing too much stock in self-love. If she confused self-love with virtue, one should note that the absence or denial of self-esteem can be as destructive as its excess.

Nor had NAWSA inherited an unblemished record from the abolitionist and suffragist alliance. From the start of the antislavery crusade, blacks were devalued by white reformers. Harriet Beecher Stowe, the most famous antislavery spokesperson of the century, is often picked as chief villain in this story, and in fact, she sometimes seemed remarkably uninterested in letting blacks speak for themselves. In the 1850s, she wanted to take over the story of a prominent fugitive slave woman named Harriet Jacobs and publish it under her own name and in her words as part of her *Key to Uncle Tom's Cabin* (1853). Jacobs turned down Stowe's offer, and her narrative, published

in 1861 as *Incidents in the Life of a Slave Girl*, was proudly subtitled *Written by Herself*. But women were hardly the only culprits. Frederick Douglass had to distance himself from William Lloyd Garrison and his periodical, *The Liberator*, in order to find effective voice; Douglass began his own antislavery paper, *The North Star*, in 1847.

Whatever her faults, Stowe was by and large a friend to Douglass, and in this instance she tried to mediate the breach between black and white abolitionists. At least she knew, as apparently the white male leadership did not, that Douglass's "change of sentiment," his partial disavowal of Garrisonian abolitionism, was not in her words "a mere political one, but the genuine growth of his own conviction . . . He holds no opinion that he cannot defend with a variety of richness of thought and expression." In a letter to Garrison of 1847, she protested this senseless "work of excommunication." And though Douglass criticized Elizabeth Cady Stanton's decision not to back black male suffrage in the late 1860s, their relations continued to be cordial. In 1884, when Douglass took, to widespread protest, a white wife named Helen Pitts, Stanton wrote to offer him her support, and in 1889, after a meeting with her, he was pleased to report her "more radical than ever—she is a noble woman, and has no snobbery." Stanton in turn eulogized Douglass after his death in February 1895 as "an African prince majestic . . . in his wrath." It is always easier and safer to lay the blame on women—their powers of reprisal being slighter than those of their male peers—but history seldom backs the practice.

William James and Gertrude Stein tried to salvage the best of this matriarchal legacy, its optimism and verve, its therapeutic emphasis on religious and oral nurture, while leaving behind its occasional disdain of hard fact and racist aims, but the urban moderns, driven by unexplored misogyny and limited cultural analysis and self-assessment, wanted to excise the matriarch altogether. As American industry scrapped obsolete technology and modes of production to invest with a minimum of cultural lag in the machinery and methods of the future, so the moderns dumped the Titaness. The obsolete had to be cremated on the altar of the up-to-date; destruction was not loss but freedom, unimpeded takeoff. Living in America's peak of historical acceleration, the moderns were moving at such high speeds that all their actions got bigger, faster, and more dramatic through the force of momentum; "bicarbonated white with speed" is the way Hart Crane, writing in *The Bridge* about the eyes of the "falcon ace" pilot, described acceleration's effect on perception. Speed produces violence, and anaesthesia to violence.

It is once again a question of whether one views the instigation that was the culture of New York in the 1920s as pathological grandiosity, self-destructive acting out, or as "grandiosity with a basis in fact," hyper-thinking

and acting directed toward real and worthy goals, goals not to be gained as swiftly or surely by another route. Either way, my aim is to see the cultural scene as my protagonists saw it; crimes don't feel like crimes until one has lost touch with the motives and feelings that prompted them. The masculinization process was not simply the result of backlash, of automatic male hostility to gains in female power, though such backlash was a crucial factor; there was also at work a legitimate dislike of the uses to which matriarchal power had been put, of the social and cultural consequences of its exercise. Victorian feminine essentialism had served a real and valid historical purpose, but by 1914 it had turned toxic; it had to be disavowed as a cultural strategy and a private resource. The moderns wanted to murder the Titaness in part because there were real gains that could not be made until her influence was flouted. The most important of these gains was access to black America, to America as itself black-and-white, and the creation of a dazzlingly diverse entertainment scene, a scene destined to give the new mass media interests their most important assets and bring America worldwide cultural influence.

The fabulously accelerated appropriation rate of American culture in the 1920s, its free and creative borrowings across race, class, and gender lines, was directly connected to the special powers of the new media, for the media are by definition content-hungry and omnivorous, but it was also closely tied to the era's masculinizing and matricidal impulses. To appropriate something is to abstract it by taking it out of its matrix, its indigenous original context, in order to resituate it in a plan of one's own making, a place alien to its natural habitat and design. Such resituation, the look and feel of a thing plucked from its original circumstances and thrust amid strange ones, is an instant-orphanage tactic, and it was the guiding principle of 1920s style, the trademark of a culture that took the helmet of the Great War soldier and redesigned it as a hat for smart girls in search of fun. When Freud used the word "instigation" in *Totem and Taboo* to describe his own habit of applying psychoanalysis to "topics" plucked from other "fields" or disciplines, he acknowledged that he could not do full justice to the appropriated material, for he was avowedly subordinating it to his own psychoanalytic purposes. To appropriate is to forget the source; appropriation is a denial of process, a form of ripping the babe betimes out of its mother's womb. (The image, fittingly, is from *Macbeth*.) Whether the original context is a masculine or a feminine world, appropriation always means the elevation of theory over therapy, of masculine artifice over feminine experience.

Studies in Classic American Literature was an act of instigation in just this sense. D. H. Lawrence, too, had ripped his subject out of its matrix, stolen it quite literally from its maternal context. Margo Jefferson has noted that the first letters of Lawrence's words about the "essential American soul"

as revealed in its literature—"hard, isolate, stoic"—spell "h.i.s.," and the acronym seems no accident; there are no women on these pages. This is not because there were no nineteenth-century American women writers, or even because there were no important women writers. American literature in the period Lawrence covers was in fact written largely by and for women. Lawrence never mentions the indisputably major feminine talents of the nineteenth century—Harriet Beecher Stowe, Emily Dickinson, and Margaret Fuller—and he passes over without a word the best-selling women authors of moderate but real talent who were contemporaneous with Melville, Poe, Hawthorne, and Whitman—Susan Warner, Maria Cummins, "Fanny Fern" (Sara Payson Willis), Ann Stephens, Louisa May Alcott, "Marion Harland" (Mary Virginia Hawes Terhune), Augusta Jane Evans Wilson, Caroline Lee Hentz, and Eddy's favorite, Mrs. E.D.E.N. Southworth—the "damned pack of scribbling women," as an envious Hawthorne had called them, any one of whose books outsold the entire output of all Lawrence's "classic" authors put together.

These women writers constituted an alternative tradition to classic American literature in much the same way that the early women doctors and Mind-cure practitioners constituted an alternative approach and corrective to official male medical wisdom, and they had many of the same strengths and weaknesses; the women authors, too, were interested in therapeutics and committed to the excitation of sometimes dangerously high levels of self-esteem. But their emphasis on domestic nurture and feminine supremacy was precisely what Lawrence sought to undo. If American women writers had outsold their masculine peers in the Victorian era, he was determined to right the balance by instating a masculine monopoly on modern critical esteem. America's most influential critics in the 1920s backed his project to the hilt. They, too, banned women writers from literary history, and again and again, in telling the story of America's male authors, they picked the women in their lives as the villain. Classic American literature, as they read it, was a long and agonized quarrel between overt feminization and covert masculine rebellion, a masked but irrepressible attack on the feminine elements that sought from without and within to destroy masculine artistry and the cultural diversity it required for its sustenance.

In *The Ordeal of Mark Twain* (1920), Van Wyck Brooks explained that Twain's talent was thwarted and emasculated by the genteel, sentimental tastes of his well-bred, half-invalid wife, Livy, and the too-cozy Nook Farm community in Hartford, Connecticut, where the Twains lived—ominously, to Brooks's way of thinking—next door to the senile but still intrusive and powerful Harriet Beecher Stowe. Raymond Weaver, Melville's first biogra-

pher, believed that the source of Melville's woes, the "Gorgon face that [he] bore in his heart, the implacable image that made his whole life a pilgrimage of despair . . . was the cold, beautiful face of his mother," Maria Melville. In his biography of Poe (1925), Joseph Wood Krutch went easier on Poe's mother, the ill-fated and kindhearted actress Elizabeth Poe, who died when Poe was not yet three, but he painted Poe as a "psychopathic" case, a victim of a lifelong mother complex, who sought in alcohol and intense but asexual flirtations with sympathetic women the symbiosis he once had with her.

Lawrence and his American peers were sure that the Titaness had blocked the recognition of America's most valuable elite cultural expression, the Calvinist-riddled, proto-psychoanalytic fiction of Melville, Twain, Haw-thorne, and Poe; Gilbert Seldes and Constance Rourke were equally sure that she had blocked the free development and exploration of the nation's bi-racial folk and popular arts. Ripping the babe betimes from the mother's womb can be a way of denying the mother to save the child, and in this case the child to be snatched from the slaughtered mother's womb was America's most unique, indigenous, and valuable cultural self-expression, its finest art, high and low.

Unlike America's popular arts, Calvinism was an all-white tradition, but from the eighteenth century on, its leaders had been concerned with the problem of the "peculiar institution," with slavery as national sin. In her novel *The Minister's Wooing* (1859), Stowe had dramatized the principled and courageous opposition of Samuel Hopkins, perhaps Jonathan Edwards's most distinguished colleague and heir, to the slaveholders in his well-to-do late-eighteenth-century New England congregation, and Melville's novella *Benito Cereno* (1855), the story of a brutal but inevitable, even justified, slave revolt, testified that the "power of blackness" Melville linked with Calvinism drew as much of its vitality from the black race over whose enslavement American Calvinism presided and agonized as from the dark form of Jehovah it figured. The "dusky body" beneath the "idealistic clothes" lay, as Lawrence had announced in 1923, at the root of America's Calvinist-steeped classic literature as surely as it formed the core identity of what became America's popular and mass arts.

Kabnis, Toomer's tortured protagonist in *Cane*, hates the "godam night-mare" that Father John, with his talk of slavery and sin, represents, but he knows it is the key to his fate as a poet. "I have the nightmares," Hemingway had said, "and I know the ones other people have." Heading back into the nightmare, America came as close as it ever did to discovering itself; to kill the mother was to free the "black man in a cellar" and, perhaps, the whites who put him there. America's strength in the early modern era lay, just as

Jung had argued in 1912 it must, in its newfound ability to look into the mirror and publicize to a waiting world the images, white and black, it discovered as its likeness.

"Craft" was a conscious artistic ideal among the artists of 1920s New York, but they did not advocate in its name a return to preindustrial handcraft, as the English artisan, poet, and social theorist William Morris did; they had as yet few quarrels with industrial capitalism. What attracted them to the word and practice of craft was its suggestion of work done with care, of standard or generic forms individualized with enormous attention to varied and precise detail, of objects seen without fuss and without hierarchializing divisions into high and low, objects seen in sharp focus as they actually are, of sounds caught with that "ear for the exact word" Twain had claimed that Eddy egregiously lacked. Most of all, the moderns liked craft for its insistent emphasis on plural authorship.

Nearly all the great songwriters of Tin Pan Alley worked in partnerships of lyricist and composer—Ira and George Gershwin, Gus Kahn and Walter Donaldson, Lorenz Hart and Richard Rodgers, Oscar Hammerstein II and Jerome Kern, Dorothy Fields and Jimmy McHugh, Irving Caesar and Vincent Youmans, Noble Sissle and Eubie Blake, Andy Razaf and Fats Waller—and they wrote their songs in collaboration with specific performers like Fred Astaire, Helen Morgan, Florence Mills, Ethel Waters, and Al Jolson, whose vocal strengths and limits they kept at all times in mind. George S. Kaufman, who did only one play in his long career without a collaborator, worked with a host of Broadway talents from Marc Connelly and Herman Mankiewicz to Morrie Ryskind, Edna Ferber, and Moss Hart, and the plays they wrote together laid the basis for the team production of Hollywood's greatest comedies in the 1930s. The finest bands of the Jazz Age, led by King Oliver, Fletcher Henderson, and Duke Ellington, perfected a sound in which unfettered soloists united to improvise an ensemble enterprise.

All the popular arts of the day were collaborative ones; the anarchist, individualist, and iconoclastic 1920s conducted much of its cultural revolution as a sibling affair, a group effort at what the critic Clifton Furness, observing a group of Southern blacks improvising a song in 1926, called "communal composition." No longer rivals for a capricious and tyrannical mother's favor, but siblings and peers in creative risk-taking, black and white artists and performers found their liberation in collaboration; the Negroization of American culture in the 1920s spelled, if not a revolution, a mutiny, and a second Emancipation Proclamation, one designed for both races.

It must be remembered that the New Negro never adopted anything like a separatist stance. Jet-black Marcus Garvey, the fierce Jamaica-born leader of the back-to-Africa movement of the 1910s and 1920s, had, whatever his

Young Ernest Hemingway at the American Red Cross Hospital in Milan, 1918
(Henry S. Villard)

A World War I battlefield
(Culver Pictures)

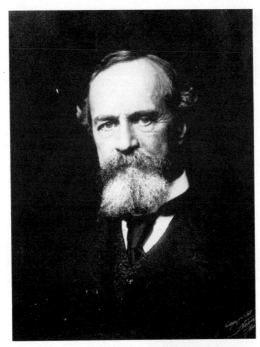

William James
(Culver Pictures)

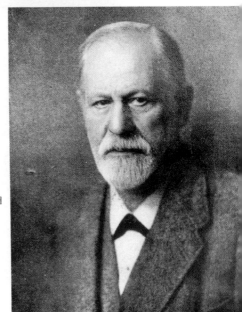

Sigmund Freud
(Culver Pictures)

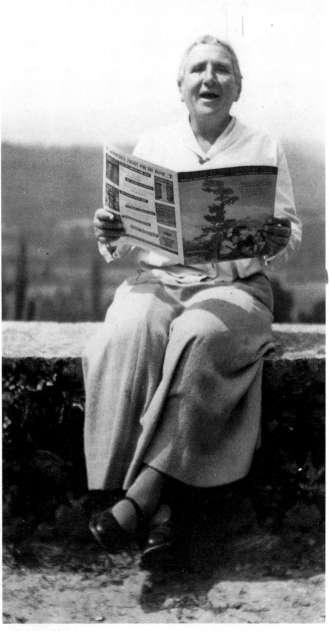

Gertrude Stein singing
(Yale Collection of American Literature, Beinecke Rare Book and Manuscript Library, Yale University)

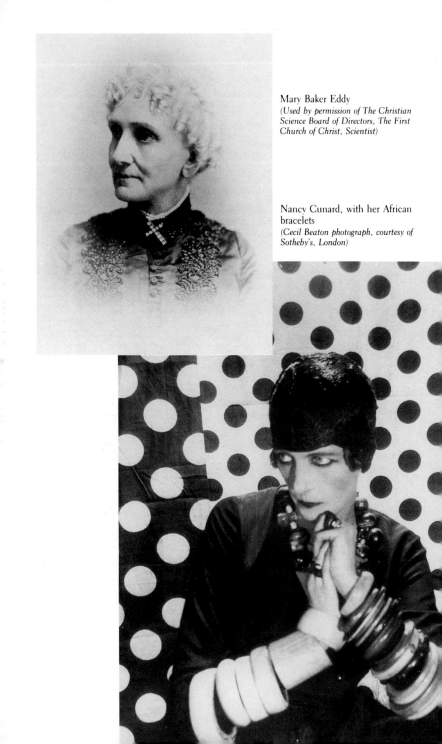

Mary Baker Eddy
(Used by permission of The Christian Science Board of Directors, The First Church of Christ, Scientist)

Nancy Cunard, with her African bracelets
(Cecil Beaton photograph, courtesy of Sotheby's, London)

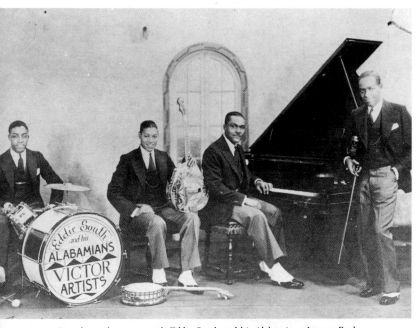

Henry Crowder at the piano, with Eddie South and his Alabamians: Jerome Burke
(drums), Gilbert McKendrick (banjo and guitar), and Eddie South (violin)
(Frank Driggs)

Langston Hughes in 1928
(*Schomburg Center for Research in Black Culture, Photographs and Prints Division, The New York Public Library, Astor, Lenox, and Tilden Foundations*)

Hart Crane and his father, Clarence Crane
(Hart Crane papers, Rare Book and Manuscript Library, Columbia University)

Young Hart Crane in sailor garb
(Hart Crane papers, Rare Book and Manuscript Library, Columbia University)

Jean Toomer
(Yale Collection of American Literature, Beinecke Rare Book and Manuscript Library, Yale University)

following among the masses, little effect on Harlem's Talented Tenth. Even the racially militant Paul Robeson, despite his quasi-expatriate status, his growing interest in Africa, his increasingly radical politics, and his commitment to the experiment in race relations he thought was being conducted in the new Soviet Union, asserted in 1932, "If the really great man of the Negro race will be born, he will spring from North America . . . [He can only] be begotten . . . in the land of ancient oppression and revolutionary emancipation." Although his audiences abroad were often more enthusiastic than those at home, Robeson believed that Americans could "understand the Negro in a way impossible to Europeans"; only America felt as if it were "really mine." This is hardly to say that black and white cultural collaboration in the 1920s was conflict-free. Racism was everywhere in white ranks, and blacks were fully aware of it. Collaboration is in any case an affair of equals, and equals are opponents as often as they are friends. But only one right fully engaged the attention of the black and white moderns: the right to appropriate anything that caught their fancy for their own needs.

"Ain't Misbehavin'" was the trademark song of the ebullient, melancholy Fats Waller, and when he sang the line "Ain't misbehavin' / Saving my love for you, for you, for you, for you," he liked to look, as he sang each "you," head nodding, eyebrows rising and falling, riding the *qui vive* of provocation, at a different woman (or group of women) in the audience: "you" and "you too," and "yes, you too!" Fats's appetite for fun, food, sex, and drink was legendary, of Babe Ruth proportions; "you," whoever you were, belonged to him, if he wanted you. His end was painful—he died, aged thirty-nine, quivering with DTs and fever, as his train pulled into Kansas City on a cold December morning in 1943—but Waller and his black and white peers dared to believe that they could expand and diversify almost infinitely and still remain in control, if not of their lives, of their art. They wagered that, in Jazz Age Manhattan, they could get away with anything, even color-line transgression at its freest and most inventive, and their art proved them right.

SIBLINGS AND MONGRELS

TAKING HARLEM

THE NEGRO AND THE IMMIGRANT: FINDING A HOMELAND

In the 1920s, for the first time in American history, many blacks and some whites viewed the black tradition in the arts not as a slight and inferior tributary to white culture but as a dominant influence on it and as a separate tradition with a complex identity and history of its own. What one might call the "post-colonial" phase of African-American culture, the self-conscious emergence of black culture from white, had begun. As surely as white America was culturally emancipating itself from Great Britain, black America was fighting to free itself from white America's dictatorial control. The process of emancipation was twofold. The historian Lawrence Levine sees this period in Negro culture as one of "look[ing] inward," of drawing on the resources of the black community in an effort of revitalization; the anthropologist Anthony F.L. Wallace calls such an attempt "a deliberate, organized, conscious effort . . . to construct a more satisfying culture." The New Negro was discovering his own cultural heritage, which, as he saw it, included the white tradition as well as the black one; but as he did so, he adopted global interests and aims. For blacks as well as whites, the war produced a new sense of culture as an international activity, and in its wake the Negro found for the first time a worldwide audience and arena, one that might aid him in his fight against injustice at home. For the African-American Talented Tenth of the Jazz Age, publicity in its broadest sense, from commercial entertainment to militant race journalism, *was* political strategy.

In his classic study *Harlem Renaissance* (1971), Nathan Huggins noted that "self-determination, an aim of the Allies in the war, became a slogan in the 1920s. Black intellectuals saw in the Yugoslavs, Czechs, and Irish a clue to their own emancipation . . . They, too, were a people to be defined."

The conjunction of the two movements, nationalism abroad and Negro independence at home, was conspicuous. As the Versailles peace conference was convening in early 1919, the International Pan-African Congress, devoted to liberating Africa from white rule, was in session a stone's throw away in London. In "The Little Peoples," a poem of 1919, Claude McKay observed that "the big men of the world" had met at Versailles and decided that "the little nations that are white and weak" should be free. Why should blacks, he queried—reversing Kipling's famous dictum about the dark races as the "white man's burden"—bear the heavy "burden" of "the white man"?

The post-colonial impetus of black Manhattan was not, I have remarked, separatist; the New Negro wanted not distance from white America but more power and recognition within it. He had, in his view, earned such recognition at least as fully as America's white elite; indeed, he saw himself as part of the American elite. Hart Crane and Jean Toomer could draw fruitfully on each other's work in part because they had a like history and status within American society. Both were marginalized, Toomer by his race, Crane by his sexuality, and their vocations and gifts were strikingly parallel; more important, their class and national identities were, unlikely as it may sound, similar. Toomer was the descendant not only of a black-and-white Southern aristocratic class but also of unknown African ancestors; Crane's forebears came to New England from England in the seventeenth century. In other words, Crane was almost as far in time and space from his Anglo-Saxon roots as Toomer was from his African origins; the recent past of both men was America and little else besides. Of course, Crane's English heritage was considered prestigious, as Toomer's African legacy was not, but the non-American heritages of both men, the English and African traditions respectively, were now long assimilated into American culture, and this distinguished them from most of their peers.

America had received its biggest wave of immigrants between 1880 and 1920; roughly 28 million people arrived in these years. By the early 1920s, about half the nation's population was first- or second-generation immigrant, and in the big cities the proportion was still higher. Three-quarters of the nation's immigrants in the late nineteenth century came to New York; a census report of the day revealed that in its sixth ward there were 812 Irish, 218 Germans, 189 Poles, 186 Italians, 39 blacks, 10 native-born white Americans, and "a scattering of unclassifiable persons." As the popular composer Ned Harrigan put it: "Below Fourteenth Street, after eight o-clock at night, the U.S. language was a hard find." By 1920, only 1 million of the city's 6 million residents were white native-born Protestants. In Chicago in 1920, a mere 23.8 percent of the population were whites born to native parents. In such a context, only the Wasp and the Negro were not recent,

visible immigrants. (American Indians were not immigrants, either—indeed, they were America's only truly indigenous group—but they were a negligible presence in the cities that set the cultural pace in the modern era.)

As the historian John Higham has demonstrated, nineteenth-century Euro-Americans had seen themselves, despite rapidly shifting demographics, as an indomitable and expansive leadership group rather than as a beleaguered and assaulted racial minority. America's long-standing "open door" policy to the world's "huddled masses yearning to breathe free," to quote Emma Lazarus's inscription for the Statue of Liberty, erected in Manhattan's harbor in 1886, came from its confidence that its ruling white Protestant elite was aggressive and disciplined enough to assimilate and "Americanize" all out-siders; immigrants, necessary in any case to the fast-expanding labor-hungry economy, did not in this view deplete the nation's strength but rather enabled and reinforced it. By the turn of the twentieth century, however, attitudes had begun to shift.

Immigrants were now coming mainly from eastern and southern Europe rather than, as had long been the case, from northern Europe. The Germans, Scandinavians, and Irish of the older immigrant groups were being replaced by countless Poles, Italians, and Jews; 2.5 million Jews arrived from Russia and eastern Europe between 1880 and 1930, and most of them settled in New York. Some of the newer immigrants were visibly different from Amer-ica's older white population, and they were no longer dispersing themselves across the nation but collecting ominously in vast city enclaves fast becoming "ghettos." Moreover, the drastic fluctuations, the sudden shifts from boom periods into sometimes tenacious depressions, downturns accompanied by massive layoffs and sometimes violent agitation, ever more visible in Amer-ica's full-fledged, more or less unregulated capitalist economy, erased the traditional image of the immigrant as part of an unending supply of docile, industrious, cheap, and quickly Americanized labor and raised in its place the alarming specter of an unemployed, ill-educated, and angry mob of foreigners with no real stake in the American enterprise, with no knowledge of its Anglo-Saxon values and traditions, and unable to speak or write what people other than H. L. Mencken were beginning to refer to as "the American Language." Faced by such a prospect, elite white America closed first its mind, then its gates, to working-class foreigners.

A new breed of race ideologues was evolving in the 1890s from the ranks of Social Darwinist sociologists, eugenicists, psychologists, and anthropol-ogists. One might say that the social sciences found their formative impetus in the problems of race and segregation, and their leading practitioners explained that "race" designated and included not just color but ethnicity, nationality, and, even by implication, class and language. The only really

"white" people were the "Nordics" of northern Europe, the educated "pure Caucasians" whose ancestors had settled America in the seventeenth century. The rest were "Mediterraneans" and "Alpines," all of them, it was feared, far less intelligent and self-controlled than their Nordic rivals. The new immigrants came from what the M.I.T. economist Francis I. Walker called "the beaten races"; in Darwinian terms, they were the least "fit" of Europe's peoples, by heredity inaccessible to any ameliorating environment, even that of America. Their tactic was promiscuous overbreeding, overrunning those they had no right or ability to conquer and reducing the civilized world to their own brute status. To let such irretrievably foreign people into the country amounted, experts concurred, to "race suicide," a wanton and willful "reversion" to the lower types of human life, to bestiality.

William James, whose unofficial withdrawal from the ranks of psychologists in the 1890s exactly coincided with the profession's growing interest in racial typologies, tried to tell his fellow Americans that the only real "reversions" evident in national life were the white lynchers, the greedy imperialists, and the bigoted of every variety. The anthropologists Franz Boas and Melville Herskovits, backed by Mencken and a host of black sociologists and satirists, later joined his attack on the racial ideologues and their update of the "white man's burden" line of reasoning. By and large, however, the white intellectual establishment buttressed rather than dismantled the new racial thinking. The notion of using literacy tests to control and check immigration took hold in the 1890s and became law in 1917; in 1924, the Johnson-Reed Act set steep quotas for non-Nordic European immigrants and put a conclusive end to mass immigration as normative policy. Of the 35.9 million Europeans who came to the United States between 1820 and 1975, 32 million came before 1924.

This newly empowered, vigilant, and aggressive white nativism had a critical and complex effect on America's black population; to tighten traditional Euro-American ideas of white supremacy was, paradoxically, to intensify both the Negro's outsider status and his sense of entitlement. The Negro was apparently no longer alone. Italians, for example, were seen as only a step or two above blacks, and white non-Nordic immigrants, Jews, and Roman Catholics were the victims of the revived Ku Klux Klan in the early 1920s as often as Negroes were, though the target in some real sense remained the black man. Immigration restrictions became a certainty when Southern congressmen joined the cause en masse at the turn of the century, and they did so because they saw the new immigrants as first cousin to the Negro; to the Southern mind, a blow against the immigrant was a blow against the black. The issue of slavery had once divided Euro-America, but

a radically expanded and pseudo-scientifically buttressed racism reunited it. Blacks and ethnics were, if not allies, victims of a common prejudice.

But any immigrant–Negro coalition was more theory than fact. Devalued and hard-pressed immigrant groups saw blacks as their only available social and economic inferiors. Racial ideologues like Madison Grant and Lothrop Stoddard who routinely conflated non-Nordic immigrants and blacks helped to craft the Johnson-Reed Act, but legislators knew that such arguments could not be openly used to explain and defend the new law. Definitions that branded most of the white population and all of the nonwhite one as un-American were neither politically feasible nor intellectually acceptable in the democracy that the United States purported to be; officially and legally, any one non-Negro was still white and better than anyone non-white. Jim Crow laws were not directed at the "Mediterranean" or "Alpine" groups. Legal literacy requirements for immigrants came late in the anti-immigration struggle and in a form so diluted that the vast majority of immigrants passed them, but they had been used early and effectively in the crusade to disenfranchise blacks.

Labor unions became increasingly pro-restriction in the first decades of the century, but they were always more anti-black than anti-immigrant. In the immigrant work force, after all, lay their historical origins, however far they might have traveled from them, however much they may have wished to forget them; Jewish working-class immigrants in particular found in the union movement their best source of economic power. In the black work force, in contrast, lay the union's oldest enemy: economic competitors forced or willing to work for less money than the unions would accept. Big business long bonded with the immigrant lobbies to keep America's door open, and a series of Presidents, including Woodrow Wilson in his first term, mindful of the immigrant vote, vetoed congressional bills that would have slammed it shut. Unions, industry leaders, and the nation's most important politicians were invariably, if not exactly a better friend, less of a foe to the immigrant than to the Negro. Rather than uniting ethnic and Negro, anti-immigration sentiment turned every immigrant into the black man's self-conscious and belligerent superior.

Blacks themselves showed little or no interest in seeing themselves as part of an expanded community of diverse peoples. Mencken had a big impact on the Negro renaissance in good part because he on occasion entertained the idea that "Negroes are superior to most American whites," as he once baldly put it; blacks were proudly aware that they were no more immigrants than "Mediterraneans" or "Alpines" were Africans or, as they saw it, Americans. I have remarked that 1920s blacks, like James Weldon Johnson, who

used the term "Afro-American" often eliminated the hyphen, producing "Aframerican"; a few whites, headed by Mencken, joined them. Teddy Roosevelt had made the word "hyphenate" a synonym for "immigrant," and terms like "Aframerican" were meant to remind whites that blacks were not immigrants, not added to America: they were there at its beginning, they helped to found and to build it. As one Negro writer in the *New York Age* rather snobbishly put it on October 5, 1916, whatever the "Negro" may be, at least "he is no hyphenate." In his pamphlet of the early 1930s on *Negro Life in New York's Harlem*, Wallace Thurman dismissed the Lower East Side as the place where "the hyphenated American groups live." The three most influential Negro leaders of the early twentieth century, Washington, Du Bois, and Garvey, were all anti-union, and the Urban League at moments openly encouraged Negro workers to serve as wage underbidders, even as scabs and strikebreakers in labor-management disputes and conflicts.

Blacks had long complained about the preferential treatment accorded to drunken Irishmen, "European paupers, blacklegs, and burglars," while the "*first tillers* of the land" were neglected; such complaints began in the 1820s, grew in intensity over the next century, and have not ceased today. In the 1960s, Malcolm X reminded his followers, "Everything that comes out of Europe . . . is already an American, and as long as you and I have been here, we are not American yet." The far more mild-mannered Langston Hughes made the same point in 1943 in a piece titled "America":

> My ancestry goes back at least four generations on American soil and through Indian blood, many centuries more. My background and training is purely American . . . I am old stock as opposed to recent immigrant blood. Yet many Americans who cannot speak English—so recent is their arrival on our shores—may travel about the country at will securing food, hotel, and rail accommodations wherever they wish . . . I may not.

But no one put the case for the American Negro's entitlement more forcibly than Du Bois did in his explication of the Negro's history and role in American culture, *The Souls of Black Folk*. Du Bois closed his book with a magisterial passage of pleading and command, a set piece laden with threats of retribution and hopes of shared redemption, and directed squarely at his white audience:

> Your country? How came it yours? Before the Pilgrims landed we were there. Here we have brought our three gifts and mingled them with yours: a gift of story and song—soft, stirring melody in an ill-harmonized and unmelodious land; the gift of sweat and brawn to beat back the wilderness,

conquer the soil, and lay the foundations of this vast economic empire two hundred years earlier than your weak hands could have done it; the third, a gift of the Spirit. Around us the history of the land has centered for thrice a hundred years . . . We have woven ourselves with the very warp and woof of this nation . . . Would America have been America without her Negro people?

Negro cries for "justice" and "mercy" must be heeded, Du Bois concluded, "lest the nation be smitten with a curse."

Marcus Garvey liked to tell his listeners that, when Europe was still a wasteland of barbarians, "Africa was peopled with a race of cultured black men . . . men, who, it was said, were like the gods," and Du Bois, a tireless proselytizer and organizer for Pan-Africanism, reminded his readers that "two thousand years ago," in the heyday of the African and Egyptian cultures, no one would have been able to conceive, much less believe, "the idea of blond races ever leading civilization." The white civilizations, in other words, came after the dark ones and might well be succeeded by a new era of black cultural supremacy. In Du Bois's telling, not only was the Negro of older lineage and greater importance than his white immigrant peers; simply as a black man, he bore a longer and more prestigious pedigree than any white man, no matter how privileged or worthy, could boast. Du Bois was as interested in rewriting genealogies as any of the white modernists, and to his way of mind, the Negro was the first, the ur-American, and might well be the last. His message became the credo of the New Negro of the 1920s. The Harlem Renaissance was founded on Du Bois's assertion that African Americans possessed a rich and significant culture of their own, one that predated, and in part determined, that of white America and entitled its participants to full rights in American society.

In thinking of the post-colonial phase of African-American culture represented by the Harlem Renaissance, consider the word "Harlem" itself. "Harlem" is a Dutch name, once spelled "Haarlem," a reminder that New York was originally a Dutch settlement called "New Amsterdam." Until 1910 or so, the word "Harlem," despite fluctuations in the area's ethnic composition and economic fortunes over the years, signified to all who heard it white New York above 110th Street. At the turn of the century, Harlem was a traditionally minded British, German, Jewish, and Irish community that prided itself on its special combination of small-town pastoral atmosphere, leisurely European-provincial ways, and big-city cultural facilities; its elegant restaurants and theaters were justly famous. As a newspaper of the day summed it up, Harlem was "the rural retreat of the aristocratic New

Yorker." In the building boom of the 1880s and 1890s, the district acquired a series of stunning brownstone neighborhoods; the crisp, light townhouses on what was called "Strivers Row" on 139th Street were designed in 1891 by New York's premier architect, Stanford White.

By the early 1920s, blacks, not whites, were living in many of these townhouses and brownstones. It is one of the ironies of Jessie Fauset's novel *Plum Bun* (1929) that her light-skinned black heroine, Angela, who is passing for white, lives in cramped and ungraceful quarters in Greenwich Village, while her dark-skinned sister Virginia, who could not pass and would never want to, inhabits a spacious flat on Strivers Row. "Harlem," the word, looked the same in the early 1920s, but it was pronounced by those who now lived there with a softer African-American sound, and with a strong note of black pride. As the African-American cultural historian Jervis Anderson remarks in his study *This Was Harlem* (1982), "Blacks living there used the word as though they had coined it themselves." And "Harlem" signified something radically different than it had a short decade ago; it meant a black community, the "race capital," as Alain Locke dubbed it, of the world.

The racial transformation of Harlem began with an ill-planned white real-estate boom sparked by the building of the Lenox Avenue subway line; opened in 1904, the Lenox line was intended to attract a flood of white middle-class investors and inhabitants to Harlem, but for various reasons the flood failed to materialize. Landlords faced vacant buildings. Black renters and realtors, led by Philip A. Payton, Jr., the daring speculator and founder of the Afro-American Realty Company, seized the advantage and moved into what were clearly the best living quarters ever available to blacks in Manhattan or America. Payton began as a disciple of Booker T. Washington, and Washington's injunction to the race "Get some property— Get a home of your own" was his first imperative, one to which he gave an aggressive spin absent in Washington's crafty "puttin' on ole massa" rhetoric. In *The Crisis of the Negro Intellectual* (1967), the African-American historian Harold Cruse has described Payton as an exemplar of "black economic nationalism"; promos for his company urged blacks to do business with him because he knew how to turn "race prejudice into dollars and cents"—in black pockets. He gave his apartment buildings proud Negro consciousness-raising names: the Douglass, the Dunbar, the Washington, and the Wheatley (after the eighteenth-century slave and poet Phillis Wheatley).

Payton was hardly above criticism, however. When blacks complained that the rents in his buildings were as high as those whites asked, he could only plead that he was charged higher interest rates than his white competitors. Down at Tuskegee Institute, Booker T., who had informants everywhere, it seemed, refused to come to Payton's aid in the various crises of

his company; clearly, the naming of the Washington apartment building didn't pacify *him*. The black directors and stockholders of the Afro-American Realty Company brought suit against Payton for fraud in 1906. Most of Harlem, however, understood his predicament. He lost his company in 1908, but not his reputation or success as a realtor; when he died in 1917, he had put more blacks in good housing than anyone would have believed possible a decade before, and he was known and revered as "the Father of Colored Harlem."

Opposition from Harlem's white tenants and other white New Yorkers to the black influx was fierce. The *Harlem Home News* exhorted its readers in July 1911: "The Negro invasion . . . must be valiantly fought . . . before it is too late to repel the black hordes." Drastic measures were proposed, most notably by John G. Taylor, head of the Harlem Property Owners Improvement Corporation. Why not create a sort of Negro "colony," Taylor suggested, consisting of "large tracts of unimproved land" in some place that was not Harlem, near but outside New York City? Taylor apparently had in mind something along the lines of the reservations imprisoning the Indian population; his plan would send urbanizing Aframerica back to abject agrarian status in a hurry. In the short run, he urged white homesteaders to erect a continuous 24-foot fence extending across their back yards, band together, sign agreements not to rent or sell to Negroes, and evict those already there. One unhappy citizen argued in a 1912 letter to the *Times* that whites should at least "have Jim Crow cars [on the subways] for these people." All else failing, as Taylor summed up his baseline position in one of many unguarded moments: "Drive them out and send them to the slums where they belong!" The white press habitually referred to the newcomers as "niggers" and "coons"; they were the "enemy." This, Gilbert Osofsky comments in *Harlem: The Making of a Ghetto* (1971), "was the language of war."

But war never broke out, at least not on any large or effective scale. Many white landlords proved anxious to turn a quick profit; after all, they could exact higher rents from blacks than they had from whites, upping prices by 15, 25, even 50 and 75 percent. Blacks knew they had to pay for the privilege of being where they weren't wanted, if only because, whether living in the Village as they had in the earlier part of the nineteenth century or in the midtown Tenderloin and San Juan Hill districts as they had in the later part of it, they always had. In any case, white realtors and landlords had little choice but to rent to Negroes; whites were vacating their holdings in droves. Their "conduct," Johnson commented in *Black Manhattan*, "could be compared to that of a community in the Middle Ages fleeing before an epidemic of the black plague." (The "black plague" was, in fact, a term used by the white press of the day.) Between 1920 and 1930, 118,792 whites left Harlem

and 87,417 Negroes arrived. JUST OPENED FOR COLORED signs were every-where. The new Harlem began tentatively in the 150s, covered much of 125th Street, and descended down to 110th Street. White default in this instance looked to be nothing short of black victory. Blacks now had, to use John Taylor's word, a "colony," one located not in some hinterland but in America's most important and sophisticated city. As the novelist Ralph Ellison, a long-time inhabitant, once put it, Harlem offered "our own home-grown version of Paris"; the indigenous and the exotic marvelously compacted and freely assorted in a single, architecturally distinguished site. It seemed fitting; whatever whites thought, as blacks saw it an elite group had finally found an elite locale.

Harlem was, in fact, a homeland of sorts for blacks. The older Harlem was a white community, but it had always had Negro residents; roughly 1,100 colored families lived above 110th Street between the East and the Hudson Rivers in 1902. Blacks were brought to Harlem as servants by the well-to-do white New Yorkers who migrated there in the late nineteenth century, but some of them were residents of long standing, descended from the slaves who'd been there in the seventeenth and eighteenth centuries. Because Harlem had been a largely rural area, slaves (not free in New York until 1827) had been unusually numerous; the census of 1790 listed 115 of them, comprising almost one-third of Harlem's population. When African Americans invaded Harlem in the 1900s and 1910s, they were, in a sense, retaking their own, reclaiming a strategic portion of the country that had enslaved them.

This act of reclamation was not only an economic coup but a political manifesto. The 1920s generation, black and white, might be self-consciously and publicly apolitical, but the blacks' stance at its apparently most apolitical was thoroughly politicized as the whites' was not. It is hardly fair that later scholars of the Harlem Renaissance have questioned its political effectiveness as well as its artistic success, often condemning it for failing to achieve their own political goals—as the African-American critic Houston Baker has pointed out, this is not a demand routinely made of comparable white movements—but the plain fact is that the leading members of the renaissance made just such demands on themselves. Politics and art were never far apart in uptown circles.

POLITICAL OPTIONS

What the two generations of Harlem blacks, the older, more genteel group led by Du Bois at *The Crisis* and the younger, more radical coalition of

blacks who put out *Fire!*, had overwhelmingly in common, despite their self-conscious and much dramatized differences, was a conviction that Booker T. Washington's humble-pie approach had proved a failure; all of them put their emphasis on the determined independence, even militancy, of the New Negro. They believed that the Negro's battle was best fought in the North and in the cities, not in that stronghold of racism the agrarian South, Washington's chosen arena, and they all thought that artistic and literary achievement could do more for the black cause at this particular historical moment than any economic or political gains they might achieve; in James Weldon Johnson's words, "A people that has produced great art and literature has never been looked upon as distinctly inferior." To accomplish their end, they were determined to take advantage of all the white aid and patronage available to them.

These two concerns, one with black militancy, the other with white-backed black cultural self-expression, might seem to be in conflict; indeed, many of those involved judged them, in hindsight, as debilitatingly contradictory. What kind of independence could be gained when the Negro's basic economic and political rights, whatever his artistic achievements, went largely unwon? When black efforts for equality were supported and directed by whites? What could be the long-term impact of a black revolution in the arts whose outlets were all-white publishers, largely white magazines, and a white-run metropolitan entertainment industry? I have addressed this question in aesthetic and cultural terms; now it must be approached as a political problem.

The NAACP had been founded in 1909 by blacks, led by Du Bois, and whites, led by a Brooklyn social worker, Mary White Ovington; despite the growing power of its Negro secretariat, headed by James Weldon Johnson and Walter White, the organization was officially run throughout the 1920s by its white board of directors. When Du Bois left the NAACP in 1934, he remarked bitterly that its quarter century of work had produced "a little less than nothing"; *The Crisis* was the NAACP organ, and a conservative editorial board severed Du Bois's last ties with it in the late 1940s.

Even Harlem's *Messenger*, begun in 1917 and self-billed as "the Only Radical Negro Magazine in America," seemed to compromise its purpose. Wallace Thurman and Langston Hughes were occasional contributors; in 1926, Thurman served for a few months as an editor. Editors in chief Chandler Owen and A. Philip Randolph felt themselves to be far to the left of Du Bois, whom they denounced as a "handkerchief head . . . hat-in-hand Negro." They said that the Negro "demands political equality . . . and unequivocal social equality. He realizes there cannot be any qualified equality." But *The Messenger* at its most radical in the late 1910s put its influence,

such as it was, behind the trade unions, hostile to Negro participation, and the American Socialist Party, whose commitment to the Negro cause would be intermittent at best. By the judgment of its able and sympathetic historian, Theodore Kornweibel, Jr., it succumbed over the course of the decade to the black bourgeoisie mentality before folding in 1928.

Whatever its quarrels with Du Bois's *Crisis, The Messenger* led the way in the early 1920s in attacking the man both deemed their most dangerous foe, not a white capitalist or a white anti-Negro politician, but the messianic black nationalist Marcus Garvey. Crying "Garvey must go!" *The Messenger* urged the United States government to jail or deport him (it did both). It seems all of a piece with the central paradox of Harlem itself, proud "race capital" on the one hand and America's premier ghetto-in-the-making on the other; one could see 1920s Harlem as an immense black community actively pursuing white America's goal of punitive and debilitating segregation while whites sat by and watched. Self-defeat seemed built into all aspects of the black Manhattan enterprise.

But what were the Negro's options? On the issue of segregation, integrated urban neighborhoods, never a widely practiced arrangement in the Northeast, vanished once the influx of Negroes coming from the South to Northern cities began to seem to whites like an "invasion" of "black hordes." Thanks to the Jim Crow practices proliferating in the North as well as in the South, New York restaurants and hotels that had once served Negroes as well as whites now barred blacks. Integration wasn't an option for blacks anywhere in America, but turning segregation into race pride, if the right conditions could be found, was. There was no point, Johnson and other Negro leaders argued, in trying to establish blacks-only facilities in every segregated town across the nation; the black population of such towns was too small and too isolated to supply the patronage necessary to keep such enterprises in business. The only workable strategy was to concentrate black resources where there was already a large Negro population able to use and support them. Harlem, backed by New York's incomparable wealth of facilities and services, fit the bill.

New York was hardly the only Northern city to receive black migrants in the 1910s and 1920s; indeed, its black population increased by only 67 percent, while Chicago's grew by 148 percent, Cleveland's by 307 percent, and Detroit's by an astonishing 611 percent. But the new black population of these other cities served simply to swell and extend their traditional black neighborhoods, thus triggering lethal hostilities in the whites on whom they were encroaching. Even in Chicago, where blacks acquired something like bona fide political power, Negroes were not, in the words of the historian Allan Spear, "establishing new communities" but expanding old ones and

multiplying white resistance as they did so. Roving white vigilante gangs were commonplace in Chicago's black South Side; bombings of black rentals and properties were everyday occurrences. The war that missed Harlem exploded in Chicago in one of the worst race riots to hit a riot-torn nation in the summer of 1919; 23 Negroes and 15 whites died, and 342 blacks and 178 whites were seriously injured.

Blacks in Manhattan, however, were moving into an area that had failed to develop a predicted rush of white renters and owners; in other words, whites had begun to lose interest in the district before the blacks arrived on the scene. The Negro invasion of Harlem was swift and decisive in territorial terms; it was simple and less costly for them to take over and hold a single area than to encroach, little by little, on white neighborhoods filled with people who had no desire and sometimes no chance to go elsewhere. White terrorism in Chicago was sparked by the whites' desire to keep the elite neighborhoods nearest the South Side, Hyde Park and Kenwood, free of blacks, and they succeeded. When the *Chicago Tribune*, surveying the casualty lists of 1919, said that "segregation will be the only means of preventing murder," it was making a shrewd, if racist, observation. The economic historian Timothy Bates has pointed out that the brief "golden age" of Negro business occurred in the 1920s at the height of segregation, and the lesson had obvious implications for black Manhattan. New York was one of the few big cities in the nation that did not experience mass convulsions of racial violence between 1916 and 1930; the segregation that a separate black community emblematized and enforced was probably the only safeguard against white violence Negroes could find, and Harlem was the only such fully developed, large-scale community in the United States.

In *The Ku Klux Klan in the City, 1915–1930* (1967), Kenneth Jackson has demonstrated that the resurgence of the Klan in the early 1920s was an urban as well as rural phenomenon; the Klan claimed somewhere between 2 and 5 million members, and many of them were located in the nation's biggest cities. Remember that the 1920s Klan, unlike its predecessor after the Civil War, was as anti-ethnic as anti-Negro; this meant that the big cities, teeming with immigrants as well as with blacks, were its natural arena. It also meant that black opposition to the Klan was backed by a multitude of white ethnic voters. Yet once again, a presumptive ethnic–black alliance failed to hold, and it is notable that only one multiethnic and racially diverse metropolis found no use for the Klan, namely New York. Boston expelled the Klan as clearly and swiftly as New York did, but its composition was less mixed; its dominant Irish population—being foreign and Catholic, a double provocation to the Klan—made the Klan defeat inevitable, even predictable. In Chicago, almost as diverse as New York, the Klan attracted more members

than in any other city; resistance was prompt and extreme, but the Klan forces were so strong that a mini civil war occupied the better part of the decade. And Detroit, America's fourth-largest metropolis, although over 25 percent of its population was foreign-born, became the center for the Michigan Klan despite persistent criticism from the Detroit press. Philadelphia and Pittsburgh were less hospitable to Klan efforts, though membership was estimated at 30,000 in Philadelphia, but Washington, D.C., proved a push-over; the Klan audaciously chose the capital as the locale for its parade in August 1925, a parade that attracted more participants and spectators than any parade had done in decades.

This is not to say that the Klan found no adherents in New York—it claimed twenty-one operating "Klaverns" in December 1922—but, rather, that the opposition to it was immediate and decisive. The *World* did a masterly exposé of Klan activities in September 1921. In 1922, Mayor John F. Hylan instructed his police commissioners to "ferret out these despicable, disloyal people" attempting to "destroy the foundations of our country," and the state legislature passed an anti-Klan bill in 1923 which effectively outlawed it. Many factors were at work in New York's relative exemption from Klan encroachment, not least of which was the city's long-standing tolerant and cosmopolitan temperament, but once again it seemed that Harlem was doing something right, that its unique territorial situation had served as a protective shield unavailable elsewhere.

In a similar fashion, one cannot assess the New Negro's turn to the cultural rather than political arena as his primary means of self-expression without asking what his options were: what kind of political activity lay open, realistically speaking, to the Negro, New or Old? The NAACP had its roots in the Niagara movement, initiated in 1905 by Du Bois and the black Boston journalist William Monroe Trotter, Booker T. Washington's severest critic, and its membership was all black. But the Niagara coalition attracted few adherents and fewer funds; it folded in 1910. Du Bois, in other words, decided to work with a biracial political pressure group because the all-black model he preferred had been unsuccessful. He knew that Washington's greatest strength had been his determination that "we [blacks] should get what we could get," in Du Bois's words, and in this instance he adopted the same principle; he was being pragmatic, not cravenly accommodational. In any case, as the African-American political theorist Manning Marable has put it in *How Capitalism Underdeveloped Black America* (1983), "a militant . . . activist can be integrationist"; "accommodation" is not always "co-optation."

In terms of the direct use of political power, the Negro's best weapon was the vote. Blacks were drawn to Northern cities in part because there were

fewer restrictions against Negro voters than in the South. Operating loosely on the idea that the party of Lincoln, the "Great Emancipator," was the one that deserved Negro support, New York's Negroes, like those in most of America, began as Republicans. But over the course of the first decades of the century, first on the local, then on the national level, they began to give their votes to Democratic candidates and causes. Du Bois, trying to be American first and Negro second, to do the right thing and get credit for it later, encouraged hundreds of thousands of Negroes to give their all to Democratic President Wilson's war effort; increasing numbers of New York's Negroes voted for Jimmy Walker for mayor, Al Smith for governor, and, in the 1930s, F.D.R. for President, all Democrats. The tactic involved in this shift of allegiance was part of a calculated attempt to make the Negro vote count. No party was to be able to presume black support; each party would have to court the Negro vote by promising to meet Negro needs. Harlem was the first large black community in America to question en masse the Negro's traditional allegiance to the Republican Party, to try to make the Negro vote mobile and hence an instrument of power.

There were other auspicious signs of a changing racial climate. After World War I, most Jim Crow laws in New York were repealed, six Negroes were elected to the state legislature, and two powerful black politicians arose, Charles Anderson and Ferdinand Q. Morton. Anderson, one of Washington's most trusted servants, controlled New York's black Republicans; Morton dominated the United Colored Democracy organization, which did business with the Democratic Tammany machine. All these appointments, prerogatives, and phenomena were firsts for New York Negroes, and their confidence in their dawning political power ran understandably high. Johnson boasted in 1924 that the Negro had "become an intelligent voter"; on July 25, 1929, Harlem's *New York Age* announced that "the idea of white men picking leaders for Negroes will no longer be tolerated." But as the political scientist Ira Katznelson has demonstrated in *Black Men, White Cities* (1973), the political situation of New York Negroes, appearances to the contrary, was deteriorating in the 1920s.

The tactic of calculated Negro party mobility was unsuccessful. The problem was that white politicians believed, often rightly, that they didn't need the Negro vote to attain office, or they reckoned, again rightly, that if they did need it, they could win it by promises they didn't intend to keep. On the national level, Washington, Du Bois, and other Negro leaders tried out alliances with Republican, Progressive, and Democratic presidential candidates, all to the same effect. Wilson was the worst offender, but Republican-Progressive Teddy Roosevelt and Republicans William Taft, Warren Harding, and Calvin Coolidge also demonstrated that election-time

promises to black Americans, when made at all, were made to be broken—openly, contemptuously broken.

Taft and T.R. were interested more in wooing white Southern Democrats to the Republican and/or Progressive side than in drawing black urban votes. T.R. thought blacks "altogether inferior to whites" and insisted that "race purity must be maintained." Taft, touring the South in 1909, openly endorsed black disenfranchisement. Negroes were to his mind "political children not having the mental stature of manhood," creatures for whom "a voice in the government [could] serve no benefit." Speaking in Birmingham, Alabama, in 1921, Harding came out against social equality for Negroes and quoted the views of the racial ideologue Lothrop Stoddard in support of his views. Although he maintained that he did support economic equality for blacks, and he was on record against lynching, he let the Dyer anti-lynching bill die in the Senate in 1922 despite the Negro leaders' remonstrances and threats of voter reprisal. Coolidge was not unfriendly to blacks, but adherence to the status quo was the only principle he invariably honored; segregation in federal ranks reached new heights during his years in office from 1923 to 1928. Harlem's district status worsened the lack of Negro clout. Unlike cities where the black population was spread out over several voting districts, Harlem's population was concentrated in one district, and as a result couldn't command the votes needed to elect a black politician to national office. Until its districts were redrawn in 1944, allowing for the election of Adam Clayton Powell, Jr., to Congress, Harlem was unrepresented in Washington.

Local politics resembled national politics: the Negro was promised a participatory role that did not materialize. Unlike their immigrant peers, most notably the Irish, blacks in New York never became insiders in the political machines that turned out voters in exchange for jobs, social services, and information. Despite the Age's ringing words, Charles Anderson and Ferdinand Morton were very much Negro leaders picked by white men. Both prided themselves on their superiority to most of their constituents, with whom they had, in any case, little contact; both, particularly Anderson, held conservative ideas on black-white relations. Such views were, of course, the price of whatever power they had.

In his letters to Washington, Anderson repeatedly referred to Du Bois and those Negroes who sympathized with him as "the enemy," as "mangy curs" and "cattle," as "that group to whom nothing is desirable but the impossible." Anderson saw to it that Hubert Harrison, the black Garveyite, socialist, and radical, who was an outspoken opponent to Washington, lost his job at the post office. Even Woodrow Wilson, whose racism, Anderson noted uneasily, was "the real thing," found uses for him, and he remained in one municipal office or another until his death in the mid-1930s. Like Morton, Anderson

was a token Negro, placed in charge of a rigidly segregated Negro block of voters and allotted few appointments to hand out to the Negroes who gave his party their votes. The percentage of blacks in New York municipal employment actually declined in the 1910s and 1920s despite the rise in the black population; moreover, the jobs allotted them were overwhelmingly menial ones, many of them in the Street Cleaning Department. By 1930, blacks had obtained less than 20 percent of the positions to which they were entitled by their numbers; even the despised Italians, next lowest on the totem pole, could claim 27 percent.

New York politics in those years, Democrat and Republican alike, were machine politics whose viability rested on a network of strong neighborhoods, each pushing and negotiating its own interests. But Morton and Anderson were the only blacks to have any political power; their jurisdiction was all of black Manhattan. This meant that Harlem's many and diverse neighborhoods, whatever their needs and party allegiances, had to funnel their political agendas through Anderson's or Morton's office. No local constituency could define, much less push its own demands; everything was subject to their approval. Their hegemony, limited though their actual power was, effectively prevented the development of just the grassroots, neighborhood-based political activity that made the Republican and Democratic machines effective and in any sense democratic.

Katznelson sums up the failure of Harlem politics in the 1920s by explaining that its elected leaders "were not descriptively representative of the group as a whole," and in this, too, they were different from their white ethnic peers. While politics served as a means of upward mobility for white ethnic politicians, high social status was a prerequisite for the Negro politician. According to Theodore Lowi, only 41 percent of New York's Irish politicians in the 1910s were better trained and educated than their constituents and only 36 percent of Jewish ones; these politicians closely mirrored the social status of those they represented. But 87 percent of Negro officeholders were superior to their constituents in professional skills and training. The blacks who held office had been selected, in other words, *because* they were cut off from their roots; they had allegiances only to those above them, to their white bosses, not to those below them who had voted for them. What little power was given to blacks on the city level in New York by the nation's major party organizations was shrewdly designed to abort any genuine and intelligently self-interested political life Harlem might have fostered.

To complete the picture, the base of economic prosperity on which some minority groups had built their political influence, most notably Jewish New Yorkers, was an impossibility for a people paid lower wages and charged higher rents than any other group in New York. Even the black bourgeoisie

could not hope for steady employment or financial security, as the failure of the Paul Laurence Dunbar Apartments, John D. Rockefeller, Jr.'s select middle-class housing complex, which opened in Harlem in 1928, bore witness. They were a small group in any case. Remember that in the midst of the most astonishing prosperity America had ever enjoyed, 71 percent of Americans were living on incomes of $2,500 or less, and most Harlem residents fell into this category. Not surprisingly, the symptoms of poverty —soaring rates of mortality, disease (especially tuberculosis), violent crime, prostitution, gambling, juvenile delinquency, school dropouts, and rip-off cult quackeries of various kinds—multiplied and intensified in Harlem over the course of the decade.

Politics, even in the corrupt form of selling and delivering votes to a political machine, did not, then, provide upward mobility for blacks as it did for other urban outsider or minority groups in New York. Indeed, blacks began to achieve some political power only when the party machines were dismantled over the course of the 1930s, 1940s, and 1950s. Greater numbers of Negroes meant more votes to cast and deliver, but they also spelled the possibility of increased black influence in municipal life. In the minds of New York's white politicians, the dangers of increased black power outweighed any benefits to be reaped from having more Negro voters; hence the extremely limited rewards granted Anderson and Morton and their constituents. It's the same logic by which more black residents in any part of the city always meant higher rents for the Negroes who wished or were compelled to live there; Negro numbers were a threat for which Negroes themselves had to pay.

The contrast between the Negro and the immigrant was sharply underlined by the fact that the black ghetto's walls were rising in exactly the same years that those of the immigrant ghettos were crumbling. Allan Spear concludes that only blacks knew the ghetto in its most basic definition, as the place that "offers no escape," and the reason was as old as America's inception. From Robert Park, Chicago's leading urbanologist of the 1920s, to more recent scholars like Katznelson, Spear, and Lowi, all students of black urban communities in America have concluded that what distinguished and separated their fate from that of all other ethnic groups was the unrelenting racism they faced.

I have said that the essentialist tactics available to white middle-class women's groups in search of greater power and status were not accessible or attractive to comparable black women's groups. Harlem's intellectual and cultural leaders in the 1920s had scant use or motive for essentialist arguments either, but they faced an essentialist mentality everywhere they turned. To be black

meant, in the mind of white America, native or immigrant, to be inferior, discountable except as a threat. Houston Baker has argued that black intellectuals must retain "race" as a category, a more or less absolute classification, because whites so often see and treat blacks from that perspective only. The characteristic physical differences between blacks and whites—skin color, bone structure, hair texture and type—may be relative in biological terms, but they make, in Baker's words, a "painfully significant difference" in social and political terms, "perhaps *the only* significant difference where life and limb are concerned" in a hostile world. Just as later critics have concluded, defeat was built into the enterprise of black Manhattan, but not by its Negro leaders.

Contrary to the experience of America's immigrant and ethnic groups, more blacks spelled less political power, not more; the most basic law of American democratic life, by which greater numbers translate into greater influence, did not operate for black Americans. What real political power Negroes in New York and in the nation might acquire would have to be conferred, as it was in the 1950s, by the government, in the form of Supreme Court decisions overruling local law and prejudice, or seized, as it was in the 1960s, by black militants in the teeth of such prejudice. Unlike their descendants, however, the black leaders of the 1920s, Du Bois, James Weldon Johnson, Charles Johnson, and A. Philip Randolph, were unwilling to use the consistent threat of violence, even had they commanded it, to achieve the ends votes were powerless to effect. Their reasons were sharply pragmatic.

Garvey's back-to-Africa position was shrewdly argued if poorly implemented. He repeatedly reminded his followers that blacks in America faced a situation quite unlike that in Africa and much of the Caribbean, for they were a tiny minority in an overwhelmingly white country. Minorities seldom achieve their rights; the price of violence is prohibitive in the face of a well-armed and hostile majority, and no majority "in all human history," as Garvey insistently put it, has voluntarily given justice to what it deemed an inferior and weak subgroup. Garvey was as sure as Du Bois, Randolph, or Weldon Johnson that only black America, and more specifically Harlem, was equipped and motivated to take the leadership role in worldwide black emancipation, but only Africa to his way of thinking was physically remote enough from the white European and American power block and sufficiently stacked demographically toward black rule to offer an open arena for black independence and achievement. Garvey's critique was endorsed by the Talented Tenth he despised, but his conclusion—migration to Africa—was not; what Garvey again and again underestimated was the strength of the Negro's conviction that America was his country, too. Whatever his African origins, the New Negro believed that the struggle must be fought here, and in ways

that eased rather than intensified racial tensions, that assured him a stronger welcome, not a still fainter one, in the land he called home.

The New Negro wished to remain in America, and he was not sure in any case that violence was necessary to achieve his aims. The simple but critical truth was that he had not yet tried, much less exhausted, all other possibilities. The Negro had not yet been, or been recognized as being, a conscious cultural force, part of the artistic power and hope of the nation; Harlem as geographical site and psychological energizer was a base from which to develop, express, and promote just such a cultural force. Until the efficacy of Negro cultural clout was tried and found—as it would be—wanting, who could say what its possibilities and limitations were? It is part of the importance of the Harlem Renaissance that it made that trial, that it dramatized for later black activists and artists where the usefulness of cultural means ended, the point at which other means—those devised in the 1950s and 1960s by Martin Luther King, Jr., and Malcolm X—became imperative.

Harlem's leaders in the 1920s were acutely conscious of the test-case nature of their movement. In his autobiography *Along This Way* (1933), Johnson warned his white readers that if they were not willing to share their power with blacks, if they refused to give the Negro justice, "there will be only one way of salvation for the race . . . and that will be through the making of its isolation into a religion and the cultivation of a hard, keen relentless hatred for everything white." The real end of the Harlem Renaissance came, not with the onset of the Depression, but five and a half years later, on March 19, 1935, when thousands of blacks, protesting the brutalization of a young Puerto Rican shoplifter named Lino Rivera at the hands of white policemen, took to the streets and destroyed $2 million of white property. Effectively deployed or otherwise, this full-scale violence gave the lie to the dream of racial collaboration on which the Harlem Renaissance was founded. The "Black Arts" movement of the late 1960s, led by Amiri Baraka, emphasized the defiantly different and separate nature of black artistic self-expression, not, as the renaissance had by and large done, the resources and styles shared by blacks and whites. Militant black artists of the last four decades, right up to today's gangsta rappers, have used their art as an assault on white culture rather than as a bridge to it.

Garvey wanted to transform derogatory race essentialism into affirmation. "The world has made being black a crime," he wrote; "I hope to make it a virtue." Du Bois, too, believed that blacks must "train" themselves to see "beauty in black," but he never wanted blacks, as Garvey and the militant leaders of the 1960s sometimes did, to see beauty *only* in black. He aspired to be pro-Negro rather than anti-white. It was inevitable in a racist culture that black men and women would sooner or later adopt their own brand of

essentialism and race prejudice, but such a posture spelled self-betrayal to the Harlem Renaissance mind, not defiance of their white oppressors but repudiation of a valuable, if conflicted and troubled, part of themselves, the part that made them irretrievably American. The renaissance marked an end as well as a beginning; it was the trial run for a set of hopes and aspirations as important to Euro-America, whether or not it knew it, as to Aframerica. When those hopes were defeated, "America" entered its real postmodern phase as the not-so-United States.

Black New Yorkers chose culture rather than politics for their self-expression, then, for several reasons. It was congenial to what many blacks and whites already recognized as an artistic people; more important, in the dawning age of the mass media and an all-out consumer society, culture was itself a palpably important form of politics. In his sometimes scathing critique of the Harlem Renaissance in *The Crisis of the Negro Intellectual*, Harold Cruse discusses at length the strike by black projectionists at Harlem's white-run and -owned Lafayette Theatre in 1926, and his analysis is crucial to this point. Black projectionists had only recently been admitted as members to Local 306 of the American Federation of Labor, and they were now demanding equal pay and status with the white projectionists employed by the same management. Although they won a nominal victory, this is not what compels Cruse's attention. What he emphasizes is that the strike was provoked, not by police brutality or by the inequitably high rents all black workers in Harlem were paying, but by events "*on the cultural plane*"; it was the result of "*the impact of [the] developing American cultural apparatus*" on the black community, and for Cruse as surely as for Du Bois or Johnson, the "cultural plane" is the critical one.

Cruse is convinced that, for Harlem in the 1920s, cultural, political, and economic factors were indivisible, but his awareness of the fate of the Harlem Renaissance, its dead end in the Depression years, kept him, I think, from seeing that its leaders saw the connections between culture, economics, and politics as clearly as he did. They may have fallen prey to the weaknesses inherent in using culture as a substitute for the economic and political arena; they may even have been, as he suggests, "emasculated" in some sense by white "cultural paternalism," but still, they played a shrewd game and, equally important, it was perhaps the only one open to them. They had no choice but to bet on the only horse willing to run under their colors. The most pressing reason for the New Negro's decision to work through culture, not politics, was that this was the closest Harlem could come to so-called real politics. When whites in the 1920s abandoned traditional politics for the realm of culture and artistic expression, they were turning their backs, as some of them discovered in the 1930s, on an arena wide open to them

had they chosen to enter it. In contrast, blacks, barred from most meaningful direct political activity, were not abandoning politics so much as translating politics into cultural terms. To be black in modern America was a command to strategize, and New York was the place to do it; by the end of the Great War Harlem had become the center of whatever black protest America could engender.

THE SILENT PROTEST PARADE

New York had long sponsored most white-financed Negro philanthropy: the Armstrong Association, the board of trustees of Tuskegee Institute, the Phelps-Stokes Foundation, and many similar organizations were located in the city at the turn of the century. By a logical progression, over the next decade or so, civil-rights organizations made New York their home, too, and whatever the limitations of their power and influence, whatever their ties to white leadership and funding, their presence was critical. New York was headquarters to the NAACP, dedicated to fighting anti-black violence and to mobilizing and protecting the Negro vote; to the National Urban League, founded in 1911 and intent on improving the Negro's economic status; to A. Philip Randolph's Trade Union Committee for Organizing Negro Workers, which began in 1925 and resulted in the pioneering and largely black Brotherhood of Sleeping Car Porters, the union with which Randolph is chiefly associated; and to Garvey's Universal Negro Improvement Association, founded in 1914. The magazines and newspapers associated with these organizations and others like them—*The Crisis, Opportunity, The Messenger,* Garvey's *Negro World,* Hubert Harrison's *Negro Voice,* and Cyril Briggs's *Crusader*—were of course New York–based as well.

Black journalism gained new vigor, authority, and independence in the late 1910s and 1920s. In 1920, Robert Klein, a white college teacher in Virginia, published a little book on the phenomenon titled *The Voice of the Negro: 1919.* His survey of black periodicals convinced him that blacks were going to their own papers for information and ideas as never before and that only in the black press could one find Negroes saying what they really thought. Black newspapers were now seen on newsstands in white as well as black neighborhoods; some, like Pittsburgh's *Courier* and Chicago's *Defender,* reached cities all across the nation. Fifty new black newspapers and periodicals appeared between 1916 and 1921, bringing the number of such publications to 500, and New York led the way with 17; the number of black newspapers in the city doubled between 1912 and 1921. Not surprisingly, the Associated Negro Press, founded in 1919, had its headquarters in Harlem.

One reason that black Manhattan was relatively free of riots and the Klan in the 1920s was the fact that it served as Aframerica's arsenal; whatever their shortcomings, its organizations and publications represented pretty much the Negro's entire repertoire of traditional political effort and commentary.

Wide-scale black violence, or the threat of it, might be in the future, but black violence was nonetheless on the rise, and this is the single most important fact to keep in mind in trying to understand black Manhattan and its renaissance. The race riots and disturbances of the day—more than twenty in the summer of 1919 alone—all started with violence on the part of whites against blacks. In East St. Louis in 1917, the trouble began with white gangs beating blacks; in Houston, also in 1917, with the unwarranted arrest of a black woman. In Longview, Texas, in 1919, the riot began with a lynching; in Elaine, Arkansas, with white policemen firing into a black church. In Chicago, trouble started when whites stoned and killed a black swimmer in Lake Michigan. But these events escalated into full-scale national incidents when blacks—and this was the new development—forcibly defended themselves against their aggressors. In St. Louis and Longview, blacks opened fire on the whites who were attacking them; in Chicago, black mobs turned on whites. In some instances, moreover, the original provocation for white violence was self-assertion on the part of Negroes; in Elaine, Arkansas, whites were upset because blacks were trying to organize a union.

Almost without exception, the Negro press cheered the new black militancy. The August 1920 *Messenger* proudly pointed out that the Negro who fought in the Great War to make "the world safe for democracy" was also willing to fight to make "America safe for himself." A year earlier, *The Messenger* had published McKay's sonnet "If We Must Die," in which he celebrated the courage of the blacks caught in the Chicago riot: "like men [they] faced the murderous, cowardly pack / Pressed to the wall, dying, but fighting back!" Writing in *The Crisis*, Du Bois, sometimes known as "the father of militant race journalism," encouraged African Americans to use force when attacked; in a moment of anger in 1920, he predicted a race war in which Negroes, allied with Asians, would overcome white Americans. The Justice Department, investigating black newspapers and journals at this time, concluded that they were "antagonistic to the white race and openly, defiantly assertive of [their] own equality and even superiority." J. Edgar Hoover, director of the Federal Bureau of Investigation, singled out *The Messenger* as "by long odds the most able and most dangerous of all Negro publications."

The accommodational moves made by most of Harlem's black leaders did not conflict with such race militance but rather expressed and fulfilled it by extending it to conscious and sustained strategizing. On July 28, 1917,

Weldon Johnson and Du Bois, responding to the riots in East St. Louis and elsewhere, brought this strategy to perhaps its finest realization in the Silent Protest Parade, the first massive Negro protest in American history. Some 10,000 blacks marched down Fifth Avenue in absolute silence save for the roll of muffled drums; women and children wore white, men black. Mayor John Purroy Mitchel had closed down traffic, and even the whites who gathered to watch kept silent. Placards were visible—"Mother, Do Lynchers Go to Heaven?" and "Mr. President, Why Not Make *America* Safe for Democracy?"—and a young Negro Boy Scout passed out a leaflet, later reprinted in the black and the white press, that read:

> We march because the growing consciousness and solidarity of race, cou-
> pled with sorrow and discrimination, have made us one, a union that may
> never be dissolved . . . We march because we are thoroughly opposed to
> Jim Crow cars, Segregation, Discrimination, Disenfranchisement, Lynch-
> ing, and the host of evils that are forced upon us . . . We march because
> we want our children to live in a better land and enjoy fairer conditions
> than have been our lot.

Johnson, the parade's organizer, was the chief exponent and practitioner of the Harlem brand of politics. He believed that the most important of the freedoms granted the Negro by the various proclamations and constitutional amendments of the Civil War and Reconstruction years was one he defined as "the [Negro's] right to contend for his rights," and no one exercised it more vigorously and intelligently than he. His "method," in his words, was one of "firm but friendly pressure," and the friendliness and the firmness were both unmistakable.

Born in 1871 and raised in Jacksonville, Florida, trained and experienced as a lawyer, musician, and teacher, Johnson began as a Bookerite. Washington had used his influence to obtain consulships for him in Venezuela and Nicaragua during T.R.'s administration; after Washington's death in 1915, Johnson continued to deploy all the old master's political skill in the pursuit of an increasingly aggressive agenda. In 1916 he joined the NAACP as its field secretary, becoming executive secretary in 1920, and found in Du Bois, Booker's greatest adversary, a colleague and ally. It is one of Johnson's most notable achievements in his NAACP years that he kept the notoriously prickly and irascible Du Bois's trust and confidence. No one else could get on with him for long, and when Johnson left for the South in the early 1930s, the final collapse of Du Bois's relations with the *Crisis* board was inevitable. A man of the utmost compassion as of the strictest conscience,

sensitive and almost celestially tactful, Johnson had a gift for friendship with difficult men, a rare ability to give others his respect without sacrificing his own autonomy and authority. His goodheartedness had a keen pragmatic edge, however, half optimism, half Machiavellian savoir-faire; the corrupt Charles Anderson was a friend as well.

When Johnson joined the NAACP in 1916, the organization had roughly seventy branches, most of them in the North, a membership of approximately 9,000, and an annual operating budget of $14,000. In 1920, after four years of his tireless traveling and proselytizing, it could claim branches all over the country and a membership of 90,000. A brilliant fund-raiser, Johnson proved as attractive and skillful at enlisting whites as he was with blacks. When the Fund for Public Service organization voted in 1925 to give $15,000 to the NAACP if it could raise $30,000 elsewhere, Johnson successfully met the challenge. Aided by his director of public relations, Herbert Seligmann, he brought national press attention to pressing NAACP concerns, and he put NAACP funds and expertise behind a series of landmark civil-rights cases, most notably *Nixon v. Herndon* in Texas in 1924; the NAACP argued that the Texas primary system that excluded blacks from voter participation was unconstitutional, and won. Johnson's most difficult struggle came in the early 1920s with the Dyer anti-lynching bill. He was the chief and most effective lobbyist for the bill, and in good part responsible for its successful passage in the House of Representatives. The bill lost in the Senate when Johnson was unable to persuade William Borah of Idaho to support it, but Johnson's biographer, Eugene Levy, has pointed out that he had still won an important victory; this was the first time that a black-led civil-rights group had engineered a push through Congress for laws concerning blacks.

In his autobiography, *Along This Way*, Johnson described his work for the NAACP as the center of his life in the 1920s, devoting scant space to his invaluable services to the Harlem Renaissance as editor, critic, historian, musicologist, novelist, and poet. But at bottom, for Johnson as for many of his Negro peers, the two activities, artistic and political, were one. The year of the Silent Protest Parade, 1917, the first complete year of Johnson's secretariat at the NAACP, was also the year he published his first collection of poems, *Fifty Years and Other Poems*; the title poem, one of Johnson's most eloquent, was a reminder of the hopes and fears that had compelled black America in the fifty years since the Emancipation Proclamation. If the Harlem Renaissance ended with the riot of 1935, one might argue that it began, not in 1923 with the publication of *Cane*, or in 1924 with the Civic Club gathering in honor of Fauset's *There Is Confusion*, but on July 28, 1917, the day of the Silent Protest Parade. Both parade and renaissance

turned protest into something like organized and conspicuous theater; both advertised their precarious psychological location between justified rage and creative restraint.

In lieu of more obvious arenas, cultural participation gave the New Negro the only form of suffrage available to him, and none of those participating in black Manhattan's renaissance was unaware of it. One of Johnson's friends and greatest contemporaries was the Negro entertainer Bert Williams, Eddie Cantor's sometime partner in the *Follies*, the man to whom Hemingway paid homage in his poem "To Will Davies." Born in 1874, closer in age and temperament to the older school of genteel Negrohood than to the New Negro's assertions of racial pride, Williams was apparently one of the least politically minded talents of black Manhattan. He started out in black minstrelsy, and he was still doing his blackface act at the time of his death in 1922. Entertaining at private white parties, he liked to begin his act with the query "Is we all good niggers here?"

In *Follies* shows of the late 1910s, Williams and Cantor put on a father-son blackface act, and they called each other "Pappy" and "Sonny" offstage, too—another sign, one might say, of cross-racial genealogical repositioning. But, socially and culturally, Cantor's claim on Williams, unlike Crane's alliance with the "black man in a cellar" or Cunard's espousal of the "Black Man," marked a step *up* for the white person involved, not a step down. Dubbed the "Apostle of Pep," Cantor was an ill-educated, Yiddish-speaking kid from the Lower East Side who liked to boast that he "took to life as a darky takes to rhythms." In contrast, the light-skinned and consummately melancholy Williams was descended from old West Indies stock and every inch, in Cantor's admiring words, "a true gentleman." Cantor's art was plebeian and rowdy all the way, but Williams was an aristocrat of comedy; his timing was a marvel of artful reserve, long pauses, and impeccably phrased elisions. Offstage he spoke flawless English with a light West Indies accent. When he donned blackface, he became, in his own words, "another person." Unlike Cantor, he said he had to work and study to play the shiftless "darky," because "he is not in me." Williams believed that "the man with the real sense of humor is the man who can put himself in the spectator's place and laugh at his own misfortunes"; his act was built, in other words, on his ability to look at the darky as the white man did, purposely to elicit white laughter at black sorrow.

Williams himself added a clause to his contract with Ziegfeld that stipulated he would never be onstage when any of the white female members of the *Follies* were there, and he also obtained Ziegfeld's promise that he would not be asked to tour the South. On tours elsewhere, he accepted without protest the segregated and inferior quarters assigned to even such Negro

superstars as himself. A humane and sophisticated man, Williams found the prejudice he encountered barbaric, grotesque; he imagined a coming age that would barely be able to credit such attitudes, but his reflective and pessimistic temperament made it impossible for him to engage in patently futile protest activities. He urged that Negroes adopt a "conservative" and "individual" response to racism. Williams paid a price for his restraint. The alcoholism that contributed to his death (officially from pneumonia) was the mark of one who had abandoned hope of full self-expression. But his formulation nonetheless left some latitude for the "individual" Negro, and in that latitude he found his art.

Once, in a St. Louis bar, when a white bartender, clearly trying to shake his patronage, told him that gin here was $50 a glass, Williams pulled out $500, put it on the bar, and said, "Give me ten of them." Not a word of protest has been uttered, but the victim has nonetheless become the avenger. Williams perfected such reversals onstage. In a 1911 *Follies* number with the white English comedian Leon Errol, he played a colored porter in Grand Central Terminal, a version of the perennial "Cuff" figure of early minstrelsy; Errol was the bossy and demanding white tourist who hires him. Like Williams's later partnership with Cantor, the Williams-Errol duo was a Mutt-and-Jeff pairing: Williams was very tall, Errol very short. In the skit, the two get lost in a construction site, and Errol cannot navigate the terrain on his own. The white man literally becomes the black man's burden, as Williams ties Errol to him by a rope, alpine-style. He saves him from one calamity after another—all, it turns out, for a 5-cent tip. Exasperated, he lets the little man drop off a girder and throws his suitcase after him for good measure, then watches as he falls to his death. (We, of course, don't see Errol, but extrapolate his course from Williams's gaze and commentary.) Errol hits the construction site below; then he's blown back up into the sky, and almost, the porter sees, grabs hold of the Metropolitan Tower in his flight. "Um," Williams notes, unperturbed but interested, "he muffed it!"

The obviousness of the subversion in this skit, written by Williams and Errol themselves, is unusual in Williams's numbers, but subversion was present in every Williams performance. His was the art of patience protracted despite abuse and misfortune, but his act also reminded viewers that all patience wears out sometime; that's always the end of the story, whether depicted or not. His signature song, "Nobody," concludes:

> *I ain't never done nothin' to nobody,*
> *I ain't never got nothin' from nobody, no time.*
> *Until I get somethin' from somebody, sometime,*
> *I'll never do nothin' for nobody, no time.*

Williams made a great show of reluctance when audiences called for this standard number, even pulling out a piece of paper from his pocket that supposedly contained the song's lyrics, then reading them, as if with difficulty, and making "mistakes." (Audiences loved the ploy.) His legendary appeal as a performer lay in just this omnipresent sense of reluctance; he'd really just as soon, as the drooping shoulders, slow shuffle, and mournfully reserved face attest, not perform at all. In every line he spoke, every step he danced, one felt a dash of death wish. But there was also an element of refusal in his art more powerful for being understated. His singing style was closer to talking than singing; his spirits were never quite high enough, it seemed, for the impudence of song, and his listeners had not, in any case, merited so supreme an effort. The last line of "Nobody" was Williams's comic and not so comic threat to his audience that he might resign his post as their entertainer. As he put it in another of his best-known numbers, "I'm gonna quit, yes suh, Sattiday!" Not today, but someday, someday soon. Williams's lawyer and friend Henry Herzbrun had a long, frank discussion on many topics with his well-read and thoughtful client just days before his death on March 4, 1922, and he later reported that the "political" views Williams shared with him on that occasion were "radical." Publicly conservative views did not rule out private radical convictions or active artistic subversion; for Williams as for his more militant Negro peers and heirs, cultural expression was political activity, and it was, at moments, a highly effective form of it.

The audience for Negro music and performers abroad grew in the postwar years, and it was one that Williams had helped to create. Back in 1903, he and his first and greatest partner, the ebullient George Walker, had had a hit in London with their all-black musical of African life *In Dahomey*; on June 23, 1903, they played a command performance at Buckingham Palace to celebrate the birthday of the young Prince of Wales. Williams sang his popular number "Evah Darkey Is a King!" but the royal family took no offense. The London triumph guaranteed and intensified domestic appreciation of Williams's work. Blacks, led by Frederick Douglass, had long used Europe as a court of higher appeal; foreign admiration helped in the struggle for independence and justice on American soil, but no earlier generation had the impact that Williams and his most gifted heirs did. In evaluating the New Negro's strategy of empowerment through art, one must remember that it is difficult altogether to ignore or devalue a group receiving the plaudits of the outside world; black art engendered followings that sometimes doubled as constituencies, lobbies, and even armies.

THE NEGRO DIGS UP HIS BLACK-AND-WHITE PAST

In *Our America* (1919), Waldo Frank announced the task of the decade to be that of recovering America's "Buried Cultures," and it was during and just after the war that white colleges began to include Euro-American writers in their curricula and black colleges in the South introduced courses in African-American culture and history. If Euro-America discovered that, unbeknownst to itself, it had already produced a classic American literature, Aframerica's promoters told a surprised world about its own tradition of literature, music, and art. Many white writers helped to excavate the Euro-American past, and many more in the Harlem Renaissance became archaeologists of the African-American tradition and publicists of its importance. They, too, wished to rewrite genealogies, and they insisted that the black man took precedence over the white one, that white achievement was built on black achievement, not the other way around.

In 1916 Carter G. Woodson, the "Father of Black History," trained at Chicago and Harvard, founded the Association for the Study of Negro Life and History in Washington, D.C., and began publication of the *Journal of Negro History*. In 1926 he established Negro History Week, to be held in February, the month in which both Lincoln and Douglass were born; he had already edited and reissued a collection of Phillis Wheatley's poems in 1915. One of Woodson's ablest collaborators was Harlem's tireless and generous Arthur A. Schomburg, born in Puerto Rico and educated in the West Indies, who had anticipated Woodson's association by five years, founding the Negro Society for Historical Research in New York in 1911. Over the next fifteen years, Schomburg amassed the largest private collection of books and papers on Negro history and culture in the United States. In 1926, his collection was bought—at one-fifth its actual value—by the 135th Street branch of the New York Public Library (rechristened the Schomburg Library, it is still in operation today), and under his continued guidance, it became one of the central collections of African and African-American materials in the world. Librarian Ernestine Rose's teas, readings, and literary gatherings made the 135th Street branch a center of Harlem's cultural life, and the collection itself provided invaluable ammunition for those trying to establish the New Negro's credentials and pedigree. As Schomburg put it in "The Negro Digs Up His Past," an essay included in Locke's anthology *The New Negro* (1925), "Here is the evidence"; in its light, "certain chapters of American history will have to be re-opened."

Schomburg tells us that the the black abolitionists were not, as the "public too often [thinks] . . . a group of inspired illiterates, eloquent echoes of their [white] Abolitionist sponsors," but the hardest workers and most gifted spokes-

331

persons, the real leaders of the antislavery crusade. In his words, the American Negro had been "throughout the centuries of controversy an active collaborator, and often a pioneer in the struggle for his own freedom and advancement"; now he "must remake his past in order to make his future. For him, a group tradition must supply compensation for persecution, and pride of race is the antidote of prejudice. History must regain what slavery took away." Like Jean Toomer in *Cane*, intent on ending black as well as white amnesia about slavery, Schomburg believed that the Negro past, long a source of racial shame, might become, once it was acknowledged and explored, a source of racial pride, if only because of the African-American protest and art it had produced. He, too, thought that Negro art was the shortest route to Negro rights; blacks were at last being recognized, he argued, not because of any politically or economically aggressive activity on their part, but because of the "growing appreciation of the skill and beauty and, in many cases, the historical priority, of the African crafts." With this heritage now made available, "the ambition of Negro youth" could at last be "nourished on its own milk."

The New Negro volume was dedicated to explaining the riches of the black heritage, and in his own essay, "The Legacy of the Ancestral Arts," the editor, Alain Locke, emphasized the importance of the recently discovered abstract art of Africa to the European avant-garde pictorial and plastic arts. Citing Picasso, Matisse, Derain, Modigliani, Utrillo, Archipenko, and Lipchitz, among others, Locke, ever a champion of miscegenation, claimed that the influence of African art had saved European artists from "decadence and sterility," the result of "generations of . . . inbreeding of style and idiom." He also pointed to the influence of Negro music on white composers like Poulenc, Stravinsky, Satie, and Dvořák, whose *New World Symphony* used Negro spirituals introduced to him by the black composer Harry T. Burleigh. The New Negro had discovered, in Locke's words, that he was "not a cultural foundling without his own inheritance" but "a conscious contributor . . . collaborator and participant in American civilization."

Dvořák's enthusiasm for the spirituals was widely shared; they had been the first Negro art form to win a wide hearing among whites at home and abroad. In 1871, in a fund-raising effort for their school, the Fisk Jubilee Singers arranged a collection of spirituals for the concert stage and began a long and successful career in America and Europe that spawned many followers and imitators. Both black and white turn-of-the-century minstrel shows incorporated spirituals into their programs. Du Bois devoted a chapter of *The Souls of Black Folk* to these "Sorrow Songs" in 1903, and interest intensified in the 1920s. James Weldon Johnson—as important to Harlem's cultural archaeology as to its politics—published a two-volume *Book of Amer-*

ican Negro Spirituals in collaboration with his brother J. Rosamund Johnson in 1925. Paul Robeson and Roland Hayes gave concerts of spirituals throughout the 1920s and 1930s for white and black audiences in America and Europe. One of the spiritual's modern descendants, Negro gospel or church music, was also beginning to gain wider attention—the Baptist National Convention published *Gospel Pearls* in 1921—and ragtime, blues, and jazz became national crazes.

I have spoken of the relative paucity of African-American literature before the modern period. Harlem's ablest critics always acknowledged that blacks had made their greatest contribution in music, dance, and oral literature, but they also demonstrated that the Negro's written output had been more voluminous and more valuable than America's white custodians had been willing to admit. Most people thought that Aframerica had produced only two poets before the modern period, Phillis Wheatley in the eighteenth century and Paul Laurence Dunbar at the end of the nineteenth, but in *Black Manhattan*, Johnson showed that thirty-odd Negroes had published poetry in the eighteenth and nineteenth centuries. Nor, contrary to received opinion, was Wheatley the first American Negro poet; always happy to add laurels to his beloved metropolis, Johnson told his readers about Jupiter Hammon, whose poetry appeared in New York in 1760. Harcourt Brace brought out Johnson's pathbreaking anthology *The Book of American Negro Poetry* in 1922, and he modeled his finest book of poems, *God's Trombones: Seven Negro Sermons in Verse* (1927), on the long, vigorous, and eloquent tradition of black vernacular preaching.

The fact that Aframerica's literature had been more often oral than written did not, black critics insisted, detract from its status as art. Arthur Huff Fauset, Jessie Fauset's half brother and another of Mrs. Mason's protégés, was folklorist, historian, and fiction writer combined, and in an essay on "American Negro Folk Literature," collected in *The New Negro*, he painstakingly separated the black folktales he was discussing from the later versions of them given by the white Southern writer Joel Chandler Harris in his popular Uncle Remus stories. Harris's tales were, in Fauset's opinion, only "an apologia for [the] social system" of slavery, and their facile, "winsome," and "highly romanticized" manner presented a sharp contrast to the "masterful," "shrewd," and "subtle" nature of their Negro originals, full of "irony," "intelligence," and "profound and abstract . . . conceptions."

In her essay on "Spirituals and Neo-Spirituals," collected in Nancy Cunard's *Negro*, Zora Neale Hurston explained that, however improvisatory the Negro folk artists' spirituals, sermons, prayers, and fables, a "form" was always being elaborated and observed. Indeed, she disliked spirituals concerts precisely because they abandoned these forms. The singers, usually dressed in

formal attire, were soloists; there was no chorus, no stage sets, and the only accompaniment was a discreet piano background. Set musical arrangements banished the possibilities of improvisation. In the authentic spiritual tradition, however, Hurston said, it's "every man for himself"; real spirituals were emotionally extravagant group affairs of "harmony and disharmony, [of] shifting keys and broken time" finding expression in black "dialects" rather than straight English. Hurston wanted Negro art to stop being ashamed of itself; its irregular and inventive idioms were superior to the white art it sometimes demeaned itself by copying.

Black copies of white art also attracted new defenders. It had long been held that Phillis Wheatley had written in servile homage to the white poets of the day, most notably Alexander Pope, but William Stanley Braithwaite, a prominent Negro editor, critic, and poet, claimed in his essay "The Negro in American Literature," also collected in *The New Negro*, that Wheatley was, whatever her deficiencies, "as good, if not a better poet than [America's first white woman poet] Ann[e] Bradstreet." Although a racial conservative in some matters—he once rejected McKay's poetry as too "Negro"—Braithwaite did not mean to advocate black imitation of white art; whatever his chosen style, the Negro artist was to concede nothing to white prejudice in his self-expression. Braithwaite believed that no white man could write the great Negro novel, because "his white psychology will always be in the way"; the successful African-American artist must "forget, for the time being at least, that any white man ever attempted to dissect the soul of a Negro." Braithwaite was urging black independence of white audiences, not of white influences, and the distinction was crucial to the Harlem Renaissance, literary and musical.

Ethel Waters, a matchless singer and actress, once in full career seldom forgot her white audience, but she had perfected her craft free of the white gaze, and she insisted that white audiences take her on her own terms. She had learned to look after herself young. Born sometime between 1896 and 1900 in Chester, Pennsylvania, near Philadelphia, she was the product of her mother's traumatic rape at the age of twelve. Her mother soon had other children whom she markedly preferred to her firstborn, and almost from infancy Ethel knew herself to be unwanted, even abhorred. Her autobiography, *His Eye Is on the Sparrow* (1951), begins with these chilling words: "I never was a child. I never was cradled, or liked, or understood by my family. I never felt I belonged. I was always an outsider." Ethel was, she writes, of the race of "outcasts."

A slum and street kid, Ethel lived most of the time with her large, poor, and conflict-riddled family of hard-drinking aunts and uncles (she herself

resolved never to drink, and didn't); her tough-minded maternal grand-mother, "Momweeze," who slaved at housework for white families and hungered in vain for respectability, was head of the household. Ethel had little schooling outside of a childhood stint with some Catholic nuns and teachers that left her a Catholic of sorts, and she also gravitated toward the evangelical Negro Church and its rich musical traditions, but she was any-thing but a God-fearing child. Early known for her profanity and her com-mitment to rough-and-ready self-defense, as a young woman she learned pugilist tricks from a boxer lover and beat up rivals for the favors of her male and female lovers. "My imagination seemed to flower most lushly," she wrote in *His Eye Is on the Sparrow*, "when I was threatening people."

A fierce advocate of her own race, Waters declared that "our survival is proof of our strength, our courage and our immunity to adversity." Wearing the chip on her shoulder like a badge of honor, she took pleasure in snubbing prejudiced whites eager to make an exception of her. But there was another, quite different side to what she herself dubbed her "Jekyll-Hyde" personality; she liked to say, perhaps in jest (though all her jests are ominous ones), that her highest ambition was to be that cynosure of polite Negritude, a rich white woman's maid. Her other grandmother, Lydia Waters, the mother of her long-gone father, "looked white," as Ethel described her, and was "a woman of wealth, poise, dignity, and . . . intelligence." Although Ethel disdained Lydia's money, she later acknowledged her influence. A fetching, light-skinned, tall and slender beauty (she'd be vastly overweight in later years), the young Waters was at once melting and tough in manner, artfully mingling flirtation and command.

There were no music lessons for Ethel, but she had seen most of the entertainment Philadelphia had to offer its black inhabitants and she pos-sessed unparalleled gifts. By the mid-1910s, she was working on the black vaudeville circuits of TOBA, so called for the (white) Theatre Owners Book-ing Association that ran it, though black performers said that it really meant "Tough on Black Asses"; she picked up W. C. Handy's "St. Louis Blues" and made it a signature song. Billed as "Sweet Mama Stringbean," she specialized in a blues style that was "new," "sweeter," and "smoother," in her words, than the one the great blues shouters like Ma Rainey and Bessie Smith were making popular with black audiences. While Ma and Bessie were Deep South talents, soaked in rural black life, from the start Ethel had a clear-as-a-bell Northern, urban sound. "I could always riff and jam and growl," she noted with a characteristic hint of disdain, "but I never had that loud approach."

In the early 1920s, Waters began singing at Edmond's Cellar, a Harlem dive, and attracting wider attention; in 1921 she did her first recording, "Oh

Daddy," on the Negro Black Swan label. Although her sophisticated blues were ideally suited for white audiences, she refused various offers to take her act into white show business. From 1915 or so until 1924, when she appeared in the *Plantation Revue* in a white theater in Chicago, Waters performed exclusively for blacks. Always primed for rejection, she feared whites wouldn't like her music; equally important, she didn't want to regularize it for audiences who lacked the background and instinct to appreciate it. Whites are "off the beat most of the time"; they wouldn't "understand my blues." She had done a few blackface "Jane Crow" parts in her early days, but she soon refused to "exaggerate . . . my characterizations" or play the "buffoon" to please an audience. "I ain't changin' my style for nobody or nothing," she said.

As it turned out, Waters, an inventive vocalist who alternated effortlessly between light comedy and tragic pathos, could sing white or black and delighted in doing both, sometimes in the confines of a single song. On her 1932 recording of Dorothy Fields and Jimmy McHugh's hit "I Can't Give You Anything but Love," she sang the first stanza in a crisply cultivated and white feminine manner, then shifted into a perfect imitation of the palpably masculine, sexual, and Negro Louis Armstrong (who'd recorded the song in 1929), complete with slurred diction, down-and-dirty growls, off-beat swagger, and scatting. Waters helped to invent pop-jazz singing, and her mix of irrepressible vitality and high artifice held together by a supreme and willed repose went over as big with white audiences as with black. She switched to the mainstream Columbia label in the late 1920s. Noted composers and lyricists of both races, including Andy Razaf, J. C. Johnson, Irving Berlin, Henry Akst, and Harold Arlen, wrote songs especially for her, and Van Vechten became one of her closest friends and best publicists. In 1939 Waters began a second career as a dramatic actress in Dorothy and DuBose Heyward's all-black-cast *Mamba's Daughters*. The white critic Arthur Pollack proclaimed her "one of [our] finest actresses black or white," and blacks idolized her as well. Garvey had urged Negro men to "take down the pictures of white women from your walls" and replace them with pictures of black women, and Langston Hughes heeded his advice; he wrote *The Big Sea*—the book that concludes with his break from Mrs. Mason—with a large photograph of Waters in *Mamba's Daughters* over his desk.

Waters's all-black apprenticeship during the second decade of the century was an important part of theatrical and racial history. Black musical theater had enjoyed a first flowering on Broadway between 1895 and 1909, the heyday of Bert Williams, but a series of deaths and career shifts among black performers and songwriters, not to mention the swelling tide of racism that resulted from the increasing numbers of Negroes migrating from South to

North, led to a dearth of black offerings in the next decade. In *Black Manhattan*, Johnson, himself a major songwriter of the 1900s, called the years between 1910 and 1917, the time when Waters began her career, "the years of exile" for black artists. But one can look at the period differently, as Allen Woll has in his seminal revisionist study *Black Musical Theatre* (1989), arguing that these were actually years of opportunity and growth for black performers.

The white entertainment establishment had censored Negro art in two ways: it did not allow black artists to express freely their Negro legacy, but it also prevented them from tapping the "white" elements of their heritage. White audiences from the mid-nineteenth century through the early twentieth century and beyond were quick to accuse adventurously intelligent or visibly trained black performers of pretending to be white, of not delivering the "coon" style they expected. When the sophisticated and elegant *Put and Take*, a Negro revue self-consciously free of the minstrel element, opened on Broadway in the summer of 1921, one reviewer, Jack Lait, reproved its cast in *Variety* on August 26 for being too "dressed up and dignified." When it came to white materials and styles, he explained, "colored performers cannot vie with white ones." Lait asked that Negro entertainment be "different [and] distinct" from that of whites; he wanted "picks [pickaninnies], Zulus, cannibals and cottonpickers." *Put and Take* lasted only a few weeks before leaving Broadway for the road. Black performance was supposed to confirm white prejudice, not challenge it.

To be banned from a Broadway that imposed such limits on its Negro talent, to be confined to appearances in black touring companies on black circuits outside New York and black Harlem repertory companies inside it, was not, then, altogether harmful; it's another instance of the benefits of segregation seen in the territorial status of Harlem itself. Negroes in theatrical exile gained more in freedom from white censorship than they lost in mainstream exposure. "Perform[ing] primarily for black audiences," in Woll's words, black performers "developed new skills, techniques and theatrical techniques without the constraint of white audiences and critics." James Weldon Johnson thought that the years of exile ended in 1917, the year of the Silent Protest Parade he helped to organize, the year that saw the publication of his *Fifty Years and Other Poems*. Using his chronology against his argument, one might say that the years of exile did not delay but rather produced the Silent Protest Parade, *Fifty Years*, and, by implication, the renaissance itself. The so-called years of exile may mark the start of Aframerica's post-colonial period, of the New Negro's complex cultural emancipation from white America.

By this reading, Waters's self-imposed exile from the white public between

1915 and 1924 was an enabling act; it allowed her to develop her special art, one more musically and theatrically varied and sophisticated, more black-and-white, than white audiences of the day would have permitted. As a young woman performing on the black vaudeville circuit, she sometimes began her act by remarking, "Well, I'm not Bessie Smith." She was not being modest (she seldom was); rather, she was announcing that she didn't sing in the expected Deep South, Negro manner. The line apparently delighted her black audiences, hungry, in her account, for more sophistication than Bessie and Ma Rainey offered—though it understandably irritated Bessie, with whom she was working when she used it. Waters's black-and-white style spelled, then, less her capitulation to white audiences than her independence of them. This is a central point: Waters developed her sophisticated mongrel style for her black listeners, not her white ones.

A woman of uncanny if partial perceptions, Waters noted and claimed to fear her own powers as a "medium"; she never showed more acuity than in her refusal to appear before white audiences until she, and they, were ready, until her style was fully formed and invincibly her own. Out on the black vaudeville circuits and in Harlem's cabarets, she could forget that any white man had ever attempted to "dissect" or limit "the soul of a Negro." Where Bert Williams worked within the white stereotype of the Negro, Waters in large part rejected it; both were masters of seduction, but where his cultural politics were subversive, hers were aggressive. She belonged to the younger branch of Harlem politicians, he to the older; she claimed a freedom he could not. For Waters, black cultural independence meant singing exactly as she chose.

Waters never lost the fierce integrity she had forged in her decade of playing for all-black audiences. A super-smart custodian of her own talent, she always demanded top pay, top *white* pay, for her services—in 1933, making $1,000 a week, she was, by her account, the highest paid female star on a Depression-depleted Broadway—but she sometimes went hungry rather than do work she felt to be demeaning to herself and her race. Although she wouldn't change her style "for nobody," she did expect whites to change their style for her. DuBose and Dorothy Heyward wanted Waters for the part of the violent, alcoholic, and heroic Hagar in *Mamba's Daughters* as soon as they heard her expound the meaning of the novel (from which the play came). She knew their character, it turned out, better than they did. Waters persuaded them to rewrite their story for the play, making Hagar, a secondary if vital character in the novel, the heroine. Irving Berlin wrote his moving protest song about lynching, "Suppertime," especially for her in 1933, and she knew that in Hagar as she conceived her she could express "all Negro women lost and lonely in the white man's antagonistic world."

James P. Johnson, acknowledged master of the New York ragtime-derived "stride" piano style and composer of the "Charleston," accompanied Waters on perhaps her finest single recording, "Lonesome Swallow," in 1928; Waters had formed her style listening to his music and his clean and inventive sound remained her artistic ideal. For James P., European music was compelling; like his colleague Willie ("the Lion") Smith and his student and friend Fats Waller, he experimented with the ideas of Bach and Beethoven and the new harmonies and forms introduced into modern classical music by Chopin, Liszt, Debussy, and Ravel. Why should James P. be less interested in white music than whites were in black music? (As if to complete the story of James P. and the high Euro-American artistic tradition, Piet Mondrian, the Dutch painter who emigrated to New York in the early 1940s, painted his abstract masterpiece of 1942–43, *Broadway Boogie-Woogie*, listening to James P.'s music; the unmistakable affinities between the two men's styles, different as their mediums were, are striking.) Unlike Waters, James P. was dark-skinned, and it's important that it was he who encouraged the light-skinned Fats Waller to incorporate European music into jazz, not the other way around. Fats was a crowd-pleaser and an early crossover artist, but the more reserved James P. began and ended with black audiences. Once again, a black artist had developed, and black audiences had encouraged, a black-and-white art.

A poet like Phillis Wheatley could be rehabilitated precisely because artists like Waters and Johnson were asserting their right as black Americans to utilize their Euro-American heritage as well as their African-American traditions. This insistence affirmed the realities of American life; after all, Waters's paternal grandmother—like Toomer's paternal grandfather, like several of Hughes's great-grandparents, like Larsen's mother—was white or near-white. Even the New Negroes' interest in skin lighteners and Kink No More hair preparations, their eager avowals of conventional ideas, polite taste, and good manners, had something in it of an assertion of black rights to white accomplishments and styles. The split between the Du Bois–*Crisis* group and the Hughes-Thurman-Hurston *Fire!* party was not as severe as it sometimes seemed, in good part because both groups claimed white ideals and practices as a prerogative; that the older group insisted on their right to Victorian decorum and the younger group on their right to modern freedom of artistic expression mattered less than that both wished to claim the double legacy, black and white, that belonged to them as Americans.

James Weldon Johnson picked 1917 as the end of the "years of exile" not only because of the Silent Protest Parade and *Fifty Years*, but because April 5 of that year was, in his words, "the date of the most important single event in the entire history of the Negro in the American Theatre." This marked

the debut of three one-act plays about black life performed by a stellar black cast, including Inez Clough and Opal Cooper, and written by a white dramatist named Frederic Ridgely Torrence. This last fact was not altogether a drawback in Johnson's eyes, and not only because white authorship and production meant bigger audiences and better press coverage; it simply did not occur to him that art in America had been or would ever be anything but a miscegenated affair, whatever the denials and demurrals on either side.

Even Marcus Garvey, despite his stress on black economic independence and territorial separation, was, as Lawrence Levine has pointed out, in no sense a *cultural* nationalist. He never worried that the new Africa he imagined would or should reject all aspects of white culture, nor did he think that black champions of the African continent like himself should be careful lest they impose their Western ideas on its indigenous inhabitants and thus destroy their precious native heritage. Multiculturalism, as we think of it, was not part of Garvey's agenda. In Levine's words, he "did not disdain Western culture, [of] which he was, after all, a part." Garvey, planning to separate geographically from Euro-America, never dreamed of leaving behind its legacy; to his mind as to Weldon Johnson's, Western blacks had creatively appropriated aspects of white culture that were now as much their own as their black blood and their African descent.

Like his brilliant critic Gerald Early, I, too, see the poet Countee Cullen as the central figure of Harlem's literary renaissance, and I do so, not despite his open proclivities for white art, but because of them. Cullen once confessed, "I fairly revel in public commendation," and in the 1920s he got it in abundance from both whites and blacks, but his reputation ended with the decade. It is surely telling that he is the only literary figure of importance in the Renaissance whose peak of popularity and prestige exactly coincided with its own, rather than succeeding it; their fortunes were inextricably intertwined. Langston Hughes accused Cullen of wanting to be white, but at bottom he knew better, or should have. Although he was not alone in thinking of Cullen's attachment to white art as a form of docility, even sycophancy, a servile placation of the genteel custodians of good taste of both races, when Cullen said that Negro poets might have "more to gain from the rich background of English and American poetry than from any rebellious atavistic yearnings towards an African heritage," he was not flattering the literary establishment so much as he was insisting on his own status as an American and acknowledging the realities of American art, black or white, and of the Western literary tradition more generally.

Keats was Cullen's favorite poet, and like his idol, he wrote a poem about Endymion. Although a white hostess rebuked him for his Keatsian affilia-

tions, asking what Endymion, a creature of Greek myth, could possibly be to him, an African, he remained, he tells us, "[un]converted." One might also ask, he speculated, what Keats, a "Cockney poet" of the early nineteenth century, was doing writing about Endymion in the first place. All art, as Cullen saw it, was appropriated from multiple sources; there was no such thing as a pure art, no "simon pure" thing, as he put it, and its definitive absence occasioned and informed his craft. Cullen's intensely elegiac verses, his extraordinary love of books and their "Bright Bindings," even when, perhaps because, such books inevitably "fail me," was part of his absorption in the complexities of borrowed language; all language is borrowed, though most refuse to admit it. His desire to see the New Negro and what a few people were calling the "New White Man" "clasp hands" came from his awareness that the pairing of the two was inescapable in any case; why not try to make those already yoked together collaborators and friends? Joseph's coat in Genesis, with its "many colors, all of which contributed to its beauty" and its "mischief working" powers, in his words, was the chosen emblem of his art.

Cullen was aware of what was omitted or forced or evaded in this often involuntary black-and-white union. He always acknowledged that his deepest identity and interests as a poet were, despite his conscious intentions, Negro, and he said that "the double burden of being both Negro and American is not so unified as we are often led to believe . . . The individual diversifying ego transcends the synthesizing hue." As Early has noted, lies are Cullen's great subject, and all his poems are dense, transparent, and vulnerable with a sense of loss, with the heartbreak that comes when authentic words, feelings, people, and selves are irretrievably gone, never to be reapprehended, but never quite forgotten. He wrote a series of children's poems not long before his untimely death in 1946—he increasingly found his best audience in children, creatures as plastic and passionate as he—and in *The Lost Zoo* (1940), he told the story of all the animals left out of the ark. Himself an orphan, Cullen often felt like one of those animals, abandoned and left behind; he repeatedly imaged himself as a ghost haunting his own poetic enterprise. In "Ghosts," he tells those living beings oblivious of him, around whom he hovers unseen if not unheard, that he cannot trouble them: "Ghosts are soon sent with a word or two / Back to their loneliness." What best represents him always excludes him.

Such notes of piercing sadness were not a denial of reality on Cullen's part, or even a refusal of militance. Unlike Waters or James P. Johnson, he chose, not to celebrate the pluralism he, too, recognized as decisive in his heritage, but to mourn the unity it banished, to lament what he described as the "murder of the spring"; he preferred the agonized and nostalgic dream

of a pure culture to the reality of an endlessly diverse one, but he never forgot that it was indeed a dream, nothing but a dream. His insistence on his white heritage was in any case itself a form of militance, and so was his adherence to black Christianity; his greatest poem, published in 1929, was "The Black Christ," about a lynched Negro as the Messiah reincarnate. His contemporaries might be interested in the legacy of black religious expressiveness, but they wanted to leave its more conventional forms behind; often more than skeptical himself, Cullen nonetheless wanted to retain and transform them. In an age "cold to the core, undeified," in his words, he was the only black writer of importance who believed that no movement or reform agenda for Negro culture that left out its traditional religious impulses and church foundations could achieve real or lasting success. The past, half-fabricated and fast retreating, was the only ark that offered all God's children refuge.

Depite the ill-fated marriage between Cullen and Du Bois's daughter, Yolande, Du Bois found Cullen the most congenial of the renaissance's younger literary talents. Eager to please and unfathomably sensitive, Cullen was wonderfully easy to get on with, and perhaps Du Bois sensed in him a creative transmutation of his own paradoxical sensibility, so drawn to free expression and so resistant to it. To cast their relationship in biblical terms, one might say that Cullen played David to Du Bois's Saul; in him lay part of the older man's buried life. Du Bois may also have guessed, as few others did, that Cullen's gentle nature domiciled a hunger for independence almost as fierce as his own. Cullen was the only important figure among the younger Harlem writers to turn down Van Vechten's offers of aid and patronage. It is not a contradiction, though some have seen it that way, that his last project, *St. Louis Woman*, a play about black lower-class urban life on which he collaborated with Arna Bontemps, was attacked by the genteel arbiters of Harlem culture as a cheap pandering to the public hunger for sensationalist fare and even as race treachery. Cullen had never really been a racial conservative, though he was unmistakably an integrationist. His goal for the black artist, like Waters's, was freedom "to create *what we will* . . . with all the power in us" (emphasis added).

Certainly Du Bois, like Cullen, assumed the black heritage to be white as well as black, and he pointed out on several occasions that only self-consciously racial considerations and readings could make full sense of much of white American literature. He thought that some white writers—his example was DuBose Heyward—wrote well of black life in good part because they displaced to their black characters the troubling truths about themselves they were not permitted to tell in polite company. If Heyward had given Porgy's situation and feelings to a white cast of characters, he would have

been "drum[med] . . . out of town," Du Bois explained in "Criteria of Negro Art," an address published in the October 1926 *Crisis*; "the only chance he had to tell the truth of pitiful human degradation was to tell it of colored people." In this view, whites and blacks, willy-nilly, see themselves in each other. In talking about themselves, they are also talking about one another; in talking about each other, they discover themselves.

I have remarked that black leaders were forced at moments to be racial essentialists; as the object and victim of essentialist thinking, the New Negro had in some circumstances to grant its reality, but he ignored and denied it whenever he possibly could, sometimes to his own apparent harm. Wallace Thurman, in particular, went out of his way to deny evidence of openly racist behavior on the part of whites. He once refused to protest when he was denied a seat in the orchestra of a white theater, a seat for which he had purchased a ticket, at one of his own plays. His refusal was perhaps mistaken, and it is certainly at odds with today's racial mores, but it was not craven and it was part of a conscious strategy. Thurman's material was always, unlike Cullen's, self-consciously black, but like Cullen, he insisted that it be judged by the strictest artistic standards, and he was so sure that his creative and psychological integrity and success depended on seeing things from an impartial point of view, on granting himself no exemption clauses, that he was willing to swallow an insult in order to win what he took to be a more important battle. He would maintain his equality with all comers, black or white, deferring to nothing but superior talent, even if it meant denying, in the face of plain evidence to the contrary, that it had been ignored. Whites might regard Thurman's assumed equal-with-whites status as a fiction, but he could not acknowledge it as such. Whites might pretend that they were not living in a miscegenated world; they might act as if whites were distinct from and superior to blacks, but that only made it doubly imperative that he not do so. Far from being evasive, his not marking such slights was to his mind a sign of his own superiority, a token of his ability to hold on to the abiding facts of racial equality and interdependence, a token more not less trustworthy because, in a given instance, only he recognized its meaning. For the New Negro to allow race to be the dominant category was to permit whites to call the shots.

The theatrical setting of Thurman's trial makes sense. For those holding a miscegenated view of culture, essentialism was something like a philosophical impossibility, but the theater became a matter of pragmatic necessity as well as an imaginative imperative. To think, as some of my protagonists did, that in America there is no such thing as a separate race or a racially distinct and superior culture, was to announce that racial identity is in good part socially constructed and man-made. In this view, identity is the result,

not only of the organism's ineradicable and inexplicable need for self-expression, but of power politics, a situation that often has little to do with justice or fair play. Identities that have been imposed demand creative rearrangement. Constructed identity is at bottom an affair of masks and role-playing, part of the politics of theatricality. Cullen's fascination with borrowed language, like Waters's black-and-white musical style, was a manifestation of black Manhattan's obsession with ascribed, shoplifted, and stolen selves and the root of its decisive, creative, and very American "will to personate."

The New Negro put too much trust in the white establishment, then, not only because no other viable option was available to him, but also because he knew what his white peers could not always admit: that, light-skinned or all-Negro, black Americans had a white heritage as well as a black one. Just as, by Du Bois's logic, American Negroes had equal claim to the privileges and opportunities of the country they helped to build, so they had the same right, even at moments the same attraction, to the white artistic tradition as whites did to the black one. By cooperating with white interests and utilizing white resources, the New Negro was not simply exercising his only option and scripting his own defeat but also announcing his status and prerogatives. The proud insistence on a common language, on black-and-white materials that animated black New Yorkers of the 1920s like Thurman, Cullen, Waters, James Weldon Johnson, and James P. Johnson goes as deep as the troubled origins and promise of American life.

THE SLEEPING GIANT IS THE HARLEM NEGRO

The musical and literary renaissance of black Manhattan was very much a part of the larger independence project of the 1920s. When America began its cultural self-exploration, no other country with comparable resources had engineered or experienced a similar feat of self-discovery. The reason is simple: there was far less in the past of the other Great Powers left to discover. The older Western nations, confident of their status, had long assumed that their best was the world's best, and celebrated it accordingly. But nineteenth-century America, a provincial society relying on outside values and judgments, had rejected its own most distinctive cultural achievements. It had withheld recognition from Melville, its greatest author, while nineteenth-century Great Britain fully acknowledged the stature of its greatest novelist, Charles Dickens, during his lifetime, and France read and praised Honoré Balzac during his. (It is impossible to imagine obituaries of Dickens or Balzac in which leading newspapers were as plainly ignorant of their subject's full name as *The New York Times* was of Melville's after his death in 1891, when

they briefly commemorated a "Henry Melville.") Likewise, few, if any, of the African-American musical and performatory traditions—the tales, songs, narratives, and sermons later studied and celebrated—received any serious attention or recognition in their day. England and Europe set the literary and artistic standards, and while these countries were interested in recovering their own oral culture of folk story and song, Africa was a "dark continent," unknown save as a field of imperial conquest and missionary endeavor. Europeans and Englishmen loved and imitated the minstrel show, and visitors noted the affecting music of the slaves, but by and large they did not consider such displays art. America had more, much more, to discover in its cultural past, because a good part of that past was black. Prewar America was seen in the postwar decade as a "sleeping giant"; the black journalist Edgar M. Grey, writing for the *Amsterdam News* on November 10, 1926, announced that the real "Sleeping Giant" had been the "Negro."

As Johnson noted in *Black Manhattan*, because the black cultural past had been so long neglected and unknown, the Negro renaissance did not seem a "development," the product of a recordable historical process, but rather "a sudden awakening . . . an instantaneous change." The black past yielded treasures as rich as the classic American literature excavated by Lawrence and others from the white past, and it did so at least as suddenly and unexpectedly. Modern America did not inherit a usable past by some natural and usual process of recognized transmission; it appropriated one. The nation's position was much like that of Molière's parvenu M. Jourdain in *Le Bourgeois Gentilhomme*, who discovers, at the hands of a tutor, that he's been speaking "prose" all his life without knowing it. America in the 1920s found itself instantly endowed with a set of important artistic traditions; if it had borrowed or stolen its earlier cultural styles from foreign powers, it acquired its new cultural sensibility from a past self, white and black, of whose existence it had been but dimly conscious. Digging up its past, America found its richest treasures, its "acres of diamonds," in the phrase of Russell H. Conwell, in its own back yard.

America was the only Great Power that went through this post-colonial period, extricating its culture from that of once-dominant foreign influences, and it did so exactly at the time that it was assuming the role of full-blown, invincible economic imperialist and cultural colonizer in its own right. In a unique, double-barreled explosion, cultural independence and world hegemony were gained in a single intoxicating sweep to power. America awoke after the Great War to find itself a millionaire possessed, not just of instant wealth, but of instant credentials. The nation had been accumulating masterpieces unawares; fabulous sums had been deposited to the giant's account while he slept.

RAGGING AND SLANGING:

BLACK-AND-WHITE ART

PERFORMING FOR THE WORLD: AMERICAN PARODY

After the war, artists and intellectuals abroad evinced a fascination with America and things American from Babe Ruth and Al Capone to skyscrapers, Madison Avenue, and Krazy Kat cartoons. Americans had often treated Europe as a vast museum of the elite arts of the past that they might visit at will, whether to worship, travesty, or plunder, but now Europeans found in America's mass-produced images and stories their pop theater, their fast food, their daily comic strip. Salvador Dali, the Spanish surrealist, wrote in his memoir *The Secret Life of Salvador Dali* (1942): "Each image that came from America I would sniff with the voluptuousness with which one welcomes the inaugural fragrances of a sensational meal." His mind repeated one refrain over and over: "I want to go to America, I want to go to America!" And go he did, first to visit, then (more or less) to stay. En route, he persuaded the ship's cook to bake a special loaf of bread for him; it was over four feet long and guaranteed, he thought, to catch the attention of the reporters who would interview him when the boat docked in New York. The boat docked, the reporters were there, Dali ostentatiously used his loaf of bread as if it were a staff, but no one noticed, no one commented. As the architectural critic Rem Koolhaas remarks in *Delirious New York* (1978), Dali had to learn that, whatever its reception in Europe, "in Manhattan surrealism is invisible."

Dali's story dates from the 1930s, but the trend was clear much earlier. In the early 1920s, Hemingway's friend Harold Loeb, editor of the short-lived *Broom*, went to Europe to solicit contributions from foreign writers, only to find that they were uninterested in their own culture's artistic traditions. In his memoir, *The Way It Was*, Loeb reported that they wanted

to talk only of "skyscrapers," "jazz," "advertising," "movies," and "New York." Fitzgerald, abroad himself in 1921, noted that London tailors were now cutting their suits to the American physique, and he concluded that "the style of man" had "passed to America."

H. L. Mencken put his finger on the source of America's powers of fascination in an essay of 1922 titled "On Being an American" in which he explained why he, for one, had no plans to expatriate. Who could leave a land that was perpetual show time? The "knavish" politicians, the "poltroon-ish" clergymen, the "American boobus," all are "birds that know no closed season."

> Here, more than anywhere else that I know or have heard of, the daily panorama of human existence, of private and communal folly—the un-ending procession of . . . miscellaneous rogueries, villainies, imbecilities, grotesqueries and extravagances—is so inordinately gross and preposterous, so perfectly brought up to the highest conceivable amperage, so steadily enriched with an almost fabulous daring and originality, that only the man who was born with a petrified diaphragm can fail to laugh himself to sleep every night and to awake every morning with all the eager, unflagging expectation of a Sunday-school Superintendent touring the Paris peep-shows.

"Here," Mencken concluded, was "the land of mirth," an "Eden of Clowns" where everything is personalized, caricatured, "dramatised." Mencken was defending America as well as mocking it. We Americans are, he was asserting, powerful and outrageous enough, not (heaven knows) to instruct or inspire the world, but to supply its limitless hunger for unabashed exhibitionism. Whether or not he knew it, he was advertising the nation's role as the creator and exporter of the world's mass arts. What Paris and Rome lacked and New York possessed was public glare: the media, modern art's popularizer, com-petitor, and usurper.

In no one of the traditional elite arts save literature did modern America discover it had an edge; most of its exciting classical music, sculpture, paint-ing, and architecture was created during and after the Great War, not before it. But the way that classic American literature suddenly and surprisingly took the lead was nonetheless emblematic of what happened with American culture more broadly speaking. The American movies' sweep of the European markets was another sign of a new cultural situation; by the 1920s, in the new, technological, media-produced or fast-becoming-media-dependent arts—records, radios, movies, advertising, the whole range of indigenous popular culture from music and baseball to cars and comic strips—the nation

was unbeatable. Little wonder, then, that its popular and mass arts made a challenge to elite art part of their content. Why not press the American advantage?

Commands like "Roll Over, Beethoven" were not new with Chuck Berry and rock and roll in the 1950s; American popular arts had originated in parody, a parody in which high European art was spoofed and replaced by low American art. The tag that was most often associated with Al Jolson, "the World's Greatest Entertainer," was his cry to his audience as he moved to up the ante, to outdo himself, "You ain't heard nothin' yet!" A veteran of the minstrel stage and America's most famous blackface performer, he was classified, not as *a* jazz singer, but as "*the* Jazz Singer," and he held himself to be at least the equal of Enrico Caruso, the legendary opera star. In 1918, the two appeared together at a benefit concert. Caruso preceded Jolson on the program, and when Jolson took the stage, he assured the audience that they, too, having listened to Caruso and about to listen to "Jolie," "ain't heard nothin' yet!"

When the popular arts had begun their ascent in the first decades of the nineteenth century, the line between them and the elite arts was not firmly drawn either in America or in Europe. Not until the second half of the century was there an audience of well-educated, well-to-do people big enough to support the fine arts like opera or high tragedy as a separate enterprise. A serious domestic drama, for instance, was likely to be followed or even interrupted by farcical skits and popular music; the plan in London as in New York was to have something on the program for everyone, to attract and hold the largest possible audience, whatever their class allegiance and social status. But Americans seemed to have a particular penchant for turning the jostling commerce of high and low into parodic fun. By definition, popular art is a mirror of the people who give it their favor, of their differences as well as their similarities. Throughout the nineteenth century in England and America, songs were marketed by their purported nation of origin— English ballads, Irish melodies, Scottish tunes, German songs, Italian airs, and "Ethiopian" music competed for the public's attention—and no country had so heterogeneous a population or threw together so broad and sharply contrasted a mix of nationalities, classes, and idioms, musical as well as linguistic, as the United States did. To travel there, art had to travel down, way down, inviting ridicule as well as homage on its way.

Bellini's *bel canto* operas were a rage in America as in Europe in the 1830s, but *La Sonnambula*, which was a hit in New York in 1837, was quickly reproduced first as *The Roof Scrambler, or La Sonnambula Travestie* and then as an "Ethiopian Burlesque." Starting in the 1840s, minstrel shows specialized in radically mixed forms. "The Virginia Rose Bud," a song written

by F. H. Kavanaugh of Palmo's Burlesque Opera Company, was half in polite Standard English diction and half in pseudo-darky dialect, and the song's chorus, whose words were all in dialect, was set to a Bellini air; the whole song was of course performed by whites in blackface. "The Virginia Rose Bud" was not intentional parody, but minstrelsy routinely included self-conscious takeoffs of elite fare. *Macbeth* became *Bad Breath*; *Lucia di Lammermoor* turned into *Lucy-Did-Sham-a-Moor*, and such spoofs continued in the early twentieth century in the various musical revues of Broadway. Bert Williams had started in minstrelsy, and in the 1916 *Follies*, he did a travesty of *Othello* and a burlesque of the Russian ballet star Nijinsky. In the 1900s, the Black Patti Troubadours also offered a popular parody act, half opera, half updated minstrelsy: the white Patti was the European opera star Adelina Patti, a singer vastly successful in America; her namesake, Black Patti, was a Negro singer, M. Sissieretta Jones.

Born Mathilda Joyner in 1868, the highly talented Jones was classically trained at the New England Conservatory, and she toured the States, then the West Indies and South America, as a serious singer with some success. Her image was always one of self-conscious if gorgeous respectability. In her favorite photograph, she was shown standing, dressed in a long, elaborately embroidered, and sumptuous gown, with her face in high and dignified profile and her right hand resting on a Grecian pedestal. Jones had, however, markedly Negroid features and a dark skin that resisted the arsenic skin-lightening treatments to which her entrepreneurial husband, Dick Jones, subjected her; she couldn't really look the part of an elite artist, as some of her light-skinned Negro contemporaries did. In any case, the ban against the Negro's appropriation of his white heritage was nowhere more marked than in classical music. Like many of the black jazzmen who succeeded her, Jones had no real professional option but to perform recognizably Negro music in recognizably Negro performance styles. By the late 1890s, when she formed the Troubadours, she had hedged her bets with inventive spoofing. Billed as "America's Premier Ragtime Entertainers," her company put on "Operatic Kaleidoscopes" of classic numbers like the "Anvil Chorus" from *Il Trovatore*, punctuated by ragtime music and blackface skits about "Jolly Coon-ey Island."

Unlike Jones, James Reese Europe, the pioneering musician and composer who headed the band of the "Harlem Hellfighters" regiment in the war, was more interested in jazz than the classics, but he, too, kept both doors open. Although he "ragged" or syncopated the classics in concert, he also did medleys of operatic melodies carefully labeled "highbrow" in his program notes. Paul Whiteman, the self-billed "King of Jazz" and the most popular white bandleader of the era, made a specialty out of lightly jazzing or ragging

the classics, too. His first record, cut in 1920 on Victor, featured "Avalon," a pop version of an aria from Puccini's *Tosca* on one side, and "Dance of the Hours," lifted from Ponchielli's opera *La Gioconda*, on the other. Although all Whiteman's musicians were white and he insisted that jazz was white, too—in his book, *Jazz* (1926), he contrived to discuss his topic without mentioning Negroes at all—his tactics were Black Patti all the way.

Like Jones, Whiteman started out as a classical musician playing the viola in various symphony orchestras in San Francisco, but in the mid-1910s California was attracting a flock of New Orleans jazz musicians; although one of them reportedly told him, "You can't jazz," he threw in his lot with the new music. Something like a nervous breakdown preceded and followed his career shift, and he remained a heavy drinker and a gargantuan eater, sometimes topping 300 pounds. Whiteman didn't renounce his claim to the classics any more than Jones did; a born entrepreneur and publicist, he aimed to make jazz respectable and classical music popular. In plain fact, he was constitutionally incapable of playing anything, classic or pop, straight. Whatever his aims, mugging was his style. In 1920, he came to New York and quickly achieved a spectacular success, a success which climaxed in a legendary Aeolian Hall concert of February 12, 1924, the concert for which George Gershwin wrote and played "Rhapsody in Blue," then considered the first important attempt at an extended and serious use of the jazz idiom; it marked Whiteman's most conspicuous effort to mix jazz, popular music, and the classics.

For the first number, the orchestra played "Livery Stable Blues," the Original Dixieland Jazz Band's hit, a piece then considered something like real jazz; they performed it as burlesque, full of comic instrumental effects in order to illustrate the superiority of Whiteman's usual smoother sound, which would be heard in the succeeding number, "Mama Loves Papa." When the distinguished audience greeted "Livery Stable Blues" with straightforward enthusiasm, Whiteman had a "panicky" moment. "They hadn't realized," he later wrote, "the attempt at burlesque . . . They were ignorantly applauding the thing on its merits." But the Original Dixieland Jazz Band, a white outfit from New Orleans, sometimes played their own music for laughs in any case; maybe the Aeolian Hall audience, like Whiteman himself, didn't quite know what was burlesque, what not. If the offerings were meant to "provide a stepping stone which will make it very simple for the masses to understand and therefore enjoy symphony and opera," in the words of the program notes, the masses, even the Aeolian Hall variety, apparently preferred to linger with the parodic possibilities of the in-between zone. In later, still more successful presentations of the Aeolian Hall material, White-

man made less and less effort to instruct his listeners as to what was serious, what burlesque, what good, what bad. Who, after all, could say?

America in the Great War era, parvenu that it so clearly was, already had the bucks; all parvenus do. Classic American literature supplied part of the missing pedigree, and the pledge that, if America could excel in one branch of the so-called elite arts, it might one day, one day soon, excel in others just as effortlessly. More important, there was the fail-safe mechanism exemplified in the minstrel travesties, in Jones, Europe, and Whiteman "ragging" the classics, and in Jolson's blackface put-down of Caruso: the certainty that the elite arts would themselves change, if not lose, value amid the torrent of competition provided by America's burgeoning popular and mass arts and their invincible democratizing impulse.

All the musical acts I've just mentioned were New York–based. New England had its own tradition of comic humor in Yankee jokes and parodic local dialects and its own heritage of popular music, but the relatively homogeneous Boston area had long been notable for its adherence to classical European music and the purer forms of American popular song, like the reform-minded songs presented by the famous Hutchinson family singers in the 1850s; its composers and music publishers tended to resist innovation rather than to push it. Oliver Ditson was Boston's most important publisher of sheet music in the mid- and late-nineteenth century, and although the firm published popular songs, it did most of its business in choral music, scores of chamber music, semiclassical piano pieces, piano arrangements of operas and oratorios, and instruction books for various instruments. T. B. Harms, New York's premier music publishing house, closed Ditson out by the turn of the century, and it did so by concentrating on popular songs to the exclusion of all else. Harms's ascendancy marked the start of Tin Pan Alley and the virtual lock on the music industry achieved by its publishers, artists, and promoters, and the Alley's notion of marketing was very different from Boston's. Ditson publicized its wares via unostentatious catalogues and discreet ads, usually placed in well-established trade journals, but the splashy ads for Tin Pan Alley's products could be found in all the big dailies, "yellow press" included, and hundreds of performers were hired to "plug" new songs on the stage and in the streets. If popular music in America was by definition an aggressively mixed music, New York was its logical home.

All the acts I've mentioned also belonged to a special branch of musical entertainment, that of "ragtime" or so-called jazz, the most thoroughly and successfully mixed of any branch of popular American music. In no field of the elite arts had the nation been so deficient as in serious or classical music. In the nineteenth century, it had produced no operas, symphonies,

or chamber music at the level of the work of Europe's greatest composers—Beethoven, Schubert, Verdi, Brahms, Wagner—and few, if any, performers equal to Europe's finest musicians. By the 1920s America's increased musical ambition witnessed the rise of three important composers—the white composers Charles Ives and Aaron Copland, and the Negro composer William Grant Still—and the opening of Juilliard and other serious music schools; white and black performers trained for and pursued important careers in opera companies and symphony orchestras. But this was just a beginning. Luckily, America had already produced a great popular music, most of it traceable to the minstrel show and to Negro culture. This music emerged first as ragtime, then as blues and jazz, and it took off in the 1910s and 1920s to world applause.

Alain Locke's claim for the influence of black music on European composers and performers was not exaggerated. The only music that the pianist Artur Schnabel brought home with him from his American tour consisted of records and sheet music of what he called "jazz." When reporters asked the French composer Darius Milhaud, then on a tour of the States, what "American music" was influencing Europe, he replied, "Jazz." Milhaud noted that the reporters were shocked by his answer, but they needn't have been. As the music historian Burton Peretti has demonstrated in *The Creation of Jazz* (1992), black jazz musicians were beginning to think of themselves as artists, and abroad, too, jazz was not seen as lowbrow fare; in the words of the American classical violinist Mischa Elman, fresh from a visit to jazz-crazy Europe in 1922, jazz had "become known as the American classical music." Perhaps it was as good as Europe's classical music; certainly it was far more powerful in its claims to cultural hegemony.

Of course, the term "jazz" was used very loosely to include everything from ragtime to blues, from Louis Armstrong to sheer Tin Pan Alley pop. But what "jazz" always meant was a loosened beat and Negro sources, and while its black origins might be denied at home, they were recognized and celebrated in many places abroad. This did not mean that Europe was somehow less inherently racist, less intolerant than white America, though many black artists understandably thought so. After all, the new racial ideologies had originated in Europe, and they governed its dealings with its non-white colonies and climaxed in Hitler's "final solution"; nationalist, ethnic, and religious prejudices had scarred its history with wars and pogroms for centuries. Yet, since European countries did not have large groups of racial others within their boundaries, they had few incentives and opportunities to develop fixed racial prejudices at home. In Europe, American blacks could be seen as exotic rather than threatening, as part of an avant-garde of primitive art.

During the war, James Reese Europe's band captivated Paris audiences, and soon after Florence Mills, an "exotic . . . pixie radiant . . . [with] a näiveté that was alchemic," in James Weldon Johnson's words, sang and danced and pantomimed her way into the hearts of Parisians and Londoners in a series of plays and revues—*The Plantation Revue* (1922), *Dixie to Broadway* (1924), and *Blackbirds*, which opened in London in 1926; the Prince of Wales went to see her sixteen times. The Josephine Baker craze in 1925 began in Paris when she performed "*la danse sauvage*" bare-breasted and irrepressible in the *Revue Négre*. By late 1926, Parisians were buying Josephine Baker dolls, Josephine Baker hair pomade (to get her slicked-back look), Josephine Baker perfume, and copies of her costumes. Speaking about his first London visit a few years later, Duke Ellington said, "We were absolutely amazed how well informed people were in Britain about us and our records. They had magazines and reviews far ahead of what we have here." As Phyllis Rose describes the Aframerican impact abroad: "Until the 1920s, as far as the rest of the world was concerned, with a few picturesque exceptions like Buffalo Bill and Mark Twain, America had no culture. When it finally turned a face to Europe, that face was black."

I have spoken of the twofold censorship white America exercised on Aframerican art, against not only blacks or whites celebrating Negro sources and achievements but also blacks utilizing the white elements of their heritage. In recent years, scholars have sometimes either underplayed or over-complicated and overironized this black indebtedness to white sources, largely, I think, because they fear acknowledging it might buttress and perpetuate white claims that blacks can't originate or think for themselves, that they have no adequate artistic legacy of their own. The fear is understandable. In the 1920s, as long before and since, the white establishment spent much more time denying black sources and achievements than it did challenging the white elements in Negro art and performance styles. Anxious to preserve their own cultural hegemony, whites were pleased at any evidence that blacks were copying them, even if they didn't want to pay good money for what they liked to consider inferior imitations of their own manner. In fact, just as the cultural archaeologists of the Harlem Renaissance insisted, the black influence in American popular culture had been dominant; it was denied and minimized not because it was faint or weak but because it was so overwhelmingly strong. But the New Negro was less willing to disguise or downplay his contributions, white or black; and in ragtime and its heir, jazz, he found a way to fuse his black-and-white heritage in one audacious sound.

Jolson, attempting to upstage Caruso, was performing in blackface; behind the American outdoing the European was the Negro outdoing the white. George and Ira Gershwin might celebrate "Fascinatin' Rhythm" (1924) and

claim "I Got Rhythm" (1930), but the Negro performer John Bubbles coun-
terruled them in a song of 1933 titled "Rhythm for Sale": since "all the world
wants rhythm bad," blacks are "mighty glad / 'Cause they got rhythm for
sale." In the *Ziegfeld Follies* of 1922, Gilda Gray, a white shimmy dancer
and singer, introduced a number titled "It's Getting Dark on Old Broadway"
that fully, if uneasily, acknowledged the black competition:

> *We used to brag about the Broadway white lights,*
> *The very serious dazzling White-Way night lights.*
> *They used to glare and glimmer,*
> *But they are growing dimmer . . .*
> *It's getting very dark on old Broadway,*
> *You see the change in ev'ry cabaret;*
> *Just like an eclipse on the moon*
> *Ev'ry café now has the dancing coon . . .*
> *Real dark-town entertainers hold the stage,*
> *You must black up to be the latest rage.*

"Real dark-town entertainers" referred to the performers in Eubie Blake and
Noble Sissle's all-black musical revue *Shuffle Along*, packed with lively
African-American dances and ragtime music, now in its second successful
year at the ramshackle 63rd Street Theatre.

Many white reviewers pointedly compared *Shuffle Along* to white Broad-
way fare. One tartly noted that "some of the big shows downtown [could]
receive a suggestion or two" from *Shuffle Along*. Another observed that "these
people make pep seem something different to the tame thing we know further
downtown." "A spirit of liveliness and good humor prevails," *Billboard* com-
mented, "that amazes anyone who has endured the languid efforts of ordinary
Broadway musical affairs." Back in 1899, a parody of Black Patti had billed
itself as the "BLACKER PATTI" and promised its viewers "a black face act, but
my—how different—nothing conventional about it, and they scream!" All
of American popular culture in the 1910s and 1920s, willingly or otherwise,
was screaming its "BLACKER" origins.

BLACK ART IN WHITEFACE

The art of Irving Berlin offers a case study in black-and-white origins and
tensions. A small, reserved man with methodical habits, Berlin had been
born Israel Baline in 1888 in Russia to the family of a Jewish cantor, but
the Balines were among the thousands of victims of the pogroms sweeping

the country in the 1890s. Berlin's only memory of his Russian childhood was that of watching his parents' modest home go up in flames. The Balines and their six children made the Atlantic crossing in 1893, traveling steerage and carrying all their possessions in eight pieces of luggage. After disembarking at Ellis Island, they settled on Cherry Street in one of the worst neighborhoods of the Lower East Side, or "Jewtown," as it was often called. The family spoke no language but Yiddish, and they were close-knit but dirt-poor. Though "Izzy" did learn English, he attended school for only five years—the family finances couldn't bear the extra expense—and he left home, or "went on the bum," as he later put it, at twelve, mainly to relieve his parents of the burden of his support. His aim was to support them, and he succeeded handsomely.

Moving around various lice-infested 15-cents-a-day lodgings in the Bowery, not far from Cherry Street, Izzy began to sing for nickels and dimes in various dives, for audiences consisting largely of German and Irish immigrant workingmen and prostitutes. Hard work, a few lucky breaks, endless ambition, and an unstoppable genius for writing popular music propelled him to the heights of Broadway fame when he was in his early twenties. Determined to control the business as well as define the art, he opened his own very successful music publishing house, Irving Berlin, Inc., in 1914. In 1926, despite her father's protests, he eloped with Ellin Mackay, one of New York's best-known and most chic young socialites. The New York *American* titled their story on the match "Rich Father Ignored for Composer by Society Bud," with a follow-up piece on the "Bridegroom's Rapid Rise to Fame"; Al Durbin and Jimmy McHugh celebrated it in a song titled "When a Kid Who Came from the Eastside (Found a Sweet Society Rose)." Berlin's beleaguered boyhood in Jewtown never prompted him to self-pity. He drew from its cramped and crowded confines a knowledge of intimacy in its most pragmatic and profound meanings, a multicolored musical and linguistic palette, a keen sense of the acrobatics of which the American class system was capable, and an infallible instinct for the commercial. As his friend George M. Cohan, a legendary song-and-dance man, once put it, Berlin was "uptown, but [he was] there with the old downtown hard sell."

Inevitably, Berlin was one of Gilbert Seldes's idols; he wrote some of the liveliest, most ravishing music in the annals of American song. "I Love a Piano," "Alexander's Ragtime Band," "Let's Face the Music and Dance," "Puttin' On the Ritz," "Cheek to Cheek," "Easter Parade," "Isn't This a Lovely Day?," "There's No Business Like Show Business," and "Fools Fall in Love" are all Berlin numbers, and for more than four decades his career was inextricably interwoven with those of Broadway's top performers. The dancers Irene and Vernon Castle, trendsetters of the time, found a showcase

in his revue *Watch Your Step!* in 1914. The music was so hot, most critics agreed, it eclipsed even the Castles. Berlin also gave Jolson his first mega-hit in 1911 in "Alexander's Ragtime Band," and Jolson put over Berlin's "Blue Skies" in the first talkie, *The Jazz Singer* (1927). Fred Astaire and Bing Crosby sang Berlin's songs in the 1930s and 1940s; in 1946, he provided Ethel Merman with her biggest hit to date in *Annie Get Your Gun*.

Like Jolson and Whiteman, Berlin was a parodist, a splicer of high and low art. In a song of 1914, "I Love a Piano," he poked good-natured fun at the "long-haired genius," the virtuoso Polish pianist Paderewski, who toured the States for decades to vast applause. In one number of *Watch Your Step!*, Verdi was made first to protest, then to welcome his music being "ragged" or syncopated. Berlin was alone, save for Cole Porter (who didn't make it big, in any case, until the 1930s), among his top Tin Pan Alley peers in writing both the music and the lyrics for his songs. This gave him double authority, double force, and he used both sides of his talent to free the New York and American musical scene from its long subservience to foreign models, most recently, the operettas of Gilbert and Sullivan and Franz Lehár, whose *Merry Widow* was the biggest hit of the season in 1907 as Berlin was beginning his career.

Berlin's primary musical interest was rhythmic. Almost all his early music was syncopated or "ragged"; by 1912 or so, he had earned the title of "the Ragtime King." "Syncopation is the soul of every American," he explained in the January 1916 issue of *Theatre Magazine*; "pure unadulterated ragtime is the best heart-raiser and worry-banisher that I know." Before Berlin's rise, fans of popular song were singing sweetened melodies with smooth and sentimental lyrics like those of Victor Herbert and Henry B. Smith's "Gypsy Love Song" (1898)—"Slumber on, my little gypsy sweetheart / Dream of the fields and the gloam"—and Herbert's "Ah! Sweet Mystery of Life" (1910)—"[My] longing, striving, waiting, yearning [is for] love and love alone!" But, a few years later, devotees of Berlin's "I Love a Piano" were voicing syncopated sentiments like these: "I love to run my fingers o'er the keys, the ivories, / . . . [of] a high-tone baby grand!" The contrast could not be stronger between the English or Anglophile idiom and the inventive, speedy, wised-up American language setting its own pace and beat.

Berlin did not end the American vogue for sentimental song, but he headed a broad-based linguistic revolution as well as a musical one, a double move toward a vernacular idiom that contributed greatly to America's enhanced popularity overseas. People were beginning to listen hard to the way Americans talked. In the early days of silent film, Americans Anglicized movie titles for British audiences, but experience proved that they preferred the American version. They wanted "nuthouse" not "madhouse," "drugstore"

not "chemist's shop," "radio" not "wireless," "frame" not "put-up job." When talkies arrived, their gritty American language proved once again a draw to their English fans, who eagerly adopted talk of "glad rags" and "gate-crashers" and expressions like "deliver the goods," "nothing doing," and "pass the buck." Virginia Woolf praised Ring Lardner in 1925 for freshening the language with America's "expressive ugly vigorous slang"; in doing so, she added, he had provided "the best prose that has come our way." Raymond Chandler, transplanted from England, set himself to learn the new hard-boiled style from Hemingway and Hammett because he believed it to be the most exciting version of the English language to take shape since Shakespeare and the Elizabethans had "roughed the language around" at the turn of the seventeenth century. After the war, many shops in London and Paris bore signs in their windows that read: AMERICAN SPOKEN HERE.

Mencken told the readers of *The American Language* that contemporary slang originated in the argot of entertainers and criminals as they congregated and performed in the big cities, in Chicago, Detroit, L.A., and, above all, New York. New York had the undisputed masters of the slang idiom: the Broadway wits—Runyon, Winchell, Hecht, Hammett, Kaufman, and Parker—the experts in Harlem slang and Negro expression, Hurston and Hughes, and the vernacular songwriters of Tin Pan Alley led by Berlin. Of course, Berlin had predecessors and peers who helped to Americanize lyrics and music. George M. Cohan wrote dozens of jaunty all-American numbers, most notably "Give My Regards to Broadway" (1904) and "You're a Grand Old Flag" (1906); the last was originally titled "You're a Grand Old Rag," but this allusion to ragtime music was judged too daring to use. Jerome Kern early favored a spanking-clean, devoid-of-frills chorus and audaciously dropped the genteel Victorian song's extended form for Tin Pan Alley's abbreviated and crisp 32-bar, AABA format. But no one's art was so daring, mixed, and free as Berlin's.

Berlin derived his style from dozens of sources—English music-hall songs, Irish ballads, Stephen Foster melodies, American marches, and the Negroes who created and played ragtime. As a singing waiter down at Nigger Mike's on 12 Pell Street in Chinatown back in 1904, Izzy sang with equal facility as an Italian, an Irishman, a German, a Jew, or, as the saloon's title promised, a nigger. The saloon was designed as a hangout for those slumming in the neighborhood, and the proprietor was, in fact, not a nigger but a Russian Jew like Izzy. Berlin had had no musical training, and he could not write or read music; although he quickly found talented arrangers, some doubted he was altogether responsible for his creations. A rumor persisted throughout the 1910s that a "little nigger boy" wrote his songs for him; others credited the black ragtime pianist Lukie Johnson, a performer at Nigger Mike's.

Although Johnson disavowed authorship, the rumors were not altogether unfounded: Berlin had learned ragtime from Johnson, then retooled it for mainstream consumption much as the Castles, under Jim Europe's tutelage, adapted the new Negro dances for white audiences. All his life Berlin composed solely on the black keys of the piano, or, as he called them, the "nigger keys." His defense of this musically illiterate method was telling: the "nigger keys are right there under your fingers." "Nigger" music was somehow already his own. As a boy staying at the Bowery flophouses, Izzy had occasionally signed himself "Cooney."

Whatever the larger hostilities between the groups to which they belonged, Jewish artists like Berlin and black artists like Lukie Johnson, both discriminated against, both outsiders, were real if touchy partners in 1920s New York. Jewish money, particularly that of the Spingarns and Julius Rosenwald, the Sears, Roebuck potentate, funded many of the Harlem Renaissance's political organizations, publications, and prizes. And there was Gershwin's friendship with Todd Duncan, his easy familiarity with the Harlem scene, and Eddie Cantor's happy collaboration with Bert Williams and the Nicholas Brothers. Most of the star Tin Pan Alley composers and lyricists were Jewish and of recent immigrant stock, and they found their finest interpreters in Negro as well as Jewish musicians and performers—Sophie Tucker, Fanny Brice, Al Jolson, Louis Armstrong, and Ethel Waters, and, later, Billie Holiday, Ella Fitzgerald, and Sarah Vaughan.

"Ragging," or syncopating, came easily to Berlin, as to all Jewish composers, because Jewish music, with its Eastern and Mediterranean sources, its complex rhythms and preference for the minor keys, had something in common with the African-American sound. Harold Arlen, who wrote "I've Got the World on a String" and "Stormy Weather," once played a Louis Armstrong record for his father, a Louisville cantor; after one riff, or "hot lick," as Arlen called it, his father asked, amazed, "Where did *he* get it?" Jolson's father, like Berlin's, was also a cantor. Yiddish, the vernacular Jewish idiom that found its golden moment in New York's Yiddish theater, helped pave the way for the use of the American vernacular in Tin Pan Alley's lyrics.

Sophie Tucker, the earthy, tough-minded, and loud-voiced Jewish singer who made it big in the early 1910s, was billed as the "Last of the Red-hot Mamas." Claiming "vocal cords of . . . steel" and specializing in lyrics saturated in a powerfully open female sexuality, Tucker apparently sided with those who believed that "the best songs come from the gutter," in the words of the music publisher Edward Marks. She had come with her family from Russia in 1887 at the age of three; Berlin was an ally and a friend. A product of the Yiddish theater, Tucker moved effortlessly from her Yiddish

numbers to slangy American songs like the bluesy "Some of These Days," her greatest hit, recorded in 1911. Significantly, when she crossed over from the Yiddish theater to English-speaking burlesque, she began as a blackface performer and coon shouter; the lyricist-composer of "Some of These Days" was the Negro songwriter Shelton Brooks. Tucker also made a hit of "It's All Your Fault," the first song written by Eubie Blake and Noble Sissle. Her career was proof that Jewish and Negro musical styles and influences could and often did flow seamlessly together.

The Jewish songwriters were hardly free, however, of the antagonism toward blacks found in all immigrant groups. Jews had been central to Broadway entertainment since the mid-nineteenth century, as blacks had not, and Tin Pan Alley didn't always like the Jewish-Negro connection. Over the years, Berlin grew increasingly quick to deny the black sources of his music. Sounding much like Whiteman, he explained that "our popular songwriters . . . are not negroes" but "of pure white blood . . . many of Russian . . . ancestry"; he had avoided the word "Jew" and expunged the Negro. In the film treatment he wrote in the mid-1930s for the biopic of his career that Darryl Zanuck did at Fox, *Alexander's Ragtime Band* (1938), his on-screen alter ego, "Alexander," was nothing like the coon shouter portrayed in the song but rather a well-bred Wasp violinist, played, laughably, by Tyrone Power. Like Kern and even Gershwin, Berlin maintained that the man he wanted to write songs for was the casually patrician and Nordic Fred Astaire; he did the music for two Astaire-Rogers pictures, *Top Hat* (1935) and *Carefree* (1938), as well as a series of later Astaire movie vehicles, most notably *Easter Parade* (1948).

Berlin's choice of Astaire as his favorite vocalist was interesting as well as obvious. If his songs "aim[ed]" to be conversation set to music," as he put it, then Astaire, with his skillful use of a limited vocal range, his impeccable timing and his genius for conversational rhythms as a singer and dancer, was the perfect Berlin interpreter. Like a number of his Jewish Tin Pan Alley peers, Berlin was a budding Anglophile despite his allegiance to American music, and Astaire had received top plaudits in London before American critics were alert to his claims. His sister, Adele, his first and best partner, retired from the stage in the early 1930s to marry into the British aristocracy.

Appearances to the contrary, however, Astaire's art owed almost as much to African-American sources as Berlin's did. He'd learned the basics of his new pop-jazz-ballroom dance style from the Castles, who'd learned it from Negro music and dances, and many of his best moves, translated, with the gift that was uniquely Astaire's, into his own fluid and perfectly timed easiness, came from the performances of black singer-dancers on the Broadway stage whom he had watched and studied for years, notably Bill ("Bojangles")

Robinson and, later, John Bubbles, the man with "Rhythm for Sale" who played Sportin' Life in *Porgy and Bess* in 1935 and appeared opposite Ethel Waters as the gambler-devil in *Cabin in the Sky* in 1940. Devastatingly handsome (as Astaire was not), the jazz-oriented Bubbles developed his special style of "rhythm tap" in the 1930s in tandem with Count Basie's music, and he brought a fully physical, palpably sexual charge to his fluid body and sharp movements that was not in Astaire's repertoire; he was arguably the greatest pop dancer, black or white, of the era. But Astaire did not mention Bubbles in his autobiography, *Steps in Time* (1959), and he treated Bojangles only in passing, with no discussion of his dancing. Although he did an homage number to Bojangles in *Swing Time* (1936), he never openly alluded on screen to the still more formidable Bubbles.

I don't mean to suggest any conscious exploitative intent on Astaire's or Berlin's part; the exploitation was bigger than any individual. It was part of the ethos of the day that white performers absorbed African-American art and performance styles, sometimes consciously, sometimes not; it was understood on Broadway: you started black or ethnic and got whiter and more Wasp as, and if, success came your way. It was a class pattern as much as a racial or ethnic one: black to white, ethnic to Wasp, lower class to upper. This was Astaire's trajectory, as it was Berlin's; a master of the "high-toned shindig," in Mencken's phrase, he, too, was one of New York's masqueraders.

Born Frederick Austerlitz, Astaire was a second-generation immigrant and an Omaha, Nebraska, boy; his father was a brewer from Vienna. Middle-class in his origins, Astaire was nonetheless a hardworking childhood veteran of vaudeville; the leisure he personified was something he knew nothing about. "The carefree, the best dressed, the debonair Astaire! What a myth!" he wrote in *Steps in Time*. He agreed with his friend James Cagney that he had, in reality, "a little of the hoodlum" in him. His formal top hat and tails, his crisp movements capable of surprisingly elegiac turns, constituted elegant chutzpah; his act was a creamy embossed calling card, printed perhaps on Tin Pan Alley presses, but meant and ready to lie on the silver salvers of Fifth Avenue's best families.

In the 1930s, Astaire became one of the new breed of "crooners," of which the most famous was Bing Crosby. (Astaire and Crosby later starred in two movie musicals together, *Holiday Inn* [1942] and *Blue Skies* [1946], both with scores written by Berlin.) The crooners' subtle nuances of phrasing and casually natural pronunciation were made possible by the invention of the electric microphone in 1925—earlier recording artists had sung into crude amplifying "horns"—and their fame was tied to the new sound media of radio and talking pictures; they marked the beginning of a shift from live to canned entertainment. The crooners personified an ultra-sophisticated,

upper-crust cool, an intimate yet bland sexuality very different from the tears-and-laughter-drenched raw cravings of Jolson's belt-it-out style. Live performers of Jolson's generation had to project, even shout, their songs by putting the energy of their entire bodies into their performance; "all upper-cuts" is the way Ethel Waters described Jolson's delivery. To listen to Crosby's 1946 recording of "Blue Skies" after hearing Jolson do the same song is to hear a song being gutted of its punch. As Berlin nostalgically remarked in a rare tribute to Jolson, he was a live—oh how live!—performer who "sang the same song for years until it meant something." The crooners gave listeners their voices in place of their bodies; they cleaned up black and Jewish sexuality for the Wasp or would-be Wasp middle-class mainstream audience.

Berlin saw Fred and Adele Astaire dance early in their careers; although Astaire worshipped Berlin and was already singing his songs, Berlin wasn't impressed, and he passed up a chance to work with them. (Gershwin was smarter; he wrote *Funny Face*, the Astaires' first big American hit, for them in 1927.) Astaire was an acquired taste for Berlin, part of a pattern of creative upward mobility; Jewish blackface performers like Sophie Tucker and Al Jolson were his roots. Yet Berlin never quite admitted how much he owed Jolson, the fellow Russian Jew who put over "Alexander's Ragtime Band" and "Blue Skies." His reservations had a number of sources, not the least of which was that Berlin, a genius with unending abilities to assimilate and reshape contemporary musical trends, simply outgrew Jolson's all-powerful but limited gifts. Still, it cannot have made him entirely comfortable to see, as all the world could and did, that Jolson, the first great Berlin interpreter, hadn't just started out at his own version of Nigger Mike's; he'd stayed there.

"Jolie," né Asa Yoelson in a small town outside of St. Petersburg in the early 1880s, was not recognized as a star in his first attempts to sing and do comedy acts in turn-of-the-century Baltimore and Washington, D.C. He became the entertainment powerhouse known as "Jolie" the moment he first put on blackface and appeared on stage as the "Black Peter Pan," in the phrase of a later critic. From the start, Jolson had been a nervous and self-conscious performer whose attacks of stage fright were awful to see; even after he had become a star, he kept a bucket waiting in the wings in case he needed to vomit between scenes. Legend has it that, in the midst of one attack of jitters during a not so successful early show, a Negro actor (in some accounts it was a white blackface performer) advised him: "You'd be much funnier, boss, if you blacked your face like mine. People always laugh at the black man." Jolson took the suggestion and went over big. He soon joined Lew Dockstader's minstrels, at that time the most important blackface troop in the country; billing himself as "the Blackface with the Grand Opera Voice," he went on to starring roles as the darky "Gus" in a series of Broadway

hits like *Robinson Crusoe, Jr.* of 1916 and *Bombo* of 1921. His trademark cry, "You ain't heard nothin' yet," was lifted, in fact, from the black vaudevillian Joe Britton.

The Jazz Singer, Jolson's first movie and biggest hit, was taken from a play of 1925 written by Samson Raphaelson and starring the Jewish vaudevillian George Jessel. Raphaelson had had Jessel, not Jolson, in mind in writing the story, but the parallels between *The Jazz Singer* and Jolson's life were striking, and many took the movie as his autobiography, a notion he did nothing to discourage. The central protagonist is a working-class Jewish blackface ragtime and jazz performer called Jakie Rabinowitz (later Anglicized, of course, to Jack Robin), a cantor's son growing up on the Lower East Side. The film is tacitly built on the affinities between Jewish music and jazz; the conflict here isn't Jewish versus Negro but sacred versus secular. While still a boy, Jakie runs away from home, turning his back on his birthright vocation, that of singing in the tabernacle like his father, but his apostasy is neither easy nor altogether voluntary. He works his way up the show-biz ladder, and in the movie's most charged scene, he is waiting in his dressing room as his moment of decision approaches: should he go onstage and sing jazz as he is this minute expected to do—it's his big chance—or go to the synagogue and sing "Kol Nidre" on the Day of Atonement to please his dying father? He looks at his face in the mirror in mute agony and confusion; he is palpably seeing a stranger. Yet, all the while, in the midst of his indecision, he is in blackface, ready to go on.

We see him black up as the scene begins. His mind clearly elsewhere, Jakie's hands automatically, skillfully, apply the heavy cork makeup to his face; he may not recognize the face in the mirror, but his hands know it intimately, completely. All he really trusts is the feel of that black grease on his face. He could apply it, he is applying it, more or less in his sleep. When his devoted and heartbroken mother (played by Eugenie Besserer) enters the dressing room to plead with him to go to the synagogue, she is startled at his appearance. Once again conflicting racial genealogies lie right beneath the surface. She's never seen him blacked up before; can he be *her* child? "This ain't you?" she asks. Yes, he nods, it's me. The difficult life choice is somehow artificial; the dark makeup is the only identity Jakie has. But blackface performers by definition have two lives. Jakie decides he'll sing in the synagogue *and* go onstage in his big role! The details of how he accomplishes this impossible feat aren't important; once in blackface, nothing can stop him.

Jolson's rise in the 1910s coincided with the so-called years of exile for black musical theater, when an all-white Broadway made possible the success of white blackface performers like Jolson, Eddie Cantor, and Frank Tinney.

362

Inevitably, the return of the black musical to Broadway, inaugurated by *Shuffle Along* in 1921, spelled the decline of white blackface, and hence of Jolson himself, but he made a big comeback in the 1940s. Remember his all-out but failed efforts to win the plum parts of De Lawd in *Green Pastures* and Porgy in *Porgy and Bess* from his Negro competitors in 1929 and 1934; he wouldn't, couldn't, give up blackface.

Jolson was as famous for singing in a straight-and-sentimental style songs that were intended as parodies (like "Sonny Boy," written by Buddy DeSylva, Lew Brown, and Ray Henderson, a hit for him in 1928) as for "jazzing" or ragging conventional lyrics; confusion was his métier. Like Paul Whiteman, he was never in control of the parodic possibilities of his material, and this sometimes worked as emotional daring and even depth. Fans and foes agreed that he was incomparably more powerful in person than on screen. But when we watch him in *The Jazz Singer* as he plays "Blue Skies" for his adoring mother and cajoles her with outrageous sweet talk—he says she's getting "kittenish"; he's going to buy her new clothes and he threatens, "You'll wear pink or die!"—when we see the stout, elderly, shy, and homely Eugenie Besserer actually grow "kittenish" under his coaxing, we catch the seductive magic of the man who held Broadway in thrall for four decades. He's made her the sole and intimate repository of all his talents; she's become the love object, the center of a universe that combines the raw charm of Coney Island with the lullaby-time safety of the nursery.

In only one other film did Jolson have such a moment of rapport with another person, in *Hallelujah, I'm a Bum* (1933), directed by Lewis Milestone with a script by the New York dramatist S. N. Behrman and music by Richard Rodgers and Lorenz Hart. Jolson plays a lord of misrule figure, the unofficial king of New York, an aristocratic and strangely self-sufficient beggar who supervises the city's doings from his squatter's-rights terrain in Central Park. He has a doomed romance with a New York beauty, played by Madge Evans, but the real relationship of the movie is that between Jolson and his black pint-size hobo sidekick, Acorn, played by the Negro actor Edgar Connor; their affection, their instinct for easy teamwork, is unmistakable.

Offscreen was probably a different story. Irresistible in performance, in real life Jolson was loud and often insulting to his acquaintances and co-workers (he seems to have had no real friends). On occasion, he actually pissed on people—he thought it funny—and he liked to pull a big wad of dollar bills out of his pocket to flash before the startled gaze of strangers. "I've got it all," such tactics seemed to say; "You've got nothing—except me." But his need of his audience went deeper than any conscious personality trait, good or bad. Jolson was the guy who sang with cunning gusto that archetypically American line "Gimmee, gimmee, gimmee, gimmee, gim-

mee, gimmee, gimmee" (yes, seven of them), on a 1913 recording of Jean Schwartz and Harold Atteridge's "You Made Me Love You." "His one true emotion was hunger," writes his biographer, Robert Oberfirst. A mix of naïveté and smarts, an exploitative devotee of black art, Jolson, "the Blackface with the Grand Opera Voice," was Berlin's never fully acknowledged double, his collaborator in the creation of musically mongrel Manhattan.

BLACK ORIGINALS

Although ragtime and jazz music like Jolson's and Berlin's was, as a commercial boom pattern, in good part a New York phenomenon, its roots were elsewhere. Ragtime had developed in the late nineteenth century among blacks in the cities of the Mid- and Southwest, most notably St. Louis, Louisville, and Chicago. When it became a national craze, it marked an important instance of the Negro's creative use of America's black-and-white heritage and the unstoppable attraction the black version of that heritage exerted on white audiences and talent.

The music itself probably arose as an accompaniment to various Negro dances, many of which bore striking resemblances to their African prototypes. The issue of how much of the Negro's indigenous culture survived transportation and enslavement has been a controversial one among scholars for a century, but historians today agree that black speech patterns, music, and dance in the United States are hybrids, invincibly Americanized and Westernized yet full of unmistakable African survivals. African music is characterized by an intense involvement in complex rhythms unknown in Europe, and it shows little interest in the harmonies and melodies that have chiefly concerned European composers or in the structures of self-conscious, unfolding, forward development that best showcase European musical intentions. Instead, the African sound is built on what can seem to Western ears like endless repetitions of rhythmic patterns that are varied in ways often too subtle for white ears to detect.

Most forms of Aframerican music over the last two centuries have kept the African emphasis on rhythm and repetition while adding various Western elements to it. Zora Neale Hurston advocated a re-Negroization of the spiritual, but its whitening had not altogether betrayed its origins. Even in its purest form as it was developed and sung in the slavery South, the spiritual was distinguished by both rhythmic complexity and a clear emphasis on melodic purity; it was as indebted to the music of the white society in which its black creators lived as to the music of the African homeland from which they had been taken. This music is unique to the Negro in America: no

Africans, no black people anywhere else, have produced anything like the spirituals, ragtime, and jazz.

Although ragtime could be sung and orchestrated, it was best known and practiced as piano music, and this had a·good deal to do with its spectacular popularity; the piano industry and its sheet-music publishing outlets dominated the American music industry until the mid-1920s. Almost from the piano's invention at the turn of the eighteenth century by the Italian Bartolomeo Cristofori, all music, whether symphonies, operas, oratorios, chamber music, or popular songs, was transcribed and sold as sheet music for the piano. Piano literacy almost matched that of print literacy among well-bred women in England and Europe as well as in America, but America claimed a special partiality. As Louis C. Elton observed in 1904 in his *History of American Music*, "There is probably no country in the world where piano-playing is so widespread as in the United States"; the piano was the "basic musical instrument," found in "almost every home, even among the humble."

The European artists who most excited the American public throughout the nineteenth century and well into the twentieth were the great virtuoso piano players: Leopold de Meyer in the 1840s, Sigismond Thalberg (affectionately known in the States as "Old Arpeggio") in the 1850s, Anton Rubinstein, Hans von Bülow, Josef Hofmann, and Ferruccio Busoni in the last decades of the century, and Berlin's "long-haired genius," Ignacy Paderewski, whose American reign lasted for thirty years. Not surprisingly, the versatile American language incorporated the piano into its allusions. The expressions to "soft-pedal" a suggestion and to serve as a "sounding board" were in frequent use in the late nineteenth century; "piano legs" meant bad (women's) legs, and in the war years "to play the piano" was slang for being fingerprinted. In the 1920s, the term "Chicago piano" designated the bootlegging gangster's new submachine guns and their expressionless "rat-a-tat" sound.

The piano had few real competitors before the Great War years. There were no radios or talkies, phonographs were still new, imperfect, and very expensive, and recording itself was a crude affair, one better able to reproduce the voice than any instrument, including the piano. Between 1870 and 1890, piano production increased 1.6 times faster than the population did; between 1890 and 1900, 5.6 times faster; between 1900 and 1910, 6.2 times faster. The peak year was 1909, with 364,595 pianos valued at $58.5 million; piano prices dropped, and the industry pioneered in installment buying. One grasps how enormous those production figures were by remembering that pianos were never designed to be disposable items or fast-outmoded victims of planned obsolescence, as cars were in the 1920s; a piano was to last the buyer's lifetime and more. The piano's heyday coincided exactly with the

rise of Tin Pan Alley and its stepped-up production and marketing of popular song sheet music. Although a number of important piano manufacturers of the day, most notably Baldwin's of Cincinnati, were located outside New York, the leading manufacturer, Steinway and Sons, was not, and all of them depended on the production and sale of sheet music, a business firmly centered in New York.

Perhaps inevitably, the art of the piano found its headquarters in the same place as the piano business. Starting in the early twentieth century, New York had its own sound, one more European-influenced, more big-band-oriented, perhaps less rhythmically adventurous than Chicago's, its greatest competitor, and keyed to the piano rather than the horn. New York's premier bandleaders in the 1920s, Fletcher Henderson and Duke Ellington, unlike King Oliver, Chicago's most important bandleader, were both piano men. If Chicago boasted the finest horn players of the day—Oliver, Louis Armstrong, Freddie Keppard, and Johnny Dodds—New York hosted the "ticklers" and composers of the "stride" style, James P. Johnson, Luckey Roberts, Willie "The Lion" Smith, and Fats Waller. Stride piano was an offspring and complication of ragtime, and whatever ragtime's origins, its fullest artistic development came in New York. Its greatest practitioner, the Negro composer and musician Scott Joplin, though a product of Texas and St. Louis, moved to New York in 1910; he died in 1917, but his wife, Lottie, outlived him, and she ran a boardinghouse for musicians at 163 West 131st Street where Willie Smith and other black pianists found a congenial home in their early days in Harlem.

Ragtime's vogue, occurring at the peak of the piano's popularity, involved virtuosos just as dazzling as Paderewski, though they often found their first audiences in the brothel rather than the concert hall. Ragtime inspired a rash of schools pledged to teach anyone to play it in "Ten Easy Lessons," but many amateurs found it beyond their skills; although they bought the sheet music in droves—Joplin's "Maple Leaf Rag" (1899) was one of the first pieces of sheet music to sell more than a million copies—they preferred to buy player pianos or convert their pianos to accommodate player-piano rolls so that they could listen to ragtime played by genuine masters—Joplin, Eubie Blake, James P. Johnson, and, a little later, George Gershwin. Lots of people apparently wanted to "Live a Ragtime Life," as a popular song of 1900 put it, and player pianos made it possible.

First widely marketed in the 1900s, the player piano used perforated rolls of music prerecorded by professional musicians that could be inserted into any player-piano model. The pianist need only sit at his instrument; it played by itself. Before the mass marketing of the radio and the phonograph, the player piano offered the possibility of music-not-made-by-the-listener, of

automatic art and effortless consumption, the *sine qua non* in the broad commercialization of any art. Player pianos soon constituted half the piano industry's sales, topping at 53 percent in 1923. Ragtime, and its promotion of piano-roll music, gave the piano business its first and last chance to join the dawning technological revolution that made canned or prerecorded sound and professional rather than amateur musicians, the dominant modes of American musical life. Player pianos were sometimes called "horseless pianofortes" to underscore their participation in the new automated age.

Ragtime also changed the piano's sound, transposing it to a more vernacular, more Negro idiom. Ragtime was startlingly percussive—there were many more beats and accents than Western ears expected—and the piano's immense percussive possibilities made it the logical ragtime instrument. By concentrating on its percussive and rhythmic capacities, the ragtime artists reinvented their instrument. Players tended not to use the pedals, as European performers did, and minimized the piano's ability to vary volume and sound. Ragtime was a pianist's art, not only because the piano was the dominant instrument in the culture that produced it, but because the piano was the popular Western instrument best able to mimic African music. As Eubie Blake told the historian Eileen Southern, the ragtime piano stood in for the African drum.

Ragtime showed its African affinities in other ways as well. Like jazz, it favored the African pentatonic or five-note mode over the Western diatonic or seven-note mode. The diatonic scale can be heard by playing a C scale on the piano; one uses all the white keys. The pentatonic scale, in contrast, involves playing not the seven white keys of the C-scale but the five black ones. When Berlin expressed his fondness for "nigger keys," he was not only marking an obvious affinity of color—black keys, black music—but showing his familiarity with African-American music. "I Love a Piano," always one of his favorites among his own compositions, was, willy-nilly, a triple tribute to Negro ragtime: it honored the pentatonic keys, celebrated the piano, and reveled in syncopated rhythms.

"Ragging," or syncopating, meant putting the emphasis on the weak or off beat; to cite a rag of 1899 by Joseph E. Howard, not "Helló, Ma Baby," but "Héllo, Ma Baby." Syncopation might be "the soul of every American," as Berlin claimed, and natural to those raised on Jewish music, but above all it was central to the rhythmically complex African musical tradition. This is not to say, however, that ragtime was itself an African form; in fact, the music was dependent for its very structure on the Euro-American tradition. Ragtime scored for the piano was built on a syncopated, rhythmically inventive, right-hand treble played against a steady 2/4 march rhythm in the left-hand bass; the march was of course a well-known Euro-American form,

seen equally in Beethoven's "Eroica" Symphony and in the music of John Philip Sousa. (Sousa understood the relationship between his music and ragtime, though he played it safe by ragging it in performance but seldom on record.) Eubie Blake remembered listening as a boy in Baltimore to black musicians working a funeral; on the way to the cemetery they played the music straight, but they "ragged the hell out of [it]" on the way back. Ragtime was surprise takeover, the Negro putting his stamp on the music he found in the New World.

Adding syncopation to a straight piece of music, as the musicians Eubie Blake observed were doing, was not technically the same thing as playing true ragtime. In Joplin's piano pieces, the syncopation was not added but inherent in every aspect of the composition. But the distinction is in some sense unimportant. The term "ragtime" probably derived from "ragged [or broken] time" and meant "tearing time apart"; the phrase "to rag" also meant to tease. The colloquial meanings of the term illuminate the music; playing ragtime on the piano, the right hand was literally teasing the left, tearing its 2/4 time apart. All ragtime, then, whether a straight tune "ragged" à la Sissieretta Jones, Whiteman, or Berlin, or true ragtime like Joplin's "Maple Leaf Rag," was in its structure a splice of the classic and the up-to-date, the white and the black, the Euro-American and the African. It was a tease and a put-on.

The ragtime model of a march-time bass refigured in a syncopating treble—or, put more broadly, of a conventional musical base reworked by an improvised, self-willed, and modern musical impulse—survived in freer form in ragtime's offspring, jazz; indeed, it was central to the jazz form until the bebop artists of the 1940s and 1950s left recognizable musical motifs behind. The white jazz man Eddie Condon once remarked that in jazz "you know what the melody is but you don't hear it"; jazz improvisation changed the music it used by subjecting the melody's claims to those of a daringly expanded and varied rhythm, both obscuring and clarifying the melody, mocking and celebrating it. Little wonder that Whiteman, Berlin, and Jolson were attracted to ragtime and to versions of jazz; if American popular art liked to parody elite European art, ragtime was on one level nothing but that parody.

Marches were a staple in America's earliest musicals, the minstrel shows, and ragtime first surfaced as vocal music in the minstrel "coon songs" of the 1890s. Coon songs, sung by black and white performers, usually in blackface, offered stereotypical takes on Negro life and attitudes under titles like "He's Just a Nigger, but He's Mine, All Mine," "You May Be a Hawaiian on Old Broadway but You're Just Another Nigger to Me," and "Coon, Coon, Coon, How I Wish My Color Would Change." Bert Williams and his partner

George Walker helped to popularize the cakewalk, a Negro dance of plantation origins set to syncopated music, and the sheet music for Williams's song "Oh I Don't Know, You're Not So Warm" (1896) included a ragtime solo. The wildly popular "All Coons Look Alike to Me," written in 1896 by Ernest Hogan, a Negro songwriter and blackface performer, had a "Negro Rag Accompaniment Chorus." White songwriters quickly flooded the field, but the coon song's black origins were indisputable. Although Hogan lived to regret his title, he might have found some consolation in the fact that, if his songs perpetuated darky stereotypes, they did so with something like real Negro rhythms and in words that had something to do with real Negro speech. The coon songs, whether by black or white authors, were largely written, not in polite Anglo-English, but in some version of what the author knew or supposed to be African-American or Black English, or, as it was often called at the time, "Negro dialect."

This wasn't just a matter of linguistic impersonation, of whites or blacks playing the darky; as the music historian Philip Furia has explained in *The Poets of Tin Pan Alley* (1990), the ragtime music of the coon song required Negro dialect or something like it because its rhythms needed irregular language, language whose rhythms had little to do with the traditional iambic pentameter of English poetry and song. The Negro dialect, with its irregular constructions, ellipses, vivid pictorial instincts, and angular lunges, fit the bill, as did, to a degree, the white ethnic slang heard in Sophie Tucker's songs. The vernacular lyrics of Berlin's "I Love a Piano" owed almost as much to Negro rhythms as did its syncopated sound.

Negro dialect, whether used by whites or blacks, was not the same thing as Black English; it was not a transcription of actual black speech. Black English is the term used by language scholars today for the special form of English developed and spoken by blacks in slavery and post-slavery days, and it was a full and complete language in its own right, with its own grammatical laws and notions of expressiveness; it seems incorrect, in other words, because outsiders do not know its rules. In contrast, the Negro dialect used by white and black artists in the nineteenth and early twentieth centuries represented a stereotypical and exaggerated take on the perceived "incorrectness" of black speech as judged solely by the criteria of Standard English. An invention as much as a practice, it was part of the minstrel tradition that culminated in the blackface routines of the first Negro performers on Broadway at the turn of the century, preceding the so-called years of exile, a parody act that advertised its own linguistic backwardness.

However jocular and dismissive of its own claims to linguistic distinction, Negro dialect was nonetheless a high-spirited attack on the Standard English it mangled. Just as ragtime was at one level nothing but a parody of the

classic music tradition, Negro dialect, precisely because it had no self-conscious linguistic identity of its own, was at some level nothing but black comic ignorance or dislike of white middle-class speech. If polite Anglo-American speech was a matter of "conventional inhibition," in Mencken's words, the coon song was an affair of appetite, of linguistic and sexual inhibition defied. "I Want You, Ma Honey!" one coon song of 1895 began. May Irwin, a white coon shouter and popular Broadway singer, announced in her hit "The Bully Song" (1895), written by white songwriter Charles Trevathan: "I've been lookin' for you nigger, and I've got you found!" In short order, "Razors 'gun a flyin', niggers 'gun to squawk, / I lit upon that bully just like a sparrow hawk." When Irwin gets through with her "nigger," "a doctor and a nurse / Wa'nt no good to dat nigger, so they put him in a hearse"—along with what remains, one might add, of polite English speech.

Predictably, black and white songwriters tried to gentrify and sentimentalize the coon song's lyrics and camouflage their minstrel origins. Joplin himself campaigned against the crude vernacular of the ragtime lyric. So did James Weldon Johnson and his brother, J. Rosamond Johnson, the ragtime pianist, singer, composer, and performer; the Johnsons collaborated with the black composer Bob Cole on love songs with light African touches, like "My Castle on the Nile," "The Congo Love Song," "Under the Bamboo Tree," and "Tell Me, Dusky Maiden," songs intended to refute the common charge that the Negro was deficient in the finer sentiments. As J. Rosamond explained, "We wanted to clean up the caricature," and they did, dropping the coon song's emphasis on Negroes as crap shooters, chicken stealers, drunken brawlers, and razor toters, and using Negro dialect sparingly as well-mannered and open artifice.

Tin Pan Alley specialized in mixed messages. The veteran songwriter Harry Von Tilzer (destined to be Judy Garland's uncle)—born Harry Gumm in Indianapolis and assuming the name "Van Tilzer" to cash in on the current vogue for Austrian and German music—alternated coon songs like "Alexander Don't You Love Your Baby No More?" ("Alexander" was thought to be the kind of grandiloquent name that ignorant darkies favored) with sentimental tearjerkers like "The Mansion of Aching Hearts." But the ragtime vernacular coon song carried the day. Cohan's pioneering vernacular songs were coon songs redone, and Kern began his career with a coon song titled "Paris Is a Paradise for Coons," written with the lyricist Edward Madden and put over on Broadway in 1911 by Jolson, in his own Broadway debut, in blackface. Berlin's first big hit, "Alexander's Ragtime Band" (1911), was a coon song; the title came, in fact, from Von Tilzer's earlier hit. Berlin loved coon songs and continued to write such numbers into the 1930s.

Follies star Fanny Brice (née Fanny Borach) did a number of coon songs as well as Yiddish comedy; like Sophie Tucker, her art was a Jewish-Negro hybrid. But unlike Tucker, she spoke more or less straight English when left to her own devices, however colloquial and profane. Yiddish was unknown in the upwardly mobile Borach household, and Fanny as a girl knew only half a dozen Yiddish words. She learned her Yiddish accent by listening to Joe Welch, the Yiddish-dialect comedian, and by mimicking Berlin, one of her first important songwriters, who wrote "Sadie Salome Go Home" for her. Brice picked up her "nigger" talk from black neighbors and black entertainers, and like Tucker, she started on the mainstream stage with black music; her first big hit, "Lovie Joe," was a coon song written for her Ziegfeld debut in 1910 by black composer Joe Jordan.

During rehearsals, the producer Abe Erlanger tried to get Brice to Anglicize the words of the song: "He can do some lovin' and some lovin' sho', / An' when he starts to love me I jes hollers 'Mo'!" He wanted the Anglo-American "sure" and "more," but Brice insisted on singing "sho" and "mo." "I live . . . on the edge of Harlem," she explained. "They all talk that way. No Negro would pronounce these words the way you did. I can't sing them any other way." Her emphasis on how real-life Negroes actually talked was prophetic. The pseudo-Negro dialect of the coon songs paved the way for the real black-and-white American vernacular in the 1920s. Just as ragtime developed into the freer and more self-sufficient jazz form, comic Negro and ethnic dialect led to the use of Black English and white self-consciously modern urban slang. The two vernacular branches of the language, Negro and white, had much in common in any case, and both were linguistic kin to ragtime music and the jazz that succeeded it.

In *The American Language*, Mencken emphasized the American fondness for turning nouns into verbs; among his examples are to "slum," to "hog," to "itemize," to "burglarize," to "bug," to "thumb," to "goose." The habit of turning nouns into verbs, he tells us, is the chief characteristic of the American language; it's how it takes shape and transforms its origins, transforms them down, not up, and it's the reason the language's most quintessential expression is slang. Mencken was sometimes dismissive of Negro contributions to the language, but Zora Neale Hurston, always a superb practitioner and defender of Black English, showed—in her "Characteristics of Negro Expression" (1934)—that African Americans had perfected, and perhaps originated, the art of turning verbs into nouns; among the examples she gives are "confidence" (" 'Taint everybody you can confidence"), "uglying away," "feature" ("she features somebody I know"), and "friend" ("I wouldn't friend with him"). The syntax was abbreviated and sped by the

practice she described; not "I wouldn't want to be friends with him," but "I wouldn't friend with him." Note that there was no real shift in vocabulary; you're still using the same ball, but you're giving it a spin.

As with Black English, white slang did not necessarily involve a special vocabulary. Ordinary words could become slang if they swerved away from their polite, conventional, and middle-class usage to a more vivid, pictorial, and streetwise signification. Hemingway discovered he could Americanize any sentence by the simple insertion of a swear word. Jake doesn't become "romantic" in *the Sun Also Rises* but "damn romantic"; Frederic Henry, responding in *A Farewell to Arms* to an inept comment on the "picturesque" loveliness of the scenery, says, "To hell with picturesque. It's damned beautiful." One might also slang a word without recourse to profanity. "Make tracks" in polite parlance simply meant to track, but it could be slanged, without changing a word, simply by tone and timing, into a phrase that meant "Get lost!" The verb "to fix" meant not only to mend something but to rig or force an outcome illegally. The World Series of 1919, the year the White Sox became the "Black Sox," had been, all the world knew, "fixed"; Fitzgerald's elegant hoodlum Jay Gatsby uses the verb in both its straight and its slang senses.

Although Berlin's "Alexander's Ragtime Band" was, musically speaking, not a rag but a straight march, it felt like a rag because its lyrics were (as Philip Furia has shown) thoroughly ragged or slanged:

> *Ain't you goin',*
> *ain't you goin',*
> *to the leaderman,*
> *ragged meter man?*
> *Grand stand,*
> *brass band,*
> *ain't you comin' along?*

Berlin had discovered that one could rag a song by syncopating its words without syncopating its music. Again, little change in vocabulary was needed; just shift the emphasis to the weaker beat, forget regular meter and correct grammar, banish politesse and censorship, and mine the surprises of the colloquial. A "rag" itself, then, functioned not as a noun but as a verb; it was less a form than an activity.

Black and white Americans have always remade language by letting verbs take over nouns, by putting the language on the run; they have always restyled Standard English, in other words, by something like a ragging process. Slanging and ragging in the 1920s, whether of classical music or Standard

English or both, simply updated, accelerated, and made self-conscious the tactic. As the ragtime pianist varied and mocked his traditional left-hand bass march time with his iconoclastic right-hand treble syncopation, the speaker of the American language, white or black, played a conventional verbal or grammatic usage off against an unconventional one. The American language gained its distinctive character by its awareness of, and opposition to, correct British Standard English; white slang was played against conventional middle-class Anglo-American speak, and the Negro version of the language worked self-consciously against the white one. In both cases, the surprise came from the awareness of conventions being flouted or violated. Ragging or slanging was the American Revolution all over again; in a stroke, British subjects became American rebels. Prerogatives were trashed; barriers were self-consciously breached.

The Prohibition era saw nightly visits of white slummers to black night spots and illegal cabarets, where bootlegging gangsters, lowbrow entertainers, and polite society were forced into close proximity and a common language. In December 1925, the year before she eloped with Irving Berlin, Ellin Mackay styled herself a "post-Debutante" and put the fledgling *New Yorker* on the map by explaining "Why We Go to Cabarets." She and her generation had apparently come to detest the old-fashioned gatherings organized by society's self-declared leaders as "bores," "absurd" occasions where people herd together on the strength of a shared class background, where depressed girls are consigned to dull men, and a hostess finds "a conglomeration of people on her hands who have not enough in common to amuse themselves." Mackay was flippantly impassioned about the right to make casual choices, to capitalize on the excitement that a world of strangers and acquaintances offers. In crowded speakeasies, nightclubs, and cabarets where daringly informal vocalists sang risqué songs on the dance floor and lingered with guests at their tables, where black performers entertained white or mixed audiences and the classes commingled, well-bred white girls could imitate the moves and sounds of the Cotton Club's "tall, tan and terrific" chorines, and posh young socialites could learn to talk like immigrant gangsters and Lower East Side songwriters.

As the 1920s understood and practiced it, slang wasn't properly slang unless it was deliberately affected by those to whom such a way of talking was not natural, not the only way they talked. If you always said "Ain't you goin'?," as Berlin did in "Alexander's Ragtime Band," you weren't slanging; you were just talking. But if you usually, by birth or training or both, said, "Aren't you going?" and *chose* to say "Ain't you goin'?," you were slanging, or ragging. One might argue that Berlin, with his immigrant parents and Lower East Side origins, was just writing the way he talked. But he knew that "Ain't

you goin'?" was incorrect English; "God Bless America," another early Berlin song, is written in impeccable Standard English. In any case, Berlin had targeted "Alexander's Ragtime Band" for a wider market than his own ethnic group; he was writing for mainstream middle-class audiences who did not naturally talk in black and/or ethnic idioms but were apparently eager to begin. The moment the speakers of a special race or ethnic group aimed at, and got, a trans-class, trans-race mass audience, an ethnic and/or racial dialect became slang. Berlin owed his career, as did Astaire and many others among his most talented white and black peers, to his instincts for creative slumming. Slang was deliberate disguise and pretense, part of William James's "will to personate," art passionately interested in downward mobility as the source of new forms of elite expression.

When Langston Hughes used the Negro working-class form of the blues and an illiterate black idiom in his second volume of poetry, *Fine Clothes to the Jew* (1927), many black reviewers were indignant. *The Amsterdam News* called him "the Sewer Dweller" and his poetry "100 pages of trash . . . reek[ing] of the gutter." Hughes was christened, not the poet laureate, but the "poet low rate" of his race. He had moved past Negro dialect into Black English, as a number of his most gifted black peers were doing, but few of his critics noticed or cared. What had happened, they asked, to classical standards of the "beautiful" and the "universal"? Hughes stated his own views in two articles—"The Negro Artist and the Racial Mountain," in *The Nation* on June 23, 1926, and "These Bad New Negroes," in the April 15, 1927, *Pittsburgh Courier*. "The life of . . . Lenox Avenue," he insisted, cannot be "expressed" in a "Shakespearean sonnet"; "no great poet has ever been ashamed of being himself." He protested the "urge within the race towards whiteness," the belief among Negroes that "white people are better than colored people," the black desire to be, as he said Countee Cullen wished to be, "a poet" only, not "a Negro poet."

Hughes seemed not only untouched by the negative publicity but proud of it. His lower-class idiom was an earned achievement, not a natural attribute; he had appropriated his black idiom as surely as he'd appropriated the white, and he'd done it far more self-consciously. The descendant of an old, well-established, and distinguished African-American family, though belonging to one of its more impoverished branches, educated in largely white schools in Kansas and Cleveland, Hughes was happiest as a child in the local library reading Edna Ferber, Whitman, and Longfellow's *Hiawatha*. He learned Black English not at home or at school but from outsiders, the dispossessed of his race.

Listen to "Ma Man," a blues poem from *Fine Clothes to the Jew* in which a female speaker eulogizes her lover:

He kin play a banjo,
Lordy, he kin plunk, plunk, plunk . . .
He kin play a banjo,
I mean plunk, plunk . . . plunk, plunk.
He plays good when he's sober
An' better, better, better when he's drunk.

Eagle-rockin' Daddy, eagle-rock with me.
Eagle-rockin',
Come and eagle-rock with me.
Honey baby, eagle-rockish as I kin be!

The banjo, a mainstay of minstrelsy, was considered a Negro instrument; "eagle-rockin'," a Negro dance step, was black slang for sexual intercourse. "Ma Man" was a coon song of sorts, but with a difference: black language was not sold out for white laughter. Hughes was having fun, but he believed in this language, believed it could yield art as easily if not more easily than Standard English could.

Remember: this was not how Hughes was trained or accustomed to speak. Like Hemingway adopting a starkly American idiom in *In Our Time* or Brice putting on a Negro accent or middle-class Americans asking, "Ain't you goin'?," this was how Hughes *chose* to speak. Like Hemingway, he was in some sense bilingual; he, too, was adopting an idiom not his own—yet more his own, he had discovered, than the speech he had been raised in. Donning the darkest of blackface, Hughes went, one might say, for the BLACKEST PATTI, a disguise sure to anger the better bred of his race. Berlin once described his search for the right word as looking for a "spear," a "punch," and Hughes, too, knew that the aim of the slang vernacular was to startle, even alarm; indignant reviews were integral to his project. Slang was another version of the "terrible honesty" ethos; slang was not slang without shock power.

It makes sense that most of the pioneers who reclaimed the American vernacular for musical and theatrical culture in the 1910s and 1920s were Jews and blacks. The claims of both groups to speak standard Anglo-American were half discounted from the start. If their need for linguistic upward mobility and the pressures on them to achieve it were stronger than anything their Wasp peers experienced, their hope of achieving it was less; they had a greater stake in defending and celebrating what they discovered they already possessed, Yiddish-American and African-American vernacular speech. But the domination of one or another ethnic or racial group is less important than the larger collaboration among them. Whether the artist was a Wasp

or a Jew or a Negro, a distinctively modern art meant undoing dispossession, making inventive use of one's buried or censored cultural and linguistic origins, and to hell with the consequences. As the young and self-consciously profane Hemingway once put it, "Fuck literature!"

GETTING THE JOKE

Slangsters appropriated their language, but naturally tended to speak another, more correct way; by definition they were defying their given tongue's most influential speakers. Once again, the enemy was depicted as feminine. In 1909, Irving Berlin had a hit in a song titled "My Wife's Gone to the Country—Hurrah! Hurrah!" The young T. S. Eliot expressed his aversion to the formal songstress of polite Victorian society as "a lady of almost any age, / But chiefly breast and rings," and in "I Love a Piano," Berlin spoke out more directly: "I detest the soprano! / She don't know when to pause." The American National Council of Teachers of English might have established "Ain't-less Weeks" and "Final-G Weeks" in 1915, but using "ain't" and dropping the final *g* (as in Berlin's "Ain't you goin'?" or Jolson's "You ain't heard nothin' yet!")—the most easily recognized characteristics of the Negro dialect—remained immensely popular. If 1920s popular music was the American spoofing the European and the Negro spoofing the white, it was also the masculinized spirit of the age defying its matriarchal custodians.

Ragtime spelled not just a vernacularization of the piano but its virilization, and some thought it needed it. As the historian Craig Roell has shown in *The Piano in America* (1989), the piano long symbolized to the Euro-American middle class the sacred trinity of Victorian values: hard work, domesticity, and moral uplift. Music teachers subjected their largely feminine pupils to the punishing *Klavierschule* regime of scale and exercises while promising them that success meant, in Longfellow's words about the importance of music, "a happy, peaceful and contented home"; "Husbands and brothers may be made almost domestic by one cheerful note," an advice manual of the 1890s explained. Music was seen as an "influence" as much as an art, and influence was woman's business. The use of "piano" as an adjective denoting "effeminate" or "weak" of course came from the Italian adjective meaning "gentle," but it seemed to elide with the name of the instrument; "too piano for me" is the way a young woman dismisses one man in Jane Austen's novel *Persuasion* (1818). Guitars, horns, even violins, and especially cellos were seen as decidedly masculine instruments. Etiquette books explained the proper methods a young lady must use in seating herself at her piano and rising gracefully from it.

Pianese, the language into which all orchestral scores were scored for domestic use, was a feminine language, one that offered its practitioners a means of speaking more "freely in the ecstasy of music," as *Everybody's* magazine put it in February 1908, than she was permitted to do in ordinary discourse. In 1922, women comprised 85 percent of music students and 75 percent of concert audiences. Some commentators were concerned about what the *MTNA Proceedings* described in 1922 as "The Feminization of Music," and queried, in the words of the February 1923 issue of *Current Opinion*, "Is Music an Effeminate Art?," but the value of genteel music was still an accepted American truth. The "Music in Industry" campaign of the late 1910s and early 1920s enrolled the Ford, Chrysler, Dodge, Western Electric, and Texaco companies, among many others, under its banner, and Calvin Coolidge said that "we cannot imagine a model . . . home without the family Bible on the table and the family piano in the corner."

Ragtime was a wholesale affront to this ethos of musical uplift. Predictably, its bitterest opponents were the big women's clubs and magazines. Settlement house workers, led by Jane Addams, had promoted piano music as a way of keeping unruly immigrant families safely occupied at home, but the idea of a music *made* by Jewish immigrants and black brothel pianists—"nigger whorehouse music" was the way an irate critic described it—was anathema. The American public might be going for a "ragtime life," but its middle-class feminine custodians in the National Federation of Women's Clubs, a staunch friend to Catt's NAWSA, pledged themselves to wrest music from "the hands of the infidel foreigner" and the low-down black. In 1902, the American Federation of Musicians, often an ally of the Women's Clubs, forbade its members to play ragtime, and in September 1914 *The Musical Observer* declared that there was no place for ragtime "in Christian homes where purity of morals are [sic] stressed." And if ragtime was un-Christian, jazz (which Alexander Woollcott aptly described in *The Story of Irving Berlin* [1925] as "ragtime gone daffy") was still worse.

In an article titled "Does Jazz Put the Sin in Syncopation?" in the August 1921 *Ladies' Home Journal*, Mrs. Max Obendorfer, president of the National Federation of Women's Clubs, declared that "jazz" was "originally . . . the accompaniment of the voodoo dances, stimulating the half-crazed barbarian to the vilest of deeds." In December of the same year, the *Ladies' Home Journal* announced that "Unspeakable Jazz Must Go." Its attack continued in the February 1922 issue with a piece on "Our Jazz-Spotted Middle West." Jazz music and the "crowd psychology" of Negro dances, it fretted, work together to produce "an unwholesome excitement." Jazz led to a "blatant disregard of even the elementary rules of civilization"; thanks to its influence, "the statistics of illegitimacy in this country show a great increase in recent

years." The "unwholesome excitement" produced by jazz was clearly kin to the "unhealthy excitement" for which Sidney Howard's mother rebuked him when he was a pilot in the Great War. What the war had begun, jazz was apparently finishing. Freud's "primaeval man within us," unleashed by the war, had stepped "into the light" and distressed, just as Freud had hoped he would, all upholders of "petticoat government."

Woollcott was one of the many white critics who gave *Shuffle Along* a rave notice; his review appeared in *The New York Times* on April 19, 1922. He was troubled, however, by the segregated seating arrangements visible at the Sixty-third Street theater. "There," in the prime seats of the orchestra, most inappropriately to his way of thinking, "sat whole rows of matinee ladies who had detrained from the social register, surveying through lorgnettes the Negro antics and agonies of which the play was wrought." Meanwhile, Woollcott noted with heavy sarcasm, "the Negroes who had ventured to come to see this piece about themselves"—a piece, one might add, acted, written, directed, and produced by members of their own race—were "shunted up into the balcony." But, as Woollcott was well aware, and as the popularity of *Shuffle Along* among white performers and songwriters demonstrated, Tin Pan Alley and its associates had abandoned the women's clubs and their musical and linguistic preferences.

Shuffle Along was hailed by blacks and whites as a critical step away from minstrelsy and its coon songs toward a modern black musical art, yet in some ways its importance stems precisely from its *return* to minstrelsy. The so-called years of exile for Negro performers had resulted, not in a diminution of modern Negro musical art, but in a proud intensification and creative complication of it, and *Shuffle Along* signaled an audacious and self-conscious mining of the Negro musical's black-and-white minstrel roots. Noble and Blake themselves called the show's grab-bag contents a "Musical Mélange." Its heady ragtime numbers, "Dixie" songs, fisticuffs, and comic dialogues full of fractured and exaggerated Negro dialect, its anti-reform impulses and comic electioneering drama serving weakly as plot, were all staples of the old minstrel stage; minstrel fans had thought nothing funnier than the Negro's thoughts and antics when faced with those activities half-forbidden to him, voting and running for office. The comedians and librettists Aubrey Lyles and Flournoy Miller performed in blackface; appropriately, Miller wrote for the *Amos 'n' Andy* show in the 1930s. Ethel Waters usually avoided the stereotypes that *Shuffle Along* refurbished and reinvented, but its creators were claiming a like artistic freedom. Anything, but anything, from the latest and hottest Negro dances to the oldest of white blackface routines, was grist to the *Shuffle Along* mill.

The minstrel show to which *Shuffle Along* paid free-form mock homage

had been a refuge against the Victorian middle-class woman and her moralizing edicts. Originally the purview of all-male casts, outspoken in its opposition to temperance and particularly woman suffrage, full of bad grammar, off-color jokes, and sheer funning, and at its inception committed to a largely male, working-class, rowdy, and participatory audience, minstrelsy was long the foe of the polite theater Victorian America wished to establish. All female parts were played by men, making sure that every woman onstage was at some level a joke. In the 1860s and 1870s, however, Tony Pastor, a New York barkeep, singer, and comic songwriter who was himself a veteran of the minstrel stage, began to clean up the variety show, the episodic working-class musical entertainment that had developed out of minstrelsy proper. Although variety performers included women as well as men and portrayed many ethnic groups, not just Negroes, its rude and roughhouse spirit gave away its minstrel origins. Pastor wanted to offer entertainment better suited to the lucrative mass audience of the family trade; he helped to create vaudeville, the better-bred if lively heir of minstrelsy and variety. Izzy Baline started out working at Pastor's; Nigger Mike's was a crucial and appropriate step *down* for the young Berlin.

In the 1880s and 1890s, the New Englanders B. F. Keith and Edward F. Albee, who later headed the powerful Keith circuit, which centralized and controlled most of American vaudeville, carried on the work that Pastor began. At the Keith shows, audiences were instructed by printed cards and signs to "avoid the stamping of the feet"; "the clapping of hands" was the correct response. "Talking during the acts" was prohibited, as were smoking, drinking, or "laughing too loudly." The prostitutes who had been the variety show's only dependable female patrons were refused admission, at least if they looked like prostitutes. No one "likely to smell 'garlicky' or to be poorly dressed" was allowed in the ever more select orchestra seats. In sum, the audience of the old variety and minstrel shows was to be housebroken or shown the door. Pastor, Keith, and Albee were courting the middle-class woman, long taught to shun the stage and its fruits as the devil's work. They succeeded; by 1903, the manager of Keith's Union Square Theater could boast that his matinees were "largely composed of females." Operettas and more serious domestic melodramas occupied the non-vaudeville stage, but the distinction between the three forms of entertainment was never complete. Many late-Victorian performers, like New York actress and singer Lillian Russell, worked in all three more or less simultaneously, and all of them attracted, to varying degrees, a preponderance of female stars and spectators.

By 1910 or so, the process contemporary critics increasingly called the "feminization of the [American] stage" was at its height. Educated guesses made at the time as to the proportion of women in the average theater

audience ranged from a cautious 50 percent to an excited 80 percent. The large and bedizened hats which fashionable ladies seemed to feel it their divine right to wear in the theater, no matter what the stature or the reaction of those seated behind them, as annoyed observers protested, elicited a series of "High Hat" bills in the 1890s prohibiting such apparel; both New York and Chicago passed High Hat legislation. In 1909, Ludwig Lewisohn, then a New York drama critic and already a misogynist, blamed drama's saccharine and uninteresting lack of "virility" squarely on "the American girl" and matron; in 1909, another critic attacked the "illiterate candyeating women" who infantilized the American stage. A reviewer for *The Nation* observed in January 1918 that "our feminized stage has long been anathema to the same critics that object to our ladylike literature," but until the 1920s their objections seemed a minority position.

The increase in the number of women actresses in these decades was prodigious: from 780 in 1870 to 4,652 in 1880, to 15,436 in 1915, and on to 19,905 in 1920. Salaries doubled, then quadrupled; Lillian Russell was earning $3,000 a week in her heyday in 1906. Women increasingly outnumbered men; according to one observer, twenty-five girls to every man attempted a stage career. This growing gender monopoly was self-consciously feminist and pro-suffrage. Russell was the proud daughter of Cynthia Russell, a suffrage pioneer who initiated the women's-club movement in Chicago in the late 1860s, and she claimed that she had been raised on "mother's milk and suffrage." "I never find any fault in a woman," Lillian said. A 1909 issue of *Billboard* carried the headline: WOMEN OF THE STAGE ALL DESIRE TO VOTE. In the same year, another New York paper asserted that the suffragist "is becoming indistinguishable from the typical actress."

Russell and her best-looking feminine peers were awarded titles like Champion Beauty and American Beauty (also the title of Russell's most famous song). These quasi-official titles were frequently contested; their belligerent ring suggested to one foreign observer "a pugilist like James Corbett of California." "The beauty of Lillian Russell," the *Morning Telegram* announced on January 27, 1901, "is as much an institution as Niagara Falls or the Brooklyn Bridge." Russell was proof that the American nation "takes second rank" to none "in the matter of beauty." "American Beauty," "Champion Beauty of the World"—these epithets promised, as one fervid feminist foretold, a "race of Queens," and anyone could tell *what* race. Herself blond-haired and blue-eyed, with a flawless pink-and-white complexion, Russell assured her fans: "I'm American clear through." In fact, she traced her descent to the Pilgrim fathers, and when she ran for mayor of New York City in 1915, she campaigned strenuously for tough anti-immigration laws. "Our melting pot," she explained, "has become overcrowded."

Although Russell was a warm and energetic woman with marked bohemian proclivities, notorious for a long series of husbands, lovers (most notably the robber baron "Diamond Jim" Brady), and unpaid debts, a staunch defender of Equity, the fledgling actors' union, and an advocate of exercise and freer clothes for women, she nonetheless represented the traditional forces of feminine censorship at least as much as she did the irreverent and mongrel forces of liberation. Née Helen Louise Leonard in Clinton, Iowa, in 1861, Russell had become a star under Tony Pastor's management in the early 1880s. A skillful light comedienne with a thin, clear, soprano voice, she specialized in operetta and burlesquing the classics, but as the years passed she herself attracted burlesque. The New York variety-vaudeville team of Joe Weber and Lew Fields (father to the lyricist Dorothy Fields, who won fame collaborating with Jimmy McHugh at the Cotton Club) used Russell in their musical skits of the 1900s much as the Marx Brothers used the stout, prim-and-proper Margaret Dumont as a straight woman two decades later; indeed, the brothers may well have gotten the routine from them.

Others had similar ideas. Djuna Barnes's interview with Russell in 1914 reveals a carefully orchestrated clash between two feminine cultures, between the old matriarchal spirit of uncritical self-approbation and the new feminist spirit of freely roving misogyny, a contest, though only one of its participants knows it, between old-fashioned good humor and modern ironic wit. Ushered into Russell's presence, the slim and voguishly tailored Barnes found herself in a "mysterious" world of "bounteous ruffles," "white duchess lace," small statuettes of "grotesque potentates," shaded windows, and dimmed lights. Russell was then in her fifties and, Barnes estimated, "twenty years beyond her prime"; the "still-beautiful eyes are only half-claimed from youth." The full-figured Russell, a pioneer in diet advice but not in diet success, seemed uninterested in such fact-facing, however; she "hate[s] a mirror," she confesses with disarming candor. The conversation turns quickly to food, and Russell tells Barnes that she has no fear of eating onions because her way of cooking them produces, "not an onion, but an epic!"

The two women's cross-purposes are revealed when Barnes asks Russell about "a freshly framed portrait of a dog" which the maid has rather portentously brought to their attention. Depicted is a "poodle pup," a "mere pen-wiper of a long-haired dog with a plaintive look in the eyes" seated upon "a morsel of velvet cushion," who was, it turns out, Miss Russell's only pet, now dead, a creature she had doted on so exclusively that she has decided to remain forever petless after its demise. Hearing the story, Barnes, without missing a beat, elicits her opinion on whether or not "things are going to the dogs." We expect her to make the connection Barnes clearly does; to one who so loves dogs, surely the notion can't be a bad one. But although

Barnes repeats the phrase, Russell doesn't get it. She simply rejects the notion in the interests of feminine essentialism: "With women in the world, how can things go to the dogs!" Groucho Marx always insisted that Margaret Dumont had not been acting—"She actually didn't understand any of the jokes"—and whatever her comedic gifts onstage, Russell, as Barnes presents her, had no ear for the language jokes in which the Marx Brothers and Barnes delighted.

The feminization of the stage that occurred in Russell's heyday was proceeding apace in just the years the coon song's ragtime idiom was developing. The two weren't altogether adversaries—Weldon Johnson, trying to gentrify the coon song, was delighted when Lillian Russell sang one of his songs. But sooner or later the conflict between the forces of feminization and the vernacular impulse was bound to surface; it did so in 1921, the year of *Shuffle Along* and *Dulcy*, the hit Broadway spoof by George S. Kaufman and Marc Connelly. *Dulcy* was *Shuffle Along*'s white sibling, the first full-grown specimen of the smart-talk comedy altogether antagonistic to the sentimental pieties of the recent Victorian stage. (It is worth noting that Kaufman wrote the book for the first musical comedy in which Margaret Dumont appeared opposite the Marx Brothers, *The Cocoanuts* [1925]; the songwriter was Irving Berlin.) *Dulcy* was the story of a flapper-matron (wonderfully played by Lynn Fontanne; the part made her a star), a youthful, innocent, good-natured, and wacky Margaret Dumont figure who almost destroys her husband's career as she tries to further it. A delightful straight woman, Dulcy is the kind of person who urges her guests to come to breakfast before "the grapefruit gets cold." *Shuffle Along*, too, had its Margaret Dumont figure, though one older and less winning than Dulcy. The wife of Sam Peck, one of the electoral candidates in the play (Sam was played by Aubrey Lyles, his wife by Mattie Wilkes), was that staple of fun from the old minstrel stage, the ardent and humorless suffragist; because of her, Sam loses the election. Barnes, with her sophisticated ear and alert wit, was part of *Dulcy*'s and *Shuffle Along*'s intended audience; the joke-immune Lillian Russell was not.

Langston Hughes can serve as spokesman for *Shuffle Along*'s chosen constituency; in *The Big Sea*, he tells us about an inspired bit of antimatriarchal spoofing he had engineered as a boy. Carrie, his temperamental, demanding, restless, and stagestruck mother, had enlisted him for her presentation, on a dramatics evening at the local church, of Cornelia, "the Mother of the Gracchi," a popular figure from the Roman past said to illustrate the nobility of mother love and self-sacrifice. Langston and another small boy were to be "dressed in half sheets as her sons—jewels, about to be torn from her by a cruel Spartan fate." But onstage, just as Carrie-Cornelia was begging heaven for mercy, Langston, out of his mother's sight, began to mug: "I roll[ed] my

eyes from side to side, round and round in my head . . . The audience tittered. My mother intensified her efforts, I, my mock agony. Wilder and wilder I mugged . . . until the entire assemblage burst into uncontrollable laughter." He was mocking the white feminine ideal his mother was impersonating at least as much as he was mocking her, but she could hardly be expected to grasp so fine a distinction. He earned a whipping and, he says, a "respect for other people's art"; it's not clear that the lesson stuck.

Hughes came to New York for the first time on September 4, 1921. He was nineteen years old and fresh from a sojourn in Mexico with his unhappy and unloving father. Taking up quarters in Harlem's 135th Street YMCA, he enrolled at Columbia College. His father, intent on seeing his son rise above "nigger" status, had supported his move to Manhattan only because Langston promised to go to school. But he didn't last long; his real reason for going to New York in any case was to be in Harlem, and to see *Shuffle Along*. Hughes saw it again and again. It was "a honey of a show," he reminisced in *The Big Sea*, "swift, bright, funny, rollicking and gay with a dozen danceable, singable tunes." Alan Dale, a white reviewer at the New York *American*, agreed. "How [the performers] enjoyed themselves! How they jigged and pranced and cavorted and wriggled and laughed! . . . Every sinew in their bodies danced; every tendon in their frames responded to their extreme energy." What made the show a hit, its composer Eubie Blake was sure, was its "lively, jazzy" air and its freedom from "mushy . . . sentimental[ity]."

In "Honeysuckle Time," a song from the show, we meet Emmeline: "Hot dog, my soul, [she's] goin'a knock 'em cold!" Shrill and coy-voiced soprano Gertrude Matthews (soon to be replaced by Florence Mills) had a hit singing "I'm Craving for That Kind of Love"; she wants "a modern Romeo . . . not a phoneo" for "at vampin' and lampin' / I'm the champ." This was all-out affection—"huddle me / cuddle me / sing to me / cling to me." Then there was Mirandy, "long, tall, seal-skin brown / With a loose and careless way." The audience of *Shuffle Along* was also instructed, visually and aurally, on how to do the "Baltimore Buzz": "Start the shimmy to shaking / Then you do a raggy draggy motion"; "Slide." Then "hesitate, / glide— / Oh honey, ain't it great!"

The pretense was still there in such lyrics; this wasn't the way the well-bred and middle-class lyricist Noble Sissle—like Hughes a graduate of Cleveland's distinguished Central High School—was raised to talk. But the pretense was complete; Sissle had gone past darky dialect, Ernest Hogan-style, not into Black English à la Hughes, but into exuberant black-and-white slang.

Musically speaking, *Shuffle Along* was high and unfettered ragtime; it

didn't take or need the next step into jazz, if only because it was too delighted with its own possibilities, too deliciously cocky and vain to wish to explore foreign territory, even that lying contiguous to its own domain. *Shuffle Along*'s happy mongrel idiom rediscovered and reinvented the omnivorously affectionate parody mode, half flattering mimicry, half creative insult, of which Jones, Whiteman, Jolson, and Berlin were the masters. The musical operetta was about to have a revival on Broadway—the Hungarian composer Sigmund Romberg and Czech Rudolf Friml were in vogue—and Sissle's "Love Will Find a Way," with its mock elevated theme ("Your love for me is a heavenly beacon") was a lighthearted homage to the operetta style. Sissle avoided the dirty words and double entendres of some of the earlier coon lyrics; *Shuffle Along*, too, wanted to attract, if not the middle-class matriarch, some of the family trade.

Sissle's longtime partner, the kindhearted Eubie Blake, was the son of ex-slaves, a street kid from Baltimore who'd learned ragtime in the black brothels of the South. His father had taught him early how to defend himself. "If anybody does anything to you, you fight," he said. "He['d] . . . beat me," Eubie later reminisced without rancor, "for being afraid." After one boyhood struggle with some white bullies, he burst out, "I hate white people!," but his father corrected him: "You don't hate all white people, only the people that did something to you." Eubie proved too interested in artistic appropriation to pause at race barriers, and he learned happily from a wide variety of white as well as black music; even the Floradora Girls from the London operetta that came to America in 1900 had something to teach him. A fan of Franz Lehár and Victor Herbert, he loved waltzes and composed many of them, and he thought Berlin a "genius" with few peers. Playing ragtime piano in Atlantic City back in the early 1910s, he had picked up "Alexander's Ragtime Band," and Berlin himself came around to hear him play it. Eubie had not forgotten his father's command to fight back and be fearless; black artistic freedom included, though it decidedly did not dictate, the unapologetic use of white as well as black materials.

The point, again, was not the choice but the freedom of choice. By this definition, Sissle's black-and-white idiom was as viable for the Negro artist as Hughes's lower-class lingo; in any case, Hughes modulated over the course of his career in and out of written versions of black speech more "white" in spelling and grammar than the language he used in *Fine Clothes to the Jew*. There was nothing wrong, for that matter, with Johnson's polite Negro dialect poetry or Bob Cole's Europeanized music; the Johnson-Cole trio were, after all, working in the idioms most natural to them, and reappropriating their white heritage as they did so. But Sissle and Blake, like their white slangster peers, had open to them a linguistic and musical range that went from high

white to low-down black, and a power of choice in selecting from it that their predecessors had not had: they had the chance to produce an exuberantly and self-consciously mongrel art, to do, in other words, what no non-American could hope to do as well if at all, and a number of Sissle-Blake fans noted the point.

On September 8, 1924, a critic from the *Herald Tribune*, reviewing *The Chocolate Dandies*, Sissle and Blake's latest Broadway musical revue, remarked that the audience was voluble in its appreciation even before the show began. The house was packed with people "who were there to greet their old favorites from *Shuffle Along*. The opening night was . . . the occasion for a boisterous housewarming [for] . . . Sissle and Blake and their compatriots." The *Tribune* concluded:

> Let it be said that it was an American Negro revue which first started . . . New Yorkers going to the same show a dozen times or more. After all, in this cosmopolitan city, and this heterogeneous nation, what can be more to the taste of New Yorkers than the productions such as the American Negro, with all his versatility and innate music, can present?

The art of Sissle and Blake signaled, in the *Tribune*'s words, a "triumphant homecoming" for all the members of this "heterogeneous nation," a nation best represented by its most "cosmopolitan" and theatrically minded metropolis, New York.

Blake and Sissle went on to write, together and separately, other Broadway shows. Eubie did the *Blackbirds* show of 1930; Ethel Waters, the star, had a hit in "Memories of You" (with lyrics by Andy Razaf). Eubie also made records and appeared on radio and film, and his career continued, with lulls but no real intermissions, until his death in 1983 at the age of 100. Sissle eventually organized his own band, the Sizzling Syncopators, and toured the United States and Europe; he died in 1975. Back in 1921, Flo Ziegfeld and other white theatrical impresarios hired the performers from *Shuffle Along* to teach the show's songs and dances to their own chorus girls. A number of Negro artists destined to play key roles in American entertainment in the 1920s and beyond got their start in *Shuffle Along* and its touring companies; singer-dancers Florence Mills, Lucille Hegamin, Josephine Baker, Adelaide Hall, Caterina Jarboro, and Freddie Washington, actor-singer Paul Robeson, and choreographer Elida Webb were all *Shuffle Along* alumni. It was definitely "getting darker," as Gilda Gray sang in 1922, "on Old Broadway," and way beyond Broadway.

Negro rhythm was, to recur to Bubbles's song, "for sale" everywhere. You could buy the sheet music and the records of *Shuffle Along*'s hit songs (on

the Okeh, Paramount, and Victor labels) and hear them on the radio, too. By 1924, *Etude* magazine reported, "tap America anywhere in the air and nine times out of ten Jazz will burst forth." Perhaps Negroes themselves could not be invited into white middle-class homes, but the new records and radios brought their music and language direct to the respectable white hearthside. Ragtime was not the only Negro music on which the new media fastened. It's time to turn to the blues, the form that gave Waters her start, Hughes his poetic art, and the entertainment media a new mini-industry.

SINGING THE BLUES

THE DEVELOPMENT OF AN AMERICAN FOLK ART

In an early musical called *Ladies First*, which opened on Broadway in late October 1918, George and Ira Gershwin introduced a spirited number called "The Real American Folk Song [Is a Rag]"; an important chapter of cultural history lies in their brash title. As a host of commentators pointed out, the Negro culture that produced ragtime had given the nation its only fully developed "folk" art. The popular arts that supplied the early media with their content had antecedents as well as descendants; if the mass media were their future, the folk arts were their past.

Constance Rourke, Gilbert Seldes, and other scholars at home and abroad explained this pattern of cultural development as a general phenomenon. Folk art preceded and laid down the base for the popular arts transmitted by live performance; the popular arts in turn supplied the mass arts that succeeded them with their material. Mass art took the popular arts and their folk origins and transmitted them via the media to the widest possible audience for the largest possible profit. "Folk" culture, then, was the basic material of both the popular and the media arts, although it did not automatically create either. A pre-media, pre-literate, oral tradition, dependent not on technology but on communal traditions of storytelling and live performance, folk culture was thought to be the earliest stage of a national art, the culture a nation had by sheer historical accretion, part of its deepest spiritual and religious origins, an expressive birthright endowment that it didn't have to work for but inherited from its own unrecordable longevity.

There was a problem with this model of development: it seemed to leave America out. Settled in what was already a print era by well-educated men and women, Euro-America was believed to lack, as no other comparable

Western power did, the preliterate past that would feed, enrich, and diversify national self-expression. It had few indigenous folk traditions like the ballads collected by Thomas Percy in England and Scotland and published in 1765, or the fairy tales compiled by the Grimm Brothers in Germany in the 1810s. American Indians, of course, had their own oral traditions, but they were conveyed in languages both unknown and irretrievably alien to the Europeans who had conquered them. Once again, it was a question of pedigree rather than current assets; Euro-America had no artistic form that reached back to an unchartable past conducted on its own shores.

Yet Euro-America *did* have a more recent tradition of folktales and songs. Rourke's work was devoted to this material, and in her last book, *The Roots of American Culture*, posthumously published in 1942, she wrote that "we are still a folk—an imperfectly formed folk—rather than a schooled or civilized people"; to her mind, even contemporary artists like Hart Crane and Vachel Lindsay revealed their indebtedness to American folklore. The difficulty, which Rourke was not always willing to acknowledge, was that America's tall tales and ballads had usually been written down within decades, not centuries, of their inception. The historical Davy Crockett, for instance, was born in 1786 in Tennessee and died at the Alamo in 1836; the legends about him began appearing in the press when he was still in his twenties. Time and again, the omnivorous print tradition cut short the long gestation and development period the arts enjoyed in older Western countries.

Euro-America had also imported a preliterate population of Africans and for two and a half centuries refused them access to its print culture. In the 1920s it discovered that some of them had been incomparable artists who had shaped a rich and diverse legacy—conveyed in something recognizably like the English language white Americans used—of just that folk culture of story and song Euro-America presumably lacked. In 1927, a white critic for *The New York Times*, reviewing *Earth*, a play written by the Negro dramatist Em Jo Basshe and starring Inez Clough, commented: "Through Negro culture our novelists and playwrights hope to find the colorful folklore that our starved literature needs most of all." In Alain Locke's opinion, the spirituals were "medieval" in their "naïveté, faith and fervor." America, of course, had no medieval period, technically speaking, but its missing artistic past had been miraculously supplied, as Locke explained it, by black culture. The argument made by those "Digging Up the Negro Past," their case for the priority of the African and African-American tradition over the white, had apparently been validated. The black tradition was the only folk past America could claim; black cash covered white deficits.

Black claims to supply America with its missing folk past were, of course, in part simply smart salesmanship, an update of the black minstrel performers'

insistence that they alone could offer authentic black songs, speech, and dances to eager white audiences, even an instance of blacks and whites collaborating in marketing a mutually profitable form of black essentialism; as folk art, the Negro past slipped once again into the safe if talismanic realm of prehistory. But such claims had undeniable roots in fact. Black culture offered the most extensive body of oral or preliterate art available in America and the most broadly valuable one in terms of both commercial clout and religious expressiveness. Negro folk culture gave the American mass arts the material, the impetus, and the distinctive vitality they needed to win and hold a worldwide audience, and they offered a portrait of the American soul unparalleled in depth and invention. The blues were the trump card of the black popular arts, not only the single most popular and influential musical form of the 1920s, but a more authentic and spiritually expressive folk art than ragtime, under examination, could claim to be.

Ragtime had developed in big cities with heterogeneous populations and multiple artistic traditions; its earliest composers were black pianists performing on the bordello scene, but all of them worked with strong European influences, notably the march-time bass. Although they were largely illiterate, working by improvisation and picking things up from one another by ear rather than from the printed page, a few of them, led by Scott Joplin, were highly literate musicians committed to writing their music down and selling it to as big a public as they could find. In any case, white performers, composers, and promoters quickly got hold of ragtime and played, printed, and reproduced it for a broad mainstream audience. The first reliable description of ragtime's appearance dates from the mid-1880s; the music became accessible to a wide public for the first time when a group of black pianists electrified the public with their "rags" at the Chicago World's Fair of 1893 and the first self-described rags were published as sheet music a few years later. Ragtime's ten-year span from first appearance to print publication, a transcription rate almost as quick as its headlong beat, was closer to Davy Crockett's fast-track progression from oral legend to print-culture hero than to the slow gestation of the Scottish ballad or the German *Märchen*.

The progression of the blues from oral to print form was very different, however, for they developed not in the cities but in the isolated rural Negro culture of the Deep South. Ragtime's heyday was in the 1900s and early 1910s, that of the blues a decade and a half later, yet the blues antedated ragtime by decades, probably beginning as a stable and recognizable form just after the Civil War. They were not written down for another fifty years and did not reach a broad audience until the early 1920s. In the first decades of their existence, then, in contrast to ragtime, the blues were an oral form, passed on from one Negro artist to another and performed for live audiences

only. With their protracted tenure as oral culture in "years of exile" more complete than anything the Negro ragtime-based musical theater experienced, the blues, America's most radically black artistic form, offered a rare example of an oral folk form developing in a media age yet largely outside and independent of media influences, a phenomenon possible only in white and black, literate and illiterate America. Ragtime was a secular form, though it was capable of almost ethereal heights of festivity; the blues, despite their insistence on the realities of this world, or rather perhaps because of it, were far closer to their spiritual and religious folk roots.

The blues came in all likelihood from the slaves' oldest work songs, carried almost intact from Africa, and they kept their African allegiances more completely than either the spirituals or ragtime did. The simple three-line (AAB) twelve-bar form of the early or "classic" blues (later varied, extended, and elaborated) was itself African, and rare in the folk music of the West. Unlike the spirituals, the blues showed relatively little interest in harmony and melody, which came as late developments and were never essential to them. Instead, they centered, as African music always had, on complex rhythms untranslatable in conventional Western systems of musical notation—there was no equivalent to ragtime's Euro-American march-time bass—and were cast in the minor and pentatonic modes favored in African music. Originally performed by a solo singer and a single instrument, usually a piano, guitar, or banjo (horns of one kind or another became increasingly de rigueur in the 1920s), they worked by internal imitation: the blues instrument emulated the voice and vice versa. Both instrument and vocalist depended on African musical techniques: "blues notes"—flatted thirds or sevenths—and microtonic slurrings between major and minor harmonics, moans, growls, hollers, and repetitive but always changing patterns of call and response. Unlike the ragtime coon song, the lyrics were not in Negro dialect but in Black English; they were unmistakably written by blacks, by blacks thinking, to recall Braithwaite's words, as if no "white man had ever attempted to dissect the soul of a Negro."

It might seem that the blues contradict the point I've repeatedly made that black art in the 1920s was in its roots white as well as black, and many black artists claimed that the real blues were inaccessible to whites. The entrepreneurial Clarence Williams, pianist, singer, music publisher, and sometime blues composer who served as Bessie Smith's first manager and accompanist and backed Ethel Waters on some of her recordings for Columbia, remarked, "I'd never have written blues if I'd been white." W. C. Handy, the "Father of the Blues," said that the blues were the Negro's "mother tongue"; their composition "can't be delegated outside the blood." In our own time, in his study *Blues People* (1963), Amiri Baraka has asserted that blues are not

properly speaking American at all; "Bessie Smith was not an American . . . she was a Negro." Without denying the blackness of the blues, I cannot altogether endorse this position; the blues, too, were the product of a bi-racial world. If their rhythms and vocal techniques, their call-and-answer patterns, were Negro and African in origin, their marketing and the needs from which they came were American and mongrel. Only blacks could have written the blues, but they could not have written them in an all-black world.

The blues craze took off on August 20, 1920, in New York when the black singer Mamie Smith recorded "Crazy Blues," written by Perry Bradford, for the Okeh label. Bradford had had trouble finding a record company interested in his project. "I'd walked out two pair of shoes going from one studio to another," he remembered in his autobiography, *Born with the Blues* (1965). Yet "Crazy Blues" was already a proven hit; Mamie Smith was wowing Harlem cabaret audiences with it in 1919. Her audiences were largely black, however, and it was believed that only white people bought records, and white people, everyone knew, liked white music. Even the black firm of Pace and Handy wanted to hire a white singer named Aileen Stanley to do the song. In 1919, Okeh, later a division of Columbia Records, had tried in vain to get Sophie Tucker to record it, but in 1920 the company was in financial trouble and Bradford promised them, "There are fourteen million Negroes in our great country, and they will buy records if recorded by one of their own." Okeh hired Mamie Smith for the job, and the recording director, Fred Hager, let Bradford back her up with an all-black Harlem jazz band led by Willie Smith on piano.

The record of "Crazy Blues" went for a stiff $1, but in four weeks an astonishing 75,000 copies had been sold; in seven months, the number was 1 million. The buyers were largely black and working-class; most educated Negroes condemned the blues as crude and illiterate, a racial embarrassment, though their resistance lessened over the decade. When the stores ran out, people bought bootlegged copies for as much as $4 or $5. Bradford, who'd been borrowing quarters for meals, received a royalty check for $10,001.01. Mamie Smith's career was launched; she made twenty-three more records for Okeh within the year. "Crazy Blues" put Okeh solidly into the black, in terms of both its profits and its audience. The music industry had discovered the Negro as artist and consumer and it held on for dear life.

Variety acknowledged that "only a Negro can do justice to the native indigo ditties," and within the next few years, the number of blues records, songs, and singers soared. The 1920s blues were largely a female tradition, and the singers who recorded them included Mamie Smith, Ida Cox, Clara Smith (none of the Smiths was related), Ethel Waters, Lucille Hegamin, Sippie Wallace, Victoria Spivey, Alberta Hunter, Trixie Smith, Jane Martin,

Monette Moore, Margaret Johnson, Edith Wilson, Mae Barnes, Chippie Hill, and, of course, "Mother of the Blues" Ma Rainey, who cut 100 sides for Paramount between 1923 and 1928, and "Empress of the Blues" Bessie Smith, who recorded 180 songs for Columbia between 1923 and 1929. Columbia had gone into receivership just months before Bessie cut her first record in 1923, but her "Down Hearted Blues," written by Alberta Hunter, sold 780,000 copies in its first year; she was as important to Columbia's financial health as Mamie Smith was to Okeh's. The number of available black female singers, till then hardly a hot commodity, was insufficient; black artists began recording for dozens of different labels under assumed names. Something like 211 black women vocalists were signed by record companies in the 1920s, and between 1920 and 1942, roughly 5,500 blues records were released, involving about 1,200 artists.

Buoyed by the blues and jazz craze, the fledgling record industry underwent a period of explosive growth in the late 1910s and early 1920s. All the major record companies began doing "race" records. Okeh, Columbia, and the small but scrappy Paramount label in particular developed extensive rosters of black artists. The business was lucrative. A single disc cost a mere twenty cents or so to make. Early performers were paid anything from $25 to $50 a song. Some singers worked out royalty arrangements; many others, like Bessie Smith, did not. Bessie's total pay for eight years of hits at Columbia was $28,575, roughly $3,500 a year, and she was the best-paid black recording artist of the decade, making $175 for every record. The sale of the first 5,000 copies of a record usually made back the company's outlay; the rest was sheer profit. In 1921, retail sales stood at $106.5 million, almost ten times the figure of 1909; Variety began to print a monthly record chart.

However exploitative their tactics, the record companies that featured this music meant to promote, if not honor, the black artists they signed. Even the label "race" record, by the 1950s a dirty word, was intended to be less a tip-off to Negrophobic whites or a push toward cultural segregation than a drawing card to black buyers, a tribute to the spirit behind Garvey's slogan, "Up you mighty race!" Several black music publishing and recording companies, most notably the Black Patti and Black Swan companies, sprang up to meet the demand and get a share of the profits. In the spring of 1921, Black Swan signed Ethel Waters to record her first record, "Oh Daddy" and "Down-Home Blues," and got its first big seller; profits for the year were a solid $104,628. The label's heyday was vivid if brief—Paramount bought it in 1924—and race-proud all the way. Du Bois himself sat on the board, Handy presided, Fletcher Henderson was recording director, and all its stockholders and employees were black. The name, like that of the Black Patti

label, was a homage to a Negro singer, in this case, Elizabeth Taylor Green-
field, who toured America and England in the mid-Victorian era billed as
"the Black Swan." Black Swan advertised its products as "The Only Genuine
Colored Record. Others Are Only Passing for Colored." There were a lot
of passers.

"Crazy Blues" had originally been titled "Harlem Blues"; Okeh changed
the name in hopes of tapping the white market, and while most of the buyers
of "Crazy Blues" were black, blues quickly became a biracial phenomenon.
Tin Pan Alley produced more than two hundred songs with "Blues" in the
title between 1920 and 1928 and every important Alley songwriter had a
couple to his credit; Kern's "Left All Alone Blues" (1920), the Gershwins'
"Yankee Doodle Blues" (1922), DeSylva, Brown and Henderson's "Birth of
the Blues" (1926), Rodgers and Hart's "Atlantic Blues" (1926), Berlin's
"Shakin' the Blues Away" (1927), Dorothy Fields and Jimmy McHugh's
"Singin' the Blues" (1927) and their "Out Where the Blues Begin" (1928)
were among them. Popular white singers like Helen Morgan, Fanny Brice,
Ruth Etting, and Libby Holman became famous for blues-based "torch
songs": Morgan's "Can't Help Lovin' That Man o' Mine" and "The Man I
Love," Brice's "My Man" (taken, however, from a French original), Etting's
"Love Me or Leave Me," and Holman's "Moanin' Low." Dorothy Parker,
a habitué of the black and white night spot scene, rephrased the blues
sensibility in her own ironic and polished mode in best-selling collections
of poems, *Enough Rope* (1926) and *Sunset Gun* (1928). Hemingway, who
frequented the racially mixed clubs of Chicago in the early 1920s, the first
big Northern outlet for the blues, used blues talk of "two-timing papas" and
"sweet jelly roll" in *The Sun Also Rises*, and his subject matter and aesthetic
had striking affinities with the blues sensibility.

Whatever his beliefs about the exclusively Negro quality of the blues,
Clarence Williams wrote and produced dozens of "whitened" blues songs
and records, and Handy, too, capitalized on their biracial appeal. In 1926,
in collaboration with a white Wall Street lawyer, Abbe Niles, and the Mex-
ican illustrator Miguel Covarrubias, he put out the scholarly and well-
received *Blues: An Anthology*; lyrics and sheet music were included, and
Niles's presence and introduction made clear that the volume was aimed at
white audiences as well as black. A few years earlier, Porter Grainger, a
Negro pianist and composer who sometimes accompanied Bessie Smith and
Clara Smith on their Columbia recordings, and the arranger Bob Pickett
had published a more obviously promotional booklet for blues fans entitled
How to Play and Sing the Blues like the Phonograph and Stage Artists. The
novice was instructed on "blues notes" and "minor" keys, on "breaks" and
"wailings, moanings and croonings," urged to play or mimic the saxophone,

trombone, or violin, and, the most audacious suggestion, to "play the role of the oppressed or depressed." Only a few weeks of practice were needed.

Paid blues performances had seldom been pure blues in any case; the imperatives of the broader white-and-black entertainment world were present from the moment the blues were sung for profit. They found their first audiences as part of the mixed entertainment format of the later minstrel shows, black and white. When Ma Rainey began to sing and write the blues in the late 1900s and 1910s, she was touring with Pa Rainey in the Rabbit Foot Minstrels, billed as the "Assassinators of the Blues." Despite his classical training, Handy spent some of his formative years in black minstrelsy; writing his greatest hit, the "St. Louis Blues" (1914), he "resorted," in his words, "to the humorous spirit of the bygone coon songs." Perry Bradford also began in black minstrel shows, where he picked up the nickname "Mule" from his trademark number, "Whoa, Mule." The young Bessie Smith traveled, first with her friend and mentor Ma Rainey in one or more of Rainey's shows, then on the black vaudeville circuits. A big woman in height and weight, from the start she was famous for her comedy and pantomime as well as her singing. When Ethel Waters picked up Handy's "St. Louis Blues" working on the TOBA circuit in the 1920s, she was as much a dancer as a singer. White coon shouters and minstrel stars Nora Bayes, Sophie Tucker, Blossom Seeley, and Al Jolson learned blues songs and brought them to white vaudeville. Blues numbers started turning up on piano rolls in the 1910s; the rolls could be bought through the same stores and mail-order catalogues that sold records.

Jazz surfaced in minstrelsy and vaudeville, too, sometimes as a comic or novelty act, and many jazz musicians served as back-up bands to the women blues singers. Louis Armstrong, then gigging in New York with Fletcher Henderson (another frequent accompanist on blues records), worked with Bessie Smith and Ma Rainey on their early recordings. Jelly Roll Morton accompanied Rainey live in Chicago. The soprano saxophonist Sidney Bechet backed Bessie on her recording of "Cake-Walkin' Babies," a number he'd also cut with Armstrong; tenor sax Coleman Hawkins accompanied Mamie Smith. Henderson and Armstrong were perfecting their mature styles when they worked with the blues singers. "Jazz" itself, in our contemporary sense of the word, developed in part from ragtime's syncopated loosening of the beat, in part from the improvisations such musicians brought to blues instrumentation, and it long retained obvious blues structures and sounds.

As the blues rooted in the Northern cities, their rural and folk nature was altered, refined, whitened. The songs were written down; the lyrics were cleaned up and elaborated, and the music was subjected to various kinds of

treatment, sometimes jazzed and ragged, more often Europeanized into conventional harmonies and turned into Tin Pan Alley pop. Black blues and jazz musicians and singers who tended to stay closer to the original "classic blues" format never sold with white audiences in the numbers their white imitators and peers did. One of Princeton's idols in the 1920s was the white cornetist Bix Beiderbecke, but most of the college remained ignorant of the black jazz world he came from; a 1928 survey of record collections there found nothing by black artists save one lone Armstrong recording. Even Okeh and Black Swan turned down the chance to record Bessie Smith in the early 1920s before Columbia signed her because they considered her vocal style too rough, too "Negro." Outside of hard-core jazz circles and the South, where she was a star on a white radio station, WMC, in Memphis, her audience was almost totally black.

While white Americans in the 1920s listened to white not black versions of the blues, some vestige of the blues tonality (the use of blues notes and blues singing and instrumental styles) and the rock-bottom blues sensibility remained in all but the most diluted of the white blues, and the black blues themselves bore the impress of the larger society from whose privileges their makers were largely barred. As Waters used her years of exile from white audiences to perfect a daringly black-and-white style, as *Shuffle Along* ended the ban on black Broadway musicals by plundering the black-and-white musical world for its colorful sound, the blues used their own long years of exile to respond to a peculiarly American white-and-black world; as the African-American critic Albert Murray has pointed out in *Stomping the Blues* (1976), only Africans-in-America composed this music or anything much like it. Even Amiri Baraka acknowledges that the experience Bessie Smith sings about "could hardly have existed outside America." To go deeper into black America was to go deeper into white America, too.

BLACK "TERRIBLE HONESTY": READING THE BIBLE

A recently unearthed birth certificate has revealed that Louis Armstrong was born, not as he long gave out, on July 4, 1900, but on August 4, 1901. Like many lower-class people of the day, he may in fact have been unsure of his birth date, but the point is the choice he made. He wanted to begin when the century did; he wanted to pair his birth with that of the nation. July 4 was a big day for black Americans, too, if one not without its ironies. In "Poor Man's Blues" (1928), Bessie Smith expressed a Negro patriotism massively exploited but strangely resilient: "Poor man fought all the battles, poor man would fight again today, / He would do anything you ask him in the

395

name of the U.S.A." The blues person knew, in Ida Cox's words in "Pink Slip Blues," that "Uncle Sam done put me on the shelf," but whatever the Negro's lot there, America was assumed not simply as the world where the blues perforce transpired but as the world they could and must reinterpret and transform.

Growing up in Harlem in the 1930s, the Negro musician William Dixon reflected: "It did seem . . . that these white people *really* owned everything. But that wasn't entirely true. They didn't own the music that I heard played." Ralph Ellison has explained that the blues and their sibling, jazz, marked "the excitement and surprise of . . . enslaved and politically weak men successfully imposing their values upon a powerful society through song and dance." The blues were both an expression of a distinctly racial experience and a powerful and archetypically American assertion of autonomy and repossession, one that can be fruitfully put in the context of a long-standing debate about the American artist and his material.

In his study of Hawthorne (1879), Henry James, explaining *sub rosa* his own expatriation, inquired darkly what the American writer could possibly find to write about in a country with no ancient and civilized past. America had

> no aristocracy, no church, no clergy, no army, no diplomatic service, no country gentlemen, no palaces, no castles, no memoirs . . . no thatched cottages, nor ivied ruins; no cathedrals, nor abbeys, nor little Norman churches; no great Universities nor public schools—no Oxford, nor Eton, nor Harrow; no literature, no novels, no museums, no pictures, no political society, no sporting class—no Epsom or Ascot!

What, then, could the American artist, faced with this bleak prospect, find to talk about? Why "nothing, but the whole of human life," replied James's friend William Dean Howells in the February 1880 *Atlantic*. Howells was a founding member of the NAACP, a vigorous if sometimes injurious pub-licist of the dialect poems of Paul Laurence Dunbar, and an admirer of the work of Charles Chestnutt. He thought Chestnutt's writing had just the quality he told James was the American writer's birthright, a quality "new and fresh and strong as life always is and fable never is," a quality he implied James might lack. It was this "whole of human life," free of contrived "fables," that the Negro announced in the blues as the portion left him by a society determined to exclude him; it was the black American artist, not the white one, who most boldly enacted Howells's injunction to create an American art.

The blues were set in a stark landscape, limited and denuded in terms of conventional mores and recognized institutional culture, just the kind of landscape that James lamented as Hawthorne's only mise-en-scène; indeed,

his words about a world barren of upper-class amenities (largely inaccurate as far as white America was concerned) were an almost reportorial description of the black America that produced the blues. The blues expressed the hopes and fears of a lower class chronically out of work, routinely stripped of what little they had:

> De blues ain't nothin'
> But a poor man's heart disease.
>
> I never had no money befo'
> and now they want it everywhere I go.
>
> Ain't it hard to stumble,
> When you got no place at all?
> In this whole world,
> I ain't got no place at all.
>
> Now, if you's white
>> You's all right,
> If you's brown.
>> Stick aroun'
> But if you's black
> Oh brother,
> Git back! Git back!
>> Git back!

As Bessie Smith sang in one of her greatest numbers, released, appropriately, only a month before the crash of October 1929: "Nobody Knows You When You're Down and Out."

Bessie's line echoed Bert Williams's signature song, "Nobody." Williams was the first black recording star (on Columbia); his debut session dated from the infancy of the recording industry in 1901. Louis Armstrong collected his records, which makes sense; his spare, plangent, wry, and down-to-the-bottom-of-the-barrel musical and monologuist style was part of the blues tradition. These were songs created and sung by "nobodies," people that "ain't got no place at all," and in a characteristically American act of reversal, they turned the successful and presumably superior somebodies who ignored or misjudged them into the real nobodies of this world. I have remarked that the New Negro, despite the wrongs and terrors of the situation he faced, was not self-consciously "lost," as his white peers were, that he often felt himself markedly superior to most of his white immigrant and native-born peers; the

blues made the same point. They were a complex and potentially elite form that resided only with the masses; in the blues, the masses *were* the elite, and they everywhere advertised their invulnerability to outside authorities.

If the dynamic of American culture, its movement and focus, was the mood, the state of mind that splices the open freedom of geographical and psychological mobility with the fixed obsessions of unchosen themes and directions, the lexicon of feeling good and feeling bad and the rapid, unpredictable shifts between them; if popular and elite art in the Jazz Age was the self-conscious explication of the inexplicable, no artistic form did it better than the blues. The blues seem never to know their emotional origins; there aren't causes, just inescapable states of mind and *faits accomplis*. "Good morning blues," Bessie sings in "Jailhouse Blues" (1923), "how do you do?" "Thinking" doesn't help here, because as Bessie reminds us in "Thinking Blues" (1928), "sometimes you just set thinkin' with a thousand things on your mind." In "Blame It on the Blues" (1928), Ma Rainey tells us about being "sad, worried" full of "troubles," but she doesn't know why; she can't hold her mother or father, or her lover or husband responsible. There's no reason; she'll just "have to blame it on the blues." In the blues, the mood is all the psychology there is.

A mood by definition defies logic and explanation; the blues singer might have no control over her feelings, but no one else does, either. The blues developed during the heyday of the Titaness, but nowhere was the Negro sense of freedom from white euphemistic gentility more confident than in the blues and the older work songs that underlay them:

> White folks on the sofa
> Nigger on the grass
> White man is talking low
> Nigger is getting ass.

Hostile to conventional middle-class morality, down-to-earth and invariably sexual, the blues offered vivid representations of orgiastic pain and pleasure. In "Empty Bed Blues," released in 1927, with Porter Grainger on piano, Bessie Smith mourns an absconded lover who "could grind my sausage" with his "brand-new grind," a man who "thrills me night and day." Challenging or ignoring the censorship laws that governed the art of Henry James—in the title of another Bessie Smith number, " 'Tain't Nobody's Bizness If I Do!" (1923)—was one shortcut to the "whole of human life," a route many white moderns, led by Hemingway, insistently traveled.

Like Hemingway's writing, like Melville's, the blues were militantly based on what the speaker, *he and no one else*, felt like; in Hemingway's words,

"You can depend on just as much as you [yourself] have actually seen and felt." In his autobiographical "rhapsody" *Pierre* (1852), Melville said he wrote "exactly as I please." An anonymous blues man echoed him a half century or so later: "I wrote these blues, gonna sing 'em as I please / . . . I'll swear to goodness there ain't no one else to please." As Hemingway and his white peers pledged to deliver the facts, give the lowdown, tell it like it is, the blues man announced, in the words of Henry Townsend, a St. Louis musician, "When I sing the blues, I sing the truth."

In their distinctively modern form, the blues had their origin in the post-slavery era. A response not only to the chronic material impoverishment of Negro life but to a particular period of Negro history, the age of the Emancipation Proclamation and Reconstruction, and of the Jim Crow laws and Ku Klux Klan tactics that undid them, they testified to the hard knowledge of a people who had been enslaved, "freed," and re-enslaved; in the words of the jazz historian Marshall Stearns, their trademark was "a lean matter-of-fact skepticism that penetrates the florid façade of our culture like a knife," a lapsarian spirit quite unlike anything in their fervent predecessors the spirituals. The makers of the spirituals, a product of the antebellum, pre-Emancipation period, don't know what the blues man knows: the earthly liberation the spirituals look forward to has already happened and has proved a farce. The blues bore witness to a moment of immense and historic disillusion; it was predictable that they attracted many white imitators and fans among a generation that found its own beginnings in a highly publicized disenchantment with the vague, large promises of its Victorian predecessors. Paradoxically, the fact that Negroes wrote the blues made them more not less authoritative and compelling for whites. Only the Negro, the blues tell us, saw America whole; only the Negro knew America as it really was.

In *Along This Way*, James Weldon Johnson noted that black people in America had survived by "learn[ing] the white man" they dealt with. Poor people have always studied the rich more carefully than the rich have studied them, but American blacks had to figure out whites, for their opinions and feelings in slavery days and long after determined not just their welfare or lack of it but their lives. Blacks "learned [the white man] through and through," Johnson wrote, in his "arrogance and gullibility" and "pride," and they did it "without ever revealing themselves." Johnson said that Negroes tend to evaluate the white man solely on the grounds of how he treats black people, but this perspective on the white man was not, in his educated estimate, a narrow one; "the absolute truth [of this "test"] averages pretty high." A white man, in other words, usually *is* how he treats the black man.

Johnson's words are suggestive. Black Americans have contributed more to popular culture in proportion to their numbers than white Americans;

blacks have dominated the arts in which they have been allowed to work, namely, music and dance, and played a major role in shaping the linguistic styles and religious expression of the nation. This has been so, I think, not simply because of the apparently superior expressive gifts of black Americans, but because they know more about the country that white and black alike call their own. In "Criteria of Negro Art" (1926), Du Bois wrote that "we who are dark can see America in a way that white Americans can not." Black people know the Negro, and they know him as white Americans intent on justifying their racial supremacy do not, but they also know white Americans as they cannot know themselves, liable as they are to confuse their power with their rights and deserts, to mistake superior status for superior soul or character. The blues were an expression of the Negro's total knowledge; a claim to such knowledge was their *raison d'être*.

The most important Western source for the blues was the Bible, particularly Proverbs and Ecclesiastes. Like these scriptural texts, the blues were a form of wisdom literature, and the aesthetic of wisdom literature presumes that everything is known, everything is understood, absorbed into the mind, the bones, of the artists involved. The authors of wisdom literature are always in some sense plural; wisdom literature, whether in the form of a proverb or a blues song, whether presented as the utterance of a single spokesperson or an entire race, claims to be the collaboration of the species. Though all knowledge cannot be present at any given time, the weight of the total knowledge which is unspoken shapes what is said. It's a version of Hemingway's idea that what you don't say will show in the telling and give that telling a force, a depth, it would otherwise lack. In the blues, America is what is known through and through; in Johnson's words in the preface to *The Book of American Negro Poetry*, the Negro's music expressed "not only the soul of [his] race, but the soul of America." As Houston Baker has recently put it in his study *Blues, Ideology and Afro-American Literature* (1984), "Blues seem implicitly to comprise the *All* of American culture."

Eubie Blake, speaking in 1924 of modern black music, remarked that "jazz," as he loosely called it, expressed the "Negro's . . . religious emotions," and the early blues were perhaps the strongest evidence of his statement. It is not that the blues were otherworldly or church-bound or morally minded—they were militantly none of these—but they had a purchase on what feels like universal and absolute truth. The wisdom literature of Proverbs and Ecclesiastes is among the least obviously religious writing in the Bible; it is pragmatic, concerned with how God's laws operate in human affairs rather than with his nature or his greater plans for mankind. If God is here at all, it is less as a supernatural force than as the sum of what human beings know about themselves as they live in a world that exceeds their powers of

comprehension. Unlike the spirituals or gospel music, the blues were not overtly concerned with God either, but if theology means, as I think it does, honesty investigating its own claims to existence and justice redefining but not losing itself in the presence of massive injustice, they were theological. If religion means the direct apprehension of the precise workings of things, of their reality-power, their ability to arouse terror and desire, an apprehension taken at a level so deep, though not necessarily so serious, that some term not altogether limited by historical circumstance is mandated to describe it, then they were religious.

This doesn't mean that the blues or any form of religious expression is exempt from the laws of historical development and complication that visibly shape all other kinds of expression—as Countee Cullen knew, there is no "simon pure" thing—but, rather, that something is left after those laws have been explicated, something unaccountable, whose unaccountabilty feels to be its nature. Religious expression might be defined as what remains when the power politics of the situation in which it occurs have been decoded, what resists and will not yield itself to such analysis, no matter how vigorously pursued, the stubborn persistence of the inexplicable human capacity for survival and grace that is peculiarly the soul's property.

Religious beliefs and expressiveness of a compelling order surface in individuals and groups in all walks of life, but root religion, an emphasis on spiritual basics as a form of collective consciousness, has usually arisen in materially impoverished circumstances, whether involuntary and imposed, like the Hebrew's lot in Babylon in the sixth century B.C., like the Negro's in America after the Civil War, or consciously sought as it was by the monastic orders and the brotherhoods of friars in the early Middle Ages, and it has often occurred outside official religious institutions and channels, even in defiance of them. The secular quality of the blues was evidence, in this reading, of their determined return to the tap root of religious experience, the moment of origin in which expression bears the complex charge of human nature unfettered in its insights and demands. If the only possible benefit of oppression and deprivation is that it can sometimes free those it afflicts from the worst vices of those who oppress them, of the corruption that the possession of power always sooner or later entails; if religious expression is what can't be analyzed away in terms of power politics, it is most likely to be found among those with the least power.

The early blues came out of a specific set of material circumstances, from the poverty, mobility, disillusion, and excitement of black life in the Reconstruction era, when America was visibly obsessed with its own identity as the site of a massive, painfully failed, and unsolved racial experiment. The fact that most of Euro-America in these decades was trying to ignore

this failure—by banning blacks from their lives and facilities, theorizing them into pseudo-scientific inferiority, lynching and disenfranchising them —necessitated and guaranteed a reaction which inevitably incorporated not just black thoughts and feelings but white ones; the blues were the fullest expression of this phenomenon. What has been denied inevitably returns, and it does so both outside and inside the deniers.

Albert Murray compares the mood of the blues to that of *Oedipus Rex*, *Hamlet*, and the myths of death and rebirth on which Eliot's *Waste Land* is based, the great tales of historical crisis, laden with meaning for the 1920s, of a generation undergoing what Robert Frost called "irremediable woes." The blues were part of the Negro's revisionist interpretation of American history and their tale of hopes raised, deferred, and reinvented was black "terrible honesty" in its most creative form. Although they were never propaganda, they were protest art, a protest both against the particular historical set of circumstances and tactics that relegated black men and women to the lowest ranks of American society, and against all such power arrangements as violations of the deepest truths the human spirit is capable of apprehending. Protest need not be an ungenerous thing, and in its possible generosity lies its claim to something like religious dimensions. Protest at its most profound offers a defense and a refuge for what those against whom it is directed have violated in themselves as well as in those they have wronged. To say that the blues were in part the repressed thoughts and emotions of whites is hardly to say that this was their chief characteristic, or that their intention was to fill this function, but it is to say that the world they read was an irretrievably black-and-white one, that they documented the place where the races were bound together in the cycle of sin, retribution, and possible redemption that is the innermost logic of America's historical life and destiny.

James Weldon Johnson might use the word "soul" easily, as he spoke of "the soul of America," but the word was usually avoided by the white moderns, unless used ironically. Fitzgerald once referred to it in passing as an "old-fashioned" word, and when one of Dorothy Parker's protagonists learns that, on a drunken spree the night before, he had confided to his date that he "really had a soul," he knows he has totally disgraced himself. Yet Fitzgerald defined his "personal conscience . . . [as] yourself stripped in white midnight before your own God" and Parker was known to talk on and on about her soul when drunk herself. Even George S. Kaufman, a non-believing Jew whose art spared no illusion, structured all his acerbic comedies around the question from Mark 8:36, "What shall it profit a man, if he shall gain the whole world, and lose his own soul?" *You Can't Take It with You*, the title of his greatest comedy, written in 1936 with Moss Hart, was a vernacular version of the same insight. The "terrible honesty" ethos gained

its edge from a fierce dislike of the pseudo-religious trappings of late-Victorian culture, the self-sanctified and militantly gendered missions conducted in its name. But its quarrel was with the falsifications of religion, not with religious experience or expression itself, and its despair came precisely from a fear that such falsifications had made real religious life impossible. The deepest motivation for the white moderns' attack on religion, their effort to mock and shred its falsifications and the women who had to their mind perpetrated them, was their obscure but persistent belief that such destruction might reveal and free what could not be destroyed, even what might save them from destroying themselves. In nihilism, they might discover or reinvent hope.

Biblical texts were never far from their minds, and they were drawn to words that came from minds patently hard beset and down to their last resources. Ecclesiastes was a white favorite, too. In *John Barleycorn, or Alcoholic Memoirs* (1913), Jack London wrestled with what he called the "Ecclesiastes Blues" and Hemingway took his title *The Sun Also Rises* and the mood of the book it headed from the same source. In the process of finding the title, he told Fitzgerald in a letter of September 15, 1927, he read Ecclesiastes "aloud to all who would listen"; he signed the letter, in one of his characteristically uneasy and jocular giveaways, "Jeremiah Hemmingstein, the Great Jewish Prophet." This was the age that patented the one-liner: "The first hundred years are the hardest"; "Never give a sucker an even break"; "Tomorrow is playing kissing games with the future." What is the one-liner but the art of getting "the last word"—a phrase that can suggest the impertinence of permanent interruption or the solemnity of final things? What is it but an effort, both parody and homage, to update as well as challenge the insights of Ecclesiastes and Proverbs? "Vanity, Vanity, and Vanity" was the way Katherine Anne Porter summed up life as she knew it, echoing the famous "Vanity—all is vanity" line of Ecclesiastes. Djuna Barnes, Zelda Fitzgerald, and Elinor Wylie seem to strain, sometimes too hard, for lines that say it all, that reek of intentionality; they wanted to give the impression of hitting bull's-eyes with their eyes closed.

Lewis Mumford's studies of urban culture drew on biblical models of prophecy and centered themselves on images of Babylon and Damascus; both Eliot's "Love Song of J. Alfred Prufrock" (1915) and Marianne Moore's "The Mind Is an Enchanting Thing" (1944) were reinterpretations of the story of John the Baptist, Herod, and Salome. Fitzgerald's "Crack-Up" essay (1936) was an extended exegesis of the question posed in Matthew 5:13: "If the salt have lost his savour, wherewith shall it be salted?" Louise Bogan took as the epigraph for her first volume of poetry, *The Body of This Death* (1923), St. Paul's cry in Romans 7:24: "Who shall deliver me from the body

of this death?" Kaufman's Dulcy, seating her guests haphazardly at dinner, remarks, with characteristically dimming brightness, "The last shall be first, and everything." She is alluding to the most important insight of the New Testament, in Matthew 19:30, and the fact that she doesn't know it, that she's assimilated the words and forgotten the source, tells us much about the society Kaufman was satirizing, enjoying, and lamenting. "The last shall be first," with its promise of surprise reversal, is as much a comic principle as a tragic one, and it was also the ur-text of the blues, with their transformation of nobodies into somebodies and vice versa. Blacks and Wasps were the largest groups of Protestants in the nation, and Protestantism is built on biblical interpretation. Negroes and Jews alike took the Old Testament to be their own story. In black-and-white modern America, the Bible was shared and contested ground.

At the turn of the century, New York blacks, petitioning various social agencies devoted to teaching Negroes to read, usually gave as their motive their wish to read the Bible; it was the book of books to black Americans. Johnson thought its vivid drama and emotional expressiveness were congenial to the African-American temperament; in biblical tales of a chosen people enslaved, tested, and delivered, Negroes found consolation for their pain and hope for a better future. But the Bible was also important because it was the dominant text in the world of nineteenth-century Euro-America, and the text that purportedly supplied precedent and justification to its "peculiar institution," slavery. The Bible, as Euro-America used it, exemplified as no other text did the planned divide between white power and black powerlessness, the engineered split between white literacy and black illiteracy. The early blues sprang up within this divide; they represented an unprivileged and illiterate tradition self-conscious of its context in a literate print culture which excluded, cheated, and disregarded its claims and needs.

Langston Hughes's bilinguality, his ability to to use both Standard English and Black English, was not a new phenomenon. Some slaves had been bilingual, too. Most of them forgot or lost their native African tongue, but they were all versed in some form of Black English. Slaves usually came from West Africa, but there were many dialects and languages spoken there; West Africans bound for America, in other words, did not necessarily speak the same language. In any case, Africans were systematically separated before deportation from other speakers of the same language; traders had learned that if the slaves could communicate with each other, they were likely to plan a strike for freedom. Blacks en route to the New World or just landed there were thus compelled to seize upon their first chance at a common language; pidgin English, the bastard idiom used in the multinational business of slave trading in the seventeenth and eighteenth centuries, supplied

it. Black English, its heir, developed much as white Standard English had some five hundred years earlier, out of a mixture of part-foreign, part-native idioms.

A number of slaves also learned the more or less Standard English used by their new masters, and they could speak whatever version or mix of Black and Standard English best suited their purpose. Black English retained many of the structural properties and some of the vocabulary of the West African languages, but most slaveowners were unaware of the presence or meaning of such survivals. "Massa" might call a house slave "Cuff" or "Cuffee," meaning, perhaps, that "Cuffee" tended to master's shirt cuffs and got his coffee, but Cuff himself might know that this was a West African name for a boy child meaning "Friday." He might also know that massa had taken the name "Cuff," like other names he used for his slaves—"Cudjo" (the West African male name for "Monday") or "Phoebe" (the West African female name for "Friday")—from his slaves rather than imposing such names, as he thought, on them. A word that had but one meaning to the master often had two for the slave; linguistically speaking, he had double vision, what Du Bois termed "double consciousness."

Negroes had strong incentives to hang on to Black English, for it allowed them to communicate with one another without being fully understood by whites, but they also needed some knowledge of white English in order to negotiate the broader culture. Of necessity to one degree or another bilingual, they understood and strategized the split between a polite Anglophile version of the English language and a back-to-basics idiom, between the euphemistic and dysphemic possibilities of the American language, between its officially literate and illiterate branches, as no other group could.

Blacks had long been aware of the literate world officially barred to them, and they knew its value. The Northerner Elizabeth Bethune, coming to the South to teach emancipated slaves the three "Rs," found that "each one regards it as an honor to be enrolled as a scholar." In 1864, Lucy Chase heard Virginia blacks singing a song that began "Oh, happy is the child who learns to read." Thomas Wentworth Higginson, the Boston writer and activist who led a Negro regiment in the Civil War, found that his men loved to read aloud from the spelling book. "They rightly recognize a mighty spell," he wrote, splicing the two meanings of "spell," "equal to the overthrowing of monarchs, in the magic assonance of *cat, hat, pat, bat.*" In 1865, 93 percent of American blacks were illiterate; in 1930, only 16 percent. Much of this must be conceded as a bare ability to parse out words and little more, a literacy level not sufficient to meet the punitively stiff literacy requirements that the South set for black voter registration after Reconstruction, but the transformation of an illiterate people to an even crudely literate one in little

more than half a century represented a willed act of reversal and a profound belief in the empowerment literacy brings.

A good part of the slaveowners' animus against black literacy had stemmed from their fear of what would happen if their Negroes could read the Bible. No one knew better than they how empowering and dangerous a book the Bible is. Nat Turner, the visionary and highly literate slave who led an armed rebellion of blacks in Virginia in 1831 that took sixty white lives before it was stamped out, had found precedent and inspiration in the Old Testament prophets, and the lesson was not lost on the Southern ruling class. The Bible that slaves heard at white-sanctioned services was frankly and strategically censored; Negroes listened to endless explications of passages mandating the obedience of "servants" to "masters." As Whitemarsh B. Seabrook, a South Carolina legislator, put it, anyone who wanted his slaves to read the entire Bible belonged in a "room in the lunatic asylum." But Nat Turner was not the only black person aware of the difference between the real Bible and the Bible as it was preached to them by white ministers and masters. Although prohibitions against teaching slaves to read tightened after Turner's rebellion, some learned on the sly. Others who could not read memorized long passages of the Bible from those who could. The hymns and songs popular at camp meetings also conveyed biblical language and sentiments to black participants. They knew, in the words of one black student at Hampton Institute in the late nineteenth century, that words urging obedience of servant to master might be the "tex'[t]" of the Bible, but it wasn't the real Bible, "de gospel," which preached liberation in this world as well as resurrection in the next.

When Father John denounces the "sin" of slavery in *Cane*, the sin is very specific: "the sin the white folks [com]mitted when they made the Bible lie." At least one white reviewer took Toomer's point. Robert Kerlin, discussing *Cane* in *Opportunity* in 1926, asked: "Who does not know that the Negroes have an understanding of *our* Scriptures—which of course are ours only by imperfect adoption—which leaves us wondering and ought to leave us humiliated?" It was the Negro, not the white, who had had the experiences needed to explicate the Bible; it was he who had endured the terrors and jokes of hell for his talismanic knowledge. He, too, had found, in Dos Passos's words, "hell . . . a stimulus." Like the sermons of the black preachers who preceded them, like *Cane*, the biblically dependent blues were a commentary on the wrongs, the lies, the omissions and commissions of interpretation, of an exclusionary literate culture; they offered a corrective, an interpretive insistence on the true text, on the gospel truth, unwritten or written. If the authors of classic American literature discovered in a "world elsewhere" not exile but a new and imperial artistic expression off limits to those who exiled

them, black blues artists found their art in a nowhere land of deprivation, as outsiders and rejects reimagining themselves as insiders and sovereigns.

Ragtime was audibly biracial, a sing-along affair; its Euro-American march-time bass and self-conscious Negro dialect presupposed and invited white collaboration. But the blues, however rapidly Tin Pan Alley whitened and cross-marketed them, at bottom resisted such assimilation and first-try participation. They, too, had massive meaning for a biracial world, but they were less an invitation to whites than a dare and a challenge. "Singin' the Blues," in the title of a Dorothy Fields and Jimmy McHugh number, offered whites the choice to join America's real elite, spiritually and musically speaking, but it might cost them everything they had, for the blues posed in its starkest form that crucial, biblical question: "What shall it profit a man, if he shall gain the whole world, and lose his own soul?" George Gershwin's early piano rolls of ragtime music bespeak an easy familiarity with their black originals missing from the work of the white blues artists; it was not that whites could never sing the blues, but that they had to reach farther and deeper inside themselves and their culture to do so; it was less an affair of appropriation than of reimagination and reinvention. To join this elite, one had in some sense to join the underclass from which it came. What was upward mobility for blacks might be downward mobility for whites. This was buried treasure.

UPWARD AND DOWNWARD MOBILITY IN THE BLUES

The blues specialized in reversals, often contained in the last line of the stanza:

> *I'm goin' down and lay my head on the railroad track,*
> *I'm goin' down and lay my head on the railroad track,*
> *When the train comes along, I'm gonna snatch it back.*

This sudden, inexplicable, and endangered shift from the will to die to the will to live included the material world as well as the spiritual one. The blacks who first wrote and sang the blues were "freedmen" in at least one real sense; no longer legally confined to their masters' plantations and farms, they began to travel, to move in multitudes north and west, and their music recorded their travels. The blues person was always "runnin' around" or riding the rails; mobility was the only solution to the implacable paradoxes of black liberty. What fascinates the blues man is the pendulum swing between the downside of deprivation and the upside of prosperity, and the

way they're connected. Happiness always has its roots in sorrow; riches can come only from rags. Success is never a given, a status quo affair, but rather the direct product of failure, drawing its energies and resources from the bottom from which it came.

Blacks knew more about the underside of the American dream than about its glittering façade, but the bonanzas of sudden success were not unknown to them. Philip Payton had worked as a handyman, a barber, and a janitor before making his career in real estate. He had a college education—many black college graduates could find work only in menial jobs—but several of his well-to-do backers in the Afro-American Realty Company had had no such advantages. The investor James E. Garner, born a slave in Maryland, had worked as a porter, a waiter, and a janitor during his early days in New York City in the 1870s, before building up his Manhattan House Cleaning and Renovation Bureau in the 1890s. Booker T. Washington had come, as the title of his autobiography proclaimed, *Up from Slavery* (1901) to the heights of power and influence. What white American dared to boast of beginnings this humble and success this astounding?

"Rags" had brought a number of turn-of-the-century black pianists more riches than any white music they could have played. But no one's success was so spectacular as that of the black divas who sang the blues live and on record in the 1920s; they comprised the first sizable group of lower-class Americans of any race to sing their way to fame and fortune, the predecessors of the great rock and roll stars of the 1950s and 1960s, Chuck Berry, Little Richard, Elvis Presley, Jerry Lee Lewis, and Tina Turner, who came from nowhere and changed the face of American culture on their journey. The other tradition of the blues in the 1920s, the masculine one—the "country blues" composed and sung to a guitar accompaniment by black men like "Papa" Charlie Johnson, Blind Lemon Jefferson, Charlie Patton, Alonzo ("Lonnie") Johnson, and, a bit later, Robert Johnson and Leadbelly—were closer to their religious roots, though the two forms had much in common, and together they led to rhythm and blues and rock and roll. Though the masculine blues were beginning to be recorded in the mid-1920s, they didn't command mass attention or big money until much later; the blues popular in the 1920s were the urban blues, and they were sung by women, and in good part written by them.

Some blues singers, like Ma Rainey and Ida Cox, wrote most of their own songs, while others, like Mamie Smith, wrote few of them, but authorship was seldom a clear-cut matter in any case. Copyright existed, but attributions could be deceptive. Even after recording began, the blues were still an oral and communal form, and words, phrases, rhythms, and musical figures were

common property, freely borrowed or stolen and varied in performance by interpretative styles that ran all the way from the rougher country sound of Sippie Wallace and Addie Spivey, to the unadorned but artful mode of Ma Rainey and Bessie Smith, on to the vaudeville sound of Mamie Smith and the pop-and-jazz-oriented style of Ethel Waters and Alberta Hunter. As Ma Rainey expressed the matter in her "Last Minute Blues": "If anyone asks you who wrote this lonesome song / Tell 'em you don't know the writer, but Ma Rainey put it on."

The music or words for a given song might originate with the accompanist, but the song still had to be worked out by the singer in performance. A number of blues artists couldn't read or write music, and the person who wrote the song down might claim authorship. So whose name ended up in the credits often had more to do with educational, economic, or managerial clout than with artistic input. Still, it seems safe to say that the top black women blues singers, in contrast to their white peers like Sophie Tucker and Helen Morgan, who wrote little or none of their own material, wrote something like a third of the songs they sang. Moreover, many of the songs they performed but did not write were composed expressly for them, and the lyrics were usually written from a woman's point of view.

The authority of the blues diva was all the more striking given the extreme masculinism of the jazz world. Both African and African-American culture had long-standing taboos against women playing the guitar or wind instruments; the earliest black jazz ensembles in New Orleans were all-male family bands. The piano was only grudgingly conceded as an instrument women could play. Armstrong's first wife, the jazz pianist Lil Hardin, was soon replaced on his recordings by Chicago's Earl Hines. Few women mastered the daunting and athletic difficulties of stride piano, and none became important recording artists. The best boogie-woogie piano artists of the 1930s and 1940s, headed by Meade Lux Lewis, Albert Ammons, and Pete Johnson, were all men, as were the later bebop artists. There has been, in fact, only one major exception in the patriarchal story of jazz. Though jazz grew in part from blues, from the improvisations musicians brought as backup bands to the music of the female blues vocalists, record companies were uninterested in recording instrumental jazz until it proved its attractiveness as accompaniment to the blues singers, and it never sold as well as their music did. The female urban blues tradition was usurped by the male country blues in the 1930s, but in the 1920s, however their male peers might feel about it, both commercially and artistically speaking the woman blues singer played parent to modern jazz.

Black women had always been vocalists, but the feminism of the blues divas went beyond mere singing or even songwriting. Waters often used a

woman pianist-accompanist, Pearl Wright, in performance and on records; Bessie had her own chorus and company, and Mamie Smith picked and controlled her backup band, Mamie Smith's Jazz Hounds. Also, most of the successful blues divas were bisexual or gay—including Bessie Smith, Rainey, Waters, and Alberta Hunter—and their relations with one another, while often competitive and sometimes openly fractious, were nonetheless close: they were bound together in a common sexual insurgency.

The blues diva was a different figure from the Negro suffragist and club woman. A diva of any race is at some level an anarchist who demands and expects the world's attention for anything and everything it pleases her to do. Unlike the matriarch, she doesn't hold herself or anyone else to conventional moral standards, for she considers them inadequate or irrelevant to her own needs; and her needs, which may well include giving vast pleasure to multitudes via her art, are her paramount concern. The middle class, which is usually the matriarch's place of origin and always her source of values, is the class of least interest to her, whatever her own class status. Generalizations are not her business, and the politics of feminism have little if anything to say to her. When woman suffrage became law, black women voted proportionately more than their white peers, but it is doubtful that Bessie Smith or Mamie Smith ever entered a voting booth. Nonetheless, black diva and suffragist had something very much in common: both were twice disenfranchised, by race and by sex, and in the 1920s the blues singers, too, seized a form of suffrage and wrote a dazzling new chapter in the Horatio Alger story. So-called politics were not the only form of politics open to them.

Although Mamie Smith was a cabaret star before she cut "Crazy Blues" in 1920, this and subsequent records made her a superstar; her recording royalties alone were estimated at $100,000. Born into the working class in Cincinnati in 1893, Mamie's life was an irregular one. She knew how to play the lady, but she was also a hard drinker, and since she found most of her lovers in her own band, her gigs occasionally grew ragged as she fought with them on stage and off. Legend has it that she carried a little pistol to shoot at troublesome men, like Perry Bradford, her songwriter, accompanist, and quasi-manager, who wanted to collect money or affection she felt was not their due. But Ida Cox's "How Can I Miss You When I've Got Dead Aim" (1925) was not her theme; whether out of compassion or vestigial discretion, she always missed her man. However unorthodox her life-style, Mamie was a shrewd director of her modest but sturdy talent. She had a way of throwing a song out and watching it land in place; musically and professionally, she showed a knack of self-positioning.

Hard times hit Mamie later—she died in poverty, nearly forgotten, in

New York in 1946—but in the early 1920s, she was in big demand on the T.O.B.A. circuit, and she also made a number of successful film shorts. Investing her money after a fashion, she bought several homes in Harlem and Long Island lavishly furnished with electric player pianos in every room. She knew that the "thousands of people who come to hear me expect much . . . They want to see me becomingly gowned, and I have spared no expense or pains"; her fans, she promised, "shall [not] be disappointed." They weren't. Light-skinned, full-figured, and big-hipped, with large liquid eyes and soft, sensual features, Mamie was a gorgeous woman, and when she walked across the stage, outfitted in her trademark silver dress, her cape of ostrich plumes (for which, it was rumored, she had paid $3,000) quivering, the diamonds clustered around her neck and on her fingers glittering in the stagelights, the crowd often broke into tumultuous applause before she'd sung a note. In the words of the "Mamie Smith Blues" (1922), an advertising jingle in thin disguise on the Okeh label, "Lots of girls wish they were Mamie Smith too." In the same year, Okeh declared a "Mamie Smith Week."

Bessie Smith did not make all the money that was her due, but without the blues, she might have been nothing but a bad-tempered, goodhearted, rough-and-ready girl born in abject poverty in the black ghetto of the railroad town of Chattanooga, Tennessee, uneducated, practically unparented (her father died in her youngest years, her mother by the time she was eight), and doomed to live and die there, unrecorded and unknown. Instead, before she was thirty, Bessie was one of Columbia's premier recording artists, the star of the TOBA circuit, and instructor and peer of Armstrong and other jazz greats. Like Mamie, she enjoyed her fame and good fortune to the hilt. On tour, Bessie traveled in her own private bright-yellow railroad car, which was seventy-eight feet long and two stories high and boasted seven opulently appointed staterooms, each with hot and cold running water.

Notorious for her binge drinking, Bessie was a bar-room brawler who packed a considerable wallop, and she had a way of taking what she wanted. On one occasion she set her heart on an ultra-fancy Cadillac displayed in a Philadelphia showroom. Although the dealer was reluctant to sell it, especially to a Negro—there were as yet, he told her, only two such cars in existence—she pulled out $5,000 in cash and drove it off the floor. Her onstage costumes were wild affairs of red or blue satin studded with sequins, topped by pearl necklaces and fake ruby jewelry. Her trademark headdress weighed up to fifty pounds and looked, her biographer Chris Albertson comments, like "a cross between a football helmet and a tasseled lampshade." Before one begins to laugh, one should remember that Bessie was also a professional comic. Nonetheless, that headdress was a crown, unwearable by one smaller than Bessie in bulk, strength, and dignity, and she

expected and got homage, homage not as one of the light-skinned, white-worshipping, pseudo-cultivated "dicty" Negroes she scorned, but as a powerful "empress," deep brown in hue and proud of it. Onstage, she surrounded herself with her own unfashionably dark-skinned chorines; if a manager tried to substitute lighter-skinned girls, she either refused to go on or set about demolishing the theater until he saw things her way. I do not exaggerate: angry, Bessie was known to pull down the theater curtains, in itself a Herculean feat, leaving the stage and orchestra a shambles.

"Misbehavin'," to quote Fats Waller, or behaving, Bessie was a performer of legendary powers. As a singer, she worked in the minimalist classic blues form. Taking a tiny handful of notes, sometimes a mere three or four in an entire song, she burrowed within their microtones, the minute intervals falling, so to speak, between the black and white keys on the piano, then drove the sound out and usually up. Hemingway's "Let the pressure build" could be her motto, too; indeed, the combination of massive muscle and utmost delicacy of touch is almost uniquely extreme in both artists. When Bessie was recording or singing onstage, one participant said, "nobody told her what to do." "She dominated the stage," the musician Danny Barker reported. "You didn't turn your head when she went on . . . You just watched Bessie . . . She could bring about mass hypnotism." An admiring Carl Van Vechten described her effect in one performance as that of an "elemental conjure woman," "harsh and volcanic, but seductive and sensuous too [with a voice that] sounded as if it developed at the sources of the Nile." After the show, he later reminisced, he went backstage and "kissed her hand"; "I hope I did," he added. If Bessie did in fact let Van Vechten kiss her hand (for that's the real issue here), it's safe to say it was one of her off days.

Although she did some sustained drinking, man chasing, and womanizing in Harlem's black bars, Bessie came to New York only for recording dates and performances—her home base, one seldom touched, was in Philadelphia—and she had no desire to socialize with the trendy whites who patronized the black Harlem night scene. But Van Vechten sought her favors with a fervor that would not take no for an answer, and on one legendary evening in April 1928, a drunk Bessie, plus her accompanist, dressed to the nines complete with a white ermine wrap, appeared at a party held at his elegant Fifty-fifth Street apartment to sing for an assembled group of white notables. The start of the evening was ominous. Offered a dry martini by her host, Bessie bellowed: "Shiit! . . . ain't you got some whiskey, man?" She got her whiskey and the entertainment was under way.

Bessie sang wonderfully. "It was the real thing," Van Vechten said later, "a woman cutting her heart open with a knife." But she was drinking steadily

and malevolently between every song. When the concert was over and Bessie was making her unsteady exit, Van Vechten's wife, Fania Marinoff, tried to give her a polite embrace. Bessie yelled, "Get the fuck away from me! I never heard of such shit!" and knocked Fania down. Van Vechten helped his wife to her feet, then turned to Bessie as if nothing out of the way had happened. "It's all right, Miss Smith," he murmured as he escorted her to the elevator; "you were magnificent tonight." White manners were on this occasion, I think, more impressive and far less confused, conflicted, and unhappy than black rudeness, and some blacks seem to have shared my view. Bessie's accompanist on the occasion, Porter Grainger, was an elegant and well-mannered homosexual whom she loved to torment, and he had only one thought as she went into action on that fateful night: "I don't care if she dies!"

Bessie's alcoholism and self-destructive fury had as much to do with the difficulties of her life as did white indifference or hostility. Van Vechten's devotion to the blues and its artists cannot be doubted. A close friend to Ethel Waters, publicist and sponsor to Hughes's blues poetry, he wrote two trailblazing articles on the blues for *Vanity Fair* in 1925 and 1926; his extensive record collection provided the basis for the blues' reissue and return to popular favor decades later. He was also the finest portrait photographer of the day, specializing in black artists, and in 1936, eight years after the historic party, Bessie agreed to a photo session with him at his home; most fans consider the pictures he took on that day the best and most revealing ones ever made of her. Van Vechten reported that Bessie was "cold sober": "She could scarcely have been more amiable or cooperative." Perhaps she knew that he was not her worst enemy, after all. But back in April 1928, the story of the Van Vechten–Bessie incident spread like wildfire all over Harlem. Bessie herself loved to tell the tale, complete with wicked imitations of the distressed and dicty Grainger and the oh-so-polite Van Vechtens and their guests. "Shiit," she exclaimed, "you should have seen them ofays lookin' at me like I was some kind of singin' monkey!" In most of Harlem—for most of Harlem, after all, was far from dicty—the tale was savored as a moment of triumph for Bessie and her race. "I never heard such Bessie Smith!" became a popular expression.

Bessie's career began to slide downhill in the early 1930s. Everyone in the business was in trouble. Vaudeville, already losing big to the new talking pictures, collapsed with the Depression. TOBA ended in 1930. The record industry was devastated; by 1932, sales had dropped from a high of $104 million in 1927 down to $6 million. Columbia, near bankruptcy, dropped Bessie in 1931. Bessie's decline wasn't just a Depression casualty, however; musical preferences, even in the South, were shifting from her elemental

plain-song powerhouse approach to Waters's lighter, more pop-and-jazz-oriented style. Bessie died in a car crash in 1937, aged somewhere around forty; her death was later depicted, not without justice, as due to the racism of doctors and observers on the scene who may have helped the white people injured in the accident before the black. But Bessie died in the midst of a comeback.

Aided by the love and financial support of her last husband, a bootlegger named Richard Morgan, in the mid-1930s Bessie was drinking less, adopting more sophisticated onstage costumes and manners, and revamping her singing style, moving toward jazz and pop variations that included the melodic line, swinging more palpably. When Van Vechten took his photos of her in February 1936, she was about to open at Connie's Inn, a legendary Harlem night spot where Louis Armstrong, Andy Razaf, and Fats Waller changed musical history; the young and already matchless Billie Holiday, who had learned her art in part from Bessie's records, had just made her debut there to rave notices. Contrary to many predictions, Bessie was a knockout success; there was serious talk of Hollywood roles and a new contract at Columbia. Her death occasioned one of the greatest black funerals of the 1930s. Although her Pennsylvania grave was not suitably marked until 1970—the new tombstone was in part the work of Janis Joplin, a disciple, who said, "Bessie showed me the air and taught me how to fill it"—her records were reissued in 1938 and they have remained available, in increasing numbers with increasingly better acoustics, ever since.

Nothing could stop Bessie Smith; she was the supreme emblem of the blues dynamic of reversal, of the transformation of nobodies into somebodies, of the assertion of black America as all the America there really is. In 1926, Ma Rainey, who remained a good friend throughout Bessie's life (Ma herself died in 1939), wrote and recorded a blues titled "Down in the Basement," a celebration of the basements of life and a manifesto for the low arts against the high. She rejects opera and parlor music as "that high brow stuff," and demands, "take me to the basement . . . Let's get dirty and have some fun." Hart Crane's "black man in a cellar" facing the "world's closed door" had become a black woman in a basement scorning the world that excluded her and having more fun than that world could even imagine. Only "Down in the Basement" could one find what Hemingway's cowardly white man in "To Will Davies" had lost, the truth his black hero held safely in his kingly possession, and some white Americans—a very few but a crucial few, a "saving remnant," to return to the ur-text of the blues, the Bible—went right down to Ma's basement to get it.

The outstanding example was Bix Beiderbecke. On one occasion in a Chicago club in the mid-1920s, he turned his pockets inside out and emptied

their contents on the table to persuade Bessie to go on singing; he spent his short, terrible, and ecstatic life, in the title of his best-known number, "Singin' the Blues." Fair-haired, gentle, intense, and self-destructive, Bix was born in 1902 and grew up in respectable and middle-class Davenport, Iowa. He learned jazz from appropriately mixed sources. Most important, as a boy, he heard the black musicians headed by King Oliver and Louis Armstrong (his idol) who played on the Mississippi riverboats; legend has it that Bix ran off, Huck Finn–style, to join them, only to be caught and sent home. He named his high-school band The Black Jazz Babies. Discovering the records of the Original Dixieland Jazz Band, the popular white group who crudely but enthusiastically played their own version of the New Orleans sound, he copied their numbers note for note on his cornet. James P. Johnson picked up some of his first jazz from the same white source; influences were always racially mixed in the Jazz Age.

Whatever the case with influences, however, jazz circles were still rigidly segregated in terms of personnel. Both Jelly Roll Morton and Alberta Hunter recorded with white bands in 1923; Fats Waller recorded with white jazzmen Jack Teagarden, Gene Krupa, and Eddie Condon in 1929; and Armstrong was also a pioneer in integrated music. But these were exceptions; on several mixed gigs in the 1930s, white musicians refused to record with Waller until he was quarantined at the other end of the studio. Bix inevitably ended up in white, not black Manhattan in the mid-1920s, playing cornet in the large all-white orchestra of Paul Whiteman, the man who wrote an entire book about jazz without mentioning Negroes. There his talents were well paid (though he never got top star salary), frequently if sparingly showcased, and musically curtailed by a band with limited knowledge or instinct for the kind of music he lived to play.

The white jazz world, better organized, better publicized, was vastly less innovative than the black one, and many have lamented the loss to Bix's music enforced by the segregated jazz scene and the Whiteman context. The loss is undeniable. Bix's best recordings were done not with Whiteman, or on the conservative Victor label that Whiteman had chosen (where he was asked to "play the melody"), but with a smaller group of like-minded white musicians on the Okeh label. Okeh wisely let Bix record his real music, melodic but free of constraints. By all accounts, his best music was the music he played in informal sessions with black musicians, none of which was ever recorded. But the professional segregation imposed on white musicians was perhaps necessary to Bix the man, no matter how limiting to his art.

Bix was always emotionally adrift outside his extreme focus on his craft; the title of his most characteristic and harmonically subtle piano composi-tions, "In a Mist" and "In the Dark," tell us much about this unformed and

strangely helpless "Little Boy Blue" (the nickname was bestowed by the white songwriter Hoagy Carmichael). Outside his music, one admirer remarked, Bix "just existed," not without a certain loose and charming sense of style, but with no plan, no clue. Eating, bathing, and changing his clothes were alien ideas; roommates fed him and reported dunking him in nearby lakes when they couldn't take the stench anymore. Money and marriage, the two traditional concerns of adulthood, held little interest for Bix. He gave away money with abandon and never seems to have had a full-fledged love affair. He didn't judge anyone or anything; "What the hell?" was his favorite, if soft-spoken, expression. "There was something missing," Hoagy Carmichael said.

Bix was an alcoholic of legendary proportions. Like Scott Fitzgerald, the decade's other doomed and alcoholic golden boy, he cracked up exactly when the Jazz Age did, and his last years in New York were awful ones. He was wasted, broken, unable to stop drinking, though he knew by now that "one drink" led to "four hundred." However his friends felt, he didn't romanticize his alcoholism; he agreed with Sidney Bechet, who believed, like most of the Negro jazz men of the day, that drugs and booze "just mess up all the feeling you got inside yourself." Bix's best recordings were done sober, but as the years passed, there were fewer and fewer of them. "I have to have it! I have to have it!" he yelled in anguish as he jumped out of a friend's car at a street corner to find a bar. At the end, he was unable to play the cornet; he'd lost the breath he needed for his instrument. "Where am I going?" he asked. Bix died in New York in 1931 at the age of twenty-eight of alcoholism, pneumonia, and what can only be called despair. No obituary appeared in *The New York Times*.

The story is heartrending, but it could have been worse; I doubt that Bix could have survived for as long as he did had he worked in the freer atmosphere of black jazz, say in Ellington's sometimes anarchically minded band. Nor could he have carved out his own ensemble from the chaotic music scene as Armstrong sometimes did, or flourished as a supreme maverick in the style of the prodigiously gifted and imperious Bechet. Bix needed the discipline of his conventional white taskmasters like Whiteman and his closest colleague, the saxophonist Frankie Trumbauer (who could, at moments, frame Bix's cornet nicely with his light C-melody saxophone sound). Hauntingly borderless outside his music, he needed boundaries stricter than the jazz he loved could supply. But inside his music, and he stayed there as much as he humanly could, he was a very different person, with extraordinary instincts for just the pellucid form, the disciplined shape, his life lacked.

In an interview with the *Davenport Sunday Democrat* published on February 10, 1929, Bix, home in a hopeless effort to sober up and regain his

squandered health, explained that jazz was the product of the "white race's sophistication" and the "half-forgotten suffering," the "anguish," of the Negro. Critics today might put the matter differently, but his tone was not, I think, condescending. Bix never did well in school—a prodigy of sorts, with a perfect ear, he started playing piano at two and he was permanently distracted by music—but his mind was quick, well tuned, even informed. Once, answering a friend who was surprised to discover that he knew a lot about Marcel Proust, he said, in the offhand way that endeared him to all the musicians he worked with, "I get around," and he did. In the interview for the *Democrat*, he was speaking about jazz's dual origins in white harmonics and African-American rhythms and experience; all his music worked this double legacy. Bix was not doing with black jazz what Berlin was doing with ragtime. He played brilliant apprentice, not robber, to black music. He was not coopting Negro jazz by adapting it to white tastes but pushing it to new frontiers of expressiveness.

Jazz in the 1920s was a nocturnal profession—"Nobody went to bed at night," Ellington later remarked—and Bix was often credited with leading white musicians to Harlem for all-night jam sessions. Louis Metcalf, who played trumpet in Ellington's band, said that Bix "didn't care nothin' about color or that jazz had a bad stamp to it. Why, Bix would come uptown and blow with us, eat with us, sleep with us. He was one of us." He took musician friends to hear Ethel Waters sing, and he listened to every Waters record he could find; her art of perfectly timed surprise and lyrically inventive linear clarification was very close to his own. Legend has it that tears rolled down King Oliver's face when he first heard Bix play, and Armstrong recognized him at once as the only musician he'd met who was "as serious about his music as I am." In his *Self-Portrait* (1966), he remembered that Bix was "never satisfied with his solos, and people raving. Always figured he had one better." "He knocked me out . . . Yeah, he was my man. Choice man, too." Gigging informally and ecstatically for hours in Chicago's Sunset Club after the doors were locked to outside patrons, Bix and Louis didn't try to "cut [outdo] each other," Armstrong later said; "we did not even think of such a mess . . . We tried to see how good we could make music sound which was an inspiration in itself."

Bix was not trying, like his friend the clarinetist Mezz Mezzrow, to be, in Mezz's words, a "Negro musician, hipping the world about the blues as only Negroes can." He had no interest in billing himself, as the white trumpeter Bill Dakin did, as "the White Louis Armstrong." Indeed, his horn style was almost diametrically opposed to Armstrong's. It's typical of the formal, even conservative streak in his musical makeup, perhaps bequeathed by his German ancestry, that he never abandoned the cornet, as other

musicians, most notably Armstrong himself, did, over the course of the twenties, for the bigger, bolder sound of the trumpet. Bix liked the cornet's smaller, more intimate sound, so close to the human voice; he preferred the poetry of precision to the bravura of all-out performance, the "sonnet" to the "epic." (The terms are those of the jazz historian James Lincoln Collier.) Bix was not Armstrong's equal—no one was—but like him, he was an original, an innovator through and through, drawn, one contemporary said, like "a baby [to] its mother," to the discovery and perfection of his own sound, his special art of jazz balladry. He was Armstrong's peer precisely because his consuming interest was in using all the musical resources, black and white, open to him to further and vary his art.

Bix introduced the whole-tone scale from modern classical music into jazz, a revolutionary move, and inquired: "Why not use it in a jazz band? What's the difference? Music doesn't have to be the sort of thing that's put in brackets." His music was characterized by its compositional clarity, but the composition changed each time he played. He explained to a friend, "I don't feel the same way twice. It's one of the things I like about jazz, kid. I don't know what's going to happen. Do you?" What Bix and the black musicians had most strongly in common, as Armstrong at once understood, was a freedom from subservience to conventional models, to any fixed form at all but that of the mood and the music it evoked. He belonged, as Baraka writes in *Blues People*, to the "new class of white Americans" appearing in the 1920s, white jazz men who identified with the black outsiders of American life, who were themselves outsiders if only because most of white America had no conception of what they were doing, no idea why they were playing the music they played. When Bix went home in sick defeat to Davenport, he found all the recordings of his work he'd mailed to his parents over the years stashed, unopened, in a closet. As Mezzrow said: "We were teenage refugees from the sunny suburbs."

Bix and his friends had a special fondness for the slang form of address "Kid." Used on adults, as it usually was, as a slang term ("kid" was merely literal addressed to a child), the word reversed and simplified and democratized things. We're all, it seems, kids: anonymous, unparented, orphaned maybe, but smart, creatures of a special streetwise beat. In jazz, Bix and his peers found an extreme openness to an America bigger than any of its standard definitions, a land dangerous but hospitable to all its "kids"; orphans can have siblings though they lack parents. If jazz was, in Eubie Blake's words, "the Negro's way of expressing his religious emotions," its white apprentices were sure it expressed theirs as well. Jazz brought them a sense of "spiritual" discovery (Hoagy Carmichael's word), or, as Eddie Condon, another of Bix's friends, put it, "The music poured into us, like daylight running down a

dark hole." The only possible proof of Bix's intentions in apprenticing himself to black music lies in what he did with it, and his art, at its best, in "Singin' the Blues" and "Riverboat Shuffle" and "I'm Comin' Virginia," has a clarity of composition, a harmonic (though not a rhythmic) inventiveness, a precision and a fleetness, a sheer ego-free quality of breathtaking restraint and joyous humility that are unmatched in jazz annals, white or black.

Avant-garde and alcoholic, Bix is often romanticized as the doomed and misunderstood hero of the Jazz Age. Because his stamina was limited, we should not forget that he was also a very lucky young man, culturally situated exactly, magically, right, and gifted in just the ways that allowed him to give superb expression to the most exciting and important news of his generation. Perhaps this exhausted his rare but precarious capacities for choice, for form and comprehension, but it was, I am sure, worth it. Besides, as for most people and all artists, there were alternatives Bix never had. The critic James Fernandez has said that no culture is so unambiguous as not to feel an attraction toward the energy of what it officially rejects. In a society whose official spectrum ranged from acceptable white to unacceptable black, there was power to be found at both ends of the continuum, for "in a competitive culture," Fernandez remarks, drawing on the Bible, "the last shall yet be first." "Singin' the Blues," Bix grasped with radical acuity what many of his white peers felt vaguely, if powerfully: the America of the black outsider, not that of the white insider, was the real America because it alone included them both. Lecturing abroad, Thomas Wolfe electrified audiences when he told them, "I believe that we are lost in America, but I believe that in America we shall be found." In the blues and its sibling, jazz, lay the expression of the soul of a generation, black and white.

MEDIA CULTURE AND FOLK CULTURE: INSTANT APPROPRIATION

Mamie Smith's "Crazy Blues," and blues and jazz in general, took off for the simple reason that she and others recorded their music and performed it on the radio. Ragtime had relied for its transmission first on piano sheet music, then on the "horseless pianoforte," but records and radio offered blues and jazz a vastly extended technological universe to explore and exploit. Recording became serious business in the second decade of the century, and radios, first marketed as a domestic utility in 1920, proliferated rapidly in the next decade. Production went from 190,000 annually in 1923 to almost 5 million in 1929; by 1927, 6 million sets were in use nationwide. The boom in records and radio spelled the demise of the piano and its sheet-

publishing outlets as the central power broker in the music industry. Although sheet-music sales did not become an altogether neglible market force until the 1950s and the takeover of the business by rock and roll, by the mid-1920s, for the first time in the history of American music, record sales routinely equaled and surpassed those of sheet music. The total number of pianos manufactured in the United States in 1929 was only 35 percent of the 1927 figure, itself a steep decline from that of 1923. In 1919, there were 191 piano companies; by 1929, only 81. Sales of the player piano fell off dramatically as well; between 1923 and 1928, production dropped by 86 percent.

Black artists and the new sound media met in mutual enthusiasm. James Reese Europe, mentor to the Castles, recorded with his orchestra on Victor in 1914; Earl Hines was broadcast by Pittsburgh's station KDKA in 1921. In 1922, Creole trombonist Edward "Kid" Ory recorded on the Los Angeles Nordskog label. King Oliver's band began recording for Okeh in the early 1920s, with the young Armstrong on cornet; starting in 1927, Duke Ellington's music was broadcast from the Cotton Club nightly on WHN. Fats Waller's "Rhythm Club" premiered on the radio, first on WWL out of Cincinnati, and by the early 1930s on ABC from New York. The start of the talkies in 1927 gave another boost to the recording industry and its black stars; Bessie Smith, Mamie Smith, Alberta Hunter, Nina Mae McKinney, Victoria Spivey, Louis Armstrong, Fats Waller, Duke Ellington, Cab Calloway, Bill Robinson, Paul Robeson, and a host of other black musical talents appeared in films of one sort or another in the 1920s and 1930s. None of them, however, had anything like the movie careers that would have been theirs if they had been white. Bert Williams's tentative film career, for example, was a direct casualty of such discrimination. Studio heads were well aware that most Americans, particularly in the South, did not want to watch Negroes on the screen.

Seeing was one thing, hearing another. Black musical performers had their biggest opportunities in the pure sound media, since radio and records were color-blind as live and visually reproduced performance could not be, and they could take black music where the black performer could not go; through them, he found white fans, even racially bigoted white fans, whom he could never have reached in live concert or on the screen. This is hardly to assert that the sound media were free of racial bias; the big radio networks refused to hire black musicians for studio work until the late 1930s. It is nonetheless important that the first group of Negroes to break the race barrier in radio were black musicians—first in live shows done by small local stations; then, when radio came under federal supervision, corporate control, and advertising sponsorship, in session work and featured programs. In these early

pioneering days, the sound media offered diverse racial and ethnic groups their first shot at mainstream exposure.

Milt Hinton, who played bass with Cab Calloway in the 1930s and after, remarked that recording and radio work formed "one of the greatest arts in the world for a black man" because "a guy hears you, he don't see you"; "if you can do the work . . . they will hire you." Hinton was interested solely in his music and in finding the broadest and best-paying possible audience for it, and he knew that the air wasn't segregated, though the earth and the recording studio were. His nonconfrontational attitude was anathema to his black bebop heirs in later decades, but it was typical of the 1920s and 1930s. If, for the New Negro, culture was politics, even suffrage, the sound media represented something like election to national office.

Radio and records offered black musicians not only a wider hearing but a more accurate one. Musicologists and folklorists had long lamented the difficulty, if not impossibility, of notating African-American rhythms and vocal patterns by traditional Western means. Conventional notation in the early twentieth century was dominated by piano reductions of choral and instrumental music, and white composers and performers naturally tended to think of notation in terms of the piano's resources. American blacks did their musical thinking differently. Like their African ancestors, they started with the resources of the voice and the body's rhythmic possibilities, resources more complex and varied than those the piano could offer, and either bypassed the piano or reinvented it as the Negro ragtime artists, creatively exploiting the piano's percussive possibilities, did in the 1890s.

In trying to transcribe black music for the piano, how could one play or script notes, like blues notes, not to be found on the diatonic scale? The usual solution was to indicate two notes or hit two keys at once, splitting the sound, so to speak. James P. Johnson did it wonderfully on his piano solo "Carolina Shout," recorded in 1921 on Okeh, and Gershwin used it, too, on his recording of "Someone to Watch over Me" on Columbia in 1926 and elsewhere. But you've got a sheerly percussive effect; you've lost the motion, the slide or slur, with which the singer or horn instrumentalist created the blues note. How to write out complex rhythms playable on a piano but alien to the simple notation procedures of Western music, rhythms w¹ ⸱ final rightness could, in any case, only be ascertained by the ear, not the eye?

How to transcribe a music that was as much improvised as composed? As one ex-slave told a white researcher in Vicksburg, Mississippi, in 1899: "Us old heads used ter make 'em [songs] up on de spur of de moment . . . Notes is good enough for you people but us likes a mixtery." How did one transcribe a "mixture" and a "mystery"? The songs in question here were spirituals,

and the reason the spirituals were simplified, formalized, and bowdlerized was not simply that black artists wanted to meet white standards of good taste; they also wanted to make the spirituals accessible by means of sheet music. Once you're performing for profit, there is little point in singing something people can't imitate or buy; it's bad business.

Duke Ellington once remarked that the jazz musician always had a "picture" in his mind as he played, though audiences might not be aware of it. Zora Neale Hurston generalized Ellington's point into explicitly racial terms in her essay "Characteristics of Negro Expression" (1934): "The white man thinks in a written language and the Negro thinks in hieroglyphics," the visual symbols or designs used in ancient Eastern and African cultures to represent objects, sounds, sights, and even feelings. Hieroglyphics, unlike alphabets, were meant to convey more to the senses than simple signs encoded for the eye or mind. Hurston's point was analogous to the musical one: a language of words like the one the white man used was one that could be printed, but hieroglyphics seemed to suit the pre-media form of painting—the art that Ellington's palette-conscious, tonally rich sound suggested to a number of hearers.

Vachel Lindsay, a white poet who was one of Langston Hughes's early patrons, offers a case study in the difficulties of print transmission of "Negro Expression." A tortured and talented Midwesterner with avidly spiritual and populist beliefs, Lindsay in 1914 wrote a long poem called "The Congo," a voodoo rite in blackface; it was the most popular of the pseudo-Negro, self-consciously "primitive" poems of the day written by white authors. "The Congo," subtitled "A Study of the Negro Race," celebrated its "Basic Savagery," "Irrepressible High Spirits," and the "Hope of [its] Religion." Punctuated by a tom-tom beat and varied "syncopated" rhythms, "The Congo" purported to be a "roaring epic ragtime tune." Fittingly, it was as often recited or declaimed as read; Lindsay included performance instructions in the margins, and in his extensive missionizing tours of the country he performed it as a kind of "Higher Vaudeville," intended, in his words, to awaken America to the "Gospel of Beauty." "The Congo" was an effort at free transcription of black musical and verbal styles, an attempt to get an oral art into printed form.

Lindsay was no radical in racial matters. The poem's main theme, the triumph of Christianity over Negro voodoo, is an echo from the not so distant Victorian missionizing past; he might celebrate ragtime, but he took a violent dislike to jazz. Lindsay grew to detest "The Congo," too. Audiences wanted to hear nothing else; he felt that he was being crucified on its popularity. But surely Lindsay was also dissatisfied because of the inherent impossibility of full transcription of his material; print wasn't adequate to his needs, any

more than sheet music suited the needs of the black musicians he desired to emulate.

The media that succeeded print, starting with motion pictures, did not share print's limitations, however, and Lindsay was one of the first to realize and welcome the fact. He was profoundly drawn to the film medium, and when he wrote his pioneering book *The Art of the Moving Picture* (1915), one year after "The Congo," the word he used to describe it was "hieroglyphics." What he recognized was that the movie medium, in its language and means of expression, was closer to a "primitive" aesthetic or epistemology than a civilized one. He declared that "the invention of the photoplay is as great a step as was the beginning of picture-writing in the stone age." The apparently illiterate movies represented a new form of literacy, and with their aid, he noted, America, long a "word-civilization," had begun to "think," as Ellington and Hurston's Negroes did, "in pictures." The photoplay and the hieroglyphic cave drawing were, in this telling, alike; in Lindsay's view, the media collapsed time and allowed a return to a more primitive culture that could not be read or written but had to be seen.

Lindsay understood that the biggest contrast in modern culture was not between literacy and illiteracy but between two different forms of literacy, and his point held for the sound media as surely as for silent films. All the post-print media get beyond the words-seen-on-a-page that is print's only material to a world of direct transmission. Everyone knows that books, like language itself, are not what we call the "real world"—the things that exist whether language recognizes them or not, the world that exists forever independent of language. Words aren't independent objects; they exist nowhere save in our minds and in books. In contrast, real objects, and the images and sounds and feelings they create, though always mediated by the human eye and ear, actually exist out there, and they are what both hieroglyphics and the post-print media try to capture. We don't figure out an image in a film, or a sound on a record or the radio; we just get it.

That is why, to adopt Marshall McLuhan's terms, print is a "cool," nonimmediate, distant medium, dependent on the working of a trained mind to have any meaning at all. If you can't read, the printed page means nothing to you. Print isn't a jump-start affair; it depends on prior knowledge. But all print's successors, able directly to convey the world's sounds and/or sights straight to one or more of the senses without enlisting the mind's self-conscious interpretive activities, are "hot," immediate media. Working by direct representation, they use no written language, need no translation, and require in their users no conventional literacy skills save the ones they bring to nonprint life in their everyday experience. Okeh recording "Crazy Blues" or WHN broadcasting Ellington's music experienced none of the difficulties

423

facing the early investigators of black music, including Lindsay. Okeh and WHN didn't need to know how to transcribe this music; they reproduced the sound.

Media scholars and literary critics have rightly insisted that no medium is a transparent one; no medium merely reproduces reality. A camera selects and shapes reality as surely as print does; recording today can and routinely does alter the sounds it transcribes by a multitude of technological tactics like overdubbing, and the use of multiple tracks. But our ability to alter sight and sound has developed enormously since the 1920s; widespread knowledge of the post-print media's capacity for duplicity is largely post-modern. Whatever their technological skills and sophistication, most people still recognize the greater immediacy and ease, if not greater veracity, of the visual and sound media over print and vastly prefer them. Today, the print market at its most extended is significantly smaller than that of the mass media. Even best-sellers may sell only a few hundred thousand copies; to be considered successful, a movie or compact disc or television show must command an audience in the millions. The people of the 1920s living in the first media era got the full impact of the change from print to the immediacy of the sight and sound media, and it took decades before critics and practitioners developed a full sense of the opacity of the newer media, their powers to betray those who use them.

Of course, the new media found skeptics and enemies from the start. In 1925, the folklorist Dorothy Scarborough voiced her fear that "Negro folksongs" would soon "vanish forever, killed by the Victrola [and] the radio"; people who could get cheap reproduced music might soon cease to make their own. Some jazz men, Sidney Bechet among them, worried that the time limits and standardization inherent to recording and broadcasting would hamper the improvisatory performing skills essential to jazz. But Burton Peretti has demonstrated that most black musicians showed little nostalgia for the folk past. Jazz was perhaps the first Negro profession, and its top practitioners saw themselves as an elite, above the folk they came from, if only in the sense that they did self-consciously and for profit what the folk did spontaneously and for free, and they were intensely interested in the cultural power only the mainstream confers. Radios and records might cut into the audience of live performance; talkies put musicians who had played piano for silent movie theaters out of jobs, but the advantages of the new media apparently outweighed such losses in the minds of most of the black musicians involved.

To begin with, the mass audience the media make possible does not in itself automatically spell complete standardization. To hear Fats Waller sing "Ain't Misbehavin' " live with a small group of like-minded persons at Con-

nie's Inn was, of course, a different experience than the one involved in catching the number on his radio "Rhythm Club" show. It was not just the difference between the feel or quality of live music and that of transmitted music; in any case, broadcast music was played live, not prerecorded, and Fats was famous for his on-air ad-libs. It was also that, in catching Fats on the radio, one was sharing the experience with thousands, perhaps millions, not dozens or hundreds of people. But the expanded audience might mean a partial transfer rather than a cancellation of jazz's powers of improvisation. In theory and sometimes in practice, the variations were built back in on another level by the variety of listeners or consumers the media automatically made possible. To participate in mass-produced and/or media-conveyed culture was to open oneself, willy-nilly, to thousands of collaborators, each with his or her own needs and style, each capable of his or her own interpretation. A few of these listeners, moreover, were themselves fledgling or professional jazz musicians, now able via the media to gain access to more and more various music than any generation of musicians before them had done, and to create their own variations on it. Remember that Bix and James P. learned some of their first jazz from records. Live performance, which is by definition unstoppable and unrepeatable, was far less hospitable than "canned" music to this form of pedagogy.

Although the post-print media did involve new forms of censorship, notably those imposed by standardization, they also made possible, for the first time in human history, something like exact representation, an abolition of the oldest form of censorship, which is sheer inaccuracy. It was an act of abolition almost as important to black Americans—and I say this fully aware how ceaselessly the media have exploited black talent—as the equally limited but nonetheless crucial Emancipation Proclamation that legally freed them in 1863. Even skillful print representations of Black English, full of phonetic spellings and carefully noted ellipses and idiosyncrasies of pronunciation, by writers as talented and informed as Harriet Beecher Stowe or Joel Chandler Harris or, in the modern era, Zora Neale Hurston and DuBose Heyward, couldn't fully convey the "tropic nonchalance" (in Alain Locke's phrase) of African-American speech. That speech, itself the source of the slides and slurs and microtones of blues singing and jazz instrumentation, was full of the same untranscribable tonalities and idiosyncratic phrasing. Books could no more accurately transcribe Black English than piano sheet music could black music. The blues, like all of African-American musical culture, couldn't have found the market they did without records, radio, and talkies. African Americans could now be heard without the distortions of an alien form of transmission.

The post-print media were to black speech and music what the book and

piano were to white speech and music. The black artist was to some degree versed in the language of America's dominant culture as well as in that of his own milieu, but he could reap whatever rewards might attend his bilingual status only when the literate white culture had something like the same ease of access to his so-called illiterate heritage as it did to its own traditions; as Lindsay saw, the post-print media made Euro-America bilingual, too. One cannot, finally, separate Harlem's literary renaissance from black Manhattan's nonprint performance traditions; the New Negro's quest for cultural empowerment was always dual, always conducted in the "literate" and "illiterate" modes, the white and the black traditions simultaneously, always expressive of what Du Bois called the Negro's "double consciousness."

One of America's strongest—if seldom acknowledged—incentives in taking the lead in post-print media development was that much of its most important, most marketable cultural legacy was fully susceptible to no other means of transmission and commodification; the conjunction of the black performance tradition and the white media was crucial to its bid for cultural hegemony. Modern America possessed, it appeared, not only a hegemonic hold on media development and technology but the greatest folk and popular art tradition in the Western world. The white-run media needed the content and energy that the black artistic tradition provided; the black tradition needed the access, the powers of accurate transmission, only the media could offer. A vast cultural problem had apparently been solved effortlessly and to the extraordinary profit of those involved; a birthright American folk inheritance had been discovered, and it had found a letter-perfect means of reproduction and distribution. Once again, something had been gained, if not for nothing, for next to nothing; assimilation and acceleration had occurred with such ease and speed that a kind of magic seemed to have been employed.

PERFORMANCE AND INSTANT ASSIMILATION

The media didn't take Negro folk music and turn it into something modern. Jazz was modern from the start; in fact, it typified and defined the modern. In 1924, Irving Berlin remarked that ragtime was part of the new age of automation and mechanization, its "new rhythm"; the age "demanded new music for new action . . . the country [had] speeded up." In "Jazz at Home," an essay included in The New Negro, the Negro critic J. A. Rogers, noting that though "the Caucasian could never have invented jazz" and "the Negro is its best expositor," "the African Negro hasn't [jazz] at all," explained that what decisively separated African-American music from its African origins

was its pace and its abrasive noise and dissonance—its reflection, in other words, of the modern American scene:

> Jazz time is faster and more complex than African music . . . It bears all the marks of a nerve-strung, strident, mechanized civilization. It is a thing of the jungles—modern man-made jungles . . . Jazz has absorbed the national spirit, the tremendous spirit of go and nervousness, lack of conventionality and boisterous good-nature characteristic of the American, white or black, as compared with the more rigid, formal natures of the Englishman or German.

Like the media, jazz recorded and increased the noise and pace of modern life, and like them it advertised itself as the prerogative of everyone, literate or illiterate.

Jazz, in the inclusive 1920s sense of the term, marketed worldwide via radio and records, belonged to the people who heard it as more traditional music never could. Its edge over classical music was not wholly a question of the media. Media distribution was open to all kinds of music, and proponents of the radio in the early 1920s pointed proudly to the numerous stations broadcasting classical music to presumably eager listeners. Caruso was a recording star, too; record sales of classical music jumped in the 1910s and 1920s. Nor can we assume that black musicians always chose to play jazz rather than classical music voluntarily; popular and patently "black" music was usually the musically inclined Negro's only option. But the ethos of jazz or popular music, however chosen or conveyed, was very different from that of classical music or any of the elite arts. As the player piano was pledged to yield "PERFECTION WITHOUT PRACTICE"—as Eastman Kodak promised, "You press the button, we do the rest"—jazz exuded an air of easiness that allowed for and encouraged instant appropriation and assimilation on the part of its fans and consumers. It was not until decades later, in the era of entertainment as self-conscious athletics, of the Arthur Freed–Gene Kelly musicals, of Method actors and rock and roll, that a pop artist would wish to advertise himself as the black soul singer James Brown did (and does) as "the hardest-working man in show business."

Far from wishing to form an elite jazz subculture, as their bop descendants did, Louis Armstrong and his contemporaries dropped much of their specialized jargon and jive talk once they were successful, and they preferred to call what they played, not "jazz," but simply "music." Ellington titled his autobiography *Music Is My Mistress* (1973) and Willie Smith called his *Music on My Mind* (1978). Armstrong thought that the bop artists, with their standoffish, even hostile demeanor, their abstruse harmonies and dif-

ficult rhythms, were trying "to make the music as hard as possible so you think they're really playing. They ain't"; they're just trying "to make the public realize how superior they are." The trouble was, Armstrong knew, that audiences don't like an art self-consciously superior to its listeners.

Armstrong's brand of jazz was complex, of course; his masterpiece, "West End Blues," recorded in 1928 with Earl Hines on piano, is as hard to imitate as any later, self-consciously difficult jazz, and Armstrong never denied the physical work his performance involved. In his *Self-Portrait*, he talked about the dangers all trumpeters faced—of split lips (he reminisced about playing with blood running down his tuxedo) and heart attacks. The super-healthy Armstrong was lucky. His lip always healed. His first heart attack didn't occur until 1959, when he was fifty-eight; his last and fatal one came in 1971. But whatever the artistic complexities involved, whatever the effort, even pain of performance, his aim was always to free the listener from worry and trouble, from any sense of the "serious"; grinning, cajoling, grimacing, and alive, he wanted his considerable labor to appear the easiest, the most effortless in the world.

Casually confident as a composer, musician, bandleader, and (unmistakably) as a man, Duke Ellington was "born rich," as he put it. A benign Count Dracula whom few mirrors caught, he liked to boast that he wrote his most acclaimed compositions, like "Mood Indigo," in a matter of minutes, and he, too, came to be troubled by the obstacles that younger jazz men put in the way of their music. He worried that jazz had developed into "one of those intellectual art forms" for the enjoyment of which people believe they have to "know" things. As a result, its audience was fast shrinking. With its new erudition, its upped literacy requirement, jazz scared people; they were "afraid of jazz," of its potential to cause them, as elite art always threatens to do, "embarrassment." Like Armstrong, Ellington knew that anyone who is actively embarrassed by his own ignorance can't have fun, and if an art doesn't engender fun for its audience, it is *ipso facto* no longer a popular art. This is not to say that one can't enjoy a particular instance of it more and more upon repetition, that one can't study it—one can, and Ellington's and Armstrong's music provide cases in point—but that first voltage of direct pleasure has to be there. By definition, we don't "learn to like" a popular art, though we may learn to understand it.

Gilbert Seldes celebrated the "lively arts" in good part because of the unself-conscious easiness they offered their patrons. We often defend ourselves against the great arts, we refuse to spend time with them, he wrote in *The 7 Lively Arts*, because "we feel ourselves incompetent to master them." We forgo whatever pleasure they might bring us because we don't want to

do the work necessary to appreciate them; because we're so constituted as to be unable to take much pleasure in what purports to be bigger and better than we are. "We will preserve our individual lives," Seldes concluded, even at the cost of "diminishing" them. In contrast, the lively arts present none of the "stress of a great name and authority"; they win from their patrons, Seldes said, quoting Walter Pater, "a consideration wholly affectionate." They take us as we are and liberate us from our sense of shame; they are nothing but that liberation and we love them for it.

This attribute of the lively arts, their knack of easiness and intimacy, could provoke criticism from elite groups as well as affection from the masses. Seldes noted that it always irritates those who pride themselves on "working" for their pleasures to realize that others are enjoying their art "just as much with none of the labor." We're all proud of our knowledge, the more hard-won the better, but we're somewhere ashamed of our affections. Our knowledge bespeaks what we've conquered; our affections tell what we're vulnerable to, what we're open to, even helpless before. Hence, Seldes remarked, the dismissive tone that some critics took toward the new popular and mass arts of the 1920s. When it came to jazz, however, Seldes himself was one of the offenders. In *The 7 Lively Arts* he wrote that black musicians might be "geniuses," but they were "wayward, instinctive and primitive" ones; nothing they did could count for much as long as they lacked, as he thought they did, "mind," the "fundamental brainwork" needed "to *write out* precisely what . . . [they] want us to hear." Some Negro critics rebuked black musicians, too; in 1921, Lucian White, a reviewer for the New York *Age*, noted that they "fail to realize the connection between mentality and musicianship."

Seldes and White were alluding to the fact that a number of successful black musicians could not read or write music—the original Clef Club Orchestra under James Reese Europe and such legendary jazz and blues greats as Kid Ory, Sidney Bechet, Ethel Waters, Alberta Hunter, and Billie Holiday were in this category; the reading and writing skills of Louis Armstrong and Bessie Smith were fairly rudimentary. Louis always felt good about the sides he'd cut backing Bessie in the mid-1920s. "Everything I did with her," he said, "I *like*." Musically, they made divine sense together; they found their music in the same place, and it was not on a page. "Always just had her blues in her head," Louis noted; "sometimes made them right up in the studio." Black artists were hardly alone here, though they were more severely criticized for their ignorance than their white peers. Irving Berlin couldn't read or write music; Al Jolson and Bix read music poorly. Bix had a habit of wandering off during rehearsals of the Whiteman band; his fellow

musicians sometimes, for a joke, put a newspaper on his stand instead of the music. Like Bessie, Bix was playing what he heard in his head, not what he saw on the page.

Berlin could be both touchy and assertive about his lack of formal training in music or anything else. "I never read Shakespeare in the original" was his idea of a joke, and halfhearted attempts to broaden his vocabulary or study composition petered out fast. As he pointed out after one failed effort, "In the time I spent taking lessons I could have written a few songs." In the same spirit, Armstrong, who left school for good in the fifth grade, explained in his *Self-Portrait*: "I didn't need the schooling. I had the horn." Playing in New York in 1925 with Fletcher Henderson's band, he realized, "I couldn't read music like a lot of the cats, but I never was embarrassed in music with bands 'cause I'd state my case. I'd say 'now I can *blow*!'" Minnie Marx, asked why she'd sent all her sons into show business, summed it up: "Where else can people who don't know anything make so much money?"

Remember Paul Poiret's dictum that the unschooled person had the best chance of adapting quickly to the new American milieu. As the young Hemingway's lack of formal training, even his apparent lack of any resourceful idiom, was his ace in the hole in his competition with highly literate British writers like Siegfried Sassoon and Robert Graves, the new jazz musicians of the 1920s seemed more freed than hampered by their lack of the formal skills useful in appropriating, and imitating, the past. Whiteman's orchestra could read music to a man, but when Don Redman, Fletcher Henderson's great arranger, tried to teach them some of his music, he found "they couldn't seem to get the real feeling." One observer insisted that the barely literate Bix could "create better than [the rest of] those guys could write." In the early 1920s, Bix had gone to Joe Gustat, a trumpeter for the St. Louis Orchestra, for lessons in reading and composition, but Gustat, after hearing him play, wouldn't take him on as a pupil. He saw that Bix was already following "his own path" and more conventional musical knowledge might deter, not aid him in his quest.

Bix was a very different case from Ethel Waters, who, as a black kid growing up in a city slum, had no chance to acquire conventional musical training; a privileged member of the white well-educated middle class, he had every opportunity to learn. His mother was proud of his precocious musical genius, whatever she thought of his later music, and she started him on piano lessons before he was five. But he neglected his lessons and eventually dropped them. He wasn't ignorant about reading music or unaware of the reasons for learning to do so; rather, he *refused* a musical education. Bix was aspiring, as Hughes did, as scores of white jazz men did after him,

to a kind of downward mobility. He was trying to diseducate himself from his class and race as a self-protective measure. If he closed off the safe and conventional way to success and slammed the door behind him, if he didn't acquire the skills associated with his social status, surely that status could never reclaim him; he'd be forced to continue in a life of high risk, whatever the temptations to turn back. And the man who never played anything the same way twice didn't really want to read music, didn't really want to know how a piece of music was supposed to turn out, how the future was going to happen.

One doesn't want to romanticize this situation. As jazz got more complex in the late 1920s, reading skills became more necessary. Bix couldn't have supported himself as a jazz musician in the white world unless he had learned to read music a little—his friend and colleague Frankie Trumbauer helped him improve his skills—and some of the greatest talents of the day, like Gershwin, Ellington, Willie Smith, and James P. Johnson, read and wrote music with ease. Whether or not they read music, however, all of them were, as Hurston said the Negro folk musicians were, artists consciously shaping a form. There was nothing that black musicians resented more than the charge that they were untutored talents whose musical gifts were "natural" ones, like Topsy's, that " 'just grows,' " as *The New York Times* once put it. The *Times* was reviewing Roland Hayes's impressive singing debut in 1920; in point of fact, he had just spent four years studying music at home and abroad. Some Negro musicans went along with white expectations in this area, but they did so with an air of self-conscious amusement. The musicians in the *Shuffle Along* orchestra all read music easily and well, yet they memorized the score and played it without sheet music as if they were improvising on the spot. Eubie Blake explained in *Reminiscing with Sissle and Blake*: "It was expected of us. People didn't believe that black people could read music—they wanted to think that our ability was just natural talent."

Even those musicians who were illiterate were anything but untrained. Armstrong's split lips and heart attacks were indicative of a larger truth: the apparently artless performance styles involved in jazz playing were physically arduous, carefully crafted, and endlessly rehearsed. James P. Johnson, speaking of himself and the other great "ticklers" of Harlem, described one of their favorite performance tactics. At some point during the piece, the pianist paused, sat sideways on the piano stool, apparently taking a breather. He chatted casually with friends in the audience as his hands idled on the keys; then, still talking, "without turning back to the piano," the player "*attacked* [the keys] without any warning, smashing right into the regular beat of the piece." "That," Johnson said proudly, "would knock them dead." This ap-

parently effortless bit of business "took," he added, "a lot of practice." The performing arts require body literacy, and body literacy is as difficult to acquire, as much the result of mental and physical discipline as print literacy; the body thinks, too, and it uses the mind in the process, though the mind can often give us no clear account of the operation.

The jazz artist, facing the tradition of white Western music and balancing its claims against those of a new tradition in the making, had to know, consciously or not, that the older tradition was far better funded, organized, represented, and rationalized, far more powerful than its upstart sibling; the larger culture is always in some sense on the side of the past. To become fully versed in the older music and its literacy demands might be to take on too big a task, to lose the nerve needed to explore and create the jazz idiom; to immerse oneself in the new and fluid jazz idiom, on the other hand, did not mean that one had automatically lost contact with the resources of the Euro-American musical past, as the careers of Johnson, Beiderbecke, Ellington, and Gershwin amply demonstrated. You *join* a top-dog team; it absorbs you. But your presence may *make* an underdog enterprise; it will suit its strategy to your gifts if they are extraordinary ones.

Bruce Barton, reviewing *The Sun Also Rises* for *The Atlantic Monthly* in 1926, remarked admiringly that Hemingway "writes as if he never read anybody's writing, as if he had fashioned the art of writing himself." Barton was not suggesting that Hemingway had learned nothing from past writers, that he had never read anybody else's writing, or that he invented the art of writing; rather, he meant that Hemingway was free of the past to just the right degree, that he knew what to learn and what to ignore, that he had situated himself so as best to create a new style without losing whatever value the old might have to contribute. To know exactly how much knowledge of tradition one needs in order to originate, to strike out on a fresh path, might be the surest sign of genius, and the situation of each artist dictates different choices. The Romantic poets, especially Keats, were crucial to Fitzgerald's enterprise and he always kept them close at hand; Hemingway dismissed the same poets as "false" and "embarrassing." James P. Johnson needed the classic Euro-American tradition for his art; Bessie Smith found nothing in it useful for her purposes.

Bix gained real advantages from his dislearning tactic. Because he never formally studied the cornet, he developed highly unorthodox methods of fingering. As anyone knows who has tried to adjust the suggested fingering of a Bach fugue scored for a keyboard instrument, different fingerings can yield surprisingly different musical results. Many of Bix's peers believed that his idiosyncratic fingering had something to do with the unduplicatable clarity of his notes, "pearls," one observer said, struck off by a "mallet." Leopold

Stokowski, the English-born conductor of the Philadelphia Symphony Orchestra, believed that "the Negro musicians of America" were playing the greatest part in the democratization or "vulgariz[ation]" of music because

> they have an open mind and an unbiased outlook. They are not hampered by conventions or traditions, and with their new ideas, their constant experiment, they are causing new blood to flow in the veins of music. The jazz players make their instruments do entirely new things, things finished musicians are taught to avoid. They are pathfinders into new realms.

In this account, to be "unfinished," even exiled from mainstream musical training, had freed rather than constrained the jazz musician; he could, as J. A. Rogers said, "release . . . all the suppressed emotions at once, blow off . . . the lid," let off "musical fireworks," and "revolt joyously against convention, custom, authority . . . [against] everything that would confine the soul of man and hinder its riding free on the air."

SKYSCRAPERS, AIRPLANES,

AND AIRMINDEDNESS:

"THE NECESSARY ANGEL"

MANHATTAN RISING

If the blues were the roots of America's modern religious sensibility, jazz was its oxygen; if the blues were buried treasure under the ocean's floor, jazz was the deep-sea diver bursting back up into the air. The generation that invented jazz was the first "to get our feet off of the ground!," as the expatriate poet Harry Crosby put it, the first to defy gravity and colonize space. It coined the word "airmindedness" and advertised its day as "the Aerial Age." Radio shows were "on the air," planes toured the heavens, and buildings competed with clouds. Everywhere people were netting the sky and finding in the air what seemed an androgynous free-for-all of spiritual energy.

Netting the sky was part of the imperial ambition of the time, of the invisible but all-powerful American empire taking over the world via its machinery, its media, and its near-monopoly on modernization, means far more effective than the old-style method of territorial conquest. William James's perception of "the air [as] itself an object" was translated in the 1920s into the commodification of the air as a marketable product, as radio frequencies, airplanes, and skyscrapers. But the religious focus James brought to his studies of the meaning of space in a world "whanging with light" was not altogether lost. Pilots like Eddie Rickenbacker, a hero of the Great War, sometimes saw themselves as "chosen pawns of the creator," and proponents of airmindedness used forbidden religious terms and phrases like "miracle," the "Holy of Holies," "saint," "evangelist," and "apostle" to describe the new creatures and events of the aerial age. Some predicted "aerial therapists" and "aerial sanitariums" where patients could have the benefit of the "therapeutic heavens" and become emblems of "the risen soul."

Scott Fitzgerald, whose first spoken word as a baby was "up," took "toplofti-

ness" as his aesthetic, and Zelda, a famous high diver in her youth, aspired to be a "falcon ace." Living at the Plaza, the Fitzgeralds' favorite hotel, in the mad and glorious days of the early 1920s, she used her belt to lash the elevator to the floor they were staying on. The Plaza, designed by the architect Henry Janeway Hardenbergh in 1907, was itself in height (though not otherwise) an early example of the skyscraper impulse; and without elevators (new in the 1880s) shuffling between ground and sky, the skyscraper age would have been impossible. Elevators were somehow meant for the Fitzgeralds. They belonged to them, like a title.

Fitzgerald wrote an unforgettable vignette of elevator travel in a story entitled "May Day" (1920). Two intoxicated revelers, who call each other "Mr. In" and "Mr. Out," are getting into an elevator at the Biltmore Hotel (another high building, dating from 1913):

> "What floor, please?" said the elevator man.
> "Any floor," said Mr. In.
> "Top floor," said Mr. Out.
> "This is the top floor," said the elevator man.
> "Have another floor put on," said Mr. Out.
> "Higher," said Mr. In.
> "Heaven," said Mr. Out.

Scott's best material lay in the Believe It or Not zone, the place where fable has become truth; drunk and foolish as they are, Mr. In and Mr. Out, demanding to go "higher," to "heaven," were prompted by fact, not fancy.

The skyscraper was the offspring of the steel frames introduced in Chicago after the Great Fire of 1871; the first steel-skeleton building in New York was the Tower Building at 80 Broadway, built in 1889. Steel frames meant that, for the first time in history, a tall building did not need to emulate a pyramid, did not need to be heavier at its base to support its vertical thrust, however high, but could, rather, spring straight from the earth with no visible dependence on it. New York's skyline began to rise in the 1890s, and it gained 100 feet in the years between 1920 and 1926. During this time the skyscraper's basic design did not alter. As Hugh Ferriss, the city's most talented and influential architectural delineator, wrote in *The Metropolis of Tomorrow* (1929), "Buildings . . . have simply grown higher and higher." The verb "grow" suggested a process both natural and magical, high stories "built with a wish," as Nick Carraway says of the skyline in *The Great Gatsby*. What was to stop the Biltmore from inching "higher" on request or of its own volition? "Heaven" might not be an unreasonable goal. A number of skyscrapers boasted "Cloud Club" restaurants at their summit, and the Chrys-

ler Building had, one story above its Cloud Club, an "Observation Deck" whose ceiling was covered with stars and whose hanging lamps looked like planets.

New York and Chicago were competitors in this race for the air. (Boston, increasingly a noncontender in the megalopolis category, showed little interest in skyscrapers.) Chicago boasted America's most innovative architects— John Wellborn Root, Louis Sullivan, and Frank Lloyd Wright; absorbing the influence of Darwin, Herbert Spencer, Walt Whitman, and Thoreau, they subscribed to a consciously "American" architectural look devoid of what Root called "purely decorative structures," a live image of "freedom," "newness," "harshness and crudity." But New York soon took the lead. The motto of New York State was and is "Excelsior!"—which is just a high-toned version of Mr. In's "Higher!" By 1929, America boasted 377 urban buildings that had more than twenty stories, fifteen of which were more than 500 feet high; 188 of them were in New York.

The race for the air was conducted within New York as well. The architectural historian Wayne Attoe distinguishes between a "democratic" skyline, in which buildings complement one another, and a "star" skyline, in which buildings compete with each other; in Manhattan, buildings challenged each other directly. In 1908, a 700-foot tower made the Metropolitan Life Insurance Company Building the world's tallest; in 1913, the title went to Cass Gilbert's Woolworth Building at 233 Broadway, at 800 feet; in 1930, the Chrysler Building, designed by William Van Alen, claimed the championship. The Chrysler Building had a competitor in the Bank of the Manhattan Company, under construction at the same time and designed by H. Craig Severance, Van Alen's ex-partner (there was a personal side to this architectural rivalry), but right after the bank's official opening, Van Alen hoisted a secret 185-foot spire into place on top of the Chrysler Building and surpassed his competitor. "No old stuff for me!" he exclaimed. "Me, I'm new! Avanti!" In 1931, the Empire State Building established its supremacy.

The erection of the Empire State Building was the stuff of instant legend, an example of "automatic architecture," in the phrase of Rem Koolhaas, the fulfillment of New York's promise to James in 1907 that "there was nothing that was not easy." Thanks to assembly-line production, buildings could be put up five times faster than they had been only a decade before, and the Empire State Building rose at the rate of close to a floor a day, without a break, until it reached its height of 102 stories or 1,250 feet, a satisfying 277 feet higher than the Eiffel Tower. A temporary restaurant was installed on the site to cut the laborers' lunch break to a minimum; every recent contribution to construction and labor efficiency—bulldozers, cranes, scaffolding, chutes, paint sprayers—was in full use. In 1930, as the actual

construction was just beginning, its designer, Richmond Shreve, made clear the nature of the feat: materials from all over the United States and the world "must come together and fit together with accuracy of measurement and precision of time." "Six months ago the working drawings . . . had not been begun; one year from now it will have been completed . . . fifty million dollars . . . twenty thousand tenants . . . two million square feet . . . fifty thousand tons of steel . . . rising nearly a quarter mile."

Buildings, sometimes fine ones integral to the city's heritage, were torn down in the haste to put up bigger, newer ones. The old Madison Square Garden was razed to make way for the New York Life Insurance Building; the old Waldorf-Astoria's site became that of the Empire State Building. The Waldorf Astoria's elevators were salvaged, but the rest of the building was dumped into the sea five miles off Sandy Hook. "The destruction of the Waldorf [was] planned," Koolhaas writes, "as part of the construction [of the Empire State Building]." It's once again the streamlined American symbiosis of destruction and production, the emphasis not on the product but on accelerated production, on productivity itself.

Most New Yorkers thought (mistakenly, as it turned out) that the sky-scrapers would be as transient as the buildings that had been demolished to make way for them. In *The North American Review* of November 1929, the sculptor Gutzon Borglum lamented that "our greatest buildings are ephemeral," and a *New York Times* editorial of October 26, 1926, remarked: "As for building for eternity, the need does not exist. Thirty years from now they will be tearing up the city once more." Hugh Ferriss, drawing the "Imaginary Metropolis" of tomorrow, a city he thought of as in the near-future, envisaged entirely new buildings; not a single building of the 1920s is to be seen on these pages. If Chrysler produced a new model every year, why shouldn't architects do the same? The skyscrapers were not only technology, soon to be junked as obsolete, but pop and mass art, and whatever else it may be, mass art is transient, disposable, replaceable. Even allowing for advertising value, the skyscrapers yielded little or no profit, because office rents did not always cover the steep cost of the necessary elevator and maintenance service. Critics commented on their wastefulness, but the architect Claude Bragdon, writing in *The American Mercury* in March 1931, explained that the motive behind them was not in any case financial but "psychological." The nation's need for self-expression, not its economic imperatives, had produced the new skyline.

Manhattan was engaged in revolutionizing its architectural identity, and shifts in architecture always spell shifts in the psyche of the people who build it. We all know the shock that comes when a new and different building goes up amid the old familiar structures of a neighborhood. It's as if we were

committed, without warning, willy-nilly, simply by the new building's ob-
trusiveness, its "sticking out," to sponsoring and incorporating it into our
corporeal and psychic image or idea of ourselves. We instinctively know that
buildings have designs on us; they insist on speaking for us, on being exten-
sions of those who build and behold them. In the "Epilogue" of *The Me-
tropolis of Tomorrow*, Ferriss explained that "architecture influences the lives
of human beings"; "specific consequences," "subconscious" effects, will turn
up in our "thoughts, feelings and actions." Buildings, in other words, affect
our unconscious and quite possibly emanate from it. Koolhaas says that the
skyscrapers were Manhattan's Rosetta Stone, the hieroglyphics of the modern
American nation; skyscraper Manhattan offered the spectator the biggest
sculpture, the largest-scale self-portrait yet seen in the world, a case study,
one might say, set in stone.

It is important to note that skyscrapers did not become the dominant form
of modern urban architecture in England or Europe. Visiting foreigners
might be awestruck in America by what the Englishwoman Mary Borden
called "the scaffolding of the world of the future," but on their home turf
they were unwilling, as the art historian Robert Hughes has pointed out in
The Shock of the New (1981), to consign the amount of space a skyscraper
required to a building that would serve only one purpose—a commercial
one—instead of answering to the many domestic, trade, and civic uses that
buildings in Paris or London were designed and accustomed to accommodate.
Raymond Hood, New York's leading skyscraper designer, finished the flam-
boyant black-and-gold American Radiator Building at 40 West Fortieth Street
(just behind the New York Public Library) in 1924. A few years later, the
National Radiator Company in London asked him to design a building for
them, in collaboration with the English architect J. Gordon Reeves. The
London firm also wanted a black-and-gold decor, but their building was to
be only eight floors high, in contrast to the New York model's twenty-two
floors, itself a very modest height in New York at the time.

Europeans and Englishmen have always liked to feel at home in their
cities; the out-of-scale skyscrapers might, to their mind, dwarf the city in-
habitant and his concerns. There were reservations at home as well. A sketch
of 1921 by Edward Hopper entitled *Night Shadows* shows a man seen from
above, from, one deduces, a very tall building. A huge lamppost casts a
foreboding diagonal shadow before the tiny figure; he looks lost. Frank Lloyd
Wright, the pioneer in low-lying organic architectural design, acknowledged
the skyline's nighttime beauty—"a shimmering verticality, a gossamer veil,
a festive scene-drop hanging against the black sky to dazzle, entertain and
amaze"—but he could not forget, he wrote in *The Disappearing City* (1932),
that the skyscrapers were "volcanic crater[s] of blind, confused human forces

. . . forcing anxiety upon all life." "The skyscraper," Wright said, is "no longer sane." Wright's negative take was, however, largely an anomaly in America.

James, who took pleasure in New York's "heaven-scaling audacity . . . and the lightness withal," saw the beginnings of the skyscraper age. Returning by train in the late 1890s from a dispiriting stay amid the overcheerful Chautauqua lecture crowd, he found the revitalization he needed, he told the listeners of his lecture "What Makes a Life Significant?" (1899), in the sight, near Buffalo, of "a workman doing something on the dizzy edge of a skyscaling iron construction"; this was human nature "in extremis." His image was literalized three decades later in Lewis Hine's *Sky Boy* photograph, the most famous of the ones he took during the construction of the Empire State Building: a young man is going to work on the building, ascending a cable; in the background we see, not, as we might expect, the city spread below, but a distant Hudson River and sheer air.

There were links between the skyscrapers and the new media; they hosted radio (and later television) wiring and served as advertisements for the industries that financed them. The self-promoted "frankly spectacular" RCA Victor Building culminated in a series of clustered Victrola-needle-like points. The Chrysler Building sported hubcaps amid its decoration, and the Radiator Building was lit at night to glow softly in the dark like an immense incandescent radiator. Marshall McLuhan has argued that the media offer to human senses and powers, not unbeatable competition, but extensions and accelerators, and by this reading, the skyscrapers were central to the first full-fledged media age; their upward thrust was meant to spur in their viewers, not comparison, but identification, even self-glorification. Admirers as well as detractors emphasized their prodigious, defiant quality: "a freak," "a stunt," "a great feat," a "tour de force" were titles bestowed on the Chrysler Building. The skyscraper was an energy-mad era's supreme self-valorization. With its steel frame and dizzying climb upward, it was a literal demonstration of Ronald Fieve's "grandiosity with a basis in fact," of James's "will to believe" or, as he later thought he should have titled it, "the *right* to believe," the *American* right to believe.

Wallace Stevens, born in 1879, was a Harvard man; although he did not study with James, he became a self-conscious subscriber to his "Will to Believe." Stevens began to write in something like his mature manner— sensual yet abstract, pampered, at moments rococo, but austere—when he was living in Manhattan, the "electric town," as he called it, in the first decade and a half of the century. Despite his attachment to his hometown, Reading, Pennsylvania, despite the intermittent unemployment and loneliness he experienced, Stevens stayed on in New York because there, he

knew, he could become the poet he wanted to be. An advocate of "supreme fiction," he was never a proponent of "terrible honesty," and in New York, he wrote, "I can polish myself with dreams [and] live in a fine false way." Although he left for Hartford, Connecticut, in the spring of 1916 to please his new wife and pursue a career in the insurance business, he regretted the move. "I miss New York abominably," he wrote one friend, but it lived on in his poetry, if not as subject, as aesthetic principle and ideal. Like Fitzgerald, Stevens favored verbs like "bloom," "gust," "flash," "glitter," "enlarge," "flock," "buoy," "blow," and "flutter"—all suggesting matter effacing its boundaries, extending its promise, rearranging its relationship with gravity, matter in a state of translation. It is no accident that his poetic awakening occurred in New York at the start of the skyscraper era; buildings attract muses and poets, too.

Describing his poetic as the "visible announced," as the "object" extended through "the proliferation of resemblances," an aesthetic based, in other words, on the changes affected in matter when it is extended outward and upward into air, when space, not time, is its predominant element, Stevens could be describing the effects sought by the architects of the skyscrapers; indeed, his language is almost identical to that used by their early promoters. The Woolworth Building, finished while Stevens was still in the city, was a solid cream-colored mass studded with windows, an extraordinary five thousand of them, elaborated with Mozartian delicacy. It rose to a Gothic tower, "gradually," in the words of Cass Gilbert, its architect, "gaining in spirituality the higher it mounts," and it was "acknowledged as premier," a 1916 promotional pamphlet claimed, "by all those who aspire toward perfection and . . . use visible means to obtain it." Material excess has triggered spiritual self-realization. The Woolworth Building, too, proceeded by a "proliferation of resemblances," by self-perpetuation with variations, to an annunciation of the visible; it, too, "celebrate[d] the marriage / Of earth and air," in the words of an early Stevens poem, "Life Is Motion."

To convince the skeptics of their claims, Spiritualists had tried to photograph the invisible world unveiled in séances. Although the fairies, spirits, and other supernatural phenomena captured by their cameras proved upon investigation to be doctored superimpositions—it seemed fair, many of them felt, to falsify evidence to gain adherents to truth—the phenomenon was still imaginatively resonant; it was another form of the "marriage / Of earth and air," another way of using "visible means" to capture "spiritual perfection." The skyscrapers made the affinities between the old Spiritualist medium and the new media explicit. Like the Spiritualist photographers, their architects aimed to achieve the look of "a soul . . . photographed in heaven," in the phrase of the critic Elizabeth Kendall; they, too, produced the ineffable

without sacrificing the delights of the concrete, an act of resurrection that honored the body as well as the soul.

The promotional pamphlet about the Woolworth Building elaborated at length its varied perspectives and services and conveniences, the multitudes of office holders and employees it held; everything one could ever want or need was apparently contained within it or sighted from it. As if to advertise the plenitude and plurality of its resources, the Chrysler Building's elevators were made of dozens of different kinds of inlaid wood, including Japanese ash, English gray hardwood, Oriental walnut, American walnut, and Cuban plum-pudding wood; no two elevators were the same. The more severe Empire State Building struck its own note of intoxicating self-sufficiency. At the center of the spare but magnificent lobby was a huge gleaming aluminum bas-relief of itself; at the heart of the building, "fine and false," in Stevens's phrase, to the core, lay its own proud self-image. Modern taboos against open displays of narcissism did not hold here. When a reviewer of Ferriss's *Metropolis of Tomorrow* wrote that the book was a "gorgeous feast," he was acknowledging the affinities between the new urban architecture and the older matriarchal values of oral gratification, self-love, and spiritual aspiration; the skyscrapers were very much, to recur to James's words, a "solid meal" and not a "printed bill of fare."

Ferriss himself offered evidence of the ties between the new architecture and older matriarchal ideals and practices. Arriving in New York from his native St. Louis as a young man in 1912, he worked with Gilbert on the Woolworth Building, and in the next two decades his drawings figured in the construction and publicity of many of the city's most notable skyscrapers, including the Radiator Building, the Chanin Building, and the Chrysler Building. But the city Ferriss drew in *The Metropolis of Tomorrow* seems less modernistic than mystic, less a futuristic city than an experiment in psychic research. Details are vague, suns are in eclipse; buildings are shafts of bodied and varying light, looming out of the shadows like spirits summoned at a séance. In fact, Ferriss dabbled in Spiritualism, Theosophy, and Gurd-jieff study groups—he and Jean Toomer were in the same Gurdjieff class in 1925—and he tells us that the skyscraper, the emblem of the "subconscious," "possesses an individual existence, varying—now dynamic, now serene—but vital as is all else in the universe." By "vital" he meant something like the *élan vital* of William James's friend Henri Bergson, the French philosopher; James sometimes used the same phrase to describe his version of the subconscious, though he usually called it, as did many Spiritualist and Mind-cure practitioners, the "subliminal self." Catching the matriarchal and Mind-cure reverberations of Ferriss's aesthetic, Rem Koolhaas describes his world of primal shadows as "the . . . womb of Manhattanism."

The feminine parallel might at first puzzle the student of New York's skyscrapers. No women were involved in designing and building them; if the decade was engaged in "reading the phallus," Manhattan might supply the text. Storming the sky, the skyscrapers were, whatever else they advertised themselves to be, an announcement of modern man's role as the belligerent pugilist-prophet of Krutch's "No-God": "There is no God and I am his prophet." Yet, as if to substantiate Freud's worst fears about a fatherless world, delirious New York also paid paradoxical homage to a feminine principle that "blurred the issue of paternity," as Koolhaas puts it. Mass art in extremis, Manhattan's new architecture expressed and proved the relation between modern popular art and old-style Victorian matriarchy.

The skyscraper phenomenon, a historical hybrid, began in the prewar decades, the heyday of the Titaness, and peaked in the boom years dominated by her matricidal offspring; some of its finest manifestations, though planned in the flush years of the boom, actually went up or were completed after the Crash, amid the mood reversals instigated by the Depression. A historical mongrel, the skyscraper offered a cultural crux, a nexus of apparently contradictory ideas, a powerfully utopian and fully realized coalition of modern masculine technology and phallic style with old-fashioned subliminal and matriarchal impulses. The moderns purported to despise the Titaness in all her guises, but the skyscraper nonetheless represented her influence via the return of the repressed; the repressed matriarchal culture had come back, less as Fury and Demon—that came in full force, I've suggested, a bit later—than as a form of toploftiness, an unrecognized yet "Necessary Angel" (the term was Stevens's) at the apex of 1920s Manhattan. The model is Jamesian rather than Freudian; James had his own ideas about the return of the repressed.

According to James, the unconscious or "subliminal self" was the diffuse and permeable "fringe" part of the psyche, the part that extends the self and diffuses it into the outer world, physical and spiritual, an instance of psychic matter revealing its secret identity as light. It represents another form of awareness which operates outside conscious control, replenishing and expanding the limited, knowable self; the subliminal self tells us, in James's words in a letter of 1906, that "the world our 'normal' consciousness makes use of is only a fraction of the whole world in which we have our being." Unlike the Freudian unconscious, James's subliminal self was not a traitor ambushing the unwary conscious self but a potential resource, even a friend, less a trap than an enlargement and an enkindling, offering a bigger, freer space for the activities of the self than the self unaided can command. One must consider the contrast between Freud at work in his dark, private, book-and-object-crammed study, and James, thinking aloud as he lectured, liking

to stop in the classroom and look out the window. Freud's unconscious was an indoor affair, a powerful generator below basement level; for James, the man who loved the "acrobatic" American climate "whanging with light," the unconscious was a kind of outdoors, full of the wonders and terrors of the world we acknowledge to be beyond our control. In his version of the unconscious, the air has been not shut out but let in; the subliminal self is the outdoors that is, so to speak, indoors, our own access to the weather of the universe.

Freud's unconscious works on a hydraulic model drawn from physics; in a world of limited space, energy, and motion, one thing automatically dislodges or imperils another. Given this dynamic, the conscious part of Freud's psyche must try to displace or repress the unconscious part, which in turn must struggle to regain its place; this struggle on the part of the unconscious for expression and dominance is what Freud meant by the return of the repressed. James honored the hydraulic principle as he did all theories with a basis in fact (he nicknamed it, after a student misnomer that amused him, the "hydraulic goat"), but his notion of the unconscious nonetheless expressed a tenacious reservation about it; he believed that there might be modes of placing that meant, not conflict for territory, but rather new ways of making room, forms of expansion and contraction difficult to conceptualize but nonetheless real. A surgeon operating on the human brain, James pointed out, is on one level simply dealing with finite matter in a portion of the cranium, a circumscribed small space; on another level, however, he's dealing with an organ that itself creates and peoples a world, though one invisible and unheard in the operating room. The many do fit into the one; the infinitely multiple can be contained in the discrete.

In James's more elastic scheme, the return of the repressed involved, not conflict between conscious and unconscious selves, though he knew that such conflict might well be present, but fresh forms of collaboration between them; something like coexistence, even cooperation, between conscious and unconscious is possible. It's not so much the return of the repressed as the survival of the unacknowledged, the re-emergence or expansion of the subliminal self. The matriarchal element of the all-male-designed skyscraper was the return of the repressed in a Jamesian guise, a happier guise than the one Freud described: the denied unconscious element continues to serve body and mind as nourishment though not as conscious idea, much less as aim or ideology.

It's important to stress that James's view of the unconscious included, even as it de-emphasized, Freud's idea of the unconscious, but the reverse was decidedly not the case; whatever his limitations, James knew more about conflict than Freud did about peace. Freud gave scant attention to what later

psychoanalysts dubbed the "conflict-free ego sphere," the place where the self learns and adapts and changes, not only because it must, but because it wants and needs to for its own full self-expression. He always cast the return of the repressed as struggle and punishment. In his schema, collaboration between conscious and unconscious might occur in rare and elated moments of creative breakthrough (moments that usually prove costly), but hardly as an everyday reality or opportunity. James's pragmatic stress on experience and results is very different; most of us know that what we forget or deny returns to us in several ways, by several routes—sometimes as unexpected Freudian vengeance, sometimes as Jamesian surprise reinforcement, even deliverance. America's moment of self-discovery spelled both the exhilaratingly dark return of Freud's "primaeval man within us" and an infusion of atmospheric optimism, an access of Jamesian weather, "a tremendous muchness," as James put it, "suddenly revealed" as if through "an open window."

Harry Houdini, a New York magician, illustrates my point about how the Jamesian return of the repressed operates. His career spanned the Victorian and the modern eras, and it was a paradigm of the tensions between them. Houdini liked to close his show with the line "Will wonders never cease?" and he, too, netted the sky. Born Ehrich Weisz in Budapest in 1874 to a Jewish family (his father was a cantor) and raised in Wisconsin, before he was ten he was working the circus and carnival circuit billed as the "Prince of the Air." His later feats included jumping from one airplane to another while both planes were in the air and getting out of a straitjacket while suspended from a skyscraper. He had matriarchal interests as well. He had practiced as a Spiritualist medium, and when his adored mother died in the 1910s, he tried repeatedly and vainly to reach her through séances and telepathy. Embittered by his failure, he embarked on his career as an exposer of mediumistic fraud. In other words, Houdini had learned the tricks of the trade which he devoted his last years to attacking as a would-be believer— "I was *willing* to believe, even *wanted* to believe," he wrote in his autobiography—and many of his fans and enemies alike insisted that he had not altogether shed these beliefs, that he himself proved the existence of the magical powers he derided.

In his autobiography, A *Magician among the Spirits* (1924), Houdini recounts a striking exchange with Freud's muse, Sarah Bernhardt, for whom he gave a special show in Paris right after the Great War. Bernhardt, who had acted almost as often in America as in Europe, was an admirer of the skyscrapers; on a visit to the States she talked about designing one herself. She had written a book titled *Dans les nuages* (*In the Clouds*) about her adventures as a balloon aviatrix in the late 1870s, and she created a "flying

costume" for women during the Great War. Although she, too, was credited with magical powers, they seemed to be failing her by the time she and Houdini met. A leg had been amputated in 1915, and she was no longer young. Gallant to the last, she'd gone on performing on one leg, on rare but electric occasions propped up by a staff bearing the French flag.

Bernhardt was enthralled by Houdini's show. When it was over, she said, "in that wonderful speaking voice with which she . . . has thrilled thousands of auditors": " 'Houdini, you do such marvellous things. Couldn't you— could you bring back my leg for me?' " Houdini was shocked. "You know my powers are limited," he told her, "and you are actually asking me to do the impossible." "But," she insisted, "you do the impossible." Bernhardt believed in the effects she created; she was only asking him do the same. (Though he did not restore her leg, they parted friends.) Houdini's wife also believed he could do the impossible. He died on Halloween in 1926, the victim of a demented fan who, taking Houdini's magical powers of invulnerability at face value, directed a series of unexpected and lethal blows to his abdomen; his wife spent the next decade in séances, trying to establish contact with him.

The title of Houdini's autobiography, A Magician among the Spirits, hardly advertised the incredulity the text itself was meant to document, and his signature line, "Will wonders never cease?," if intended as irony, was also an invitation. His shows during the 1920s involved re-creating all the effects the mediums achieved—tappings, voices, apparitions—then demonstrating the "trickery," the purely human means that produced them. But while his interest lay in the moment of exposure, in the demonstration of fraud, in "terrible honesty" as entertainment, his viewers' most eager attention went to the pretense not the fact, the impostor not the critic. In their eyes, he gained his force in part through possession of the powers he had repudiated but assimilated; he suggested to others his own denied source of sustenance. What he repressed did not fight him as much as it fed him. A similar logic was evident in the skyscrapers.

Inside Raymond Hood's tall, clean-featured Daily News Building (1929), at 150 East Forty-second Street, was a surprise in the form of a stunningly farfetched lobby which featured a moving ten-foot inset globe with a mirror beneath it and a black glass-faceted ceiling above; it was one of the womb structures Koolhaas finds everywhere on the all-masculine architectural scene. What had seemed suppressed had been but submerged, and it had resurfaced to complete rather than challenge the dominant design. If the moderns' tactic of appropriation, an activity brought to a peak in Manhattan's new skyscrapers, was the matricidal one of ripping the babe betimes from the womb, killing the mother to save the child, one must remember that

the child snatched from the mother's womb is still part of the mother; the mother destroyed to save the child nonetheless lives on in the child. The best of the matriarchal culture which the skyscraper era officially repudiated was less essentialist than all-inclusive, vitally concerned with inmost corporeal and spiritual truths, and it was this culture on which Stein and James built their modernist art; it was carried, intact, in the womb of the skyscrapers.

This male-female presence, the realized alliance of masculine and feminine impulses, was crucial to the special euphoria of top promises fulfilled, the sense of heaven here on earth that the skyscrapers inspired in those who designed and viewed them. Only when the masculine and feminine elements are present in equal strength, only when the genders collaborate rather than compete, only when they come fully abreast or flush of each other, can the artifact or culture involved be, by a process of simultaneous gender reinforcement and gender cancellation, both gender-doubled and beyond gender and so satisfy the deepest needs of the human heart, mind, and psyche. Houdini remarked that "if the wish is father to the thought, it is mother to the hallucination." The New York skyline, "built with a wish," was that thought and that hallucination.

Marianne Moore believed that, to be "exact," one must be "reckless," and she chose a like-minded passage from William James when she wrote a preface to a later compilation of her work in *The Marianne Moore Reader* (1960): "Man's chief difference from the brutes lies in the exuberant excess of his subjective propensities. Prune his extravagance, sober him, and you undo him." Skyscraper Manhattan embodied James's "exuberant excess of . . . subjective propensities," the modern American psyche boldly, irrepressibly proliferating in symbols, symptoms, and self-advertisements, a pandemonium of the pleasure principle, at once the city that Ford Madox Ford celebrated in 1926 as "the city of the good time" and the apotheosis of the "world elsewhere" envisaged by classic American literature and improvised, in a different guise, by the new jazz music "riding free on the air," in J. A. Rogers's words; it was materialist pragmatism converted into what Spiritualists and psychic researchers would have called its "astral body" as sheer poetry.

AMERICAN MASQUERADE

The Manhattan skyline, "star" architecture in the full theatrical sense of the word, suggested not just the immensity and aspiration of James's "subliminal self" and its "will to believe" but the diverse drama of his "will to personate." Fittingly, Forty-second Street, memorialized in song by Al Dubin and Harry Warren in 1933 as the heart of New York's theater district, boasted more

than its share of skyscrapers. The Chanin Building at 122 East Forty-second Street was designed by Sloan and Robertson in 1929 to stand high and gorgeous opposite the site of what was to be the Chrysler Building; with its terra-cotta-clad tower lit by floodlights at night, its promoters advertised it as the "mise-en-scène of the romantic drama of American business." The Chrysler Building's lobby featured doorways designed to look like draperies parted before a deep embrasure; "Curtain's up," as they said nightly at theaters on West Forty-second Street. William Van Alen, its architect, was dubbed "the Ziegfeld of his profession."

Hugh Ferriss summed up the impact of Hood's controversial Radiator Building in *The Metropolis of Tomorrow*: "It stops people daily in their tracks; they exclaim how much they like or dislike its emphatic form and radical color scheme." Agreeing with Louis Sullivan that "form follows function," that, in a building, "utility" comes before conventional notions of beauty, Ferriss nonetheless added a characteristically Manhattan proviso: "Effect follows form." Ferriss had participated in amateur theatricals at the Theatre Guild in his early days in the Village with his wife, Dorothy Lapham, an illustrator and editor at *Vogue*, and he knew that conventional beauty might be forsworn but drama was a necessity.

On one occasion in 1931, a group of skyscraper architects came to a costume ball at the Astor Hotel dressed as their buildings. Van Alen wore a cardboard facsimile of the Chrysler Building façade; a cut-out effigy of its tower was his party hat. Duke Ellington believed that New Yorkers were by definition "performers," and so were their newest buildings. There's a wonderful story about a very tall Texas college student named Jack Earle who liked to visit the touring circuses and their sideshows in the 1920s; at seven foot seven he welcomed the companionship of other freaks and monstrosities. On one such occasion, Clyde Ingalls, a Ringling Brothers entrepreneur, sized him up and asked: "How would you like to be a giant?" Earle was already gigantic, but Ingalls was offering him something different and better: the chance to turn a physiological attribute, or disability, into a persona, a role, and a profit. (Earle accepted the offer.) So, too, with Manhattan's new buildings. They weren't just gigantic; in an immense act of impersonation and appropriation, they played at being "giants," giants from a range of cultures as diverse as those represented in the Ringling Brothers' sideshows.

When I argued that the skyscraper drew on the repudiated older matriarchal culture as sustenance rather than idea or ideology, I meant that the moderns could use matriarchal forms and impulses in order to express and champion a worldview, a set of cultural values, that was antithetical to those held by the Titaness at her most repressive. James's thinking had lent itself to matriarchal gifts and needs while it criticized matriarchal claims, and similarly,

447

Houdini used what seemed magical powers to disprove their existence; this paradoxical utilization of old energy with new for the modern task was the era's supreme act of appropriation. Nowhere was the urban moderns' espousal of America's cultural pluralism (so distasteful to the Titaness) clearer than in their most characteristic architecture, suffused though it might be with echoes of the older matriarchal ethos.

If the skyscraper represented, as some said, Babel, the implications weren't all bad. Babel was a cacophony of different languages; so were the skyscrapers. As New York's theaters became important for the world's dramas—with pioneering productions of Ibsen, Shaw, Synge, and Strindberg, as well as of plays and musical revues by a host of American talents, many of them of immigrant or Negro stock—its new architecture made itself the host for motifs and styles from widely diverse cultures, present and past. Zigzag designs from American Indian culture and angular geometric patterns from ancient Babylon and Assyria and Africa contradicted and supplemented Gothic towers, gargoyles, and Art Deco ornamentation. Writing about *The Skyscraper* in 1981, Paul Goldberger calls it "the art of grafting . . . historical forms onto modern frames."

Gilbert Seldes had explicated this grafting tactic three decades earlier in *The Great Audience* (1950). Protesting the standardization imposed by the new mass media, he made an eloquent and sustained plea for heterogeneity and diversity. Drawing explicitly on James, particularly *The Varieties of Religious Experience* and *A Pluralistic Universe*, he argued that America, with its vast geographical spread, was in its very nature a land of "pluralities"; unlike the more homogeneous and cramped Europeans, Americans "lead plural lives in a diversity of climates." The nation was founded on the revolutionary principle that anyone can become an American by a simple act of will; in Seldes's words, "He not only can make something of himself, he can make himself over." Seldes was eliding the unequal difficulties of Americanization faced by different racial and ethnic groups to focus on what he took to be the essential dynamic of American citizenship. There are no Americans, he believed, in the sense that there are British, Italian, French, German, or African people. Whoever chooses to be an American is choosing, whether he knows it or not, to belong to a country that is part German, part Italian, part English, part African, and so on *ad infinitum*, and thus anyone who elects to be an American automatically partakes of all these nationalities and races himself.

A male colleague of Ruth St. Denis, the histrionic modern dance pioneer, once remarked: "She acted all the time; she couldn't get away from it." Yet he found her "a genuinely natural person . . . at all times," because "her natural self was an actor." As Seldes understood him, the "natural self" of

the American was an actor, too. Citizenship in America was an almost infinitely multiple act of impersonation; the essence of the stable American identity was to have no stable identity at all. The "plurality of lives" we "crave" but cannot, Freud had insisted in "Thoughts for the Times on War and Death," have, was, to Seldes's mind as to James's, the American reality. "Variety" is Seldes's central word and concept here, and he drew it in part, he tells us, from James, and in part, I believe, though he doesn't say so, from the New York theatrical sheet he was fond of quoting, *Variety*, begun by the journalist Sime Silverman in 1905. Specializing in factual reportage and an abbreviated show-biz idiom, the trade paper took its name from the famous theatrical tradition; it was the word that best conveyed the racial and immigrant plurality of the American polis and the diverse, mixed entertainment that Seldes considered its most characteristic and valuable self-expression. It's an ideal the new architecture honored, too; the Manhattan skyscraper was a creature much like Seldes's American citizen, a loose coalition of multiple selves whose purpose was "to offer attractively more kinds of experience" by extending, almost indefinitely, "the range of choice."

Interest in variety was not a modern monopoly. Late-Victorian culture had been fascinated by foreign and imported Orientalism; Ruth St. Denis's most celebrated early dances, *Rahda* (1906) and *Egypta* (1910), paid homage to the mysterious East. The eclectic Manhattan skyscraper on one level simply continued this fascination; among the events and influences that the art historian Eva Weber cites as important for the Art Deco style, seen at a peak in the Chrysler Building, are the opening of King Tutankhamen's tomb in 1922 and the flood of interest in Egyptian, Assyrian, and Minoan art it released. But unlike the Oriental motifs in St. Denis's dances, many of the foreign elements represented by the modern skyscraper were from America's own buried cultures. Just as Martha Graham, St. Denis's successor, turned to American Indian and black dance for many elements in her choreography and pioneered in having people of color in her dance troupe, the skyscrapers of the 1920s drew ideas and sustenance from local as well as foreign sources. Native American art, increasingly on view in the city's art galleries; *Primitive Art* (1928), the pioneering study by Zora Neale Hurston's mentor Franz Boas; Negro music; and the anthropological, historical, and literary researches into African and African-American culture undertaken by members of the Harlem Renaissance and their allies—all played a part in the skyscraper aesthetic.

The "sky-scaling iron construction" that James saw near Buffalo satisfied his need for "something primordial and savage"; later observers and practitioners of the new urban architecture had similar thoughts. One design submitted for the Chicago Tribune Building of 1923—Raymond Hood won

the contest—was by the German architect Heinrich Mossdorf; it culminated in the massive head of an Indian wielding a tomahawk. Mossdorf was half-spoofing, but he, too, like D. H. Lawrence in *Studies in Classic American Literature*, published the same year, was reminding America of its primitive peoples, its role as King Kong in the modern world. Hood's Radiator Building, with its Gothic-primitive fancifulness and innovative black-brick and gold-leaf coloration made one viewer think of "jazz," of "tom-toms and gleaming spear points," of the "Ku Klux [Klan]" and prizefighter "Jack Johnson's Golden Smile." (The 1920s mindset was not, as I've repeatedly remarked, a civil-rights mentality—note how casually this reviewer elides discordant elements.)

Texas-born Jack Johnson, more than six feet tall and one of the greatest of all heavyweights, had held the world championship from 1908 to 1915, the first Negro ever to do so, to the horror of most white fans and the delight of all black ones. Johnson combined a terrific wallop with an extraordinary lightness and speed of motion; he could redirect his left punch in what seemed mid-air. A fascinated and unhappy Jack London reported that watching him defeat the white heavyweight champion Tommy Burns in 1908 was like watching "a grown man cuffing a naughty child." Heavy shells in the Great War were nicknamed "Jack Johnsons."

Johnson was a complex, good-natured, and intelligent man fond of reading Herbert Spencer and Gibbon, but confronted with a solid wall of prejudice, he reacted with brutal in-the-ring sniping, drunken escapades, and a series of white mistresses and wives. Still, he had a partial refuge. "Thank God for the theatre," Essie Robeson remarked after a particularly ugly racial incident; Johnson could play a decent bass and sing ragtime, and as soon as he won the championship, he set off on a three-month vaudeville tour. After he'd lost the title in 1915, he continued his vaudeville career, appearing on the same bill with Ethel Waters in Philadelphia in November 1921 on a tour she did with Fletcher Henderson. Johnson also organized his own jazz orchestra and fronted the Harlem establishment that became, in other hands, the Cotton Club; he staged exhibition fights and starred in two all-black-cast boxing films, *As the World Turns* and *For His Mother's Sake*.

By the time the Radiator Building was finished, Johnson had become something of a national hero; America was more eager to welcome its black talent than it had been a decade earlier. His story hit Broadway in 1926 as *Black Boy*, a play written by Jim Tully and Frank Dazey and produced by Horace Liveright, with Paul Robeson in the lead. Everyone knew about "Jack Johnson's golden smile," golden because he had been wont to flash it at hostile white crowds just as he prepared to finish off some forlorn "white hope" in the ring and collect another huge purse, golden because even his

enemies conceded the magnetism of that magnificent cheek-to-cheek grin, one of those "rare smiles" Fitzgerald described in *The Great Gatsby* that seem to concentrate and project the amplitude and excitement of a world, not a person. Like the Radiator Building, Johnson was a hieroglyphic in black and gold, part of what the critic Peter Brooks has called (in a different context) the "aesthetic of astonishment."

The new serial comic strips of the day were part of that aesthetic, too; Popeye and Krazy Kat and others were transforming the already combustible American language into a series of linguistic explosions. John Held, Jr., the most famous illustrator of the Jazz Age, did a cover for the February 3, 1927, issue of *Life* called "Comic Strip Number," full of his trademark angular forms here uttering strange ballooned words: "Wauf!" "Pow!" "Wham!" "Socko!" "Glug!" "Zowie!" and "Bam!" (after the "Bambino," as Italian-American fans called Babe Ruth). Like the language of the comic strips, like Babe Ruth's swing and Johnson's punch, the Radiator Building was an explosive force, part of the "frightfully expensive scenery built to knock the beholder's eye out," in the words of *The New York Times* on November 3, 1935, summing up two decades of architectural history.

In *Beer Can by the Highway* (1961), John Kouwenhoven, trying to explain jazz, used an urban metaphor: the city's grid is comparable to jazz's basic 4/4 or 2/4 beat, and the skyscrapers are its solo improvisations. New York in the 1920s became a mecca for jazz musicians: Louis Armstrong, Sidney Bechet, Jelly Roll Morton, and many others left Chicago for short or long periods of time to gig with New York bands and artists. What better acoustic chamber could they have had than a city built *of* solid stone and *on* solid stone? (Chicago rests on mud, not stone; its skyscrapers were made possible by caissons invented in the bridge-building orgy of the 1870s and 1880s.) Those who built skyscrapers had much in common with their jazz musician peers; the Jamesian ethos of improvisational pluralism serves to explicate both the new music and the new architecture. Sounding much like Bix Beiderbecke, Raymond Hood pledged not "to build the same building twice," and he never did. As an admiring interviewer noted in a *New Yorker* profile of him on April 11, 1931, the only quality common to his buildings was their "dramatic" look.

After the quasi-Gothic Radiator Building of 1924 came Hood's Daily News Building of 1929 at 150 East Forty-second Street. Despite its spectacular lobby, it had a blunt top (no Gothic tower here) and a flat façade broken by radical setbacks and horizontal stripes. When Royal Cortissoz, the *Herald Tribune*'s art critic, said that the building wasn't architecture, Hood, who seemed to talk in sharp explosive bursts, replied: "So much the better!" The Daily News Building, at least on the outside, prefigured the starker look of

his next big venture, the McGraw-Hill Building at 330 West Forty-second Street, built in 1931. Although its startling blue-green color was a tribute to its Art Deco antecedents, many architectural historians consider it the start of the International style in America, a style antithetical to the Gothic eclecticism that had characterized Hood's early career. His designs for Rockefeller Center (begun in 1929 and finished in 1940), the first skyscraper group in New York's—or indeed any city's—history, were another new idea, one whose widespread application the Depression postponed more or less indefinitely.

Hood may have encountered James's writings in his college days at Brown University at the turn of the century, but in any case he was a kindred spirit. Born in Rhode Island in 1881 to well-to-do Baptist parents of old New England stock, he studied at the Ecole des Beaux Arts in Paris in the 1900s and later moved to Greenwich Village. There the bon vivant Hood patronized Placido Mori's restaurant, where Mori trustingly fed him on credit—"He must be a genius," Mori decided; "he eats so much"—and occupied himself by decorating the waiting room to his unvisited office with gilt paper. Lack of funds stopped the project, but his friends called the anteroom "Hood's Gold Room"; it was a partial anticipation, it seems, of the Radiator Building's color scheme. Hood was over forty when he got the all-important commission for the Chicago Tribune Building in 1923, and during his long and obscure apprenticeship, his only "method," in his words, was "to do everything that comes up as thoroughly and as hard as possible —not to miss an opportunity—to work blindly but hard," to "work without thinking"; New York induced "a sort of coffee-existence—you live on your nerves." Koolhaas sums up the Hood ethos as "Manhattan: no time for consciousness."

Many in his day were talking in dire terms about the growing congestion of urban life, a state of affairs worsened by skyscrapers, but Hood declared: "Congestion is good." In his designs for Rockefeller Center, with its fountains, skating rink, terraces, and restaurants, its different heights and shapes and widths, he created large-scale conviviality, an outdoor cabaret alive with intimate impersonality. Frederick Lewis Allen described it as a "shipboard scene full of animation and sunlight and the sense of holiday," a place, like the Harlem jazz clubs Hood sometimes visited on a spree, where congestion was turned into fun. Hood found the activity of crowds suggested the improvisatory collaboration of neighbors. He agreed with his colleague Harvey Wiley Corbett that "people swarm to the city *because* they like congestion," and he saw New York as "the first place in the world where a man can work within a ten minute walk of a quarter of a million people . . . Think how

it expands the field from which we can choose our friends, our co-workers and contacts, how easy it is to develop a constant interchange of thought!" Congestion was just instant gratification as a way of life.

Hood built differently each time, he said, because he built according to the needs of the people who used the building, not according to the tastes of those who looked at it. As the ebullient young Hemingway had remarked, "Fuck literature!" Hood insisted, "This beauty stuff is all bunk!" Speaking of literature, Hood was not a reader; he told the New Yorker interviewer that in four years "nobody will read." Like Vachel Lindsay's motion pictures, like Hurston's "Negro Expression," like Duke Ellington expressing in his music a picture he saw in his mind's eye, Hood, too, was a creature of body literacy, of hieroglyphics. His own fancy played a part in his creations, too. If he had been "under the spell of . . . Chinese pagodas" when he built the Radiator Building, he said, it would have looked like a Chinese pagoda. Why not? "A man should have as many horizontal or vertical lines as [he] wants." As The New Yorker put it, "Hood builds what Hood feels"; it's the jazz ethos. Indeed, in their work methods, his large office staff resembled a jazz band more than a bureaucracy; work was done in a ferment of creative chaos. Hood hired an efficiency expert, but he promptly fired him when he caught the man checking up (as it was presumably his job to do) on the draftsmen's time cards.

The New Yorker saluted Hood as the "brilliant bad boy" of American architecture, and he welcomed the absence of tradition manifest in the skyscrapers; traditions, in his opinion, were merely "hurdles which must be jumped." He saw New York—its people and buildings crowded every which way on an irregular non-gridlike grid, constantly shoved into instant close-ups and surprising long-shot vistas—as an unending exercise in shifting perspectives as stimulation. To his mind, it compelled innovation, and he counted himself lucky to face "the problems of a new and modern city, the problems which architects and city planners have dreamed [of] for years. Can there, then, be a better time and place for an architect?" Once again the absence of tradition allowed the artist to be "free as the breeze," "free as the devil," free to find a "freedom of the spirit" and embody it in stone and glass and steel. Pressed to define his style, he responded: "I am as much in the air about style as I am about everything else." Hood wore his hair cropped; it looked, in the words of The New Yorker, like "a shock of amazing gray-black bristles sticking straight up in the air." He built and flew endless kites and he loved to set off firecrackers and watch their aerial pyrotechnics. "In the air," in the American air, was just the place Raymond Hood wanted to be.

THE RISING GENERATION

There were people going farther and faster into the sky's "inmost day" (a phrase from Crane's "Voyages") than the skyscraper architects: the new breed of stuntsters called pilots. In 1927, Charles Lindbergh made the first successful nonstop transatlantic solo flight. The twenty-five-year-old Lindbergh departed from New York's Roosevelt Field at 7:52 a.m. on May 20 and landed at 10:22 p.m. on May 21 at Paris's Le Bourget airport; he had covered roughly three thousand miles in thirty-three and a half hours, averaging about 100 miles per hour. On arriving in France, his first words to the assembled crowd, excited to frenzy long before his appearance, were strikingly modest: "I am Charles A. Lindbergh," he said, and offered the French officials his letter of identification. But all the world knew who Lindbergh was; everyone within reach of a radio or a newspaper had been following his flight.

Three pairs of pilots, six in all, had tried to cross the Atlantic in 1926. All lost their lives, but experts agreed that the team approach was the safer one. Yet Lindbergh chose to go it alone, without a partner, without even a radio or life raft. He had no interest in daredevil acts; he flew without copilot, radio, or raft because he knew that the lighter his plane, the safer he would be and the greater his chance of success. Lindbergh, the "Galahad of the Air," had disarmed before the air, and his calm, his self-confidence, his aura of reserves yet to be tapped—arriving at Le Bourget, he said he was "tired but not exhausted"—seemed bestowed by the air itself as reward.

Like Fitzgerald, an ardent fan, Lindbergh hailed from Minnesota, and Fitzgerald fancied affinities between them. He hoped Lindbergh's flight might offer a "way out" of the growing desperation and violence of the Jazz Age: "Maybe our restless blood could find frontiers in the illimitable air." In Paris, Janet Flanner reported for *The New Yorker* the response of Anne, Comtesse de Noailles: "More generous than Christopher Columbus, he has delivered to us the continent of the sky." Harry Crosby thought Lindy might be "the new Christ"; even Hemingway called him an "angel." Hart Crane admitted in a letter home to being "a little jealous of Lindy!" and began to think of *The Bridge* as a parallel aerial feat, a modern "myth" of "Time and Space." He subsequently researched and wrote a section for *The Bridge* on pilots and the "alcohol of space" entitled "Cape Hatteras."

No other parade of this parade-crazy era, including the huge parades celebrating the close of the Great War and the return of its troops, attracted as much attention as the one in honor of Lindbergh's victorious return to the States. In New York on June 13, 1927, a crowd of New Yorkers and visitors estimated at 4.5 million turned out; 1,800 tons of confetti and ticker

tape stormed down on his entourage. *The New York Times* devoted fifteen pages to the occasion, the *Herald Tribune* nine, the *American* ten, the *World* eight, the *Mirror* twenty-three, and the *Daily News* sixteen. George M. Cohan wrote a popular song about "Lindy"; a new dance was christened the "Lindy Hop," and a Pennsylvania railroad car sported his name. Lindbergh's flight provided free advertising for the new aeronautic interests (after his flight, he worked with Trans World Airlines), but like Madison Avenue advertising, like the skyscrapers, it finally publicized excitation itself. Excitation, one must add, distasteful to the proper and straitlaced young man who kicked it off.

Lindbergh quickly came to hate the flood of publicity his flight unleashed, but before he could duck from view, photographers had snapped him repeatedly in what became his trademark look: young ("My heart," Damon Runyon wrote, "how young he seemed!"), clean-cut, blond, Nordic—Hitler was an early admirer of Lindbergh's; unfortunately, the attraction proved mutual—hatless, tousled. One year later, Amelia Earhart became the first woman to cross the Atlantic by air—as a passenger, not as a pilot—but in 1932 she flew her own craft over the Atlantic. Fair-haired and blue-eyed, she was promoted as "Lady Lindbergh," and she emulated Lindy's hatless, windblown look. Harry Crosby threw away his hats, still *de rigueur* for men as for women, and urged his contemporaries to "stand bare-headed on the top of the hill with the thunderbolt of the sun in our heads." Most Americans went on wearing hats, but hats did not stop their hopes from rising higher than planes could climb.

Men and women had been rising into the air in lighter-than-air balloons filled first with hot air, later with hydrogen gas, balloons that rose by the law of gravity, since the late eighteenth century, but sustained flight in heavier-than-air craft, flight that defied or repealed gravity's law as the skyscrapers did, had been first successfully ventured by the Wright Brothers, Orville and Wilbur, in Kitty Hawk, North Carolina, on December 17, 1903. The Wrights' plane traveled 120 feet in twelve seconds before it came down; those seconds changed history. Their achievement went almost unpublicized, however, for five years. There had been few eyewitnesses at Kitty Hawk, and as Orville Wright later wrote, "Scarcely anyone [could] believe in it until he actually saw it with his own eyes." Recognition did not come for another five or six years, after further demonstrations by the Wrights in America and Europe.

Leading the pack as usual when it came to publicizing the spankingly modern, the *World* assigned a full-time reporter to the aerial beat as early as 1910. But it was, of course, the Great War, the first war in history to be fought in the air as well as on land and sea, that forced the fledgling American

aviation industry into overnight maturity. The industry had not existed in 1909, but by 1914 its profits totaled $1 million; by 1919 they stood at $14 million. Government airmail service was inaugurated in 1918, and the first scheduled passenger flight took place in 1914. The first nonstop cross-country flight came in 1923; it took twenty-seven hours. In the last six months of 1928 alone, $1 billion worth of aviation securities were traded on the New York Stock Exchange; new aviation facilities in the United States included 61 passenger lines, 47 mail lines, and 32 express lines serving trade areas that contained 90 million people. Technological progress was so fast that planes built from 1927 through the mid-1930s were outmoded, obsolete, within six months. Extensive advertising began only in the mid-1920s, but by April 1928, the aviation interests were boasting in print and on the air of sponsoring "well over a million miles of useful commercial flying"; the "astounding miracle of man's conquest of the sky [has] become an accepted fact of everyday life." A miracle is the ultimate in magic, and Hollywood, the nation's chief manufacturer of magic, began filming and fictionalizing America's colonization of the sky. The movies bore exuberantly airminded titles like *Air Circus*, *Cloud Riders*, *Flight*, *Sky Skidder*, *Won on the Clouds*, *Phantom Flyer*, and *Wings*.

Like the skyscraper craze, the infatuation with "airmindedness" was in good part an American phenomenon. Although European intellectuals and artists, most notably the Futurists of Italy led by Filippo Tommaso Marinetti, were wildly excited by aviation, and the response to Lindbergh's flight was as intense in Paris as it was in New York, the unalloyed enthusiasm of Americans for aviation long outlasted that of their European and English peers. As Joseph J. Corn, the historian of the aviation cult, points out in *The Winged Gospel* (1983), numerous anti-aviation articles with titles like "The Aerial Peril" and "The Airship Menace" were appearing in the English press even before the war, and the war, in which planes damaged and wrecked civilian areas in unprecedented aerial warfare, left most of England and Europe with what we today would consider a realistic assessment of aviation's potentially lethal role in world affairs; this had no real echo in America until the 1930s and the rise of Fascism's openly worldwide ambitions. America's size and isolation, its exemption from the Great War, its ongoing freedom from fears of invasion and attack, and its long tradition of tying utopian hopes to technological advancement kept its enthusiasm for aviation white-hot. Only in America could you get mass-produced piggy banks, purses, fans, clocks, lamps, and (a rarer item) coffins shaped like airplanes.

Predictably, city dwellers used airplanes more extensively than rural citizens did; by 1919, 48 percent of airline business was concentrated in seven

urban areas, with New York in the lead. The Great War's ace pilots found the metropolis highly receptive to their skills and stunts. Jack Savage, a reckless and charming Englishman, aviator, and veteran, attracted Madison Avenue's eye when he skywrote HELLO USA above the city; it was he who piloted the plane used in Edward Bernays's Lucky Strike skywriting campaign of 1928. Hubert Fauntleroy Julian, the West Indies–born black pilot who emigrated to Harlem in 1921 and was dubbed the "Black Eagle" by the New York *Telegram*, didn't fly in the Great War—no Negroes were allowed in the air corps—but he was the first Negro to obtain a pilot's license, and he, too, contributed to New Yorkers' entertainment.

As a Negro, Julian never got the backing the all-Anglo-Saxon Lindbergh effortlessly attracted. Indeed, he experienced obstacles and reverses that would have stopped a lesser spirit. There was the plane meddled with, or "crooked," in his word, by rival white French pilots in Ethiopia, where he served briefly in 1930 as Haile Selassie's personal pilot. His planned journey to Africa, set to begin in the summer of 1924 on (of course) July 4, was delayed because Clarence Chamberlain, his white patron, wouldn't let him take off until the money due him had been raised from the gathered crowd. The plane Julian planned to use was cheap and ramshackle, all he could afford, and it crashed in Flushing Bay five minutes after takeoff. Fights between Julian's West Indian friends and rival American Negroes also on occasion disrupted his plans; a gang of American blacks trashed a plane he had put on exhibition in a vacant Harlem lot to convince the "doubting Thomases" and attract donations for his next flight.

White journalists loved Julian for the colorful copy he provided, but they invariably cast even his most heroic exploits in terms of updated minstrel comedy, presenting him as a boastful and too stylish Zip Coon figure. Dignified reminders from Julian, "No monkey business with this story. It's very serious," were of no avail. Like many West Indian and American blacks, Julian used two forms of English; he called it being "ambidextrous." In addition to various European and African tongues, he spoke both Standard English and a mixture of West Indies and Black English; journalists liked to parody what they saw as his linguistic confusion. But Julian, an ebullient man and a positive thinker, refused to be discouraged. On his first flight as a young pilot training in Canada, he had "discovered the air, a new medium unlike any other," he tells us in his autobiography, *The Black Eagle* (1964): "This, I felt, was my real element," and he never left it for long. When last seen, he was a world-renowned arms dealer who did most of his work in Africa and Cuba. He'd become a freedom fighter of sorts, one with his eye on the profits as well as the ideals at stake. (Julian's final days are uncharted,

and perhaps not yet over; he dropped out of sight sometime in the 1970s, but we have no hard evidence of his death. The customary biographical entry on him today reads "Julian, Hubert Fauntleroy [1897–?]."

Julian was early dubbed the "Lindbergh of His Race," and despite his lack of financial backing, expert firsthand witnesses agreed that he was Lindbergh's equal as a pilot; he was certainly his superior in terms of political intelligence and sympathies. Unlike the "Lone Eagle" (or the "Lone Ostrich," as a disillusioned reporter later redubbed Lindbergh) the "Black Eagle" detested Fascism of all kinds. In the late 1930s, he attempted to assassinate Mussolini, or so he said, and on another occasion, he challenged Hitler's minister Hermann Göring to a duel in the air; he resented the attack on blacks as "apes" in Hitler's *Mein Kampf*. (Göring did not accept the challenge.) Julian tried in vain to convince F.D.R. that Pan-Africanism and Third World development might one day end America's world supremacy if its racism continued unchecked. Unlike the suspiciously modest Lindbergh, Julian had few peers as a showman, even in the Jazz Age; one of his mottos was "Make headlines and always leave calling cards."

Julian once told the press that a doctor had pronounced him "phenomenally perfect"; tall, athletic, light-skinned, with aristocratic features, and impeccably dressed on all occasions, he was a glamorous and charismatic man, a sheik-type, black America's more sophisticated version of Rudolph Valentino. (Unfortunately, though he'd help produce and publicize a film by black director Oscar Micheaux, *The Notorious Elinor Lee*, in 1940, he never made a movie himself.) A follower of Marcus Garvey in the 1920s and pilot to Father Divine, the Harlem guru and conman, in the 1930s, Julian neither smoked nor drank, but he did believe that "tak[ing] a maiden a day" was good for a man's health. Essie, his boyhood sweetheart and devoted wife, didn't seem to mind; it was she who thought up Julian's kisses-for-sale fund-raising act in the mid-1920s. The kisses went for a steep $5, but his customers got, he tells us, their money's worth. He lost Haile Selassie's favor temporarily when he crashed the Emperor's costly plane (this was the plane the French aviators had "crooked") on a surprise exhibition flight in Ethiopia. When reporters asked him on his return to New York why he had taken the plane up, he explained: "I wanted to give the Emperor a thrill. After all, even an emperor needs a thrill, now and then."

Harlem got its share of thrills, too. In April 1923, there were signs everywhere reading: "WATCH THE CLOUDS—JULIAN IS ARRIVING FROM THE SKY." He parachuted on this occasion from a plane down onto Seventh Avenue and 140th Street dressed in a skin-tight scarlet outfit and bearing a sign for Hoenig Optical (the Harlem eyeglasses concern that funded the leap). Six

months later, he descended on Harlem once more, this time wearing a devil's costume, complete with horns and tail, and playing a saxophone. He was trying, he told reporters, "to make the world a more fundamental place to live." Again, one can't trust the accuracy of the reportage where Julian is concerned, but the sentiment of "a more fundamental place" sounds right. Julian lectured at Negro colleges, telling students to learn from his example that "you can do anything you please," and barnstormed across American with the Negro aerial performers Marie Dickinson and William Powell. Fittingly, Tom Moore, his New York mentor and agent, was a musician; Julian loved Harlem's jazz clubs and revues, and he lifted members of the various *Blackbirds* casts, literally speaking, to new heights.

Julian never camouflaged his hunger for publicity or his *amour propre*— telling the New York press what Haile Selassie looked like, he said, "The Emperor elect is a fine man with a beard, who looks something like I do" —but there was a larger purpose to his self-display. He named the plane he tried to fly to Africa *Abyssinia*, and the legend on its side read: DEDICATED TO THE ADVANCEMENT OF THE NEGRO RACE. All his exploits, he tells us, had one "basic cause . . . and that is that I am a Negro." Facing the racism of 1920s America, he had determined to show that "Negroes really are as other men are," capable of the most difficult and daring feats modern man can attempt. As (in the *Evening Graphic*'s words) "this only black bird ever to cleave the azure on man-made wings," Julian represented "white man's magic," in the words of his biographer, John Peer Nugent, "in a black man's hands."

Before air traffic was regulated, Julian liked to swoop his plane daringly close to Harlem's buildings, as if making a raid or preparing to land; hopes of landing amid the city's crowded streets were not deemed fantastic. Operation of the new heavier-than-air planes of the 1910s and 1920s, with their built-in need of long takeoff runways, clearly required non-urban spaces, but Americans of the 1920s didn't want to think so; they expected and even planned inner-city airports in New York and elsewhere whose foundations would rest on a series of skyscrapers. The ceiling murals in the Chrysler Building's lobby included a picture of airplanes; a projected (never built) "150-story Super-Skyscraper," to go up on Broadway and Church Street, expected to use its rooftop acreage as a landing field. How could an Aerial Age, airminded to an extreme, not expect skyscrapers and airplanes to make sense of each other? Planes were seen as the answer to the urban congestion Hood loved and others protested; the limitless sky would accommodate and alleviate the traffic that was overtaxing the earth. It was some compensation for this lost dream of inner-city airports when a swank Art Deco–fronted

Airlines Terminal, not an airport but a PR symbol and a clearinghouse for various commercial airlines and their passengers, opened at 42 Park Avenue opposite Grand Central Station in 1938.

Some speculated that the aviation age might breed an "aerial person," a kind of superhuman American creature who would live in the newly habitable altitudes. Couples got married in airplanes, and a few expectant mothers, hoping to elevate if not improve the species, jumped into planes (piloted, of course, by others) when their labor pains began and delivered in space members of what *The New York Times* saluted as "the Rising Generation." Young Jack Chapman was a member of this generation; though not born in the air, he took to it early as a pilot. By the age of eleven, he had become a national hero, but he found himself mandatorily if prematurely retired in 1927 by a law that specified people must be sixteen or older to have a flying license. Many people believed that Americans would soon own their own planes and operate them as easily as they did their cars. Henry Ford, who had taken Emerson's injunction "Hitch your wagon to a star" as his motto, was doing a steady business in a large "trimotor" and a small "flying flyver" by the late 1920s. On August 7, 1926, a New York *Sun* columnist was inspired to print this ditty:

> I dreamed I was an angel
> And with the angels soared,
> But I was simply touring
> The heavens in a Ford.

In his autobiography, Julian tells of one early flight in which his plane failed him and he was forced to land by parachute in a farmyard. An irate farmer soon appeared, shotgun in hand, to get this "thief" who had set his chickens "squawking away in a panic." " 'Hold on, hold on,' Julian shouted as he disentangled himself from the parachute; " 'it's a messenger from heaven come to call on you.' " Amazed, if only by the sight of a black angel, the farmer put up his gun and Julian made his escape. In his memoir, *We* (1927), Lindbergh records a similar incident that occurred in his early days as a stunt pilot at local fairs and exhibitions. His plane had grounded near Maben, Mississippi, and to pay for the new propeller he'd been obliged to purchase, he offered to take six citizens of Maben up in his plane. One old Negro woman came up to ask him: "Boss! How much you all charge toah take me up to Hebben and leave me dah?" Like Bernhardt asking Houdini to restore her leg, like Fitzgerald's Mr. In and Mr. Out demanding to go to heaven, this woman had simply surveyed the scene and assumed the best.

As Julian was reported to have said when serving as master of ceremonies at the Harlem premiere of *The Notorious Elinor Lee*, "On with the show. Let joy be unconfirmed." For a brief, wonderful moment, the realities of the aerial age seemed to prove that, in Stevens's words in *The Necessary Angel* (1951), "absolute fact includes everything that imagination concludes."

DESCENT: "I SHALL BE MORE
BLESSED THAN DAMNED"

The Depression conclusively ended Manhattan's building spree. In 1932, the journalist Elmer Davis described the "newest New York" as a "sixty-story city unoccupied above the twentieth floor." Some nicknamed the Empire State Building the "Empty State Building." Raymond Hood died unexpectedly, of rheumatoid arthritis, in 1934. Although Hood was only in his early fifties and at the peak of his talent, Walter Kilham, Jr., his junior colleague and biographer, felt his death was not "tragic," since the Depression had already "closed the door" on the kind of buildings he delighted to create. He had been spared the loss of prestige and practice that beset his most brilliant peers. William Van Alen's career ended in eclipse, as did Hugh Ferriss's; in 1935, Ferriss repudiated the skyscrapers he had loved as examples of "individualism" run amok, of "waste" and "exploitation." Skyscrapers were not of paramount interest to architects again until after the Second World War. Buildings were adopting a lower profile.

Heights were now seen as places from which people could fall; whatever the benefits of aerial life, flying was dangerous business. Herbert Julian, whose ability to find his destination in all kinds of weather awed his passengers, explained his secret: "Clairvoyance." He needed it. Throughout the 1920s, planes had only the most primitive of equipment to ascertain and cope with shifting weather and terrain. Legend has it that Lindbergh, as he reached the end of his record-breaking transatlantic flight, lowered his plane to shout to a fishing boat: "Which way is Ireland?" Back in October 1911, *Scientific American* had claimed that the crowds who flocked to see pilots do their stunts at fairs and exhibitions were motivated by "the savage desire to look upon mangled bodies and hear the sob of expiring life." While aviation

enthusiasm continued unchecked over the next few decades, the number of bodies mounted.

In 1925, after six years of U.S. postal air service, only ten of its forty original pilots were still alive, and it was known as a "suicide club." Pilots had died trying to cross the Atlantic before Lindbergh accomplished the feat; seven more went down the week after his flight and ten more in the week after that. In Ottawa in late June 1927, one of the twelve U.S. Army planes escorting Lindbergh crashed; the pilot was killed instantly. One insider in the late 1920s could think of only one pilot who did not drink heavily; he meant the teetotaling Lindbergh, though Julian was also an abstainer. Amelia Earhart was not a drinker either, but the alcoholism of two of her co-pilots, her first, Bill Stultz, and her last, Fred Noonan, caused her serious worry on several of her record-breaking flights and may even be a part of the still-unknown circumstances of her disappearance over the Pacific in 1937. History had its own tragedy in store for Lindbergh. In 1932 he lost his son to a kidnapper and what little privacy he had to the most flamboyant criminal trial of the era; he turned his back on America in 1935 and took his remaining family abroad. Alarmed at the mortality rate attending aviation, Henry Ford terminated aircraft production in 1933.

Fitzgerald saw the Wall Street crash of 1929 as an act of aerial suicide; "as if reluctant to die outmoded in its bed [the decade] leaped to a spectacular death in October 1929." The stocks of the automobile industry, which had provided the mainline financing of the boom, plummeted with the rest—one-third of all automakers went out of business—and took many advertising accounts with them. By mid-November 1929, radio stocks, advertising's biggest, newest outlet, had lost almost three-fourths of their September value. Consumers began to organize and protest their role as "guinea pigs" for advertising and industry. Women's hemlines, which had risen dramatically in the early 1920s and fluctuated nervously throughout the decade somewhere around the knee, dropped conclusively to the lower calf. Breasts and waists reappeared. Recently mandatory "bobs" seemed to grow out overnight; the back of the neck was once again a secret. Young women no longer looked freightless, no longer seemed designed for the possibilities of sudden and violent motion. They aspired to "glamour" (a word that came in big in the early 1930s); they had reacquired mass.

The 1920s had begun with a presidential collapse, and they went out as they came in. Herbert Hoover, elected in 1928, was held responsible for the Depression, as Wilson had been blamed for the disastrous peace treaty of Versailles. The collections of shanties spawned by the Crash were christened "Hoovervilles." Hoover's mother had died when he was a child, and he had much of the oversensitivity of the self-consciously orphaned. A dull, even

deadly dull, speaker, by his own telling, a man "terrorized" by any and all public occasions, Hoover was helpless before the barrage of insults and misapprehension he suffered. A world-renowned engineer and self-made millionaire before he entered politics, he knew that the American people had held an "exaggerated" idea of him as some kind of "superman"; he had been "sacrificed [to] the unreasoning disappointment of a people who expected too much." On taking office, he had promised every American "a standard automobile, a standard telephone, a standard bathtub, a standard electric light, a standard radio, and one and a half hours less average daily labor" (the words show his characteristically emphatic, even defiant monotony of speech), but he delivered nothing. By the time Roosevelt challenged him for the presidency in 1932, Hoover was being scorned as a "timid, fat capon" (by the journalist William Allen White), pelted with rotten eggs (in Elko, Indiana), and urged, in the words of one legendary telegram, to "vote for Roosevelt and make it unanimous."

Prohibition ended in 1933. Al Capone had been jailed, for income-tax evasion, in 1931. In 1935, Damon Runyon attended a gangster get-together; he told a friend afterward that he knew the underlords were losing their grip because they had started to "reminisce." The Depression persisted despite Roosevelt's pragmatic magic, and Fascism, bullied into vast life by Hitler and Mussolini, was on the rise abroad and even at home; another world war, whose dimensions everyone knew would be horrific, was imminent. Trying to understand the ominous nature of the new world scene, F.D.R. turned to Kierkegaard and began to think about the nature of evil. By the early 1930s, the lighthearted Algonquin Round Table was a thing of the past, and some of its former members, led by Dorothy Parker and Robert Sherwood, recent converts to political earnestness, went on record with condemnations of their earlier "smarty-pants" selves and the "disastrous folly" of the Jazz Age. Sherwood became a speechwriter and biographer for F.D.R.'s administration and Parker flirted with Communism. Walter Winchell turned his flamboyant talents to an all-out attack on Hitler and his pogroms. In 1936, Hemingway fought for the Loyalist cause in Spain; long and proudly apolitical, he turned propagandist and wrote a play, The Fifth Column, and worked on a movie, The Spanish Earth, to win support for Franco's opponents. Parker and Langston Hughes also protested the Franco regime; Hughes and Countee Cullen had both voted the Communist ticket in the presidential election of 1932.

Although only some 2,000 blacks joined the newly aggressive American branch of the Communist Party, politics were on everyone's mind uptown as well as down. The Tribune estimated that the Crash had produced five times more unemployment in Harlem than in any other part of the city.

Desperate whites were now offering their services as porters, bellhops, red-caps, and street cleaners, just the menial jobs that had long been black labor's only monopoly. Of the 18 million Americans on relief in 1935, 3 million were Negroes. On Christmas Day, 1934, the Cotton Club gave out 3,000 food baskets. Harlem and other black urban centers began to develop the boycott tactic, directed against white-owned stores in black neighborhoods that refused to hire black workers, a tactic Adam Clayton Powell, Jr., Harlem's first elected congressman, perfected a few years later; he aimed to make his father's church "a mighty weapon, keen-edged and sharp-pointed," in the struggle for black rights. Even Harlem's frivolous *Tatler* magazine was printing a political "platform" in the early 1930s.

John L. Lewis's Congress of Industrial Organizations, expelled from the American Federation of Labor in 1938, proved more hospitable to black membership than its predecessor, and both the NAACP and the Urban League dropped their anti-union stance. Eleanor Roosevelt became the first figure of national importance actively to protest anti-Negro discrimination, and Mary McLeod Bethune, Robert C. Weaver, and William H. Hastie were given modest but symbolically important federal posts. Langston Hughes now denounced as "Bunk!" the notion on which the Harlem Renaissance had been founded, that "art could break down color lines . . . and prevent lynching," and so did Arthur Fauset; even Alain Locke excoriated the "Pollyanna complacency" of the 1920s: "There is no cure . . . in poetry or art . . . for unemployment . . . civic neglect, [and] capitalistic exploitation." Du Bois advocated what he called "voluntary . . . segregation" or open black separatism; he had begun the radicalizing process that led to his repatriation in Ghana in 1961. The writer Dorothy West remarked that the "promise [of the] New Negro . . . is enormously depleted," and Father Divine, whose power in Harlem increased to dictatorial proportions, refused to use the word "Negro" in his pronouncements.

For the first time in recent history, more people were moving from New York to the suburbs than vice versa, and once diehard New Yorkers left the city for longer and longer periods of time. Robert E. Sherwood's country home was to be found no longer in upstate New York but in Surrey, England. Conspicuous visibility had ceased to be the *sine qua non* of American life. A bewildered Babe Ruth was all but eclipsed by Lou Gehrig in the 1933–34 season. In 1934, the Yankees signed Joe DiMaggio, whose line drives and team instinct were antithetical to the Babe's game, and Ruth retired to a life of vociferous misery. "It's hell to grow old," he said. Brett Ashley of *The Sun Also Rises*, with her gaunt look and her man's felt hat pulled down on her head, "Lady Brett," who explored "hell on earth," was passé. The star system that the anarchic 1920s had patented was sharply out of style.

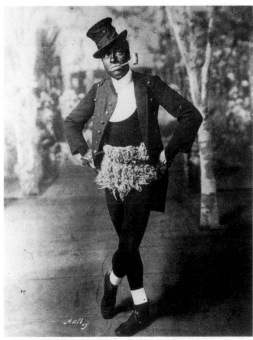

Bert Williams in blackface
(Frank Driggs)

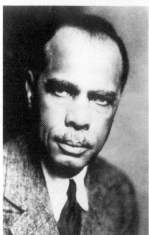

James Weldon Johnson
(National Association for the Advancement of Colored People)

Ethel Waters
(Frank Driggs)

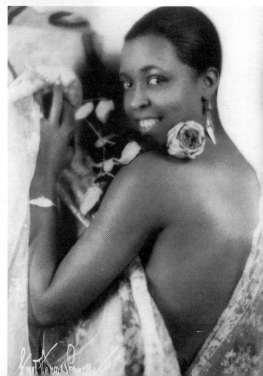

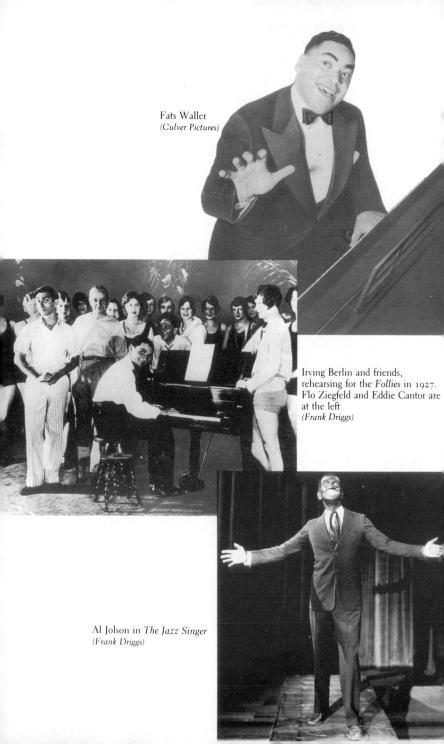

Fats Waller
(Culver Pictures)

Irving Berlin and friends,
rehearsing for the *Follies* in 1927.
Flo Ziegfeld and Eddie Cantor are
at the left
(Frank Driggs)

Al Jolson in *The Jazz Singer*
(Frank Driggs)

Noble Sissle and Eubie Blake
(Frank Driggs)

Mamie Smith
*(Schomburg Center for Research in Black Culture,
Photographs and Prints Division, The New York
Public Library, Astor, Lenox, and Tilden
Foundations)*

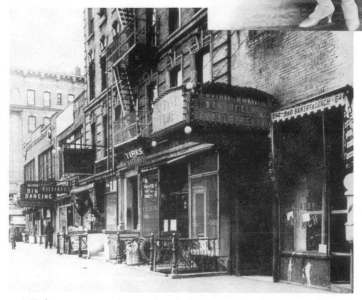

A Harlem street scene, showing the entrance
to the Cotton Club
(Frank Driggs)

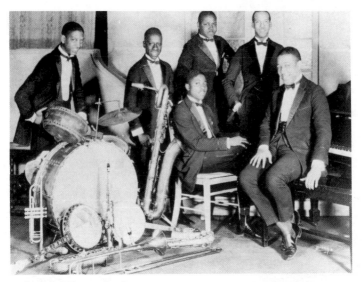

The Duke Ellington Band, 1923
*(Schomburg Center for Research in Black
Culture, Photographs and Prints Division,
The New York Public Library, Astor, Lenox,
and Tilden Foundations)*

Bessie Smith in two photographs
by Carl Van Vechten
*(Yale Collection of American Literature, Beinecke
Rare Book and Manuscript Library, Yale Univer-
sity, Estate of Carl Van Vechten, Joseph Solomon,
Executor)*

Bix Beiderbecke in the early 1920s
(*Frank Driggs*)

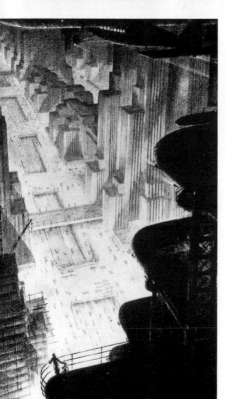

Louis Armstrong, Chicago, 1927
(*Frank Driggs*)

Hugh Ferriss's drawing
of a skyscraper hangar in a metropolis
(*Hugh Ferriss Collection, Division of
Drawings and Archives, Avery Library at
Columbia University*)

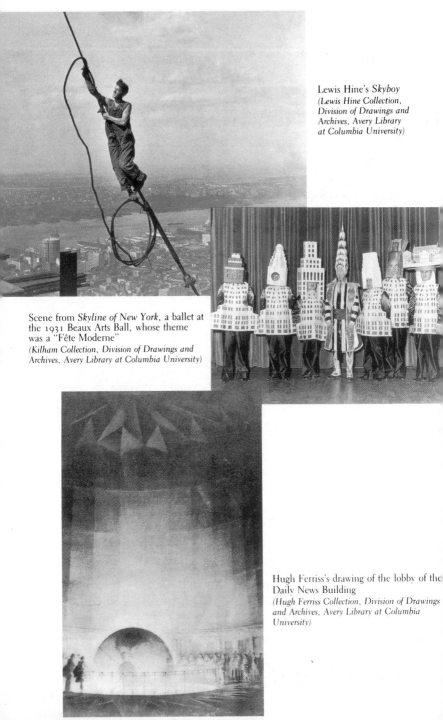

Lewis Hine's *Skyboy*
(Lewis Hine Collection, Division of Drawings and Archives, Avery Library at Columbia University)

Scene from *Skyline of New York*, a ballet at the 1931 Beaux Arts Ball, whose theme was a "Fête Moderne"
(Kilham Collection, Division of Drawings and Archives, Avery Library at Columbia University)

Hugh Ferriss's drawing of the lobby of the Daily News Building
(Hugh Ferriss Collection, Division of Drawings and Archives, Avery Library at Columbia University)

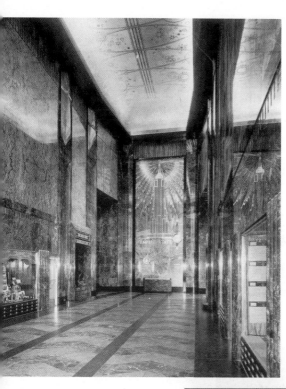

The Empire State Building
lobby bas-relief
*(Pennsylvania State University
Library, Historical Collections and
Labor Archives)*

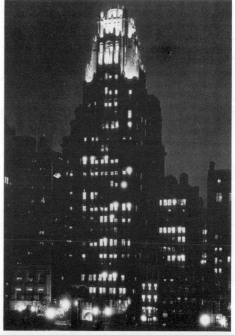

American Radiator Building
by night
*(Kilham Collection, Division of Draw-
ings and Archives, Avery Library at
Columbia University)*

Jack Johnson
*(Schomburg Center for Research in
Black Culture, Photographs and Prints
Division, The New York Public Library,
Astor, Lenox, and Tilden Foundations)*

Raymond Hood
*(Kilham Collection, Division of Drawings
and Archives, Avery Library at Columbia
University)*

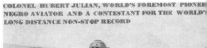

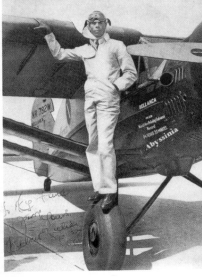

Hubert Julian and his plane, *Abyssinia*
*(Schomburg Center for Research in Black Culture,
Photographs and Prints Division, The New York
Public Library, Astor, Lenox, and Tilden
Foundations)*

Charles Lindbergh and his plane, *The Spirit
of St. Louis*
(Culver Pictures)

The urban entertainment business was in big trouble. The record industry took a dive, vaudeville disappeared, and the legitimate theater rapidly contracted. Harlem's little theater groups all but vanished, black musical revues were passé, and Broadway theaters were closing in record numbers; many of them became movie houses. The Craig Theatre, new in 1928 (later renamed the George Abbott), was the last big legitimate theater to open on Broadway. In the theaters that remained, plays were offered that were very different from those of the previous decade. In 1935, Clifford Odets, hailed as the playwright of the proletariat, hit Broadway with three plays about Jewish working-class life. A number of the performers and entrepreneurs who dominated the theater in the 1920s died in the early 1930s, some prematurely. The flamboyant Jeanne Eagels, who had starred in *Rain* (1922), a long-running sensationalist saga about a tough-talking prostitute written by John Colton and Clemence Randolph, vowed to "say nothing and be a legend"; she died at thirty-five in 1929, of alcoholism, drugs, and sheer excess. Charles Gilpin died in 1930, also of alcoholism. David Belasco, the king of Broadway melodrama, was gone in 1931, Flo Ziegfeld in 1932. The nightclub scene, dependent on Prohibition, lost patrons with its repeal. Brash Texas Guinan died in 1933, and the Cotton Club closed in 1936; it reopened downtown, at Broadway and Forty-eighth Street, but folded for good in 1940.

A number of radio shows relocated in Los Angeles. Hollywood's drain of Broadway talent, well under way in the 1920s, continued, but with a difference. The playwrights and directors who had gone West in the 1920s usually left behind well-established careers on Broadway, but those emigrating in the 1930s, including the two most promising new talents, Odets and Preston Sturges, departed after what amounted to only a start on the stage, albeit a very successful one. Hollywood was beating Manhattan to the punch. New York was too big, too absorbent, too prodigal, for anything but the media to outgrow. When they did, as the entertainment industry moved more and more of its branches West, it spelled the end of the city's position as quasi-exclusive curator and instigator of the nation's culture. Nathanael West, chronicler of the media's impact on American life, set his first novel, *Miss Lonelyhearts*, begun in the late 1920s, in New York, but his last, *The Day of the Locust* (1939), was set in Hollywood. The West Coast, not the East, now served as funnel and expressive outlet for the vast, inchoate, violent impulses of the hinterland.

Although Hollywood sponsored New York in the great screwball comedies of the 1930s, the genre did not long survive. Preston Sturges's first Broadway play had been *Strictly Dishonorable* (1929), a fast-paced, witty drama of nightclub life, but the mood of his peerless movie comedies from the 1940s was subtly different from that of their screwball predecessors. His major

protagonists, like Barbara Stanwyck in the *The Lady Eve* (1941) or Eddie Bracken in *Hail the Conquering Hero* (1944), are often in disguise. They are thinking all the time, and not just for the fun of it: there's real danger afoot. In a Sturges comedy, people can be hurt, badly hurt. The precious immunity to the painful compromises of life, lightly but invincibly worn in 1920s Broadway and 1930s screwball fare, bred a virus for which it now had no antidote. The notion of who one really is no longer served simply as a pretext for high-handed wit and creative impersonation.

John Held, Jr., discovered that he drew long skirts less well than short. Russell Patterson quickly took his place as cartoonist of the day, and Held turned to a bitter series of fictive studies of his former models titled *Grim Youth* (1930). The sources for the new urban American slang that had caught the world's imagination—quack medicine shows, criminal rackets, vaudeville, "doughboys," Ellis Island immigrants—were waning. Hollywood's self-imposed Production Code of 1934 outlawed not only immoral plots but indecent words: "floozy," "slut," "fairy," "hot mamma," and "sex," as well as most forms of profanity, were out.

The *World*, New York's premier newspaper, ceased publication in 1931, when Joseph Pulitzer summarily shut it down. *The Messenger* had ended in 1928, Garvey's *Negro World* in 1933. *Opportunity* struggled on to diminished sales, but folded in 1949; *The Crisis* was cut from fifty pages to twenty. Horace Liveright was driven out of his firm in 1930 and died in 1933 of alcoholism. New York was still the center of the nation's literary life, but publishers faced a shrinking market and they sharply curtailed their sponsorship of black authors. The *Partisan Review* crowd was forming; Philip Rahv, William Phillips, and F. W. Dupee took over the magazine in 1937 and dedicated it to "the Europeanization of American Literature," in Rahv's ominous words. Led by the "New Critics" R. P. Blackmur and Yvor Winters, and by the Southerners John Crowe Ransom, Allen Tate, and Randall Jarrell, critics renounced the study of culture and biography as a necessary background to the understanding of literature and divided art into high and low—all virtue lay in the high; the master texts were newly protected and policed, and Henry James made a triumphant return to favor—undoing the philosophical, critical, and temperamental assumptions that had made possible a black-and-white, illiterate and literate, self-consciously American and mongrel art a decade earlier. The "New York intellectual" was no longer a barrier breaker. When white critics, spurred by the prodigious advent of Richard Wright, began to comment again on black literature in the 1940s and 1950s, they did so largely from a sociological perspective, one incapable of assessing the achievements it surveyed.

Departures and deaths decimated the old literary crowd. Du Bois left

Harlem for Atlanta University in 1933; he published no fiction after *The Dark Princess* (1928). In 1931, James Weldon Johnson took a post at Fisk University, abandoning his career as poet and novelist, and died in 1938. Nella Larsen went back to nursing and Jessie Fauset retreated to the suburbs; both stopped writing. Hurston returned to the Deep South. Hughes paid a visit to the Soviet Union. Cullen and Arna Bontemps turned to teaching to support themselves. Rudolph Fisher and Wallace Thurman both died in 1934. A'Lelia Walker, the daughter of Madame C. J. Walker, empress of hair-straightening products, had used her fortune to sustain and entertain the Harlem Renaissance. She died unexpectedly in August 1931; at her funeral, Julian flew his plane overhead and dropped a floral wreath on her grave. Elinor Wylie was dead in 1928, Crane in 1932, and Ring Lardner in 1933. Harry Crosby came home to stage his suicide at the Hotel des Artistes on December 10, 1930. Sara Teasdale killed herself in 1933. Zelda, Louise Bogan, Van Wyck Brooks, and Edmund Wilson were hospitalized for mental illness in the late 1920s. The reputations of Countee Cullen, Sinclair Lewis, Joseph Hergesheimer, Sherwood Anderson, James Branch Cabell, Thomas Beer, H. L. Mencken, Wylie, and Fitzgerald, sky-high in the boom decade, dropped precipitously.

As the 1920s closed, the white magic of the early modern urban era, expressed in astonishing feats of architecture, aviation, automobilization, and fiercely inventive and original art, gave way to something like black magic, an affair, apparently, of prices paid and curses fulfilled. New Yorkers helped to write, produce, and act fables of monsters who will not lie quiet in their graves: *Dracula*, a Broadway play of 1927 and a Hollywood film of 1931 directed by Tod Browning, with Bela Lugosi in the lead; James Whale's film *Frankenstein* (1931), starring Boris Karloff; and the movie *King Kong* (1933), directed by Merian C. Cooper and Ernest B. Schoedsack. In 1923 D. H. Lawrence had depicted America as a savage among civilized nations, a figure of regenerative violence, but a decade later, King Kong, the emblem of the "primitive" culture that New York had celebrated in an ebullient frenzy of Aztec decorative motifs and a heady foregrounding of its Negro talent, kills those who want to exploit him as entertainment and study him in the name of science; he is himself ultimately a victim, gigantic in his pathos and helplessness, of the modern metropolis. Kong falls from the Empire State Building to his death.

As the era of intense masculinization began to collapse, the moderns began their painful, tentative search for the Mother God they had deposed. They had learned they were mortals who needed her much-vaunted and, in fact, not inconsiderable healing powers. In Vienna, Freud ventured on his partial recognition of the pre-Oedipal, mother-dominated phases of human devel-

opment, of the "death wish" and its strongly oral components, of the occult interests that his old enemy Mary Baker Eddy had commandeered. Cancer claimed him in 1939 and Ernest Jones pronounced his epitaph: "Freud died as he had lived—a realist." The imperatives of "terrible honesty," of histrionic and savage truth-telling, had lost their master. At home, Gilbert Seldes and others immersed themselves in the work of William James. The female-centered melodrama of the high-Victorian stage, dominated by mega-stars like Sarah Bernhardt, Mrs. Minnie Fiske, and Mrs. Leslie Carter and based squarely on the sentimental blockbusters of the women novelists whom Lawrence had excised from the American canon, had specialized in the high histrionics of the soul's quest for salvation, and it resurfaced with growing insistence in the dramas and comedies of the 1930s, even those by George S. Kaufman, Broadway's acerbic master of feminine-phobic smart talk. Eugene O'Neill, always melodrama's half-reluctant child, began his greatest series of mother-centered plays, culminating in A Moon for the Misbegotten (1947), in which a mother figure soothes and forgives a matricidal son.

Zora Neale Hurston turned with new urgency and authority to the folklore of African-American rural life and the study of voodoo practices; she published her fable of the modernized black matriarch, Their Eyes Were Watching God, in 1937. It was in these years that Ethel Waters undertook her reinvented "mammy" roles, in Mamba's Daughters, Vernon Duke's Cabin in the Sky (1940), and finally as the brooding and troubled dark god of Carson McCullers's The Member of the Wedding (1950). Marianne Moore, who claimed her poetry was largely a transcription of her adored mother's conversation, was increasingly recognized as the great feminine poet of the age. In 1933, Hemingway published "After the Storm," an anguished, eerie tale about a predatory and desperate seaman's attempt to break into the treasure-filled realm of the lost, drowned mother. A year later, little Shirley Temple, a wised-up Pollyanna impersonator with a "darky" often in tow, more a midget matriarch than a child, became a national cult. By the late 1940s, the full-figured woman (though not the plump one), all breasts and hips, was back in fashion; the matriarch had been reincarnated as sex goddess. Marilyn Monroe, all-forgiving, delectable, intuitive, even angelic, was waiting her cue.

The 1920s had delighted in hard surfaces, but now people were obsessively exploring the cost of the "hardened heart" explicated in the Exodus story of the Pharaoh who would not let Moses and his people go to their promised land. In a poem ominously entitled "Let No Charitable Hope," Wylie tells us that she lives "by squeezing from a stone / The little nourishment I get." Hers is "the hard heart of a child." In his middle years, Hemingway remarked that he could no longer pray. "Perhaps," he added, "it is because I have in

some way become hardened." Thurman experienced an "utter absence of desire"; he couldn't seem to feel anything but despair. *Miss Lonelyhearts* (1933), Nathanael West's almost clinical study of melancholia, centered on an alcoholic male sob sister on a New York newspaper. Tortured by his inability to respond, to find "room in his heart" for the grotesquely unhappy people who seek his advice, he finds a "clue" to his dilemma in the sky-scrapers' "tons of forced rock and tortured steel," and speculates: "Americans have dissipated their social energy in an orgy of stone breaking. In their few years they have broken more stones than did centuries of Egyptians. And they have done their work hysterically, desperately, almost as if they knew the stones would someday break them." To Miss Lonelyhearts, America itself is a vast hardened heart that will be broken but not mended. Speed had promised the moderns, not just swift attainment of their desires, but pain-free defiance of the conventional values rooted deeply in their elders, and themselves; we all know the saying "It'll happen so fast you won't even feel it." But anaesthesia now seemed a worse affliction than the pain it had been intended to relieve. "I want to believe," one of O'Neill's protagonists cries, "so I can feel!"

The 1920s had been a superstitious age, perhaps with reason. Preparing for what would turn out to be her last flight, Amelia Earhart fought off worries that her "luck [had] run out." When a reporter expressed his hope that she would do no more flying in the darkening skies of the 1930s, she asked him: "Do you think that luck only lasts so long and then lets a person down?" According to Langston Hughes, Thurman had always been sure that the Harlem Renaissance was doomed. The Negro's vogue had "flattered and spoiled" those he liked to call the "niggerati" and provided them with "too many easy opportunities"; they had gotten drunk and stayed drunk. Looking back in 1931, Fitzgerald agreed. His generation had indulged in the "gaudiest spree in history"; the decade was "borrowed time." "Borrowed time" suggests extra time, illegal hours, time out from some appointed combat; it hints at a sinister version of the installment plan, the notion of something apparently gotten for nothing, for free, "a prize for everyone," as he put it, which in fact entails an ever steeper price to pay in the near and unimaginable future. Zelda, writing in 1932 about what now seemed the wastefulness and over-extended risk taking of the decade, remarked, "I so wanted to be paid for my soul." With her characteristic half-crazed superlucidity, she raised the stakes and shifted the meaning of "borrowed time" decisively from the financial to the Faustian. As "borrowed time," as prodigious achievement and reckless loss, the 1920s were somehow comparable to the decade of creativity and omnipotence for which Faust had pledged his soul to the Devil.

So much was given to the metropolitan moderns, so soon, so fast, so

conspicuously; inevitably, some of them came to wonder at what price they had been granted such powers, what bargain they had made. What would be exacted of them in return? Had they not acquired powers via the new media and technology eerily like those Faust possessed? They, too, could enjoy a consumer paradise of foods and other delicacies and goods out of season; they, too, could, it seemed, defy society's prohibitions, even ignore the laws of gravity, space, and time. Did not such parallels argue that they, like Faust, were operating on a timer system, that their powers were temporary ones achieved, as all superhuman powers are, by a pact with the Devil, one whose due date could be forgotten but not forestalled? The lines spoken by Marlowe's Faust as he nears his end, "Now hast thou but one bare hour to live / And then thou must be damned perpetually," reverberated through the decade. Hart Crane could recite all Faust's great speeches and, when deep in his cups, often did.

Of the age's mood swings, I have said that manic-depressive symptoms like these represent a disorder of the belief system. If the manic organism, whether a person or a culture, chooses to believe everything it wants to, the depressive one chooses to believe in nothing, or in nothingness itself, what Hemingway called *nada*. Although the depressive organism is no longer a navigator, a "conquistador" assured of victory, it has turned prophet and gotten by a different route the goal it sought in mania: conviction, an authoritative worldview, immunity. America in the 1920s, the first avowedly, and uneasily, secular era in its history, fueled by a long tradition of utopian and democratic optimism and an equally long and powerful tradition of elite pessimism, came in spectacularly short order to an apparently effortless position of world power after the Great War, a position backed and floated by an extraordinary cultural renaissance drawn from hitherto unknown or unrecognized sources, only to be brought up short a decade later by the Depression and the spreading evil of Fascism. This was a kind of paradigmatic setup for manic-depressive illness, an illness with which I believe America is still, and at times, it seems, helplessly, afflicted.

Freud and his American followers had seen themselves as pioneers, creatures of tax-free energy, immune to ordinary constraints, but in the 1930s they became aware of the kickback that attends frontier breaking. They dreaded the end of youth, for youth is that period when we perform our most exciting detours on the road to death, that brief time when we are all, to one degree or another, pioneers. Hemingway, consoling Gerald and Sara Murphy for the loss of their teenaged son, Baoth, on March 19, 1935, wrote that the only "victory" was to die young. After a "happy childhood," if one has had it, nothing remains but the diminishing repetition of the lost "fine time," and the inevitable "death by defeat, our bodies gone, our world

destroyed." Ben Hecht aphorized that, after youth, our "brief sanity," our only "performance as individuals," "the rest is suicide." "What's the good of fooling?" Parker queried on her fiftieth birthday. "People ought to be one of two things, young or dead." Surveying what he took to be the thinning talents of a generation, Fitzgerald concluded that "American lives have no second acts." If modernism was a sustained instigation, an affair of stolen goods plucked from their original context, a nerves marathon, the Depression signaled the inevitable delayed-shock reaction to it.

The economic downturn hit blacks hardest, but the psychological crash was in some ways more severe, though no more costly, among whites. Negroes were painfully accustomed, as whites were not, to reversals of fortune and favor. Lowered expectations were no surprise; long-standing deprivation develops its own immunity system as well as its own breaking point. This is hardly to suggest that black artists did not suffer turmoil and defeat during the Depression years equal to what whites experienced, but it is to say that they did not self-destruct in the same flamboyant way. Thurman's case is exceptional. Larsen's retirement into nursing, however awful to contemplate, is not the same thing as Dorothy Parker's descent into suicidal alcoholism. Countee Cullen's lost prestige, his forced turn from full-time writing to teaching, is something different from Hart Crane's wanton destruction of his poetic gift. We will never know if Charles Gilpin, the greatest Negro actor of the day, would have drunk himself to death if the theater had been fully open to black talent, but John Barrymore, its most formidable white actor, did so although the American stage and cinema were his to command. White artists were apparently destroyed from within; black artists, if they were destroyed, from without. If the white moderns were self-consciously "lost" as their black peers were not, if the matricidal impulse and its underlying theological and psychoanalytic preoccupations were stronger in the white group than the black, so, inevitably, were their consequences. But the matter is not quite so simple.

I have suggested that we don't have psychological configurations that fit and express the black experience or psyche as Freud's suited the white moderns. Indeed, it is not yet clear what psychology can best produce fruitful and inclusive paradigms of black consciousness. Perhaps the complexities of performance, the dialectic of individual and group, the art of masking, both political and aesthetic, in which all black Americans have been to one degree or another, willy-nilly, trained, offers the best starting point for such a paradigm, and it suggests the nature of black psychic pain in the dark aftermath of the 1920s. By performance, I do not mean the aggressive psychic imperialism for chosen parts of the self congenial to the white moderns but, rather, a simultaneous assertion of the self and an unfathomable and almost

permanent decoy from it. Black performance always flirted with silence and withdrawal more seriously than white performance did, if only because its broadest audience was known to be more hostile, more fickle, and less skilled than that white performers faced; silence and withdrawal were the fate of some of the greatest black artists of the 1920s in the Depression and after.

The near-disappearance of mainstream publishing outlets for blacks in the 1930s does not fully explain Larsen's silence or Fauset's retreat or Hurston's downward slide. That silence was often to some degree imposed rather than sought meant that it might be anticipated and internalized as self-punishment; that self-destruction was imposed from the outside did not make it less terrible on the inside. The cost of silence, however inflicted, is as high as that of public disintegration. Black self-negation is pathology, even self-destruction, too, though in this version the self is not the sole author of the script. Parker, Crane, and Barrymore at least kept their personae intact to the end, tarnished, conflicted, and sterile as those personae may have become. Larsen, Fauset, Hurston, Gilpin, and Cullen were in some sense stripped of their parts, by whatever hand, ejected from the play and even from the audience.

Yet the black legacy of the 1920s did survive. The underground was not a no man's land but, however hidden its secrets, an occupied and populous thoroughfare, an underground railroad meant to carry black culture safely through enemy territory. "Years of exile" had long spelled incubation as well as loss. Hughes put his money on the proposition that the group, the race, did not perish, though the individual sometimes did. He believed, or tried to, that, whatever happened, "my world won't end," and his subsequent career, which reached a new peak of artistry in the 1950s, proved him right. In a late, great poem entitled "Not What Was," published in 1965, just two years before his death, Hughes found that "the air is music" though its melody spirals and widens into a "universe that nothing can contain," into "unexplored space / which sends no answers back."

The melancholia and disintegration that afflicted white American artists, though often a painful story, is not entirely a gloomy one either. If the story spelled regression, it was in part performed in the service of survival, if not of the body, of the soul. Forced to reinvestigate their much-vaunted orphan status, some of them found new solutions and re-examined old ones put away with deceptive finality but a decade before. "Terrible honesty" had been a liberating but a punitive ethos; as Wallace Stevens put it, "We have been a little insane about the truth." Bill Wilson, drawing on the work of William James, founded Alcoholics Anonymous in 1935, and though none of the New Yorkers joined it, a few of them, like O'Neill, Fitzgerald, Carl Van Vechten, and Laurette Taylor, stopped or curbed their drinking, and many of them entertained, half unawares, the Necessary Angel. They had

courted terrible deaths, and many found them, but it should not be forgotten that they had hoped all along, obscurely but, I think, powerfully, that the pace the modern era had set, the pace they had embraced if not chosen, would propel them, not only to crack-up, but beyond it, to something like the redemption that surely lies, they wagered in an Augustinian gamble, somewhere down the line of such a violently taken and reckless course. Don't emergencies precipitate rescue?

In his memoir, *That Summer in Paris* (1963), Hemingway's friend Morley Callaghan wrote of the 1920s generation that they were all "children of St. Paul." These words were not lightly chosen. Paul was the follower who doubted Christ longest; he was, in fact, a persecutor of the early Christians, and he was not converted to the new faith until after Christ's death. It took a miracle—Christ's voice speaking to him on the road to Damascus, saying "Why persecutest thou me?"—to persuade him. In the context of the biblical presentation of Christ, this miracle is a very significant one. The miracles Christ worked in his lifetime—the healing of the sick, the raising of the dead—came about because the people he helped already believed in him. "Your faith has made you whole" is again and again the only explanation he offers for his miraculous cures. But Paul was the doubter, the rebellious and defiant intellectual, a proto-theologian who bargained with God and made his conversion dependent on the miracle he demanded. If Christ said that there could be no miracle without faith, Paul reversed the proposition; he refused to believe until he had seen the proof. His doubt was somehow not just his problem but God's. Paul's position could be summarized as "no miracle—no faith," and it was the demand of the white moderns, too. They wanted to be saved, as Paul was, as the Prodigal Son, perhaps the biblical figure they alluded to most frequently, was, in the very midst of their sins, even because of them. Faust, the ultimate prodigal child, exposed not only his own sinfulness but God's neglect; if a person is lost, someone must have lost him. Voluntary degradation, even selling one's soul, was a dare to God to compete with the Devil.

Bill Wilson tells us that alcoholism is a debased quest for religious experience. Only what Wilson, borrowing from James and Jung, called a "spiritual awakening," can relieve the alcoholic of his compulsion to drink; alcoholism is an effort to enter the spiritual realm from below. In the gutter, one sees, at last, the sky. In 1915, as a young man in George Baker's play-writing workshop at Harvard, O'Neill vowed *to be an artist or nothing.* It would be a mistake to read this pledge simply as O'Neill's statement that his art was immeasurably more important to him than anything else, that everything else counted as "nothing" next to the intensity of his desire, his need, to be an artist, though all this, of course, was true. He also meant that he

wanted to be "nothing" almost as much as he wanted to be an "artist," and this compulsion underlay the terrible alcoholism that nearly wrecked him in mid-career. He said later that "the most interesting thing about people is the fact that they don't really want to be saved"; they have "an ambition [for] self-destruction." Not, note, a "tendency" to self-destruction, not a "fatal drive" toward it, not an "unhealthy need" of it, but an "*ambition*" for it. Wanting to be an "artist" and wanting to be "nothing" were somehow one and the same thing.

Although O'Neill swore off alcohol in 1928, he never regretted his drinking, and he continued to use it as his primary subject matter; if alcoholism had threatened his talent, he nonetheless saw it as integral to it. In Nancy Cunard's "misery," her painful promiscuity, her alcoholism, one friend remarked, lay "her only hope." Perhaps self-destruction could precipitate its own transformation as grace. The last might, indeed, be first. In the words of the writer Donald Newlove, alcoholics might be "grounded angels," readying themselves for flight; "terrible honesty" was a trial incarnation of the truth instinct, a "cry in the wilderness," as O'Neill described his own work, "protesting against . . . [its] own faithlessness." If degradation begets grace, "walking in one's Sunday shoes in the mud," as Gene Fowler described John Barrymore's tormented mission, could be the way to God. The German poet Hölderlin wrote, in lines Jung quoted in *Modern Man in Search of a Soul* (1933), "*Wo Gefähr ist / Wachst das Rettende auch.*" Where danger is, there awakens deliverance. One finds repeatedly in the later lives of the white American artists of the 1920s a moment when hope seems briefly to flare from the depths of ruin, a hope that lives *only* amid ruin. They had to destroy what they had to get what they needed.

In 1952, Sinclair Lewis, his health ravaged by long years of alcoholism, nicotine addiction, and strangely rootless and enraged living, lay dying in a clinic for psychiatric disorders outside Rome. He had outlived his fame by two decades, but his survival had not been altogether voluntary; he had persistently consulted and persistently ignored a series of doctors who had insisted that he must stop drinking and smoking if he wished to live. The creator of Babbitt, the ambivalent satirist of the species that his friend Mencken delighted to attack as "the American Boobus," was in self-imposed exile from his native land. "Europe is home to me now," Lewis said, as he compiled with self-confessed horror ever longer lists of those—ex-wives, friends, editors, and colleagues—whose doors were shut to him. A sympathetic friend, one of the few who remained, explained his expatriation: "A prodigal son, tired and ill, does not return to his house if he does not have a father who awaits him." During the bout of D.T.s that dictated his final hospitalization, Lewis, perhaps thinking of his own doctor father, whose

approval he had always sought and never found, called the unknown Italian doctor in attendance "Father." On the morning of January 10, 1951, he died of what the doctors, in a moment of more than medical wisdom, chose to term *paralisi cardiaca*, a paralyzed heart. In a brief moment of partial consciousness just before his death, Lewis, almost blind, looked at the new day and said: "There, the sun!"

In the early 1930s, Zelda was writing her only completed novel, *Save Me the Waltz* (1932), under medical surveillance in the psychiatric wing at the Johns Hopkins Hospital. With her knack for personifying the Zeitgeist, she took as the book's epigraph some lines from *Oedipus Rex*:

> We saw of old blue skies and summer seas
> > When Thebes in the storm and rain
> Reeled like to die.
> O, if thou canst again,
> > Blue sky—blue sky!

Ill and schizophrenic, incarcerated, "dying" from the "incessant and bitter beating I'm taking," in her words from another asylum, Zelda swerved instinctively toward the sky. And Elinor Wylie, in the months just before her death, having boasted of living on "aspirin and scotch" and believing that "the ashes of this error shall exude Essential Verity," insisted: "I shall be more blessed than damned / When this my servitude is done."

Before his death on December 21, 1940, F. Scott Fitzgerald asked to be buried in the churchyard of St. Mary's Church outside Washington, D.C., next to his father. St. Mary's was a Roman Catholic church, however, and the officials involved ruled that he could not be buried in consecrated ground. Because he had not performed his "Easter duty" (the Catholic's obligation to take Mass and do penance before and after Easter Sunday) most likely for decades, possibly since childhood; because his works, while never listed among the Church's *Index librorum prohibitorum*, were hardly by conventional standards evidence of adherence to any religious creed, much less the Catholic one, Fitzgerald was judged to be in some sense excommunicated: he was not in a "state of grace." His friends made do with an Episcopalian funeral service, conducted by the Reverend Raymond P. Black, who had not known Fitzgerald or even heard of him. "It made no particular difference to me" who the deceased was, Black said. The burial service was held in the Rockville Cemetery in Washington in a driving rain with only a handful of mourners present. Dorothy Parker, who had been a friend, was not there, but quoting one of Gatsby's three mourners, she pronounced the short bitter elegy: "The poor son of a bitch." The ironic scoffer-in-the-sky Fitzgerald

had depicted in *Gatsby* as T. J. Eckleberg had apparently scripted his end.

In 1975, however, the church relented, and Scottie Fitzgerald had her parents exhumed, then buried in St. Mary's as Scott had wished, near his father. Cardinal Baum, a man profoundly in touch with Fitzgerald's vision and the religious and spiritual traditions of which it was so intimately a part, wrote that his work was a study of the "human heart caught in the struggle between grace and death." Fitzgerald had "experienced," the cardinal continued, "in his own life the mystery of suffering, and we hope, the power of God's grace." What Sheilah Graham, Fitzgerald's lover in the last two years of his life, said about him could be extended to his generation, white and black, as a whole: "Nothing," *nothing*, could permanently "check the eagerness of [their] minds."

Preternaturally quick on the take, adept in getting the first and the last word, the urban moderns produced their own history and epitaphs with dazzling rapidity. Most of the works I have quoted in this book as standard authorities on the urban 1920s were themselves written in the 1920s or shortly thereafter by men and women who were very much a part of the world they were describing. Such proximity to one's sources is traditionally believed to produce works sometimes of exceptional vividness but often of limited insight; that belief finds scant substantiation here. Fitzgerald wrote "Echoes of the Jazz Age," still the most brilliant essay on the urban 1920s, in 1931, the year that saw the publication of Frederick Lewis Allen's *Only Yesterday* and Constance Rourke's *American Humor*, the year after James Weldon Johnson wrote *Black Manhattan*. America had been officially declared an urban nation only in 1920, yet Lewis Mumford's studies of the "Culture of Cities," begun in the late 1920s, are read today, not as historically dated documents able to speak only about their own time but as a part of the best analysis available today about our own era.

In the early 1910s, the most successful of the writers specializing in various forms of the vernacular—Mark Twain, "Mr. Dooley" (Finley Peter Dunne), and George Ade among them—still reverted to Standard English diction when they wanted to be taken seriously. Today we no longer read their "straight" works, not even Twain's *Joan of Arc*, or, for that matter, with the momentous exception of Twain, their forays into the American vernacular. "Mr. Dooley's" Irish lingo reads like a foreign language. Yet Mencken's *American Language*, issued a few years after Dooley's and Twain's heyday, is still acknowledged as the standard work, and the most entertaining one, on its subject, and the greatest practitioners of that language among Mencken's contemporaries have not dated at all. Alexander Woollcott insisted that *Broadway* (1926), a fractious, fast-paced play of urban life and slang by Philip Dunning and George Abbott, would have been incomprehensible to a New

York audience of 1915, yet whatever may distance us from the work of Dunning and Abbott, from that of Hughes, Hurston, Hemingway, Ring Lardner, and Parker, it is not their idiom. Even if we don't know all the terms, their language still works the way our minds do.

To review the wide-ranging critique and dramatization of American life that was presented in the critical, fictional, and theatrical work of the 1920s is to be convinced that it offers the largest arsenal of penetrating analysis, sophisticated spoofing, and exciting storytelling the American mind ever stocked at one time. I would claim that we do not formulate one serious criticism or spin one entertaining narrative or tell one good joke about the American experience, with its painful limitations and prodigious achievements, its vivid hopes and rampant fears, its Puritan past, its consumer present, its technologically organized future, and its tangled gender and race relations, that was not first aired then.

Wherever they were located, most of the artists of later decades visited New York on occasion, and all of them were to one degree or another indebted to its legacy, good and bad. The overt politicization of the 1930s was not a lasting feature of American intellectual and artistic life, at least not in the form of the Soviet Marxism fashionable in the Depression years. With the affluence and paranoia that followed the Second World War, and more particularly Hiroshima and Nagasaki, the Nativist crusades and Red scares of the 1910s and 1920s became national ideology and burgeoned ominously into the Cold War mentality. The radical doubts of the 1930s gave way to a new era of self-confidence, enforced optimism, and a militant sense of world mission, though one shadowed with darker thoughts than the 1920s entertained, and the 1920s found new heirs and interpreters.

The Harlem boxer Joe Louis was a brilliant successor to Jack Johnson, and seconded by Jackie Robinson in the 1940s, he consolidated the black athlete's claim to championship status. Whatever Ellington's and Armstrong's reservations, the bebop artists of the 1940s and 1950s carried jazz to new artistic heights. Ella Fitzgerald, Billie Holiday, Dinah Washington, and Sarah Vaughan took up where Ethel Waters and Bessie Smith left off. Tin Pan Alley continued to dominate the pop music scene with a seamless flow of talent until the early 1950s. Nat King Cole inherited and vastly enriched the crooner tradition of Crosby and Astaire, and Frank Sinatra, collaborating with Tommy Dorsey and Count Basie, lent it the magic of "the Voice." The great rhythm and blues artists of the 1940s and 1950s, based largely in Chicago and led by Elmore James, Little Walter, Muddy Waters, Sonny Boy Williamson (II), and Big Mama Thornton, brought a boogie beat to the classic blues form and revolutionized popular music in the process. White folk artists, with Woody Guthrie and later Bob Dylan at their head, re-

established their ties with the blues, too. The American language produced a second slang revolution, a cool yet ecstatic idiom drawn from black jazz lingo and popularized by the writings of Jack Kerouac and the "Beat Generation" he led. Kerouac, self-consciously aligning himself with the world's darker peoples, dreamed of being reborn a Negro and called his art "Bop prosody." Although popular art was never again as black-and-white as it had been in the 1920s, his era saw a second explosion of biracial music in the great chart-crossing rock and roll hits of the mid-1950s by Chuck Berry, Bill Haley, Fats Domino, Elvis Presley, and the Platters.

Like many of his contemporaries, Kerouac drew deeply on Thomas Wolfe, Hemingway, and Fitzgerald. Thurman, Toomer, Hurston, and Hughes were rivaled and fulfilled by Richard Wright, Ralph Ellison, Chester Himes, Gwendolyn Brooks, and Ann Petry. James Baldwin picked up the mantle of Cullen's "Black Christ." O'Neill's anguished quest for spiritual salvation amid physical dissolution found its fullest expression in the work of his younger rival and successor, Tennessee Williams. Williams kept a picture of Hart Crane near him always. Kerouac, Delmore Schwartz, Richard Wright, and James Dean quoted Crane's poetry, as did the rock star Jim Morrison a decade later, and the Actors' Studio, of which Marlon Brando and James Dean were the icons, formally inculcated the compulsive expressionism that had marked both O'Neill's and Crane's work and personae. "The young man" of "electrical insight," driven "out of his mind" by "wit and passion" and "alive with surplus love," as John Berryman described the type in his *Dream Songs* (1969), seen in the Beat rebels, the early rock and roll heroes, and the first Method actors, was a figure Crane and O'Neill helped to create. Marilyn Monroe was not only the matriarch sexualized but a student of the Actors' Studio and a long-term psychoanalytic patient, the 1920s "It girl" updated as sensitive rebel, the only girl in a pack of Beat men. The influence of Freud reached its apogee in the postwar decades and flowered in the sinister and stunning films of the "film noir" directors— Robert Siodmak, Fritz Lang, Douglas Sirk, Jacques Tourneur, Sam Fuller, and Nicholas Ray. The Neo-Orthodox movement that began in America in the 1920s culminated in the work of the Niebuhr brothers, Richard and Reinhold, and Paul Tillich, in the 1940s and 1950s.

Rourke, Seldes, and Hurston could be said to have established the credentials of popular culture as the center of American Studies, a discipline officially organized in the 1940s and 1950s amid the McCarthyite crusade for an all-American polis. The 1920s stress on popular music as the most telling map of the national psyche was perpetuated and strengthened in the 1960s and after by the black scholar Albert Murray and by the new rock critics Nik Cohn, Greil Marcus, David Dalton, and Lester Bangs. Hem-

ingway's dictum that the writer must talk only about what he himself has known and experienced, his assertion of the openly subjective posture as the best means to a new and shocking objectivity about one's times, bore fruit in the New Journalism of Tom Wolfe and Hunter Thompson. The political theater in which black Manhattan had specialized re-emerged in the civil-rights movement of the 1950s, the student protests of the 1960s, the Black Arts movement led by Amiri Baraka, and even in the Black Panthers, the group that most defiantly repudiated the racially accommodationist ideals of the 1920s. The 1920s demand for sexual freedom, birth control, and intellectual adventure for women hibernated for a few decades under what Betty Friedan called "the feminine mystique," itself an heir to the anti-political animus of the 1920s flapper, then re-emerged and exploded in the militant feminism of the 1960s. Madison Avenue regained in the 1950s the affluence and hegemony it established in the 1920s, and America has remained, as it became in the 1920s, an alcoholic and addictive society.

Despite these visible and powerful continuities, however, the 1920s has kept its unique aura, its sense of having been a specially privileged and charged site of American experience. Its participants were sure that there had never been, and might not be again, a time quite like their own; they had broken most of history's rules and established rule breaking as cultural activity. As participants described and experienced them, the 1920s resembled what earlier generations had considered an event rather than what was usually defined as an epoch; they were a phenomenon too momentous and unique to be easily subsumed into the neighboring historical landscape. Today, we think in discrete decades almost as naturally as we think in months and years. We talk of the 1920s, the 1930s, the 1940s, on up to the present, all in decades. Yet we don't divide the period before the 1920s so decisively. The Gay Nineties would seem to be an exception, but it was the "roaring twenties" that popularized the "gay nineties"; Beer's study of the 1890s, *The Mauve Decade*, appeared in 1926. Only then did scholars of the Victorian past began to particularize and commodify it, to speak of "the Fabulous [Eighteen] Forties" and "the Feminine [Eighteen] Fifties"; the titles were thought up, not surprisingly, by two critics of the 1920s, Meade Minnigerode and Fred Lewis Pattee respectively. The idea of the decade as a special, marketable package was, in fact, largely a 1920s invention.

Post-1920s commentators preserved the Victorian period's own sense of itself with generalizing, even sweeping titles like *American Renaissance* (1941) by F. O. Matthiessen, *The Age of Jackson* (1945) by Arthur Schlesinger, Jr., and *The Life of the Mind in America* (1965) by Perry Miller. In the nineteenth century, historical time did not appear in discrete packages; Providence dropped no stitches. Insofar as the Victorians thought in historical periods,

their ideas were more biblical than modern. To their minds, American history was a mighty process beginning with the coming of the Puritans, taking decisive form in the Revolution, and climaxing in the Civil War. Each successive sweep of history spawned a "generation": the men of the 1850s were the "sons" of the "Founding Fathers" and even of the "Pilgrim Fathers."

Nineteenth-century Americans like Harriet Beecher Stowe gained stature and significance in their own eyes because they believed God had assigned them parts in a drama more exciting and important than any since the Hebrews' search for the Promised Land or Rome's rise and fall. They kept alive a reach of historical awareness, no matter how imprecise or distorted its content, altogether alien to the consciousness of the 1920s. Stowe found it natural to write on her all-consuming subject—Protestantism and its vicissitudes—from many historical perspectives, ranging from the medieval period in Europe, in *Agnes of Sorrento* (1862), to eighteenth-century America, in *The Minister's Wooing* (1859) and *Oldtown Folks* (1869), on to her own day, in *Pink and White Tyranny* (1871) and its sequels. While writers of the 1920s confined their literary efforts to depicting events occurring "In Our Time," as Hemingway titled his first book, Stowe ranged freely as an artist and a quasi-prophet over what was to her a continuum of activity and identity.

Fitzgerald's efforts at historical demarcation were dramatic, even cataclysmic in tone, but sharply limited in scope. He might describe the 1920s as "the gaudiest spree in history," but he believed that the spree had changed decisively by 1923 and had lost its exhilaration by 1927. A period, as his retrospective essays demonstrated, could best be described, not by inferring a deity's intentions for coherence, not even by marshaling the collective motives of those living in it, but by collating sharp details thrown out by random human activity into a pattern that might hold validity for, at best, five or ten years. Fitzgerald was acutely sensitive to tabloid shock headlines like "A BABY MURDERED A GANGSTER" and snappy phrases like the song title "Yes, We Have No Bananas," a hit of 1923. A decade in this view was one roll of the dice, lawless but decisive, a performance, insulated by caprice and destiny from what had preceded it and would succeed it.

If the favored musical forms of the Victorians were the symphony and the concerto, with their long, orchestrated swells and subsidings, and the ballad, with its pastoral melodies and subdued ¾-time waltz pulse, the favorite musical forms of the moderns were the suite, with its short movements and quick, even dissonant extremes, and the breezy popular song, with its brief phrases, its syncopated beat of urban variation and transience. These were songs, as the American composer Frederic Jacobs once remarked about Gershwin's music, that had the "high attribute of making people fall in love with them,"

that came and went, that spoke, when heard by chance in later years, Seldes wrote in *The 7 Lively Arts*, not to public events, but to passing "private memories." They crystallized, Seldes said, "not eternal truths," but "the sights and sounds and smells, the very quality of the air we breathed when they were in their heyday." Seldes thought that traditional classic art spoke to the eternal, folk art to the collective cultural past; but the lively arts of the 1920s were always part of the present. Like the tramp cutout that advertised the presence of a Charlie Chaplin film at your neighborhood theater, they all wore somewhere a sign that said, "I am here today," and, Seldes adds, "gone tomorrow."

The 1920s could be said to have patented the idea of history as a form of instant irony, as a funhouse mirror revealing every distortion and falsity in things once held timeless and true, and it is hard to use irony on those who perfected it. The men and women of the urban 1920s remain, as they wished and aimed to be, in some sense culturally invulnerable, impervious to historical hindsight. What the members of this pioneering generation, whose every instinct was sharpened by the dangers attendant on liberation and exile from past illusions and constraints, knew about themselves and us may be more than we, or they, think they could have known. One could hope, apparently, to acquire hindsight about the past, not in a century or a generation or a decade, but in a few years, months, weeks, even days, and one's insights into the present might yield what amounted to predictive powers. It was as if, having gotten the rhythm, the pace, and "The Tempo of Modern Life," in James Truslow Adams's famous title, they already knew how the rest of the song must go. With a touch of Faustian acuity, they had cornered the market, and whatever their past and future, their present was an extraordinarily imperial one, appropriating with unparalleled inventiveness everything it needed for its own dazzling self-expression.

BIBLIOGRAPHICAL ESSAY
AND SELECTED DISCOGRAPHY

Most of the books and articles identified in the text are readily available in libraries and bookstores. Full bibliographical details are given, under each chapter heading below, of the less accessible of these works, and of books and articles not directly cited but important to the subject under discussion. The Selected Bibliography is a short list of books that I have found indispensable.

SELECTED BIBLIOGRAPHY

Adams, John Truslow. *The Tempo of Modern Life*. 1931; rpt., Freeport, N. Y.: Libraries Press, 1970.

Allen, Frederick Lewis. *Only Yesterday: An Informal History of the 1920's*. 1931; rpt., New York: Perennial Books, 1964.

Anderson, Jervis. *This Was Harlem: A Cultural Portrait 1900–1950*. New York: Farrar, Straus & Giroux, 1981.

Beer, Thomas. *The Mauve Decade: American Life at the End of the Nineteenth Century*. 1926; rpt., New York: Vintage, 1960.

Eksteins, Modris. *Rites of Spring: The Great War and the Birth of the Modern Age*. 1989; rpt., New York: Anchor, 1990.

Ellington, Edward Kennedy. *Music Is My Mistress*. 1973; rpt., New York: Da Capo, n.d.

Ellison, Ralph. "The World and the Jug" and "Blues People" in *Shadow and Act*. 1964; rpt., New York: Vintage, 1972.

Fitzgerald, F. Scott. "Echoes of the Jazz Age" (1931) and "My Lost City" (1932) in *The Crack-Up*. New York: New Directions, 1945.

Gates, Henry Louis Jr. *Figures in Black: Words, Signs and the "Racial Self."* New York: Oxford University Press, 1987.

Hale, Nathan G. Jr. *Freud and the Americans: The Beginnings of Psychoanalysis in the United States, 1876–1917*. Vol. 1. New York: Oxford University Press, 1971.

Hughes, Langston. *The Big Sea: An Autobiography*. 1940; rpt., New York: Hill & Wang, 1964.

Hurston, Zora Neale. "Characteristics of Negro Expression" (1934) in *The Sanctified Church: The Folklore Writings*. Berkeley, Calif.: Turtle Island Press, 1981.

Johnson, James Weldon. *Black Manhattan*. 1930; rpt., New York: Da Capo, 1991.

Keegan, John. *The Face of Battle: A Study of Agincourt, Waterloo & the Somme*. New York: The Viking Press, 1976.

Kendall, Elizabeth. *Where She Danced: The Birth of American Art-Dance*. New York: Alfred A. Knopf, 1979.

Kennedy, Paul. *The Rise and Fall of the Great Powers: Economic Change and Military Conduct from 1500 to 2000*. New York: Random House, 1986.

Koolhaas, Rem. *Delirious New York*. New York: Oxford University Press, 1978.

Leuchtenburg, William E. *The Perils of Prosperity, 1914–1932*. Chicago and London: University of Chicago Press, 1958.

Levine, Lawrence W. *Black Culture and Black Consciousness: Afro-American Folk Thought from Slavery to Freedom*. New York: Oxford University Press, 1977.

Lewis, David Levering. *When Harlem Was in Vogue*. New York: Oxford University Press, 1981.

Lynd, Robert S., and Helen Merrell Lynd. *Middletown: A Study in Modern American Culture*. 1929; rpt., New York: Harcourt Brace, 1954.

Marchand, Roland. *Advertising the American Dream: Making Way for Modernity 1920–1940*. Berkeley: University of California Press, 1985.

Mencken, H. L. *The American Language: An Inquiry into the Development of English in the United States*, with annotations and new material by Raven I. McDavid, Jr., with the assistance of David W. Maurer. New York: Alfred A. Knopf, 1977.

Mumford, Lewis. *The Culture of Cities*. 1938; rpt., New York: Harcourt Brace, 1966.

———. *Technics and Civilization*, 1934; rpt., New York: Harcourt, Brace, 1963.

The New Negro. Ed. Alain Locke. 1925; rpt., New York: Atheneum, 1968.

Rourke, Constance. *American Humor: A Study of the National Character*. 1931; rpt., Garden City, N.Y.: Anchor, 1953.

Seldes, Gilbert. *The 7 Lively Arts*. 1924; rev. ed., New York: Sagamore Press, 1957.

———. *The Stammering Century: Minor movements, cults, manias, fads, sects and religious excitements in 19th century America*. 1928; rpt., New York: Harper & Row, 1965.

Stern, Robert A.M., Gregory Gilmartin, and Thomas Mellins. *New York 1930: Architecture and Urbanism Between the Two World Wars*. New York: Rizzoli, 1987.

Taylor, William R. *In Pursuit of Gotham: Culture and Commerce in New York*. New York: Oxford University Press, 1992.

Trachtenberg, Alan. *The Incorporation of America: Culture and Society in the Gilded Age*. New York: Hill & Wang, 1982.

A number of contemporary magazines and newspapers are important for my subject, most notably the *World*, *Vanity Fair*, *Smart Set*, *The New Yorker*, *The Crisis*, *Opportunity*, and *Ladies' Home Journal*.

INTRODUCTION
ORPHANS: LOSS AND LIBERATION

W. W. Rostow's article on "Take-Off" (1956) is in *Social Change: Sources, Patterns, and Consequences*, eds. Amitai Etzioni and Eva Etzioni (New York: Basic Books, 1964). For useful general histories of the 1920s, see Henry Steele Commager, ed., *The Story*

of America: The Twenties (New York: Toronto Star Books, 1975); Frederick J. Hoffman, The Twenties: American Writers in the Post War Decade (1949; rpt., New York: The Free Press, 1965); Burt Noggle, Into the 1920s: The United States from Armistice to Normalcy (Urbana: University of Illinois Press, 1974); and Arthur M. Schlesinger, Jr., The Age of Roosevelt: The Crisis of the Old Order 1919–1933 (Boston: Houghton Mifflin, 1957). There is also James Truslow Adams, The Epic of America (Boston: Little, Brown, 1931); Paul Carter, Another Part of the Twenties (New York: Columbia University Press, 1977); and the often inaccurate and opinionated but provocative Paul Johnson, Modern Times: The World from the 1920s to the 1980s (New York: Harper & Row, 1983). An important anthology of essays on the period is The Aspirin Age 1919–1941, ed. Isabel Leighton (New York: Simon & Schuster, 1949). The best recent collections of original documents are The Plastic Age (1917–1930), ed. Robert Sklar (New York: George Braziller, 1970); Fords, Flappers and Fanatics, ed. George E. Mowry (Englewood Cliffs, N.J.: Prentice Hall, 1963); and Ain't We Got Fun? Essays, Lyrics and Stories of the 1920s, ed. Barbara H. Solomon (New York: New American Library, 1980). Agnes Roger and Frederick Lewis Allen capture the era in photographs in I Remember Distinctly: A Family Album of the American People 1918–1941 (New York: Harper Bros., 1947).

The men who occupied the White House during the 1920s also tell us much about the era; studies on Woodrow Wilson are listed in the Bibliographical Essay for Chapter 3, those on Herbert Hoover under the Epilogue, but see also Robert K. Murray, The Harding Era (Minneapolis, Minn.: University of Minnesota Press, 1969); William Allen White, A Puritan in Babylon: The Story of Calvin Coolidge (New York: Macmillan, 1938); and The Talkative President: The Off-the-Record Press Conferences of Calvin Coolidge, eds. Howard H. Quint and Robert H. Ferrell (Amherst: University of Massachusetts Press, 1964). It is worth noting that all the Presidents of the decade save Coolidge had something like a breakdown in office, seeming to echo the boom-and-bust rhythm of the larger culture; Coolidge in any case seemed to be in a state of therapeutic arrest (told he had died, Dorothy Parker asked, "How could they tell?"). F.D.R. stabilized the office, though not the nation. Paula F. Fass, The Damned and the Beautiful: American Youth in the 1920s (New York: Oxford University Press, 1977) is an outstanding and detailed study of the changing mores and sexual habits of the Jazz Age.

For the city in general and New York in particular as an emblem of resistance to the Victorian reform impulse, the best book is Paul Boyer, Urban Masses and Moral Order in America 1820–1920 (Cambridge, Mass.: Harvard University Press, 1978). Also valuable on the image of the city are The Historian and the City, eds. Oscar Handlin and John Burchard (Cambridge, Mass.: Harvard University Press, 1963), especially the essays by Oscar Handlin and Frank Friedel; Morton and Lucia White, The Intellectual in the City: From Thomas Jefferson to Frank Lloyd Wright (Cambridge, Mass.: Harvard University Press, 1962); Don S. Kirschner, City and Country: Rural Responses to Urbanization in the 1920s (Westbrook, Conn.: Greenwood, 1970); and Anselm Strauss, Images of the American City (Glencoe, Ill.: The Free Press, 1961). Emerson's response to Margaret Fuller's move to New York is found in The Letters of Ralph Waldo Emerson, ed. Ralph Rusk (New York: Columbia University Press, 1939), Vol. 3, 19–20, 29. For late-Victorian ideas and representations of New York, see Matthew Hale Smith, Sunshine and Shadow in New York (Hartford, Conn.: J. B. Burr, 1869); Helen Campbell, Thomas W. Knox, and Thomas Byrnes, Darklight and Daylight, or Lights and Shadows of New York Life (Hartford, Conn.: A. D. Worthington, 1891); Josiah Strong, Our Country (1886; rpt., Cambridge, Mass.: Harvard University Press, 1963); Jacob Riis, How the Other Half Lives: Studies Among the Tenements of New York (1890, rpt., New York: Hill & Wang, 1957); and Theodore Dreiser, The Color of a Great City (New York: Horace Liveright,

1922). For an influential, positive, contemporary response to the city, see John Giffen Thompson, *Urbanization: Its Effects on Government and Society* (New York: E. P. Dutton, 1927).

The city's resistance to reform made it an emblem of the intractable unconscious whose workings Freud and others were studying and publicizing at the turn of the century; psychoanalysis might be said to have taken hold as an interpretative strategy when social control failed. Melville could describe New York in *Pierre* in much the same terms he used to describe the great whale in *Moby Dick*; both are emblems of the inscrutable forces within and without. This view of the **city as a vast collective unconscious** received its first influential expression in Baudelaire's essay "The Painter of Modern Life," collected in Charles Baudelaire, *Selected Writings on Art and Literature*, trans. P. E. Charvet (1972; rpt., New York: Penguin Books, 1992). A pathbreaking and stunning explication of the mysterious city is Carl Schorske's "The Idea of the City in European Thought: Voltaire to Spengler" in *Fin de Siècle Vienna: Politics and Culture: Seven Studies* (New York: Alfred A. Knopf, 1979). A number of modern European and American sociologists attempted to understand the city's workings, giving birth to the discipline of urbanology in the process; the most important of the Europeans were Max Weber, Georg Simmel, and Oswald Spengler. See Max Weber, *The City*, eds. Don Martindale and Gertrude Neuwirth (New York: Collier Books, 1962); selections from Weber, Simmel, and Spengler are available in *Classic Essays in the Culture of Cities*, ed. Richard Sennett (Englewood Cliffs, N.J.: Prentice Hall, 1969). Sennett's collection also includes essays by the two leading American theorists of the city, both based in Chicago, Robert E. Park (one of William James's students) and Louis Wirth. See Louis Wirth, "Urbanism as a Way of Life" in *American Journal of Sociology*, 44 (1938) and Roderick Duncan McKenzie, *The Metropolitan Community* (New York: McGraw-Hill, 1932). Richard Sennett, *The Fall of Public Man: On the Social Psychology of Capitalism* (New York: Alfred A. Knopf, 1974) is excellent on the influence of the modern city on manners; Peter Conrad, *The Art of the City: Views and Versions of New York* (New York: Oxford University Press, 1984) is a brilliant study of New York's powers to seduce in the modern era. Several books on New York by New Yorkers are also invaluable on its evocative powers and ambiance. See Paul Rosenfeld, *The Port of New York* (1924; rpt., Urbana: University of Illinois Press, 1961) and Benjamin de Casseres, *Mirrors of New York* (New York: Joseph Lauren, 1925); *Christopher Morley's New York* (New York: Fordham University Press, 1988) is a gifted reporter's coverage of all aspects of the city in the 1920s and 1930s.

The best short histories of New York are George J. Lankevich and Howard B. Furer, *A Brief History of New York City* (New York: Associated Faculty Press, 1984); Edward Robb Ellis, *The Epic of New York City* (New York: Coward-McCann, 1966); Smith Hart, *The New Yorkers: The Story of a People and Their City* (New York: Sheridan House, 1938); and the superb *New York Panorama* (New York: Random House, 1939) from the Federal Writers Project; the essay on Harlem is by Richard Wright. On the geography and look of the city, see Norval White, *New York: A Physical History* (New York: Atheneum, 1987); also Agnes Rogers and Frederick Lewis Allen, *Metropolis: An American City in Photographs* (New York: Harper Bros., 1934). John Kouwenhouven, *The Columbia Historical Portrait of New York: A Graphic History* (1955; rpt., New York: Harper & Row, 1972) is justly a classic. The development of the New York highway system is traced in Frederic L. Paxson, "The Highway Movement 1916–1935," *American Historical Review* 51 (January 1946), 236–53, and Kenneth T. Jackson, *Crabgrass Frontier: The Suburbanization of the United States* (New York: Oxford University Press, 1985).

Books on the city's architecture are listed in the Bibliographical Essay for Chapter 11. On the intellectual life of the city, see Thomas Bender, *New York Intellect* (New York:

Alfred A. Knopf, 1987) and *Towards an Urban Vision: Ideas and Institutions in Nine-teenth Century America* (Lexington: University of Kentucky Press, 1975) and Christopher Lasch, *The New Radicalism in America* (New York: Alfred A. Knopf, 1965).

On the life and politics of **James Walker**, see Gene Fowler, *Beau James: The Life and Times of Jimmy Walker* (New York: The Viking Press, 1949). Fowler was himself a colorful and influential reporter and a friend of Walker's; his portrait is highly stylized and favorable. For a more critical reading of the problems and errors that led to Walker's fall, see Herbert Mitgang, *The Man Who Rode the Tiger: The Life of Judge Samuel Seabury and the Story of the Greatest Investigation of City Corruption in This Century* (New York: The Viking Press, 1970) and Thomas Kessner, *Fiorello H. La Guardia and the Making of Modern New York* (New York: The Viking Press, 1989). For Roosevelt's role in deposing Walker, see Mitgang, *The Man Who Rode the Tiger* and Kenneth S. Davis, *FDR: The New York Years 1928–1933* (New York: Random House, 1985). An important source on New York politics in the Walker era is the memoir of New York Governor Alfred E. Smith, *Up from the City Streets: A Biographical Study in Contem-porary Politics* (New York: Grosset & Dunlap, 1927). See also Oscar Handlin's classic *Al Smith and His America* (Boston: Little, Brown, 1958).

Prohibition expressed and exacerbated the city-country hostilities of the era, since most cities were "wet" or for repeal of Prohibition while rural states and districts were "dry" and pro-Prohibition. The best studies of Prohibition and the role of drinking in American life are John Kobler, *Ardent Spirits: The Rise and Fall of Prohibition* (New York: G. P. Putnam, 1973); Mark Edward Lender and James Kirby Martin, *Drinking in American History* (New York: The Free Press, 1982); Norman H. Clark, *Deliver Us from Evil: An Interpretation of American Prohibition* (New York: W. W. Norton, 1976); Andrew Sin-clair, *Prohibition: The Era of Excess* (Boston: Little, Brown, 1962); Herbert Ashbury, *The Great Illusion: An Informal History of Prohibition* (Garden City, N.Y.: Doubleday, 1950); and *Carry Nation* (New York: Alfred A. Knopf, 1929); and the superb, analytic W. J. Rorabaugh, *The Alcoholic Republic: An American Tradition* (New York: Oxford University Press, 1979). On **bootlegging and nightclubs**, see Kenneth Alsop, *The Bootleggers and Their Era* (Garden City, N.Y.: Doubleday, 1961); Henry Lee, *How Dry We Were: Prohibition Revisited* (Englewood, N.J.: Prentice Hall, 1963); and Robert Sylvester, *No Cover Charge: A Backward Look at the Nightclubs* (New York: Dial Press, 1956). James Gavin picks up the story of the clubs in the 1940s and 1950s in *Intimate Nights: The Golden Age of the New York Cabaret* (New York: Limelight Editions, 1992).

There are several moving, anguished memoirs of **the drinking life** told by self-confessed alcoholics: see Jack London, *John Barleycorn* (1913; rpt., New York: Signet, 1990) and William Seabrook, *Asylum* (New York: Harcourt Brace, 1935) and *No Hiding Place* (Philadelphia: J. B. Lippincott, 1942). On drinking and the literary life more generally, the best book is Tom Dardis, *The Thirsty Muse: Alcohol and the American Writer* (New York: Ticknor & Fields, 1989); see also Thomas B. Gilmore, *Equivocal Spirits: Alcoholism and Drinking in Twentieth Century Literature* (Chapel Hill: University of North Carolina Press, 1987) and Donald Newlove, *Those Drinking Days: Myself and Other Writers* (New York: Horizon Books, 1989). Burton Bernstein describes Thurber's drinking in detail in his excellent biography, *Thurber* (New York: Dodd, Mead, 1975). Drinking and alco-holism form one of the great literary subjects of this generation, and Thurber left a haunting vignette of alcoholic loneliness in "One Is a Stranger," and a spoof of alcoholic decision-making in "If Grant Had Been Drinking at Appomattox"; both sketches are collected in *The Thurber Carnival* (New York: Harper Bros., 1945). See also Helen Thurber and Edward Weeks, eds. *Selected Letters of James Thurber* (Boston: Little, Brown, 1981). Louis Sheaffer covers O'Neill's drinking and later barbiturate addiction in his

superb two-volume biography, *O'Neill: Son and Playwright* (New York: Paragon Books, 1968) and *O'Neill: Son and Artist* (New York: Paragon Books, 1973), but the most detailed account of O'Neill's early alcoholism is that of his first wife, Agnes Boulton, *Part of a Long Story* (Garden City, N.Y.: Doubleday, 1958). O'Neill's most resonant dramatization of the alcoholic life is *The Iceman Cometh* (1947; rpt., New York: Vintage, 1967). Some of Robert Ripley's columns are collected in *Believe It or Not!* (New York: Simon & Schuster, 1929), a best-seller of the day, and his friend and biographer Bob Considine describes his extravagant life, alcoholism, and desperate end in *Ripley, The Modern Marco Polo* (Garden City, N.Y.: Doubleday, 1961).

For the rise of mass culture and the consumer society, the indispensable books are Warren I. Susman, *Culture as History: The Transformation of American Society in the Twentieth Century* (New York: Pantheon, 1984), and Richard Wightman Fox and T. Jackson Lears, eds., *The Culture of Consumption: Critical Essays in American History 1880–1980* (New York: Pantheon, 1983). Also extremely useful are Iain Chambers, *Popular Culture: The Metropolitan Experience* (London: Methuen, 1986); Luc Sante, *Low Life: Lures and Snares of Old New York* (New York: Farrar, Straus & Giroux, 1990); Daniel Horowitz, *The Morality of Spending: Attitudes Toward the Consumer Society in America, 1875–1940* (Baltimore, Md.: The Johns Hopkins University Press, 1985); Lawrence Levine, *Highbrow/Lowbrow: The Emergence of Cultural Hierarchy in America* (Cambridge, Mass.: Harvard University Press, 1988); Herbert G. Gans, *Popular Culture and High Culture: An Analysis and Evaluation of Taste* (New York: Basic Books, 1974); Russell Nye, *The Unembarrassed Muse: The Popular Arts in America* (New York: Dial Press, 1970); see also Edward Shils, "Daydreams and Nightmares: Reflections on the Criticism of Mass Culture," *Sewanee Review* 65 (1957), 587–608; David Madden, "The Necessity for an Aesthetic of Popular Culture," *Journal of Popular Culture* 7 (1973), 1–13; Norman F. Cantor and Michael S. Werthman, *The History of Popular Culture Since 1915* (London: Macmillan, 1968); John W. Cawelti, "Notes Towards an Aesthetic of Popular Culture," *Journal of Popular Culture* 5 (1971), 255–68; Joffre Dumazadier, *Toward a Society of Leisure*, trans. Stewart E. McClure (New York: The Free Press, 1967); *Mass Culture: The Popular Arts in America*, eds. Bernard Rosenberg and David Manning White (New York: The Free Press, 1957); *Mass Leisure*, eds. Eric Larrabee and Rolf Meyersohn (Glencoe, Ill.: The Free Press, 1958); Leo Lowenthal, *Literature, Popular Culture and Society* (Palo Alto: University of California Press, 1961); Patrick Brantlinger, *Bread & Circuses: Theories of Mass Culture as Social Decay* (Ithaca, N.Y.: Cornell University Press, 1983); and Neil Postman, *Amusing Ourselves to Death: Public Discourse in the Age of Show Business* (New York: Elisabeth Sifton Books, 1984).

The standard work on the **development of radio** is Eric Barnouw, *A Tower in Babel: A History of Broadcasting in the United States*, 2 vols. (New York: Oxford University Press, 1966). Television, too, was a development of the 1920s, though sets were not broadly marketed until the post-World War II years. See Eric Barnouw, *Tube of Plenty: The Evolution of American Television* (New York: Oxford University Press, 1977). On the **development of the movie industry**, see Lewis Jacobs, *The Rise of the American Film: A Critical History* (1939; rpt., New York: Teachers College, Columbia University, 1968) and Robert Sklar, *Movie-Made America: A Social History of American Movies* (New York: Random House, 1975). Hollywood stars who campaigned for Liberty Bonds are discussed in Larry May's extremely useful *Screening Out the Past: The Birth of Mass Culture and the Motion Picture Industry* (New York: Oxford University Press, 1980). Waldo Frank, *In the American Jungle 1925–1936* (New York: Farrar and Rinehart, 1937) is a troubled study in mass-culture psychology by a contemporary. Edward Bernays describes his **advertising** tactics and campaigns in *Biography of an Idea: Memoirs of Public*

Relations Counsel Edward L. Bernays (New York: Simon & Schuster, 1965). John Kouwenhoven's study of the relationship between American technology and popular culture, *Made in America: The Arts in Modern Civilization* (Garden City, N.Y.: Doubleday, 1948), is classic; John F. Kasson has brought Kouwenhoven's approach to new heights in *Civilizing the Machine: Technology and Republican Values in America 1770–1900* (1976; rpt., New York: Penguin Books, 1977) and *Amusing the Million: Coney Island at the Turn of the Century* (New York: Hill & Wang, 1978). For racism as the unifying force in early mass culture and its later difficulties in the light of this heritage, see the excellent study by David Nassow, *Going Out: The Rise and Fall of Public Amusements* (New York: Basic Books, 1994).

In the last ten years, studies of mass culture have focused largely on its postmodern phase, one quite different, as I argue in Chapter 1, from its 1920s incarnation; most of these studies lie outside the scope of my book, but see *The Anti-Aesthetic: Essays on Postmodern Culture*, ed. Hal Foster (Port Townsend, Wash.: Bay Press, 1983) and *Postmodernism and Its Discontents: Theories, Practices*, ed. E. Ann Kaplan (London: Verso, 1988) for an interesting selection of recent essays. The most distinguished theoretical studies of postmodern mass culture are Andrew Ross, *No Respect: Intellectuals & Popular Culture* (New York: Routledge, 1989) and Frederic Jameson, *The Ideologies of Theory: Essays 1971–1986* (Minneapolis: University of Minnesota Press, 1988), especially "The Politics of Theory: Ideological Positions in the Postmodern Debate" and "Periodicizing the 60s." John Storey, *An Introductory Guide to Cultural Theory and Popular Culture* (Athens: University of Georgia Press, 1993) is an extremely useful general survey from Matthew Arnold to the present.

Dorothy Parker's verses on "Mrs. Stowe" are in *Sunset Gun* (1928), collected in *The Portable Dorothy Parker*, ed. Brendan Gill (New York: The Viking Press, 1973). The best biography is Marion Meade, *Dorothy Parker: What Fresh Hell Is This?* (New York: Villard, 1988), though John Keats's *You Might As Well Live: The Life and Times of Dorothy Parker* (New York: Simon & Schuster, 1970), while occasionally inaccurate, is still a vivid and compelling presentation. As yet, no one has dated or located the first appearance of Parker's various poems and sketches. On the Algonquin Circle more generally, see James R. Gaines, *Wit's End: Days and Nights of the Algonquin Round Table* (New York: Harcourt Brace Jovanovich, 1977) for a factual, intelligent, but unduly harsh and shortsighted reading. The inventive comic spirit of the group is better conveyed in memoirs by contemporaries, particularly those of the Algonquin's owner, Frank Case, *Tales of a Wayward Inn* (New York: Frederick A. Stokes, 1938) and *Do Not Disturb* (New York: Frederick A. Stokes, 1940); his daughter, Margaret Case Harriman, *Blessed Are the Debonair* (New York: Rinehart, 1956) and *The Vicious Circle: The Story of the Algonquin Round Table* (New York: Rinehart, 1951); and Round Tablers Donald Ogden Stewart, *By a Stroke of Luck! An Autobiography* (New York: Paddington Press, 1975) and Marc Connelly, *Voices Offstage: A Book of Memoirs* (New York: Holt, Rinehart & Winston, 1968). Robert E. Drennan has anthologized selections of their work in *The Algonquin Wits* (New York: Citadel, 1968). A selection from Franklin P. Adams's newspaper columns can be found in *The Diary of Our Own Samuel Pepys*, 2 vols. (New York: Simon & Schuster, 1935), and *The Column Book of F.P.A.* (Garden City, N.Y.: Doubleday, 1928). The dramatist S. N. Behrman, who knew many of the members of the Algonquin circle, gives a moving and thoughtful picture of some of them, particularly Woollcott, in his memoir, *People in a Diary* (Boston, Mass.: Little, Brown, 1972).

Moss Hart's poignant and witty memoir, *Act One: An Autobiography* (New York: Random House, 1959), and Ben Hecht's contrived but insightful reminiscences, most notably *A Child of the Century* (New York: Simon & Schuster, 1954) and *Charlie: The*

Improbable Life and Times of Charles MacArthur (New York: Harper Bros., 1957) are also valuable. For Raymond Chandler, see *Selected Letters of Raymond Chandler*, ed. Frank MacShane (New York: Columbia University Press, 1981) and Frank MacShane, *The Life of Raymond Chandler* (New York: E. P. Dutton, 1976).

Robert Benchley was a friend of James Walker, and his essay on criminals, "First Catch Your Criminal," is collected in *The Benchley Roundup: The Best of Benchley*, ed. Nathaniel Benchley (New York: Harper & Row, 1976). Most of Benchley's work is out of print, but he was the most widely loved of the Algonquinites and remains the funniest and smartest observer of the New York cultural scene in the modern era. The two best collections of his sketches are *Of All Things* (New York: Harper Bros., 1921) and *Love Conquers All* (New York: Henry Holt, 1922); his drama criticism has been republished as *Benchley at the Theatre*, ed. Charles Getchell (Ipswich, Mass.: The Ipswich Press, 1985). Norris W. Yates, *The American Humorist: Conscience of the Twentieth Century* (Ames: Iowa State University Press, 1964) and *Robert Benchley* (New York: Twayne, 1968) include intelligent discussions of Benchley's persona and goals. There is as yet no adequate biography; Nathaniel Benchley's *Robert Benchley* (New York: McGraw-Hill, 1955) is affectionate but heavily censored, with little or no discussion of Benchley's alcoholism and compulsive womanizing.

Louise Brooks's relationship to New York is discussed in her own *Lulu in Hollywood* (New York: Alfred A. Knopf, 1982) and Barry Paris, *Louise Brooks* (New York: Alfred A. Knopf, 1989); **Damon Runyon's** in Edwin P. Hoyt, *A Gentleman of Broadway* (Boston: Little, Brown, 1964) and Tom Clark, *The World of Damon Runyon* (New York: Harper & Row, 1978). For some of his best work, see *The Bloodhounds of Broadway and Other Stories by Damon Runyon* (New York: William Morrow, 1981). Damon Runyon, Jr., *Father's Footsteps* (New York: Random House, 1953) is a moving account of his later years. Gene Fowler, *Skyline: A Reporter's Reminiscence of the 1920s* (New York: The Viking Press, 1961), contains a vivid account of his own arrival in New York from Colorado; Runyon took him to a subway station and said, "Listen"—the city was talking.

Arna Bontemps writes of his **response to Harlem** in "The Awakening: A Memoir," in *The Harlem Renaissance Remembered*, ed. Arna Bontemps (New York: Dodd, Mead, 1972). Mae Gwendolyn Henderson's "Portrait of **Wallace Thurman**," which gives the most complete account of his life and art, is in the same collection. Gerald Haslem, "Wallace Thurman" in *Western American Literature* (Spring 1971); Dorothy West, "Elephant's Dance: A Memoir of Wallace Thurman," *Black World* (November 1971); and Daniel Walden, " 'The Canker Galls . . .' or, The Short Promising Life of Wallace Thurman," in *The Harlem Renaissance Reexamined*, ed. Victor A. Kramer (New York: AMS Press, 1987), are also useful.

See *The Letters of Hart Crane, 1916–1932*, ed. Brom Weber (New York: Hermitage, 1952) and *Letters of Edna St. Vincent Millay*, ed. Allen Ross Macdougall (New York: Grosset & Dunlap, 1952) for their **responses to New York**, and E. B. White, "Here Is New York," in *The Essays of E. B. White* (New York: Harper & Row, 1977). Rudolph Fisher's "City of Refuge" is in *The New Negro*, ed. Alain Locke. Leacock's sketch "A Hero in Homespun" is in *Nonsense Novels* (1911; rpt., Toronto: McClelland and Stewart, 1969). On **Walter Winchell** and New York, see St. Clair McKelway, "Gossip Writer," *The New Yorker* (June 15, 22, 29, 1940) and Walter Winchell, *Winchell Exclusive* (Englewood Cliffs, N.J.: Prentice Hall, 1975); see also John Mosedale, *The Men Who Invented Broadway: Damon Runyon, Walter Winchell & Their World* (New York: Richard Marek, 1981); of interest for the Winchell legend is Michael Herr, *Walter Winchell: A Novel* (New York: Alfred A. Knopf, 1990).

Zelda Fitzgerald treats New York in her novel, *Save Me the Waltz* (1932), collected

in *Zelda Fitzgerald: The Collected Writings*, ed. Matthew J. Bruccoli (New York: Scribner's, 1991). See also Nancy Milford, *Zelda: A Biography* (New York: Harper & Row, 1970). The best biography of F. Scott Fitzgerald is Matthew J. Bruccoli, *Some Sort of Epic Grandeur: The Life of F. Scott Fitzgerald* (New York: Harcourt Brace, 1981). More limited in scope but very insightful is Scott Donaldson, *Fool for Love: F. Scott Fitzgerald* (New York: Congdon & Weed, 1983); also excellent is André Le Vot, *F. Scott Fitzgerald: A Biography*, trans. William Byron (Garden City, N.Y.: Doubleday, 1983). Bruccoli and Margaret M. Duggan have edited the *Correspondence of F. Scott Fitzgerald* (New York: Random House, 1980); *The Letters of F. Scott Fitzgerald*, ed. Andrew Turnbull (New York: Delta Books, 1965) contains material not in Bruccoli and Dugan, as do *As Ever, Scott Fitz—Letters Between F. Scott Fitzgerald and His Literary Agent, Harold Ober 1919–1940*, ed. Matthew J. Bruccoli (Philadelphia, Pa.: J. B. Lippincott, 1972) and *Dear Scott, Dear Max*, eds. John Kuehl and Jackson R. Bryer (New York: Scribner's, 1971). *The Notebooks of F. Scott Fitzgerald*, ed. Matthew J. Bruccoli (New York: Harcourt Brace, 1978) is also an invaluable biographical source. The best single critical study of Fitzgerald is still Matthew J. Bruccoli, *The Composition of Tender Is the Night: A Study of the Manuscripts* (Pittsburgh, Pa.: University of Pittsburgh Press, 1963). James R. Mellow, while a superb biographer of Gertrude Stein and Ernest Hemingway, has done the Fitzgeralds and their students a disservice in *Invented Lives: F. Scott & Zelda Fitzgerald* (Boston, Mass.: Houghton Mifflin, 1984) by a presentation so ungenerous (particularly to Scott) as to verge occasionally on distortion of the materials consulted. Jeffrey Meyers, *Scott Fitzgerald: A Biography* (New York: HarperCollins, 1994) is detailed on his alcoholism but blind to his gifts and achievements, even punitive. Fitzgerald's recent largely male American biographers and critics, and their inability to respect their subject, would repay study.

On book clubs, see Charles A. Madison, *Book Publishing in America* (New York: McGraw-Hill, 1966). On the Melville revival in New York in the 1920s, see Michael P. Zimmerman, "Herman Melville in the 1920s: A Study in the Origins of the Melville Revival with an Annotated Bibliography," unpublished Ph.D. dissertation, Columbia University, 1963. For crucial essays and books on Melville by New York critics of the 1920s, see Carl Van Vechten, "The Later Work of Herman Melville," in *Excavations: A Book of Advocacies* (1926; rpt., New York: Books for Libraries Press, 1971); Carl Van Doren, "Lucifer from Nantucket: An Introduction to *Moby Dick*," *Century* (August 1925), 495–501; Raymond M. Weaver, *Herman Melville, Mariner and Mystic* (1921; rpt., New York: Pageant Books, 1961); Lewis Mumford, *Melville* (New York: Harcourt Brace, 1929); and Henry A. Murray, "In Nomine Diaboli," *Endeavors in Psychology: Selections from the Personology of Henry A. Murray*, ed. Edwin S. Shneidman (New York: Harper & Row, 1981). Mumford's immersion in Melville almost produced a nervous breakdown; see Donald L. Miller, *Lewis Mumford: A Life* (New York: Weidenfeld & Nicolson, 1989).

1 WHITE MANHATTAN IN THE AGE OF "TERRIBLE HONESTY"

For the mood of the Victorian era as it neared its end, the best book is still Henry F. May's vivid, judicious study *The End of American Innocence: A Study of the First Years of Our Own Time 1912–1917* (1959; rpt., Chicago, Ill.: Quadrangle Books, 1964). See also his "The Revolt of the Intellectuals, 1912–1917," in *Ideas, Faiths and Feelings: Essays on American Intellectual and Religious History 1952–1982* (New York: Oxford University Press, 1983). The seminal book that precipitated and expressed modern dis-

illusion with Victorian ideals was Lytton Strachey's best-selling *Eminent Victorians* (1918; rpt., New York: Harcourt Brace, n.d.).

For *Pollyanna* and other **Mind-cure fiction** on the prewar best-seller list, see James D. Hart, *The Popular Book: A History of America's Literary Taste* (New York: Oxford University Press, 1950); Frank Luther Mott, *Golden Multitudes: The Story of Best Sellers in the United States* (New York: Macmillan, 1947); and Alice Payne Hackett, *Sixty Years of Best-Sellers 1895–1955* (New York: R. R. Bowker, 1956). *Pollyanna's* author Eleanor Porter (1868–1920) was the daughter of a New England Congregationalist minister. She died, with odd appropriateness, in 1920, right after the war, but much of Pollyanna's spirit resurfaced in the Shirley Temple vehicles of the 1930s; Walt Disney remade *Pollyanna* as late as 1960 with Hayley Mills. For details on Porter, see Fred E.H. Schroder's entry on her in *Notable American Women*, ed. Edward T. Jones, Vol. 3 (Cambridge, Mass.: Harvard University Press, 1971) and Grant Overton, *The Women Who Make Our Novels* (New York: Moffat, Yard, 1922). Overton warns those "who are sophisticated, worldworn, cynical and merely flippant" to "stand aside!" By 1933, the National Council of Women more or less officially reclassified *Pollyanna* as a "juvenile" entry; see *The One Hundred Best Books by American Women . . . 1933–1937 as chosen for the National Council of Women*, ed. Anita Browne (Chicago, Ill.: Associated Authors Service, 1933). James Truslow Adams's essay on "Pollyanna, Our Patron Goddess" is included in his collection *The Tempo of Modern Life*.

On the **Mind-cure movements**, the definitive work remains the wide-ranging, insightful study by Donald Meyers, *The Positive Thinkers: A Study of the American Quest for Health, Wealth and Personal Power from Mary Baker Eddy to Norman Vincent Peale* (Garden City, N.Y.: Doubleday, 1965). T. J. Jackson Lears, *No Place of Grace: Antimodernism and the Transformation of American Culture 1880–1920* (New York: Pantheon, 1981) is massively researched, excellent on the Mind-cure mentality in all its permutations among the elite at the close of the Victorian era. Further information on Mind cure and Spiritualism can be found in the Bibliographical Essay for Chapter 3.

Brendan Gill, *Here at The New Yorker* (New York: Random House, 1975) is detailed, informative, and witty on the *New Yorker* staff and ethos; James Thurber's *The Years with Ross* (New York: Grosset & Dunlap, 1959), while exceedingly controversial among *New Yorker* writers—Katharine and E. B. White considered the book self-serving and unfair to Ross; their friendship with Thurber never really recovered—is still a vivid portrait and a comic masterpiece. *Ross, The New Yorker and Me* (New York: Raynel, 1968), written by Ross's ex-wife, Jane Grant, is also a marvelous memoir of the *New Yorker* circle. E. B. White's complicated but warm relationship with Ross is detailed in Scott Elledge, *E. B. White: A Biography* (New York: W. W. Norton, 1985) and *The Letters of E. B. White*, ed. Dorothy Lobrano Guth (New York: Harper & Row, 1978). Linda H. Davis, *Onward and Upward: A Biography of Katharine S. White* (New York: Harper & Row, 1987) is revealing about Katharine White and *The New Yorker*, though it is superficial and overpious. S. J. Perelman's satiric sketches of consumer culture, which first began appearing in *The New Yorker* and elsewhere in the early 1930s, are collected in *The Most of S. J. Perelman* (New York: Simon & Schuster, 1958); see Dorothy Hermann, *S. J. Perelman: A Life* (New York: G. P. Putnam, 1986) for his troubled life.

To date, the only biography of **Horace Liveright** is Walker Gilmer's accurate but unimaginative *Horace Liveright: Publisher of the Twenties* (New York: David Lewis, 1970), though Tom Dardis is working on a detailed study. Like most of his contemporaries, Liveright was theater-struck, bringing the English production of *Dracula* to Broadway in 1927, producing *Hamlet in Modern Dress*, set in New York, in 1925, and trying unsuccessfully to break into Hollywood as a producer-director shortly before his death of

alcoholism in 1933. It seems inevitable that his co-worker **Donald Friede**, who left the best account of 1920s publishing in New York in *The Mechanical Angel: His Adventures and Enterprises in the Glittering 1920s* (New York: Alfred A. Knopf, 1948), also went to Hollywood in the 1930s to try to establish himself as an agent; he had an affair with Jean Harlow and tried (in vain) to persuade her to marry him. See David Stenn, *Bombshell: The Life and Death of Jean Harlow* (New York: Doubleday, 1993).

On **advertising** and the rise of Madison Avenue, the definitive study is Roland Marchand's exhaustive, brilliant *Advertising the American Dream*. Useful on the advertising ethos as well are Michael Scudson, *Advertising: The Uneasy Persuasion: Its Dubious Effects on American Society* (New York: Basic Books, 1984); Vance Packard, *The Hidden Persuaders* (rpt., New York: Washington Square Press, 1980); J.A.C. Brown, *Techniques of Persuasion: From Propaganda to Brainwashing* (London: Cox & Wyman, 1963); and Stephen Fox, *The Mirror Makers: A History of American Advertising and Its Creators* (New York: William Morrow, 1985). Steward Ewen, *Captains of Consciousness: Advertising and the Social Roots of Consumer Culture* (New York: McGraw-Hill, 1976), while flawed by a too literal reading of advertising claims and a heavy-handed conspiracy theory, is nonetheless insightful and provocative. David Potter, *People of Plenty: Economic Abundance and the American Character* (Chicago, Ill.: University of Chicago Press, 1954) is still seminal.

Several contemporary accounts of advertising by insiders are valuable: see especially Walter Dill Scott, "The Psychology of Advertising," *The Atlantic Monthly* 93 (1904), 29–36, which marks the beginning of Freudian influences on Madison Avenue. James Presbrey, *The History and Development of Advertising* (Garden City, N.Y.: Doubleday, 1929) conveys all the excitement of the industry in its early days. James Rorty, a disillusioned veteran of Madison Avenue, wrote the pioneering critique of its social and class biases in *Our Master's Voice: Advertising* (New York: John Day, 1934) and Walter Lippmann in *The Phantom Public* (New York: Harcourt Brace, 1925) takes a grim and elitist view of publicity culture more generally. E. S. Turner, *The Shocking History of Advertising* (London: Michael Joseph, 1952) and James Pleysted Wood, *The Story of Advertising* (New York: Ronald Press, 1958) give colorful accounts of its excesses.

Roi Cooper Magrue's and Walter Hackett's *It Pays to Advertise* is anthologized in *Representative American Plays*, ed. Montrose Moses (Boston, Mass.: Little, Brown, 1931); Marianne Moore's affinities with advertising are discussed in Charles Molesworth's excellent biography, *Marianne Moore: A Literary Life* (New York: Atheneum, 1990). Edmund Wilson—perhaps Fitzgerald's closest friend, who served as intellectual mentor and astute, if palpably envious, critic (Fitzgerald in turn found Wilson at times a bit "sec," or dry, but gave him the same generous and free-spirited devotion he brought to all his friendships)—comments on Fitzgerald's proclivities for advertising in one of his finest essays, a witty "Imaginary Dialogue" entitled "The Delegate from Great Neck," in *The Shores of Light: A Literary Chronicle of the Twenties and Thirties* (1952; rpt., New York: Farrar, Straus & Giroux, 1974); the essays in *Shores of Light* comprise an invaluable commentary on the modern New York scene. Wilson discussed the theatrical nature of Fitzgerald's talent in "A Weekend at Ellerslie" and "F. Scott Fitzgerald," both collected in *The Shores of Light*, and the problems of "language developed beyond its theme" in the aptly titled "The Muses Out of Work" in the same volume. For Fitzgerald's self-advertisements, see "Self-Interview," "The Credo of F. Scott Fitzgerald," "What I Was Advised to Do and Didn't," "How I Would Sell My Books," and "All Women over Thirty-five Should Be Murdered," in *F. Scott Fitzgerald in His Own Time*, eds. Matthew J. Bruccoli and Jackson R. Bryer (New York: Popular Library, 1971), and "How to Live on $36,000 a Year," "How to Live on Practically Nothing a Year," and "Ten Years in

the Advertising Business" in F. Scott Fitzgerald, *Afternoons of an Author: A Selection of Uncollected Stories and Essays*, ed. Arthur Mizener (New York: Scribner's, 1957).

The best books on **Babe Ruth** are Robert W. Creamer, *Babe: The Legend Comes to Life* (New York: Penguin Books, 1974) and Ken Sobol, *Babe Ruth and the American Dream* (New York: Ballantine Books, 1974); Sobol, while overharsh, is particularly astute in reading his career and personality as part of the developing advertising ethos of the day. Dorothy Ruth Pirone remembers her father in his pathos as well as his glory in *My Dad the Babe: Growing Up with an American Hero* (Boston, Mass.: Quinlan Press, 1988).

The best recent biography of **Sigmund Freud** is Peter Gay, *Freud: A Life for Our Time* (New York: W. W. Norton, 1988); despite his downplaying or evasion of Freud's driven, even demonic nature, Gay offers a balanced, intelligent account of Freud's development and gives unusually full consideration to the larger cultural context of psychoanalysis in Europe and the United States. Ernest Jones's monumental hagiography, *The Life and Work of Sigmund Freud*, is available in an abridged volume, eds. Lionel Trilling and Steven Marcus (1960, rpt., Garden City, N.Y.: Anchor Books, 1963). All citations to Freud's works, unless otherwise specified, are to *The Standard Edition of the Complete Psychological Works*, trans. under the general editorship of James Strachey in collaboration with Anna Freud, assisted by Alix Strachey and Alan Tyson, 24 vols. (London: Hogarth Press, 1953–74; hereafter abbreviated as *SE*); the major works of this edition are available in paperback from Collier Books under the general editorship of Philip Rieff. Rieff has written what still stands as the single best book on Freud in English, *Freud: The Mind of the Moralist* (Chicago, Ill.: University of Chicago Press, 1959; 3d ed., 1979); see also his brilliant study *The Triumph of the Therapeutic: Uses of Faith after Freud* (New York: Harper Bros., 1966), which contains the best analysis available of Jung's and Freud's relative strengths and weaknesses. On the broader development of psychoanalysis, Henri F. Ellenberger's magisterial, humane *The Discovery of the Unconscious* (New York: Basic Books, 1970) is indispensable. The major collections of letters are *The Letters of Sigmund Freud*, trans. Tania and James Stern (New York: Toronto, 1964); *The Freud/Jung Letters*, trans. Ralph Manheim and R.F.C. Hull and ed. William McGuire (Princeton, N.J.: Princeton University Press, 1974); and *The Complete Letters of Sigmund Freud to Wilhelm Fliess 1887–1904*, trans. and ed. Jeffrey Moussaieff Masson (Cambridge, Mass.: Harvard University Press, 1985).

Freud's writings on therapeutic technique are in *Freud, Therapy and Technique* (New York: Collier Books, 1963); "Psychoanalytic Method" (1904) and the three essays on "Further Recommendations in the Technique of Psychoanalysis" (1913, 1914, 1915) have special relevance to Madison Avenue "scare copy." **Freud wrote on "hysteria"** throughout his early career: see Sigmund Freud and Josef Breuer, *Studies on Hysteria* (1895; rpt. New York: Avon Books, 1966); Freud, *Early Psychoanalytic Writings* (New York: Collier Books, 1963), particularly the essays on "Charcot" (1893) and "The Aetiology of Hysteria" (1896); and Freud, *Dora: An Analysis of a Case of Hysteria 1905* (New York: Collier Books, 1963). Freud's work on hysteria has attracted much, often critical attention in recent decades: the most important studies are William J. McGrath, *Freud's Discovery of Psychoanalysis: The Politics of Hysteria* (Ithaca, N.Y.: Cornell University Press, 1986); Wayne Koestenbaum, *Double Talk: The Erotics of Male Literary Collaboration* (New York: Routledge, 1989); *In Dora's Case: Freud-Hysteria-Feminism*, eds. Charles Bernheimer and Claire Kahane (New York: Columbia University Press, 1985), particularly the essays by Charles Bernheimer, Jacqueline Rose, Toril Moi, Jane Gallop, and Neil Hertz; *Seduction Theory: Readings of Gender, Repression and Rhetoric*, ed. Dianne Hunter (Urban: University of Illinois Press, 1989), especially the essays by Dianne Hunter and Martha Noel Evans; Steven Marcus, *Freud and the Culture of Psychoanalysis: Studies*

in the Transition from Victorian Humanism to Modernity (Boston, Mass.: George Allen & Unwin, 1984); and Robin Tolmach Lakoff and James Coyne, *Father Knows Best: The Use and Abuse of Power in Freud's Case of Dora* (New York: Teachers College Press, 1993). Jeffrey Masson has taken a controversial but important, highly critical position on Freud and his work with hysterics in *The Assault on Truth: Freud's Suppression of the Seduction Theory* (New York: Farrar, Straus & Giroux, 1984).

Freud's essay "Instincts and Their Vicissitudes" is collected in *A General Selection from the Works of Sigmund Freud*, ed. John Rickman (Garden City, N.Y.: Anchor Books, 1957); "Thoughts for the Times on War and Death" is in *Freud on Creativity and the Unconscious*, ed. Benjamin Nelson (New York: Harper Bros., 1958); "Psychopathic Characters on the Stage" is in *SE*, Vol. 7, 303–10; "The Passing of the Oedipus-Complex" is in *Sexuality and the Psychology of Love* (New York: Collier Books, 1963); *Leonardo da Vinci and a Memoir of His Childhood* and *Beyond the Pleasure Principle* are also Collier books. Peter Brooks is brilliant on Freud's idea of the "death instinct" in *Reading for the Plot* (New Haven, Conn.: Yale University Press, 1984). Books on other aspects of Freud's life and thought can be found in the Bibliographical Essays for Chapters 3–6.

On **Sarah Bernhardt** and Freud, see Nina Auerbach's imaginative, erudite *Woman and the Demon: The Life of a Victorian Myth* (Cambridge, Mass.: Harvard University Press, 1982). On Bernhardt's life and art, see the evocative but sometimes sketchy Arthur Gold and Robert Fizdale, *The Divine Sarah: A Life of Sarah Bernhardt* (New York: Alfred A. Knopf, 1991); Cornelia Otis Skinner's robust *Madame Sarah* (Boston, Mass.: Houghton Mifflin, 1967); and *Bernhardt and the Theatre of Her Time*, ed. Eric Salmon (rpt., Westport, Conn.: Greenwood Press, 1977). Sardou's *Théodora* is available in *Illustration Théatricale*, Vol. 5 (1907). Bernhardt's pornographic appeal was closely tied, if not to the death instinct, to necrophilia; she was famous for dying onstage in a variety of ways, all dramatic and protracted, and Freud was palpably thrilled to witness her strangulation in the last act of *Théodora*.

Hysteria had been diagnosed and discussed for decades before Freud studied it. Ilsa Veith provides a useful survey, beginning with the Greeks, in *Hysteria: The History of a Disease* (Chicago, Ill.: University of Chicago Press, 1965). On the treatment of hysteria in nineteenth-century America, see *Women and Health in America: Historical Readings*, ed. Judith Walzer Leavitt (Madison: University of Wisconsin Press, 1984), particularly the essays by Ann Douglas Wood and Regina Markell Morrantz; and Carroll Smith-Rosenberg, *Disorderly Conduct: Visions of Gender in Victorian America* (New York: Alfred A. Knopf, 1985). G. J. Barker-Benfield, *The Horrors of the Half-Known Life: Male Attitudes Toward Women and Sexuality in Nineteenth-Century America* (New York: Harper & Row, 1977) is a valuable study of male gynecologists and their views. A *Dark Science: Women, Sexuality, and Psychiatry in the Nineteenth Century*, ed. Jeffrey Moussaieff Masson (New York: Farrar, Straus & Giroux, 1986) and Elaine Showalter, *The Female Malady: Women, Madness and English Culture 1830–1980* (rpt., New York: Penguin Books, 1987) offer important comparative material and analysis. On the pornographic tradition of Freud's day, see Steven Marcus, *The Other Victorians: A Study of Pornography in Mid-Nineteenth Century England* (rpt., New York: Meridian Books, 1977). The freak-show tradition is traced and analyzed in Robert Bogdan's excellent study, *Freak Show: Presenting Human Oddities for Amusement and Profit* (Chicago, Ill.: University of Chicago Press, 1988).

For the shift in **sexual mores in post-Great War America**, see Paula Fass, *The Damned and the Beautiful* (New York: Oxford University Press, 1977); John D'Emilio and Estelle B. Friedman, *Intimate Matters: A History of Sexuality in America* (New York: Harper & Row, 1988) and Glenda Riley, *Divorce: An American Tradition* (New York: Oxford

University Press, 1991). For the devaluation of the mother, see Glenna Matthews's perceptive, compact study, *"Just a Housewife": The Rise and Fall of Domesticity in America* (New York: Oxford University Press, 1987); for a broader survey of domestic work, see Susan Strasser, *Never Done: The History of American Housework* (New York: Pantheon, 1982).

The best general studies of **woman's changing role** are Carl Degler, *At Odds: Women and the Family in America from the Revolution to the Present* (New York: Oxford University Press, 1980); Nancy F. Cott, *The Grounding of Modern Feminism* (New Haven, Conn.: Yale University Press, 1987); William Henry Chafe, *The American Woman: Her Changing Economic and Political Roles, 1920–1970* (New York: Oxford University Press, 1972) and *The Paradox of Change: American Women in the 20th Century* (New York: Oxford University Press, 1991); Mary Ryan, *Womanhood in America: From Colonial Times to the Present* (New York: New Viewpoints, 1971); and Sheila M. Rothman, *Women's Proper Place: A History of Changing Ideals and Practices, 1870 to the Present* (New York: Basic Books, 1978). For **Margaret Sanger and birth control**, see Ellen Chesler's superb biography, *Woman of Valor: Margaret Sanger and the Birth Control Movement in America* (New York: Simon & Schuster, 1992) and Margaret Sanger, *An Autobiography* (New York: W. W. Norton, 1938).

For the new antagonism to the prevailing pruderies, see **Heywood Broun** and Margaret Leech's attack on Anthony Comstock, the powerful crusader for censorship of all kinds, *Anthony Comstock: Roundsman of the Lord* (New York: Boni & Liveright, 1927) and Leslie Fishbein, *Rebels in Bohemia* (Chapel Hill: The University of North Carolina Press, 1982). For Heywood Broun as an outspoken but uneasy, ambivalent rebel, see Dale Kramer, *Heywood Broun: An Autobiographical Portrait* (New York: Current Books, 1949) and *Collected Edition of Heywood Broun*, ed. Heywood Hale Broun (Freeport, N.Y.: Libraries Press, 1941).

Greenwich Village was the headquarters of the revolt in sexual mores; see Caroline F. Ware, *Greenwich Village 1910–1930: A Comment on American Civilization* (Boston, Mass.: Houghton Mifflin, 1935); Floyd Dell, *Love in Greenwich Village* (New York: George H. Doran, 1923) and *Homecoming: An Autobiography* (New York: Farrar and Rinehart, 1933). Dell writes about **Edna St. Vincent Millay** as "It" in the Village; so does Edmund Wilson in his extraordinary and just homage, "Edna St. Vincent Millay" (1952), included in *The Shores of Light*.

We still await a full and up-to-date biography of Millay; although sometimes inaccurate and virtually silent on her bisexuality and alcoholism, Miriam Gurko, *Restless Spirit: The Life of Edna St. Vincent Millay* (New York: Thomas Y. Crowell, 1962) and Norman A. Brittin, *Edna St. Vincent Millay* (New York: Twayne, 1967) are useful. The memoirs by two of her friends, Vincent Sheehan, *The Indigo Bunting* (New York: Harper Bros., 1952) and Max Eastman, *Great Companions: Critical Memoirs of Some Famous Friends* (New York: Farrar, Straus & Cudahy, 1959), are candid and insightful. William Drake discusses Millay intelligently in *The First Wave: Women Poets in America 1915–1945* (New York: Macmillan, 1987), but, like Jane Stanborough in her essay "Edna St. Vincent Millay and the Language of Vulnerability," in *Shakespeare's Sisters: Feminist Essays on Women Poets*, eds. Sandra M. Gilbert and Susan Gubar (Bloomington: Indiana University Press, 1979), he misses her strength, even toughness. Frances O. Mattson, *Edna St. Vincent Millay* (New York: New York Public Library, 1991) and Joan Dash, *A Life of One's Own* (New York: Harper & Row, 1973) are useful studies; see also *Critical Essays on Edna St. Vincent Millay*, ed. William B. Thesing (New York: Macmillan, 1993). Millay takes on Comstockery in "Our All-American Almanac and Prophetic Messenger,"

a witty sketch included in *Distressing Dialogues* (New York: Harper Bros., 1924), published under the pseudonym "Nancy Boyd."

Elinor Glyn, the flamboyant English author of the scandalous novel *Three Weeks* (1907; rpt., New York: Macauley, 1924), who inspired the immortal limerick about "sin[ning] with Elinor Glyn / Upon a tiger skin," captured Hollywood in the late 1910s; her story and that of her equally successful sister are vividly told in Meredith Etherington-Smith and Jeremy Pilcher, *The "It Girls": Lucy, Lady Duff Gordon, the Couturière "Lucile" and Elinor Glyn, Domestic Novelist* (New York: Harcourt Brace, 1986). S. J. Perelman spoofed *Three Weeks* and his early infatuation with it memorably in "Cloudland Revisited: Tuberoses and Tigers," collected in *The Most of S. J. Perelman*.

The best-seller lists of the day were dominated by novels about **sexually liberated women**; see especially John Erskine, *The Private Life of Helen of Troy* (Indianapolis, Ind.: Bobbs-Merrill, 1925). Mae West tells her story as self-invented sex goddess in her autobiography, *Goodness Had Nothing to Do with It* (1959; rpt., New York: Belvedere Publishers, 1981). For the sexualization of popular dance in New York in the 1910s, see Lewis A. Erenberg's useful *Steppin' Out: New York Nightlife and the Transformation of American Culture, 1890–1930* (Westport, Conn.: Greenwood Press, 1981); the best overall study is Marshall and Jean Stearns, *Jazz Dance: The Story of American Vernacular Dance* (New York: Macmillan, 1968), which pays special attention to African-American styles and influence.

The definitive biography of **Josephine Baker** is Jean-Claude Baker and Chris Chase, *Josephine: The Hungry Heart* (New York: Random House, 1993), although Phyllis Rose, *Jazz Cleopatra: Josephine Baker in Her Time* (New York: Doubleday, 1989) is interesting on her reception by whites. Baker's autobiography, *Josephine*, written with Jo Bouillon, trans. Mariana Fitzpatrick (New York: Paragon, 1988), is still illuminating.

The best book on **Martha Graham**'s career is the superb, moving *Martha: The Life and Work of Martha Graham* (New York: Random House, 1991) by her friend Agnes de Mille. **Isadora Duncan**, who danced at Village salons in the 1910s, had been a pioneer in showcasing an open female sexuality, half modern daring, half intoxicated cliché; see "*Your Isadora": The Love Story of Isadora Duncan and Gordon Craig*, ed. Frances Steegmuller (New York: Random House, 1974); Fredrika Blair, *Isadora: Portrait of the Artist as a Woman* (New York: McGraw-Hill, 1986); and Isadora Duncan, *My Life* (New York: Boni & Liveright, 1927). Scott Fitzgerald flirted with her on the Riviera, and Dorothy Parker reviewed *My Life* with an agonized thrill of recognition as "Poor, Immortal Isadora," in *The Portable Dorothy Parker*. For more information on modern dance, see the Bibliographical Essay for the Epilogue.

On **the rise of anthropology** and its connection with Freudian theory, see Daniel Lawrence O'Keefe, *Stolen Lightning: The Social Theory of Magic* (1982; rpt., New York: Vintage, 1983) and Marvin Harris, *The Rise of Anthropological Theory* (New York: Thomas Y. Crowell, 1968). For the New York school of anthropologists, see Melville J. Herskovits, *Franz Boas: The Science of Man in the Making* (New York: Scribner's, 1953); Franz Boas, *The Mind of Primitive Man* (1911; rpt., New York: Macmillan, 1946); George Simpson, *Melville Herskovits* (New York: Columbia University Press, 1973); Judith Schachter Modell, *Ruth Benedict: Patterns of a Life* (Philadelphia: University of Pennsylvania Press, 1983); Ruth Benedict, *Patterns of Culture* (1934; rpt., New York: New American Library, 1953); Derek Freeman, *Margaret Mead and Samoa: The Making and Unmaking of an Anthropological Myth* (Cambridge, Mass.: Harvard University Press, 1983); and Jane Howard, *Margaret Mead: A Life* (New York: rpt., Fawcett, 1985). Mencken's essay on the Scopes trial, "The Hills of Zion," is in *The Vintage Mencken*, ed. Alistair Cooke (New York: Vintage, 1955).

The best biography of **H. L. Mencken** is Fred Hobson, *Mencken* (New York: Random House, 1994); also useful are William Manchester, *Disturber of the Peace: The Life of H. L. Mencken* (New York: Harper Bros., 1950) and Sara Mayfield, *The Constant Circle: H. L. Mencken and His Friends* (New York: Delacorte, 1968); Charles A. Fecher, *Mencken: A Study of His Thought* (New York: Alfred A. Knopf, 1978); Maxwell Geismar, *The Last of the Provincials: The American Novel 1915–1925* (New York: Hill & Wang, 1939); *The Diary of H. L. Mencken*, ed. Charles A. Fecher (New York: Alfred A. Knopf, 1989); and *Letters of H. L. Mencken*, ed. Guy J. Forgue (Boston, Mass.: Northeastern University Press, 1981). Like all the moderns who attacked the old pieties, Mencken had a sentimental, Victorian streak, evident in his correspondence with his invalid wife; see *Mencken & Sara: A Life in Letters*, ed. Marion Elizabeth Rodgers (New York: McGraw-Hill, 1987).

For the dieting craze and America's new, leaner cuisine, see the superb studies by Hillel Schwartz, *Never Satisfied: A Cultural History of Diets, Fantasies and Fat* (New York: Free Press, 1986); Joan Jacobs Brumberg, *Fasting Girls: The History of Anorexia Nervosa* (Cambridge, Mass.: Harvard University Press, 1989); and Harvey A. Levenstein, *Revolution at the Table: The Transformation of the American Diet* (New York: Oxford University Press, 1988). For vivid accounts of dieting and advice by contemporaries, see Lulu Hunt Peters, *Diet and Health: With a Key to the Calories* (Chicago, Ill.: Reilly and Lee, 1918); as well as **Fannie Hurst**, *No Food with My Meals* (New York: Harper Bros., 1935) and *The Anatomy of Me: A Wanderer in Search of Herself* (Garden City, N.Y.: Doubleday, 1958). Hurst was from immigrant Jewish-German stock; in her literary style, she was a Steinian of sorts, and her novels form an artistically impressive, socio-logically rich, but neglected source on the emergence of modern feminine sexuality; see especially *Lummox* (1923; rpt. New York: New American Library, 1989); *Imitation of Life* (1933; rpt., New York: Harper & Row, 1990); and her masterpiece, *Back Street* (New York: Grosset & Dunlap, 1930). All three books focus obsessively on food and eating. The *Times* coverage of the "[Fifty] Fat Women" ran from October 20 to November 13, 1920.

The ethos of "terrible honesty" had important analogues in European modernism; see Franco Moretti, "The Moment of Truth," in *Signs Taken for Wonders: Essays in the Sociology of Literary Forms*, trans. Susan Fischer, David Forgass, and David Miller (New York: Verso, 1988). On **Neo-Orthodoxy** and **Karl Barth**, see Eberhard Busch, *Karl Barth: His Life from Letters and Autobiographical Texts*, trans. John Bowden (Philadelphia, Pa.: Fortress Press, 1976). Karl Barth's own *Protestant Theology in the Nineteenth Century: Its Background and History* (London: S.C.M. Press, 1972) is a monumental, sustained critique of the liberalization process; see also his *The Epistle to the Romans*, trans. Edwyn C. Hoskyns (1933; rpt., New York: Oxford University Press, 1972). On the liberalization of Protestantism in America and the Neo-Orthodox response to it, see Sydney Ahlstrom, *A Religious History of the American People* (New Haven, Conn.: Yale University Press, 1972); Langdon Gilkey, *Naming the Whirlwind: The Renewal of God-Language* (New York: Bobbs-Merrill, 1969); William R. Hutchison, *The Modernist Impulse in American Protestantism* (New York: Oxford University Press, 1976); Ann Douglas, *The Feminization of American Culture* (New York: Alfred A. Knopf, 1977); Donald B. Meyer, *The Protestant Search for Political Realism 1919–1942* (Berkeley: University of California Press, 1961); and Stowe Persons, "Religion and Modernity 1865–1914" in *The Shaping of American Religion*, eds. James Ward Smith and A. Leland Jamison (Princeton, N.J.: Princeton University Press, 1961). One biography of **Reinhold Niebuhr** is Richard Wightman Fox, *Reinhold Niebuhr: A Biography* (New York: Pantheon, 1987). Niebuhr's early disillusion with liberal Protestantism is detailed in his *Leaves from the Notebook of a Tamed Cynic*

(1929; rpt., Hamden, Conn.: Shoestring Press, 1956). The most important piece of Neo-Orthodox revisionist scholarship to come from this generation of American theologians is H. Richard Niebuhr, *The Kingdom of God in America* (1937; rpt., New York: Harper Bros., 1959).

Neo-Orthodoxy and **irony** went hand in hand; from the perspective of the disasters of the Great War, the belief in progress and reform that had seduced the Protestant Church into collaborating with this-worldly, secular developments and ideas over the course of the nineteenth century looked to be the rankest of follies and the most naïve of illusions. Theorists of modern irony have stressed that it is the peculiar property of those who have only recently lost their faith; in other words, this brand of irony characterizes first-time secularists still anxious to stay in contact with their disappearing beliefs, if only by the arts of hostility, doubt, and denial. On secularization as a general pattern, see Owen Chadwick, *The Secularization of the European Mind in the Nineteenth Century* (Cambridge, England: Cambridge University Press, 1975) and Peter Berger, *The Sacred Canopy: Elements of a Sociological Theory of Religion* (Garden City, N.Y.: Doubleday, 1968). The seminal works on the **modern form of irony** are Søren Kierkegaard, *The Concept of Irony* (1841), trans. Howard V. Hong and Edna H. Hong (Princeton, N.J.: Princeton University Press, 1989) and Georg Lukács, *The Theory of the Novel*, trans. Anna Bostock (Cambridge, Mass.: MIT Press, 1971). The two most influential critics to theorize this view of irony in the modern era are T. E. Hulme, "Romanticism and Classicism" in *Speculations*, ed. Herbert Read (New York: Harcourt Brace, 1936) and Wilhelm Worringer, *Abstraction and Empathy*, trans. Michael Bullock (New York: International Universities Press, 1963); Hulme was important to the artistic development of T. S. Eliot, the leading ironist writing in English. Recent and authoritative expositions of the modern view of irony are Paul de Man, "The Rhetoric of Temporality," in *Blindness and Insight: Essays in the Rhetoric of Contemporary Criticism* (Minneapolis: University of Minnesota Press, 1983) and *The Rhetoric of Romanticism* (New York: Columbia University Press, 1984); Geoffrey Hartmann, "Criticism, Indeterminacy, Irony," in *Criticism in the Wilderness* (New Haven, Conn.: Yale University Press, 1980); and Walter J. Ong, "From Mimesis to Irony: The Distancing of Voice," in *The Horizon of Literature*, ed. Paul Hernadi (Lincoln: The University of Nebraska Press, 1982). Modern irony was a special, historically determined form, not all-inclusive; Wayne C. Booth, *A Rhetoric of Irony* (Chicago, Ill.: University of Chicago Press, 1974) takes a useful broader view of irony as a literary strategy.

In his memoirs of the Lost Generation, Malcolm Cowley consistently sees it as self-consciously ironic; see especially his *Exile's Return: A Literary Odyssey of the 1920s* (1957; rpt., New York: Penguin Books, 1969) and *A Second Flowering: Works and Days of the Lost Generation* (1973; rpt., New York: Penguin Books, 1980). The ironist prides himself on seeing clearly and remembering what he sees; it is of some importance that the camera, new in the mid-nineteenth century, was mass-produced and became a craze at the turn of the twentieth century. On the **development of the camera**, see Reese V. Jenkins, *Images and Enterprise: Technology and the American Photographic Industry 1839 to 1925* (Baltimore, Md.: Johns Hopkins University Press, 1975), and Eaton S. Lothrop, Jr., *A Century of Cameras* (Dobbs Ferry, N.Y.: Morgan & Morgan, 1973). On the history of photography in America, see Alan Trachtenberg, *Reading American Photographs: Images as History from Mathew Brady to Walker Evans* (New York: Hill & Wang, 1990); and *Classic Essays on Photography*, ed. Alan Trachtenberg (New Haven, Conn.: Leate's Island Books, 1980); and Beaumont Newhall, *The History of Photography* (New York: The Museum of Modern Art, 1964). On Stieglitz, see William Taylor, *In Search of*

Gotham, and William Innes Homer, *Alfred Stieglitz and the American Avant-Garde* (Boston, Mass.: New York Graphic Society, 1977).

On **the development of the New York theater**, the seminal, authoritative work is still Jack Poggi, *Theatre in America: The Impact of Economic Forces 1870–1967* (Ithaca, N.Y.: Cornell University Press, 1968). Mary C. Henderson, *The City & the Theatre* (Clifton, N.J.: James T. White, 1973) is an illustrated history of the playhouses themselves from the turn of the eighteenth century through the 1930s. Allen Churchill, *The Great White Way: The Recreation of Broadway's Golden Era of Theatrical Entertainment* (New York: E. P. Dutton, 1962) and *The Theatrical Twenties* (New York: McGraw-Hill, 1975) are chatty, sometimes inaccurate, but entertaining and wonderfully illustrated. Gerald Bordman, *The Oxford Companion to the American Theatre* (New York: Oxford University Press, 1984) and *American Musical Theatre: A Chronicle* (expanded and corrected ed.; New York: Oxford University Press, 1986) are the standard reference works. See also Brooks McNamara, *The Shuberts of Broadway* (New York: Oxford University Press, 1990) and Brooks Atkinson and Albert Hirschfield, *The Lively Years 1920–73* (New York: Association Press, 1973). Garff B. Wilson traces the changes in acting styles in *A History of American Acting* (1966; rpt. Westport, Conn.: Greenwood Press, 1980).

As for **New York and the movies**, Pauline Kael, *Raising Kane: The Citizen Kane Book* (Boston, Mass.: Little, Brown, 1971) is a brilliant, passionate explication of the connections between the New York stage, its playwrights and newspapermen, and Hollywood in the 1920s and 1930s; Richard Koszarski documents the movie industry in New York in his meticulously informative *The Astoria Studio and Its Fabulous Films* (New York: Dover, 1983). For a wonderful discussion of *The Awful Truth* and the best single book on Hollywood comedy, see Elizabeth Kendall, *The Runaway Bride: Hollywood Romantic Comedy of the 1930s* (New York: Alfred A. Knopf, 1990); James Harvey, *Romantic Comedy in Hollywood from Lubitsch to Sturges* (New York: Alfred A. Knopf, 1987) is also excellent.

For histories and criticism by **New York's drama critics of the 1920s**, see Joseph Wood Krutch, *The American Drama Since 1918: An Informal History* (New York: George Braziller, 1957); Burns Mantle, *American Playwrights of Today* (New York: Dodd, Mead, 1930); Stark Young, *The Flower in Drama: A Book of Papers on the Theatre* (New York: Charles Scribner's, 1923); and George Jean Nathan, *The Theatre, the Drama, the Girls* (New York: Alfred A. Knopf, 1921). Eleanor Flexner, *American Playwrights 1928–1938: The Theatre Retreats from Reality* (New York: Simon & Schuster, 1938) is also useful, if hypercritical. *Broadway Interlude* (New York: Payton & Clarke, 1929), a roman à clef by Achmed Abdullah and Faith Baldwin, offers a lively, gossipy picture of the Broadway scene. For further background material on the 1920s theater and its sources in Victorian melodrama, see the Bibliographical Essay for the Epilogue.

Biographies and works drawn on in this chapter include the excellent family portrait of **the Barrymores** by Margot Peters, *The House of Barrymore* (New York: Alfred A. Knopf, 1990) and Hollis Alpert, *The Barrymores* (New York: Dial Press, 1966). Gene Fowler's *Goodnight, Sweet Prince: The Life and Times of John Barrymore* (1944; rpt., San Francisco, Calif.: Mercury House, 1989) is a moving, sympathetic, and detailed portrait by one who knew and loved him well; John Kobler's *Damned in Paradise: The Life of John Barrymore* (New York: Atheneum, 1977) is also masterly, and John Barrymore's own memoir, *Confessions of an Actor* (Indianapolis, Ind.: Bobbs, Merrill, 1926) conveys his youthful high spirits and cavalier wit. On **George S. Kaufman and his collaborators**, see Scott Meredith, *George S. Kaufman and His Friends* (Garden City, N.Y.: Doubleday, 1974) and Malcolm Goldstein's more analytic study, *George S. Kaufman: His Life, His Theatre* (New York: Oxford University Press, 1979). *The Man Who Came to Dinner* is anthologized in *Six Plays by Kaufman and Hart*, ed. Brooks Atkinson (New York: Modern Library,

1942). Howard Teichman, *Smart Aleck: The Wit, World and Life of Alexander Woollcott* is entertaining if superficial; Samuel Hopkins Adams, a friend, depicted him vividly in *Alexander Woollcott: His Life and His World* (New York: Reynal & Hitchcock, 1945). See also *The Letters of Alexander Woollcott*, eds. Beatrice Kaufman and Joseph Hennessy (New York: The Viking Press, 1944) and Alexander Woollcott, *While Rome Burns* (New York: The Viking Press, 1934), a best-selling anthology of his occasional pieces that contains some of his best drama criticism.

There are other interesting **biographies of stars**. Lee Israel tells Bankhead's story in *Miss Tallulah Bankhead* (New York: G. P. Putnam's, 1972); see also Tallulah Bankhead's lively memoir, *Tallulah: My Autobiography* (New York: Harper Bros., 1952). Gilbert Maxwell, *Helen Morgan: Her Life and Legend* (New York: Hawthorn Books, 1974) is a sentimental but moving account; David Stenn, *Clara Bow: Runnin' Wild* (New York: Doubleday, 1988) is vivid on her Brooklyn origins and troubled psyche. On **Ring Lardner**, see Jonathan Yardley, *Ring: A Biography of Ring Lardner* (New York: Random House, 1977) and Donald Elder, *Ring Lardner: A Biography* (Garden City, N.Y.: Doubleday, 1956); for his work, see *The Best Short Stories of Ring Lardner* (1925; rpt., New York: Scribner's, 1957), and Ring Lardner, *You Know Me Al* (1914; rpt., Urbana: University of Illinois Press, 1992). Scott Fitzgerald wrote a poignant elegy, "Ring" (1933), collected in *The Crack-Up*; Delmore Schwartz, "Ring Lardner: Highbrow in Hiding" (1956) in *Selected Essays of Delmore Schwartz*, ed. Donald A. Duke and David H. Zucker (Chicago, Ill.: University of Chicago Press, 1970) is unerring.

The only biographical study of Constance Rourke is Joan Sheilly Rubin's intelligent *Constance Rourke and American Culture* (Chapel Hill: University of North Carolina Press, 1980); for more information on Rourke's life, see the Bibliographical Essay for Chapter 11.

John O. Margolis, *Joseph Wood Krutch: A Writer's Life* (Knoxville: University of Tennessee Press, 1980) is a comprehensive study. Krutch's most influential work, a bible to Robert E. Sherwood and others, was *The Modern Temper: A Study and a Confession* (1929; rpt., New York: Harcourt, Brace, 1956), a gloomy study of the Zeitgeist; Reinhold Niebuhr reviewed it astutely in "The Unhappy Intellectuals," *The Atlantic Monthly* (June 1929), 790–94. Michael Reynolds, *The Young Hemingway* (Oxford, England: Basil Blackwell, 1986) and Peter Griffin, *Along With Youth: Hemingway, The Early Years* (New York: Oxford University Press, 1985) are the best sources for **Hemingway's Oak Park milieu**; see also *Ernest Hemingway: Selected Letters, 1917–1961*, ed. Carlos Baker (New York: Scribner's, 1981). More background material on Hemingway is given in the Bibliographical Essay for Chapters 3, 5, and 6; information on T. S. Eliot can be found in the Bibliographical Essay for Chapter 3.

As for **Elinor Wylie and other women poets**, an unsympathetic if perceptive biography is Stanley Olson, *Elinor Wylie: A Life Apart* (New York: Dial Press, 1979); an excellent critical study is Judith Farr, *The Life and Art of Elinor Wylie* (Baton Rouge: Louisiana State University Press, 1983). See also *Collected Poems of Elinor Wylie* (New York: Alfred A. Knopf, 1977) and *Collected Prose of Elinor Wylie* (New York: Alfred A. Knopf, 1946). Wylie is a brilliant minor poet and an arcane but fascinating novelist, only beginning to receive the critical attention she merits. Elizabeth Frank, *Louise Bogan: A Portrait* (New York: Alfred A. Knopf, 1985) is superb, as is William Drake's *Sara Teasdale, Woman and Poet* (Knoxville: University of Tennessee Press, 1979); see also *The Collected Poems of Sara Teasdale* (New York: Macmillan, 1965). There are two excellent studies of modern American women poets, Cheryl Walker, *Masks Outrageous and Austere: Culture, Psyche, and Persona in Modern Women Poets* (Bloomington: Indiana University Press, 1991) and William Drake, *The First Wave: Women Poets in America 1915–1945*. On Djuna Barnes,

see Andrew Field, *The Life and Times of Djuna Barnes* (New York: G.P. Putnam, 1983). *New York: Djuna Barnes*, ed. Alyce Barry (Los Angeles, Calif.: Sun & Moon Press, 1989) contains her early journalistic writings about New York.

Babette Deutsch writes of "mouthfuls of bitterness" in her poem "Of Banquets," collected in *Fire for the Night* (New York: Jonathan Cape, 1930). Dorothy Parker talks of bowling her "shattered heart" down the street in "Threnody" from *Enough Rope* (1926) in *The Portable Dorothy Parker*; she describes her generation as "a ladies' auxiliary of the damned" in her essay "Sophisticated Verse and the Hell with It," in *Fighting Words*, ed. Donald Ogden Stewart (New York: Harcourt Brace, 1940), and she writes of insomnia in "The Little Hours," a sketch collected in *The Portable Dorothy Parker*. Matthew Bruccoli discusses Fitzgerald's use of "time words" in the Introduction to *New Essays on "The Great Gatsby,"* ed. Matthew Bruccoli (Cambridge, England: Cambridge University Press, 1985). On Fitzgerald and the "nightmare of biology," see Robert A. Ferguson, "The Grotesque in the Novels of F. Scott Fitzgerald," *The South Atlantic Quarterly* 78 (1979), 460–77.

2 BLACK MANHATTAN WEARING THE MASK

The best general study of African-American history is John Hope Franklin and Alfred A. Moss, Jr., *From Slavery to Freedom: A History of Negro Americans* (New York: McGraw-Hill, 1988). August Meier and Elliott Rudwick, *From Plantation to Ghetto* (1966; 3d ed., New York: Hill & Wang, 1976); Benjamin Quarles, *The Negro in the Making of America* (3d ed., revised, updated, and expanded; New York: Collier Books, 1987); and Lerone Bennett, Jr., *Before the Mayflower: A History of Black America* (1962; rpt., New York: Penguin Books, 1982) are substantial surveys. On the migration of black Americans from country to city and from South to North, see Carole Marks, *Farewell —We're Good and Gone: The Great Black Migration* (Bloomington: Indiana University Press, 1989), which offers a detailed account of migration from country to city within the South as well as to the North. Nicholas Lemann, *The Promised Land: The Great Black Migration and How It Changed America* (New York: Alfred A. Knopf, 1991) concentrates on the later phase of the migration. Also useful is Florette Henri, *Black Migration: Movement North, 1900–1920* (Garden City, N.Y.: Doubleday, 1976). W.E.B. Du Bois gives a valuable sketch of early Negro migrants in "The Black North," *The New York Times*, November 17, 1901. Manning Marable, *How Capitalism Underdeveloped Black America: Problems in Race, Political Economy and Society* (Boston, Mass.: South End Press, 1985) discusses the shift in black occupations.

The Harlem Renaissance and the development of Harlem as a "race capital" in the 1920s has attracted a good deal of attention in the last several decades. David Levering Lewis, *When Harlem Was in Vogue* is a brilliant study; though Lewis is unduly harsh in his judgments, seeming to demand of Harlem's leaders powers of hindsight inevitably, as I argue in Chapter 8, inaccessible to them, and scorning the notion of what he wittily calls "Civil Rights by Copyright," the attempt to achieve political ends through literary means, his work is formidable, and my book has been largely an effort to engage and debate his views. Harold Cruse, *The Crisis of the Negro Intellectual: A Historical Analysis of the Failure of Black Leadership* (1967; rpt., New York: Quill, 1984) is a forerunner to Lewis's work, also highly critical, focusing on the discrepancy between the black leadership's goals and the economic and political realities of the times; Gilbert Osofsky offers a detailed, far more sympathetic, but equally grim economic reading in *Harlem: The Making of a Ghetto* (New York: Harper & Row, 1971). Jervis Anderson, *This Was Harlem*:

A *Cultural Portrait* 1900–1950 is a lively, wise, and indispensable study, particularly valuable on the black entertainment scene, and Nathan Irvin Huggins, *Harlem Renaissance* (New York: Oxford University Press, 1971) is strenuously impartial on the literature of the renaissance, judging it on the whole as unsuccessful, but illuminating it and Harlem culture more generally at every turn. For a less inclusive, sometimes convoluted, but appreciative and at moments brilliant study, see Houston A. Baker, *Modernism and the Harlem Renaissance* (Chicago, Ill.: University of Chicago Press, 1987); Baker understands that music is as important to the renaissance as literature and tries to describe the Harlem project in its own terms. Gerald Early's long introductory essay about Countee Cullen in his edition of *My Soul's High Song: The Collected Writings of Countee Cullen* (New York: Anchor Books, 1991) is not only a superb exegesis of Cullen's life and work but the best single essay on the Harlem Renaissance; Early finds its twin poles in black boxing and religious concerns. Gerald Early, *Tuxedo Junction: Essays on American Culture* (1989; rpt., Hopewell, N.J.: Ecco Press, 1994) is brilliant on the broader black aesthetic and its American context. See also the insightful Cary D. Wintz, *Black Culture and the Harlem Renaissance* (Houston, Tex.: Rice University Press, 1988); James de Jongh, *Vicious Modernism: Black Harlem and the Literary Imagination* (Cambridge, England: Cambridge University Press, 1990) carries the story up to the 1960s. Charles Scruggs, *The Sage in Harlem: H. L. Mencken and the Black Writers of the 1920s* (Baltimore, Md.: Johns Hopkins University Press, 1984) is an intelligent, detailed study of Mencken's considerable influence. For books on Harlem politics, see the Bibliographical Essay for Chapter 8.

The Harlem Renaissance Remembered, ed. Arna Bontemps (New York: Dodd, Mead, 1972); *Harlem Renaissance: Revaluations*, eds. Amritjit Singh, William S. Shiver, and Stanley Bodwin (New York: Garland, 1989); *The Portable Harlem Renaissance Reader*, ed. David Levering Lewis (New York: Viking, 1994); *Voices from the Harlem Renaissance*, ed. Nathan Irvin Huggins (New York: Oxford University Press, 1976); *The New Negro Renaissance: An Anthology*, eds. Arthur P. Davis and Michael W. Peplow (New York: Holt, Rinehart, 1975) are valuable collections of critical essays and original writings. *The Harlem Renaissance: A Historical Dictionary of the Era*, ed. Bruce Kellner (New York: Methuen, 1984) is an indispensable, broad-based encyclopedia of information with an excellent bibliography; see also Margaret Perry, *The Harlem Renaissance: An Annotated Bibliography and Commentary* (New York: Garland, 1982). Arnold Rampersad's peerless *Life of Langston Hughes*, Vol. 1, *I, Too, Sing America* (New York: Oxford University Press, 1986) gives a detailed, illuminating picture of the era.

The best contemporary accounts of Harlem life in the 1920s are found in James Weldon Johnson, *Black Manhattan*; Langston Hughes, *The Big Sea*; Claude McKay, *Harlem: Negro Metropolis* (1940; rpt., New York: Harcourt Brace, 1968) and *Home to Harlem* (1928; rpt., Boston, Mass.: Northeastern University Press, 1987); and Wallace Thurman, *Negro Life in New York's Harlem* (Girard, Kans.: Haldeman-Julius, 1928). Thurman's "Negro Artists and the Negro," *The New Republic* (August 31, 1927), 37–39 is interesting on the literary scene, and his magazine *Fire!* has been reissued as *Fire!* (Metuchen, N.J.: Fire Press, 1982).

Henry Louis Gates, Jr., "Criticism in the Jungle," in *Black Literature & Literary Theory*, ed. Henry Louis Gates, Jr. (New York: Methuen, 1984) is an important essay on the ethos of black literature; when Gates writes that "the 'heritage' of each black text written in a Western language is, then, a double heritage, two-toned, as it were . . . white and black . . . standard and vernacular," he could be summing up the achievement of much of the Harlem Renaissance. Gates, *Figures in Black*, and *The Signifying Monkey* (New York: Oxford University Press, 1988) are important explications of the tactic of

"wearing the mask" and themselves brilliant exercises in the same political aesthetic.

I have also benefited greatly from Marcellus Blount, *In a Broken Tongue: Rediscovering African-American Poetry* (Princeton, N.J.: Princeton University Press, forthcoming), which traces signifying and doubleness in African-American poetry with particular emphasis on the sonnet. The poetry of the renaissance has been anthologized in *The Book of American Negro Poetry*, ed. James Weldon Johnson (1922, 1931; rpt., New York: Harcourt Brace, 1969) and *Shadowed Dreams: Women's Poetry of the Harlem Renaissance*, ed. Maureen Honey (New Brunswick, N.J.: Rutgers University Press, 1989). Gloria T. Hull, *Color, Sex & Poetry: Three Women Writers of the Harlem Renaissance* (Bloomington: Indiana University Press, 1987) is a pioneering study of the women poets; see also Houston A. Baker, Jr., *Afro-American Poetics: Revisions of Harlem and the Black Aesthetic* (Madison: University of Wisconsin Press, 1988).

For comparisons between black and white literature and the argument that the two traditions are in a not always conscious dialogue with each other, see three excellent studies: Eric J. Sundquist, *To Wake the Nation: Race in the Making of America Literature* (Cambridge, Mass.: Harvard University Press, 1993); Toni Morrison, *Playing in the Dark: Whiteness and the Literary Imagination* (1992; rpt., New York: Vintage, 1993); and Kenneth Warren, *Black and White Strangers: Race and American Literary Realism* (Chicago, Ill.: University of Chicago Press, 1993). Michael J. North, *The Dialect of Modernism: Race, Language and Twentieth Century Literature* (New York: Oxford University Press, 1994) is a first-rate study of black-white collaboration in the modern era, with an emphasis on white bad faith.

On black musical theater, Jervis Anderson, *This Was Harlem*, and Allen Woll, *Black Musical Theatre: From Coontown to Dreamgirls* (1989; rpt., New York: Da Capo, 1991) are invaluable; on black theater more generally, see Allen Woll, *Dictionary of the Black Theatre: Broadway, Off-Broadway and Selected Harlem Theatre* (Westport, Conn.: Greenwood Press, 1983); James Haskins, *Black Theatre in America* (New York: Crowell, 1982); and *Black Magic: A History of the African-American in the Performing Arts*, eds. Langston Hughes and Milton Meltzer (1967; rpt. New York: Da Capo, 1990). For anthologies of black plays and plays about blacks, see *Plays of Negro Life*, eds. Alain Locke and Montgomery T. Gregory (New York: Harper Bros., 1927); *Black Drama in America: An Anthology*, ed. Darwin T. Turner (Greenwich, Conn.: Fawcett, 1971); and *Black Female Playwrights: An Anthology of Plays Before 1950*, ed. Kathy A. Perkins (Bloomington: Indiana University Press, 1989). Eric Lott, *Theft and Love: Blackface Minstrelsy and the American Working Class* (New York: Oxford University Press, 1993) is a path-breaking, in-depth study of minstrelsy; Robert C. Toll, *Blacking Up* (New York: Oxford University Press, 1974) is still useful. Joseph Buskin, *Sambo: The Rise & Fall of an American Jester* (New York: Oxford University Press, 1986) looks at the stereotypes of minstrelsy more broadly, and Mel Watkins's intelligent study, *On the Real Side: Laughing, Lying and Signifying—The Underground Tradition of African-American Humor* (New York: Simon & Schuster, 1994), contextualizes it within the larger patterns of African-American humor. William Torbert Leonard, *Masquerade in Black* (Metuchen, N.J.: Scarecrow Press, 1968) is valuable on the white blackface tradition.

On primitivism and modernism more generally, see Marianna Torgovnick, *Gone Primitive: Savage Intellects, Modern Lives* (Chicago, Ill.: University of Chicago Press, 1990); James Clifford, "Histories of the Tribal and the Modern" in *The Predicament of Culture* (Cambridge, Mass.: Harvard University Press, 1988); Rosalind Kraus, "Preying on Primitivism," *Art & Text* 17 (April 1985), 58–62; Gail Levin, " 'Primitivism' in American Art: Some Literary Parallels of the 1910s and 1920s," *Art Magazine* (November

1984), 101–5; and Hal Foster, "The 'Primitive' Consciousness of Modern Art," *October* 34 (Fall 1985), 47–50.

Gilbert Osofsky's "Introduction" to *Puttin' On Ole Massa: The Slave Narrative of Henry Bibb, William Wells-Brown, and Solomon Northrup*, ed. Gilbert Osofsky (New York: Harper & Row, 1969); Peter H. Wood, *Black Majority: Negroes in Colonial South Carolina from 1670 through the Slave Rebellion* (New York: Alfred A. Knopf, 1974); and Lawrence Levine, *Black Culture and Black Consciousness* contain valuable discussions of the "**puttin' on the ole massa**" **tactics** of blacks in slavery times. On the musical contributions of the minstrel tradition, see Charles Hamm, *Yesterdays: Popular Song in America* (New York: W. W. Norton, 1983). Background books on African-American music can be found in the Bibliographical Essays for Chapters 9 and 10.

Melvin Patrick Ely's *The Adventures of Amos 'n' Andy: A Social History of an American Phenomenon* (New York: Free Press, 1991) documents black and blackface humor in radio and television. On **blacks in film** and their biased treatment by the movie industry, see Thomas Cripps, *Slow Fade to Black: The Negro in American Film 1900–1942* (New York: Oxford University Press, 1993) and Donald Bogle, *Toms, Coons, Mulattoes, Mammies & Bucks: An Interpretative History of Blacks in American Films* (New York: Frederick Ungar, 1992). The **black nightclub scene** is wonderfully described in Jervis Anderson, *This Was Harlem*; George Tickenor's response is cited on pp. 168–69. See also the superficial but well-illustrated Jim Haskins, *The Cotton Club* (New York: Random House, 1977) and Clarence Major, *The Cotton Club* (Detroit, Mich.: Broadside Press, 1973).

In my discussion of **white religious expression in the nineteenth century**, I have relied on my research for *Feminization of American Culture*; on the white revival tradition, see William G. McLaughlin, Jr., *Modern Revivalism: Charles Grandison Finney to Billy Graham* (New York: Ronald Press, 1959). Stirring accounts of white and black ministers of the evangelical sects, usually Methodist and Baptist though sometimes Presbyterian, preaching to racially mixed nineteenth-century congregations, can be found in the magisterial *Annals of the American Pulpit*, ed. William B. Sprague, 9 vols. (New York: Robert Carter, 1857–69). See also *The Autobiography of Peter Cartwright the Backwoods Preacher*, ed. W. P. Strickland (New York: Carlton & Porter, 1856); Cartwright, known as the "Methodist Bulldog," was a powerhouse of masculine energy, and he had nothing but scorn for the white, non-evangelical Protestant denominations.

On **black religion**, the best general study is Lawrence Levine's *Black Culture and Black Consciousness*; E. Franklin Frazier, *The Negro Church in America* and C. Eric Lincoln, *The Black Church since Frazier*, included in one volume (New York: Schocken Books, 1974), are classic studies. See also Albert J. Raboteau, *Slave Religion: The "Invisible Institution" in the Ante-Bellum South* (New York: Oxford University Press, 1978); Gayraud S. Wilmore, *Black Religion and Black Radicalism: An Interpretation of the Religious History of the Afro-American People* (1973; rev. ed., New York: Anchor Books, 1983); *Afro-American Religious History: A Documentary Witness*, ed. Milton C. Sernett (Durham, N.C.: Duke University Press, 1985); and *The Black Church in the African American Experience*, eds. C. Eric Lincoln and Lawrence H. Mamiya (Durham, N.C.: Duke University Press, 1990). There are two excellent books on the black preaching tradition: Bruce A. Rosenberg, *Can These Bones Live? The Art of the American Folk Preacher* (Urbana: University of Illinois Press, 1988) and William H. Pipes, *Say Amen, Brother! Old-Time Negro Preaching: A Study in American Frustration* (Detroit, Mich.: Wayne State University Press, 1992). For accounts of black religion in the cities by contemporaries, see Arthur Huff Fauset, *Black Gods of the Metropolis: Negro Religious Cults of the Urban North* (Philadelphia: University of Pennsylvania Press, 1971); Countee Cullen, *One Way to Heaven* (1932), a first-rate novel reprinted in *My Soul's High Song: The*

Collected Writings of Countee Cullen; and Nella Larsen, *Quicksand* (1928) in *An Intimation of Things Distant: The Collected Writings of Nella Larsen*, ed. Charles R. Larson (New York: Anchor Books, 1992).

Herbert G. Gutman argues for the survival of a traditional black family in *The Black Family in Slavery and Freedom 1750–1925* (1976; rpt., New York: Vintage, 1977); E. Franklin Frazier was less optimistic in *The Negro Family in the United States* (rev. and abridged ed., Chicago, Ill.: University of Chicago Press, 1966).

Arnold Rampersad, "Biography and Afro-American Culture" in *Afro-American Literary Study in the 1990s*, eds. Houston A. Baker, Jr., and Patricia Redmond (Chicago, Ill.: University of Chicago Press, 1989) takes a qualified but positive view of the relevance of Freud to black lives and psychology; Robert G. O'Meally, Nellie Y. McKay, and Michel Fabre support Rampersad's views with reservations in three "Responses," also included in *Afro-American Literary Study in the 1990s*. A test case of the strengths (and limits) of Freudian theory applied to black psyches can be found in Allison Davis, *Leadership, Love and Aggression: As the Twig Is Bent: The Psychological Factors in the Making of Four Black Readers, Frederick Douglass, W.E.B. Du Bois, Richard Wright and Martin Luther King* (New York: Harcourt Brace, 1983). Bruce Perry, *Malcolm: The Life of a Man Who Changed Black America* (Barrytown, N.Y.: Station Hill Press, 1991) demonstrates that psychoanalysis applied to a black subject by a white biographer can work simply as hostility, trivialization, and incomprehension, but the usual method, a sociological approach that views the black subject largely as the victim of racism in America, is equally inadequate as a dominant biographical strategy. Nellie McKay argues in her "Response" to Rampersad that literary criticism of black authors will inevitably incorporate (and, one might add, transform) psychoanalytic ideas; in other words, literary criticism, now deeply invested in psychoanalytic theory, may be the arena where the psychological discourse is modified to meet modern black needs. The works I have cited by Rampersad, Baker, and Gates bear out this notion; Gates's and Baker's explorations of what is essentially black performance strategy as the starting point for a psychological language about blacks seem to me seminal modifications and continuations of the work of the black West Indian psychoanalytic theorist, Frantz Fanon. See Fanon, *Black Skin, White Masks*, trans. Charles Lam Markmann (1952; rpt., New York: Grove Weidenfeld, 1968). It is my own contention that, for black Americans in the 1920s, theater was psychology and vice versa; black performance in the 1920s, unlike white, does not point to a self-beyond-performance. For gay male sexuality in the Harlem Renaissance, see David Levering Lewis, *When Harlem Was in Vogue* and Eric Garber, " 'Tain't Nobody's Bizness': Homosexuality in Harlem in the 1920s," *The Advocate* (May 13, 1990). For gay men in New York more generally, see the insightful, detailed George Chauncey, *Gay New York: Gender, Urban Culture, and the Making of the Gay Male World 1890–1940* (New York: Basic Books, 1994).

For biographical information on blacks, given the lack of full treatment for a number of the people I consider here, I have often relied on more general sources, in particular, David Levering Lewis, *When Harlem Was in Vogue*, whose portraits are always sharply memorable; *Dictionary of American Negro Biography*, eds. Rayford W. Logan and Michael R. Winston (New York: W. W. Norton, 1982); and the superb *Black Women in America. An Historical Encyclopedia*, ed. Darlene Clark, 2 vols. (Brooklyn, N.Y.: Carlson, 1993).

There is a pathbreaking, monumental, definitive biography of W.E.B. Du Bois by David Levering Lewis, *W. E. B. Du Bois: Biography of a Race, 1868–1919*, Vol. 1 (New York: Henry Holt, 1993); see also Arnold Rampersad, *The Art and Imagination of W.E.B. Du Bois* (1976; rpt., New York: Schocken Books, 1989) and "W.E.B. Du Bois as a Man

of Literature," *American Literature* 51 (March 1979), 50–68, and Elliot Rudwick, "W.E.B. Du Bois: Protagonist of the Afro-American Protest" in *Black Leaders of the Twentieth Century*, eds. John Hope Franklin and August Meier (Urbana: University of Illinois Press, 1982). Manning Marable, "William E.B. Du Bois (1868–1963)," *Classics in Cultural Criticism*, Vol. 2, *U.S.A.* (New York: Peter Lang, 1990) rightly sees him as both politician and poet. Du Bois's autobiographies are invaluable; see *Dusk of Dawn* (1940), collected in *W.E.B. Du Bois, Writings* (New York: Library of America, 1986), and the moving, late *Autobiography of W.E.B. Du Bois* (New York: International Publishers, 1968). For **James Weldon Johnson**, see Eugene Levy's excellent *James Weldon Johnson: Black Leader, Black Voice* (Chicago, Ill.: University of Chicago Press, 1973) and Robert E. Fleming, *James Weldon Johnson* (New York: Twayne Publishers, 1987); Robert Stepto has given an important reading of Johnson's seminal novel, *The Autobiography of an Ex-Colored Man*, in *From Behind the Veil: A Study of Afro-American Narrative* (Urbana: University of Illinois Press, 1979), if one that overweights the ironic intentions of the narrative; Michael G. Cooke's discussion of *The Autobiography* in *Afro-American Literature in the Twentieth Century: The Achievement of Intimacy* (New Haven, Conn.: Yale University Press, 1984) is also useful.

On **Charles S. Johnson**, see Patrick J. Gilpin, "Charles S. Johnson: Entrepreneur of the Harlem Renaissance," in *The Harlem Renaissance Remembered*, ed. Arna Bontemps; on **Walter White**, see Edward E. Walter Walrond, *Walter White and the Harlem Renaissance* (Port Washington, N.Y.: Kennikat Press, 1978) and Charles F. Cooney, "Walter White and the Harlem Renaissance," *Journal of Negro History* 57 (July 1972), 231–40. On **Alain Locke**, see Jeffrey C. Steward, "A Biography of Alain Locke," unpublished Ph.D. dissertation, Yale University, 1979; Jonny Washington, *Alain Locke: A Quest for Cultural Pluralism* (Westport, Conn.: Greenwood Press, 1986); and *The Critical Temper of Alain Locke*, ed. Jeffrey C. Stewart (New York: Garland, 1983). On **Zora Neale Hurston**, see Robert E. Hemenway's excellent *Zora Neale Hurston: A Literary Biography* (Urbana: University of Illinois Press, 1977) and her own autobiography, *Dust Tracks on a Road* (1942; rpt., New York: HarperCollins, 1991), which reveals more about her style than her psyche or her life; it's a performance rather than a memoir—or again, performance for Hurston *is* psychology.

On **Jean Toomer**, see the thorough, thoughtful *The Lives of Jean Toomer: A Hunger for Wholeness* (Baton Rouge: Louisiana State University, 1987) by Cynthia Earl Kerman and Richard Eldridge; aside from *Cane*, most of Toomer's work is unpublished, but for selections from his letters, writings, and journals, see *A Jean Toomer Reader*, ed. Frederik L. Rusch (New York: Oxford University Press, 1993) and *The Collected Poems of Jean Toomer*, eds. Robert B. Jones and Margery Toomer Latimer (Chapel Hill: University of North Carolina Press, 1988). For the Toomer-Frank alliance, see Mark Heibling, "Jean Toomer and Waldo Frank: A Creative Friendship," *Phylon* (June 1980), 167–78; Michael A. North gives a detailed and insightful reading that emphasizes Frank's racism in *The Dialect of Modernism: Race, Language and Twentieth Century Literature*. The best biography of **Claude McKay** is Wayne F. Cooper, *Claude McKay: Rebel Sojourner in the Harlem Renaissance* (New York: Schocken Books, 1987); his autobiography, *A Long Way from Home* (1937; rpt., New York: Harcourt Brace, 1970) is energetic, revealing, and highly astute.

Arnold Rampersad is **Langston Hughes**'s best biographer, but Faith Berry, *Langston Hughes, Before and Beyond Harlem* (New York: Citadel Press, 1983) is excellent though not comprehensive; I have also benefited from reading portions of George Cunningham's eloquent biography-in-progress "Langston Hughes." Hughes himself edited the only anthologies of his work, *Selected Poems* (1959; rpt., New York: Vintage, 1974) and *The*

Langston Hughes Reader (New York: George Braziller, 1958); they offer materials for a study of his habit of rearranging and masking his life and career rather than comprehensive coverage of his work. Here, too, we see a performing self rather than a traditionally historical one. With Hughes's poetry, the reader is better served by going back to the individual volumes in which the poems were first collected. *Arna Bontemps–Langston Hughes: Letters, 1925–1967*, ed. Charles H. Nichols (New York: Paragon House, 1990) includes a selection of his letters to his closest lifelong friend.

In addition to Gerald Early's "Introduction" to **Countee Cullen**, see Houston A. Baker, Jr., "A Many-Colored Coat of Dreams: The Poetry of Countee Cullen," in *Afro-American Poetics*; "Countee Cullen, 1903–1946," in *Black Literature Criticism*, Vol. 1, ed. James P. Draper (Detroit, Mich.: Gale Research, Inc., 1992) is a useful overview of the criticism with selections from it. **Theophilus Lewis and George Schuyler** are discussed extensively in Charles Scruggs, *The Sage in Harlem* and in Theodore Kornweibel, Jr., *No Crystal Stair: Black Life and The Messenger, 1917–1928* (Westport, Conn.: Greenwood Press, 1975); see also "Theophilus Lewis and the Theatre of the Harlem Renaissance" in *The Harlem Renaissance Remembered*, ed. Arna Bontemps; and Michael W. Peplow, *George S. Schuyler* (New York: Twayne, 1980). Schuyler's memoir, *Black and Conservative: The Autobiography of George S. Schuyler* (New Rochelle, N.Y.: Arlington House, 1966) conveys his incisive, witty, iconoclastic style.

On **Nella Larsen**, see Mary Helen Washington, "Lost Women: Nella Larsen: Mystery Woman of the Harlem Renaissance," *Ms.* (December 1980) and *Invented Lives: Narratives of Black Women 1860–1960* (1987; rpt., New York: Anchor Books, 1988); Charles Larson's "Introduction" in *An Intimation of Things Distant*; Hiroko Sato, "Under the Harlem Shadow: A Study of Jessie Fauset and Nella Larsen" in *The Harlem Renaissance Remembered*, ed. Arna Bontemps; Thadious M. Davis, "Nella Larsen's Harlem Aesthetic," in *Harlem Renaissance: Revaluations*, ed. Amritgit Singh, a strangely vindictive portrait that nonetheless contains valuable biographical information; and Deborah McDowell's analytic, intelligent "Introduction" in her edition of *Quicksand and Passing* (New Brunswick, N.J.: Rutgers University Press, 1986). Nella Larsen's essay about Walter White's novel *Flight* (New York: Alfred A. Knopf, 1926) is reprinted in *The Gender of Modernism: A Critical Anthology*, ed. Bonnie Kime Scott (Bloomington: Indiana University Press, 1990).

On **Jessie Fauset**, see Hiroko Sato, "Under the Harlem Shadow"; Ann du Cille, "Blues Notes on Black Sexuality: Sex and the Texts of Jesse Fauset and Nella Larsen," in *American Sexual Politics: Sex, Gender, and Race Since the Civil War*, eds. John C. Faut and Maura Shaw Tantillo (Chicago, Ill.: University of Chicago Press, 1993); Carolyn Wedin Sylvander, *Jessie Redmon Fauset, Black American Writer* (Troy, N.Y.: Whitson, 1981); Deborah E. McDowell, "Introduction" in Jessie Fauset, *Plum Bun: A Novel Without a Moral* (1928; rpt., Boston: Beacon Press, 1990) and "The Neglected Dimension of Jessie Redmond Fauset" in *Conjuring: Black Women, Fiction, and Literary Tradition*, eds. Marjorie Pryse and Hortense J. Spillers (Bloomington: Indiana University Press, 1985); and Thadious M. Davis, "Foreword" in Jessie Fauset, *There Is Confusion* (1924; rpt., Boston, Mass.: Northeastern University Press, 1989).

Hazel V. Carby has written an excellent study of the nineteenth-century **black feminine literary tradition**, *Reconstructing Womanhood: The Emergence of the Afro-American Woman Novelist* (New York: Oxford University Press, 1987); the best over-all study is Barbara Christian, *Black Women Novelists: The Development of a Tradition, 1892–1976* (Westport, Conn.: Greenwood Press, 1980). See also Amritgit Singh, *The Novels of the Harlem Renaissance: Twelve Black Writers, 1923–1933* (University Park: Pennsylvania State University Press, 1975) and Michael Awkward's sometimes brilliant *Inspiriting*

Influences: Tradition, Revision, and Afro-American Women's Novels (New York: Columbia University Press, 1989).

On the various **theatrical stars** discussed in this chapter, there are a number of sources. On Charles Gilpin, see Jervis Anderson, *This Was Harlem* and James Haskins, *Black Theatre in America*; for his failed film career, see Thomas Cripps, *Slow Fade to Black*. On Paul Robeson, see the superb, detailed, if extraordinarily uncritical Martin Bauml Duberman, *Paul Robeson: A Biography* (New York: Alfred A. Knopf, 1988), and Robeson's eloquent memoir, *Here I Stand* (1958; rpt., Boston, Mass.: Beacon Press, 1988). On George Gershwin, John Bubbles, Todd Duncan, and *Porgy and Bess*, see the excellent, painstaking Hollis Alpert, *The Life and Times of Porgy and Bess: The Story of an American Classic* (New York: Alfred A. Knopf, 1990) and Edward Jablonski, *Gershwin: A Biography* (New York: Doubleday, 1987). Cary Grant's early career is covered in Charles Higham and Roy Moseley, *Cary Grant: The Lonely Heart* (New York: Harcourt Brace, 1989). Eddie Cantor's career is discussed in Robert W. Snyder, *The Voice of the City: Vaudeville and Popular Culture in New York* (New York: Oxford University Press, 1989); see also Cantor's lively memoir, Eddie Cantor with David Freeman, *My Life Is in Your Hands* (New York: Harper Bros., 1932). For Ziegfeld, see Charles Higham, *Ziegfeld* (Chicago, Ill.: Henry Regnery, 1972). Mary Austin on Bojangles is cited by Johnson in *Black Manhattan*, 215. Hurston, "Spirituals and Neo-Spirituals" is collected in *The Sanctified Church*; Alain Locke, "The Negro Spirituals" is in *The New Negro*. Louis Schaeffer discusses the opening of *All God's Chillun* in O'Neill: *Son & Playwright*. "Mrs. Adis" is in Sheila Kaye-Smith, *Joanna Godden Married* (London: Carshill, 1926). Sammy Price is quoted in Barry Singer, *Black and Blue: The Life and Lyrics of Andy Razaf* (New York: Schirmer Books, 1992), xviii.

3 OFFSTAGE INFLUENCES: FREUD, JAMES, AND STEIN

The best biography of **T. S. Eliot** is Peter Ackroyd, *T. S. Eliot: A Life* (New York: Simon & Schuster, 1984), which does him the service of an informal, accessible, even gossipy, always perceptive treatment. Lyndall Gordon, *Eliot's Early Years* (New York: Oxford University Press, 1977) and *Eliot's New Life* (New York: Farrar, Straus & Giroux, 1988) are superb studies of the life and art. See also *The Letters of T. S. Eliot, Vol. 1, 1898–1922*, ed. Valerie Eliot (New York: Harcourt Brace, 1988) for the gradual emergence of the "T. S. Eliot" persona. The chief collections of Eliot's prose are *The Sacred Wood: Essays on Poets and Criticism* (1920; rpt., New York: Barnes & Noble, 1960); *Selected Essays of T. S. Eliot* (New York: Harcourt Brace, 1950); and *On Poetry and Poets* (New York: Farrar, Straus & Giroux, 1957). See also T. S. Eliot, *The Complete Poems and Plays, 1909–1950* (New York: Harcourt Brace, 1950). The composition of *The Waste Land* can be traced in T. S. Eliot, *The Waste Land: A Facsimile and Transcript of the Original Drafts Including the Annotations of Ezra Pound*, ed., Valerie Eliot (New York: Harcourt Brace, 1971). The best general critical essays are still Delmore Schwartz, "T. S. Eliot as International Hero" (1945), "T. S. Eliot's Voice and His Voices" (1954, 1955), and "The Literary Dictatorship of T. S. Eliot" (1949), in *Selected Essays of Delmore Schwartz*, ed. Donald A. Duke and David H. Tucker (Chicago, Ill.: University of Chicago Press, 1970). Jacqueline Rose, *"Hamlet—the 'Mona Lisa' of Literature,"* in *Sexuality in the Field of Vision* (London: Verso, 1986) is a brilliant landmark study of Eliot's interpretation of *Hamlet* and his complex misogyny. Wayne Koestenbaum writes insightfully of the Eliot-Pound-Vivienne triangle and its re-creation in *The Waste Land* in *Double Talk: The Erotics of Male Literary Collaboration* (New York: Routledge, 1989).

Clive Bell connects Eliot to jazz in "Plus de Jazz," *The New Republic* 28 (September 21, 1921), 92–96. David Chinitz is superb on Eliot's use of minstrel conventions in "Jazz and Jazz Discourse in Modernist Poetry: T. S. Eliot and Langston Hughes," an unpublished Ph.D. dissertation, Columbia University, 1993; Michael North is equally insightful, though far more critical, in *The Dialect of Modernism: Race, Language, and Twentieth Century Literature* (New York: Oxford University Press, 1994). Charles Sanders, "The Waste Land: The Last Minstrel Show," *Journal of Modern Literature* 8 (1980): 23–38 is an extended and detailed comparison. Some of the Groucho Marx–T. S. Eliot correspondence is included in *The Groucho Letters: Letters from and to Groucho Marx*, ed. Arthur Sheekman (New York: Simon & Schuster, 1967).

Ernest Hemingway's time in Kansas City is covered in Michael Reynolds, *The Young Hemingway* (Oxford, England: Basil Blackwell, 1986), and Peter Griffin, *Along with Youth: Hemingway, the Early Years* (New York: Oxford University Press, 1985). The best source on Hemingway's Paris years is James R. Mellow, *Hemingway: A Life Without Consequences* (New York: Houghton Mifflin, 1992); despite the unfortunate subtitle, Mellow gets the undertones, the textures of Hemingway's emotional life, and he is an authority on Paris in the 1920s. Michael Reynolds, *Hemingway: The Paris Years* (Oxford, England: Basil Blackwood, 1989) is useful and evocative. Denis Brian offers valuable documentation in *The True Gen: An Intimate Portrait of Hemingway by Those Who Knew Him* (New York: Delta Books, 1989); Carlos Baker, *Ernest Hemingway: A Life Story* (New York: Scribner's, 1969) is still the indispensable source on all aspects of his life, and Kenneth S. Lynn, *Hemingway* (New York: Simon & Schuster, 1987) provides an important psychoanalytic reading of Hemingway's relationship with Stein and the lesbian scene of Paris. Jeffrey Meyer is excellent in conveying Hemingway's tough masculine modern ethos in *Hemingway: A Biography* (New York: Harper & Row, 1985); unlike Lynn and Mellow, he does not feel compelled to discredit it. (The larger crisis in contemporary masculinity represented by the attitudes of Hemingway's all-male biographers of the last decade would itself make an interesting study.) Hemingway's negotiations with Maxwell Perkins are covered in Scott Berg, *Max Perkins: Editor of Genius* (New York: E. P. Dutton, 1978); Kenneth Lynn is also detached and shrewd on Hemingway's self-promotion with publishers.

For writings and memoirs about the expatriate scene in Paris in the years Hemingway was there, see Janet Flanner, *Paris Was Yesterday (1925–1939)* (New York: The Viking Press, 1972); Morley Callaghan, *That Summer in Paris: Memories of Tangled Friendships with Hemingway, Fitzgerald, and Some Others* (1963; rpt., New York: Penguin Books, 1979); Harold Stearns, *The Street I Knew* (New York: Lee Furman, 1935); Kay Boyle and Robert McAlmon, *Being Geniuses Together* (Garden City, N.Y.: Doubleday, 1968); Malcolm Cowley, *Exile's Return: A Literary Odyssey of the 1920s* (1957; rpt., New York: Penguin Books, 1969) and *A Second Flowering: Works and Days of the Lost Generation* (1973; rpt., New York: Penguin Books, 1980); Matthew Josephson, *Life Among the Surrealists* (New York: Holt, Rinehart, 1962); and Harold Loeb, *The Way It Was* (New York: Criterion Books, 1959). Despite extreme dissatisfaction with crass America and a deep love of Europe, Van Wyck Brooks fought the urge to expatriate, and wrote astutely about the expatriates in *An Autobiography* (New York: E. P. Dutton, 1965); there and in *Days of the Phoenix: The 1920s I Remember* (New York: E. P. Dutton, 1957), he writes movingly about his youth and his terrible breakdown in the late 1920s. His survey of American literature, *America's Coming-of-Age* (New York: B. W. Huebsch, 1915), stands as one of the most brilliant and eloquent discussions of the subject. See James Hooper, *Van Wyck Brooks: In Search of American Culture* (Amherst: University of Massachusetts Press, 1977) and Raymond Nelson, *Van Wyck Brooks: A Writer's Life*

(New York: E. P. Dutton, 1981) for intelligent discussion of this seminal figure. J. Gerald Kennedy, *Imagining Paris: Exile, Writing and American Identity* (New Haven, Conn.: Yale University Press, 1993) is an excellent analytic study of Hemingway, Stein, Fitzgerald, Djuna Barnes, and Henry Miller in Paris and the psychology of expatriation. Michel Fabre, *From Harlem to Paris: Black American Writers in France, 1840–1980* (Urbana: University of Illinois Press, 1991) covers the black expatriates. Hemingway praises Walter Winchell and other American writers in "The Christmas Gift" in *Look* (April 20, 1950, 29–37; May 4, 1954, 79–89). Wallace Thurman extols Hemingway in *Infants of the Spring* (1932; rpt., Salem, N.H.: Ayer, 1972), 35. Parker's review of Claude McKay's *Home to Harlem* is included in *The Portable Dorothy Parker*, ed. Brendan Gill (New York: The Viking Press, 1973); McKay writes of Hemingway in *A Long Way from Home*, 249–52. Although Ralph Ellison thought (mistakenly, I believe) that Hemingway "ignored the dramatic and symbolic possibilities" of the Negro (*Shadow and Act*, 29), Robert O'Meally has written perceptively of Hemingway's affinities with Ellison's aesthetic in "The Rules of Magic: Hemingway and Ellison's Ancestor," *Southern Review* 21 (July 1985), 751–69.

On **William James**'s life, see Gay Wilson Allen's informative and readable *William James: A Biography* (New York: The Viking Press, 1967); see also the magisterial R.W.B. Lewis, *The Jameses: A Family Narrative* (New York: Farrar, Straus & Giroux, 1991) and F. O. Matthiessen, *The James Family: A Group Biography* (New York: Alfred A. Knopf, 1947). Howard M. Feinstein is superb on the young James in *Becoming William James* (Ithaca, N.Y.: Cornell University Press, 1984). Jean Strouse, *Alice James* (Boston, Mass.: Houghton Mifflin, 1980) sheds light on William James, as does Leon Edel in *Henry James*, 5 vols. (New York: Harper & Row, 1953–72). The best critical explication is Gerald E. Myers, *William James: His Life and Thought* (New Haven, Conn.: Yale University Press, 1986). *The Letters of William James*, ed. Henry James, 2 vols. (Boston, Mass.: Atlantic Monthly Press, 1920) remains valuable, though a new and expanded edition is needed. George Santayana wrote on James in "The Genteel Tradition in American Philosophy," in *Winds of Doctrine: Studies in Contemporary Opinion* (New York: Scribner's, 1913) and "William James," in *Santayana on America: Essays, Notes and Letters on American Life, Literature and Philosophy*, ed. Richard Colton Lynn (New York: Harcourt Brace, 1968). Bennett Ramsey, *Submitting to Freedom: The Religious Vision of William James* (New York: Oxford University Press, 1993) is important because Ramsey takes James at his word, as I do, and finds his thoughts and writings on religion to be central to his entire career, though he does not discuss his Spiritualist activities. See also Robert Vanden Burgt, *The Religious Philosophy of William James* (Chicago, Ill.: Nelson Hall, 1981) and Harry Levinson, *The Religious Investigations of William James* (Chapel Hill: University of North Carolina Press, 1981). R. Lawrence Moore, *In Search of White Crows: Spiritualism, Parapsychology and American Culture* (New York: Oxford University Press, 1977) is a first-rate, major study of James and the women mediums of Spiritualism.

On **Spiritualism** more generally, see Donald Meyer, *The Positive Thinkers* (Garden City, N.Y.: Doubleday, 1965); Ruth Brandon, *The Spiritualists* (New York: Alfred A. Knopf, 1983); and Geoffrey K. Nelson, *Spiritualism and Society* (New York: Schocken Books, 1969); for excellent studies focused on England (in whose society for Psychical Research James was involved through his friend Frederic W.H. Myers), see Janet Oppenheim, *The Other World: Spiritualism and Psychical Research in England, 1850–1914* (Cambridge, England: Cambridge University Press, 1985) and Alex Owen, *The Darkened Room: Women, Power and Spiritualism in Late Victorian England* (Philadelphia: University of Pennsylvania Press, 1990). The serious study of Spiritualism as a historical

phenomenon and a literary influence has only begun; its importance will inevitably be recognized as enormous. T. S. Eliot dabbled in séances and his wife Vivienne believed herself to possess mediumistic powers; with its spectral voices, ghosts, and undead, *The Waste Land* can be read as a vast séance translated into literary terms. Tan Lin of the English Department of the University of Virginia has written a masterful, breathtaking, unpublished essay on the links between *The Waste Land* and psychic research titled "How Not to Read *The Waste Land*: Hoaxes, Magic and Fear of the Disappearing Corpse." For James's writings on Spiritualism, see *Essays on Psychical Research*, ed. Frederick Burkhardt (Cambridge, Mass.: Harvard University Press, 1986), especially "Telepathy" (1895), "The Final Impression of a Psychical Researcher" (1909), and "Report on Mrs. Hodgson-Control" (1909). My citations from James are drawn largely from his religious and parapsychological writings: see William James, *The Varieties of Religious Experience* (1902; rpt., New York: New American Library, 1958); "The Will to Believe" in William James, *Essays on Faith and Morals* (New York: World Publishing, 1962); William James, *A Pluralistic Universe*, ed. Frederick Burkhardt (Cambridge, Mass.: Harvard University Press, 1977); and William James, *Exceptional Mental States: The 1896 Lowell Lectures*, ed. Eugene Taylor (New York: Scribner's, 1983). James's two essays on "The Medical Registration Act," both from 1894, and his review of Breuer and Freud, *Studies in Hysteria* are in *Essays, Comments and Reviews*, ed. Frederick Burkhardt (Cambridge, Mass.: Harvard University Press, 1987).

Du Bois's relations with James at Harvard are documented in *Blacks at Harvard: A Documentary History of African-American Experience at Harvard and Radcliffe*, eds. Werner Sollors, Caldwell Titcomb, and Thomas A. Underwood (New York: New York University Press, 1993). Kenneth W. Warren discusses the exchange between the James brothers on *The Souls of Black Folks* in *Black and White Strangers: Race and American Literary Realism* (Chicago, Ill.: University of Chicago Press, 1993). James's attack on the "Epidemic of Lynching" (1903) is in *Essays, Comments and Reviews*. William James's dislike of Mind-cure leaders (probably Eddy in particular) is expressed in *Letters* II, 69–70. Lippmann's changing assessment of James is documented in Ronald Steele, *Walter Lippmann and the American Century* (Boston, Mass.: Little, Brown, 1980). Elizabeth Blackwell speaks of "commit[ing] heresy with intelligence" in *Pioneer Work in Opening the Medical Profession to Women* (New York: Longmans, Green, 1895), p. 173. Dashiell Hammett speaks about "Style" in *Fighting Words*, ed. Donald Ogden Stewart (New York: Harcourt Brace, 1940). On the development of Alcoholics Anonymous and the influence of James, see Ernest Kurtz, *Not-God: A History of Alcoholics Anonymous* (Center City, Minn.: Hazeldon Educational Services, 1979); Nan Robertson, *Getting Better: Inside Alcoholics Anonymous* (New York: William Morrow, 1988); and *"Pass It On": The Story of Bill Wilson and How the A.A. Message Reached the World* (New York: Alcoholics Anonymous World Services, 1984).

The best single volume on Gertrude Stein is still Janet Hobhouse, *Everybody Who Was Anybody: A Biography of Gertrude Stein* (New York: G. P. Putnam, 1975), which is wonderfully illustrated. James R. Mellow, *Charmed Circle: Gertrude Stein & Company* (New York: Praeger, 1974) is superb on the Paris milieu; Richard Bridgman, *Gertrude Stein in Pieces* (New York: Oxford University Press, 1970) is perceptive though at moments hostile, and John Malcolm Brinnin, *The Third Rose* (Boston, Mass.: Little, Brown, 1959) is useful. On Stein and Toklas, see Diana Souhami, *Gertrude and Alice* (New York: Pandora, 1991) and Linda Simon, *The Biography of Alice B. Toklas* (Garden City, N.Y.: Doubleday, 1977). Many contemporaries left portraits of Stein, but the most telling is in Mabel Dodge Luhan, *Movers and Shakers* (New York: Harcourt Brace, 1936). On Leo Stein, see Leo D. Stein, *Journey into the Self: The Letters, Journals and Papers of*

Leo Stein, ed. Edmund Fuller (New York: Crown, 1950). The reading of Stein I have found most persuasive is Priscilla Wald's brilliant *Constituting Americans: Cultural Anxiety and Narrative Form*, forthcoming from Duke University Press, winter 1994–95; Wald contextualizes Stein in the national debate about immigrants, blacks, and Native Americans. Other valuable discussions of Stein's development and art are found in Jayne L. Walker, *Gertrude Stein: The Making of a Modernist* (Amherst: University of Massachusetts Press, 1984); Wendy Steiner, *Exact Resemblance to Exact Resemblance: The Literary Portraiture of Gertrude Stein* (New Haven, Conn.: Yale University Press, 1978); Ellen Berry, "On Reading Gertrude Stein," *Gender* 5 (Summer 1989), 1–20; Catherine Stimpson, "The Mind, the Body, and Gertrude Stein," *Critical Inquiry* 3 (1977), 489–506; and Marianne DeKoven, *Rich and Strange: Gender, History, Modernism* (Princeton, N.J.: Princeton University Press, 1991). Neil Schmitz, *Of Huck and Alice: Humorous Writing in American Literature* (Minneapolis: University of Minnesota Press, 1989) makes a persuasive, creative case for Stein as an American humorist; Lisa Ruddick, *Reading Gertrude Stein: Body, Text, Gnosis* (Ithaca, N.Y.: Cornell University Press, 1990) is a somewhat subdued study of Stein's connections to James and Freud. For an interesting reading of the more experimental Stein by one who feels (as I decidedly do not) that her autobiographical works are relatively unimportant, see Ula Dydo, "Standards in Meditation: The Other Autobiography," *Chicago Review* 35 (1985), 4–20.

Michael North is intelligent and highly critical on Stein's attitudes toward race and primitivism in *The Dialect of Modernism* (New York: Oxford University Press, 1994), as is Sonia Saldivar-Hull in "Wrestling Your Ally: Stein, Racism and Feminist Critical Practice" in *Women Writing in Exile*, eds. Mary Lynn Broe and Angela Ingram (Chapel Hill: University of North Carolina, 1989), but Martin Duberman finds in Stein's views of blacks an anticipation of Ralph Ellison (*Paul Robeson* [New York: Alfred A. Knopf, 1988], 598), and Richard Wright became a devoted admirer of her writing. Stein's letter about "niggers and serving girls and the foreign population generally" is in her papers in the Beinecke Library at Yale University; Priscilla Wald quotes it in *Constituting Americans*. Some of the essays Stein wrote while she studied with James at Harvard can be found in Rosalind S. Miller, *Gertrude Stein: Form and Intelligibility* (New York: Exposition Press, 1949). For Stein's distrust of the New England character and its "habit of self-repression and intense self-consciousness," see Gertrude Stein, "Cultivated Motor Automatism: A Study of Character in Its Relation to Attention," *Psychological Review* (1899), 299–306. The *Vanity Fair* piece on Stein appeared in 1917 and can be found in *Vanity Fair: Selections from America's Most Memorable Magazine*, eds. Cleveland Amory and Frederic Bradless (New York: The Viking Press, 1960), 20, 21. Gene Stratton-Porter on the world's love of "sweets" is cited in James D. Hart, *The Popular Book*, 216; James Weldon Johnson's praise of "Melanctha" is quoted in Eugene Levy, *James Weldon Johnson*, 313. Claude McKay, however, said that Melanctha was simply a disguised "Jewess" in *A Long Way from Home* (1937; rpt., New York: Harcourt Brace, 1970), 248. For a collection of Stein's best work, see *Selected Writings by Gertrude Stein*, ed. Carl Van Vechten (New York: Vintage, 1962). Other important works by Stein used in this chapter are Gertrude Stein, *Fernhurst, Q.E.D. and Other Early Writings*, ed. Leon Katz (New York: Liveright, 1971) and Gertrude Stein, *Lectures in America* (1935; rpt., New York: Vintage, 1975).

My view that **Freud's claims for the scientific value of his work** are largely spurious has been ably and exhaustively demonstrated by a number of studies in the past two decades, the most important of which are Frank J. Sulloway, *Freud, Biologist of the Mind: Beyond the Psychoanalytic Legend* (New York: Basic Books, 1979); Adolf Grunbaum, *The Foundations of Psychoanalysis* (Berkeley: University of California Press, 1984);

Malcolm Macmillan, *Freud Evaluated: The Completed Arc* (North Holland: Elsevier, 1991); and John Kerr, *A Most Dangerous Method: The Story of Jung, Freud, and Sabina Spielrein* (New York: Alfred A. Knopf, 1993); this last subject is also ably explicated from original documents in Aldo Laratenuto, *A Secret Symmetry: Sabina Spielrein Between Jung and Freud*, trans. Arno Pomerans, John Shepley, Krishna Winston (New York: Pantheon, 1982). Frederic Crews has intelligently and forcefully summarized the recent attack on Freud in "The Unknown Freud," *The New York Review of Books* (November 18, 1993), 55–66. What Freud lost as a scientist, however, he gained back as a cultural critic and a driven poet of the unconscious, and there are a number of superb works on these aspects of his career. Mark Kanzer is the authority on Freud's self-analysis; see *Freud and His Self-Analysis*, eds. Mark Kanzer and Jules Glenn (New York: Jason Aronson, 1983), especially the essay by Leonard Shengold on "The Freud/Jung Letters." In "Freud and the Demon," *Journal of the Hillside Hospital* 10 (1961), 190–20, and "Freud and His Literary Doubles," *American Imago* 33 (1976), 231–43, Mark Kanzer explores Freud's fascination with demonology and literary role models, particularly Faust. Lewis Mumford's essay on Freud's work as autobiography, "The Revolt of the Demons" (1964), is collected in *Interpretations and Forecasts 1922–1972: Studies in Literature, History, Biography, Technics and Contemporary Society* (New York: Harcourt Brace, 1973).

There are several important books and articles on **Freud's quarrel with religion**: David Tracy, "Freud and Religion," in *The Trials of Psychoanalysis*, ed. Françoise Meltzer (Chicago, Ill.: University of Chicago Press, 1989); Hans Küng, *Freud and the Problem of God*, trans. Edward Quinn (New Haven, Conn.: Yale University Press, 1979); Peter Gay, *A Godless Jew: Freud, Atheism and the Making of Psychoanalysis* (New Haven, Conn.: Yale University Press, 1987); and Paul C. Vitz, *Sigmund Freud's Christian Unconscious* (New York: Guilford Books, 1988). Judith Van Herik is illuminating on Freud's aversion to religion as feminine in *Freud on Femininity and Faith* (Berkeley: University of California Press, 1982), and Jean Starobinski discusses his reification of psychoanalysis as a quest into the inferno in "Acheronta Movebo" in *The Trial(s) of Psychoanalysis*, ed. Françoise Meltzer. The debate between Freud and Romain Rolland over religion is detailed in an important article, David James Fisher, "Sigmund Freud and Romain Rolland: The Terrestrial Animal and His Great Oceanic Friend," *American Imago* 33 (1976), 1–59; the letters of both are quoted at length. Sander L. Gilman is excellent on *Freud, Race and Gender* (Princeton, N.J.: Princeton University Press, 1993); although his primary concern is with Jews as a "race" and Freud as Jew, he also draws parallels between the status of Jews and blacks; as Kafka saw, the Jew was in some sense the Europeans' "Negro."

On **Freud and his followers**, Henry Ellenberger, *The Discovery of the Unconscious* and Peter Gay, *Freud: A Life for Our Time* are illuminating, but the classic history is the detailed, impartial, and insightful Paul Roazen, *Freud and His Followers* (New York: Alfred A. Knopf, 1971). Phyllis Grosskurth, *The Secret Ring: Freud's Inner Circle and the Politics of Psychoanalysis* (Reading, Mass.: Addison-Wesley, 1991) is excellent, as are Janet Sayers, *Mothers of Psychoanalysis: Helene Deutsch, Karen Horney, Anna Freud, Melanie Klein* (New York: W. W. Norton, 1991) and Lisa Appignanesi and John Forrester, *Freud's Women* (New York: Basic Books, 1992) on Freud's women followers. For Freud and Jung, see Philip Rieff, *The Triumph of the Therapeutic* (New York: Harper Bros., 1966); Colin Wilson, *C. G. Jung: Lord of the Underworld* (New York: The Aquarian Press, 1984); Gerhard Wahr, *Jung: A Biography*, trans. David M. Weeks (Boston, Mass.: Shambhala, 1988); Paul J. Stern, *C. G. Jung: The Haunted Prophet* (New York: Delta Books, 1976); C. G. Jung, *Freud and Psychoanalysis*, trans. R.F.C. Hull (Princeton,

N.J.: Princeton University Press, 1961); and his remarkable memoir, C. G. Jung, *Memories, Dreams, Reflections*, ed. Aniela Jaffé, trans. Richard and Clara Winston (1961; rpt., New York: Vintage, 1965). On Freud's other European followers, see the lively autobiography by Ernest Jones, *Free Associations: Memoirs of a Psychoanalyst* (New York: Basic Books, 1959); E. James Lieberman, *Acts of Will: The Life and Work of Otto Rank* (New York: The Free Press, 1985); the moving, brilliant *Clinical Diary of Sandor Ferenczi*, ed. Judith Dupont, trans. Michael Balint and Nicholay Zarday Jackson (Cambridge, Mass.: Harvard University Press, 1988); *The Correspondence of Sigmund Freud and Sandor Ferenczi*, eds. Eva Brabant, Ernst Falzelier, and Patricia Giampieri-Deutsch, trans. Peter T. Hoffen (Cambridge, Mass.: Harvard University Press, 1994); Elisabeth Young-Bruehl, *Anna Freud: A Biography* (New York: Summit Books, 1988); Phyllis Grosskurth, *Melanie Klein: Her World and Her Work* (Cambridge, Mass.: Harvard University Press, 1987); and Paul Roazen, *Helene Deutsch: A Psychoanalytic Life* (Garden City, N.Y.: Anchor Books, 1985). Jeffrey Moussaieff Masson, *The Assault on Truth: Freud's Suppression of the Seduction Theory* (New York: Farrar, Straus & Giroux, 1984) is valuable on the Freud-Ferenczi relationship and the importance of Ferenczi's work.

The literature on **Freud and America** is vast. It should be noted that Freud's hatred of America in general and Woodrow Wilson in particular as the authors of his woes was commonplace in postwar Austria and Germany. Wilson had beaten them in war, seduced them to seek peace by promises of "self-determination" and pledges to avoid unjust reprisals, than betrayed and punished them at Versailles. And Freud's complaints about America's cheap, easy, and seductive abundance, lax-minded democratic ways, miscegenated population, and absence of true culture were commonplace in the Nazi propaganda of the 1920s and 1930s; the Nazis, however, focused their criticism particularly on the dominance of Jews in American life—another tie binding the Jewish Freud, willy-nilly, to the nation he professed to despise. For German and Austrian attitudes toward America, see Robert Edwin Hertzstein, *Roosevelt & Hitler: Prelude to War* (New York: John Wiley & Sons, 1989). For Freud's impact on American psychiatry, the indispensable source is Nathan G. Hale, Jr.'s meticulous, masterly, and insightful *Freud in America*, Vol. 1; see also Nathan G. Hale, Jr., "From Berggasse XIX to Central Park West: The Americanization of Psychoanalysis 1919–1940," *Journal of the History of the Behavioral Sciences* 14 (1979), 299–315. I have relied on Hale's work throughout Chapters 3 and 4. *Freud, Jung and Hall the Kingmaker: The Historic Expedition to America* (1909), ed. Saul Rosenzweig (St. Louis, Mo.: Rana House, 1993) ably documents Freud's 1909 visit. Frederick J. Hoffman, *Freudianism and the Literary Mind* (Baton Rouge: Louisiana State Press, 1957), based on interviews as well as research, is still the best source on Freud's impact on modern American writers. For Freud's influence on New York theater, see W. David Sievers, *Freud on Broadway: A History of Psychoanalysis and the American Drama* (New York: Cooper Square, 1970). John Barrymore's biographers Gene Fowler, John Kobler, and Margot Peters discuss his production of *Hamlet* in depth; Peters tells the story of the *Macbeth* production. There is no biography of Ludwig Lewisohn, but the *World* covered his divorce in detail in February 1924. For the **Snyder-Gray trial**, see John Kobler, *The Trial of Ruth Snyder and Judd Gray* (Garden City, N.Y.: Doubleday, 1938), a collection of original documents and transcripts with a lengthy introduction; see also Judd Gray, *Doomed Ship* (New York: Horace Liveright, 1928), and *Ruth Snyder's Own True Story, or 'My own true story—so help me God!'* by Ruth Brown Snyder (New York: King Features Syndicate, 1927). Every reporter of note wrote something on the Snyder-Gray trial, but Damon Runyon's coverage was the most scathing and sensationalist. See "The Dumbbell Murder" in Damon Runyon, *Trials and Other Tribulations* (Philadelphia, Pa.: J. B. Lippincott, 1947). Gene Fowler's coverage also became famous;

it is reprinted in H. Allen Smith, *The Life and Legend of Gene Fowler* (New York: William Morrow, 1977).

Maxwell Bodenheim was a talented novelist, poet, and an alcoholic, the emblem of the Lost Generation in the Village; a friend to Crane, O'Neill, and Tennessee Williams, he ended as a homeless person, finally beaten to death by a psychotic indigent in 1954. See Jack B. Moore, *Maxwell Bodenheim* (New York: Twayne, 1970) and Ben Hecht, *A Child of the Century* (New York: Simon & Schuster, 1954) for accounts of this "man lost in some private Hell," "a scarecrow body and a dead soul," in Hecht's words. Freud's influence is visible in all Bodenheim's work; see especially Maxwell Bodenheim, *Introducing Irony: A Book of Poetic Short Stories and Poems* (New York: Liveright, 1922) and *New York Madness* (New York: Macaulay, 1933). Robert Benchley's psychoanalytic spoofs are collected in Robert Benchley, *My Ten Years in a Quandary* (Garden City, N.Y.: Blue Ribbon Books, 1940) and *Benchley—or Else!* (New York: Harper Bros., 1938), Thurber's in *The Thurber Carnival* (New York: Harper Bros., 1945). Thurber's relationship with Eliot is detailed in Burton Bernstein, *Thurber* (New York: Dodd, Mead, 1975). See also James Thurber and E. B. White, *Is Sex Necessary? Or, Why You Feel the Way You Do* (1929; rpt., New York: HarperCollins, 1990). Benchley on Al Jolson's shows is quoted in Herbert G. Goldman, *Jolson: The Legend Comes to Life* (New York: Oxford University Press, 1988), 136. Freud's letters to Bernays are reprinted in Edward Bernays, *Biography of an Idea*.

Freud, "Future Prospects of Psychoanalytic Therapy" (1910), "Transference Love" (1915), "Turnings in the Ways of Psychoanalytic Therapy" (1919), and "Analysis Terminable and Interminable" (1937) are collected in Freud, *Therapy and Technique* (New York: Collier Books, 1963), as are "Hypnotism and Suggestion" (1888), "A Case of Successful Treatment by Hypnotism" (1893), and "The Occult Significance of Dreams" (1925); for Freud and the occult, see also the essays in Freud, *Studies in Parapsychology* (New York: Collier Books, 1963), especially "The Uncanny" (1919). "One of the Difficulties of Psychoanalysis" (1917), "A Childhood Recollection from *Dichtung and Wahrheit*" (1917), "Dostoevsky and Parricide" (1928), and "A Disturbance of Memory on the Acropolis" (1937) are collected in Freud, *Character and Culture* (New York: Collier Books, 1963). The *Taboo of Virginity* (1918) and "The Psychogenesis of a Case of Homosexuality in a Woman" (1920) are in Freud, *Sexuality and the Psychology of Love* (New York: Collier Books, 1963), and "Negation" is in *A General Selection from the Works of Sigmund Freud*, ed. John Rickman (Garden City, N.Y.: Anchor Books, 1957).

4 ''YOU ARE ABOUT TO DISCOVER YOURSELVES''

There are two invaluable books that deal with **the Great War**: John Keegan's meticulous, polished, wise *The Face of Battle* (1976), which makes clear the dramatic escalation in military brutality it signified, and Modris Eckstein's brilliant *Rites of Spring* (1989), whose massively researched, eloquent interpretation of the Great War era as one of cultural crisis and high theater is closest to that of participants. Eric Leeds, *No Man's Land: Combat and Identity in World War I* (Cambridge, England: Cambridge University Press, 1979) gives particular attention to shell shock, with an excellent bibliography; John Toland, *No Man's Land: 1918, The Last Year of the Great War* (Garden City, N.Y.: Doubleday, 1980) is detailed and magisterial on the year of fighting that saw full American involvement. Allan Reed Millett and Peter Maslowski, *For the Common Defense: A Military History of the United States of America* (New York: Macmillan, 1984) and Hew. Strachan, *European Armies and the Conduct of War* (Boston, Mass.: Allen & Unwin,

1983) are extremely useful on the broader military history. For close-up views of the Great War, see Alan Lloyd, *The War in the Trenches* (New York: David McKay, 1976) and John Ellis, *Eye-Deep in Hell: Trench Warfare in World War I* (New York: Pantheon, 1976), both lavishly illustrated. Reginald Pound, *The Lost Generation* (London: Constable, 1964) is a historical elegy for the young Englishmen who died in the war; Paul Fussell, *The Great War and Modern Memory* (New York: Oxford University Press, 1975) is elegantly persuasive on the cultural and psychological repercussions of the war in England.

On **American involvement** and the responses of ordinary "doughboys" (whose reactions, unlike those of the literary elite, were often positive; many thought the war a heroic crusade out of Sir Walter Scott), see David M. Kennedy, *Over There: The First World War and American Society* (New York: Oxford University Press, 1980); see also Robert C. Walton, *Over There: European Reaction to Americans in World War I* (Ithaca, Ill.: F. E. Peacock, 1971). For popular reports by veterans, see Philip Gibbs, *Now It Can Be Told* (New York: Harper Bros., 1920); Erich Maria Remarque, *All Quiet on the Western Front*, trans. A. A. Sheen (1929; rpt., New York: Fawcett, 1990); and Laurence Stallings, *The First World War: A Photographic History* (New York: Simon & Schuster, 1933) and *The Doughboys: The Story of the AF, 1917–18* (New York: Harper & Row, 1963). *What Price Glory?*, a play by Laurence Stallings and Maxwell Anderson about the brutalities of the war, was a hit on Broadway in 1924; it was credited with making profanity fashionable in respectable circles. The play was published in *Three American Plays* (New York: Harcourt Brace, 1926).

Shell shock and hysteria are important topics in feminist studies in the last two decades; Sandra Gilbert has argued that shell shock was feminine hysteria, now afflicting (as Freud had always claimed it did) men as well as women. See Sandra Gilbert, "Soldier's Heart" in *Speaking of Gender*, ed. Elaine Showalter (New York: Routledge, 1989) and, for an overview of women writers in the war era, Sandra Gilbert and Susan Gubar, *No Man's Land: The Place of the Woman Writer in the Twentieth Century*, 2 vols. (New Haven, Conn.: Yale University Press, 1988–89). Elaine Showalter has amplified this view in *The Female Malady* (New York: Penguin Books, 1987) in important ways; also of interest on women and World War I are Nancy Huston, "The Matrix of War: Mothers and Heroes," in Susan Suleiman, *The Female Body in Western Culture: Contemporary Perspectives* (Cambridge, Mass.: Harvard University Press, 1985) and *Arms and the Woman: War, Gender and Literary Representation*, eds. Helen M. Cooper, Adrienne Auslander Munich, Susan Merrill Squier (Chapel Hill: University of North Carolina Press, 1989), especially the essays by James Longenbach, Jane Marcus, Sharon O'Brien, and Carol J. Adams. I argue that men and women were appropriating each other's styles throughout this period, and the idea that a "female" disease would cross over to men just as women were about to borrow heavily from men's fashions makes sense; "hysteria," a term of disapprobation when the illness was attributed solely to women, became respectable, even honorific, once men in battle showed its symptoms and was upgraded linguistically to "shell shock" or "war shock." But this gendered reading does not cover all the facts; there were other pressing reasons for the shift in terminology.

Many decades before the war, psychiatrists and alienists divided hysteria into two categories, female hysteria ("nervous shock") and industrial trauma ("traumatic shock"). Although the symptoms of the two were similar, female hysteria was supposed to arise from the female organism's peculiar sexual structure and functions, to have no fully adequate cause in the outside world, while industrial trauma came from outside sources, from the massive accidents on railroads and in factories that occurred with ever greater frequency in the fully industrialized late-Victorian age. Since World War I was the first

entirely industrialized war, shell shock was usually viewed as a subset of industrial non-sexualized trauma. Freud and his followers disputed this interpretation; driven to prove that all neurotic malfunctioning stems from sexual causes, Freud widened sexuality to include "narcissism," which he explicated in "On Narcissism: An Introduction," an important essay of 1914 (collected in *A General Selection from the Works of Sigmund Freud*, ed. John Rickman [Garden City, N.Y.: Anchor Books, 1957]). In this reading, the blows to self-esteem involved in shell shock are sexual since they damage the victim's erotic self-love, or narcissism. At stake was Freud's claim that the war had proved his theories right, and his followers backed him in his assertion. But other doctors and psychiatrists, like the Englishman W.H.R. Rivers, a pioneer in the treatment of shell shock who helped Siegfried Sassoon, although now convinced that the unconscious could make men sick, just as Freud had said, persisted in seeing shell shock as nonsexual, as part of industrial trauma.

The feminist reading of hysteria and shell shock holds good inasmuch as it was true that the masculine version of hysteria was honored, the feminine version denigrated—army officials who considered shell shock as a version of female hysteria called it "malingering" or cowardice and punished it with extreme harshness, as Eckstein and Leeds demonstrate; Freud objected to such treatment in his "Memorandum of the Electrical Treatment of War Neurotics" (1920), collected in *SE*, Vol. 17, 211–15. And it is partially valid in that both versions of hysteria have objective causes, usually in some form of traumatic experience. However, it fails to account for the original historical context: shell shock and female hysteria belonged to begin with in different categories that were firmly established in the 1880s; four decades before the war American doctors like S. Weir Mitchell who observed the "battle fatigue" afflicting Civil War veterans were formulating the idea of war shock as akin to industrial trauma. See *Weir Mitchell: His Life and Letters*, ed. Arna Robeson Burr (New York: Duffield, 1930); see also S. Weir Mitchell, *Fat And Blood: And How to Make Them* (Philadelphia, Pa.: J. B. Lippincott, 1877) and *Doctor and Patient* (Philadelphia, Pa.: J. B. Lippincott, 1888) for his later work with "nervous," largely women, patients. Doctors today, like most of Freud's peers in the 1910s, do not ascribe a sexual etiology to all traumas, regularly distinguishing between the post-traumatic stress syndrome of the malfunctioning family and that attendant on technological accidents and natural disasters. As James predicted, Freud's assertion that all mental illness stems from sexual disorders could not stand the test of time and experience, and feminist critics today occasionally perpetuate his too-inclusive emphasis on sexual causes.

Henri Ellenberger discusses both kinds of hysteria in *The Development of the Unconscious*, as does Freud in *Beyond the Pleasure Principle* (1920; rpt., New York: Collier Books, 1961). For the Freudian camp's claim that shell shock was a version of female hysteria, see Sandor Ferenczi, Karl Abraham, Ernst Simmel, and Ernest Jones, *Psychoanalysis and the War Neuroses* (London: The International Psychoanalytical Library, 1921). For those (the vast majority) who viewed shell shock implicitly or explicitly as a form of industrial trauma, see W.H.R. Rivers, "The Repression of War Experience," *Lancet* (1918); 171–8; M. D. Eder, *War-shock: The Psycho-neuroses in War Psychology and Treatment* (London: Heinemann, 1917); W. N. Maxwell, *A Psychological Retrospect of the Great War* (London: Allen & Unwin, 1923); and Thomas W. Salmon, *The Care and Treatment of Mental Diseases and War Neuroses ("Shell Shock") in the British Army* (New York: War Work Committee, 1917). Freud's letters to Andreas-Salomé about the war are in *Sigmund Freud and Lou Andreas-Salomé: Letters*, ed. Ernst Pfeiffer, trans. William and Elaine Robson-Scott (New York: Harcourt Brace, 1966). John Murray Cuddihy, *The Ordeal of Civility: Freud, Marx, Lévi-Strauss and the Jewish Struggle with*

Modernity (New York: Basic Books, 1974) is illuminating about the welcome Freud gave the bad news for Western civilization that the Great War brought. Jung's dream about no man's land as a symbol of the "unconscious" is recorded in C. J. Jung, *Memories, Dreams, Reflections* (1961; rpt., New York: Vintage, 1965), 203.

On the **prewar status and mind-set of America** relative to those of the other Great Powers, I have drawn on Paul Kennedy's exciting, massive, detailed study, *The Rise and Fall of the Great Powers*, and Henry May, *The End of American Innocence* (1959; rpt., Chicago, Ill.: Quadrangle Books, 1964). For critical **European and English travelers** to America, see Mrs. Frances Trollope, *Domestic Manners of the Americans*, ed. Donald Smalley (1832; rpt., New York: Vintage, 1949); Charles Dickens, *American Notes* (1842; rpt., New York: Thomas Nelson, n.d.); Francis Joseph Grund, *The Americans in their Moral, Social and Political Relations* (Boston, Mass.: Marsh, 1837); and Frederick Marryat, *A Diary in America with Remarks on Its Institutions*, ed. Sydney Jackman (1839; rpt., New York: Alfred A. Knopf, 1962). More positive reports can be found in Frederika Bremer, *America of the Fifties*, ed. Adolph B. Benson (New York: American-Scandinavian Foundation, 1924); Anthony Trollope, *North America*, ed. Robert Mason (New York: Harper Bros., 1862); and Isabella Lucy Bird, *The Englishwoman in America*, ed. Andrew Hill Clark (1856; rpt., Madison: University of Wisconsin Press, 1966). *Abroad in America: Visitors to the New Nation 1776–1924*, ed. Marc Pachter (Reading, Mass.: Addison-Wesley, 1976) is a useful anthology of travelers' memoirs. For Rupert Brooke's visit, see Rupert Brooke, *Letters from America* (1931; rpt., London: Sidgwick & Jackson, 1987). Jung's exhortation to America is in C. J. *Jung Speaking: Interviews and Encounters*, ed. William McGuire and R.F.C. Hull (Princeton, N.J.: Princeton University Press, 1977); he also remarked that the American is "a European with negro manners and an Indian soul" (cited in Robert Edwin Hertzstein, *Roosevelt & Hitler: Prelude to War* [New York: John Wiley & Sons, 1989], 18). **Paul Poiret** discusses his trip to America in 1913 in *En Habillant L'Époque* (Paris: Bernard Woset, 1930); his extraordinary career as couturier and artist is covered in Palmer White, *Poiret* (New York: Clarkson N. Potter, 1973) and Yvonne Deslandres with Dorothée Lalanne, *Paul Poiret 1879–1944*, trans. Paula Clifford (New York: Rizzoli, 1987), which is lavishly illustrated. For D. H. Lawrence and America, see the Bibliographical Essay for Chapter 7. For the "feminization" of late-Victorian America, I have relied on the research for my own *Feminization of American Culture*, but Gilbert Seldes makes the same case (and uses the term "feminization") brilliantly in *The Stammering Century* (1928). H. L. Mencken tells the story of "Better Speech Week" and the National Council of Teachers in *The American Language*, Part I, 5, "The Position of the Learned"; see Part VI, 7, "Euphemisms," for American euphemism. For other books on the characteristics of the American language, see the Bibliographical Essay for Chapter 9.

On **Woodrow Wilson** and his last years in office, see Gene Smith, *When the Cheering Stopped: The Last Years of Woodrow Wilson* (New York: William Morrow, 1964) and *Selected Literary and Political Papers and Addresses of Woodrow Wilson*, Vol. 3 (New York: Grosset & Dunlap, 1926); Edwin A. Weinstein, *Woodrow Wilson: A Medical and Psychological Biography* (Princeton, N.J.: Princeton University Press, 1981) is a penetrating psychoanalytic study. On Wilson's intensely intimate relations with his second wife, see Tom Schachtman, *Edith & Woodrow: A Presidential Romance* (New York: G. P. Putnam, 1981). Freud's attack on Wilson is found in William Bullitt and Sigmund Freud, *Thomas Woodrow Wilson: A Psychological Study* (Boston, Mass.: Houghton Mifflin, 1967), and his letter to Nathan Hale is cited in Peter Gay, *Freud: A Life for Our Time* (New York: W. W. Norton, 1989), 555. Mencken's dismissal of Wilson as "The Archangel Woodrow" was published in *Smart Set* (January 1921).

The standard biography of **Mary Baker Eddy** is Robert Peel, *Mary Baker Eddy*, 3 vols. (New York: Holt, Rinehart, 1966–77). Lyman P. Powell links Woodrow Wilson and Eddy in *Mary Baker Eddy: A Life Size Portrait* (Boston, Mass.: Christian Science Publishing, 1930); Powell's book was intended to refute Edwin Franden Dakin, *Mrs. Eddy: The Biography of a Virginal Mind* (New York: Scribner's, 1929). Willa Cather and Georgina Milmine wrote a highly critical, informative biography, *The Life of Mary Baker Eddy & The History of Christian Science* (1909; rpt. Lincoln: University of Nebraska Press, 1993), and Eddy's follower Augusta E. Stetson writes revealingly if effusively about her in *Reminiscences, Sermons and Correspondence 1884–1913* (New York: G. P. Putnam, 1914). Robert David Thomas, *"With Bleeding Footsteps": Mary Baker Eddy's Path to Religious Leadership* (New York: Alfred A. Knopf, 1994) is a brilliantly analytic, carefully researched, sympathetic study of her development. See Mary Baker Eddy, *Introspection and Retrospection* (1891; rpt., Boston, Mass.: First Church of Christ Scientist, 1968); *Poems* (Boston, Mass.: Allison V. Stewart, 1911); and *Science and Health with Key to the Scriptures* (1875; rpt., Boston, Mass.: First Church of Christ Scientist, n.d.) for the best examples of her writing. Stefan Zweig links Freud and Eddy in *Mental Healers: Franz Anton Mesmer, Mary Baker Eddy, Sigmund Freud*, trans. Eden & Cedar Paul (New York: The Viking Press, 1932). Freud's membership in the English and American Societies for Psychic Research is described in Janet Oppenheim, *The Other World* (Cambridge, England: Cambridge University Press, 1985), 245.

In my discussion of the connections between American Mind-cure and technology, I have drawn on several classic studies on **the development of technology in America** and in the West more generally; particularly useful were Alan Trachtenberg's superbly imaginative, synthetic *The Incorporation of America*; Nathan Rosenberg, *Technology and American Economic Growth* (New York: Harper & Row, 1972); David F. Noble, *America by Design: Science, Technology, and the Rise of Corporate Capitalism* (New York: Alfred A. Knopf, 1977); John Kasson, *Civilizing the Machine* (1976; rpt., New York: Penguin Books, 1977); Taylor and Irene P. Neil, *The American Railroad Network* (Cambridge, Mass.: Harvard University Press, 1956); Siegfried Giedion, *Mechinzation Takes Command* (New York: W. W. Norton, 1948); and David S. Landes, *The Unbound Prometheus: Technological Change and Industrial Development in Western Europe from 1750 to the Present* (Cambridge, England: Cambridge University Press, 1969). Neil Hariss, "Utopian Fiction and Its Discontents," in *Uprooted Americas: Essays to Honor Oscar Handlin*, ed. Richard Bushman (Boston, Mass.: Little, Brown, 1979) is excellent on the connection between technology and American utopianism. On John Roebling and the building of the Brooklyn Bridge, see Alan Trachtenberg, *Brooklyn Bridge: Fact and Symbol* (1965; rpt., Chicago, Ill.: University of Chicago Press, 1979) and David McCullough's detailed and insightful *The Great Bridge* (New York: Simon & Schuster, 1972), one of the finest studies of American culture in any of its aspects, which documents Roebling's Spiritualist activities. Biographies of Henry Ford and studies of the early auto industry can be found in the Bibliographical Essay for Chapter 5.

Harry Emerson Fosdick, *Adventurous Religion and Other Essays* (New York: Associated Press, 1926) is another best-selling **Mind-cure** book of the day that links the power of positive thinking and the new technology (in this case, the radio). The career and Mind-cure doctrines of Emile Coué are discussed in J. Louis Orton, *Emile Coué: The Man and His Work* (London: Francis Mort, 1935), particularly interesting because Orton was a disaffected and ill-used ex-partner of Coué. Coué's views of America are presented in Emile Coué, *My Method, Including American Impressions* (Garden City, N.Y.: Doubleday, 1927); the book, a best-seller, was largely ghostwritten, however, by an unidentified journalist from the New York *World*.

As for the connections between **Freud and Mind-cure**, Morris Fishbein lumps Freud with Christian Science in *The New Medical Follies* (New York: Boni & Liveright, 1927); Ernest Jones quotes Joseph Collins's remarks on psychoanalysis as "bosh, rot and nonsense" in *The Life and Work of Sigmund Freud*, eds. Lionel Trilling and Steven Marcus (1961; rpt., Garden City, N.Y.: Anchor Books, 1963), 295. Freud's exuberant "The Future Prospects of Psychoanalysis" is in *Therapy and Technique* (rpt., New York: Collier Books, 1963). For Trigant Burrow's long and eventually troubled relationship with Freud, see *A Search for Man's Sanity: The Selected Letters of Trigant Burrow with Biographical Notes*, ed. William E. Galt (New York: Oxford University Press, 1958); for Putnam's relationship with Freud, see *James Jackson Putnam and Psychoanalysis: Letters Between Putnam, Sigmund Freud, Ernest Jones, William James, Sandor Ferenczi and Morton Prince 1877–1917*, ed. Nathan G. Hale, Jr. (Cambridge, Mass.: Harvard University Press, 1971) and J. J. Putnam, *Addresses on Psychoanalysis* (New York: International Psychoanalytical Press, 1921). Putnam possessed a humane, searching intelligence, and his effort to persuade Freud that psychoanalysis could not afford to neglect people's social and religious needs is still moving, even authoritative. G. Stanley Hall, "A Medium in the Bud," *American Journal of Psychology* 29 (1918), 144–58, is Hall's account of the miraculous cure Freud effected in 1909. Max Eastman discusses his relationship with Freud, one that ended in partial disillusion on his side, in *Great Companions: Critical Memoirs of Some Famous Friends* (New York: Farrar, Straus & Giroux, 1958) and *Heroes I Have Known* (New York; Simon & Schuster, 1942).

William James makes the comparison between "optimistic" and "pessimistic" mediumship in *William James on Exceptional Mental States*, ed. Eugene Taylor (New York: Scribner's, 1983), 109. James's essay "The Moral Equivalent of War" (1909) is in William James, *Essays on Faith and Morals*, ed. Ralph Barton Perry (New York: World Publishing, 1962); his "Address on the Philippine Question" (1903) is in William James, *Essays, Comments, and Reviews*, ed. Frederick Burckhardt (Cambridge, Mass.: Harvard University Press, 1987). Frank Lentricchia analyzes **James's anti-imperialism** in "On the Ideologies of Poetic Modernism: The Example of William James 1890–1913," in *Reconstructing American Literary History*, ed. Sacvan Bercovitch (Cambridge, Mass.: Harvard University Press, 1986); in *Constituting Americans* (forthcoming, Duke University Press, 1994–95), Priscilla Wald argues that the imperialistic impulse James opposed nonetheless manifests itself in his style and rhetoric. In his brilliant book *The Gold Standard and the Logic of Naturalism: American Literature at the Turn of the Century* (Berkeley: University of California Press, 1987), Walter Benn Michaels discusses James's *Principles of Psychology* (1890) to elucidate late-nineteenth-century ideas and representations of ownership, appropriation, hoarding, and the will, and in the process lays the groundwork for a critique of James's attitudes toward imperialism. Richard Poirier is also brilliantly illuminating on James's pragmatic individualism in *The Renewal of Literature* (New York: Random House, 1987). It should be noted that Freud wrote a partial critique of war in a 1932 public exchange of letters with Albert Einstein, but he offers no specific comments on his own country's conduct and pauses to rebuke so-called civilized man for permitting "uncultivated races and backward strata of the population . . . [to] multiply more rapidly than highly cultivated ones"; see "Why War?" in Sigmund Freud, *Character and Culture*, ed. Philip Rieff (New York: Collier Books, 1963).

The title of **Stein's** essay in *The Atlantic* on World War II, "The Winner Loses" (1940), is her reprise on **Hemingway's** title of 1933, *Winner Take Nothing*. Hemingway meant to say that the winner gets no satisfaction from his victory, that the real winner is one who, in a spirit of bleak but exhilarating self-denial, refuses satisfaction, who finds his creativity in extinction, and "likes," as Stein summarizes the ethos in "The Winner

Loses," "to rise," like the phoenix, "from the ashes" of annihilation. Stein's emphasis, however, is not on what the winner loses or sacrifices but on what the defeated gain; hopes at last fulfilled do not fall short of anticipation but exceed it. Stein's eye is ever, to return to William James's phrase, on the "solid meal," not "the printed bill of fare." Indeed, one reason that she does not take the advice of various friends and officials who urge her to leave occupied France lest she, a Jew, be sent to a concentration camp is that such a move would interfere with her diet, and she is very "fussy" about what she eats. *Wars I Have Seen* is, among other things, a detailed account of exactly what foods were obtainable in a small village in occupied France; the coming of the Americans in 1945 was thrilling not least because it meant the return of a full cuisine.

Burrow's assessment of modern American culture as part of a manic-depressive cycle is cited in Fishbein, *New Medical Follies*, 68. Mary Borden on the "scaffolding of the future" and Ferdinand Léger on "audacious America" are cited in Modris Ecksteins, *Rites of Spring*, 268–69. Freud's aversion to reading "thick books" is quoted in Ernest Jones, *The Life and Work of Sigmund Freud*, 281. Lewis Mumford, "The Origins of the American Mind" (1926), is in Lewis Mumford, *Interpretations and Forecasts* (New York: Harcourt Brace, 1973). On manic depression, see Ronald R. Fieve, *Moodswing* (New York: William Morrow, 1975) and the encyclopedic Frederick K. Goodwin and Kay Redfield Jamison, *Manic-Depressive Illness* (New York: Oxford University Press, 1990). Bertram P. Lewin, *The Psychoanalysis of Elation* (New York: W. W. Norton, 1950), long a standard work, is of particular interest to me because he connects the disorder to oral fixation and a longing for the mother. Louis A. Sass, *Madness and Modernism: Insanity in the Light of Modern Art, Literature and Thought* (New York: Basic Books, 1992) traces the parallels between modernism and schizophrenia, drawing on the ideas of William James (among others) in the process: the book is compelling, though my own preoccupation has been with modernism and manic depression. Few of the American moderns who sought psychiatric treatment were diagnosed as schizophrenics (though Zelda, of course, was), and many more were afflicted with disorders of the manic-depressive or bipolar category: Fitzgerald, Hemingway, Al Jolson, Elinor Wylie, Sinclair Lewis, Hart Crane, Robert Sherwood, Dashiell Hammett, Eugene O'Neill, John Barrymore, Jed Harris, Maxwell Bodenheim, Walter Winchell, Van Wyck Brooks, Lewis Mumford, S. J. Perelman, Edmund Wilson, Wallace Thurman; and to a lesser degree Dorothy Parker, Robert Benchley, Louise Brooks, Sara Teasdale, and Louise Bogan show manic-depressive symptoms. All but Jolson, Sherwood, Brooks, and Mumford were alcoholics or addicts; manic-depressives often use alcohol and other drugs to monitor or self-medicate their extremely volatile psychic states. Strange to tell, the moderns seemed to bequeath this disorder to the next generation of American writers: Delmore Schwartz, Robert Lowell, John Berryman, Theodore Roethke, Sylvia Plath, Jean Stafford, Anne Sexton, Jack Kerouac, and Allen Ginsberg experienced bipolar disorders, Lowell eventually being treated with lithium, first marketed in this country in the early 1960s; all but Plath and Ginsberg were alcoholics.

The writers of the 1920s repeatedly diagnosed themselves, each other, and their culture as victims of mood disorders; Van Wyck Brooks, *The Malady of the Ideal* (1913; rpt., Philadelphia: University of Pennsylvania Press, 1947) and *America's Coming-of-Age* (New York: B. W. Huebsch, 1915); Frederick Lewis Allen, *Only Yesterday*; and Edmund Wilson, *The Shores of Light* (1952; rpt., New York: Farrar, Straus & Giroux, 1974), *The American Earthquake: A Documentary of the Twenties and Thirties* (Garden City, N.Y.,: Doubleday, 1958) and *The Twenties: From Notebooks and Diaries of the Period*, ed. Leon Edel (New York: Farrar, Straus & Giroux, 1975) reach for this diagnosis, even implying that the affliction is somehow not only individual and cultural but organic or biochemical

(as we today know bipolar illness is), though without the analytic tools and terms to clinch the point. Although a fully scientific understanding of manic-depressive bipolar illness did not begin until the 1950s and 1960s, the German psychiatrist Emil Kraeplin named and described it in 1904, and Eugen Paul Bleuler, the Swiss pioneer in the treatment of schizophrenia who was consulted on Zelda's case, wrote about what we would think of as manic depression in his classic *Textbook of Psychiatry*, trans. A. A. Brill (New York: Macmillan, 1924); Ernest Jones diagnosed Hamlet, the chosen exemplar of the age, as a "severe case of hysteria on a cyclothymic basis" in *Hamlet and Oedipus* (1910; rev. ed., New York: W. W. Norton, 1949). Cyclothymia, or manic depression, was seen as a form of "nervous" hysteria or close kin to it—both disorders specialize in split affects; hysterics and manic-depressives alike are by turn numbed, anesthetized, and overstimulated, oversensitized; by turn depressed and manic. The New York moderns tended to use the words "hysterical" or "nervous" where we might use the term "manic" (though Frederick Lewis Allen, describing America in the 1920s in *Only Yesterday*, speaks sometimes of "mania" and sometimes of "hysteria"), but all of them agreed that their age, and their city, was one of sudden excitations and abrupt deflations, and endless quick oscillations between the two conditions.

In "Echoes of the Jazz Age," Fitzgerald described the modern mood as "a state of nervous stimulation, not unlike that of big cities behind the lines of a war" (16). In *Save Me the Waltz* (1932), looking at the evidence of the modern urban age, Zelda hazarded a guess that all emotions are just "nerves," and reported that "hectic" was a favorite adjective and "delirium" the order of the day. Louise Bogan, a hard-core New Yorker, could find herself exhausted, she wrote a friend on November 13, 1929, by "New York['s] hysteria." (See *What the Woman Lived: Selected Letters of Louise Bogan 1920–1970*, ed. Ruth Limmer [New York: Harcourt Brace, 1973], 50). The New York author Julian Street dubbed the city's smart set the "Hectics." Psychoanalyzing the nation in *Our America* (New York: Boni & Liveright, 1919), Waldo Frank wrote that New York is "too high-pitched . . . [Its] nervous and spiritual fiber tears in . . . strain"; New York is both "electrified" and "sucked void"—it is "the nervous city" (173, 178).

Mental illnesses have their own history, which is one of cultural fashion, among patients and doctors, as well as medical fact, and my own contention is that the manic-depressive bipolar illness that afflicted the 1920s was a development of Victorian hysteria, even a modernization of it; manic depression was in part an updating of hysterical nervous illness, the major mental malady of the nineteenth century—again, there was more continuity between the Victorians and the moderns than the latter were usually ready to admit—and both were in part a response to the accelerating technological culture and to the special American temperament, now at fever pitch. As George M. Beard had insisted in *American Nervousness: Its Causes and Consequences*, ed. Charles Rosenberg (1881; rpt. New York: Arno Press, 1972) several decades earlier, "nervousness," and its siblings hysteria and manic depression, seemed to be synonymous with America. Though Jung, in 1912 a loyal Freudian, insisted that America's "nervous" state was the result of "prudery" or repressed sexuality (in other words, that it was female hysteria), it was, in fact, at least as much a part of industrial shock, and it was certainly natural, if not organic, to a culture that had long made the mood central to its discourse.

5 THE CULTURE OF MOMENTUM

For America's emergence as a superpower, I have relied on Paul Kennedy, *The Rise and Fall of the Great Powers*. Felix Gilbert, *The End of the European Era, 1890 to the Present*

(New York: W. W. Norton, 1978); Harold G. Vatter, *The Drive to Industrial Maturity: The U.S. Economy, 1860–1914* (Westport, Conn.: Greenwood, 1975); and Ernest R. May, *Imperial Democracy: The Emergence of America as a Great Power* (New York: Harcourt Brace, 1961) are also extremely useful. Ernest R. May, *American Imperialism: A Speculative Essay* (New York: Atheneum, 1968) is illuminating on the special nature of America's imperial ambitions and tactics. Walter Benn Michaels develops the idea of American imperialism as an "invisible empire," though in a different context, a racial one—his analogy is with the Ku Klux Klan—in a pathbreaking essay, "The Souls of White Folk," in *Literature and the Body: Essays on Populations and Persons,* ed. Elaine Scarry (Baltimore, Md.: The Johns Hopkins University Press, 1988). See also Walter Benn Michaels, "Anti-Imperial Americanism," in *Cultures of United States Imperialism,* eds. Amy Kaplan and Donald E. Pease (Durham, N.C.: Duke University Press, 1993), a valuable anthology; see the essays by Amy Kaplan and Donna Haraway on Teddy Roosevelt in the Philippines and New York. Michaels is currently finishing a book titled *Our America: Nativism, Pluralism and Modernism.*

On **modernization** more generally, see the essays by David Lerner, James Coleman, and Ronald P. Dore under "Modernization," in *International Encyclopedia of the Social Sciences,* ed. David L. Sills (New York: Macmillan, 1968) and the essays by Neil Smelser, Wilbert E. Moore, Horace E. Kallen, Ralph Lynton, and Karl Mannheim in *Social Change: Sources, Patterns and Consequences,* eds. Amitai Etzione and Eva Etzione (New York: Basic Books, 1964), Part IV. On the **auto industry,** see the excellent studies by James J. Flink, *America Adopts the Automobile 1895–1910* (Cambridge, Mass.: M.I.T. Press, 1970) and *The Car Culture* (Cambridge, Mass.: M.I.T. Press, 1975); for shifts in car styles, see Philip Van Doren Stern's lavishly illustrated *A Pictorial History of the Automobile* (New York: The Viking Press, 1953). Peter Collier and David Horowitz tell Henry Ford's colorful story in *The Fords: An American Epic* (New York: Summit Books, 1987), and Caroline Latham & David Agresta, *Dodge Dynasty: The Car and the Family that Rocked Detroit* (New York: Harcourt Brace, 1989) details the bitter feuds between rival automobile interests. Matthew Josephson, *Edison* (New York: McGraw-Hill, 1959) is an illuminating biography of the man and his times by a 1920s writer. On the development of the **fashion industry,** see J. Anderson Black and Madge Garland, *A History of Fashion* (London: Orbis, 1975) and Elizabeth Ewing, *History of Twentieth Century Fashion* (London: Batsford, 1985); Axel Madsen, *Chanel: A Woman of Her Own* (New York: Henry Holt, 1990) is an insightful, in-depth portrait of the woman, herself a legend, and the industry she revolutionized. Garth Jowett, *Film: The Democratic Art* (Boston, Mass.: Little, Brown, 1976), a definitive study, documents the **American takeover of the international film market;** Eric Rhode, *A History of the Cinema from Its Origins to 1970* (New York: Hill & Wang, 1976) also covers the international scene. Arthur Knight, *The Liveliest Art: A Panoramic History of the Movies* (New York: Macmillan, 1957) discusses the celluloid shortage caused by the war. The European film industry was also hurt by the wartime draft of actors and directors and the closing of the markets of enemy nations to each other's products, while America, of course, was officially neutral and draft-free until the spring of 1917. Marcus Loew's attitudes are documented in Larry May, *Screening Out the Past: The Birth of Mass Culture and the Motion Picture Industry* (New York: Oxford University Press, 1980). Scott Berg, *Goldwyn: A Biography* (New York: Alfred A. Knopf, 1989) is a superlative portrait of the man and the industry.

Broadway boasted its own replication of the **new accelerated assembly lines.** In January 1913, Flo Ziegfeld inaugurated the first modern cabaret revue, the *Midnight Frolic,* atop the New Amsterdam Theatre; the revue form, usually a series of loosely connected jazz numbers with operetta touches performed by singers and chorines within the time span

of twenty to forty minutes, a smaller, faster, less formal version of the *Ziegfeld Follies* and *George White's Scandals*, caught on at once. By March 1915, Lewis Erenberg tells us in his study of New York nightlife, *Steppin' Out* (Westport, Conn.: Greenwood, 1981), eleven cabarets had followed Ziegfeld's lead and were offering or preparing to offer revues. Revues took names like *Keep Moving*, *Full of Speed*, *Dance and Grow Thin* (whose composer/lyricist was Irving Berlin); *Variety's* highest praise, elicited by the 1916 *Revue at the Garden*, was that its twenty minutes seemed like five, "so active is the continuous entertainment that never stops for an instant," and it touted *Seeing Broadway* because "it's bing bang all the time, with succeeding artists walking on as the other finishes, cutting out even the opportunity for applause and necessary encores" (Erenberg, 208–12). Full-length plays also adopted a faster pace. In his memoir, *Present Indicative* (Garden City, N.Y.: Doubleday, 1947), Noël Coward wrote of his first experience with an American play, Rachel Crothers's *Nice People* (1921), with Katharine Cornell and Tallulah Bankhead. "What interested me most," he writes, was "the tempo." Bred as he was in the "gentle tradition of English comedy," for the first ten minutes he couldn't understand "what anyone was saying" because "they all seemed to be talking at once"; but he soon realized that "American acting" means "the technique of realising . . . which lines in the script are superfluous and . . . knowing when, and how, to throw them away" (128–29). As theater people say, the actors were "stepping on" each other's lines, one actor beginning to speak before the other has finished (a technique perfected by Alfred Lunt and Lynn Fontanne), yet another translation of the stepped-up pace of American production, another instance of demolishing the obsolete to advance the new.

On **cultural lag**, see William Fielding Ogburn, *Social Changes: With Respect to Culture and Original Nature* (1922; rpt., New York: The Viking Press, 1952). Ogden, a Southerner by birth, taught at Columbia University (where he received his Ph.D.) from 1919 to 1927 before leaving for Chicago, and his life and thought offer an illustration of the cultural-lag phenomenon. On Ogden's career, see Robert C. Bannister, *Sociology and Scientism: The American Quest for Objectivity, 1880–1940* (Chapel Hill: University of North Carolina Press, 1987). Acceleration and cultural lag also form the subject matter of James Truslow Adams's seminal essay, "The Tempo of Modern Life" (1931), in which Adams argues that the pace of modern life (especially in America) has picked up and is still accelerating at unprecedented levels; Copernicus's discovery in 1543 that the earth revolved around the sun was not accepted until the early 1900s; Darwin's theories of evolution, published in 1859, waited for broad endorsement until the early 1900s, but Einstein's discovery of relativity in 1919 was received as truth within months. More may not be happening in modern times than before, but "more events are happening to man of which he is conscious" (85); he lives in a "hailstorm of sensations" (89). Acceleration is connected to rhythm, and rhythm, Adams explains, explicating the ethos of the age, determines perception: "For example, certain rhythmical waves of energy (to use a loose term), of long wave length and low frequency, make themselves known to us as heat; increase the rhythm a little by shortening the wave length and increasing the frequency, and we become aware of them as color; continue the process and we get electricity; do so again, and we get a phenomenon which we can use but cannot perceive by our senses, the X-rays; and so on. A change of rhythm, whatever it may be in reality, is for us a change in essential nature" (86). Mass production and the stepped-up perceptions of the new mass media change reality itself. But acceleration can't continue indefinitely: sooner or later, the "law of diminishing returns" will take effect—Adams believes it already has. The congestion caused by traffic may outweigh the benefits of automobiles; the skyscrapers' collective blockage of the sky counts for more than their thrust upward, and so on.

Adams closes his essay with a haunting parable about the most serious cultural-lag

effect of modernization, an anecdote about a white man working in the wilds of the Amazon. Called by an emergency back to civilization, he sets out for the nearest town, with native guides to find the way. But on the third day he learns that they refuse to continue, because, as his translator explains, "they cannot move till their souls have caught up with their bodies." Adams's point is that, while primitive people may have the option to refuse the process of modernization, his fellow Americans do not. We cannot halt the process of "scientific discovery" by which one invention begets another "without a complete collapse of our civilization which is based on it. We must now go on, seeking new inventions, new sources of power, or crash—a civilization in a nosedive" (93–94). Adams's use of the racial other to symbolize the soul tells us much about the primitivism of the day.

Twain's essay on "Mental Telepathy" is in Mark Twain, *In Defense of Harriet Shelley and Other Essays* (New York: Harper Bros., 1929). In my discussion of **Siegfried Sassoon**, I have drawn on his *Memoirs of an Infantry Officer* (1930; rpt., New York: Collier Books, 1969); *Siegfried's Journey 1916–1920* (London: Faber & Faber, 1945); *Memoirs of a Fox-Hunting Man* (New York: Coward-McCann, 1929); and *Collected Poems, 1908–1956* (London: Faber & Faber, 1947). S. N. Behrman reminisces movingly about Sassoon and his homosexuality in *People in a Diary: A Memoir* (Boston, Mass.: Little, Brown, 1972). For Graves, see **Robert Graves**, *Goodbye to All That* (1929; rpt., New York: Anchor, 1957) and *Collected Poems* (Garden City, N.Y.: Doubleday, 1955); Richard Perceval Graves, *Robert Graves: The Assault Heroic 1895–1926* (London: Weidenfeld & Nicolson, 1986) is a detailed biographical study of his early years. See also *The Collected Poems of Wilfred Owen with a Memoir by Edmund Blunden* (1931; rpt., New York: New Directions, 1963); like Sassoon, Owen was homosexual. The homoerotic implications of the Great War experience are considered intelligently in Michael C.C. Adams, *The Great Adventure: Male Desire and the Coming of World War I* (Bloomington: Indiana University Press, 1990).

For the **American war writers**, see *Letters and Diary by Alan Seeger* (New York: Scribner's, 1923); Geoffrey Woolf, *Black Sun: The Brief Transition and Violent Eclipse of Harry Crosby* (New York: Random House, 1976); William Faulkner, *Soldier's Pay* (New York: Boni & Liveright, 1926); e. e. cummings, *The Enormous Room* (1922; rpt., New York: Modern Library, 1949); Charles Norman, *E. E. Cummings: The Magic Maker* (New York: Duell, Sloan, 1964); Richard S. Kennedy, *Dream in the Mirror: A Biography of E. E. Cummings* (New York: Liveright, 1980); John Dos Passos, *One Man's Initiation: 1917* (Ithaca, N.Y.: Cornell University Press, 1969); *Three Soldiers* (1921; rpt., Boston, Mass.: Houghton Mifflin, 1949); and *The Best Times: An Informal Memoir* (New York: New American Library, 1966). Dos Passos's postwar dissatisfaction with "gentle" Europe is cited in Townsend Ludington, *John Dos Passos: A Twentieth Century Odyssey* (New York: E. P. Dutton, 1980), 196–97.

American women's war novels are significant, too; see especially Edith Wharton, *A Son at the Front* (New York: Scribner's, 1923); Willa Cather, *One of Ours* (New York: Alfred A. Knopf, 1922); and Dorothy Canfield, *The Deepening Stream* (New York: Grosset & Dunlap, 1934). Cather won the Pulitzer Prize for *One of Ours*, but Hemingway scorned it, claiming she lifted the battle scenes from *The Birth of a Nation*: "Poor woman, she had to get her war experience somewhere" (cited in Kenneth Lynn, *Hemingway* [New York: Simon & Schuster, 1987], 222). Cather was the spokeswoman of an older generation and, like Wharton and other women writers who took on the war, she idealized its aims and consequences while, of course, being exempt by sex and age from participation. Hemingway labeled all such vicarious experience "alibis," and defined modernism as a

spirit fully available only to those who were expert in the battlefield, the streets, and the barroom, all arenas more or less forbidden to women.

On **Hemingway's participation in the Great War**, the indispensable study is Michael Reynolds, *Hemingway's First War: The Making of "A Farewell to Arms"* (Princeton, N.J.: Princeton University Press, 1976); Peter Griffin, *Along with Youth* (New York: Oxford University Press, 1985) is also illuminating. Michael Reynolds examines the loss of Hemingway's early manuscripts and its consequences perceptively and in detail in *Hemingway: The Paris Years* (Oxford, England: Basil Blackwell, 1989); see also *Hemingway in Love and War: The Lost Diary of Agnes Van Kurowsky*, eds. Henry S. Villard and James Nagel (Boston, Mass.: Northeastern University Press, 1989).

On **Hadley Richardson Hemingway**, see Peter Griffin, *Along with Youth*; Berenice Kert, *The Hemingway Women* (New York: W. W. Norton, 1983); Alice Hunt Sokoloff, *Hadley: The First Mrs. Hemingway* (New York: Dodd, Mead, 1973); and Gioia Diliberto, *Hadley* (New York: Ticknor & Fields, 1992). Hemingway romanticized Hadley in *A Moveable Feast*, but most of his close friends, particularly those who knew all four of his wives, held her in the same high regard. The letters and journals cited by her various biographers reveal an extraordinary woman, herself a talented (amateur) writer and critic, who helped the young Hemingway formulate and express his own sense of his special style; the "iceberg" metaphor he used later to describe it came from one of Hadley's early letters about his work.

Many critics have written well on the famous **Hemingway style**, but I have been especially aided by the insights of Harry Levin, "Observation on the Style of Ernest Hemingway" (1957), in *Hemingway: A Collection of Critical Views*, ed. Robert P. Weeks (Englewood Cliffs, N.J.: Prentice Hall, 1962); Sean O'Faolain, "A Clean Well-Lighted Place" (1961), also in *Hemingway*, ed. Robert P. Weeks; and Edmund Wilson, "Hemingway: Gauge of Morale" (1941), in *The Portable Edmund Wilson*, ed. Lewis M. Dabney (New York: The Viking Press, 1983). Hemingway's *Paris Review* interview of 1954, George Plimpton, "An Interview with Ernest Hemingway," is collected in *Ernest Hemingway*, *Modern Critical Views*, ed. Harold Bloom (New York: Chelsea House, 1985). For Ernest Fremont Tittle, who lost his faith while serving at the front, see Robert Moats Miller, *How Shall They Hear Without a Preacher? The Life of Ernest Fremont Tittle* (Chapel Hill: University of North Carolina Press, 1971).

The contrast between the nineteenth-century **American and British narrative traditions** turns on the use of detail. English narrative endorses what Freud called (in *Studies on Hysteria*) a "category of indifferent things," descriptions of objects, people or places undertaken not to nail down any particular meaning but simply to let in what most people understand as the real world, a plethora of easily recognizable phenomena used as a backdrop and grounding for significance but neutral in themselves, affording the pleasure and therapeutic value of "things," in Matthew Arnold's famous phrase, "as in themselves they really are." The assumptions of the British mimetic-narrativist include, however, a definition of the reality that he purports to imitate: reality is what most people—not the lunatic, the deviant, or even the poet—mean by the term. George Eliot sets the opening scene of *Adam Bede* (1859; rpt.; New York: Holt, Rinehart, 1948) by describing a carpenter's workshop, and much of what she tells her readers serves to let us feel not *why* but simply *that* we are there. She takes time off to describe a dog called Gyp, who lies contentedly on a heap of "shavings . . . occasionally wrinkling his brow" to look up at the workmen (1). Nothing will be made of this; in some way that relieves the strain of our interpretative activity. Gyp just happens to be here—it's a free world. Eliot allows us to watch things add up over a period of time long enough so that we can discern the "soul-making" process she, with Keats, believed the purpose of life, the social

interactions that make sense of our wayward impulses, the historicizing contextualizations that give dignity and significance to our too utterly personal and sometimes wasted lives.

In contrast, nineteenth-century American narrative everywhere asserts that we live in a world of projected and partial truths, that everything outside ourselves must be read in terms of our own psyche, that nothing is neutral, outside the tangled game of our interpretative aggression. Nathaniel Hawthorne, describing *The House of the Seven Gables* (1851; in *The Complete Novels and Selected Tales of Nathaniel Hawthorne*, ed. Norman Holmes Pearson [New York: Modern Library, 1937]), mentions "scattered shavings, chips, shingles and broken halves of bricks" that tell of recent carpentry, but he at once prompts us to read more deeply: "These together with the lately turned earth, on which the grass has not begun to grow, contributed to the impression of strangeness and novelty proper to a house that had yet its place to make among men's daily interests" (249). "Strangeness and novelty" are the operative words; the house is not a part of that mimetic world of "daily interests" that men agree to call "real" and make so by their shared participation in it. Detail doesn't exist for itself but, rather, functions like the literal level of allegory, a reality that prompts the reader to search for what it means—what we don't know is more telling than what we do know, more pressing, more ominous: the Maule house, we soon learn, is under a curse which has already killed several of its occupants and will kill more. Hawthorne's readers are at the mercy of an exacting guide on a trip through enemy territory, insomniacs of interpretive control who are solicited to supply, not adaptiveness, but adrenaline and concentration. There can be mimetic detail, "a category of indifferent things," only when trust is a possibility: a world trusted is a world historicized; a world distrusted is a world psychologized, even pathologized. The curse that lies on the house tells us that, while British narrative is the orthodox believer among narrative forms, American narrative is the heretic.

My views on the narrative in European and American literature have been formed in part by a lifetime of voluminous reading in both traditions, but a number of important and stimulating critics have shaped my interpretations. Erich Auerbach, *Mimesis: The Representation of Reality in Western Literature*, trans. William Trask (Garden City, N.Y.: Doubleday, 1963) is definitive on the mimetic narrative and its use of detail. Georg Lukács, *Studies in European Realism* (New York: Grosset & Dunlap, 1964); F. R. Leavis, *The Great Tradition* (New York: New York University Press, 1960); George Levine, *The Realistic Imagination: English Fiction from Frankenstein to Lady Chatterley* (Chicago, Ill.: University of Chicago Press, 1981); Wayne Booth, *The Rhetoric of Fiction* (Chicago, Ill.: University of Chicago Press, 1961); Frank Kermode, "Recognition and Deception" and "Secrets and Narrative Sequence," in *The Art of Telling: Essays on Fiction* (Cambridge, Mass.: Harvard University Press, 1983); and Robert Scholes and Robert Kellogg, *The Nature of Narrative* (New York: Oxford University Press, 1966) are all classic studies, important for the English tradition; Roy Schafer, "Narration in the Psychoanalytic Dialogue," in *On Narration*, ed. W.J.T. Mitchell (Chicago, Ill.: University of Chicago Press, 1981) is useful on narrative as a stabilizing force. Tsvetan Todorov examines the "grammar" of narrative in *The Poetics of Prose*, trans. Richard Howard (Ithaca, N.Y.: Cornell University Press, 1977), and Frederic Jameson is brilliant on "a world of *worn things*" as the subject of narrative in "Beyond the Cave: Modernism and Modes of Production," in *The Horizon of Literature*, ed. Paul Hernadi (Lincoln: University of Nebraska Press, 1982). The most eloquent statement of mimetic narrative's moral, therapeutic aims is Lionel Trilling, "Manners, Morals, and the Novel," in *The Liberal Imagination: Essays in Literature and Society* (1951; rpt., London: Mercury Books, 1964); see also Lionel Trilling, *Sincerity and Authenticity* (New York: Harcourt Brace, 1974).

Since classic American literature is a form of horror literature, a "fantasia of the

unconscious," to borrow a title from D. H. Lawrence, rooted in allegory and its sometimes demonically particularized abstractions, a number of the critical works that best illuminate it are not ostensibly about American literature but are, rather, centered on **allegory and demonic themes** more generally. See especially Agnes Fletcher's brilliant, monumental *Allegory: The Theory of a Symbolic Mode*, (Ithaca, N.Y.: Cornell University Press, 1964), which explains that allegory works by projections, creating a totally "verbal universe" and values a "secret mental survival" over physical survival. Paul de Man, "Pascal's Allegory of Persuasion," in *Allegory and Representation: Selected Papers from the English Institute 1979–80*, ed. Stephen J. Greenblatt (Baltimore, Md.: The Johns Hopkins University Press, 1981) praises allegory as the "purveyor of demanding truths" and describes its method as "at the furthest possible remove from historiography; its emphatic clarity of representation does not stand in the service of something that can be represented" (1,2). Joel Fineman details a "vivifying archeology of occulted origins" in "The Structures of Allegorical Desire," in *Allegory and Representation* (29); Maureen Quilligan's ideas of a biblical "pre-text" which she discusses in *The Language of Allegory: Defining the Genre* (Ithaca, N.Y.: Cornell University Press, 1979) is also important for classic American literature and its theological obsessions. Murray Krieger, " 'A Waking Dream': The Symbolic Alternative to Allegory," in *Allegory, Myth and Symbol*, ed. Morton W. Bloomfield (Cambridge, Mass.: Harvard University Press, 1981); René Girard, *Violence and the Sacred*, trans. Patrick Gregory (Baltimore, Md.: Johns Hopkins University Press, 1977); and Michel Foucault, "What Is an Author?" and "A Preface to Transgression" in *Language, Counter-Memory, Practice: Selected Essays*, trans. Donald F. Bouchard (Ithaca, N.Y.: Cornell University Press, 1977) are stimulating as well; Peter Brook's extraordinary, pathbreaking *The Melodramatic Imagination: Balzac, Henry James, Melodrama, and the Mode of Excess* (New Haven, Conn.: Yale University Press, 1976) elaborates an "aesthetics of astonishment."

The two best books on **the American tradition** are still Leslie Fiedler's provocative, brilliant *Love and Death in the American Novel* (New York: Delta Books, 1966), which pioneered in seeing race and gender as the obsessive themes of American literature, and Richard Poirier's elegantly audacious *A World Elsewhere: The Place of Style in American Literature* (New York: Oxford University Press, 1966), superb on American literature as stylistic experimentation. For the psychological damage evident in classic American literature, see Pamela A. Boker, *Mothers, Masculinity, and Mourning: The Grief Taboo in American Literature* (forthcoming, New York University Press, 1995), a compelling, massively researched psychoanalytic study of the inability to mourn in Melville, Twain, and Hemingway and its roots in maternal loss. Michael Davitt Bell is excellent on the gender tensions in Hawthorne; see *Hawthorne and the Historical Romance of New England* (Princeton, N.J.: Princeton University Press, 1971), and his perceptive broader study of the antisocial aspects of classic American narrative, *The Development of American Romance: The Sacrifice of Relation* (Chicago, Ill.: University of Chicago Press, 1980). For comparisons between the English and American traditions, I am particularly indebted to Edwin M. Eigner, *The Metaphysical Novel in England and America: Dickens, Bulwer, Melville, and Hawthorne* (Berkeley: University of California Press, 1978); Jonathan Arac, *Commissioned Spirits: The Shaping of Social Motion in Dickens, Carlyle, Melville and Hawthorne* (New York: Columbia University Press, 1989) also makes interesting transatlantic comparisons. Andrew Delbanco, "Melville's Sacramental Style" in *Raritan* (Winter 1993), 69–91, is masterful, eloquent, perhaps the best essay ever written on the subject. Melville wrote to Hawthorne about his "wicked book" in November 1891 in a letter cited in Jay Leyda, *The Melville Log: A Documentary Life of Herman Melville 1819–1891*, Vol. 2 (1951; rpt., New York: Gordian Press, 1969), 435; Twain spoke of

needing "a pen warmed up in hell" in a letter of September 22, 1889, to William Dean Howells in *Selected Mark Twain–Howells Letters 1872–1910*, eds. Frederick Anderson, William M. Gibson, and Henry Nash Smith (New York: Atheneum, 1968). Hemingway criticized *Huckleberry Finn* in *The Green Hills of Africa* (New York: Scribner's, 1935), 22.

6 THE "DARK LEGEND" OF MATRICIDE

For **Annie Payson Call**'s career, see Donald Meyers, *The Positive Thinkers* (Garden City, N.Y.: Doubleday, 1965). William James reviewed her earlier work favorably; see *"Power through Repose*, by Annie Payson Call (1891)," and "*As a Matter of Course*, by Annie Payson Call (1895)," in William James, *Essays, Comments, and Reviews*, ed. Frederick Burkhardt (Cambridge, Mass.: Harvard University Press, 1987). See also Annie Payson Call, *Nerves and the War* (Boston, Mass.: Little, Brown, 1918).

There are a number of excellent studies of **the national suffrage movement**: see Nancy Cott, *The Grounding of Modern Feminism* (New Haven, Conn.: Yale University Press, 1987); Aileen S. Kraditor, *The Ideas of the Woman Suffrage Movement* (1965; rpt., New York: W. W. Norton, 1981); Carrie Chapman Catt and Nettie Rogers Shuler, *Woman Suffrage and Politics: The Inner Story of the Suffrage Movement* (New York: Scribner's, 1923); William L. O'Neill, *Everyone Was Brave: The Rise and Fall of Feminism in America* (Chicago, Ill.: University of Chicago Press, 1969); Ellen Carol Du Bois, *Feminism and Suffrage* (Ithaca, N.Y.: Cornell University Press, 1978); and Eleanor Flexner, *Century of Struggle: The Woman's Rights Movement in the United States* (1959; rpt., New York: Atheneum, 1970).

On **the Woman's Christian Temperance** Union, see John Kobler, *Ardent Spirits* (New York: G. P. Putnam, 1973); Ruth Bordin, *Women and Temperance: The Quest for Power and Liberty, 1873–1900* (1981; rpt., New Brunswick, N.J.: Rutgers University Press, 1990); Barbara Leslie Epstein, *The Politics of Domesticity: Women, Evangelism and Temperance in Nineteenth Century America* (Hanover, N.H.: University Press of New England, 1986); Helen E. Tyler, *Where Prayer and Purpose Meet: The Woman's Christian Temperance Union Story, 1874–1949* (Evanston, Ill.: Signal Press, 1949); Elizabeth Putnam Gordon, *Women Torch Bearers: The Story of the Woman's Christian Temperance Union* (Evanston, Ill.: National W.C.T.U Publishing House, 1924); and Agnes D. Hays, *Heritage of Dedication: One Hundred Years of the National Woman's Temperance Union* (Evanston, Ill.: Signal Press, 1971).

For **Willard**'s career, see the painstaking and positive Ruth Bordin, *Frances E. Willard: A Biography* (Chapel Hill: University of North Carolina, 1986) and Frances E. Willard, *Glimpses of Fifty Years: The Autobiography of an American Woman* (Philadelphia, Pa: H. J. Smith, 1889). On **Catt**, see Mary Gray Peck, *Carrie Chapman Catt: A Biography* (New York: H. H. Wilson, 1944). On **Stanton**, Lois W. Banner, *Elizabeth Cady Stanton: A Radical for Woman's Rights* (Boston, Mass.: Little, Brown, 1980) is excellent; see also Alma Lutz, *Created Equal: A Biography of Elizabeth Cady Stanton, 1815–1902* (New York: John Day, 1940). Elizabeth Cady Stanton, *Eighty Years and More: Reminiscences* (London: Fisher Unwin, 1858) is a stirring, vivid memoir; see also *The Woman's Bible* by Elizabeth Cady Stanton and the Revising Committee (1898; rpt., Seattle, Wash.: Seattle Coalition Task Force on Women and Religion, 1974). Stanton's essay "The Matriarchate" (1891) is reprinted in *Up from the Pedestal: Selected Writings in the History of American Feminism*, ed. Aileen S. Kraditor (Chicago, Ill.: Quadrangle Books, 1968). For **Clara Barton** and other Civil War nurses who traded on their maternal nature, see

Ann Douglas Wood, "The War Within a War: Women Nurses in the Union Army," in *Civil War History* 18 (1972), 197–212. Barton was the sister of Hemingway's minister William E. Barton in Oak Park, and came frequently to lecture; see Michael Reynolds, *The Young Hemingway* (Oxford, England: Basil Blackwell, 1986), 10–12.

Kathleen Norris was the most interesting novelist of feminine and matriarchal sentimentalist essentialism in the 1910s and 1920s; vastly popular, with a curious literary style that seems to owe a good deal to Henry James, she developed the themes that would dominate the soaps of early radio, aroused the ire (and perhaps envy) of Dorothy Parker, was adored by Alexander Woollcott (always a fan of the matriarch), and took care of Elinor Wylie's stepchildren (they were related by marriage); forgotten today, she is well worth in-depth study. Of particular interest are her novels *Josselyn's Wife* (Garden City, N.Y.: Doubleday, 1918), in which the heroine is a potent emblem of "wizardry"; *Martie the Unconquered* (Garden City, N.Y.: Doubleday, 1917), whose heroine is robust, wide-eyed, and extremely ambitious; *Harriet and the Piper* (Garden City, N.Y.: Doubleday, 1920), a tale of feminine upward mobility via marriage; *Second Hand Wife* (Garden City, N.Y.: Doubleday, 1932), a study of heroic feminine self-sacrifice; and *Beauty's Daughter* (Garden City, N.Y.: Doubleday, 1935), a fictionalized manual on how-to-hold-your-man that contains Norris's richest character study in the heroine's mother, Magda, an aging, acerbic, colorful ex-actress.

Edna Ferber was another talented novelist of matriarchal feminism; see especially *Emma McChesney & Co.* (New York: Frederic A. Stokes, 1915), the story of a successful businesswoman and her subordinate spouse; *Show Boat* (1926; rpt., Garden City, N.Y.: Doubleday, 1941), a tale of a woman vanquished in love but a smash in her career, which became a hugely successful musical in 1927; and *So Big* (Garden City, N.Y.: Doubleday, 1924), about a magnificent woman farmer and her effete, corrupt son. Somehow Ferber's women always diminish their men by their overwhelming vitality; as one friend astutely tells the heroine of *So Big*, "Life! You'll be hogging it all yourself and not knowing it" (211). Ferber describes her own matriarchal family (her father was blind) in her superb memoir, *A Peculiar Treasure* (New York: Literary Guild of America, 1939), an important source for the period. The huge sales of Norris's and Ferber's books remind us that middlebrow America did not endorse the matricidal aims of the literary elite.

On **Sidney Howard**, see Sidney Howard White, *Sidney Howard* (Boston, Mass.: Twayne, 1977). In Howard's play *The Silver Cord* (New York: Scribner's, 1927), the older son, goaded by his feminist wife, finally breaks with Mrs. Phelps, the horrific mother of the play, denouncing her as he leaves; the younger son remains "engulfed forever," a helpless and willing victim. The split conclusion indicates the state of the modern matricidal psyche, one part loathing the matriarch, the other deeply dependent, unable to repudiate her. It is important that the most serious charge brought against Mrs. Phelps is that she won't wean her sons; "Grown man that you are," the daughter-in-law tells her husband, "down, down in the depths of her, she still wants to suckle you at her breast!" (199). In *Hemingway* (New York: Simon & Schuster, 1987), Kenneth Lynn rightly argues that **Hemingway's relationship with Grace** was the central one of his life, that he inherited his ebullient side from her (as he inherited his depressive tendencies from his father), that he needed more, not less, of her positive thinking in his own life and psyche. Sometime in the 1930s, Hemingway wrote a revealing, untitled story, never published, that supports this view. A young wounded soldier named Orpen wants to leave "Valhalla"—he had only "pretend[ed] to like" fighting; really, "it was horrible"—to return to the comfort and love of his mother, who is intimately associated with his creativity as a composer; here Hemingway views his code of manhood as self-induced anesthesia for

the unbearable pain of maternal loss, "ether in the brain." See Peter Griffin, *Along with Youth* (New York: Oxford University Press, 1985), 222–24, for the story. Mary Welsh Hemingway talks about her religious upbringing in her memoir, *How It Was* (New York: Alfred A. Knopf, 1976); she also documents Hemingway's final, harrowing despair: "He was immovably convinced he could not be healed."

John Unterecker has written an inclusive, eloquent biography of **Hart Crane,** *Voyager: A Life of Hart Crane* (New York: Farrar, Straus & Giroux, 1969), one of the finest biographies ever written of an American poet; in a preface to an updated edition (New York; Liveright, 1987), Unterecker regrets that he had not fully acknowledged the all-encompassing influence of Crane's alcoholism in his last years. Philip Horton, *Hart Crane: The Life of an American Poet* (New York: The Viking Press, 1937), while more limited in scope, is also moving and intelligent. Crane has attracted far less critical attention than his most important poetic peers, T. S. Eliot and Wallace Stevens, but some of the criticism we do have is extraordinary, particularly Allen Grossman's peerless essay, "Hart Crane and Poetry: A Consideration of Crane's Intense Poetics," in *Modern Critical Views: Hart Crane*, ed. Harold Bloom (New York: Chelsea, 1986). Grossman, himself a distinguished poet as well as a critic, brings criticism to the same heights that Crane achieved at his best as a poet; the essay actually furthers our knowledge of the imagination's workings and capacities. I have also been aided greatly by the superb work on Crane by Grossman's former student Elisa New, now at the University of Pennsylvania; see Elisa New, *The Regenerate Lyric: Theology & Innovation in American Poetry* (Cambridge, England: Cambridge University Press, 1993). Lee Edelman, "Voyages," in *Modern Critical Views, Hart Crane* is excellent; Thomas E. Yingling, *Hart Crane and the Homosexual Text: New Thresholds, New Anatomies* (Chicago, Ill.: University of Chicago Press, 1990) is interesting, reasonable, and persuasive on the importance of Crane's homosexuality for his poetry.

Patricia Yaeger's essay on the "Pre-oedipal Sublime" is in *Gender and Theory: Dialogues in Feminist Criticism*, ed. Linda S. Kauffman (Oxford, England: Basil Blackwell, 1989). For recent feminist critical studies of the idea of a "mother tongue," see *The (M)other Tongues: Essays in Feminist Psychoanalytic Interpretation*, eds. Shirley Nelson Garner, Claire Kahane, Madelon Sprengnether (Ithaca, N.Y.: Cornell University Press, 1985).

On Crane's vexed relations with the emerging, very pro-Eliot "New Criticism" of the day, a number of whose practitioners were close friends (particularly Allen Tate and Yvor Winters), see his own letters and statements in *The Complete Poems and Selected Letters and Prose of Hart Crane*, ed. Brom Weber (1966; rpt., Garden City, N.Y.: Anchor Books, 1966) and *Hart Crane and Yvor Winters: Their Literary Correspondence* (Berkeley: University of California Press, 1978); although Winters was often a harsh critic in Crane's lifetime, fifteen years after his death he wrote of Crane's "highly developed intelligence" and passion for poetry, and confessed: "I would gladly emulate Odysseus, if I could, and go down to the shadows for another hour's conversation with Crane on the subject of poetry" (109). Despite the uncanny parallels in their lives, Hemingway and Crane did not know each other, but they knew a good deal about one another from mutual acquaintances like Harry Crosby. Crane was bowled over by *The Sun Also Rises*. "It's a brilliant and a terrible book," he wrote a friend (cited in John Unterecker, *Voyager*, 477). Although Hemingway dismissed Crane in a (deleted) passage in *To Have and Have Not* (1937) as "an unfortunate bugger, always propositioning the wrong sailors and getting beaten up" (cited in James Mellow, *Hemingway*, [New York: Houghton Mifflin, 1982], 487), he himself had a fascination with beating and being beaten, in "taking it," as the psychotic veterans in *To Have and Have Not* make abundantly clear, and his own homoerotic impulses have been intelligently explored in James Mellow, *Hemingway*.

Hemingway wrote an important, sympathetic sketch of homosexuality; see "A Simple Inquiry" in Ernest Hemingway, *Men Without Women* (New York: Scribner's, 1927). For Sherwood Anderson, see Kim Townsend's expressive, intelligent biography, *Sherwood Anderson: A Biography* (Boston, Mass.: Houghton Mifflin, 1987) and Sherwood Anderson, *Selected Letters*, ed. Charles E. Modlin (Knoxville, University of Tennessee Press, 1984).

The only **Fitzgerald** biographer whose estimation of Mollie Fitzgerald's influence on her son is adequate is Scott Donaldson, *Fool for Love: F. Scott Fitzgerald* (New York: Congdon Weed, 1983). **Overprotective or too-powerful mothers** lurk in the background of many Fitzgerald stories; see especially "Crazy Sunday" in F. Scott Fitzgerald, *Babylon Revisited and Other Stories* (New York: Scribner's, 1960) and "The Freshest Boy" in F. Scott Fitzgerald, *The Basil and Josephine Stories* (New York: Scribner's, 1973). His first novel, *This Side of Paradise* (1920; rpt., New York: Scribner's, 1960), begins: "Amory Blaine inherited from his mother every trait, except the stray inexpressible few that made him worthwhile" (3). The original matricidal version of *Tender Is the Night* is described in detail in Matthew J. Bruccoli, *The Composition of Tender Is the Night: A Study of the Manuscripts* (Pittsburgh, Pa.: University of Pittsburgh Press, 1963). Freud's praise of **Ludwig Lewisohn's** *The Case of Mr. Crump* is quoted on the dust jacket of the 1961 reissue by Farrar, Straus & Giroux; originally banned at home, *Mr. Crump* was not published in America until 1947. Lewisohn's first wife, Mary Arnold Bosworth Crocker, the original for Anne in *The Case of Mr. Crump*, understandably assumed a self-pitying, martyred pose after her much publicized divorce, but she dramatized her side of the split vigorously in *Josephine*, included in *One-Act Plays for Stage and Study*, ed. Martin Flavin (New York: Samuel French, 1931). She had been writing powerful, angry, feminist plays for decades: see *The Last Straw*, *The Baby Carriage*, *The First Time*, and *The Cost of a Hat* in Mary Bosworth Crocker, *Humble Folk: One Act Plays* (Cincinnati, Ohio: Stewart Kidd, 1923).

The talented dramatist **George Kelly**, who was Grace Kelly's uncle and himself homosexual, had a hit in 1925 with his matricidal play, *Craig's Wife* (Boston, Mass.: Little, Brown, 1926), twice made into a movie, the first time with Rosalind Russell as *Craig's Wife* (1936), the second with Joan Crawford as *Harriet Craig* (1950). In Kelly's play, Mrs. Craig has sacrificed whatever need she may have for children to her obsession with controlling her husband. Mr. Craig, who identifies with a friend who recently murdered his wife "because she was dishonest," finally refuses to be infantilized, a "wife-ridden sheep," any longer, and leaves her alone in her perfectly furnished, ominously empty house. But the play is ambivalent; a nostalgic idealization of the Victorian mother lies right below the surface. Mrs. Craig is terrible in part because she is so little a mother— she "makes men believe that the mothers who nursed them are their arch enemies" (63). **Frederic Wertham** does not tell the readers of *Dark Legend: A Study in Murder* (New York: Duell, Sloan, 1941) when Gino murdered his mother; see also Frederic Wertham, "Catathymic Crisis," *Archives of Neurology and Psychiatry* 37 (1937), a festschrift for Adolf Meyer (another of Zelda's doctors). Richard Wright was very impressed by *Dark Legend* and became a patient and close friend of Wertham; they worked together to free a black prisoner named Clinton Brewer, who had murdered his girlfriend, the mother of two—once released, however, Brewer murdered another woman—and Wright later helped Wertham found the Lafargue clinic in Harlem, where blacks found psychiatric help at no cost. See Michel Fabre, *The Unfinished Quest of Richard Wright*, trans. Isabel Barzun (New York: William Morrow, 1973), 135–37, 292f. Wright's novel *Savage Holiday* (New York: Avon, 1954) was based partly on the Clinton Brewer case, and partly on *Dark Legend*; Wertham wrote an important essay stressing the matricidal elements in

Wright's *Native Son* (New York: Harper Bros., 1940), "An Unconscious Determinant in *Native Son*," *Journal of Clinical Psychopathology* 6 (July 6, 1944), 111–15.

Freud's relations with women and femininity are detailed in Lisa Appignanesi and John Forrester, *Freud's Women: Family, Patients, Followers* (New York: Basic Books, 1992), and Lucy Freeman and Herbert S. Strean, *Freud and Women* (New York: Frederick Unger, 1981). Freud speaking of *Totem and Taboo* as "my last good work" is cited in Ernest Jones, *The Life and Work of Sigmund Freud*, eds. Lionel Trilling and Steven Marcus (1961; rpt., Garden City, N.Y.: Anchor Books, 1963), 281. Freud, "Feminine Sexuality" (1931) is in *Sexuality and the Psychology of Love* (New York: Collier Books, 1963); "Some Character-Types Met with in Psycho-analytic Work" (1915) is in *Character and Culture* (New York: Collier Books, 1963). For other important works on Freud and gender, see the Bibliographical Essay on Freud and hysteria for Chapter 1. Freud's critique of Otto Rank's paper on the *Oresteia* is in *Minutes of the Vienna Psychoanalytic Society*, Vol. 1, 1906–8 (New York: International Universities Press, 1962), 1–13. Rank's views were developed in Otto Rank, *Das Inzest-Motiv in Dichtung und Saga* (1912); see Otto Rank, *The Incest Theme in Literature and Legend*, trans. Gregory Richter (Baltimore, Md.: Johns Hopkins University Press, 1991). J. J. Bachofen, "Athens," in *Myth, Religion and Mother Right: Selected Writings of J. J. Bachofen*, trans. Ralph Manheim (Princeton, N.J.: Princeton University Press, 1967) offers a matriarchal interpretation of the *Oresteia*. Ernest Jones, *Hamlet and Oedipus* (1910; rev. ed., New York: W. W. Norton, 1949) takes the Freudian view of both plays, but he lays the basis for a study of the matriarchal fury in *On the Nightmare* (London: Hogarth, 1931), largely written before World War I, in which he sees the nightmare as "an enormous vampyre" (21) whose violence comes from the fact that its "incestuous reunion with the Mother Earth" is prohibited (104). It cannot be too much stressed that Freud and his most orthodox followers were all visibly drawn to varying forms of the matriarchal figure they denied and minimized—refused a daylight entrance, she reappears as nightmare, a diva of the darkness—and those who broke from Freud, like Rank, Jung, and Ferenczi, openly announced matriarchal interests and allegiances. For further reading on the vampire cult of the 1920s, see the Bibliographical Essay for the Epilogue.

I am using the Greeks for the same reasons that Freud did. "The instincts are our myths," he wrote in "Instincts and Their Vicissitudes," and the idea came in good part from his readings in Greek tragedy. I, too, believe that the Greek tragedies are dramatizations of the psyche's secrets, of the "family romance," articulated constellations of emotions so powerful that they can be used to explain, even predict, phenomena in our own lives and culture. See Ann Douglas, "The Dream of the Wise Child: Freud's 'Family Romance' Revisited in Contemporary Narratives of Horror," *Prospects*, Vol. 9 (Cambridge, England: Cambridge University Press, 1984), 293–348. For an intelligent overview of women in Greek art and life, see Helene P. Foley, "The Conception of Women in Athenian Drama," in *Reflections of Women in Antiquity*, ed. Helene P. Foley (New York: Gordon & Breach, 1981). Philip E. Slater, *The Glory of Hera: Greek Mythology and the Greek Family* (Boston, Mass.: Beacon, 1968) is a controversial but vivid account of Greek matriarchy and misogyny; see also Sarah B. Pomeroy, *Goddesses, Whores, Wives and Slaves: Women in Classical Antiquity* (New York: Schocken Books, 1975). I have relied on the following translations for my discussion: *Agamemnon* in *Aeschylus I: Oresteia*, trans. Richmond Lattimore (Chicago, Ill.: University of Chicago Press, 1953); *Oedipus the King* in *Sophocles, I*, trans. David Grene (Chicago, Ill.: University of Chicago Press, 1954); Sophocles, *Electra and Other Plays*, trans. E. F. Watling (Middlesex, England: Penguin, 1953); *Electra* in *Euripides V*, trans. Emily Townsend Vermeule (Chicago: University of Chicago Press, 1959); and *Orestes* and *Iphigenia in Aulis* in

Euripides IV, trans. respectively William Arrowsmith and Charles R. Walker (Chicago, Ill.: University of Chicago Press, 1958).

Contemporary feminist criticism has gone through roughly four stages in its twenty-five-year history, though the stages overlap and none of them has disappeared. The first, dominant until the late 1970s, was largely historical, concerned with rediscovering and resurrecting forgotten women authors in their original context. The second, which ran until the mid-1980s, heavily indebted to French feminism and sometimes dubbed "gyno-criticism," concentrated exclusively on women and at moments abandoned history and male models entirely in the interests of exploring feminine values and subjectivity. The third, which occupied center stage until very recently, exchanged "feminism" for the more inclusive and socially conscious concept of "gender" (men were part of the subject again), using largely Freudian and/or Lacanian models. The most recent is historically minded, concerned with race (and to a lesser degree class) as well as gender, and the connections between them. My discussion of matriarchy and matricide has benefited immeasurably from all these developments, though the work of the second phase has served me largely as a negative example. Carol Gilligan, probably its most influential American exponent, seems to offer only a thinly modernized version of the Victorian essentialist belief in woman's superior moral nature, a view unpleasantly manifest in the contemporary writings of Catherine MacKinnon on pornography and female victimization. Whatever the biological determinants of gendered identity, any view of women that slights social constructions and historical perspectives appears to me misguided, self-serving, and dangerous; self-criticism must play a larger role than self-promotion in any seriously feminist enterprise. The consequences of forgetting larger values in the interests of so-called feminism are apparent in the racist legacy of the nineteenth-century women's-reform movements. On **gender essentialism** as a force in contemporary criticism, see Diana Fuss, *Essentially Speaking: Feminism, Nature & Difference* (New York: Routledge, 1989). Adrienne Rich makes an impassioned case for an updated and modified version of the matriarchal essentialist view in *Of Woman Born* (New York: W. W. Norton, 1976); Teresa de Lauretis, "Sexual Indifference and Lesbian Representation," in *Performing Feminisms: Feminist Critical Theory and Theatre*, ed. Sue-Ellen Case (Baltimore, Md.: Johns Hopkins University Press, 1990) argues intelligently for the partial retention of essentialist feminist values.

My greatest obligations are to **the psychoanalytic school of feminism**. When Freud remarked that women seemed unintelligent only because they were forbidden to think about sex, that he, too, could think only if he thought about sex, he was announcing, unawares, an important cultural, psychoanalytic trend; as F. W. Dupee observed that Henry James was "the great feminine novelist of a feminine age of letters" (*Henry James: His Life and Writings* [Garden City, N.Y.: Doubleday, 1957], 97), one might say that Freud was the first great feminine theorist of sexuality, and he has a number of gifted heirs among today's feminist critics. For Freud's (mis)interpretations of his Greek models, I am particularly indebted to Marianne Hirsch's brilliant analysis of Oedipus and the Sphinx in *The Mother/Daughter Plot: Narrative, Psychoanalysis, Feminism* (Bloomington: University of Indiana Press, 1989); Teresa de Lauretis's pathbreaking discussion of Oedipus in *Alice Doesn't: Feminism, Semiotics, Cinema* (Bloomington: University of Indiana Press, 1989); Laura Mulvey, "The Oedipus Myth: Beyond the Riddles of the Sphinx," in *Visual and Other Pleasures* (Bloomington: Indiana University Press, 1989); and Shoshana Felman, "Beyond Oedipus: The Specimen Story of Psychoanalysis," *MLN Comparative Literature* 98 (1983), 1029–45. The definitive study of Freud's matrophobia is the superb Madelon Sprengnether, *The Spectral Mother: Freud, Feminism, and Psychoanalysis* (Ithaca, N.Y.: Cornell University Press, 1990); also extremely valuable are Marie Balmary,

Psychoanalyzing Psychoanalysis: Freud and the Hidden Fault of the Father, trans. Ned Lukacher (Baltimore, Md.: Johns Hopkins Press, 1982) and Mary Jacobus, "Judith, Holofernes, and the Phallic Woman," in *Reading Women: Essays in Feminist Criticism* (New York: Columbia University Press, 1986). Mary Ann Doane writes perceptively on misogyny as the need for "defeminization" in "Clinical Eyes: The Medical Discourse" in *The Desire to Desire: The Woman's Film of the 1940s* (Bloomington: Indiana University Press, 1987); Jessica Benjamin intelligently criticizes Freud's overemphasis on power, his failure to understand "relatedness" or "co-feeling," the ability "to experience sameness without obliterating difference," in *The Bonds of Love: Psychoanalysis, Feminism, and the Problem of Domination* (New York: Pantheon, 1988), a superb study limited only by an unexplored utopian impulse which jostles uneasily with Benjamin's declared dislike of the "reactive valorization of femininity." Nancy J. Chodorow with Susan Contratto discusses matrophobia among feminists in an excellent essay, "The Fantasy of the Perfect Mother," in Nancy J. Chodorow, *Feminism and Psychoanalytic Theory* (New Haven, Conn.: Yale University Press, 1989).

The consequences of **matricidal impulses in women** are different than they are in men in one important respect: the woman is symbolically killing a figure she inevitably identifies with more closely than a man can; in killing her mother, she in some sense kills herself. Marianne Hirsch discusses this pathology perceptively in *The Mother/Daughter Plot*, but its supreme explication is Julia Kristeva, *Black Sun: Depression and Melancholia*, trans. Leon S. Roudiez (New York: Columbia University Press, 1989). Kristeva's discussion of the rage and possible madness involved in symbolic matricide and "deferred obedience" to the mother, what she calls "mourning for the maternal object," helps to explain the psychology of a number of the most gifted white women writers of the 1920s, in particular, Sara Teasdale, Louise Bogan, Elinor Wylie, and Dorothy Parker, who had different but extremely difficult relations with their mothers. Bogan, Wylie, and Parker's repeated demonization of themselves into a "witch" persona seems to express this dual sense of maternal abandonment and suffocation (in Parker's case, by a stepmother) and the hostility it aroused. The ethos of self-hatred they took as their trademark style had lethal consequences in blocked creativity and alcoholism—Bogan virtually stopped writing poetry at the age of thirty-seven shortly after her mother's death in 1936. George Kelly wrote a fascinating play entitled *Behold, the Bridegroom* (Boston, Mass.: Little, Brown, 1928) about a young, fashionably wicked flapper who starves herself to death because she believes her sins have cost her the love of the upright, ministerial man she picks as her mentor; absorbed in her father, she has not seemed to miss her dead mother, but the doctor who tends to her explains that she has picked a very female illness—dying of unrequited love. The title is an allusion to the biblical parable of the Foolish Virgins (Matthew: 25: 1–12); the loss of the mother is the loss of religious/spiritual as well as oral sustenance.

For **women's fashions in the 1920s**, see Elizabeth Ewing, *History of Twentieth Century Fashion* (London: Batsford, 1985); J. Anderson Black and Madge Garland, *A History of Fashion* (London: Orbis, 1975); *American Fashion*, ed. Sarah Tomerlin Lee (New York: Quadrangle, 1975); Nancy Hall-Duncan, *The History of Fashion Photography* (New York: Alpine Books, 1979); and the superbly illustrated Caroline Rennolds Milbank, *New York Fashion: The Evolution of American Style* (New York: Harry N. Abrams, 1989). Agnes Rogers and Frederick Lewis Allen, *I Remember Distinctly* (New York: Harper Bros., 1947), dramatizes (and illustrates) the swiftness of the fashion change between 1914 and 1920; Lois Banner, *American Beauty* (New York: Alfred A. Knopf, 1983) discusses depilation and other particularly American trends. Brenda Leland shud-

dering at her former "matronly" self is cited in Hillel Schwartz, *Never Satisfied* (New York: Free Press, 1986), 160. **Katharine Cornell**, who played Iris March on Broadway, was one of the most gifted, beautiful actresses of the day; she specialized in fallen-women roles. Tad Mosel with Gertrude Macy, *Leading Lady: The World and Theatre of Katharine Cornell* (Boston, Mass.: Little, Brown, 1978) is an excellent biography, though it makes no mention of Cornell's well-known lesbian orientation. Michael Arlen, *The Green Hat* (New York: George H. Doran, 1924) gave Fitzgerald part of his plot in *The Great Gatsby*; though Hemingway professed to scorn Arlen's book, he reproduced Iris March in Brett Ashley in *The Sun Also Rises*.

For the flapper and her ethos, see Paula Fass, *The Damned and the Beautiful* (New York: Oxford University Press, 1977); Kenneth A. Yellis, "Prosperity's Child: Some Thoughts on the Flapper," *American Quarterly* 51 (1969), 44–64; and Caroll Smith-Rosenberg, "The New Woman as Androgyne," in *Disorderly Conduct* (New York: Alfred A. Knopf, 1985). For contemporary assessments, see Bruce Blinn, "Flapper Jane," *The New Republic* 44 (1925), 65–67, and G. Stanley Hall, "Flapper Americana Novissima," *The Atlantic Monthly* 129 (1922), 771–80. *The Nation* symposium of 1920s feminists has been republished as *These Modern Women: Autobiographical Essays from the Twenties*, ed. Elaine Showalter (Old Westbury, N.Y.: Feminist Press, 1978); *Our Changing Morality: A Symposium*, ed. Freda Kirchwey (New York: Boni, 1924) is another round-table discussion about modern women by male doctors and intellectuals as well as women. Scott and Zelda Fitzgerald helped to invent the flapper; Scott was interviewed on the topic "Has the Flapper Changed?" by *Motion Picture* in July 1927, collected under the title "Flappers Are Just Girls with a Splendid Talent for Life" in *F. Scott Fitzgerald in His Own Time*, eds. Matthew J. Bruccoli and Jackson Bryer (New York: Popular Library, 1971). Zelda remarked that the flapper had simply applied "business methods to being young" and memorialized her in several short stories; see "Our Own Movie Queen," "The Original Follies Girl," "The Girl the Prince Liked," and "The Girl with Talent," in Zelda Fitzgerald, *The Collected Writings*, ed. Matthew J. Bruccoli (New York: Scribners, 1991). **Sophie Treadwell**'s career is discussed in Phyllis Marshall Ferguson, "Women Dramatists in the American Theatre," unpublished dissertation, University of Pittsburgh, 1957; see also Judith E. Barlow's "Introduction" to her anthology, *Plays by American Women: 1900–1930* (New York: Applause, 1985), which includes *Machinal*.

Olive Higgins Prouty's career is discussed in Edward Butscher, *Sylvia Plath: Method and Madness* (1976; rpt., New York: Pocket Books, 1977); Anne Stevenson, *Bitter Fame: A Life of Sylvia Plath* (Boston, Mass.: Houghton Mifflin, 1989); and most extensively in Paul Alexander, *Rough Magic: A Biography of Sylvia Plath* (New York: The Viking Press, 1991). See also Olive Higgins Prouty, *Stella Dallas* (1923; rpt. New York: Perennial Library, 1990). **Fanny Brice** was a famous matrophobic daddy's girl of the day; see Herbert G. Goldman, *Fanny Brice: The Original Funny Girl* (New York: Oxford University Press, 1992). Margaret Leech, an honorary member of the Algonquin Round Table, studied the possessive, "hysterical" matriarch and her effect on her troubled sons in *The Feathered Nest* (New York: Horace Liveright, 1928); Leech, unjustly neglected today, also wrote *Tin Wedding* (1926; rpt., New York: W. W. Norton, 1986), a superb novel about the trials of a modern marriage. Edith Wharton presented a complex portrait of a mother's sexuality, a taboo subject, in *The Mother's Recompense* (New York: D. W. Appleton, 1925), in which a divorced woman discovers that her daughter's fiancé is her own former lover; Marianne Hirsch analyzes the novel in *The Mother/Daughter Plot*.

7 "BLACK MAN AND WHITE LADYSHIP"

There are a number of excellent studies of **Reconstruction and the "Jim Crow" era**; see C. V. Woodward, *The Strange Career of Jim Crow* (3d ed.; New York: Oxford University Press, 1974); Charles A. Lofgren, *The Plessy Case: A Legal-Historical Interpretation* (New York: Oxford University Press, 1987); Leon Litwak, *Been in the Storm So Long: The Aftermath of Slavery* (1978; rpt., New York: Vintage, 1979); Joel Williamson, *A Rage for Order: Black-White Relations in the American South Since Emancipation* (New York: Oxford University Press, 1986); Eric Foner, *Reconstruction: America's Unfinished Revolution, 1863–1877* (New York: Harper & Row, 1988); and Willie Lee Rose, *Slavery and Freedom* (New York: Oxford University Press, 1982), a brilliant, broader study. For general histories of the **Progressive era**, see George E. Mowry, *The Era of T.R. and the Birth of Modern America, 1900–1912* (New York: Harper Bros., 1958) and Robert H. Wiebe, *The Search for Order 1871–1920* (New York: Hill & Wang, 1967).

On **suffragists and the Negro question** as well as "race" more generally (including immigrants), see Aileen S. Kraditor, *The Ideas of the Woman Suffrage Movement* (1965; rpt., New York: W. W. Norton, 1981); Vron Ware, *Beyond the Pale: White Women, Racism and History* (London: Verso, 1992); and Robert L. Allen, *Reluctant Reformers: Racism and Social Reform Movements in the United States* (Garden City, N.Y.: Doubleday, 1975). On **Jane Addams's** career, see the thoughtful and comprehensive Allen F. Davis, *American Heroine: The Life and Legend of Jane Addams* (New York: Oxford University Press, 1972); Katherine Kish Sklar, "Hull House in the 1890s: A Community of Women Reformers," in *Unequal Sisters: A Multi-Cultural Reader in U.S. Women's History*, eds. Ellen Carol DuBois and Vicki L. Ruiz (New York: Routledge, 1990); and Jane Addams, *Twenty Years at Hull House with Autobiographical Notes* (New York: Macmillan, 1915). On settlement workers more generally, see Allen F. Davis, *Spearheads for Reform: The Social Settlements and the Progressive Movement 1890–1914* (New York: Oxford University Press, 1968); for an impassioned protest against the soulless regimentation of the settlement house mentality, see the novel *Salomé of the Tenements* (New York: Boni & Liveright, 1923) by Anzia Yezierska, herself a Jewish Russian immigrant and a gifted if overwrought novelist and screenwriter. Mary Ovington, the New York social worker, fiction writer, and co-founder with W.E.B. Du Bois of the NAACP, dedicated herself to the Negro; see her memoir, *The Walls Came Tumbling Down* (1947; rpt., New York: Schocken, 1970) and her study, *Half a Man: The Status of the Negro in New York* (1911; rpt., New York: Schocken, 1969). Not all Southern suffragists were racists; see Jacquelyn Dowd Hall's excellent study *Revolt Against Chivalry: Jessie Daniel Ames and the Women's Campaign Against Lynching* (New York: Columbia University Press, 1979).

For **links between American racism and Nazi Germany**, see Stefan Kühl, *The Nazi Connection: Eugenics, American Racism, and German National Socialism* (New York: Oxford University Press, 1994). Michael H. Kater, *Different Drummers: Jazz in the Culture of Nazi Germany* (New York: Oxford University Press, 1992) is an intelligent discussion of Hitler's attempt to ban the African-American music popular in Germany in the 1920s and 1930s; Hitler repeatedly denounced what he called the "negroization of culture," the "mongrelization" and "promiscuous bastardization" of race in America (cited in John Toland, *Adolf Hitler* [Garden City, N.Y.: Doubleday, 1976], 234). Official Nazi horror at American miscegenation is also covered in Robert Edwin Herzstein, *Roosevelt & Hitler: Prelude to War* (New York: John Wiley, 1989). Heinrich Himmler was Hitler's right-hand man, and his racist ideology and fascination with Spiritualism, telepathy, and other forms of occultism are well documented in Peter Padfield's superb

biography, *Himmler: Reichsführer-SS* (New York: Henry Holt, 1990). *The Christian Science Monitor* was often sympathetic to the Nazi position; see Deborah E. Lipstadt, *Beyond Belief: The American Press and the Coming of the Holocaust 1933–1945* (New York: Free Press, 1986). The anti-Negro, anti-Semitic writings of Henry Ford, Lothrop Stoddard, and Madison Grant were studied by German schoolchildren; Hitler cited American slavery and U.S. policy toward American Indians as precedents for his treatment of Jews.

On **black women suffrage and club movements**, I am particularly indebted to Paula Giddings, *When and Where I Enter: The Impact of Black Women on Race and Sex in White America: A Documentary History* (New York: William Morrow, 1984), an intelligent, detailed overview. *Black Women in Nineteenth Century American Life*, eds. Bert James Loewenberg and Ruth Bogin (University Park, Pa.: Penn State University Press, 1976) is an excellent anthology of primary sources by and about black women; *Up from the Pedestal: Selected Writings in the History of American Feminism*, ed. Aileen Kraditor, presents speeches and writings by white suffragists advocating the exclusion of Negroes and some immigrant groups.

On **black women leaders**, I have relied also on *Black Women in America: An Historical Encyclopedia*, ed. Darlene Clark Hine 2 vols. (New York: Carlson, 1993); unless otherwise specified, all cited words by black and white feminists come from these four sources. See also the posthumously published, stirring memoir, *Crusade for Justice: The Autobiography of Ida B. Wells*, ed. Alfreda M. Duster (Chicago, Ill.: University of Chicago, 1970). Hazel Carby discusses Frances Harper's career as a temperance advocate in *Reconstructing Womanhood* (New York: Oxford University Press, 1987); see also Harper's best-known novel, *Iola Leroy or Shadows Uplifted* (1893; rpt., New York, Oxford University Press, 1988). The story of **black women in slavery** is told in Paula Giddings, *When and Where I Enter*; Elizabeth Fox-Genovese, *Within the Plantation Household: Black and White Women in the Old South* (Chapel Hill: University of North Carolina Press, 1988) is a comparative black-white study. Fox-Genovese explicates her exemplary brand of feminist historiography in an important book, *Feminism Without Illusions: A Critique of Individualism* (Chapel Hill: University of North Carolina, 1991); see particularly Chapter 8, "American Individualism Between Community and Fragmentation." Black women workers are the subject of Jacqueline Jones's fine study, *Labor of Love, Labor of Sorrow: Black Women, Work, and the Family from Slavery to the Present* (1985; rpt., New York: Vintage, 1986). On interracial liaisons in the Reconstruction South, see Martha Hodes, "The Sexualization of Reconstruction Politics: White Women and Black Men in the South after the Civil War," in *American Sexual Politics: Sex, Gender and Race Since the Civil War*, eds. John C. Font and Maura Shaw Tantillo (Chicago, Ill.: University of Chicago Press, 1993). Hortense J. Spillers, "Mama's Baby, Papa's Maybe: An American Grammar Book," *Diacritics* (1987), 69–95, is a breathtakingly intelligent interpretation of black family patterns and the importance of the black mother, couched in elegantly conceptual literary terms.

The most insightful and detailed biography of **Harriet Beecher Stowe** is Joan Hedrick, *Harriet Beecher Stowe: A Life* (New York: Oxford University Press, 1994). Stowe's relationship with Harriet A. Jacobs is discussed in Jean Fagan Yellin's "Introduction" in Harriet A. Jacobs, *Incidents in the Life of a Slave Girl Written by Herself*, ed. Jean Fagan Yellin (Cambridge, Mass.: Harvard University Press, 1987). For the difficulties of exslaves trying to write their own stories within the context of the white abolitionist movement, see William C. Andrews, *To Tell a Free Story: The First Century of Afro-American Autobiography, 1760–1865* (Urbana: University of Illinois Press, 1986); in *Constituting Americans* (Duke University Press, forthcoming, 1994–5), Priscilla Wald discusses the

problem of black authorship in her critique of **Frederick Douglass**'s autobiographies (see particularly *Narrative of the Life of Frederick Douglass: An American Slave: Written by Himself*, ed. Benjamin Quarles [1849; rpt., Cambridge, Mass.: Harvard University Press, 1988]) and the autobiographical novel by Harriet Wilson, *Our Nig: or, Sketches from the Life of a Free Black*, ed. Henry Louis Gates, Jr. (1859; rpt. New York: Vintage, 1983). My discussion of Frederick Douglass, his views, and his relations with Harriet Beecher Stowe and Elizabeth Cady Stanton is drawn largely from William S. McFeely's superb biography, *Frederick Douglass* (New York: Simon & Schuster, 1991); see also *Frederick Douglass on Women's Rights*, ed. Philip S. Foner (1976; rpt., New York: Da Capo, 1992).

Sources for the lives of Hemingway and Crane can be found in the Bibliographical Essays for Chapters 3, 5, and 6; those for Zora Neale Hurston, Jean Toomer, and Langston Hughes in the Bibliographical Essay for Chapter 2. Sherwood Anderson's letter to Crane about "Black Tambourine" is cited in John Unterecker, *Voyager* (New York: Farrar, Straus & Giroux, 1969), 109. Hemingway's poem "To Will Davies" is collected in Ernest Hemingway, *88 Poems*, ed. Nicholas Georgiannis (New York: Harcourt Brace, 1979). The *Chicago Tribune*'s coverage of the double hanging is cited in Michael Reynolds, *The Young Hemingway* (Oxford, England: Basil Blackwell, 1986), 214–15. **Mrs. Mason's** background and her **relationship with Hughes** is covered in detail in Arnold Rampersad, *The Life of Langston Hughes* (New York: Oxford University Press, 1986), Vol. 1; Faith Berry, *Before and Beyond Harlem: Langston Hughes* (New York: Citadel Press, 1983); and David Levering Lewis, *When Harlem Was in Vogue*. Hughes's various parables of maturation in *The Big Sea, Not Without Laughter* (1930; rpt., New York: Collier Books, 1969), and elsewhere are closer to theater than to autobiography; his repeated promise of a conclusive movement toward a settled, stable self is a trope, one he has no intention of finalizing. *Not Without Laughter* was dedicated not to Mrs. Mason but to "J. E. and Amy Spingarn," his Jewish benefactors; on the Spingarns, see Joyce B. Ross, *J. E. Spingarn and the Rise of the NAACP, 1911–1932* (New York: Atheneum, 1972). Arnold Rampersad and Faith Berry explicate Hughes's relationship with Amy Spingarn and Mary McLeod Bethune in their biographies of Hughes. There are two first-rate books on Scottsboro: Dan T. Carter, *Scottsboro: A Tragedy of the American South* (New York: Oxford University Press, 1969) and James Goodman, *Stories of Scottsboro* (New York: Pantheon, 1994).

Hurston, "How It Feels to Be Colored Me" is in *I Love Myself When I Am Laughing and Then Again When I Am Looking Mean and Impressive: A Zora Neale Hurston Reader*, ed. Alice Walker (Old Westbury, N.Y.: Feminist Press, 1979). For her relations with Mrs. Mason, see Robert E. Hemenway, *Zora Neale Hurston* (Urbana: University of Illinois Press, 1977); for her skillful glorification of her black heroines, see **Zora Neale Hurston**, *Their Eyes Were Watching God* (1937; rpt., New York: Fawcett, 1969), in which Janey gets the best of her various husbands and moves toward a supreme contemplation of the richness of her own experience while Hurston protects her from possible reader disapproval: Janey kills her last husband, the charming if abusive Tea Cake, but only, it seems, because he has contracted rabies from a mad dog and will otherwise kill her. The book is complex, superbly written, a minor masterpiece, but it's hard to resist the sense that Hurston, determined to see that Janey shares the spotlight with no one, has obligingly eliminated the competition. Augusta Rohrbach makes a controversial, important comparison between Hurston's essentialist notions (and the warm welcome they sometimes find today) and Wallace Thurman's difficult, unpopular notion of identity as socially constructed, in her Epilogue ("The Blacker the Berry, the Sweeter the Feminism: Who Isn't a Woman?") to "Riddles of Identity: Ideologies of Race and Gender in

Early Twentieth Century American Literature," unpublished dissertation, Columbia University, 1994, a study of Edith Wharton, Rose Terry Cooke, Pauline Hopkins, James Weldon Johnson, and Nella Larsen; she argues convincingly for constructed and theatrical notions of gender and race identity.

Anne Chisholm, *Nancy Cunard* (New York: Alfred A. Knopf, 1979) is an excellent biography which minimizes neither her achievements nor her losses and problems; Chisholm makes a persuasive case in her Appendix for **Nancy Cunard's** influence on *The Waste Land* (Eliot was an acquaintance, even a soulmate, whom Cunard admired enormously until the end of her life). See also *Nancy Cunard: Brave Poet, Indomitable Rebel*, ed. Hugh Ford (London: Chilton, 1968) and Mrs. Daphne Fielding, *Emerald and Nancy: Lady Cunard and Her Daughter* (London: Eyre & Spottiswoode, 1968). *Black Man and White Ladyship* has been reprinted in *Gender of Modernism: A Critical Anthology*, ed. Bonnie Kime Scott (Bloomington: Indiana University Press, 1990); for Cunard's best writings, see Nancy Cunard, *Negro*, ed. and abridged Hugh Ford (1934; rpt. New York: Frederick Unger, 1970); *Outlaws* (London: Elkin Matthews, 1921); and *G.M.: Memories of George Moore* (London: Hart-Davis, 1956). Michael North is extremely critical of Cunard's attitudes toward race and the tactics she used to compile *Negro* in *The Dialect of Modernism* (New York: Oxford University Press, 1994); see also Henry Crowder (with Hugo Speck), *As Wonderful as All That? Henry Crowder's Memoir of His Affair with Nancy Cunard, 1928–1935*, ed. Robert Allen (Navarro, Cal.: Wild Trees Press, 1987).

The material on Madame Sarah Breedlove Walker and Harlem's middle-class tastes, its predilection for hair straighteners and skin lighteners, comes largely from Jervis Anderson, *This Was Harlem* (New York: Farrar, Straus & Giroux, 1982); Robeson speaking of "the really great man of the Negro race" being born in America is cited in Martin Duberman, *Paul Robeson* (New York: Alfred A. Knopf, 1988), 133. For Fats Waller's art and life, see Maurice Waller and Anthony Calabrese, *Fats Waller* (New York: Schirmer Books, 1977), a personal memoir by his son; Ed Kirkeby, *Ain't Misbehavin': The Story of Fats Waller* (1966; rpt., New York: Da Capo, 1985); and Alyn Shifton, *Fats Waller: His Life & Times* (New York: University Books, 1988). Clifton Furness's description of black "communal composition" is cited in Lawrence Levine, *Black Culture and Black Consciousness*, 27.

On **Carl Van Vechten's** life, see Edward Lueders, *Carl Van Vechten* (New York: Twayne, 1965); Bruce Kellner, *Carl Van Vechten and the Irreverent Decades* (Norman: University of Oklahoma Press, 1968); and Carl Van Vechten, *Fragments from an Unwritten Autobiography* (New Haven, Conn.: Yale University Press, 1955). For Van Vechten's father and his support of black education, see Laurence Clifton Jones, *Piney Woods and Its Story* (New York: Fleming Revell, 1922). For Van Vechten's relations with Harlem, see *Keep A Inchin' Along: Selected Writings of Carl Van Vechten about Black Arts and Letters*, ed. Bruce Kellner (Westport, Conn.: Greenwood Press, 1979) and two superb collections of his photographs of black (among other) artists, *Generations in Black & White: Photographs by Carl Van Vechten*, ed. Rudolph P. Byrd (Athens: University of Georgia Press, 1993) and *The Passionate Observer: Photographs by Carl Van Vechten*, ed. Keith F. Davis (Kansas City, Mo.: Hallmark, 1993). Nathan Huggins is perceptive on Van Vechten's role in *Harlem Renaissance* (New York: Oxford University Press, 1971); Martin Duberman, *Paul Robeson* details Van Vechten's gay orientation and his photograph collection of nude black men. Robeson's increasingly left, pro-Russian sympathies and race militancy distanced him eventually from Van Vechten, though Van Vechten remained on good terms with Essie Robeson. *Nigger Heaven* (1926; rpt., New York: Harper Bros., 1971) is not the most interesting or accomplished of Van Vechten's novels; see the wonderful *Parties* (New York: Alfred A. Knopf, 1930) about a young

couple in the New York smart set, loosely based on Van Vechten's friends the Fitzgeralds, in which Van Vechten elaborates his witty creed—"Let's keep this . . . light-opera" (4); *The Blind Bow-Boy* (New York: Alfred A. Knopf, 1923); and its sequel *Firecrackers* (New York: Alfred A. Knopf, 1925), both devoted to Campaspe Lorillard, Van Vechten's version of the Iris March femme fatale, a consummate New Yorker and strangely ascetic voyeur. Fitzgerald particularly admired *The Blind Bow-Boy*. Van Vechten was ahead of his times in many ways and he was perhaps the first American self-consciously to write "camp" from a gay perspective, a deft, exhilarating blend of wide-eyed enthusiasm and heartfelt cynicism.

D. H. Lawrence's views of *Nigger Heaven* and Harlem more generally are cited in Nathan Huggins, *Harlem Renaissance*, 114–15; Langston Hughes thought his relationship with Mrs. Mason was uncannily prefigured in Lawrence's short story "The Lovely Lady," written in 1927, collected in *The Portable D. H. Lawrence*, ed. Diana Trilling (New York: The Viking Press, 1947), and it is not hard to see why. The "Lovely Lady," Mrs. Attenborough, is a wealthy, well-bred, authoritatively charming, still radiant but malign widow who holds her unhappy son Robert in a death grip of attraction and revulsion. Like Mrs. Mason, Mrs. Attenborough, a pioneer in collecting Indian and African art, has a "passion" for the "primitive." She, too, claims "telepathic," even magical powers, and her preternaturally youthful air of excitement and vivacity makes good the claim, but she is in reality a "devil," a sister of Count Dracula who knows that "a woman might live forever . . . if she absorbs as much vitality as she expends! or perhaps a trifle more!" (134). She is feminine essentialist as vampire, "feed[ing] on other lives . . . suck[ing] up one's essential life" (146). Although Robert feels "murder" in his heart, it is his homely cousin Cecilia, the proverbial poor relation Mrs. Attenborough supports and belittles, an Electra figure and herself in love with Robert, who takes the openly matricidal role; in a *Gaslight* scenario, she destroys Mrs. Attenborough's almost supernatural vitality, precipitating her sudden, grotesquely vivid aging and final defeat.

The circumstances under which D. H. Lawrence wrote *Studies in Classic American Literature* (1923; rpt. New York: The Viking Press, 1961) are detailed in Jeffrey Meyers, *D. H. Lawrence: A Biography* (New York: Alfred A. Knopf, 1990), 284–88. Lawrence had been staying with Gertrude Stein's friend Mabel Dodge Luhan in Taos, New Mexico, when he began *Studies*, but he found her the archetype of "the dominating American woman," a type he hated. They fought and he moved out, but he vowed to "*cut her throat!*" and did, symbolically at least, by excluding women writers from his study; *Studies in Classic American Literature*, like Twain's *Christian Science* (New York: Harper Bros., 1907), was an act of matricide, and in this act the American canon was born. (The most important essay on the making of the canon is Nina Baym's pioneering "Melodramas of Beset Manhood: How Theories of American Fiction Exclude Women Authors," in *The New Feminist Criticism: Essays on Women, Literature & Theory*, ed. Elaine Showalter [New York: Pantheon, 1985], to which I am greatly indebted.) Lawrence also associates America with the primitive archaic self in the novella *St. Mawr* (1925), collected in *St. Mawr and the Man Who Died* (New York: Vintage, 1959). It must have galled Lawrence that Luhan was happily married to a Native American at the time he visited her (and remained so until her death in 1962); he was more interested in America's Indians than its Negroes. See his toxic novel about a love affair between a white woman and a Native American, *The Plumed Serpent* (1926; rpt., New York: Alfred A. Knopf, 1951). In 1929, Lawrence wrote a follow-up attack on "the dominating . . . woman," a fierce little allegory about the modern reversal in gender roles titled "Cocksure Women and Hensure Men" (in *Gender of Modernism: A Critical Anthology*, ed. Bonnie Kime Scott), his take on what Freud thought of as feminine narcissism, a gloating explication of the collapse of

the matriarchal reform movements in the 1920s. When hens try to act like cocks, Lawrence explains, when women take men's parts as they do in the modern world, they seem to do it better than any man can, because they are full of the inexplicable conviction (which comes of bearing the children of the species) that they are deep down, immutably right, superior to all men and to any gods there might be. But for women, being "Boss" is in societal terms, whatever the biological picture, a borrowed role; while a "cocksure" man knows that to assert authority is to elicit a "challenge," not only from other would-be authorities but from reality itself, the hensure woman recognizes no authority greater than her own, and this guarantees her defeat, her pitch down to "nothingness." *She has not imagined her adversary*. Lawrence was a biased, even malign observer, but a shrewd one. Certainly, he was the non-American white modern author most important and congenial to Harlem's major male writers, Hughes, Toomer, and McKay, and the most influential critic for the white male moderns.

For the attacks on the women in the lives of the authors of classic American literature, see the studies on Melville cited in the Bibliographical Essay for the Introduction. See also Joseph Wood Krutch, *Edgar Allan Poe: A Study in Genius* (1925; rpt., New York: Alfred A. Knopf, 1965) and Van Wyck Brooks, *The Ordeal of Mark Twain* (New York: E. P. Dutton, 1920).

Critical work on the **nineteenth-century women writers** has been abundant in the last several decades; for valuable, pathbreaking discussions, see Nina Baym, *Woman's Fiction: A Guide to Novels by and about Women in America, 1820–1870* (Ithaca, N.Y.: Cornell University Press, 1978), a vigorous, invincibly intelligent defense of the feminine tradition; Mary Kelley, *Private Woman, Public Stage: Literary Domesticity in Nineteenth-Century America* (New York: Oxford University Press, 1984), a detailed, superbly imaginative, sympathetic discussion; and Jane Tompkins, *Sensational Designs: The Cultural Work of American Fiction, 1790–1860*, also highly sympathetic and particularly valuable on Susan Warner and on Stowe's centrality and motivation. Sally Allen McNall, *Who Is in the House? A Psychological Study of the Two Centuries of Women's Fiction in America, 1775 to the Present* (New York: Elsevier, 1981) argues convincingly that this fiction is concerned primarily with working through the heroine's relationship to her mother; Cheryl Walker, *The Nightingale's Burden: Women Poets and American Culture Before 1900* (Bloomington: Indiana University Press, 1982), a painstaking, illuminating study, has the merit of making a strong case for the Victorian women poets without overstating their achievement; Elaine Showalter, *Sister's Choice: Tradition and Change in American Women's Writing* (New York: Oxford University Press, 1991) demystifies the notion of a single "American" identity, taking the tradition at its most diverse. My own work in this field focused largely on the woman writer's use of her status as writer to make her way in a vociferously capitalist society; see Ann Douglas Wood, " 'The Scribbling Women' and Fanny Fern: Why Women Wrote," *American Quarterly* 23 (1971), 3–25; "Mrs. Sigourney and the Sensibility of the Inner Space," *New England Quarterly* 45 (1972), 163–81; "The Literature of Impoverishment: The Women Local Colorists in America, 1865–1914," *Women's Studies* 1 (1972), 3–45; and Ann Douglas, "Mysteries of Louisa May Alcott," *The New York Review of Books* (September 28, 1978), 60–63. Aided by the work of a number of extraordinarily gifted graduate students, most notably Patricia Crain, Marianne Noble, Alison Giffen, and Maria Russo, I have become more aware of the strengths and psychological complexities of these writers and the pleasure they afford without being able to see most of them by any objective criteria as writers of the first rank. Aside from Stowe and Alcott, the most talented and powerful of the nineteenth-century women writers to my mind is Mrs. E.D.E.N. Southworth; see particularly *The Deserted Wife* (Philadelphia, Pa.: T. B. Peterson, 1855) and *Retribution: A Tale of Passion* (1849; rpt., Philadelphia,

Pa.: T. B. Peterson, 1856). Neither novel is currently in print, and there is as yet no full-length study of Southworth's life and work, though Mary Kelley treats her intelligently at length in *Private Women, Public Stage*.

"Craft" meant the collective achievement of the excellence of the average product, and the literary version of the ideal was at its height in *The New Yorker*-Algonquin group and in the men who wrote for the New York–based *Black Mask* detective magazine in the 1920s and 1930s under the brilliant editorship of Joseph Shaw; Dashiell Hammett, Raymond Chandler, Erle Stanley Gardner, and Horace McCoy were all *Black Mask* regulars at the start of their careers, though the magazine folded in the 1950s, unable to compete with television and comic books. See *Selected Letters of Raymond Chandler*, ed. Frank MacShane (New York: Columbia University Press, 1981); *The Black Mask Boys: Masters in the Hard-boiled School of Detective Fiction*, ed. William F. Nolan (New York: William Morrow, 1985), an anthology; Frank Gruber, *The Pulp Jungle* (Los Angeles, Cal.: Sherbourne Press, 1967); Ron Goulart, *Cheap Thrills: An Informal History of the Pulp Magazines* (New Rochelle, N.Y.: Arlington House, 1972); and Dashiell Hammett, *The Big Knockover* (New York: Vintage, 1972). For Hammett's alcoholic, troubled, but strangely dignified life, see Diane Johnson, *Dashiell Hammett: A Life* (New York: Random House, 1983).

Generally men in their thirties, *Mask* writers were not well paid (Frank Gruber estimated he got a penny per word), but they were sociable, given to throwing parties for each other which boasted no food but plenty of bathtub gin; the *Black Mask* Christmas party was an institution to which contributors came from all over the country. Those who lived in New York often lunched together at Rosoff's restaurant on Forty-fourth Street; many of them had the same agent, Ed Bodin. Raymond Chandler, hardly gregarious by temperament, explained that pulp writers helped each other out because they didn't overestimate the value of their work: "We all grew up together . . . and we all wrote the same idiom . . . A lot of *Black Mask* stories sounded alike, just as a lot of Elizabethan plays sound alike. Always when a group exploits a new technique, this happens" (*Letters*, 67). The style, as Joseph Shaw described it, was "hard, brittle . . . [involving] a full employment of . . . dialogue . . . a very fast tempo, attained . . . by economy of expression" (cited in Gruber, *The Pulp Jungle*, 182). " 'You see, crooks is my meat,' " says John Daly's detective Race Williams, explaining his vocation (cited in Goulart, *Cheap Thrills*, 117). In Hammett's "The Big Knockover" the "Op" finds the part of San Franciso he's investigating in turmoil: "Hell was on a holiday . . . for the next six hours I was busier than a flea on a fat woman" (358). Individual authorship was always subordinated to the group product—most *Black Mask* writers worked some of the time under pseudonyms—yet they developed diverse styles within their shared tradition. In a March 1947 letter, Chandler summed up the possibilities the "formula" offered: "I obeyed the formula because I honestly liked it, but I was always trying to stretch it, trying to get in bits of peripheral writing which were not necessary, but which I felt would have a subconscious effect even on the semi-literate readers" (87). Craft was jazz, individual variations on a common theme. Lillian Hellman, Hammett's longtime companion, makes him an emblem of the nonchalant stoic glamour of the craft ideal in *An Unfinished Woman: A Memoir* (1969; rpt., New York: Bantam, 1973). "I had never seen anybody work that way," Hellman writes; "the care for every word, the pride in the neatness of the typed page itself, the refusal for ten days or two weeks to go out for a walk in fear something would be lost (236)." When Hammett was facing his painful death from lung cancer, she asked if he wanted to talk about it; "he said, almost with anger, 'No. My only chance is not to talk about it' " (225).

8 TAKING HARLEM

For post-colonial stirrings after the Great War, see Paul Kennedy, *The Rise and Fall of the Great Powers*, 286f. I am not arguing that Euro-America or even Aframerica was a post-colonial nation or people in the sense that the African nations and India are. Euro-America emerged from its legal dependency in the eighteenth century; its future importance was already clear to many then, and by the 1920s, when it achieved cultural independence, it was hardly a "backward" economy still needing massive aid from older, highly developed countries but, rather, the most economically powerful and modernized nation in the world, an implacably imperial power in its own right. Nor did America, on gaining independence, possess a large, much less majority, population of native, racially distinct inhabitants as the African and Eastern nations did; America's Indians, always a small group by white standards, never stood a chance, and by the late nineteenth century, they were reduced to a thin, impoverished, policed, and sequestered minority. White Americans considered themselves very much a master race while still themselves officially a "colonial" people; they usually identified with the colonizers rather than the colonized. Black Americans were, of course, in some real sense, colonized people—it was in part their presence, after all, that allowed white Americans to focus on themselves as a master race—but they had been transported from their homeland rather than being enslaved within it; once in America (unlike the imported African population of much of the West Indies), they were and remained a minority, and over centuries of forced miscegenation with the white population they lost their own languages and pure racial identity, as Africans colonized within Africa by and large did not. In no other colonial or post-colonial power were racially and legally distinct groups as assimilated—no matter the fear, antagonism, or indifference on both sides—as blacks and whites were in the United States. What America's situation after the Great War did have in common with that of other post-colonial nations, however, was the tension generated by a multiracial but viciously hierarchialized national identity, and efforts—multiple and distinct—to define and separate its own languages and cultures from those of colonizing external and internal influences.

On America as a post-colonial and a colonizing power, I am indebted particularly to the brilliant work of my colleagues in the English Department of Columbia University. See especially the masterworks of Edward W. Said, *Orientalism* (New York: Random House, 1979) and *Culture and Imperialism* (New York: Alfred A. Knopf, 1993) on the complex interlocking of imperial and subject discourses; and Gayatri Chakravorti Spivak, *The Post-Colonial Critic: Interviews, Strategies, Dialogues*, ed. Sarah Harasym (New York: Routledge, 1990). Spivak is authoritatively provocative on the feminist role in this discourse; see "French Feminism in an International Frame" in her *Essays in Cultural Politics* (New York: Routledge, 1988). Anne McClintock, *Imperial Leather: Race, Gender and Sexuality in the Colonial Contest* (New York: Routledge, 1994) is a superb study of the interaction between England and Africa, with special attention to mass culture. Rob Nixon, in *Homelands, Harlem and Hollywood: South African Culture and the World Beyond* (New York: Routledge, 1994) demonstrates the interconnections among South Africa, the Harlem Renaissance, and American media, discussing the latter as an international, colonizing, and, in certain contexts, liberating force; and in *London Calling: V. S. Naipaul, Postcolonial Mandarin* (New York: Oxford University Press, 1992) provides a valuable study of the colonial and post-colonial imagination of exile, protest, and entanglement. Gauri Viswanathan, "The Naming of Yale College: British Imperialism and American Higher Education," in *Cultures of United States Imperialism*, eds. Amy Kaplan and Donald E. Pease (Durham, N.C.: Duke University Press, 1993), is an

imaginative reminder of the complexities of America's own colonial status in the eighteenth century. For a useful intelligent overview of post-colonial literary strategies with relevance to Aframerica, see Bill Ashcroft, Gareth Griffiths, Helen Tiffin, *The Empire Writes Back: Theory and Practice in Post-Colonial Literatures* (New York: Routledge, 1989). Samir Amin, *Eurocentrism*, trans. Russell Moore (New York: Monthly Review Press, 1989) is a critique of Euro-capitalism as a super-imperialism that masks its aggression as historical inevitability and disowns the equally influential but different economic development of Arab-Islamic nations; I contend that America in the modern era carried this impulse to its apogee. Quentin Anderson illuminates the imperial nature of the American psyche authoritatively and eloquently in *The Imperial Self: An Essay in American Literary and Cultural History* (New York: Alfred A. Knopf, 1971) and *Making Americans: An Essay on Individualism and Money* (New York: Harcourt Brace, 1992), both classic studies.

For **the anti-immigration movement and blacks**, I have relied largely on John Higham's classic, detailed *Strangers in the Land: Patterns of American Nativism 1860–1925* (1955; rpt., New York: Atheneum, 1973). Thomas F. Gossett, *Race: The History of an Idea* (New York: Schocken, 1968) and R. Fred Walker, *Ethnicity, Pluralism and Race* (Westport, Conn.: Greenwood Press, 1983) are valuable intellectual histories, and Michael Omi and Howard Winant, *Racial Formation in the United States from the 1960s to the 1980s* (New York: Routledge, 1986), while focused on the post-World War II period, provides an overview and a critique of the inadequacies of current racial definitions. Bonnie Menes Kahn, *Cosmopolitan Culture: The Gilt-Edged Dream of a Tolerant City* (New York: Atheneum, 1987) and Chris McNickle, *To Be Mayor of New York: Ethnic Politics in the City* (New York: Columbia University Press, 1993) are interesting, if at moments superficial, commentaries on New York immigrant culture and politics. For a moving, detailed, comprehensive narrative of immigrant Jews in New York, see Irving Howe, *World of Our Fathers: The Journey of the East European Jews to America and the Life They Found and Made* (New York: Harcourt Brace, 1976). For an excellent broader survey, see Howard M. Sacher, *A History of the Jews in America* (New York: Alfred A. Knopf, 1992). Abraham Cahan, *The Rise of David Levinsky* (1917; rpt., New York: Harper Bros., 1966); Anzia Yezierska, *Salome of the Tenements* (New York: Boni & Liveright, 1923) and *Bread Givers* (1925; rpt., New York: Persea Books, 1975); Michael Gold, *Jews Without Money* (1930; rpt., New York: Avon, 1965); and Henry Roth, *Call It Sleep* (1934; rpt., New York: Avon, 1968) are classic, powerful fictional accounts of the Jewish immigrant experience in New York; see also Jacob Riis, *The Making of an American* (New York: Macmillan, 1901) for a superb memoir of the Americanization process. In Yezierska's *Salome*, Sonya Vronsky, a tenement-born couturière, is a strange amalgam of the sentimental, melodramatic heroine and the racial other; Yezierska repeatedly describes Russian Jews as "primitive" and "savage," language much like that native-born whites were then using to describe blacks. On Yezierska, see Mary V. Dearborn, *Love in the Promised Land: The Story of Anzia Yezierska and John Dewey* (New York: The Free Press, 1988) and *Pocahontas's Daughters: Gender and Ethnicity in American Culture* (New York: Oxford University Press, 1986), a more general study that includes Gertrude Stein as an immigrant writer. Jack Salzman has edited a first-rate collection of essays on Jewish-black relations, *Bridges and Boundaries: African Americans and American Jews* (New York: George Braziller, 1992); see especially the Introduction by Jack Salzman and David Levering Lewis, "Parallels and Divergences: Assimilationist Strategies of Afro-American and Jewish Elites."

For the argument that all American literature is **ethnic literature** and an intelligent study of the meanings of ethnicity, see Werner S. Sollors, *Beyond Ethnicity: Consent*

and Dissent in American Culture (New York: Oxford University Press, 1986). Ignatius Donnelly, *Caesar's Column: A Story of the Twentieth Century* (1890; rpt., Cambridge, Mass: Harvard University Press, 1960) is a fascinatingly turgid novel about America as racial nightmare in which Jews, Italians, and Negroes are seen as more or less identical threats to the populist agrarian polis that Donnelly, himself a candidate for national office, championed.

For studies of the rise of the social sciences in America, see Daniel J. Kelves, *In the Name of Eugenics: Genetics and the Use of Human Heredity* (New York: Alfred A. Knopf, 1985); Thomas L. Haskell, *The Emergence of Professional Social Science* (Urbana: University of Illinois Press, 1977); Allen Chase, *The Legacy of Malthus* (New York: Alfred A. Knopf, 1977); and Dorothy Ross, *The Origins of Social Science* (Cambridge, England: Cambridge University Press, 1991). Ross is excellent on the problematics of assimilating African Americans into Robert E. Park's influential integrationist vision of a developing American polis; see also *Race and Culture*, Vol. 1, *The Collected Papers of Robert E. Park*, ed. Everett Hughes (Glencoe, Ill.: The Free Press, 1950). For influential racist arguments about the threat posed by blacks and immigrants, see Madison Grant, *The Passing of the Great Races, or the Racial Bias of European History* (New York: Scribner's, 1923) and Lothrop Stoddard, *The Rising Tide of Color* (New York: Scribner's, 1920). Scott Fitzgerald mocked, without altogether discounting, the doctrines of the last work in *The Great Gatsby*; Walter Benn Michaels analyzes *Gatsby* from this viewpoint in "The Souls of White Folk," in *Literature and the Body: Essays in Populations and Persons*, ed. Elaine Scarry (Baltimore, Md.: Johns Hopkins University Press, 1988). Most of Fitzgerald's short stories were appearing in *The Saturday Evening Post* during the 1920s and its editor, George Horace Lorimer, was a racial conservative who encouraged similar views in his magazine; see Jan Cohn, *Creating America: George Horace Lorimer and the Saturday Evening Post* (Pittsburgh, Pa.: University of Pittsburgh Press, 1990).

For important discussion, pro and con, of race as an essentialist marker for black Americans, see Anthony Appiah, "The Uncompleted Argument: Du Bois and the Illusion of Race," *Critical Inquiry* 12 (1985), 21–27; Houston A. Baker, Jr., "Caliban's Triple Play," *Critical Inquiry* 13 (1986), 182–96; Henry Louis Gates, Jr., "Writing 'Race' and the Difference It Makes," *Critical Inquiry* 12 (1985), 1–20; and Isaac Julien, " 'Black Is, Black Ain't': Notes on De-Essentializing Black Identities," in *Black Popular Culture*, ed. Gina Dent (Seattle, Wash.: Bay Press, 1992). The best statement of the attitude toward race adopted by most of the leaders of the Harlem Renaissance is Ralph Ellison, "The World and the Jug," in *Shadow and Act*. Ellison refuses to accept the notion that "unrelieved suffering is the only 'real' Negro experience," insisting that "there is also an American Negro tradition which teaches one to deflect racial provocation and to master and contain pain"; the Aframerican "is a product of the interaction between his racial predicament, his individual will and the broader American cultural freedom in which he finds his ambiguous existence . . . He, too, in a limited way, is his own creation" (111–13). Ellison, born in 1914, belonged to a later generation, but his stress on black self-creation and "discipline" amid the deprivations and curtailed but exhilarating opportunities of his American milieu is that of the 1920s. On Ellison's vision and art, see the excellent study by Robert G. O'Meally, *The Craft of Ralph Ellison* (Cambridge, Mass.: Harvard University Press, 1980).

On Philip Payton, Jr., and the takeover of Harlem by blacks, I have relied on Jervis Anderson, *This Was Harlem*; Gilbert Osofsky, *Harlem: The Making of a Ghetto* (New York: Harper & Row, 1971); James Weldon Johnson, *Black Manhattan*; and *The Negro in New York: An Informal Social History 1626–1940*, eds. Roi Ottley and William J. Weatherby (New York: Frederick A. Praeger, 1969). For black politics in New York,

my chief source has been the brilliant, seminal Ira Katznelson, *Black Men, White Cities: Race, Politics and Migration in the United States, 1900–30, and Britain, 1948–68* (Chicago, Ill.: University of Chicago, 1973); see also Theodore Lowi, *At the Pleasure of the Mayor* (New York: Free Press, 1964) and Harold Cruse, *The Crisis of the Negro Intellectual* (1967; rpt., New York: Quill, 1984). James Weldon Johnson describes the organizing of the Silent Protest parade in *Along This Way: The Autobiography of James Weldon Johnson* (1933; rpt., New York: Penguin Books, 1990), an invaluable source for the politics of the day. On various aspects of the black economic situation, see Manning Marable, *How Capitalism Underdeveloped Black America* (Boston, Mass.: South End Press, 1985); Timothy Bates, *Black Capitalism: A Quantitative Analysis* (New York: Praeger, 1975); and E. Franklin Frazier, *The Black Bourgeoisie* (Glencoe, Ill.: The Free Press, 1957). Daniel McBride is excellent on the problems of black health and how racial ideologues construed them in *From TB to AIDS: Epidemics among Urban Blacks since 1900* (Albany: State University of New York Press, 1991).

On the development of **black Chicago**, see Allan H. Spear, *Black Chicago: The Making of a Negro Ghetto 1890–1920* (Chicago, Ill.: University of Chicago Press, 1967) and St. Clair Drake and Horace A. Cayton, *Black Metropolis: A Study of Negro Life in a Northern City* (1945; rev. ed., Chicago, Ill.: University of Chicago Press, 1993), with an Introduction by Richard Wright. On the Ku Klux Klan, see Kenneth T. Jackson, *The Ku Klux Klan in the City 1915–1930* (1967; rev. ed., Chicago, Ill.: Elephant Paperbacks, 1992). On the Chicago race riot of 1919, see Charles S. Johnson and Graham R. Taylor, *The Negro in Chicago: A Study of Race Relations and a Race Riot in 1919* (1921; rpt. New York: Arno Press, 1968), a study undertaken in the aftermath of the riot; when Johnson came to New York a few years later, he was determined to prevent similar racial turmoil in the black community there. See also William M. Tuttle, *Race Riot: Chicago in the Red Summer of 1919* (New York: Atheneum, 1970) and *Race Riots in Black and White*, ed. Paul Mitchell (Englewood Cliffs, N.J.: Prentice Hall, 1970), a more general survey of contemporary documents.

David Levering Lewis describes the 1935 race riot in Harlem in *When Harlem Was in Vogue*. Charles Flint Kellogg, *NAACP: A History of the National Association for the Advancement of Colored People* (Baltimore, Md.: Johns Hopkins University Press, 1967) and Nancy J. Weiss, *The National Urban League* (New York: Oxford University Press, 1974) are intelligent, detailed studies; Weiss focuses on the black leaders of the League. On **black journalism**, see Roland E. Wolseley, *The Black Press, U.S.A.* (Ames: Iowa State University Press, 1971); Stephen R. Fox, *The Guardian of Boston: William Monroe Trotter* (New York: Atheneum, 1970); and Theodore Kornweibel, Jr. *No Crystal Stair: Black Life and the Messenger, 1917–1928* (Westport, Conn.: Greenwich Press, 1975). On Carter G. Woodson, see Charlemae Hill Rollins, *They Showed the Way: Forty Negro Leaders* (New York: Thomas Y. Crowell, 1964); on Arthur Schomburg, see Eileen Des Vernay, "Arthur Alphonso Schomburg," unpublished dissertation, Columbia University, 1977. See also Earl E. Thorpe, *Black Historians* (New York: William Morrow, 1971) and *Negro Historians in the United States* (Baton Rouge, La.: Fraternal Press, 1958).

Black Leaders of the Twentieth Century, eds. John Hope Franklin and August Meier (Urbana: University of Illinois Press, 1982) is an excellent collection of essays; I am particularly indebted to Lawrence W. Levine, "Marcus Garvey and the Politics of Revitalization" and his citation of Anthony F.C. Wallace's views (113). On **Marcus Garvey**, Edmund David Cronon, *Black Moses: The Story of Marcus Garvey and the Universal Negro Improvement Association* (Madison: University of Wisconsin Press, 1955) and Judith Stein, *The World of Marcus Garvey: Race and Class in Modern Society* (Baton Rouge: Louisiana State University Press, 1986) are first-rate, in-depth treatments. For collections

of Garvey's speeches and writings, see *Philosophy and Opinions of Marcus Garvey*, ed. Amy Jacques-Garvey (1925; rpt. New York: Atheneum, 1992) and *Marcus Garvey, Life and Lessons*, ed. Robert A. Hill (Berkeley: University of California Press, 1987). On **Booker T. Washington**, see Louis R. Harlan, *Booker T. Washington: The Making of a Black Leader, 1856–1901* (New York: Oxford University Press, 1972) and *Booker T. Washington: The Wizard of Tuskegee, 1901–1915* (New York: Oxford University Press, 1983), a monumental, informative, lively biography of the man and his times. For studies of Du Bois, see the Bibliographical Essay for Chapter 2. Jervis Anderson, *A. Philip Randolph: A Biographical Portrait* (1973; rpt. Berkeley: University of California Press, 1986) is informative, smart, wise, a model of its kind. *The Souls of Black Folk* is reprinted in *W.E.B. Du Bois: Writings* (New York: The Library of America, 1986); Langston Hughes, "America," is collected in *The Langston Hughes Reader*, ed. Langston Hughes (New York: George Braziller, 1958). Early black protest against the neglect of "the *first* tillers of the land" and the claims that the Negro is "no hyphenate" are cited in Gilbert Osofsky, *Harlem: The Making of a Ghetto*, 45. For Malcolm X's denunciation of Euro-America's privileging of white immigrants over black native-born Americans, see "The Ballot or the Bullet" in *Malcolm X Speaks: Selected Speeches and Statements*, ed. George Breitman (New York: Grove-Weidenfeld, 1990), 25–26.

Ethel Waters's paramount musical and cultural importance is only beginning to be assessed; as Susannah McCorkle writes wryly in "The Mother of Us All," a pathbreaking appreciation in *American Heritage*, 45 (February/March 1994), 60–73, "You don't become a jazz legend by growing old, playing grandmothers, and palling around with Billy Graham and Richard Nixon." Waters must also be seen as a casualty of changing racial mores; an emblem of the invincibly black-and-white spirit of the Harlem Renaissance, her reputation inevitably went into eclipse with the advent first of bebop, then of Black Power. It should be remembered, however, that Waters gave a copy of Richard Wright's *Native Son* to every member of the cast of *Mamba's Daughters*; she knew as much about black anger as Wright did. In the absence of a biography, the best sources (though often self-serving, sometimes obfuscating, and even inaccurate) are her own lively autobiographies, *To Me It's Wonderful* (New York: Harper & Row, 1972) and, with Charles Samuels (who wrote the book from extensive interviews), *His Eye Is on the Sparrow* (1951; rpt. New York; Da Capo, 1992). Waters is considered briefly in a number of histories of jazz singing; see Linda Dahl, *Stormy Weather: The Music and Lives of a Century of Jazzwomen* (1984; rpt., New York: Limelight Editions, 1992); Richard Hadlock, *Jazz Masters of the 1920s* (New York: Macmillan, 1972); and Will Friedwald, *Jazz Singing: America's Great Voices from Bessie Smith to Bebop and Beyond* (New York: Macmillan, 1990). Gary Giddins's essay on Ethel Waters, "The Mother of Us All," included in *Riding on a Blue Note: Jazz & American Pop* (New York: Oxford University Press, 1981) is, with Susannah McCorkle, the best to date. No one has yet discussed her bisexuality in print, though it was well known, even notorious, in her own day. Alberta Hunter, a rival, makes pointed allusion to Waters's self-destructive, rude, and lesbian side in Frank C. Taylor with Gerald Cook, *Alberta Hunter: A Celebration in Blues* (New York: McGraw-Hill, 1987), based on extensive interviews with Hunter. (Hunter does not, however, acknowledge that she herself was gay.) DuBose Heyward, *Mamba's Daughters* (Garden City, N.Y.: Doubleday, 1929) is in itself an extraordinary piece of fiction that deserves to be better known.

There is no biography of **James P. Johnson**, but he is treated extensively in the biographies of Fats Waller listed in the Bibliographical Essay for Chapter 7. See also Dick Katz, "Jazz Pianists: An Overview," as well as the entry on Johnson in *Jazz Piano* (Washington, D.C.: Smithsonian Institution, 1989) and Tom Davin, "A Conversation with James P. Johnson," a major interview collected in *Ragtime: Its History, Composers*

and Music, ed. John Edward Hasse (New York: Schirmer Books, 1988). There is an excellent study of **Bert Williams**: Ann Charters, *Nobody: The Story of Bert Williams* (New York: Macmillan, 1970). Reviews of *Put and Take* are cited in Barry Singer, *Black and Blue: The Life and Lyrics of Andy Razaf*, 86–87. For recordings by Bert Williams, James P. Johnson, and Ethel Waters, see Selected Discography. For Countee Cullen, see the Bibliographical Essay for Chapter 2. In assessing Cullen's radical sympathies, one should remember that he and Richard Wright were friends; indeed, Wright thought of titling *Black Power* (New York: Harper Bros., 1954), an attack on European colonalism and a plea for African independence, "What Is Africa to Me?," the opening line of Cullen's "Heritage," his most famous poem.

9 RAGGING AND SLANGING

H. L. Mencken, "On Being an American" is reprinted in H. L. Mencken, *Prejudices: A Selection*, ed. James T. Farrell (New York: Vintage, 1955). Constance Rourke, *American Humor* and *Trumpets of Jubilee: Henry Ward Beecher, Harriet Beecher Stowe, Lyman Beecher, Horace Greeley, P. T. Barnum* (1927; rpt., New York: Harcourt Brace, 1963) are still the classic studies of the **American fondness for parody**. M. Sissieretta Jones is discussed in Ann Charters, *Nobody: The Story of Bert Williams* (New York: Macmillan, 1970); James Reese Europe in James Haskins, *Black Music in America: A History Through Its People* (New York: Harper & Row, 1987); Jervis Anderson, *This Was Harlem*; David Levering Lewis, *When Harlem Was in Vogue*; Samuel B. Charters and Leonard Kunstadt, *Jazz: A History of the New York Scene* (1962; rpt., New York: Da Capo, 1981); and Eileen Southern, *The Music of Black Americans: A History* (2nd ed., New York: W. W. Norton, 1983), a classic, comprehensive study. Southern also covers the career of William Grant Still and other blacks who worked in the classical field. On Whiteman, see Thomas A. DeLong, *Pops: Paul Whiteman, King of Jazz* (Piscataway, N.J.: New Century, 1983); Paul Whiteman and Mary Margaret McBride, *Jazz* (New York: J. H. Sears, 1923); and the liner notes by Thornton Hagert to *An Experiment in Modern Music: Paul Whiteman at Aeolian Hall* on RCA Records (Smithsonian Collection, 1981). For books on mass culture and media development, see the Bibliographical Essay for the Introduction and Chapter 1.

On the music industry, see Russell Sanjek & David Sanjek, *The American Popular Music Business in the 20th Century* (New York: Oxford University Press, 1991); see also Roland Gelatt, *The Fabulous Phonograph, 1877–1977* (New York: Collier Books, 1977) and Serge Denisoff, *Solid Gold: The Popular Record Industry* (New Brunswick, N.J.: Transaction Books, 1975). Craig T. Roell, *The Piano in America, 1890–1940* (Chapel Hill: University of North Carolina Press, 1989) covers the development of the player piano as well as the vogue of the piano and its music.

Charles Hamm, *Yesterdays: Popular Song in America* (1979; rpt., New York: W. W. Norton, 1983), is excellent on the sheet-music industry and offers a lively, intelligent general survey of **popular music**. Also useful as overviews are David Ewen, *American Popular Songs from the Revolutionary War to the Present* (New York: Random House, 1966) and Sigmund Spaeth, *A History of Popular Music in America* (New York: Random House, 1948). William Arms Fisher, *Notes on the Music in Old Boston* (Boston, Mass.: Oliver Ditson, 1918) depicts the comparatively staid world of New England music and music publishing; see also John Wallace Hutchinson, *Story of the Hutchinsons* (*Tribe of Jesse*), 2 vols. (Boston, Mass.: Lea & Shepard, 1896) for the most popular, idealistic singing group in antebellum America portrayed by one of its members. On the operetta

tradition that Berlin and his peers in part displaced (learning much from it as well), see Richard Traubner, *Operetta: A Theatrical History* (1983; rpt., New York: Oxford University Press, 1989). Arnold Shaw, *The Jazz Age: Popular Music in the 1920s* (New York: Oxford University Press, 1987), while superficial, relates the music, white and black, to the times. James R. Morris, "Introductory Essay," in *American Popular Song: Six Decades of Songwriters and Singers* (Washington, D.C.: Smithsonian Institution, 1984) and Dwight Blocker Bowers, *American Musical Theater: Shows, Songs and Stars* (Washington, D.C.: Smithsonian Institution, 1989) are invaluable, detailed guides. Popular songs in the 1910s and 1920s had their premiere as part of stage musicals; songs sometimes made little to do with the story, though *Show Boat* (1927), with music by Jerome Kern and lyrics by Oscar Hammerstein II, began the trend of the unified musical; see Miles Kreuger, *Show Boat, The Story of a Classic American Musical* (New York: Oxford University Press, 1977). The indispensable book on Broadway musicals is the encyclopedic Gerald Bordman, *American Musical Theatre: A Chronicle* (expanded and corrected ed., New York: Oxford University Press, 1986).

The best book on **Fred Astaire**'s art, and one of the finest books on any aspect of American popular culture, is Arlene Croce, *The Fred Astaire & Ginger Rogers Book* (New York: Outerbridge & Lazard, 1972); see also Fred Astaire, *Steps in Time: An Autobiography* (1959; rpt., New York: Harper & Row, 1987). On **John Bubbles**, see Marshall and Jean Stearns, *Jazz Dance* (New York: Macmillan, 1968) and Burton W. Peretti, *The Creation of Jazz: Music, Race, and Culture in Urban America* (Urbana: University of Illinois Press, 1992); Bubbles's song "Rhythm for Sale" is cited in Peretti, 54. On **Bill "Bojangles" Robinson**, see Marshall and Jean Stearns, *Jazz Dance*, and Lynne Fauley Emery, *Black Dance from 1619 to Today* (rev. ed., Princeton, N.J.: Dance Horizons, 1988), which strangely makes no mention of Bubbles. On Bojangles's relationship with Shirley Temple, his dance partner in a number of movies, see Anne Edwards, *Shirley Temple: American Princess* (New York: William Morrow, 1988). Bojangles, born in 1878, was the seminal progenitor for both Astaire and Bubbles, but the younger men departed significantly from his dance style. While Bojangles kept his torso mute to emphasize his intricate foot work, Astaire and Bubbles brought their whole bodies into play. Bojangles excised all emotion in favor of a balancing-act air of self-sufficient, frozen-smile attentiveness, calmly alert, seldom shifting expressive keys. In contrast, Astaire specialized in sudden turns from the nonchalant and comic modes to a longing, serious, even pleading urgency; part of Bubbles's choreographic aggression was his ability to change feelings, with rhythms, on a dime. Despite the partnership with Temple, Bojangles was essentially a soloist, though any kind of male-female partnership was difficult for Negro dancers aiming at a broad audience; (adult) white partners were, of course, out, but any reminder of Negro sexuality, even in the form of a black duo, was often off limits in Bojangles's heyday as well. Astaire was at his best with a partner (particularly Adele Astaire, Ginger Rogers, and, in the early 1940s, Rita Hayworth); Bubbles was a partner, too, though his forays here were more limited than Astaire's, partly because of the racial-sexual taboo, partly because his instincts were of the one-man-show variety.

David Ewen, *The Life and Death of Tin Pan Alley: The Golden Age of American Popular Music* (New York: Funk and Wagnalls, 1967) is a useful survey of the Alley's history. For legendary **Tin Pan Alley** talents, see George M. Cohan, *Twenty Years on Broadway* (New York: Harper Bros., 1924), a memoir that conveys wonderfully Cohan's jaunty style; John McCabe, *George M. Cohan: The Man Who Owned Broadway* (1973; rpt., New York: Da Capo, 1980); Gerald Bordman, *Jerome Kern: His Life and Music* (New York: Oxford University Press, 1980); and Charles Schwartz, *Cole Porter: A Biography* (New York: Dial, 1977), which is frank about the composer's homosexuality and

addictive life-style as well as illuminating on the music. Lawrence Bergreen, *As Thousands Cheer: The Life of Irving Berlin* (New York: The Viking Press, 1990) is a first-rate, comprehensive biography that covers **Irving Berlin**'s beginnings, heyday, and long-drawn-out, painful end; he died in 1989 at the age of 101 after years of depression, seclusion, and barbiturate addiction. For the ebullient young Berlin, see Alexander Woollcott, *The Story of Irving Berlin* (New York: G. P. Putnam, 1925), written with Berlin's cooperation. On Sophie Tucker, see Sophie Tucker, with Dorothy Giles, *Some of These Days* (Garden City, N.Y.: Doubleday, 1945) and Lewis A. Erenburg, *Steppin' Out* (Westport, Conn.: Greenwood Press, 1981); Erenberg also details the smaller scale and increased intimacy of the new cabaret scene of the late 1910s.

For the Jewish domination of Tin Pan Alley, see Kenneth Aaron Kanter, *The Jews of Tin Pan Alley* (New York: Ktav, 1982). Michael Rogin explains that Jewish performers used black stereotypes to enter the entertainment mainstream in "Blackface, White Noise: The Jewish Jazz Singer Finds His Voice," *Critical Inquiry* 18 (1992), 435–56. On Jewish humor on Broadway in the decades before the war, see Armond Fields and L. Marc Fields, *From the Bowery to Broadway: Lew Fields and the American Popular Theatre* (New York: Oxford University Press, 1993), a rich, detailed history of the era.

On **Al Jolson**, see Herbert G. Goldman, *Jolson* (New York: Oxford University Press, 1988); Robert Oberfirst, *Al Jolson: You Ain't Heard Nothin' Yet* (New York: A. S. Barnes, 1980); and Michael Freedland, *Jolson* (New York: Stein & Day, 1972); the last two (especially Oberfirst) are ill documented, sketchy, speculative, and sometimes inaccurate, but they contain material (not in the more reliable Goldman) of interest to the Jolson legend. Oberfirst's book is based on extensive interviews with Jolson's brother Henry, his first partner (never really successful on his own), who claimed that Jolson suffered from lifelong impotence; he adopted children because he could not consummate his marriages. Goldman attests to persistent rumors that Jolson was a closet homosexual—his act was replete with eye rolling, limp wrists, centered on "Mammy" songs, reeking deliciously of camp—though no evidence of actual gay activity has materialized. True or not, these rumors make sense; Jolson's only real sexual object was clearly his audience, and his happiest performances were those entertaining the all-male troops of World War II.

With Berlin, the greatest lyricists of the 1920s, masters of the American language, were **Lorenz Hart**, who collaborated with composer Richard Rodgers, and **Ira Gershwin**, who worked usually with his brother George; see *The Complete Lyrics of Lorenz Hart*, eds. Dorothy Hart and Robert Kimball (New York: Alfred A. Knopf, 1986) and *The Complete Lyrics of Ira Gershwin*, ed. Robert Kimball (New York: Alfred A. Knopf, 1993), both superbly edited and annotated. See also Samuel Marx and Jan Clayton, *Rodgers and Hart* (New York: G. P. Putnam, 1976); Edward Jablonski, *Gershwin: A Biography* (New York: Doubleday, 1987), provides full coverage of Ira Gershwin before and after George's tragically early death of a brain tumor in July 1937 at the age of thirty-eight.

Philip Furia, *The Poets of Tin Pan Alley: A History of America's Greatest Lyrics* (New York: Oxford University Press, 1990) is an imaginative, painstaking, loving exposition of the Alley's genius in its heyday, manifest in a new relationship between words and music. Jerome Kern's most important early collaborator was the witty English writer P. G. Wodehouse, with whom he did a series of shows for the small-scale, intimate Princess Theatre between 1915 and 1918. The usual Anglo-American method of songwriting was first to write the lyrics, then "set" them to music, but Wodehouse wrote the lyrics *after* Kern had composed the music. This was an important change, Furia points out, because the music now called the shots. Ira Gershwin, who followed the same practice, described his craft as "fitting words mosaically to music," sometimes beginning with "dummy" titles, any words that got the rhythm of the music, words that could be replaced later by

more suitable ones; "It Ain't Necessarily So" was a "dummy" title for a song sung by Sportin' Life (John Bubbles) in *Porgy and Bess*. In this case, the dummy title stayed, but, as Ira pointed out, he could just as easily have worked from the title "Tomórrow's the Fóurth of Julý" or "An Órder of Bácon and Éggs."

Lorenz Hart, a specialist in triple rhymes and intricately witty slang collages, couldn't write until he had Rodgers's music before him. Rodgers and Hart's "Manhattan," a hit in the 1925 *Garrick Gaieties*, hailed as putting "New York . . . into the limelight," with its inside jokes and unabashed, expansive urban spirit ("We'll take Manhattan, the Bronx and Staten Island too"), its play on ethnic accents ("spoil/goil"), its delectably clever rhymes and absurdist touches, announced that only the vernacular American language could keep up with the new "ragged" American music. Vocalists imitated the sound of jazz instruments (an important innovation), another way of putting music over words. The Jazz Age ended, Furia believes, when Rodgers and Hart split up in 1943 (Hart died, just months later, of pneumonia and alcoholism), because Rodgers wanted to work on less sophisticated material and in more conventional musical forms; he wrote *Oklahoma!* with Oscar Hammerstein II, a sentimental, conservative lyricist who, unlike Hart, preferred to write the words before the music had been composed. In *Show Boat*, he'd given the vernacular lyrics to black characters and provided smoother rhythms and more conventional language for the white (or passing-for-white) ones, a status split that Hart, like Ira Gershwin and Irving Berlin at their best, usually disdained. *Oklahoma!* can be seen as Broadway's return to the euphemistic, racially unmixed operetta vogue, a form now translated into a strangely decorous all-American boisterousness.

On the development of **ragtime**, the classic work is Rudi Blesh and Harriet Janis, *They All Played Ragtime* (1950; 4th ed., New York; Oak Publications, 1971). Also extremely useful are Edward Berlin, *Ragtime: A Musical and Cultural History* (Berkeley: University of California Press, 1980); *Ragtime: Its History, Composers and Music*, ed. John Edward Hasse (New York: Schirmer Books, 1988); Terry Waldo, *This Is Ragtime* (1976; rpt., New York: Da Capo, 1991), which has an introduction by Eubie Blake and draws on extensive interviews with him; and Tom Whitcomb, *Irving Berlin and Ragtime America* (New York: Limelight Editions, 1988), which pays particular attention to white expropriation of black music. Marshall W. Stearns, *The Story of Jazz* (New York: Oxford University Press, 1956) is a peerless account, still authoritative on jazz and its origins in ragtime and the blues. On Scott Joplin, see Addison W. Reed, *The Life and Works of Scott Joplin* (Chapel Hill: University of North Carolina Press, 1973) and the definitive if plodding Edward A. Berlin, *King of Ragtime: Scott Joplin and His Era* (New York: Oxford University Press, 1994). On coon songs and their place in the development of the American musical, see Thomas L. Morgan and William Barlow, *From Cakewalks to Concert Halls: An Illustrated History of African-American Popular Music from 1895 to 1930* (Washington, D.C.: Elliott & Clark, 1992), which has wonderful full-page reproductions of the sketches of darkies used to sell ragtime sheet music.

On the Johnson-Cole trio, see James Weldon Johnson, *Along This Way* 1933; rpt., New York: Penguin Books, 1990). Bob Cole and Rosamond Johnson performed as a duo (James Weldon was always the offstage partner) in immaculate evening dress with sophisticated manners to match—another break with the minstrel tradition, in which darkies wore fine clothes only to make themselves ridiculous by their lack of taste—and they had a huge success in London in 1905. Though he used both Negro dialect (in his early poems) and black English (in *God's Trombones*), James Weldon Johnson, reared on the English classics, fluent in French and Spanish, believed that Paul Laurence Dunbar's poetry has been marred by his enforced commitment to dialect (Dunbar thought so as well), which was capable only of "pathos" and "comedy," and he early resolved not to

endure the same restrictions. The trio's first big cross-race hit came when Flo Ziegfeld's wife, singer Anna Held, picked up their song "The Maiden with the Dreamy Eyes" in 1901. Weldon Johnson explains that the collaborators had decided on the phrase "dreamy eyes" rather than "blue" or "brown" or "black" or "gray" eyes, so as to exclude none and "appeal to everyone" (179–80). Many of their fans assumed they were white, a fact that gave Johnson several uncomfortable moments. See also James Weldon Johnson, *Fifty Years and Other Poems* (Boston, Mass.: Cornhill, 1917).

On **Eubie Blake**, see Al Rose, *Eubie Blake* (1979; rpt., New York: Schirmer Books, 1983), based on extensive interviews with Blake. The book for *Shuffle Along* has not survived, but the show and its history as well as the Sissle-Blake partnership are vividly re-created in Robert Kimball and William Bolcom, *Reminiscing with Sissle and Blake* (New York: The Viking Press, 1973), based on interviews with Sissle and Blake.

On the connections between the literature and music of Harlem, see *Black Music in the Harlem Renaissance: A Collection of Essays*, ed. Samuel A. Floyd, Jr. (Knoxville: University of Tennessee Press, 1990), especially the essays by Samuel A. Floyd, Jr., John Graziano, Rae Linda Brown, and Richard A. Long. Nathan Huggins, *Harlem Renaissance* (New York: Oxford University Press, 1971), is especially useful on **black and white language in the 1920s**. Huggins points out that black and white writers alike were stripped of their native idioms by their middle-class education. Malcolm Cowley, speaking in *Exile's Return* of his schooling (first in high school in Pennsylvania, then at Harvard), complains that he was taught that "America was beneath the level of great fiction . . . the only authors to admire were foreign authors . . . A definite effort was being made to destroy all trace of local idiom or pronunciation and have us speak 'correctly'—that is, in a standardized Amerenglish as colorless as Esperanto . . . Our instructors were teaching [us] a dead language" (8). Cowley never altogether shed this more formal language. **Claude McKay**, reared in Anglophile colonial Jamaica, himself a sophisticated student of global colonialism and a model for the "Négritude" movement among black writers of the 1930s and 1940s in French Africa, explains in his novel *Banana Bottom* (1933; rpt., New York: Harcourt Brace, n.d.) that he was taught that "[artistic] greatness could not exist in the backwoods . . . greatness was a foreign thing" (18). The very terms "university" and "seat of learning," McKay writes elsewhere, meant young men leaving home and coming back transformed, sporting "a new style of clothes, a different accent, a new gait," taking a "high road to wisdom" by disavowing their "own free, informal way[s]" (cited in Wayne F. Cooper, *Claude McKay* (New York: Schocken Books, 1987), 76). McKay spoke both the black Jamaican dialect and the proper English he'd learned in school, later acquiring several foreign languages and picking up black English in the States. Conveying the complexities of his linguistic situation, he once described English as "my native adopted language." Although he knew that the great English poets he studied in school had themselves expressed "their race, their class, their roots" in their so-called classic verse, though he praised Langston Hughes for *Fine Clothes to the Jew*, after his first volume of poems, *Songs of Jamaica* (1912), an innovative and pioneering foray in Jamaican dialect and subject matter, he never again wrote poetry in dialect. His colloquial black idiom was saved for the confused but rich pages of his novels: his poems, despite their incendiary sentiments, are impeccably Anglo-European in their regular meter and standard English diction. See *Selected Poems of Claude McKay* (New York: Harcourt Brace, 1953).

On the **white slang vernacular**, see especially **Ben Hecht**'s memoir, *A Child of the Century* (New York: Simon & Schuster, 1954); it includes a classic account of the self-conscious acquisition of the American language, which Hecht takes to be immigrant English and inner-city, underworld patois. The child of Russian immigrants, growing

up in Racine, Wisconsin, he learned Anglo-American in school, but his home boasted a fantastic collection of nonstop talkers, Jewish aunts and uncles who spoke a colorful blend of Yiddish and American slang vernacular. In 1910, at the age of sixteen, he ran away to Chicago, where he apprenticed himself to the brutal, lively linguistic chaos of the *Chicago Daily*. While the older reporters drank and talked, he sat unnoticed, a "stowaway on Parnassus." "And I heard language" (245). He never forgot the maxim of his boss Sherman Reilly Duffy (whose only prayer was "Ales, women, liquor and cigars"): "Be sure your style is so honest that you can put the word 'shit' in any sentence without fear of consequences" (204). Hecht also absorbed "the gabble of sailors, burglars, pimps, whores, hop-heads," especially whores; their "talk became my well-worn dictionary to be used forever" (183). Sportswriters (who often covered criminal stories and trials as well), led by Ring Lardner, Grantland Rice, Bugs Baer, and Damon Runyon, pioneered in the use of slang—it was no accident that Hemingway began as a journalist with a special interest in sports, crime, and tough talk. See particularly Charles Fountain, *The Life and Times of Grantland Rice* (New York: Oxford University Press, 1993) and Tom Clark, *The World of Damon Runyon* (New York: Harper & Row, 1978).

There has been much debate about where **Damon Runyon** got his special slang—in part from the tough Colorado newspapermen he'd worked with at the start of his career, in part from the New York gangsters he routinely covered, in part from the locals on the Upper West Side, where he lived on arriving in the city in 1910—but there can be no doubt that it was a conscious acquisition and creation; he liked to brag that he had the finest "collection" of slang in the world. "Alley-apple" was Runyonese for "rock," "parties" for "persons," "equalizer" for "gun," "scrap" for "kill," "scramola" or "do a scrammola" (he liked decorative lengtheners) and "drop dead" for "go away." Winchell, a pal, said Runyon had an "underworld complex." As Hecht displayed his versatility by sometimes writing in the exquisitely overwrought style of Elinor Wylie, James Cabell, and Joseph Hergesheimer (Hecht's early novel *Eric Dorn* [New York: G. P. Putnam, 1921] is the ornate apogee of the postwar epigraphic craze), Runyon sprinkled his lingo with archaisms like "hither and yon." When the famous vaudeville comic Joe Cooke was told by a waitress at a restaurant that they were out of apple pie, he snapped back: " 'Fake it' " (cited in Anita Loos, *A Girl Like I* [New York: The Viking Press, 1966], 120). This audacious command for fraud, theft, and sheer inventiveness was 1920s slang.

It should be noted that not all American slang fits the 1920s pattern: 1920s slang gains much of its shock power from its determined secularism—all references are militantly, self-consciously this-worldly—but the Beat slang of the 1940s and 1950s adopted a vocabulary that resurfaced religious meanings. "Beat" itself meant, at least in Jack Kerouac's circle, "beatific" as well as "beaten down" and "in the know." Kerouac's Sal Paradise (note the name) describes Dean Moriarity, the driven angel of *On the Road* (1957; rpt., New York: Signet, n.d.), as a "holy goof." The Beats borrowed the word "soul" from black bebop musicians, and its slang meaning of "extra, inexplicable, major power" is not altogether opposed to its original religious one. Where 1920s slang is denotative, limiting then exploding meanings, Beat slang is connotative, infusive. Slang as cultural fashion must always be historicized.

The indispensable secondary sources on **slang** are H. L. Mencken, "American Slang," Part Six of *The American Language*, and Eric Partridge, *Slang Today and Yesterday* (rev. ed., New York: Barnes and Noble, 1970). Mary Helen Dohan, *The Making of the American Language* (New York: Dorset Press, 1974) discusses the preference of English moviegoers for the American idiom; Irving Lewis Allen, *The City in Slang: New York Life and Popular Speech* (New York: Oxford University Press, 1993), a superb study, has an extensive bibliography. Also extremely useful, though with differing definitions of

slang, are Gilbert M. Tucker, *American English* (New York: Alfred A. Knopf, 1921); Richard A. Spears, *Slang and Euphemism: A Dictionary* (Middle Village, N.Y.: Jonathan David, 1981); Don B. Wilmeth, *The Language of American Popular Entertainment* (Westport, Conn.: Greenwood Press, 1981); *Dictionary of American Slang*, eds. Harold Wentworth and Stuart Berg Flexner (New York: T. Y. Crowell, 1975); John S. Farmer and W. E. Henley, *Dictionary of Slang and Its Analogues*, 2 vols. (rev. ed., New Hyde Park, N.Y.: The Viking Press, 1966); and Godfrey Irwin, *American Tramp and Underworld Slang* (New York: Sears, 1931).

George Ade's *Fables in Slang* (1899) was a model to writers of the 1920s; see Lee Coyle, *George Ade* (New York: Twayne, 1964); *The Permanent Ade: The Living Writings of George Ade*, ed. Fred C. Kelly (New York: Bobbs-Merrill, 1947); and *The Best of George Ade*, ed. A. L. Lazarus (Bloomington: Indiana University Press, 1985). See also Walter Winchell, "A Primer of Broadway Slang," *Vanity Fair* (November 1927), 68. Richard W. Bailey, *Images of English: A Cultural History of the Language* (Ann Arbor: University of Michigan Press, 1991) and Tony Crowley, *Standard English and the Politics of Language* (Urbana: University of Illinois Press, 1989) are intelligent, informative, broader studies. In treating **Hemingway** as a seminal figure in the making of the American language, one might also note that, in Delmore Schwartz's words in "The Fiction of Ernest Hemingway" (1955) in *Selected Essays of Delmore Schwartz*, ed. Donald A. Duke (Chicago, Ill.: University of Chicago Press, 1970), his famous style sounds like "the simplified speech which an American uses to a European ignorant of American speech," a "stylized foreign version" of English which imitates the cadences and word order of the European language from which it's apparently being translated (a phenomenon particularly visible in the strange Spanish-into-English idiom of *For Whom the Bell Tolls*). In Schwartz's view, Hemingway's seemingly all-Wasp idiom is, in fact, something like "the speech of immigrants" (259–60); like Stein's language, it is a language shaped by the presence of outsiders.

In considering the uses and development of **Negro dialect**, I have been aided by the brilliant Homi Bhabha, "Of Mimicry and Man: The Ambivalence of Colonial Discourse," in *October* 28 (1984), 125–33, which describes mimicry as "a complex strategy of reform, regulation and discipline . . . appropriat[ing] the Other," yet presenting the "*menace* [of a] *double* vision." Laura O'Connor's superb work on W. B. Yeats and his creation of a self-consciously Irish sensibility out of a largely Standard English idiom, part of "Celtic Resistance to Anglicization" (a dissertation-in-progress at Columbia University), has also been illuminating. See also C. Alphonso Smith, "Dialect Writers," in *The Cambridge History of American Language*, ed. W. P. Trent (New York: G. P. Putnam, 1918). On black English, see J. L. Dillard, *Black English: Its History and Usage in the United States* (New York: Random House, 1973), a passionate, learned defense of its validity as a complete language, and Clarence Major, *Juba to Jive: A Dictionary of African-American Slang* (New York: Viking Penguin, 1994). For further references on the development of Black English, see the Bibliographical Essay for Chapter 10.

For the **feminization of the Victorian stage**, I have relied on my own research on Victorian melodrama (see Bibliographical Essay for the Epilogue) and on Albert Auster's carefully documented, intelligent *Actresses and Suffragists: Women in the American Theatre 1890–1920* (New York: Praeger, 1984). Auster has an excellent chapter on Lillian Russell, but see also Parker Morrell, *Lillian Russell: The Era of Plush* (New York: Random House, 1940) and John Burke, *Duet in Diamonds: The Flamboyant Saga of Lillian Russell and Diamond Jim Brady in America's Gilded Age* (New York: G. P. Putnam, 1972); Djuna Barnes's interview with Russell is in Djuna Barnes, *Interviews*, ed. Alyce Barry (Washington, D.C.: Sun Moon Press, 1985). On Margaret Dumont and Groucho

Marx, see "Appendix 1 (Margaret Dumont)," in Allen Eyles, *The Marx Brothers: Their World of Comedy* (New York: A. S. Barnes, 1966). The joke-immune matriarch was hardly new with Russell and Dumont. Twain learned by experience that his beloved, well-bred wife, Livy, who read all his manuscripts, often did not get his jokes—she would pencil, excise, question, or, worse yet, plain miss them—so he took to writing in the margins beside a particularly delicious burst of humor: "This is a joke, my literal-minded Livy." For Twain's interaction with his genteel Hartford community, see Kenneth R. Andrews, *Nook Farm: Mark Twain's Hartford Circle* (Seattle: University of Washington Press, 1950); Twain was divided in his linguistic sympathies between the old and the new. For a well-researched explication of the role of women in elite European theater, see Gail Finney, *Women in Modern Drama: Freud, Feminism and European Theatre at the Turn of the Century* (Ithaca, N.Y.: Cornell University Press, 1989).

For Tony Pastor, B. F. Keith, Edward F. Albee, and the clean-up of the minstrelsy and variety show, see Robert W. Snyder, *The Voice of the City* (New York: Oxford University Press, 1989); Pastor is also covered in Edward B. Marks's anecdotal history, *They All Sang: From Tony Pastor to Rudy Vallee* (New York: The Viking Press, 1934). Kathy J. Ogren describes the resistance to jazz in *The Jazz Revolution: Twenties America and the Meaning of Jazz* (New York: Oxford University Press, 1989); see also Neil Leonard, "The Opposition to Jazz in the United States 1918–1928," *Jazz Monthly* 4 (1958), 2–4, and Neil Leonard, *Jazz and the White Americans: The Acceptance of a New Art Form* (Chicago, Ill.: University of Chicago Press, 1962). In "Back to Pre-war Morals: Toddling to the Pit," *Ladies' Home Journal* (November 1921), John R. McMahon writes that "if Moses had foreseen jazz he would have written an eleventh commandment" (106). Phyllis Rose talks of the black face America turned to Europe in the 1920s in *Jazz Cleopatra: Josephine Baker in Her Time* (New York: Doubleday, 1989), 80; Gilda Gray's song "It's Getting Dark on Old Broadway" is cited in Allen Woll, *Black Musical Theatre*, 76; Brice's insistence on using black pronunciation in singing "Lovie Joe" is described in Herbert G. Goldman, *Fanny Brice* (New York: Oxford University Press, 1991), 44–47.

10 SINGING THE BLUES

For studies and examples of black music as "folk" art, see Dana J. Epstein, *Sinful Tunes and Spirituals: Black Folk Music to the Civil War* (Urbana: University of Illinois Press, 1977) and Harold Courlander, *Negro Folk Music, U.S.A.* (New York: Columbia University Press, 1963). Alan Lomax, with his father, John Avery Lomax, a (sometimes exploitative) pioneer in collecting and recording black folk music (particularly the blues of the Mississippi Delta), writes about his travels and the culture he explored in *The Land Where the Blues Began* (New York: Pantheon, 1993); see also Alan Lomax, *Folk Style and Culture* (New Brunswick, N.J.: Transaction Books, 1968) and *The Folk Songs of North America* (Garden City, N.Y.: Doubleday, 1960), an anthology. For more general studies of African-American folk art, as well as specific articles on folk elements in the blues, see *Mother Wit from the Laughing Barrel: Readings in the Interpretation of Afro-American Folklore*, a valuable collection of criticism edited by Alan Dundes (Jackson: University Press of Mississippi, 1990); see particularly the articles by Harold Preece, Sterling A. Brown, and the classic "Negro Writers in America: An Exchange," a debate between Stanley Edgar Hyman ("The Folk Tradition") and Ralph Ellison ("Change the Joke and Slip the Yoke") about the uniqueness of Aframerican folklore. The idea of blacks as a "folk" people was attractive to whites in part because it could be used to discredit their artistry while exalting their instincts. The *Times*, reviewing Em Jo Basshe's

Earth as an example of "colorful folklore" in 1927, explained that "Negro acting has a tremendous depth that is not so much artistry as frankness" (cited in *The Harlem Renaissance: An Historical Dictionary for the Era*, ed. Bruce Kellner [New York: McThuen, 1984], 111). In this view, the "primitive" or folk virtues were a resource, not for the blacks who possessed them (but presumably didn't know how to capitalize on them), but for the whites who observed them.

In "Really the Blues," an essay review in *The New York Review of Books* (August 11, 1994), 46–52, Luc Sante has made a cogent, at times brilliant, argument for the blues' status not as a "folk art" but as the thoroughly historical work of particular artists in particular places at specific times, though these may sometimes be hard to trace. Sante reminds us that there is no such thing as a "folk art" from the perspective of those who actually create it; it exists as "folk art" only from the perspective of those who transcribe and re-create it, who need it for their own purposes—as did, I suggest, a number of white and black Americans in the 1920s. In any case, the blues still bear the characteristics of wisdom literature, a genre that appears in media as well as pre-media cultures; Gertrude Stein's media-savvy, autobiographical writings are wisdom literature, too. Davy Crockett's quick progress to print hero is chronicled in Walter Blair and Hamlin Hill, *America's Humor: From Poor Richard to Doonesbury* (New York: Oxford University Press, 1978), which, unlike Constance Rourke's *Davy Crockett* (New York: Harcourt Brace, 1934) and *American Humor*, everywhere stresses the rapidity with which white oral culture became print culture.

For the development and meaning of the blues, I have relied on Marshall Stearns, *The Story of Jazz* (New York: Oxford University Press, 1956); Eileen Southern, *The Music of Black Americans* (2nd ed., New York: W. W. Norton, 1983); Paul Oliver, *The Story of the Blues* (Philadelphia, Pa.: Chilton, 1969); James Lincoln Collier, *The Making of Jazz: A Comprehensive History* (New York: Delta Books, 1979); Albert Murray, *Stomping the Blues*, a fine study of American culture as well as of a particular musical tradition; and, above all, the superb, compendious, imaginative Lawrence Levine, *Black Culture and Black Consciousness*. W. C. Handy tells his story and that of the blues more generally in his classic *Father of the Blues: An Autobiography* (1941; rpt. New York: Da Capo, 1969); *Blues: An Anthology*, ed. W. C. Handy (1926; rev. ed., New York: Da Capo. 1990) is still the indispensable collection. Amiri Baraka (LeRoi Jones) makes an eloquent argument for the blues as an all-black form in *Blues People: The Negro Experience in White America and the Music That Developed from It* (New York: William Morrow, 1963). These works provide much coverage of the "country blues" and their origins than of the "city blues" that are my concern; see also Samuel B. Charters, *The Country Blues* (1959; rpt., New York: Da Capo, 1975) and *The Blues Makers* (New York: Da Capo, 1991); and Robert Palmer, *Deep Blues: A Musical and Cultural History of the Mississippi Delta* (New York: Penguin Books, 1981).

Music historians have by and large slighted the feminine tradition of the city blues to focus on the male country blues form that eventually produced boogie woogie, rhythm and blues, and rock and roll (while the city blues moved toward pop and jazz), yet the two traditions were never altogether separate. Bessie Smith singing "He's Got Me Goin' " to James P. Johnson's raggy, swinging piano accompaniment in the late 1920s is not far from boogie, and the Spivey girls (particularly Addie, though Victoria was famous for her "Moanin' Blues") ventured right on into a loping, crude boogie beat. The great R & B numbers of Big Mama Thornton, Etta James, Tina Turner, and Janis Joplin in the 1950s and 1960s are inconceivable without Bessie's and Rainey's all-out, deep-voiced, gender-bending performances, and the fact that R & B was a feminine as well as a masculine tradition underlines its debt to the feminine city blues of the 1920s. Billie

Holiday's oft-emphasized debt to Bessie's records for her jazz vocal style is no greater (if as great) than her unacknowledged debt to Ethel Waters, like Billie a pop/jazz rather than blues singer, but no longer in favor with the musicians Billie worked with. The envious Ethel snubbed Billie at the start of her career and Billie was not one to forget a slight; for their troubled relations, see Donald Clarke, *Wishing on the Moon: The Life and Times of Billie Holiday* (New York: The Viking Press, 1994), 74, 138, 209. Bessie was, in any case, as important to R & B as to jazz, and even Waters had heirs there. However well mannered and musically pop her style, she long had a specialty (as did Bessie and Ma Rainey) in the "dirty" lyrics that would be central to R & B. Daphne Duvall Harrison, *Black Pearls: Blues Queens of the 1920s* (New Brunswick, N.J.: Rutgers University Press, 1988) and Dexter Stewart Baxter, *Ma Rainey and the Classic Blues Singers* (New York: Stein and Day, 1970) are useful studies of the women's blues tradition. Burton Peretti is excellent on the masculinist bias of jazz (and jazz critics) in *The Creation of Jazz* (Urbana: University of Illinois, 1992); Hazel Carby, " 'It Just Be Dat Way Sometime': The Sexual Politics of Women's Blues," in *Unequal Sisters*, ed. Ellen Carol DuBois and Vicki L. Ruiz, stresses the gender aspects of the women's blues in the 1920s. Sandra Lieb, *Mother of the Blues: A Study of Ma Rainey* (n.p.: University of Massachusetts Press, 1981) is an excellent study of the tradition as well as of Rainey. Samuel B. Charters and Leonard Kunstadt, *Jazz: A History of the New York Scene* (1962; rpt., New York: Da Capo, 1981) details the early commercial development of the city blues; Porter Grainger and Bob Pickett, *How to Play and Sing the Blues Like the Phonograph and Stage Artists*, is cited here (97–98). Robert W. Dixon and John Goodrich, *Recording the Blues* (New York: Stein and Day, 1970) and *Blues & Gospel Records 1902–1942* (London: Storyville Publications, 1969) document the industry's response and the development of the Black Swan label; Arnold Shaw, *The Jazz Age* discusses the white craze for the blues.

On the **survival of Africanisms in Black English**, see J. L. Dillard, *Black English* (New York: Random House, 1973); Peter H. Wood, *Black Majority* (New York: Alfred A. Knopf, 1974), especially Chapter 6; Melville J. Herskovits, *The Myth of the Negro Past* (1941; rpt., Boston, Mass.: Beacon Press, 1990), especially Chapter 8; Lorenzo Turner, *Africanisms in the Gullah Dialect* (Chicago, Ill.: University of Chicago Press, 1949); and William A. Stewart, "Continuity and Change in American Negro Dialects," *The Florida FL Reporter*, 6 (1968). Richard Alan Waterman argues for the African elements in Negro music in "African Influence on the Music of the Americas," in *Mother Wit*, ed. Alan Dundes. Janheinz Jahn identifies African survivals in the blues in "Residual African Elements in the Blues," in *Mother Wit*; D. K. Wilgus, "The Negro-White Spiritual," also in *Mother Wit*, is a useful, brief survey of the scholarship on the black and white, African and Euro-American, elements in the spirituals.

Nathan Irving Huggins describes the separations and horrors of slave ship crossings in *Black Odysseus: The Afro-American Ordeal in Slavery* (New York: Pantheon, 1977). On Nat Turner, see Stephen B. Oates's compelling narrative *The Fires of Jubilee: Nat Turner's Fierce Rebellion* (New York: Harper & Row, 1975). Northerners commenting on black eagerness for literacy after the Civil War are cited in Levine, *Black Culture and Black Consciousness*, 155–56. Howells's relationship to Charles Chestnutt is covered in Kenneth S. Lynn, *William Dean Howells: An American Life* (New York: Harcourt Brace, 1970). Du Bois, "Criteria of Negro Literature," is collected in W.E.B. Du Bois, *Writings* (New York: Library of America, 1986); Robert Kerlin's review of *Cane* is cited in Henry Louis Gates, Jr., *Figures in Black*, 219. William Dixon's remark that the whites "didn't own the music I heard" is cited in Levine, *Black Culture and Black Consciousness*, 297; the Negro who distinguished between biblical "tex'" and "de gospel" in Levine, 26. On

Aframerican use of the Bible, see the superb study by Theophus H. Smith, *Conjuring Culture: Biblical Formations of Black America* (New York: Oxford University Press, 1994); Lawrence Levine is also excellent on black biblical culture in *Black Culture and Black Consciousness*. See Bruce A. Rosenburg, *Can These Bones Live?* (Urbana: University of Illinois, 1988) and William H. Pipes, *Say Amen, Brother!* (Detroit, Mich.: Wayne State University Press, 1992) for the Bible in black preaching. James H. Cone, *The Spirituals & the Blues: An Interpretation* (New York: Harper & Row, 1972) and Jon Michael Spencer, *Blues and Evil* (Knoxville: University of Tennessee Press, 1993) are valuable discussions of the religious and spiritual meanings of the blues.

On the Bible as wisdom literature and spiritual expression, see two classic studies, Mary Ellen Chase, *The Bible and the Common Reader* (rev. ed.; New York: Macmillan, 1952), short on scholarly references but expressive and insightful, and the magisterial, erudite, and sometimes wrenching Arthur Weiser, *The Psalms: A Commentary*, trans. Herbert Hartwell (Philadelphia, Pa.: Westminster Press, 1962). I am also immeasurably indebted to my studies of the Bible as wisdom literature with the late Morton Bloomfield at Harvard University, during my training as a Ph.D. candidate in Medieval Studies in 1966–70; his example, the power of the text he explicated, and my own needs made me a regular, dedicated, grateful Bible reader.

The Dorothy Parker sketch in which a young man discovers with horror that he's been talking about his "soul," "You Were Perfectly Fine," is in *The Portable Dorothy Parker* ed. Brendan Gill (New York: The Viking Press, 1973). The themes of success-as-failure and selling out are constant in Parker's work, as they are in the plays of George S. Kaufman, S. N. Behrman, Ben Hecht, and Philip Barry. See Dorothy Parker and Elmer Rice, *Close Harmony* (New York: Samuel French, 1929); Edna Ferber and George S. Kaufman, *Stage Door* (Garden City, N.Y.: Doubleday, 1936); George S. Kaufman and Herman J. Mankiewicz, *The Good Fellow* (New York: Samuel French, 1926); George S. Kaufman and Marc Connelly, *Beggar on Horseback* (New York: Boni & Liveright, 1924) and *Merton of the Movies* (New York: Samuel French, 1922); George S. Kaufman, *The Butter and Egg Man* (New York: Samuel French, 1924); George S. Kaufman and Moss Hart, *Merrily We Roll Along* (in *Six Plays by Kaufman and Hart*, ed. Brooks Atkinson [New York: Modern Library, 1942]); S. N. Behrman, *The Second Man* (New York: Samuel French, 1928) and *No Time for Comedy* (New York: Random House, 1939); Philip Barry, *Holiday*, in *Famous American Plays of the 1920s*, ed. Kenneth MacGowan (New York: Dell, 1959); and Ben Hecht, *Nothing Sacred*, a screenplay of 1937. Hecht also worked on the Dorothy Parker/Alan Campbell/Robert Carson screenplay for *A Star Is Born* (1937), an overwrought depiction of what could be called the "fallen man" motif that reached its apogee in the fiction of Hemingway and Fitzgerald (particularly Hemingway's "Snows of Kilimanjaro" [1936] and *To Have and Have Not* [1937], and Fitzgerald's *Tender Is the Night*).

Herman Mankiewicz commented on what he took to be the hollowness of Kaufman's lamentations over the loss of his soul, specifically in *Merrily We Roll Along* (1934), about a successful, wealthy, but increasingly corrupt, unhappy playwright named Richard Niles, based on Kaufman himself, and his friendship with an alcoholic idealist named Julie Glenn, patently modeled on Dorothy Parker (Kaufman and Parker, the two wittiest people in New York, both Jewish, were uneasy allies and rivals): "Here's this wealthy playwright who has repeated successes and earned enormous sums of money, has mistresses as well as family, an expensive town house, a luxurious beach house, and a yacht. The problem is: how did the son-of-a-bitch get into this jam?" (cited in Malcolm Goldstein, *George S. Kaufman* [New York: Oxford University Press, 1979], 233). Who really cares, Mankiewicz seems to query, about the soul? Apparently, however, *he* did—as the script of

Citizen Kane he co-wrote with Orson Welles amply testifies—and Niles's degeneration is so frightening, grim, and moving as to ruin, reviewers noted, the comic mood of *Merrily We Roll Along.* One observer tells Niles: "You've only got so many good years, and when they're gone . . . if you haven't made use of them . . . you've got nothing" (162). Niles is in a small understated way another of the Faust figures that dot 1920s literature, selling their souls for the "good years" but failing to make use of them.

Mamie Smith's career and style are detailed in Samuel Charters and Leonard Kunstadt, *Jazz*; see also the entry on her by William Barlow in *Black Women in America,* ed. Darlene Clark Hine, 2 vols. (New York: Carlson, 1993). For **Bessie Smith**'s life and career, I have relied on the informative, intelligent Chris Albertson, *Bessie* (New York: Stein and Day, 1972). For studies of her music, see Edward Brooks, *The Bessie Smith Companion* (New York: Da Capo, 1982); *Bessie,* ed. Clifford Richter (New York: Walter Kande & Son, 1975); Richard Hadlock, *Jazz Masters of the '20s* (New York: Macmillan, 1972); Will Friedland, *Jazz Singing* (New York: Macmillan, 1990); Linda Dahl, *Stormy Weather* (1984; rpt., New York: Limelight Editions, 1992); and Gunther Schuller, *Early Jazz: Its Roots and Musical Development* (New York: Oxford University Press, 1968), a detailed, technical, exciting, authoritative discussion. For responses to her by musicians, see *Hear Me Talkin' to Ya': The Story of Jazz as Told by the Men Who Made It,* eds. Nat Shapiro and Nat Hentoff (1955; rpt., New York: Dover, 1966), an invaluable source of contemporary views on jazz and its heroes.

Bix Beiderbecke's career is exhaustively, intelligently detailed in Robert M. Sudhalter and Philip R. Evans, *Bix, Man and Legend* (New Rochelle, N.Y.: Arlington House, 1974); Ralph Barton, *Remembering Bix* (New York: Harper & Row, 1974) is also valuable, and Chip Deffaa, *Voices of the Jazz Age: Profiles of Eight Vintage Jazzmen* (Urbana: University of Illinois Press, 1992) sheds new light on the life, especially its end, detailing a go-nowhere affair Bix had in his last year with a young woman who understood nothing about his music—a sad effort to show his parents that he was getting his life together. Important discussions of his art can be found in *Hear Me Talkin' to Ya',* which gives the accounts of his peers; Richard Hadlock, *Jazz Masters of the '20s;* Gunther Schuller, *Early Jazz;* James Lincoln Collier, *The Making of Jazz;* and Martin Williams, *The Jazz Tradition* (rev. ed., New York: Oxford University Press, 1983). See also *We Called It Music* (1947; rpt., New York: Da Capo, 1992), a memoir by Bix's friend Eddie Condon (with Thomas Sugrue). James Fernandez writes that "the last shall yet be first" in "Persuasions and Performances: Of the Beast in Everybody . . . and the Metaphors of Every Man," *Daedalus* 101 (1972), 45.

On the **Chicago jazz world** from which Bix came, see William Howland Kenney, *Chicago Jazz: A Cultural History, 1904–1930* (New York: Oxford University Press, 1993), which is excellent on both Bix and **Louis Armstrong**. Sidney Bechet, with Bix and Armstrong the greatest jazz talent to visit Chicago in the 1920s, has left a superbly moving memoir, *Treat It Gentle* (New York: Hill & Wang, 1960); see also John Chilton, *Sidney Bechet, The Wizard of Jazz* (New York: Oxford University Press, 1987). Armstrong reminisces about working with Bix and Bessie, the Chicago–New York scene, and changing styles in jazz, in Richard Merryman, *Louis Armstrong—A Self-Portrait: The Interview* (New York: Eakins Press, 1971). For Armstrong, I have relied also on Gary Giddins, *Satchmo* (New York: Doubleday, 1988), a balanced, savvy, gorgeously illustrated, wonderfully written study that analyzes and celebrates Armstrong's self-proclaimed dual status as "actor and musician." While usually settling in Chicago, all the New Orleans musicians visited New York and left their mark. Bechet was a profound influence on Ellington when he gigged in his band; Armstrong revolutionized the sound of Fletcher Henderson's musicians during his stay, and Jelly Roll Morton, who claimed to have turned ragtime

into jazz, affected Harlem stride piano. The influence was mutual, notably in Armstrong's case. Although he played with Henderson for only fourteen months in 1924–25—Henderson wouldn't let him sing, and worse, his hard-drinking musicians weren't, to Louis's mind, "serious" about their music—he idolized Bert Williams and Bojangles, both of whom commanded a mass audience that no jazz musician to date had found. By his own account in his *Self-Portrait*, New York, as Armstrong experienced it recording and gigging with Henderson and playing at Connie's Inn on his return in the late 1920s, made him "show business" and audience-conscious as the musically formative years in Chicago did not. From then on, he put his money on what he called "showmanship," the New York commodity. Many jazz musicians, however, lamented the move from Chicago to New York, which they found overcommercialized and unfriendly.

On **Jelly Roll Morton**, see Alan Lomax, *Mister Jelly Roll: The Fortunes of Jelly Roll Morton, New Orleans Creole and "Inventor of Jazz"* (1950; rpt. New York: Pantheon, 1993). There is as yet no altogether satisfying biography of **Duke Ellington**, but see the essay by him in Leonard Feather, *The Encyclopedia of Jazz* (1960; rpt., New York: Da Capo, n.d.), which is the transcription of a taped interview with Ellington; see also James Lincoln Collier, *Duke Ellington* (New York: Oxford University Press, 1987) and John Edward Hasse, *Beyond Category: The Life and Genius of Duke Ellington* (New York: Simon & Schuster, 1993). Ellington's memoir, *Music Is My Mistress*, conveys the man at his most charming; Mercer Ellington with Stanley Dance, *Duke Ellington in Person: An Intimate Memoir* (Boston, Mass.: Houghton Mifflin, 1978) is a son's revealing account of life with a very difficult and sometimes cruel, even sadistic, genius. *The Duke Ellington Reader*, ed. Mark Tucker (New York: Oxford University Press, 1993) is a masterful, indispensable compendium of criticism and reminiscences spanning Ellington's entire career, including a *Variety* pseudo-hip review of his first show at the Cotton Club in 1927, pronouncing his "jazzique just too bad" and urging New Yorkers to "get a load of the Cotton Club" (32). Recordings by Mamie Smith, Bessie Smith, Bix Beiderbecke, Louis Armstrong, and Duke Ellington are listed in the Selected Discography.

Only repeated, prolonged immersion in the recordings, memoirs, and what film clips we have of black performers of the 1920s can instruct us on performance as the heart of the black aesthetic, as black psychology. All theory must be fact-specific, if only because, while facts can get along without theory, theory can't exist without factual data; I distrust the current practice of taking anthropological theories based on studies of specific cultures and applying them to other, quite differently culturally situated styles and traditions. Theory—valid in itself, useful, even indispensable in circumnavigating the new, expanded, multicultural, multigendered curriculum—is here nothing but a superhighway over reality, a poor substitute for thorough, broad research and detailed, specific knowledge, a kind of cocaine high in which facts are blurred by fake velocity. But a number of anthropological works offer important starting points for understanding **black performance**, most notably Victor Turner's pathbreaking work, *From Ritual to Theatre: The Human Seriousness of Play* (New York: PAJ Publications, 1982) and *The Anthropology of Performance* (New York: PAJ Publications, 1987). Richard Schechner has amplified Turner's theories ably in *Performance Theory* (new and expanded ed.; New York: Routledge, 1988); Richard Bauman, *Verbal Art as Performance* (Austen: University of Texas Press, 1977) discusses the importance of performance for "emergent culture[s]" in ways very suggestive for the development of blues and jazz. *Performers and Performances: The Social Organization of Work*, eds. Jack B. Kammerman and Rosanne Mortorella (New York: Praeger, 1983) analyzes the interaction between social work and entertainment styles, as does John Kasson, *Amusing the Million: Coney Island at the Turn of the Century*

(New York: Hill & Wang, 1978). On black performance styles, see Ben Sidran, *Black Talk* (1970; rpt., New York: Da Capo, 1971); *Black America*, ed. John Szwed (New York: Basic Books, 1970); and Roger Abraham, *Deep Down in the Jungle: Negro Narrative Folklore from the Streets of Philadelphia* (Hawthorne, N.Y.: Aldine Publishers, 1970) and *Positively Black* (Englewood Cliffs, N.J.: Prentice Hall, 1970). John Blassingame, *The Slave Community: Plantation Life in the Ante-bellum South* (New York: Oxford University Press, 1979) examines performance rituals in slave culture. Levine is illuminating on performance throughout *Black Culture and Black Consciousness*, as is Giddins in *Satchmo* and Kathy Ogren in *The Jazz Revolution* (New York: Oxford University Press, 1989).

James P. Johnson on performance techniques of stride pianists is cited in James Lincoln Collier, *The Making of Jazz*, 197. The *Times* review of Roland Hayes is cited in *The Harlem Renaissance*, ed. Bruce Kellner (New York: Methuen, 1984), 162; Minnie Marx in Gary Snyder, *The Voice of the City*, 46. Dorothy Scarborough's worries about the effect of the new media on black folk music are cited in Ogren, *The Jazz Revolution*, 108; black preference for "a mixtery" in Levine, *Black Culture and Black Consciousness*, 26; Bruce Barton's review of Hemingway in James Mellow, *Hemingway* (New York: Houghton Mifflin, 1992), 334. J. A. Rogers quotes Stokowski's praise of the new jazz musicians in "Jazz at Home" in *The New Negro*, ed. Alain Locke.

For **Vachel Lindsay**, see Vachel Lindsay, *The Congo and Other Poems* (New York: Macmillan, 1915) and *The Art of the Moving Picture* (1915; rpt., New York: Liveright, 1970). Du Bois publicly opposed Lindsay's primitivist fantasies in *The Crisis*, to Lindsay's dismay, since he saw "The Congo" and his poem "King Solomon and the Queen of Sheba" as the "prophecy of a colored utopia." Speaking for Du Bois, Joel Spingarn explained to Lindsay in a letter of November 6, 1916, that blacks wanted "a common civilization in which all distinctions of race are blurred (or forgotten)," not a "separate and different" status. The falling out with Du Bois was inevitable; "King Solomon and the Queen of Sheba" was dedicated to Booker T. Washington, one of Lindsay's heroes. For Du Bois, Spingarn, and Lindsay, see Avin Massa, *Vachel Lindsay: Fieldworker for the American Dream* (Bloomington: Indiana University Press, 1970), 162–70. Glenn Joseph Wolfe, *Vachel Lindsay: The Poet as Film Theorist* (New York: Arno, 1973) treats Lindsay's idea of "Hieroglyphics" as a new theory of symbolism. William Drake, *Sara Teasdale: Woman & Poet* (1979; rpt., Knoxville: University of Tennessee Press, 1989), tells the story of Lindsay's passionate, strained infatuation with Teasdale, his deepening depression, and his tragic suicide in 1931.

11 SKYSCRAPERS, AIRPLANES, AND AIRMINDEDNESS

Robert A.M. Stern, Gregor Gilmartin, Thomas Mellins, *New York 1930: Architecture and Urbanism between the Two World Wars*, a masterpiece of scholarship and prose, is the definitive work on New York's architecture in the 1920s, exhaustive, filled with precise information, making imaginative connections between the buildings and the larger metropolitan culture at every turn. *New York 1900: Metropolitan Architecture and Urbanism 1890–1915* (New York: Rizzoli, 1983), by Stern, Gilmartin, and John Massengale, is of equal scope and value. Christopher Tunnard and Henry Hope Reed, *American Skyline: The Growth and Forms of Our Cities and Towns* (Boston, Mass.: Houghton Mifflin, 1953) compares the various architectural schools; John Burchard and Albert Bush-Brown, *The Architecture of America: A Social and Cultural History* (Boston, Mass.: Little, Brown, 1961) is an indispensable over-all history which criticizes the failure to deal with vertical

space by the skyscraper architects, favors the Chicago school, and describes the erection of the Empire State Building in detail; see also Jonathan Goldman, *The Empire State Building Book* (New York: St. Martin's Press, 1980). William R. Taylor's *In Pursuit of Gotham* has an excellent chapter on the skyscraper city as "visual text"; John A. Kouwenhoven, *The Columbia Historical Portrait of the New York* (1985; rpt., New York: Harper & Row, 1972) discusses the origin of the word "skyline." Peter Conrad, *The Art of the City* (New York: Oxford University Press, 1984) makes Fitzgerald's story "May Day" central to its discussion of skyscrapers; the story is in F. Scott Fitzgerald, *Babylon Revisited and Other Stories* (New York: Scribner's Sons, 1960).

Skyscrapers have inspired some of the best writing to date about New York; in a class by itself is Rem Koolhaas, *Delirious New York: A Retroactive Manifesto for Manhattan* which is, as its title suggests, a kind of updated Futurist manifesto about New York's power of intoxication, written with the ferocity of hindsight and filled with breathtaking insights, extraordinary writing, and a passionate, hallucinated love of its subject; it's the starting point and ending place for any consideration of the New York skyscraper, and it led me to spend hours and days walking and looking around New York's buildings—the Chrysler, Empire State, Daily News, and McGraw-Hill buildings in particular became charged, irreplaceable love objects. Paul Goldberger, *The Skyscraper* (New York: Alfred A. Knopf, 1989), also superb, focuses on the heterogeneity and abundance of the Manhattan style. Extremely useful and perceptive are Charles Jencks, *Skyscrapers—Skycities* (New York: Rizzoli, 1980) and Wayne Attoe, *Skylines: Understanding and Molding Urban Silhouettes* (New York: John Wiley, 1981), which speaks of "netting the sky." Robert Hughes, *The Shock of the New* (New York: Alfred A. Knopf, 1981) is an excellent, comparative study of modernist culture. Cervin Robinson and Rosemary Haag Bletter, *Skyscraper Style: Art Deco New York* (New York: Oxford University Press, 1975) and Eva Weber, *American Art Deco* (Greenwich, Conn.: Dorset Press, 1985) are first-rate studies of the Art Deco style that dominated many of New York's skyscrapers, particularly the Chrysler Building. Nathan Silver, *Lost New York* (New York: American Legacy Press, 1967) documents (and laments) the buildings razed to make way for other buildings; *Yesterday's Tomorrows: Past Visions of the American Future*, ed. Joseph J. Corn and Brian Horrigan (New York: Summit Books, 1984) includes pictures of projected plans and designs for the coming urban utopia.

The Woolworth Building is described and eulogized in *The Cathedral of Commerce* (New York: Woolworth Building, 1916). Hugh Ferriss, *The Metropolis of Tomorrow* (1929: rpt., Princeton, N.J.: Princeton Architectural Press, 1986) includes a fine essay by Carol Willis about Ferriss's career and aesthetic. On **Raymond Hood**, see "Man Against the Sky," a profile in *The New Yorker* (April 11, 1931), 24–27; Walter H. Kilham, Jr., *Raymond Hood, Architect: Form Through Function in the American Skyscraper* (New York: Architectural Book Publishing, 1973); and Robert A.M. Stern, *Raymond Hood* (New York: Rizzoli, 1985). On William Van Alen, see Kenneth Murchison, "The Chrysler Building As I See It," *American Architect* 138 (1930), 24–30, an interview. Edward Hopper's *Night Shadows* is reproduced in *Art of the Twenties*, ed. William S. Lieberman (New York: Museum of Modern Art, 1979). Orrick Johns made the comparison between the Radiator Building and **Jack Johnson**; he said the building "broke through the color line" (cited in *New York 1930*, 576). Jack Johnson's career is ably detailed in Denzel Batchelor, *Jack Johnson & His Times* (1956; rpt., London: Weidenfeld & Nicholson, 1990); Al-Tony Gilmore, *Bad Nigger! The National Impact of Jack Johnson* (Port Washington, N.Y.: Kennikat Press, 1975); and Randy Johnson, *Papa Jack: Jack Johnson and the Era of White Hopes* (New York: The Free Press, 1983); Lawrence Levine discusses Johnson's status as a black folk hero in *Black Culture and Black Consciousness*.

Jack London called for a white champion to "remove the golden smile from Jack Johnson's face" (cited in Al-Tony Gilmore, *Bad Nigger!*, 35).

For **Wallace Stevens**'s years in the city, see the intelligent, fair-minded biography by Milton J. Bates, *Wallace Stevens: A Mythology of Self* (Berkeley: University of California Press, 1985). Critical studies that have helped me in understanding Stevens's aesthetic include the superb Helen Hennessy Vendler, *On Extended Wings: Wallace Stevens' Longer Poems* (Cambridge, Mass.: Harvard University Press, 1969), which stresses Stevens as a poet of "eddyings"; Harold Bloom's brilliant *Wallace Stevens: The Poems of Our Climate* (Ithaca, N.Y.: Cornell University Press, 1976), which sees Stevens as peculiarly Emerson's heir, a poet of "surprise and wonder"; and Elisa New, *The Regenerate Lyric* (Cambridge, England: Cambridge University Press, 1983); New first brought "Life Is Motion" to my attention. See also Wallace Stevens, *The Necessary Angel: Essays on Reality and the Imagination* (1951; rpt., New York: Vintage, nd.), for his own statement of his aesthetic. Wallace Stevens, *The Palm at the End of the Mind*, ed. Holly Stevens (1971; rpt., New York: Vintage, 1972) and *The Collected Poems of Wallace Stevens* (1959; rpt., New York: Vintage, 1982) are the standard collections of the poetry; not all the poems are reprinted in both collections. William James's essay "What Makes a Life Significant?" is included in William James, *Essays on Faith and Morals* (New York: Meridian Books, 1967).

For **Houdini**, see Christopher Milbourne, *Houdini: The Untold Story* (New York: Thomas Y. Crowell, 1969) and Harry Houdini, *A Magician Among the Spirits* (New York: Harper Bros., 1924). Edmund Wilson was fascinated by Houdini, whom he saw as the embodiment of secular skepticism, of what one might call the will to *dis*believe; Houdini is determined, in Wilson's words, "never [to be] duped," and this gives him "a certain nervous excitement, as of a man engaged in a critical fight." See "Houdini" and "A Great Magician" in Edmund Wilson, *The Shores of Light* (1952; rpt., New York: Farrar, Straus & Giroux, 1974).

On **Ruth St. Denis**, see the excellent Suzanne Shelton, *Divine Dancer: A Biography of Ruth St. Denis* (Garden City, N.Y.: Doubleday, 1981), which pays special attention to her use of Oriental motifs; on Orientalism and its place in late-Victorian American culture, see T. J. Jackson Lears, *No Place of Grace* (New York: Partheon, 1981). Elizabeth Kendall, *Where She Danced*, a classic work of American Studies written in a prose so buoyant, open, charged, and evocative as to deserve comparison with the work of Scott Fitzgerald, is itself a profound, moving exposition of American light and air, brilliant on St. Denis and the other pioneers of modern dance. Modern dance was largely an American invention, and Kendall downplays the darker side of her figures—St. Denis made a devastatingly bad choice of a partner/husband in the opportunistic, even untalented Ted Shawn, and the mistake shadowed and diminished her career; Isadora succumbed to open alcoholism and a series of affairs with men bent, it seemed, on destroying her; Martha Graham, also an alcoholic, was early as famous for her histrionics of sadistic willpower as for her indisputable genius as a dancer/choreographer—to emphasize modern dance as part of women's rediscovery and assertion of their untrammeled, uncorseted bodies at the turn of the century, involving a "rhapsodic" release of "a primal spirit of animal delight" and a new awareness of the open spaces in which the freed body moves and choreographs its way. In Kendall's words, by putting "a solo human figure in space" (xiv), St. Denis, Duncan, and Graham sought "the means to look at the other world, to colonize it" (213). Isadora "incorporated a new upper body space, and along with it, the air above the stage" (68); Martha Graham's avant-garde costume, made of yards of synthetic jersey, twisting in motion, in *Lamentation* (1930) "recalled . . . a skyscraper reeling" (208).

It can be no accident that dancers left the concert hall for out-of-door movement in the 1900s and 1910s, heading toward California and the promise of Hollywood (where St. Denis established her famous school in 1915), just as buildings were rising in height, planes were first coming into use, and the media were being invented; the air had become an irresistible invitation to the extended play of the human body and imagination. Marshall McLuhan is trailblazing on the media as human wishes come true (a utopian fantasy he at moments shares) in *Understanding Media: The Extensions of Man* (New York: McGraw-Hill, 1964). Jack Earle's story is told in Robert Bogdan, *Freak Show: Presenting Human Oddities for Amusement and Profit* (Chicago, Ill.: University of Chicago Press, 1988).

Roger E. Bilstein, *Flight in America: From the Wrights to the Astronauts* (Baltimore, Md.: Johns Hopkins University, 1984) is a definitive account of the development of aviation. Joseph J. Corn, *The Winged Gospel: America's Romance with Aviation 1900–1950* (New York: Oxford University Press, 1983) is a detailed, imaginative study of the "air-mindedness" cult, full of fascinating Americana. On the pioneers of aviation, see Tom Crouch, *The Bishop's Boys: A Life of Wilbur and Orville Wright* (New York: W. W. Norton, 1989). The two best biographical treatments of Lindbergh are Leonard Mosley, *Lindbergh: A Biography* (Garden City, N.Y.: Doubleday, 1976), which takes a critical view, and Joyce Milton, *Loss of Eden: A Biography of Charles and Anne Morrow Lindbergh* (New York: HarperCollins, 1993), an important, favorable account which details the young Lindbergh's belief in airmindedness, his conviction that aviation would usher in a peaceful utopia, and his subsequent disillusion. Milton rightly sees airmindedness as an extension of something like the Mind-cure ethos, and proves her point by documenting the Lindberghs' late interest in New Age thinking, a resurgence of Mind-cure in the 1950s and 1960s; Anne's *Gift from the Sea*, a best-seller of 1955, was itself an important source of revamped Mind-cure attitudes.

Mary S. Lovell, *The Sound of Wings: The Life of Amelia Earhart* (New York: St. Martin's Press, 1989) is an impartial and compelling account. Amelia Earhart, born in 1897 in Kansas, tried social work and medical school before becoming a pilot; she was a tomboy as a child and a 1920s-style feminist as an adult who denied, of course, that she was a feminist, at least in the older, Victorian sense of the word—her views were simply "modern thinking," she said. She wanted women to emulate men ("Women must try to do things as men have tried" [13]) by choosing lives of hard work, adventurousness, freethinking on manners and morals (she was reluctant to marry, insisting on a contract for marital freedom with her husband, George Putnam), and technological expertise: women should learn "the art of flying by instruments only" (124), she believed, an art that, so far, only men had mastered. Although she was not a natural as a pilot and never became a first-rate one, by 1935 a poll established that she and Eleanor Roosevelt were the best-known women among Americans (Hitler and F.D.R. were the best-known men); she had shrewd commercial instincts, publishing a book after each major flight, one audaciously titled *The Fun of It* (New York: G. P. Putnam, 1932), and a charmingly nonchalant style; turning to her husband over breakfast one morning in 1930, she asked casually, "Would you mind if I flew the Atlantic?" (179). George Putnam, the entrepreneurial head of the famous publishing firm, didn't mind; he published Lindbergh's *We* (1927) and all his wife's books, and pioneered in promotion, once arranging to be kidnapped to publicize a book. As one observer put it: "George would have stopped on the middle of a rotten plank over a chasm a hundred feet deep to broadcast his reaction to a waiting world" (84). Putnam was an appropriate mate for an airminded stuntster; a "conjuror" whose "instinct for the spectacular was

almost occult" (79), in the words of a friend, he seemed at moments to have magical powers himself.

On **Hubert Julian**, see John Peer Nugent, *The Black Eagle* (New York: Stein and Day, 1971) and his own high-spirited memoir, with John Bullock, *Black Eagle* (London: The Adventurers Club, 1964).

See **Constance Rourke**, *American Humor*, for her dazzling interpretation of the **American hybrid identity** that Gilbert Seldes explicated in *The Great Audience* (New York: The Viking Press, 1950). Rourke, a graduate of Vassar, was a professor there from 1910 to 1915, and a frequent visitor to New York. Although she moved back home to Grand Rapids, Michigan, in 1915, where she lived with the strong-minded, tyrannical mother she adored until her death in 1941 at the age of fifty-six, she continued to spend weeks and months every year in New York; a reserved, cool, and enigmatic creature, she nonetheless frequented Harlem clubs and Broadway shows, loved the movies (she sold *Davy Crockett* to Hollywood in 1934, but the movie was never made), jazz, and later swing. Like the skyscrapers, like *The Great Audience*, *American Humor* is a celebration of the polyglot national character.

Paul Poiret, seeking redress against the American clothing business for pirating his designs, rebuked Americans for their habit of imitating others and themselves—they lack, he wrote in *En Habillant l'Epoque* (1930), any sense of "property" and "propriety"; "don't you know," he indignantly demanded, that "to copy is to steal?"—but Rourke saw that the fun, excitement, and risk are greatest when one steals one's style. With no indigenous traditions save what it can export, steal, or fabricate, America has sustained a "grotesque" (the word is not pejorative for Rourke) performance in "mimicry" specializing in borrowings from dazzlingly diverse sources—the British, the Europeans, its own Indians and Negroes; her heroes in *American Humor* are itinerant Yankee peddlers, the shrewd middlemen who passed on the stories and ways of one geographic or ethnic group to others, making American culture an endless chain letter forever being added to, forwarded, and never arriving at a final destination. Like Seldes, Rourke sees American culture as ethnic, racial vaudeville—her first important published piece, which appeared in *The New Republic* on August 7, 1919, was titled "Vaudeville"—as appropriation, transformation, and assimilation, defined as much by its methods of transmission and reproduction as by the content of what is transmitted. In this view, what is most original in American culture is, paradoxical as it may sound, its gift for fast-and-loose imitation, role-playing, and replication, even mass production and media reproduction, the apparently infinite process of change as exchange, the endless reproduction of similar objects, images, and sounds.

Commenting on the new mass-produced fashions cut from cheap fabrics—what Coco Chanel popularized as "the poor look"—that allowed everyone a daily change of attire in class-blind clothes, a businessman in Muncie, Indiana, told the Lynds: "I used to be able to tell something about the [class] background of a girl applying for a job by her clothes, but today I have to wait till she speaks, shows a gold tooth or otherwise gives me a . . . clue" (*Middletown*, 101). The "final decision," as *The New Yorker* put it on November 28, 1925, "as to whether artificial jewelry can ever be considered permanently smart," a question "on which depends the future peace of the world," was answered in the affirmative; wealthy girls who could afford diamonds delighted in glass beads, and working-class girls could now buy that long drop of single-strand pearl necklace *de rigueur* for the flapper's fancier moments. James's "will to personate" was literalized in the 1920s, opening the door to the vast charade in which Rourke locates the promise of American life. Karl Marx's collaborator, Friedrich Engels, strangely enough, made a similar point. Outliving Marx by over a decade (Engels died in 1895), he came to fear that America

would disprove their prophecy of a revolution by an ever more impoverished proletariat against its capitalist masters, thus resisting the reality principle, a law of diminishing returns that Marx championed as sternly as Freud did. In a letter of December 2, 1893, Engels said that "American conditions involve very great and peculiar difficulties" for the spread of Marxist ideas among the working classes. Chief among these difficulties are the diversity of the American people—"Irish . . . German . . . Czechs, Poles, Italians, Scandinavians, etc. And then the Negroes"—and the nation's "prosperity, no trace of which has been seen here in Europe for years now," which allows working-class people to fancy themselves, even to become, middle-class (Karl Marx and Friedrich Engels, *Basic Writings on Politics and Philosophy*, ed. Lewis S. Feuer [Garden City, N.Y.: Anchor, 1959], 458).

EPILOGUE
DESCENT: ''I SHALL BE MORE BLESSED THAN DAMNED''

For **John Held's** later career, see the comprehensive, fully illustrated Shelley Armitage, *John Held, Jr.: Illustrator of the Jazz Age* (Syracuse, N.Y.: Syracuse University Press, 1987); see also John Held, Jr., *Grim Youth* (New York: Vanguard Press, 1930). On **Herbert Hoover**, see the excellent David Burner, *Herbert Hoover: The Public Life* (New York: Alfred A. Knopf, 1978) and Richard Norton, *An Uncommon Man: The Triumph of Herbert Hoover* (New York: Simon & Schuster, 1989). On the *Partisan Review* crowd, see Terry A. Cooney, *The Rise of the New York Intellectuals: Partisan Review & Its Circle* (Madison: University of Wisconsin Press, 1986). On Harlem's radicalization in the 1930s, see Mark Nelson, *Communists in Harlem During the Depression* (New York: Grove Press, 1983) and Cheryl Lynn Greenberg, *Or Does It Explode? Black Harlem in the Great Depression* (New York: Oxford University Press, 1991). Sara Harris, *Father Divine* (1953; rev. ed., New York: Collier Books, 1971) is a lively account. **Adam Clayton Powell, Jr.,** is a seminal figure, combining the insouciance of the 1920s with the more politicized aims that emerged in the black community in the 1930s; see two excellent studies, Charles V. Hamilton, *Adam Clayton Powell, Jr.: The Political Biography of an American Dilemma* (New York: Atheneum, 1991) and the more informal Wil Haygood, *King of the Cats: The Life and Times of Adam Clayton Powell, Jr.* (Boston, Mass.: Houghton Mifflin, 1993). On **Preston Sturges,** see James Curtis, *Between Flops: A Biography of Preston Sturges* (New York: Harcourt Brace, 1982). For the career of **Clifford Odets,** see Margaret Breman-Gibson, *Clifford Odets: American Playwright: The Years from 1906 to 1940* (New York: Atheneum, 1981), a psychoanalytic study. *Six Plays of Clifford Odets*, ed. Harold Clurman (New York: Grove Press, 1979) includes his three hits of 1935, *Waiting for Lefty, Awake and Sing,* and *Till the Day I Die.* Odets's leftist leanings and unstylized penchant for confessional histrionics attracted the satire of the *New Yorker* crowd; see John McCarten, "Revolution's Number One Boy," a profile in *The New Yorker* (January 22, 1936), 21–27; it was the beginning of the war between the older craft ideal of the theater and the new "Method" techniques espoused by what would become the Actors' Studio. For **Robert Sherwood's** move leftward in the 1930s, see John Mason Brown, *The Worlds of Robert E. Sherwood: Mirror to His Times, 1896–1939* (New York: Harper Bros., 1962); S. N. Behrman did a wonderful sketch of Sherwood titled "Old Monotonous" for *The New Yorker* (June 1 and 8, 1940), 33–40, 23–34, that emphasized, albeit wittily, his growing gloom. **Jeanne Eagels's** life and career are detailed in Edward Doherty's

sensationalist *The Rain Girl: The Tragic Story of Jeanne Eagels* (Philadelphia, Pa.: Macrae, Smith, 1930), a contemporary account.

There are a number of excellent studies of **the melodramatic tradition**, its origins, stars, and plays; see in particular Peter Brook, *The Melodramatic Imagination* (New Haven, Conn.: Yale University Press, 1976); David Grimstead, *Melodrama Unveiled: American Theatre and Culture 1800–1850* (1968; rpt., Berkeley: University of California Press, 1987); Frank Rahill, *The World of Melodrama* (University Park: Pennsylvania State University Press, 1967); Gilbert B. Cross, *Next Week—East Lynne: Domestic Drama in Performance 1820–1874* (Lewisburg, Pa.: Bucknell University Press, 1977); Michael R. Booth, *English Melodrama* (London: Herbert Jenkins, 1965); Robert Bechtold Heilman, *Tragedy and Melodrama: Versions of Experience* (Seattle: University of Washington Press, 1968); Arthur Hobson Quinn, *A History of the American Drama from Its Beginnings to the Civil War* (New York: F. S. Crofts, 1946); and *When They Weren't Doing Shakespeare: Essays on Nineteenth Century British & American Theatre*, eds. Judith L. Fisher and Stephen Watt (Athens: University of Georgia Press, 1989), especially the essays by Bruce A. McConachie, Myron Matlow, and Martha Vicinus. See also *American Melodrama*, ed. Daniel C. Gerold (New York City: Performing Arts Journal Publications, 1983), an anthology which includes George Aiken's dramatization of *Uncle Tom's Cabin* (1853) and David Belasco's *Girl of the Golden West* (1905).

The novels by women authors that spawned the largest number of melodramatic dramatizations include Susanna Rowson, *Charlotte Temple* (1791; rpt., New York: Penguin Books, 1991); Mrs. Henry Wood, *East Lynne* (1861; rpt., New Brunswick, N.J.: Rutgers University Press, 1984); Mary Jane Holmes, *Tempest and Sunshine* (1854; rpt., New York: F. M. Lupton, n.d.); Mary Elizabeth Braddon, *Lady Audley's Secret* (1862; rpt., New York: Dover, 1974); E.D.E.N. Southworth, *Retribution: A Tale of Passion* (1849; rpt., Philadelphia, Pa.: T. B. Peterson, 1896), and many of its seventy-odd successors (Mrs. Southworth in bulk is probably the best-selling American author of all time), and, of course, Stowe's *Uncle Tom's Cabin* (1852; rpt., New York: Penguin Books, 1981).

There were some blockbusters by men that became perennials of melodrama as well, most importantly Alexandre Dumas fils, *La Dame aux camélias* (1848); the play version, also by Dumas, is included in *Camille and Other Plays*, ed. Stephen S. Stanton (New York: Hill and Wang, 1957). Charles Fechter, *The Count of Monte Cristo* (1883), based on a novel by Alexandre Dumas, the blockbuster melodrama in which James O'Neill starred for decades (and which his son Eugene could never shake as a model for his own art), is included in *Best Plays of the Early American Theatre: From the Beginning to 1916*, ed. John Gassner (New York: Crown, 1967).

Sarah Bernhardt in France and **Mrs. Minnie Fiske** in the United States hired and directed their own companies, picked their plays, sometimes rewrote them, and established a matrilinear descent. Bernhardt's illegitimate son, Maurice, who adored her, adopted her clothes, makeup, and hairstyle, took her name not his father's (the Prince de Ligne of Belgium), and produced a grandchild apparently more to perpetuate and please his mother than his wife. For books on Bernhardt, see the Bibliographical Essay for Chapter 1. Mrs. Fiske, who brought Ibsen's plays to America, at the age of fifty-six adopted a baby boy she had found abandoned near a Philadelphia theater, and for a year gave him no name. Her husband and manager, Harrison Fiske, explained to the press in 1922 that the child was his wife's property, and she "doesn't have to call him anything if she doesn't want to." The child eventually became "Bolie" (Mrs. Fiske has seen the name on a sign somewhere on the road). See Archie Binns, *Mrs. Fiske and the American Theatre* (New York: Crown, 1955) and Alexander Woollcott, *Mrs. Fiske: Her Views on*

Actors, Acting and the Problems of Production (New York: Century Company, 1917), based on extensive interviews, and one of Woollcott's numerous acts of diva worship.

Mrs. Leslie Carter, who starred in some of David Belasco's most famous melodramas, including *The Heart of Maryland* (1895), *Zaza* (1899), and *Du Barry* (1901), was an all-out diva, extravagant on stage and off. In 1890, fresh from a sensational, scandalous divorce trial in Chicago—women and children had been barred while her husband named half a dozen correspondents and gained custody of their children—Carter threw herself at Belasco's feet, announcing, "If being hurt by people can make one act, I can act!" Belasco, the "wizard" of Broadway, who claimed to understand women as no one else did—"There is a strong strain of woman in my nature . . . there is nothing hidden from me"—played Svengali to her Trilby, and soon made her "hot hysterics," as one critic called them, famous. The two split up when Mrs. Carter married the actor William Louis Payne in 1906. "I would as soon think of the devil taking holy water!" Belasco exclaimed, and refused ever to see her again, though, unsuccessful on her own, she barraged him with touchingly eager letters until his death in 1931. **Belasco** also trained Billie Burke and Mary Pickford, who thought him "the King of England, Julius Caesar, and Napoleon, all rolled into one!" See David Belasco, *The Theatre Through the Stage Door* (New York: Harper Bros., 1919); Craig Timberlane, *The Bishop of Broadway: The Life and Work of David Belasco* (New York: Library Publishers, 1954), which includes many of Carter's letters; and Charles H. Harper, "Mrs. Leslie Carter: Her Life and Acting Career," an excellent unpublished dissertation, University of Nebraska, 1978. For *The Heart of Maryland*, see David Belasco, *The Heart of Maryland & Other Plays*, eds. Glenn Hughes and George Savage (Princeton, N.J.: Princeton University Press, 1941). For other important **actresses of the late-Victorian stage**, see William Weaver, *Duse: A Biography* (New York: Harcourt Brace, 1984); Margot Peters, *Mrs. Pat: The Life of Mrs. Patrick Campbell* (New York: Alfred A. Knopf, 1984) (Mrs. Pat was another of Woollcott's idols); and Nina Auerbach, *Ellen Terry: Player in Her Time* (New York: W. W. Norton, 1987), a rambling but inclusive, insightful study of one of the most influential actresses of the era.

The histrionic style went out of fashion with the advent in the late 1910s of **Alfred Lunt and Lynn Fontanne**, who opposed the star system, refusing even to take curtain calls apart from the rest of the cast, insisted that "the play itself," not the actors, "is what counts," and believed that "nothing is too subtle for theatre audiences if it is lifelike"; see Jared Brown, *The Fabulous Lunts: A Biography of Alfred Lunt and Lynn Fontanne* (New York: Atheneum, 1986), an excellent but unduly pious study which makes no mention of the fact that both actors were gay. Almost every important playwright of the period went on record against melodrama, drawing their stories from real life, contemporary fiction, and newspapers, not the Victorian classics, yet the melodramatic tradition never really died. Belasco continued to have successes into the 1920s. Charles MacArthur collaborated happily with **Ned Sheldon**, who had been discovered by Mrs. Fiske; she made a hit of his melodrama *Salvation Nell* in 1908 (included in *Best Plays of the Early American Theatre*, ed. John Gassner). In the 1910s, Sheldon became bedridden, paralyzed by a lethal case of rheumatoid arthritis, but he continued to minister to friends in his luxurious apartment, becoming a kind of secular saint, an emblem of "sustained gallantry," to John Barrymore, MacArthur, Woollcott, and others, telling them, "You must forgive yourself"; see Eric Wollencott Barnes, *The Man Who Lived Twice: The Biography of Edward Sheldon* (New York: Scribner's, 1956). Versions of *Uncle Tom* were successfully revived into the 1930s (Odets even essaying Simon Legree in a radio presentation); see Harry Birdoff, *The World's Greatest Hit: Uncle Tom's Cabin* (New York: S. F. Vanni, 1947). John Barrymore masculinized the Camille role in movies like *Dinner at Eight*

(1933); the "fallen man" motif, the male protagonist who sells out in the fiction and plays of the day, owed something to Camille.

The theater historian Jack Poggi reminds us that the biggest hits of the 1920s in New York, mainly detested by the Algonquinites, were sentimental blockbusters like Anne Nichols's *Abie's Irish Rose* (1922), Benchley's bête noir, and outside New York, melodrama on stage and screen (where it found a powerful new home) effortlessly kept and enlarged its audience; on film melodrama, see Robert Lang, *American Film Melodrama: Griffith, Vidor, Minnelli* (Princeton, N.J.: Princeton University Press, 1989). George S. Kaufman's entire career can be read as an unsuccessful effort to banish the matriarch of melodrama, who resurfaced in Kaufman and Edna Ferber's *The Royal Family* (1927) and *Dinner at Eight* (1932), and in Kaufman and Hart's *Merrily We Roll Along* (1934), in which a colorful, aging actress of the old school dismisses the plays of Richard Niles (and presumably Kaufman): "What they get away with today! . . . Acting for Christ's sake! Leslie Carter swinging on that bell in *The Heart of Maryland* . . . that was acting' " (*Six Plays by Kaufman and Hart* ed. Brooks Atkinson [New York: Modern Library, 1942], 192). Laurette Taylor, perhaps the most gifted actress of the 1920s, modernized melodramatic timing and brought it to its greatest heights of subtlety in her portrayal of Amanda Wingfield, the dominating mother of Tennessee Williams's first great success, *The Glass Menagerie* (1945); Taylor's late style is impossible to imagine without the melodramatic vehicles in which she served her apprenticeship. See Marguerite Courtney, *Laurette: The Intimate Biography of Laurette Taylor* (New York: Atheneum, 1968), which fully details her invincible charm and tragic alcoholism.

Stanley Cavell has remarked that the presence of the mother produces melodrama while her absence creates comedy; see Stanley Cavell, "Psychoanalysis and Cinema; The Melodrama of the Unknown Woman," in *Trials of Psychoanalysis*, ed. Françoise Meltzer (Chicago, Ill.; University of Chicago Press, 1988). By this definition, much of 1920s self-consciously modern theater can be seen less as comedy than as a not-always-successful quest for comedy. Belasco thought "the capacity to feel" more important in the theater than "intelligence," and what the melodramatic tradition and the largely feminine literature that underlay it offered an generation increasingly terrified by its "hardened heart" was a culture of the feelings; melodrama is the antithesis of irony, representing emotions-in-crisis, emotions to the rescue—someone is "always saving or being saved," to quote Fitzgerald (speaking of his own work)—emotional exhibitionism. Misogynist Louise Bogan praised, almost against her will, the predominately feminine melodramas and sentimental genres of the Victorian and early modern period for keeping "the emotional channels open" in an age "artificial and dry," for possessing "the courage to be adult." For Bogan on women writers, see Elizabeth Frank, *Louise Bogan* (New York: Alfred A. Knopf, 1985), 364–70. Bernhardt, Duse, Carter, and Fiske were routinely associated with the symbolism of the supernatural—"There was thunder and lightning, there was heaven and hell," reported one awestruck Bernhardt fan—and Belasco claimed to be, if not God, aiding God in creating "the grand, divine, eternal Drama"; melodrama, the most powerful theatrical discourse of religious expressiveness in Victorian America, was the suppressed content of the modern secular age.

Freud, who thought of himself as a Faustian figure and studied Goethe's works throughout his career, wrote the seminal text on the pact with the Devil in "A Neurosis of Demoniacal Possession in the Seventeenth Century" (1923), included in Freud, *On Creativity and the Unconscious*, ed. Benjamin Nelson (New York: Harper Bros., 1958). Freud's subject was a seventeenth-century painter and, Freud thought, an hysteric and melancholic who sold his soul to the Devil, fell ill, then was exorcised, only to renew his pact with the Devil, ending finally as a monk, more or less at peace. Freud hypothesizes

that the painter, suffering from the recent loss of his father and a consequent artist's block, wished to become the Devil's son and thus regain his powers, but he acknowledges that, in his various apparitions to the painter, the Devil always had breasts; the painter might be a figure of the "eternal suckling," in Freud's words, who can't "tear" himself from "the mother's breast" (298–99). Freud also explains that "gods can turn into evil spirits when new gods replace them"—"God and the Devil were originally one and the same," in any case (278)—and implies that the Devil is the more powerful incarnation of the God impulse; Freud comes very close here to an open expression of the Satan-worship at the heart of his own creative genius. Generalizing on the essay as a parable of the modern Zeitgeist, one could say that Freud's painter sells his soul to the Devil to get a father and regain his art, only to discover that the father is actually a mother, now become a demon, whom he both fears and desires. For Freud and Goethe, see Freud, "Address Delivered at the Goethe House in Frankfurt" (1930), in SE, Vol. 21 (London: Hogarth Press, 1953–74), 206–12, written when Freud won the prestigious Goethe Prize for "creative work," an honor that pleased him immensely; and Mark Kanzer, "Freud and His Literary Doubles," *American Imago* 33 (1976), 231–43. The era's fascination with **vampires** was another sign of its Faustian inclinations, for Dracula has sold his soul for eternal, albeit mortal, life. See Paul Barber, *Vampires, Burial and Death: Folk-lore and Reality* (New Haven, Conn.: Yale University Press, 1988) for a superb, detailed historical account of the origins of vampire lore. In light of the alcoholism so rampant in the age, it's worth noting that there are historical links between vampires and alcoholics; Barber demonstrates that the people who were believed to have returned from the dead as vampires were usually alcoholics whose corpses showed strange forms of phosphorescent decay (as a result of alcohol toxicity) that could look like signs of life-in-the-grave. David J. Skal, *Hollywood Gothic: The Tangled Web of Dracula from Novel to Stage to Screen* (New York: W. W. Norton, 1990) is a brilliant study of the vampire myth from Bram Stoker's novel *Dracula* (1897) through Bela Lugosi and later interpreters.

Bela Lugosi was a Horace Liveright discovery (and, some noted, a Liveright look-alike); Liveright picked him to star in his production in 1927, though in the original English production of the play by Hamilton Deane and John Baldeston, *Dracula: The Vampire* (1927; rpt., New York: Samuel French, 1933) Raymond Huntley played the lead. Lugosi had come to the States from his native Hungary in 1921, a veteran of the Great War and of European melodrama; his English was primitive when he undertook the part—his famous pauses and elaborate, hissing enunciation were yet another version of immigrant English—and his sinister, slow-motion etiquette and glamorous outfits attracted thousands of letters from women fans. Lugosi, too, was a Faustian figure who repeatedly played, on stage and off, "a half-mad poet [possessed with] the insane energy of a man concerned only with his own demented experiments," in the words of his biographer, Arthur Lennig; he never had another hit comparable to *Dracula*, though he worked in films into the 1950s, also playing Las Vegas, and died in 1956 after decades of drug addiction and abusive relationships. See the superb Arthur Lennig, *The Count: The Life and Times of Bela "Dracula" Lugosi* (New York: G. P. Putnam, 1974). The movie *Frankenstein* grossed twice as much as *Dracula* did, earning $1 million; on Boris Karloff and his relationship with Lugosi, see Gregory William Mank, *Karloff and Lugosi: The Story of a Haunting Collaboration* (London: McFarland, 1990). On the European interest in symbols of evil, see the excellent, encyclopedic Bram Djikstra, *Idols of Perversity: Fantasies of Feminine Evil in Fin-de-Siècle Culture* (New York: Oxford University Press, 1986). It should be remembered that the vampire, who suckles others at his breast, giving them blood, is, like the seventeenth-century painter's Devil, feminine as well as masculine; see Franco Moretti, "The Dialectic of Fear," in *Signs Taken for Wonders*, trans. Susan

Fischer, David Forgass, and David Miller (New York: Verso, 1988). On *King Kong*, see Orville Goldner and George E. Turner, *The Making of King Kong: The Story Behind a Film Classic* (New York: A. S. Barnes, 1975). James Snead, *White Screen: Black Images* (New York: Routledge, 1994) is provocative and insightful on the film's racial implications. On the monster genre as central to the American imagination, see David J. Skal, *The Monster Show* (New York: W. W. Norton, 1993).

On Fitzgerald's burial and his religious beliefs, see Joan M. Allen, *Candles and Carnival Lights: The Catholic Sensibility of F. Scott Fitzgerald* (New York: New York University Press, 1978). Hemingway, too, held something like real religious beliefs until the end of his life, though he increasingly feared that he was excluded from redemption; see H. R. Stoneback, "In the Nominal Country of the Bogus: Hemingway's Catholicism and Biographies," in *Hemingway: Essays of Reassessment*, ed. Frank Scafella (New York: Oxford University Press, 1991), a defense of Hemingway's Catholicism as central to his life and art and one of the finest articles ever written about him. See also Gregory H. Hemingway, *Papa: A Personal Memoir* (Boston, Mass.: Houghton Mifflin, 1976), a restrained, moving, and convincing account which never loses sight of Hemingway's superstitious and religious side. It is interesting that a number of 1920s writers (including Dorothy Parker) turned to Catholicism or other forms of religious belief, but none went back to the Protestant churches in which they had been raised. On the last days of Sinclair Lewis, see the classic, exhaustive, compassionate biography by Mark Schorer, *Sinclair Lewis: An American Life* (New York: McGraw-Hill, 1961).

SELECTED DISCOGRAPHY
(Asterisked entries are also available on compact discs.)

* *American Musical Theater* (Smithsonian Collection), 4 vols., CBS Records RC 036
* *American Popular Song* (Smithsonian Collection), 4 vols., CBS Records PT17984-7
* *Louis Armstrong and His Hot Five*, Columbia ML 54383
* *Louis Armstrong and His Hot Seven*, Columbia ML54384
 Louis Armstrong and King Oliver (1923–24), Milestone 47017
 Genius of Louis Armstrong (1923–1933), 2 vols., Columbia CG 30416-7
* *The Bix Beiderbecke Story*, 3 vols., Columbia, CL844-6
* *American Songbook Series: Irving Berlin* (Smithsonian Collection), Elektra/Asylum RC 048-1
 Irving Berlin, And Then I Wrote, Time Records S/2113
* *Eubie Blake: Early Rare Recordings*, 2 vols., EBM4-7
* *Big Band Jazz* (Smithsonian Collection), 3 vols, RCA DMK/3-0610A-F
 Lew Leslie's Blackbirds of 1928, Columbia OL6770
* *Duke Ellington: The Beginnings* (1926–28), MCA 1358
* *Duke Ellington: Hot in Harlem* (1928–29), MCA 1359
* *This Is Duke Ellington*, RCA VPM 6042
 George Gershwin: From Tin Pan Alley to Broadway (piano rolls), Mark 56 680
 George Gershwin Plays Gershwin & Kern, Klavier 122E
* *American Songbook Series: George Gershwin* (Smithsonian Collection), RC 048-2
 The Gospel Sound, Columbia 631086, K631595
* *Jazz Piano* (Smithsonian Collection), 4 vols., RC 039
* *James P. Johnson: Rare Piano Rolls*, Biograph 10030, 1009Q
 James P. Johnson 1921–1926, Olympic 7132

° *Best of Al Jolson*, 2-MCA 1002E

Ma Rainey: Blame It on the Blues, Aircheck 20

Ma Rainey: Down in the Basement, Biograph 12001

Music of Rodgers & Hart, Heritage of Broadway, Bainbridge

° *American Songbook Series: Rodgers/Hart* (Smithsonian Collection), RC 048-6

Roots n' Blues: The Retrospective, 1925–30, 4 vols., Columbia C4T 47-911-5

Sissle and Blake's Shuffle Along, New World, NW260

° *The Bessie Smith Story*, 4 vols., Columbia CL 855-58

° *The Smithsonian Collection of Classic Jazz*, 7 vols., CBS Records, R033

° *The Story of the Blues*, Columbia CG3008

Sophie Tucker: Greatest Hits, MCA 263

Sophie Tucker: Cabaret Days, Mercury MG 20046

Fats Waller: Ain't Misbehavin', RCA LPM 1246

Fats Waller: The Joint Is Jumpin', RCA 6288-4

Fats Waller: Piano Solos (1929–41), Bluebird AXM 2-5518

Fats Waller: Rediscovered Solos (from player-piano rolls, 1923, 1926), Riverside 1010

Ethel Waters: The Greatest Years, Columbia KG 31571

Ethel Waters: 1921–4, Biograph 12022

° *Ethel Waters on Stage and Screen (1925–40)*, CSP CCL 2792

An Experiment in Modern Music: Paul Whiteman at Aeolian Hall (Smithsonian Collection), R028

Bert Williams, Nobody, Folksongs RBF 602

Women of the Blues, RCA LPV-534 (includes Mamie Smith, Addie and Victoria Spivey)

INDEX

Making of Americans, The (Stein), 142, 180
Malcolm X, 308, 322, 551
"Maledictions upon Myself" (Wylie), 41
"Ma Man" (Hughes), 374–75
Mamba's Daughters (Heyward), 336, 338, 470
Mamoulian, Rouben, 61
manic depression, cultural, 168–69, 172–74, 472, 524–25
Mankiewicz, Herman, 61, 195, 298, 562–63
Man Nobody Knows, The (Barton), 143
Man's Unconscious Conflict (Lay), 152
Man Who Came to Dinner, The (Kaufman and Hart), 37
Marable, Manning, 316, 509
Marble Faun, The (Hawthorne), 207
marches, 367–68, 372
Marconi, Guglielmo, 190
Marcus, Greil, 480
Marinetti, Filippo Tommaso, 456
Marinoff, Fania, 413
Marks, Edward, 358
Marks, Percy, 52
Marlowe, Christopher (Doctor Faustus), 114, 472
Marx, Karl, 20, 134, 187, 194
Marx Brothers, 61, 112, 381, 382, 430, 558–59
Marxism, 155, 290, 479, 569–70
Mason, Charlotte, 282–88, 290, 291, 333, 336, 542
Mason, Rufus Osgood, 282
Masses, The, 180
Matisse, Henri, 120, 180, 332
"Matriarchate, The" (Stanton), 242
matricidal impulse, 217–53, 533–36; benefits of, 292–99; of Crane, 225–30, 234, 246, 267; of Cunard, 273–78; daughters and, 246–52, 538; Freud on, 229–39, 536; Great War and, 217–18; of Hemingway, 220–30, 246, 269–70, 533–34
Matthews, Gertrude, 383
Matthiessen, F. O., 481
Mauve Decade, The (Beer), 43, 241, 481
"May Day" (Fitzgerald), 435
Mead, Margaret, 49–50, 499

Megrue, Roi Cooper, 66
Mein Kampf (Hitler), 458
Mellow, James, 110, 493, 512
melodrama, 470, 571–72
Melville, Herman, 42, 154, 160, 194, 201, 202, 208, 212, 296–97, 344, 398–99, 493; Lawrence on, 166, 167, 296; "power of blackness" of, 21, 43; Seldes on, 241; works by, see specific titles
Melville, Maria, 297
Melville, Mariner and Mystic (Weaver), 202
Member of the Wedding, The (McCullers), 470
Memphis Students, 104
Mencken, H. L., 90, 97, 109, 244, 305, 370, 469, 476, 499–500; on Astaire, 360; blacks and, 76–77, 81, 93, 306–8, 505; Lewis and, 476; on Mead, 50; on Scopes trial, 49; on Woodrow Wilson, 164; works by, see specific titles
Mental Healers (Zweig), 152, 165
Merman, Ethel, 102, 356
Merriam, Charles, 292
Merrily We Roll Along (Kaufman and Hart), 55, 562–63
Merry Widow, The (Lehár), 356
Mesmer, Franz Anton, 152
Messenger, The, 88, 290, 313, 314, 324, 325, 468
Metcalf, Louis, 417
Metro-Goldwyn-Mayer, 189
Metropolis of Tomorrow, The (Ferris), 435, 438, 441, 447, 566
Metropolitan Life Insurance Company Building, 436
Meynell, Viola, 202
Mezzrow, Mezz, 417, 418
Michaels, Walter Benn, 523, 526, 549
Micheaux, Oscar, 458
Middletown (Lynd and Lynd), 39
Midler, Bette, 249
Milestone, Lewis, 363
Milhaud, Darius, 352
Millay, Edna St. Vincent, 15–17, 23, 25, 27, 48, 55, 70, 71, 82, 90, 98, 124, 212, 498–99
Miller, Flournoy, 378